Abstraction in the Twentieth Century

Abstraction in the Twentieth Century: Total Risk, Freedom, Discipline by Mark Rosenthal

GUGGENHEIM MUSEUM

Abstraction in the Twentieth
Century: Total Risk, Freedom,
Discipline

Solomon R. Guggenheim Museum
February 9–May 12, 1996

This exhibition is sponsored by
Philip Morris Companies Inc.

ISBN 0-8109-6890-8 (hardcover)
ISBN 0-89207-167-2 (softcover)

Printed in Germany by Cantz

Hardcover edition distributed by
Harry N. Abrams, Inc.
100 Fifth Avenue
New York, New York 10011

Guggenheim Museum Publications
1071 Fifth Avenue
New York, New York 10128

*cover and frontispiece to chapter 2:
Detail of Vasily Kandinsky,* Black Lines,
December 1913 (fig. 12).

*frontispiece to introduction: Detail of Piet
Mondrian,* Composition with Grid 4
(Lozenge); Composition in Black and
Gray, *1919 (figs. 2 and 21).*

*frontispiece to chapter 1: Detail of Claude
Monet,* Grainstack (Snow Effect), *1891
(fig. 3).*

*frontispiece to chapter 3: Detail of Vladimir
Tatlin (after),* Model for "The
Monument to the Third International,"
*1920, built 1983 by Smithsonian Institution
Office of Exhibits Central and the
Hirshhorn Museum and Sculpture Garden
(fig. 69).*

*frontispiece to chapter 4: Detail of Jackson
Pollock,* Number 3, *1950 (fig. 120).*

*frontispiece to chapter 5: Detail of
Eva Hesse,* Untitled (Rope Piece), *1970
(fig. 204).*

Contents

1
Introduction

5
Chapter 1
Into the Twentieth Century: Prelude to Abstraction

11
Chapter 2
The Pioneers

65
Chapter 3
Between the Wars

93
Chapter 4
Recovering the Self and Other Directions

163
Chapter 5
Extreme Statements

238
Notes

259
Chronology
Ivy Barsky, Rebecca Butterfield, Denise McColgan

301
Selected Bibliography

306
Index of Reproductions

Lenders to the Exhibition

The Josef and Anni Albers Foundation
Albright-Knox Art Gallery, Buffalo
Harry W. and Mary Margaret Anderson
Art Gallery of Ontario, Toronto
Ambassador and Mrs. Donald Blinken
Irma and Norman Braman
The Carnegie Museum of Art,
 Pittsburgh
Paula Cooper, New York
Des Moines Art Center
Mr. and Mrs. Daniel W. Dietrich II
Mr. and Mrs. Thomas Dittmer, Chicago
Ralph and Helyn Goldenberg
The Greenwich Collection Ltd.
The Grinstein Family
Peggy Guggenheim Collection, Venice
Solomon R. Guggenheim Museum,
 New York
Haags Gemeentemuseum, The Hague
Ronnie and Samuel Heyman, New York
Hirshhorn Museum and Sculpture
 Garden, Smithsonian Institution,
 Washington, D.C.
Mrs. Ruth Horwich, Chicago
Indiana University Art Museum,
 Bloomington
Annely Juda Fine Art, London
Ellsworth Kelly
Kunstsammlung Nordrhein-Westfalen,
 Düsseldorf
Mr. and Mrs. Robert Lehrman
Henry S. McNeil, Jr., Philadelphia
The Menil Collection, Houston
Milwaukee Art Museum
Adriana and Robert Mnuchin
Moderna Museet, Stockholm
The Montreal Museum of Fine Arts
Musée d'Art Moderne de la
 Communauté Urbaine de Lille,
 Villeneuve d'Ascq
Musée National d'Art Moderne, Centre
 de Création Industrielle au Centre
 Georges Pompidou, Paris
The Museum of Contemporary Art,
 Los Angeles
Museum of Fine Arts, Boston
The Museum of Modern Art, New York
The Patsy R. and Raymond D. Nasher
 Collection, Dallas
National Gallery of Art,
 Washington, D.C.
Öffentliche Kunstsammlung Basel,
 Kunstmuseum
Panza Collection
Philadelphia Museum of Art
Mr. and Mrs. David N. Pincus
Robert Rauschenberg
Lyn and George Ross
Rostovo-Yaroslavskij Arkhitekturno-
 Khudozhestvennyj Muzej-
 Zapovednik, Russia
Mr. and Mrs. Keith L. Sachs,
 Philadelphia
The Saint Louis Art Museum
Mrs. Hannelore B. Schulhof
Seattle Art Museum
Richard Serra
Estate of Robert Smithson
Stedelijk Museum, Amsterdam
Frank Stella

Tate Gallery, London
Fundación Colección Thyssen-
 Bornemisza, Madrid
University Art Museum and Pacific
 Film Archive, University of California
 at Berkeley
Wadsworth Atheneum, Hartford,
 Connecticut
Walker Art Center, Minneapolis
John Weber Gallery, New York
Whitney Museum of American Art,
 New York
Yale University Art Gallery, New
 Haven, Connecticut

Lenders who wish to remain anonymous

This exhibition provides a singular opportunity to examine the birth and growth of abstraction, the artistic style that has dominated our century. Abstract artists left behind the age-old goal of imitating reality. Instead, they searched for new means of expression and powerful emotional resonances in gesture, light, color, shape, and texture. Through these essential elements, they achieved a new kind of art, one that has proven nearly universal.

At Philip Morris, we have supported innovation in the arts for nearly forty years. For much of that time, we have also enjoyed a productive relationship with the Guggenheim, a museum whose fundamental mission is closely tied to the pioneering art of abstraction. This exhibition is especially exciting because it brings together a century's worth of abstract masterpieces in one of the most unique spaces ever built for the presentation of art.

Geoffrey C. Bible
Chairman and Chief Executive Officer
Philip Morris Companies Inc.

Foreword

More than any other artistic style or orientation, abstraction has prevailed as the defining aesthetic of twentieth-century art. It has been promoted by some as a beacon of hope, an infinitely beautiful realm of spirituality articulated in a universal visual language. Others have deployed abstraction as the end of art, arguing that, as the purest form of visual expression, it offers nowhere further for art to evolve. In between these two ideologies are many who have taken less extreme positions, where negation and spirituality comfortably co-exist. Whatever their differences, abstract artists share a fundamentally important conviction: the rejection of representation.

In its earliest manifestations, abstract art was described as nonobjective (*gegenstandslos*)—literally "against the object"—and in 1939, in solidarity with the sentiments expressed by such art, the Guggenheim opened its doors as the Museum of Non-Objective Painting. The museum's collection gave Americans—and New York artists in particular—their first extensive exposure to the paintings of Vasily Kandinsky, one of the great pioneers of abstraction, as well as work by a range of European innovators in this still revolutionary style. The Guggenheim, while no longer devoted solely to abstract art, has continued to champion abstraction through its collections and exhibitions. It is only fitting, then, that as the turn of the century approaches, this museum is mounting the first major exhibition to examine abstraction from its beginnings early in this century through the present day.

Abstraction in the Twentieth Century: Total Risk, Freedom, Discipline was conceived and organized by Mark Rosenthal, formerly Consultative Curator at the Guggenheim and now Curator of Twentieth-Century Art at the National Gallery of Art, Washington, D.C. As enormously complex undertakings, both the exhibition and publication have required painstaking research guided by clear and thoughtful vision. Rosenthal has deftly succeeded in presenting a commanding and sensitive interpretation of the subject.

Crucial works were necessary if the story of abstraction was to be told correctly and with the appropriate emphases. This has been made possible through the splendid generosity of the institutional and private lenders who, in recognizing the historic nature of this project, graciously agreed to lend works from their collections. We are most appreciative of their patience and kindness.

Abstraction has always been the preserve of those daringly inclined artists willing to court risks in order to attain unimagined freedom of expression. We are deeply grateful to Philip Morris Companies Inc. for having recognized the significance of this enterprise and the unique position it holds in the soul of the Guggenheim Museum.

Thomas Krens
Director
The Solomon R. Guggenheim Foundation

Acknowledgments

This project has existed in my imagination in various forms for many years. I always felt that the remarkable phenomenon of abstract art was staring at the inhabitants of the twentieth century, ubiquitous and yet unrecognized. There was even a false start on an exhibition some twenty years ago, which should have indicated to me then that this enterprise would have a difficult birth. That it finally has seen the light of day is due to many individuals who believed in its value and encouraged my efforts. I am grateful to James Elliott, Anne d'Harnoncourt, Hilton Kramer, and Robert Rosenblum for their expressions of enthusiasm, which propelled the project forward at various times. Thomas Krens next took up the enterprise, and has been remarkably supportive of it at the Guggenheim Museum, where it certainly belongs. Earl A. Powell III graciously accepted the time constraints that this project placed on my work in Washington.

I am deeply appreciative of the kindness and invaluable generosity of all the institutional and private lenders. Without their help, my dream for an historic overview of abstraction could never have become a reality. I express my gratitude in particular to those professional colleagues who through the extraordinary loan commitments of the following institutional lenders showed a special belief in this project: Douglas Schultz, Director, and Michael Auping, former Chief Curator, Albright-Knox Art Gallery, Buffalo; Paul Winkler, Director, and Walter Hopps, Founding Director and Consulting Curator of Twentieth-Century Art, The Menil Collection, Houston; Glenn Lowry, Director, Kirk Varnedoe, Chief Curator of Painting and Sculpture, and Cora Rosevear, Assistant Curator of Painting and Sculpture, The Museum of Modern Art, New York; Earl A. Powell III, Director, National Gallery of Art, Washington, D.C.; Anne d'Harnoncourt, Director, and Ann Temkin, Curator of Twentieth-Century Art, Philadelphia Museum of Art; James Burke, Director, and Jeremy Strick, Curator of Modern Art, The Saint Louis Art Museum; Rudi Fuchs, Director, Stedelijk Museum, Amsterdam; and David Ross, Director, and Adam Weinberg, Curator of Permanent Collections, Whitney Museum of American Art, New York.

I am also grateful to the many other colleagues and their institutions whose generous loans made this exhibition possible: Nicholas Fox Weber, Executive Director, The Josef and Anni Albers Foundation; Glenn Lowry, former Director, and Maxwell Anderson, Director, Art Gallery of Ontario, Toronto; Phillip Johnston, Director, and Richard Armstrong, Chief Curator, The Carnegie Museum of Art, Pittsburgh; I. Michael Danoff, Director, Des Moines Art Center; Philip Rylands, Deputy Director, Peggy Guggenheim Collection, Venice; J. L. Locher, Director, Haags Gemeentemuseum, The Hague; James Demetrion, Director, Neal Benezra, Director of Public Programs and Chief Curator, and Valerie Fletcher, Curator of Sculpture, Hirshhorn Museum and Sculpture Garden, Smithsonian Institution, Washington, D.C.; Adelheid M. Gealt, Director, Indiana University Art Museum, Bloomington; Armin Zweite, Director, Kunstsammlung Nordrhein-Westfalen, Düsseldorf; Russell Bowman, Director, Milwaukee Art Museum; Björn Springfeldt, Director, Moderna Museet, Stockholm; Pierre Théberge, Director, The Montreal Museum of Fine Arts; Jöelle Pijaudier, Chief Curator, Musée d'Art Moderne de la Communauté Urbaine de Lille, Villeneuve d'Ascq; Germain Viatte, Director of Exhibitions, Musée National d'Art Moderne, Centre de Création Industrielle au Centre Georges Pompidou, Paris; Richard Koshalek, Director, and Paul Schimmel, Chief Curator, The Museum of Contemporary Art, Los Angeles; Malcolm Rogers, Director, Trevor Fairbrother, Curator of Contemporary Art, and Robert Boardingham, Assistant Curator of European Paintings, Museum of Fine Arts,

Boston; Katharina Schmidt, Director, Öffentliche Kunstsammlung Basel, Kunstmuseum; Vjacheslav Alexandrovich Kim, Director, Rostovo-Yaroslavskij Arkhitekturno-Khudozhestvennyj Muzej-Zapovednik, Russia; Mary Gardner Neill, Director, and Patterson Sims, former Associate Director and Chief Curator, Seattle Art Museum; John Weber, John Weber Gallery, New York, on behalf of the Estate of Robert Smithson; Nicholas Serota, Director, Tate Gallery, London; Tomás Llorens, Chief Curator, Fundación Colección Thyssen-Bornemisza, Madrid; Jacqueline Baas, Director, University Art Museum and Pacific Film Archive, University of California at Berkeley; Patrick McCaughey, Director, Wadsworth Atheneum, Hartford, Connecticut; Kathy Halbreich, Director, Walker Art Center, Minneapolis; and Susan Vogel, Director, and Sasha Newman, former Curator of European Art, Yale University Art Gallery, New Haven, Connecticut.

I am most appreciative also of the generosity of the following private collectors who have so kindly agreed to lend their important works: Harry W. and Mary Margaret Anderson; Ambassador and Mrs. Donald Blinken; Irma and Norman Braman; Mr. and Mrs. Daniel W. Dietrich II; Mr. and Mrs. Thomas Dittmer; Ralph and Helyn Goldenberg; The Greenwich Collection Ltd.; The Grinstein Family; Ronnie and Samuel Heyman; Mrs. Ruth Horwich; Mr. and Mrs. Robert Lehrman; Henry S. McNeil, Jr.; Adriana and Robert Mnuchin; The Patsy R. and Raymond D. Nasher Collection; Panza Collection; Mr. and Mrs. David N. Pincus; Lyn and George Ross; Mr. and Mrs. Keith L. Sachs; Mrs. Hannelore B. Schulhof; and those lenders who wish to remain anonymous.

The art dealers who particularly helped my cause were Doris Ammann, Thomas Ammann Fine Arts, Zurich; Ernst Beyeler and Claudia Neugebauer, Galerie Beyeler, Basel; Paula Cooper, Paula Cooper Gallery, New York; Renato Danese, formerly C&M Arts, New York; Anthony d'Offay and Lorcan O'Neill, Anthony d'Offay Gallery, London; Larry Gagosian and Andrew Fabricant, Gagosian Gallery, New York; Joseph Helman, Joseph Helman Gallery, New York; Rhona Hoffman, Rhona Hoffman Gallery, Chicago; Annely Juda, Annely Juda Fine Art, London; Arne Glimcher and Susan Dunn, PaceWildenstein, New York; and John Weber, John Weber Gallery, New York.

Many artists directly participated in this exhibition in numerous ways, and I am most grateful for the kindness, patience, and support of Carl Andre, Helen Frankenthaler, Ellsworth Kelly, Richard Long, Agnes Martin, Martin Puryear, Robert Rauschenberg, Gerhard Richter, Robert Ryman, Richard Serra, and Frank Stella. I would also like to thank all those in the artists' studios who participated in this project, especially Earl Childress, Trina McKeever, Jack Shear, and David White.

I am most appreciative of others who supplied important information and support, including David Anfam, Berta Katz, Jaap van Lier, Barry Rosen, and Andrew and Denise Saul. The help and support of Zelfira Tregulova, VUART-VKHPO, Moscow, has been instrumental to the success of this project.

I could not be more grateful to Philip Morris Companies Inc. for its interest and generous support, in particular Stephanie French and Karen Brosius for their unflagging enthusiasm and assistance. Philip Morris has provided substantial and innovative support for cultural programs for nearly forty years, and I am proud that this exhibition can be counted as one of its projects.

Many individuals at the Guggenheim Museum have provided invaluable assistance, starting with Carole Perry, Curatorial Assistant, who has been the principal force in steadily and carefully shepherding the many details of this enterprise to completion; she was preceded by

Theresa Bramlette, who also did a splendid job. Michael Govan, former Deputy Director, and Lisa Dennison, Curator of Collections and Exhibitions, helped on a myriad of loan and organizational matters. Diane Waldman, Deputy Director and Senior Curator, provided counsel, too, on numerous occasions.

I am most grateful to Lynne Addison, Exhibitions Registrar, for skillfully overseeing all aspects of transportation and insurance. My thanks also go to Pamela Myers, former Administrator for Exhibitions and Programming, and Kelly Parr, Project Assistant, for their keen insight into many design issues. Thanks also to Peter Read, Jr., Manager of Fabrication and Exhibition Services, Adrienne Shulman, Lighting Technician, David Johnson, Fabrications, Jon Brayshaw, Fabrications, Richard Gombar, Construction/Exhibition Services Supervisor, and Christopher Skura, Technical Specialist. The talent and professionalism of the installation team—especially Scott Wixon, Manager of Installation and Collection Services; David Veater, Senior Exhibition Technician; Joseph Adams, Senior Exhibition Technician; and James Cullinane, Exhibition Technician—have also been instrumental to the success of this project.

I express my gratitude also to Paul Schwartzbaum, Assistant Director for Technical Services and Chief Conservator, and Gillian McMillan, Conservator, who meticulously saw to the care and safety of the works in this exhibition.

For applying their skill and talent to this project, I thank Anthony Calnek, Director of Publications, and other members of the Publications and Graphic Design departments. Cara Galowitz, Manager of Graphic Design Services, designed this book, and Elizabeth Levy, Production Editor, handled its production. Edward Weisberger, Assistant Managing Editor, oversaw many aspects of the editorial work and photo research, Stephen Robert Frankel edited the essay, and Jennifer Knox White, Assistant Editor, edited the chronology entries; Carol Fitzgerald, Editorial and Production Assistant, contributed to several facets of the publication, and Keith Mayerson provided invaluable assistance. I am also grateful to David Heald, Manager of Photographic Services, who photographed many of the works in this exhibition. Rebecca Butterfield and Denise McColgan provided invaluable research; others who assisted in the research of this book were Margaret Doyle, Karsten Harries, Andreas Huyssen, Joseph Masheck, Lisa Servon, Susan Trauger, Christine Vigiletti, and the staff of Avery Art and Architecture Library, Columbia University. Rebecca Butterfield, who worked on compiling the bibliography, and Denise McColgan were also responsible, together with Ivy Barsky, for writing the entries in the chronology. Cara Galowitz also designed the exhibition didactics, which were edited by Laura Morris, Associate Editor.

Special thanks are also due to Ward Jackson, former Archivist, whose insight, experience, and intimate familiarity with the history of the Guggenheim have been most valuable and appreciated. Mary Sharp Cronson, Producer, Works and Process at the Guggenheim, kindly supported the exhibition through her interest in programming. Marilyn JS Goodman, Director of Education, worked on various educational initiatives, and Matthew Drutt, Assistant Curator for Research, thoughtfully wrote wall texts. Special thanks to Vivien Greene, Curatorial Assistant, for stepping in at the eleventh hour to assist with this project. My gratitude is also extended to Maryann Jordan, former Director of External Affairs, for working tirelessly and successfully on funding; and to Judith Cox, General Counsel; Amy Husten, Manager of Budget and Planning; George McNeely, Director of Corporate and Foundation Giving; and Suzanne Quigley, Head

Registrar, Collections and Exhibitions, for their help in realizing this project. Finally, I thank the curatorial interns who assisted in various ways: Jonathan Applefield, Sarah Bancroft, Jan-Philipp Frühsorge, Clare Rogan, Maximiliana Spinola, and Nicole Zador.

To all those who contributed to the success of this project, I extend my deepest appreciation and gratitude.

M.R.

The twentieth century consists of an astonishing sequence of innovations in nearly every area of endeavor. In the field of art, there has been a startling, previously unimaginable rupture with the past: abstraction. As dramatic in its way as the achievement of manned flight or the invention of the computer, abstraction is uniquely of the period, generating or underlying a great deal of art produced since its inception. Perhaps because of the diversity of its manifestations, abstraction has rarely been examined with the kind of individual attention devoted to other, more specifically defined approaches to art making in this century. Moreover, critics and art historians have tended to subsume all the diverse tendencies of the century within the more general category of "Modernism," and therefore the aspirations of abstract artists demand specific attention. Although abstract artists have not belonged to a single, overtly stated cause or movement, it can be argued that when seen in the context of the whole of art history, the creation of art without recognizable subject matter has been a defining practice.

Until this century, nearly every painting and sculpture produced in the Western world exhibited a subject that was relatively easily recognized by the viewer. Audiences could always grasp at least the outward intention of a depiction, and perhaps even its underlying content, if the work of art was produced by a contemporary in the same geographical locale. But in our period, artists have created paintings and sculptures that have no recognizable subject at all, presuming instead that formal composition is the sine qua non of art. For the uninitiated, this art offers few clues to implicit subject matter or content. As heterogeneous as this impulse has been throughout the century, the fact of its having been sustained for so long offers an important indication of the international strength and vitality of abstraction. Indeed, the tendency of so-called Postmodernist artists to select abstract passages to imitate when quoting or parodying Modernism indicates that abstraction is fundamental to the outlook of modern art. And, despite these Postmodern manifestations, there is no neo-abstract movement, because abstraction has never ceased to exist. It continues to be an enticing and viable alternative for artists.

Unfortunately, there is no single, appropriate term that captures the spirit of the art on which the present volume focuses. For example, if a work is described as "abstract," we might imagine that the artist started with a recognizable source and then reduced its aspects, or "abstracted from" the stimulus. If art is called "nonobjective" or "nonrepresentational," it implies that it has no relationship to objects in nature and rejects the imitation of recognizable forms. To categorize a particular approach to art making as "pure" can be more of an ethical than a stylistic matter, and to call it "absolute" seems a rhetorical position. And if such works as I have in mind are termed "concrete" or "realistic," only an initiate would understand the usage. The issue is further complicated by the existence of some degree of abstraction in all art objects throughout history. After all, even artists who create representational works often employ methods that can be thought of as abstracting—that is, summarizing, abbreviating, and/or stylizing. Perhaps we should accept the problem of terminology as inherent to the concept and history of this approach to art making, and call it "abstraction" because the word is widely accepted in contemporary usage and is therefore a practical and sensible choice.

A comparison of two works from the 1910s, a Cubist painting by Pablo Picasso, *Man with a Violin*, 1911–12 (fig. 1), and an abstract painting by Piet Mondrian, *Composition with Grid 4 (Lozenge); Composition in Black and Gray*, 1919 (fig. 2), may clarify my definition of abstraction. Both artists were engaged in the process of simplification.

In the Picasso painting, the few recognizable elements from the world of appearances (a moustache, a violin) are combined with a nonreferential, linear scaffolding. In effect, the viewer is persuaded to note the similarities between passages of pure form and references to life, or to imagine that the former may signify the latter. When Picasso made extensive use of nondescriptive components, it was for the purpose of building a representation or conception of a place, such as a Parisian café with its inhabitants. Even at his most abstract, Picasso included at least a fragment of something from life—even if just a word—to give his picture a context, for his art is fundamentally about the recognizable world. Thus, sustaining the mainstream tradition of art history, Cubism remained rooted in the matrix of appearances. Moreover, a great deal of twentieth-century art has operated in this in-between sphere, flirting with the completely abstract while refusing to eliminate the knowable, anecdotal realm.

The painting by Mondrian, like all the abstract art I am considering, is hardly, if at all, concerned with this flirtation or with combining the representational and the nonrepresentational. There is no implication of a specific context—the artist's nationality or gender, the year of the work's creation, and so forth—and not the least anecdotal hint remains. If a subject exists, it is so veiled as to emerge only subliminally. Although he began as a painter of traditional landscape and still life, Mondrian does not *seem* to have started this particular painting in the world of appearances, let alone to have been interested in analyzing that area of experience; no reference points or signs are present to help the viewer. Whereas Picasso represented a world outside the picture plane, Mondrian broke free of that long-held relationship between the artwork and a subject. His work intends only to *be*, independent of any reference to the visible, physical world. The differences in intention between Picasso and Mondrian are crucial to the phenomenon of abstraction. But it is indicative of the complexity of the historical issues I am examining that, in 1936, when Alfred H. Barr, Jr. differentiated a general strain of abstraction from the formerly dominant representational tendency, he included *both* Picasso and Mondrian in that new category.[1] Yet in their own time, Picasso and Mondrian each recognized that a line had been drawn in the sand and that they were on opposite sides in the field of twentieth-century art. However similar their works appear in relation to traditional narrative art, and however dependent his development was on the innovations of Picasso, Mondrian made the more complete break with illusionism and representation and established his position as one of the pioneers of pure abstraction.

By leaving the world of appearances out of their work, abstract artists have courted new issues, often with a great deal of self-importance and an avowed sense of adventure. Eva Hesse evoked this adventurous spirit when she described her art as "total risk, freedom, discipline."[2] Operating on an aesthetic frontier—"the edge of the abyss,"[3] in the words of Mondrian—abstract artists have tended to take positions and to proclaim differences with colleagues and the public. To a notable extent, the most revolutionary of these artists have not generally been French. Indeed, they have often rejected the French tradition of empirical rationalism to work in territory that is uncharted and without conventions. The stated rewards of this quasi-rootless existence include the assertion of an exalted state of freedom to act, at least on the artistic plane. Rejection of representation may be seen, then, as a dramatic gesture of defiance with regard to the history of art, and perhaps even a symbolic triumph over the material world. Finally, abstract artists have often claimed a new degree of skilled manipulation of formal means (what Hesse called

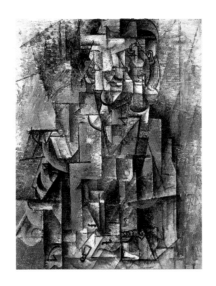

1. Pablo Picasso, Man with a Violin, *1911–12. Oil on canvas, 39 ⅜ x 28 ¾ inches (100 x 73 cm). Philadelphia Museum of Art, The Louise and Walter Arensberg Collection.*

2. Piet Mondrian, Composition with Grid 4 (Lozenge); Composition in Black and Gray, *1919. Oil on canvas, 23 ⅝ x 23 ⅝ inches (60 x 60 cm); lozenge, axes (irregular) 33 ½ - 33 ¼ inches (85 - 84.5 cm). Philadelphia Museum of Art, The Louise and Walter Arensberg Collection.*

"discipline"), as if art had been reinvented and had then assumed a new set of conventions.

Even though artists' interest in, and use of, the word "abstraction" is a crucial aspect of this study, only a few of them ever specifically aligned themselves with the style as if it were a movement. Nevertheless, there is much evidence that links them together, starting with the nonobjective appearance of their productions, and the fact that many of the artists were, or are, motivated by similar beliefs and goals—beliefs and goals not shared by artists who have explored the recognizable world in their work. It therefore seems reasonable to speak of an overriding abstract outlook and style, even if each phase of it is differentiated by its specific context.

Many abstract artists have declared the expression of powerful, personal emotions to be crucial to their art. While eliminating or minimizing referentiality, these individuals have stripped art down to pure expressivity, evoked in correspondingly pure formal terms. Hardly sentimental or effusive, these emotions are depicted in some works as if "recollected in tranquillity" (to use William Wordsworth's phrase) and in others are baldly stated, as if of the moment. Even if occasionally present in earlier art, such heightened sensations—or at least the attempt to express them—are the particular province of abstraction. Abstract art offers a voyage of self-discovery and a means of stating a feeling about the world; when these are successfully integrated in an artist's work, the result is a unique signature style. Moreover, some abstract artists, motivated by idealism, have claimed a morally uplifting purpose and a sublime vision for their art.

To many of its practitioners, abstraction has represented the pole of "high art," whereas representational art, which is merely a likeness, is rooted in the superficial detritus of the world and is thus "low art." The ambition of abstract artists has tended toward the formulation of permanent statements that can stand with eternal and universal phenomena such as are found in nature. Whereas most works of art draw closely on transitory phenomena and our perception of them (as was the case in much nineteenth-century French art, culminating in this century with Cubism) or aspire to the verisimilitude of "realism," the realm of abstract art remains outside the temporal. Abstract works seem to be self-contained worlds unto themselves, with no references or connotations except those that pertain to art. Followers of the nonobjective vision have even held that only through this way of looking at things is a kind of faith in the power of Art maintained, and that only in this kind of art is the individual's uniqueness preserved against a buffeting, all-pervasive society. These arguments hark back to the eighteenth century, to French author and philosopher Denis Diderot, who insisted that art have a high "moral mission,"[4] a purpose that at the time was embodied by history painting.[5] Abstraction is imbued with a similar ideal, in contrast to the still-life approach of the Cubists, for example, whose art alludes to ephemeral events and momentary perceptions, often transformed by a playful attitude.

Rejecting representations of known or recognizable incidents for the expression of "felt" experience, abstract artists have made great demands on the observer. Rather than giving viewers a starting point in the natural world, the abstract artist has required them to suspend disbelief and to instinctively enter into the work of art through the contemplation of phenomena that offer nothing tangible with which to identify. Continuing the analogy to eighteenth-century painting, and drawing on the formulations of Michael Fried, one can speak of abstract art as demanding an "absorptive" state from its viewer. Fried suggested that an artwork that inspires this absorption refuses to acknowledge the viewer's presence;[6] to look at such a work is to

experience something largely impassive, like staring at the ocean. Whether the experience is bewildering or enthralling,[7] intense contemplation is demanded.

However, the creator of an abstract painting or sculpture does not necessarily ignore the viewer altogether, as nature does. The abstract artist usually seeks, at least, to affect viewers and to communicate using the traditional means of visual language. Throughout history artists have expressed serenity by using symmetrical compositions, or agitated states by using diagonal thrusts; artists have even made use of particular facial expressions in their depictions of figures in order to direct the viewer's response.[8] Likewise, an abstractionist may manipulate formal elements to exploit conventional associations. For example, if the black of night is perceived as potentially a time of horrors, then the use of black paint might similarly evoke a sense of foreboding, as in certain compositions by Mark Rothko. Indeed, a viewer might interpret other compositional elements in various abstract works as evoking any number of themes, including anguish, eroticism, exhilaration, turbulence, vulnerability, and wonder. This is not to say that abstract artists have generally sought such specific associations; but it may be the case that an artist, using entirely nonreferential elements, has created an abstract work intended to evoke a quasi-literary subject or a specific meaning. While the nonassociative elements of an artwork are subject matter enough for many of these artists, others have acknowledged their preoccupation with a theme in the usual sense. And fundamental to the work of some abstractionists has been the attempt to give tangible appearance to something that is inherently intangible, if not divine. Consequently, a viewer contemplating an abstract work might ponder whether an ineffable concept is represented there and what its nature is. A number of works, however, are so imbued with the essence of the artist that it is clear that the subject of each work is that essence itself.

Abstraction's inception at the start of the century has been subjected to extensive examination, yet abstraction has rarely been acknowledged as a continuous, century-long phenomenon, a virtual movement that has predominated and remained vigorous throughout the entire period. Indeed, decade after decade, the intellectual and emotional force of abstraction has attracted artists to it, even if each generation has used it differently. No doubt the now-discredited role of doctrinaire formalism is partly to blame for the scarcity of such overviews of abstraction. Usually the subject, if dealt with at all, is buried within or integrated with studies of precisely defined groupings of artists based variously on their overt commitment to a specific program or on their geographical proximity to one another.

Another issue currently inhibiting a broad view of abstraction is the conflicting interpretation of what constitutes an art style, as well as the claim that style is hardly worthy of examination.[9] In art history, style is traditionally defined as a set of visual components that enable us to identify art by its artist, culture, and period, a definition that seems to be more applicable to art preceding the modern period, when societies tended to be more homogeneous. Nevertheless, this kind of analysis is still useful with regard to abstraction. In examining the work of an artist who has chosen an approach consisting of an arrangement of formal elements, viewers can identify it as abstract and as probably belonging to the twentieth century. Hence, abstraction is a visual style from the most basic standpoint: it *looks* different from the art that precedes it and from the other forms of art contemporaneous with it.

Let us consider abstraction as a stylistic category in itself, with certain underlying premises, whether one assumes that a style is strictly defined by its visual attributes, or that it is a synthesis of these

and a content shared by its practitioners (as in fifteenth-century Italian painting, for example). All abstract art focuses exclusively on arrangements of shape, line, and color, and therefore may be regarded as sharing this single approach, even if there are substyles based on variations within that approach. In their deliberate rejection of recognizable imagery, abstract works are often about nothingness— nothingness being a positive quality that encompasses many phenomena beyond the realm of objects, current events, and history.

From its start, abstraction quickly became a pliant vehicle for various points of view, each peculiar to a particular place and time. The abstract artworks of each generation and locale are permeated with intentions, psychological motivations, period concerns, and historical conditions that differ from one to the next, even if such attributes might not be apparent. Consider, for instance, the ongoing practice of monochrome painting since Kazimir Malevich initiated it around 1918. Although Aleksandr Rodchenko may have considered his own *Last Painting*, 1921 (fig. 72), to be the final word on the subject— and painting's death knell—Ad Reinhardt, Ellsworth Kelly, Yves Klein, and Robert Ryman all felt that they had something new to add to it. Each of these artists, inspired by motives peculiar to their time and place as well as personal aims, reinvigorated and made a particular "endgame" strategy of the monochrome mode. If we examine abstract art as it has changed through the century, and note the external forces that influenced or shaped it, abstraction itself emerges as something much larger, more forceful and ambitious, more resilient and characteristic of the century than has previously been recognized.

My aim is to present the kind of overview of this century of abstraction that an art historian living a hundred years from now might write—that is, to imagine having the increased perspective and objectivity that time is alleged to impart to the retrospective observer. Although this notion is useful to my enterprise here, it is impossible to pretend that complete impartiality is possible. I became interested in art during the late 1960s, when formalism was a dominant concern. I believed then that abstraction was an all-pervasive development that had swept aside all other modes and movements and that it would continue to maintain its dominant position and determine the future agenda of art. It did not turn out that way. And, furthermore, there has been no inexorable, steadily evolving progress in the development of abstraction, akin to early explanations of Italian Renaissance art as a systematic evolution toward more and more accomplished depictions of natural space.[10] Indeed, advances have occurred, if at all, in fits and starts, with only occasional moments of progressive thinking and deliberate self-criticism. Instead, the internal needs and expressive intention of each individual artist has taken precedence.

The subject of abstraction is vast, and neither the exhibition that inspired this book nor a study of this size can encompass all of it. What follows, then, is a selective history, with an effort at delineating the basic terrain of this still-developing subject. While the familiar sources of early abstraction are reviewed, as is the expansion of the abstract impulse from painting to other mediums, the core of my discussion concerns the phenomenon of abstraction as an ongoing revolution in the history of art, including analyses of its frequent changes in character and context, and the reactions to it. This endeavor is simply an early attempt—and hardly the last word—at distinguishing some of the stations on the journey of abstraction.

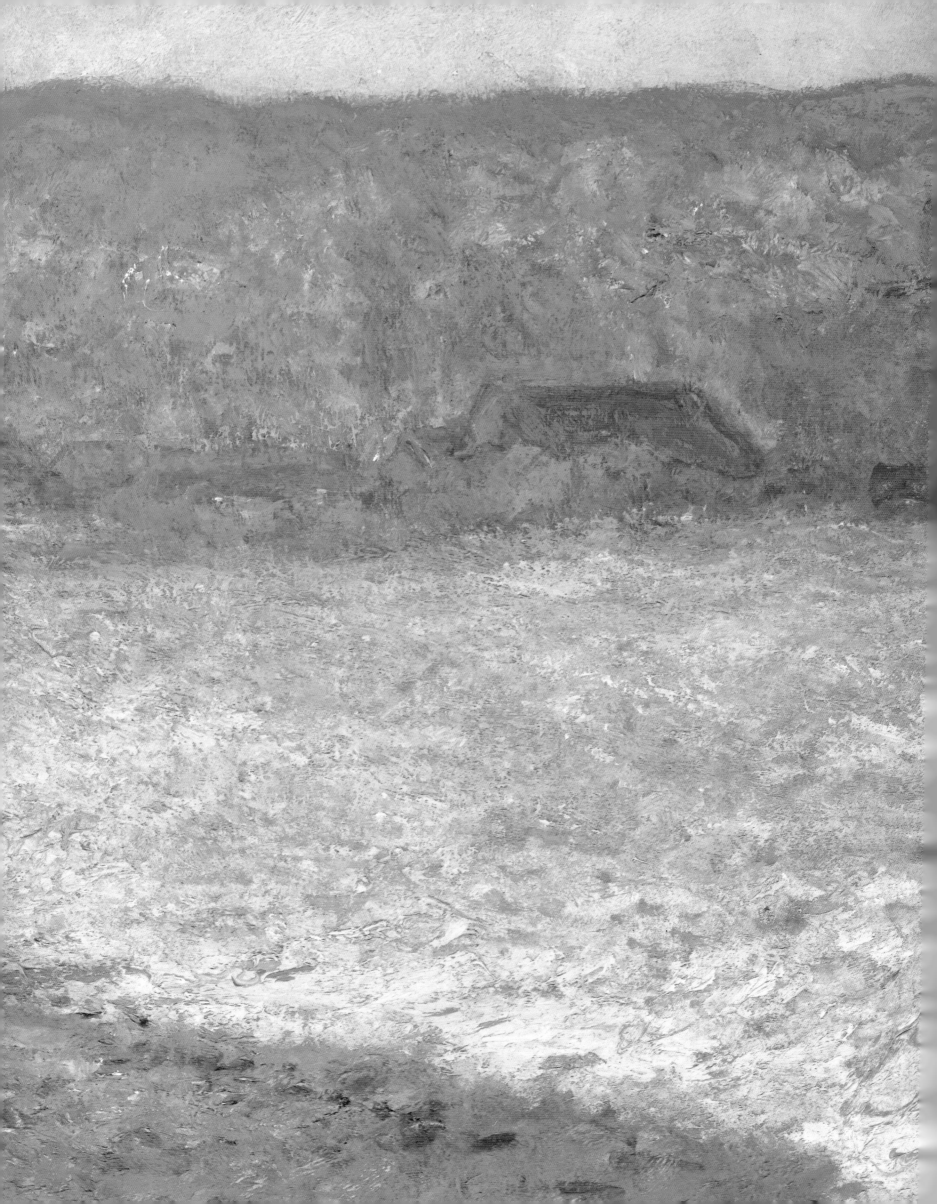

When Vasily Kandinsky, one of the pioneers of abstraction, attributed his innovations in that area partly to his viewing of a *Grainstack* painting by Claude Monet (for example, fig. 3; see also Chronology),[1] he delineated the French context of abstraction's birth. From the mid-nineteenth century to the early twentieth century, Paris was the unchallenged cultural capital of the West, and it was where the most progressive art was being practiced. Artworks created in Paris, whether they radiated a sense of "luxe, calme, et volupté" (as Charles Baudelaire put it in his poem "L'Invitation au voyage"), delightful anecdotal incident, or intense concentration on analytic and perceptual concerns, dominated thinking throughout Europe.

French Impressionism was the specific springboard for the initial forays into abstraction. Kandinsky was astonished by the indecipherability of Monet's works, in which the motif appears to be lost in a coloristic harmony and an abstract atmosphere.[2] With regard to both paint handling and theme, Impressionism generally seemed to celebrate an unprecedented degree of spontaneity and freedom from conventional, academic thinking,[3] to such an extent that the freely drawn sketch was held in high esteem.[4] Spatial distortions—whether a high or absent horizon, cutoff views, or disjunctive connections—suggested a playful, if not disrespectful, attitude toward the apparent stimulus for a picture. But Impressionism contained within it a mixed message for future abstractionists, because, in the profoundest sense, it was based on Realism. Even when the subject seemed to become a mere motif, as in the hands of Paul Cézanne, the artist never entirely severed the work's relationship with nature.[5]

Nevertheless, in the work of Cézanne and several other French Post-Impressionist painters, the traditional subject became less important and/or less defined than it had been; in the writings of these artists, one even comes across some discussion of the potential of the process of abstraction. Without actually using the word "abstraction," Cézanne referred to the abstracting process when he described distilling a picture from a source: "constructions after [nature] . . . suggested by the model."[6] Paul Gauguin was more extreme: "Do not paint too much after nature. Art is an abstraction; derive this abstraction from nature while dreaming before it, and think more of the creation which will result than of nature. Creating like our Divine Master is the only way of rising toward God."[7] For Gauguin, an abstraction replaces a specific motif, the latter becoming merely the stimulus for "dreaming." So elevated is the resultant object that the artist ascends toward the realm of the Creator. Moreover, Gauguin particularly valued a work if it was "absolutely incomprehensible," thereby attaining "complete abstraction."[8] Although in his own works his theories yielded complex narratives rather than purely abstract compositions, his words predicted later developments.[9]

In their paintings, Gauguin and his friend Vincent van Gogh exalted the instinctual and spiritual aspects of art, an approach that influenced the principles of the early abstractionists. Van Gogh was less enamored of the practice of abstraction than Gauguin,[10] but he found inspiration in the "abstractions" of music. He regarded the art of musical composition, which uses a self-contained language without reference to the observable world, as a higher achievement than most painting.[11] His interest in music was fueled by its apparent emphasis on "felt" experience and its capacity for personal expression by using purely formal means.[12] The application to painting of such an approach further eroded the practice of faithfully rendering a motif or subject and, instead, favored an art imbued with intense feeling or suggestive of a revelation.

These ideas were reinforced and codified in the various strains of French Symbolism—for example, Jean Moréas asserting in 1886 that he wanted to "objectify the subjective"[13] by using arbitrarily applied color and line, or distortion. Symbolist artists stressed their subjective and emotional perceptions, and insisted that ineffable qualities should replace the experiences of daily life as the subject of art. In this regard, Symbolism drew on a reservoir of prehistoric and tribal thinking that valued the expression of something unseen, perhaps even divine.[14]

Symbolism, together with several related tendencies in late-nineteenth-century and early twentieth-century art, spawned theories and practices that contributed to the development of abstraction. Various trends—first the Arts and Crafts movement in England, then Art Nouveau in France and Jugendstil in Germany and Austria—integrated the fine arts and the decorative arts, while emphasizing the free use of color and line for expressive purposes at the expense of narrative concerns. August Endell, a graphic designer in Munich, wrote in 1898 about an art that he designated "Form-art [*Formkunst*]," with "forms, which are like nothing known, that represent nothing and symbolize nothing, that work through freely found forms, as music does through free tones . . . which will carry the human heart away to intoxicating enthusiasm and unimaginable delight."[15] (See fig. 4.) Endell was one of many who recognized the potentially rich psychological possibilities of formal and decorative elements once these were released from descriptive function, likening the effect to that produced by music. Also in Germany, Adolf Hölzel had begun, in the period just before 1900, to make drawings he called "Abstract Ornaments" (fig. 5),[16] thereby linking the word "abstract" to a term taken from decorative art.

Influenced by Gauguin, Maurice Denis became an important Symbolist spokesman in France. He minimized subject matter in his famous prescription of 1890: "It is well to remember that a picture—before being a battle horse, a nude woman, or some anecdote—is essentially a plane surface covered with colors assembled in a certain order."[17] Elsewhere, Denis elaborated on the expressive possibilities of color, explaining that emotions indicative of spiritual states could be communicated by this means.[18]

In England, American expatriate James Abbott McNeill Whistler, whose art from the 1860s onward manifested a private aesthetic order that foreshadowed the Symbolists, was intent on substituting a concern for subject matter with a formalist emphasis on color and line.[19] In his *Nocturne* series of the 1870s, Whistler replaced objective description with subjective impressions and atmospheric effects, an antinarrative approach in which the evocation of mood and a nuanced suggestion of form were paramount. "Art for art's sake" became the watchword of artists who shared such views, many of whom regarded music as the art form to be emulated.[20] Whistler, in his "Ten o'Clock" lecture of 1885, made the comparison to music explicit: "Nature contains all the elements, in colour and form, of all pictures, as the keyboard contains the notes of all music. But the artist is born to pick, and choose, and group with science, the elements, that the result may be beautiful—as the musician gathers his notes, and forms his chords, until he bring forth from chaos glorious harmony."[21] Whistler's ideas had much in common with the Arts and Crafts movement in England, within which Symbolist concepts were made programmatic. The participants in that movement had a messianic view of the power of art to wage war with the forces of materialism, the goal of which was spiritual enlightenment and a utopian society.[22]

It is notable that many of the new ideas were expressed in the context of the decorative arts, the realm of the nonutilitarian "decorative" having become an alternative to narrative concerns,[23] and

3. *Claude Monet*, Grainstack
(Snow Effect), *1891. Oil on canvas,
25 ¼ x 36 ⅛ inches (65.4 x 92.3 cm).
Museum of Fine Arts, Boston, Gift of
Misses Aimée and Rosamond Lamb in
Memory of Mr. and Mrs. Horatio A.
Lamb.*

a breeding ground for abstraction. Particularly important to the development of abstraction was the specific element of ornament, including the simpler, more rectilinear designs of Scottish architect and designer Charles Rennie Mackintosh and the related work of Henry van de Velde, a Belgian painter, designer, and theorist. Van de Velde had a profound influence in Britain and Germany. He championed the notion of "one style principle: that of the rational conception of every form," which led him to reject ornament that imitated nature in favor of a more abstract ornament "realized in the play of proportion and volume, suffused with a rhythm that animates and transports."[24] Ornament was long seen as allowing for arbitrary play apart from a functional—that is, representational—role. Karsten Harries has traced this approach to ornament back as far as the rococo style of the late Baroque period, and to philosopher Immanuel Kant, who, in his *Critique of Judgment* (1790), demonstrated that "the requirements of a completely free beauty and of representation are . . . incompatible."[25] Free beauty, for Kant, arises from a degree of self-containment not found in representation. In his own time, Kant could name only music and ornament among the arts that manifest the qualities of beauty and independence, arts that he described as "free from all servitude, free even from representation and thus abstract."[26] As early as Kant, then, "abstraction" appears as a goal of art, and is associated with an exalted view of decorative art.

Historically, decorative elements were characterized by flatness and emphatic surface adornment, formal qualities that, along with the term "decorative" itself, came to have positive connotations in many of the arts through the late nineteenth century.[27] Decoration was linked by the Symbolists to painting too, as if that art form's most intrinsic qualities up to then—representation and spatial organization—were now of lesser importance.[28] The work of the turn-of-the-century Vienna Sezession group, whose members were referred to as "style-artists [*Stilkunstler*]" by contemporary critics, epitomized some of these concerns. Style—or stylization—was the overriding issue, with decorative and design tendencies displacing naturalism.

By rejecting traditional narrative subject matter, Symbolist artists established the foundations of formalism, an approach associated with early modern art. In nineteenth-century Germany, this emphasis on the significance of an artwork inhering in its formal qualities can be traced from the materialist historical ideas of Gottfried Semper to the theory of "pure visibility" articulated by Conrad Fiedler and the antinarrative notion of sculptural form developed by Adolf von Hildebrand, which culminated in the art-historical formulations of Heinrich Wölfflin.[29] This approach stressed the importance of the structural elements of a work of art more than the subject depicted, with the result that national and period differentiations were minimized. Hildebrand, who was a sculptor himself, perceived a close kinship between sculpture and architecture, thus emphasizing the architectonic in the visual arts[30] and helping to liberate sculpture from anecdotal tendencies. These interests peaked during the 1910s in England in the art criticism of Clive Bell and Roger Fry, particularly in the former's notion of "significant form."[31] Their models were not, however, contemporaneous abstractionists[32] but the Impressionists and Post-Impressionists, who created the "ultimate triumph of form over content."[33] With this "triumph," abstract and decorative interests became the focal point for progressive artists, and formalism became linked with avant-gardism. Beverly H. Twitchell has described how, with the rise of the avant-garde, the dissemination of these values led to concomitant elitist and apolitical points of view, and that this "cult of purity" left many viewers alienated and hostile.[34]

However, even in more mainstream art circles, there was dissatisfaction with the pre-existing traditions of sculpture and painting, a growing emphasis on the art object as "object,"[35] and a search for new models among the other arts. As has been noted, music was admired by visual artists and theorists for its expression of emotional and inner states solely through nonreferential, formal elements, without any reliance on narrative and description.[36] Architecture, too, was held up as a model of structure and structural integrity, unencumbered by narrative concerns. Even in literature, traditional descriptive and temporal elements might be eliminated if an author felt that they would inhibit the effective abstract expression of emotions. Poetry, in particular, was seen as the most apt medium in which to eliminate the "inessentials" dictated by tradition, in order to communicate emotions directly.[37]

These artistic developments occurred in the context of late-nineteenth-century Romanticism, the tenets of which were established earlier in the century, during the great "Romantic protest against the Age of Reason," to use the phrase of John H. Randall, Jr.[38] Faith in things irrational, instinctual, and spiritual replaced the beliefs of the preceding Age of Enlightenment, which had stressed rationalized religion, belief in progress, and reliance on mathematics and scientific explanations of the universe. In response to the sense of rootlessness, disillusionment, pessimism, and dread about the world that had accompanied rationalism,[39] Romantics found greatest consolation in varied notions of an infinite realm,[40] with a Hegelian-type Idea underlying all superficial events occurring in the present. The world perceived by the senses was understood to be merely an insubstantial likeness of what existed elsewhere.[41] Fundamental to these concepts was the Idealism of German philosophers Johann Gottlieb Fichte, Georg Wilhelm Friedrich Hegel, Kant, and Arthur Schopenhauer, much of whose writings were devoted to aesthetic matters and who favored various transcendental or fantastic imagery.[42]

In the last decade of the nineteenth century, the forces of the spirit again rebelled against positivistic thinking, this time targeting not only science, but also materialism and naturalism.[43] Leo Tolstoy and Fyodor Dostoyevsky were especially influential, extolling the values of religion as practiced in tribal and peasant societies, truths gained through subjective and emotional means, and a spiritual rebirth triumphing over bourgeois conditions.[44] Such developments resulted in a great flowering of interest, during the succeeding decades, in untraditional religious and occult practices[45] and in the transformative powers of art.[46]

The rapid-fire scientific and technological advances around the turn of the century offered a significant challenge for those who celebrated spiritual values. Subject to analysis by science's increasingly sophisticated investigative methods, phenomena that had formerly proved fertile for Romantic mystification, including the human mind and physical matter, became demystified to a great extent.[47] Moreover, scientific discoveries were greeted with great popular attention, especially the X-ray and the relationship of matter to space and time.[48] In contrast to this forward-thinking trend, German Idealist philosophy, continuing the patterns begun in the late eighteenth and early nineteenth centuries, largely favored metaphysics and "inner understanding." Science was suspected of being a danger to human values, individuality, and creative or irrational inspiration.[49] But the threat that science seemed to pose to artists interested in transcendental ideas during that period was mitigated by a crucial premise of physics: the existence of what was referred to at the time as an unseen "world beyond our senses."[50] This thesis encouraged the

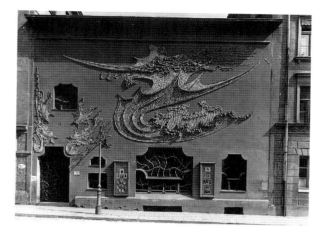

4. August Endell, façade of Atelier Elvira, Munich, ca. 1896.

5. Adolf Hölzel, Black Ornament on Brown Ground, *1898. Ink on paper, 12 ⁹⁄₁₆ x 8 ¼ inches (32.6 x 20.9 cm). Galerie der Stadt Stuttgart.*

postulation of models of how the universe was constructed, and how we perceive its existence—that is, metaphysics. During the nineteenth century, a fascination grew for the concept of the void, infinity, or "nothingness." This was not thought of in a negative sense, but as describing the presence of something specific, which remained to be discovered beneath the dross of ordinary existence by the imaginative observer.[51]

To many who have attempted to describe it, the process of apprehending a deeper reality appears to depend on emotion: reality understood by instinctive means. Central to the experience of both the viewer and the artist-creator, according to some discussions in formalist art writing, is the artist's emotion, which is considered to be embedded in the work of art.[52] That is, the artist is thought either to be filled with an emotional plenitude or to have responded deeply and subjectively to some motif in the world; the resulting emotions fill the work of art to which a receptive viewer might have a corresponding emotional response. Put another way by Søren Kierkegaard, the world is simply there to be "fashioned" by a feeling individual, with artistic formulations taking precedence over narrative depictions of life.[53] The creative individual is thought of as a genius and is accorded enormous dignity for his/her freedom of expression and uninhibited intellect.[54]

There have been various sources for these ideas, including Hegel, who placed considerable emphasis on the faculty of subjectivity;[55] Friedrich Wilhelm Nietzsche, who attacked the rational part of the mind as a factor in producing mediocrity and inhibiting creativity;[56] and Tolstoy, who stressed that art should express emotional responses to the world.[57] But probably the best-known spokesman for these views at the beginning of the twentieth century was a Frenchman, Henri Bergson.[58]

Bergson based his theory of the fluid nature of time and human consciousness on the faculty of intuition, which he described as "the kind of intellectual sympathy by which one places oneself within an object in order to coincide with what is unique in it and consequently inexpressible."[59] For him, one's intellectual apparatus is modulated by emotion. Bergson described rational faculties as passive and as yielding a vision of a static reality, but believed that, with intuition, the individual could acquire an understanding of the world's dynamic qualities and our own existence in time, which he called "duration [durée]."

Bergson's philosophy was based on the concept of a mind possessed of a tremendous freedom to perceive and act. This intuitive and dynamic universal "life force [élan vital]" could be compared to Nietzsche's concept of the "will to power" and to Sigmund Freud's discussion of the "libido."[60] All these formulations glorify the subconscious, a place of enormous insight, creativity, and pure dynamism, acting against the overbearing influence of the rational mind, materialism, and science. By using intuition, spontaneous speculation by the free-associating mind could strive to understand any phenomena in the world. Naturally, for many who followed such a line of thinking, the artist became an important personification of this free-wheeling individual.

At the beginning of the twentieth century, a great dichotomy emerged about the basis of our knowledge of existence, mainly between French and German thinkers.[61] The former (with the exception of Bergson) were convinced of the certainty of science, whereas the latter believed that our ultimate source of understanding lies within our own experience, our own spiritual nature. The French emphasized reason, the Germans, intuition and even exaltation. The fundamental dichotomy was one of physics versus metaphysics—the same dichotomy that distinguishes the context of Cubism (which arose in Paris) from its progeny, abstraction (the development of which occurred mostly outside France).

Cubism, though, set the stage for abstraction. Extending the aesthetic practices of Cézanne, Analytic Cubist painting and sculpture—the initial phase developed from about 1908 to 1912 by Georges Braque and Pablo Picasso—paid particular attention to the object in space and presented it as having no fixed or finite form. These artists "analyzed" an object or figure by depicting it from various points of view simultaneously, breaking it up into a scaffoldlike structure of small conjoined or overlapping planes of color with a few realistic details embedded in it, and rendering the ostensibly empty space around it as tangible and substantial. This approach was in tune with concepts of scientific analysis,[62] and was thoroughly French—that is, inquiring, rational, and confident about advances in modern life.[63] Perhaps due to its abstractness as compared to other contemporary modes of painting, Analytic Cubism was in its own time often considered by its chief apologists to be a "pure" art, manifesting "metaphysical" intentions,[64] descriptions that today are seen to have been misleading.

Magdalena Dabrowski has proposed an excellent analysis of how Cubism established the groundwork for abstraction: (1) Analytic Cubism encouraged a "search for a pictorial language no longer based on the imitation of forms observed in the surrounding world and represented in an illusionistic space"; (2) it established as a format the "linear grid in a shallow space"; (3) it "conceptualized the subject and subordinated it to the pictorial structure"; and (4) with Synthetic Cubism, from 1913 onward, came "flatly painted synthesized forms, abstract space, and the 'constructional' aspect of the composition."[65]

Although various artists have been dubbed "prophets of abstraction,"[66] their efforts had only a slight impact. In this regard, perhaps the most prophetic figure of the early twentieth century was an art historian, Wilhelm Worringer. Worringer wrote a dissertation for the University of Munich in 1906 entitled *Abstraction and Empathy: A Contribution to the Psychology of Style* (first printed privately, as is traditional for German dissertations, in 1907, and then published in 1908).[67] His thesis not only summarizes and schematizes much nineteenth-century thinking that set the stage for the birth of abstraction, but serves as a theoretical counterproposal to the contemporaneous artistic development of Cubism in Paris. Because of his prescience and the value of his synthesis of earlier thinking, it is worth summarizing Worringer's principal concepts. He divided the history of art into two streams or "urges." One urge, which he called "empathy," produced an art that conveys a comfortable relationship with the conditions of life and finds satisfaction in the beauty seen there. The second, which he called "abstraction," expresses an uneasy relationship with the world, inclines toward transcending immediate reality, and seeks "beauty in the life-denying inorganic, in the crystalline."[68] Each of these tendencies are examples of an "artistic volition," by which Worringer, following Austrian art historian Alois Riegl's definition,[69] meant that each embodies latent characteristics of its society; for him, individuals behave instinctively in accordance with their life conditions. The resulting artworks are complex objectifications of each volition, much like cultural artifacts. Worringer elaborated a number of concomitant aspects of each approach. Empathic thought leads to the naturalistic depiction of space, whereas abstract thought leads to the renunciation of such renderings. Worringer explained that abstract artists, when they do deal with objects in their work, remove them from a naturalistic realm

of appearance in order to project a sense of serenity otherwise absent from their world outlook. In this way, the abstract tendency seeks "deliverance from the fortuitousness of humanity as a whole, from the seeming arbitrariness of organic existence in general," and instead desires "contemplation of something necessary and irrefragable."[70] Empathically inclined artists, according to Worringer, have a more tactilely sensuous, rational approach, whereas abstractionists believe that the world is very nearly unfathomable and "mocks all intellectual mastery."[71] Hence, the abstractionist prefers transcendental thinking to assuage his or her anxiety.

Without knowledge of abstract art as we now think of it,[72] Worringer employed examples from history. Comparing Egyptian to Greek art, and medieval to Renaissance art, he declared that Egyptian and medieval art, exemplifying the abstract urge, are characterized by simplified, rectilinear forms and flattened, stylized spaces, whereas Greek and Renaissance art, both of which typify the empathic volition, usually exhibit curvilinear shapes and naturalistically organized spaces. In sum, empathically oriented societies, according to Worringer, project with their art a profound, rational comfort in the realm of appearances; and abstractly inclined cultures experience anxiety and seek refuge in renderings divorced, extracted, or transformed from life, and made transcendent if possible.

It is important to reiterate that Worringer interpreted abstraction as an emotional solution to the torment induced by the flux of the world.[73] In his view, abstraction either psychologically removes viewers beyond their present space and time or, in effect, seeks to eternalize the things of the world. Although Worringer's explanations are quasi-ahistorical and formalistic—based entirely on pictorial structures—they include psychological assessments of the artist-creators in terms of their respective cultural milieus. Using that framework, he attributed the origin of the urge to abstraction to northern European cultures. Worringer's views reinforce much German Romantic and Idealist philosophy, and also speak to a larger sphere that is specifically non-French—that is, Russian, Dutch, and Central European: the orbit in which abstraction was born.[74]

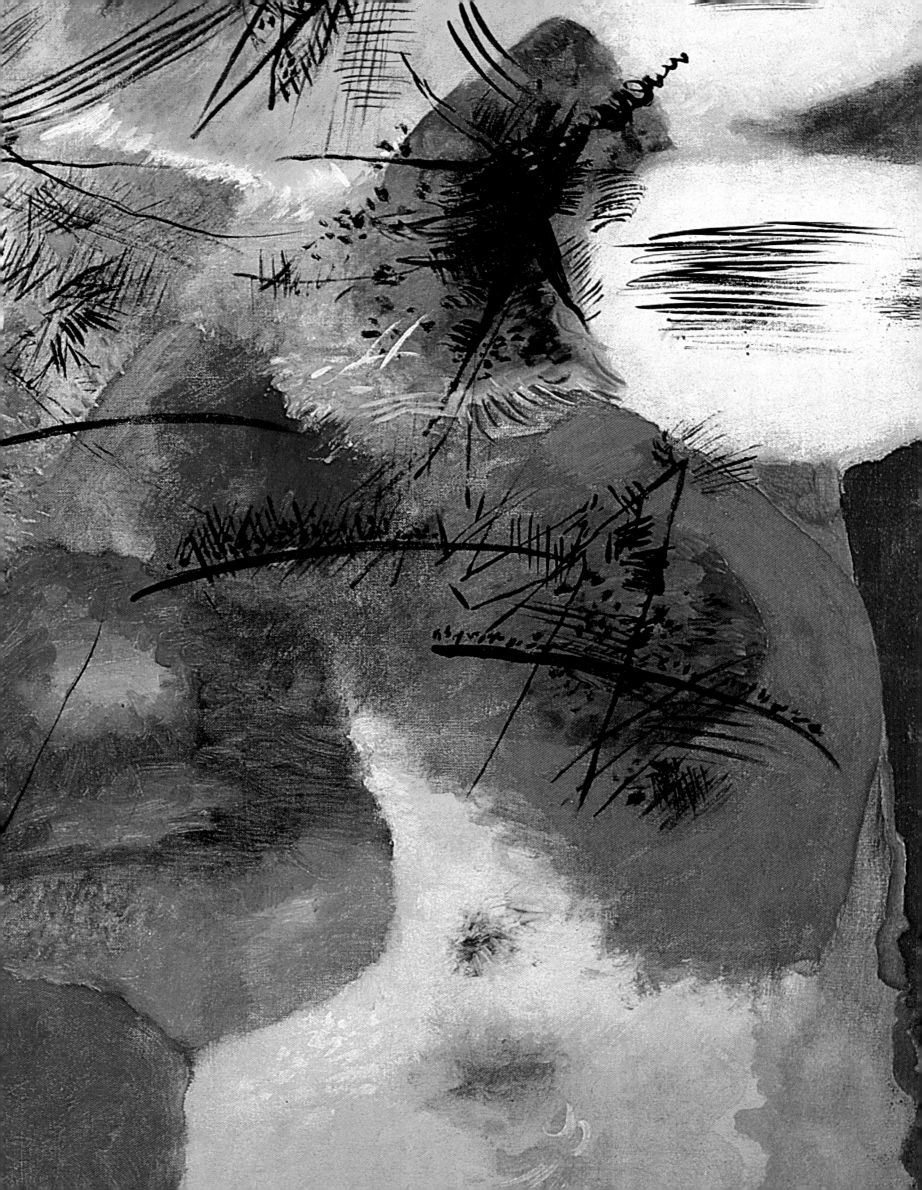

The issue of who made the first completely abstract painting is largely irrelevant, for while certain prophetic innovators may be named, their works were either experiments or little known. The true pioneers of abstraction were Vasily Kandinsky, Kazimir Malevich, and Piet Mondrian—two Russians, the first of whom spent his crucial years of early maturity in Munich, and a Dutchman, whose abstract style evolved after he moved to Paris. They developed their ideas in the context of late-nineteenth- and early twentieth-century art and philosophy, and then created a new artistic language in the 1910s. While sharing many of the same fundamental concepts about art, each produced a unique body of work.

Kandinsky's sustained experimentation and theorizing about abstraction from 1910 through 1914 broke more completely with traditional notions of art than ever before. By 1910, he was forty-four years old, and had been living in Munich for most of the last fourteen years. Although he had continued to participate in exhibitions in his native Russia and throughout Europe, his activities were centered in that city, where he founded the Neue Künstlervereinigung München (NKVM; New Artists' Society of Munich) in January 1909 and, almost three years later, an even more avant-garde group called Blaue Reiter (Blue Rider). When he arrived in Munich from Moscow in 1896, he had been educated in law and was sophisticated in the arts but was still a devotée of Russian peasant art, religion, and culture. Perhaps it was this non-Western orientation that led him in 1904 to become aware that Moslems prohibit representations of living beings and to find that fact significant.[1] Kandinsky was the first modern artist to synthesize the various tendencies, philosophical and aesthetic, that encouraged experimentation with the pure elements of art, alone and for themselves. In 1911—the exact date is often debated[2]—he began to make works that appear to contain little or no reference to the recognizable world; by 1912, the break was virtually complete, with his first compositions consisting entirely of free-floating lines and areas of color. Such freedom of handling and disconnected areas of color show the influence of Henri Matisse's Fauve-period canvases. But while there are antecedents for Kandinsky's early abstractions, his exuberantly painted lines are perhaps the most liberated gestures of the hand in the history of art up to that time, and the apparent freedom from subject matter of these ambitious paintings was unprecedented. Even where it seems that certain elements have figurative sources, the overall effect was startlingly nonassociative and fully conceived. By 1912–13, he further loosened his formal vocabulary from recognizable sources, producing paintings on canvas and on paper that are usually without references. These compositions exhibit an impressive breadth of invention, some characterized by a chaotically dense compression of forms—as in *Painting with Black Arch*, 1912 (fig. 11), and *Painting with White Border*, 1913 (fig. 29)—and others revealing a spacious lightness, as in *Black Lines* (fig. 12) and *Light Picture* (fig. 13), both 1913.

Based on letters Kandinsky wrote in 1936 to Alfred H. Barr, Jr., director of the Museum of Modern Art in New York, and in 1936 and 1937 to Hilla Rebay, advisor to Solomon R. Guggenheim (one of the artist's most devoted collectors),[3] it is now apparent that Kandinsky looked on his art of 1910 to 1914 as being divisible into two types. He distinguished between those works intended to be completely abstract and those in which he abstracted forms from specific sources. In *Painting with Black Arch*, Kandinsky may have started with forms based on nature, but he transformed them so thoroughly in the course of making the painting that it may be considered one of his earliest works in a completely abstract mode. Although Kandinsky envisioned complete abstraction as a stylistic position to be taken and practiced at

will, he felt that at first he had to assume a moderate approach, for, he later said, "I was all alone at that time [1911] and had no precedents to follow."[4] In the same letter to Barr, he specified a handful of pictures that were entirely abstract through 1913, including *Black Lines* and *Light Picture*, both of which he had completed in December 1913;[5] and he added another work to that list—his supreme achievement, *Composition VII* (fig. 6), which he had finished that same month—in his 1937 letter to Rebay.[6] Despite Kandinsky's assertions, the degree to which these paintings are nonobjective is debatable.

Kandinsky's early abstraction was almost never so pure that it did not have an implied or intentionally subliminal subject. He often imbued his works of 1910 to 1914—especially those that were not completely abstract—with Christian themes, and gave some of them titles keyed to those themes, such as *The Last Judgment*, 1910 (Private collection), and *Improvisation, Deluge*, 1913 (fig. 7). One can even see such themes in some of the pictures that he regarded as completely abstract—perceiving, for example, the evocation of a heavenly sphere in his depiction of an illusionistic space, as in *Light Picture*. In this regard, one could consider Kandinsky more a transitional figure than a pioneer, if one were to use purity of abstraction as the criterion. But the same issue of purity can be raised with each abstractionist throughout the century, making the issue moot and keeping Kandinsky's pioneer status intact. Indeed, abstraction is rarely as free of the world or of content as some of its proponents assert, or as purely decorative as its enemies say. Kandinsky's work predicts these long-running issues.

The next major innovator, Malevich, was also a Russian, and became familiar with Kandinsky's innovations through a variety of sources. Although Kandinsky still felt relatively "alone" in 1914, declaring that abstraction was "in the reach of few artists at present,"[7] these few were converted primarily through the influence of Kandinsky himself, whose art and writings about abstraction attracted considerable attention. In autumn 1910, Kandinsky returned to Moscow, where he participated in the *Jack of Diamonds* exhibition along with Malevich; he came back to Moscow again in autumn 1912 (showing in the second *Jack of Diamonds* exhibition) and in 1913. During his 1910 and 1912 stays in Russia, he also visited St. Petersburg, Odessa, and Ekaterinoslav, and had work exhibited in all three cities.[8]

In December 1910, Kandinsky completed the German version of *Concerning the Spiritual in Art* (published in Munich a year later); he also prepared a shortened version in Russian, which was given a public reading in St. Petersburg by Nicolai Kulbin at the Second All-Russian Congress of Artists in December 1911, and he lectured in that city himself the following year. David Burliuk, another Russian who took part with Kandinsky in the Blaue Reiter, frequently shuttled between Munich and Moscow and therefore would have been transmitting the latest of Kandinsky's innovations back to an eager Russian art scene that included Malevich.[9] And in March 1912, Malevich was invited to show at the second Blaue Reiter exhibition in Munich. Kandinsky's return to Moscow at the end of 1914, due to the outbreak of World War I, could have only reinforced his already established position in Russia, a position that resulted in his being hailed, in 1920, as "'The Russian Messiah.' With his work he prepares the way for the victory of absolute art."[10]

Like Kandinsky, Malevich was steeped in the traditions and values of peasant Russia, especially admiring naïve art, religious icons, and cultures imbued with spiritual values. But Malevich was also quick to embrace the latest stylistic innovations from Western Europe; from 1912 to 1914, his work was an amalgam of Russian subject matter

6. *Vasily Kandinsky,* Composition VII, *1913. Oil on canvas, 6 feet 6 ¾ inches x 9 feet 10 ⅛ inches (2 x 3 m). State Tretiakov Gallery, Moscow.*

7. *Vasily Kandinsky,* Improvisation, Deluge, *1913. Oil on canvas, 37 ⅜ x 59 ¹/₁₆ inches (95 x 150 cm). Städtische Galerie im Lenbachhaus, Munich.*

8. *Kazimir Malevich,* Woman at the Advertising Column, *1914. Oil and collage on canvas, 28 x 25 ¼ inches (71 x 64 cm). Stedelijk Museum, Amsterdam.*

clothed in a Cubist and then a Futurist mode. Elements of his mature work began to emerge in 1913–14, in his set designs for a Futurist opera, *Victory Over the Sun,* 1913, and in paintings such as *Woman at the Advertising Column,* 1914 (fig. 8). One of the backcloths that Malevich designed for the opera is little more than a large square divided into two triangles, one black and the other white; and in the paintings, standing out among the fragmentary motifs derived from representational sources are isolated forms that are larger and more abstract than the others—rectilinear, flattened planes of color. It was only a short step from these to his complete isolation, in 1915, of a single flat plane of black or red against a white field. He called his new innovation Suprematism.

The titles that Malevich gave to his completely abstract works of 1915 are either appropriately nonreferential or include allusions to a representational source, such as *Suprematism (Painterly Realism of a Football Player. Color Masses in the Fourth Dimension)* (fig. 9). The use of both types of designation suggests an ambivalence similar to Kandinsky's before 1914. Allusive titles may have also been intended as an aid for the audience. By 1916, however, Malevich dropped the descriptive approach in giving titles to many of his abstract works, simply calling them *Suprematism.*

Although Malevich's abstract paintings suggest none of the tumultuous illusionistic space seen in Kandinsky's works of this period, they are not without spatial references. Set against a white field, each colored plane seems to hover in that possibly heavenly space, like a Russian icon with a background of white instead of gold. The same floating phenomenon also occurs in the paintings in which several planes overlap or lie side by side, including *Suprematism (Blue Triangle and Black Rectangle),* 1915 (fig. 14).[11] *Suprematist Composition: White on White,* 1918 (fig. 18), is filled with a sense of space, as the white icon appears to become engulfed by the white "air" that surrounds it. Thus, even this, the first monochrome painting in the history of art, retains a sense of place, however mysterious.

Whereas Kandinsky's vocabulary is loose and seemingly organic, Malevich's is hard-edged and appears at times to be governed by geometric precision. But this is not entirely true. The central "squares" in the paintings that he made starting in the 1910s—such as *Black Square,* 1915 (see Chronology), and *Red Square (Painterly Realism: Peasant Woman in Two Dimensions),* 1915 (fig. 10)—are in fact rectangular, and hence do not precisely match the shape of the canvases, which are almost perfectly square.[12] Moreover, in many other works of that period, Malevich made further departures from strict geometry or symmetry by placing his geometric motifs off-center, as in *Suprematist Composition: White on White*; deforming them, as in *Suprematism (Yellow Square on White),* 1917–18 (fig. 17); or combining them in seemingly random arrangements, as in *Suprematism (Eight Red Rectangles),* 1915 (fig. 15). But if Malevich is not the first true geometrician of abstraction, then that designation could be assigned to Mondrian.

Mondrian's art seems to have developed independently of the Munich–Moscow connection. However, Mondrian was living in Paris from January 1912 to July 1914 and might have seen three of Kandinsky's highly abstract *Improvisations* when they were shown at the Salon des Indépendants in 1912; and he might also have been aware of the critical attention that Kandinsky received from Guillaume Apollinaire, the most important of Cubism's advocates. But, like Malevich, Mondrian came to abstraction via Cubism, from the time he first saw Cubist paintings by Georges Braque and Pablo Picasso in Amsterdam in 1911. During his initial period of abstraction,

Mondrian used the procedures of Analytic Cubism to break down images of trees, seascapes, and architecture into compositions of interlocking black lines and planes of muted color, as in *Tableau No. 2; Composition VII*, 1913 (fig. 19). Over the next few years, Mondrian's paintings became even more abstract as the pictorial motif became nearly unrecognizable—disappearing entirely from his works in 1916, as in *Composition 1916* (fig. 20)—and his scaffolding of black lines became increasingly rectilinear, with the elimination of all curved and diagonal elements and of any suggestion of volume. These, together with similar paintings by Bart van der Leck and Theo van Doesburg, were the starting point of the Dutch De Stijl movement, which was established officially in 1917. By 1918, Mondrian began to make paintings based on a purely rectilinear grid, without any sign of the subject remaining. However, it could be argued that Mondrian made his first completely abstract paintings as early as 1916, for, without knowledge of Mondrian's analytic process, a viewer could hardly imagine that a subject observed in the world had inspired *Composition 1916* or other paintings from that year.[13] Unlike Kandinsky, in whose work one can occasionally spot a fragmentary recognizable reference, Mondrian's art more resembled that of the Suprematist Malevich. But Mondrian went one step further toward a geometric vocabulary, restricting himself to compositions consisting of straight vertical and horizontal lines with sharply drawn, hard edges and carefully charted rectangular and square areas of color, and flattening the remaining sense of space, so that little if any illusion was present.

These early abstract works by Mondrian differ from those by Kandinsky and Malevich not only in his tendency toward hard-edged geometric rigor but also in his development of an allover style of composition, as in paintings such as *Composition with Grid 4 (Lozenge); Composition in Black and Gray*, 1919 (fig. 21), in which similar elements are distributed over the surface of the canvas and no single area is given greater emphasis than any other (thus making them even more reductive than the Analytic Cubist works by Braque and Picasso). Though arrived at through systematic investigation, Mondrian's form of abstraction is infused with as much vitality as Kandinsky's more expressionistic one, but is characterized by a lightness of feeling that comes from the deceptive simplicity of the compositions. Mondrian's lines and areas of color are always arrayed in a dynamic equilibrium, so that no one element dominates. There are delightful ambiguities and daring conceits, such as the large, emphatically off-center square of white in *Tableau 2; Composition 2*, 1922 (fig. 22), floating among and anchored by its surrounding "frame" of blue, yellow, red, black, and white rectangles, some of them barely slivers on the edge of the canvas; his use of the diagonal edges of *Tableau No. IV, Lozenge Composition with Red, Gray, Blue, Yellow, and Black*, 1925 (fig. 23), to truncate every shape except the upper-central white square (and even one corner of this square's black border has been cut off), thus creating triangles and polygons that can be read as incomplete squares and rectangles that continue invisibly past the edge of the canvas; his distillation of such complex diamond-format ambiguities into the simplicity of *Composition No. I; Composition IA*, 1930 (fig. 24), and *Composition with Yellow Lines*, 1933 (fig. 25), with their two pairs of vertical and horizontal bars, all painted one color (black or yellow), which frame a large truncated white square and mark off white triangles in the four corners; the stacked horizontal and vertical rectangles above and below a transecting horizontal black bar in *Composition No. I; Composition*, 1938–39 (fig. 26), punctuated by a sliver of red at the bottom; and the compositional activity of *Trafalgar Square*, 1939–43 (fig. 27). Such

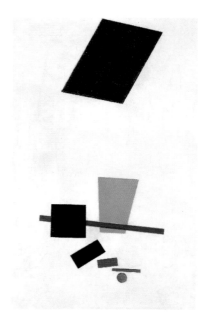

9. *Kazimir Malevich,* Suprematism (Painterly Realism of a Football Player. Color Masses in the Fourth Dimension), *1915. Oil on canvas, 27 ½ x 17 ⅜ inches (69.9 x 44 cm). Stedelijk Museum, Amsterdam.*

10. *Kazimir Malevich,* Red Square (Painterly Realism: Peasant Woman in Two Dimensions), *1915. Oil on canvas, 20 ⅞ x 20 ⅞ inches (53 x 53 cm). State Russian Museum, St. Petersburg.*

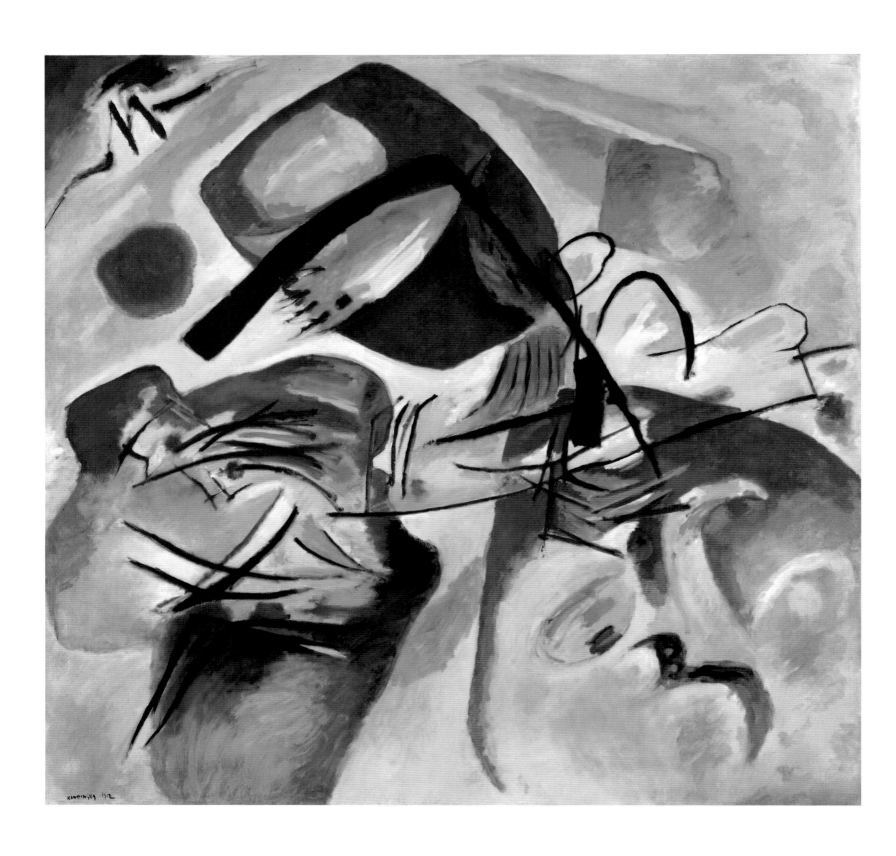

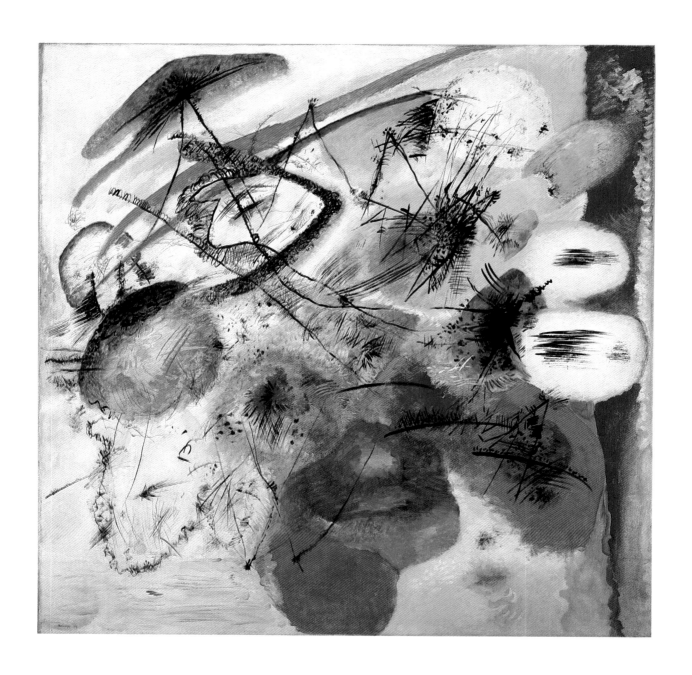

11. *Vasily Kandinsky,* Painting with
Black Arch, *1912. Oil on canvas,*
6 feet 2 ⅛ inches x 6 feet 6 inches (1.89 x
1.98 m). Musée National d'Art Moderne,
Centre de Création Industrielle au Centre
Georges Pompidou, Paris, Gift of Nina
Kandinsky, 1976.

12. *Vasily Kandinsky,* Black Lines,
December 1913. Oil on canvas, 51 x
51 ⅛ inches (129.4 x 131.1 cm). Solomon R.
Guggenheim Museum, New York, Gift,
Solomon R. Guggenheim 37.241.

13. *Vasily Kandinsky*, Light Picture,
*December 1913. Oil on canvas, 30 ⅛ x
39 ½ inches (77.8 x 100.2 cm). Solomon R.
Guggenheim Museum, New York, Gift,
Solomon R. Guggenheim 37.244.*

14. *Kazimir Malevich*, Suprematism
(Blue Triangle and Black Rectangle),
*1915. Oil on canvas, 26 ⅛ x 22 ½ inches
(66.5 x 57 cm). Stedelijk Museum,
Amsterdam.*

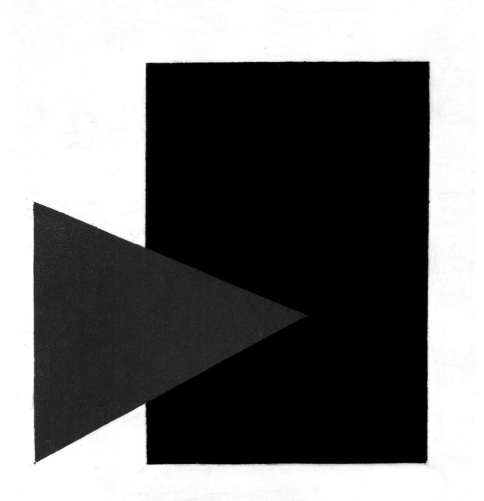

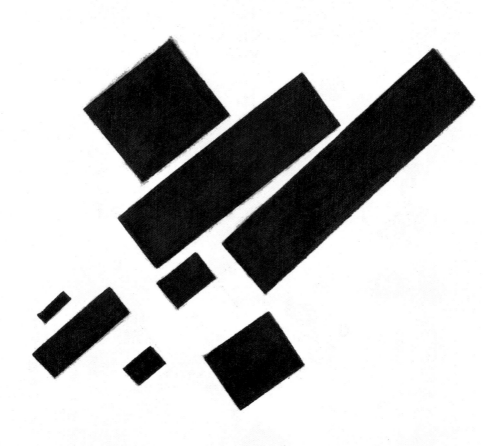

15. *Kazimir Malevich,* Suprematism
(Eight Red Rectangles), *1915. Oil on
canvas, 22 ⅛ x 19 ⅛ inches (57.5 x 48.5 cm).
Stedelijk Museum, Amsterdam.*

16. *Kazimir Malevich,* Suprematism
(Sound Waves), *1917. Oil on canvas,
38 ¹⁄₁₆ x 27 ½ inches (97 x 70 cm). Stedelijk
Museum, Amsterdam.*

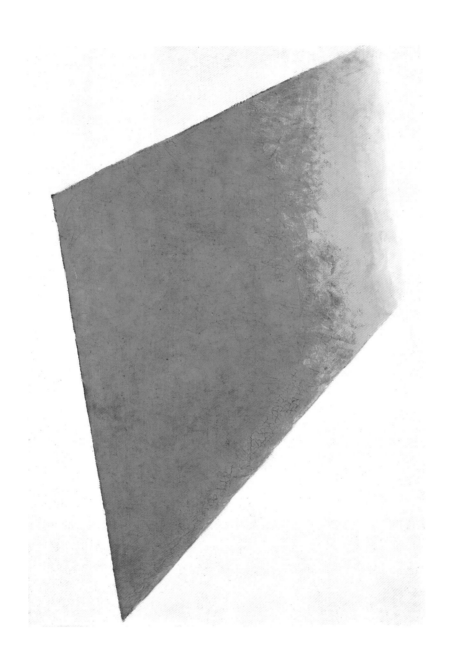

17. Kazimir Malevich, Suprematism
(Yellow Square on White), *1917–18.*
Oil on canvas, 41 ¼ x 27 ¾ inches (106 x
70.5 cm). Stedelijk Museum, Amsterdam.

mastery and variety of nuance would rarely be equaled by subsequent geometric abstractionists.

Wilhelm Worringer, who divided all art into two rigid stylistic categories, could not foresee the enormous variety that would be demonstrated by twentieth-century abstraction. Indeed, the range of styles initially represented by Kandinsky, Malevich, and Mondrian was an early indication of how abstraction would subsequently evolve: Kandinsky's unfettered Dionysian expressiveness and wealth of freely described forms; Mondrian's precise Apollonian rigor, control, and brilliant compositional inventiveness; and Malevich's spatial arrangements of quasi-geometric iconic forms, inhabiting barren fields.

Theoretical Formulations

Although theorizing has held a significant role in the lives of artists throughout history and became even more prominent in the nineteenth century, that activity came to dominate early twentieth-century artistic life, and especially that of the first abstractionists. As if to justify and explain their new art to other artists and to a skeptical public, Kandinsky, Malevich, and Mondrian all wrote extensively. It was important to them to place their innovations in an evolutionary continuum and at the same time to claim their work as a breakthrough against the conventions of a rigid academic establishment. Their theoretical writings have the tone and seriousness of the German Idealists, stressing matters of the mind over those of the body, and the universal over the anecdotal, and completely lack the raucous irony of the Parisian avant-garde. Though often possessing a systematic philosophical cast, their writings are partisan and impassioned. Like Sigmund Freud and Karl Marx, who proposed sweeping theories about society and human behavior, they made great claims for their ideas about art; filled with conviction, they believed in abstraction as if it were an ideology.

These three pioneers felt a need to find and define a terminology for their activity in order to distinguish it from representation as well as from other contemporary modes. Certainly Worringer's 1908 tract, *Abstraction and Empathy*, with its emphasis on the word "abstraction," must have represented a highly significant precedent. In *Concerning the Spiritual in Art*, Kandinsky too made liberal use of the word. For him, it seems, an abstraction is synonymous with a symbol,[14] although its appearance either yields no outer clue as to its identity, or has a veiled relationship—indicated by its formal structure—with something else.[15] The first steps toward abstraction, Kandinsky claimed, required the elimination of modeling, and the replacement of the illusion of three-dimensional space in favor of a "single plane." Paradoxically, it would ultimately be necessary for him to destroy "the theory of one single surface"[16] so that abstraction could encompass spatiality.

Whereas *Concerning the Spiritual in Art* has a personal tone, both ruminative and probing, *The Blaue Reiter Almanac* of 1912 is more of a public introduction to the new ideas being explored. Here, along with his collaborator Franz Marc, and speaking on behalf of a group of artists, Kandinsky described the theories and positions of this rebellious Munich branch of the avant-garde. While proclaiming an anarchic, forward-thinking outlook, he related their approach to other periods and cultures (including those of Benin and Egypt) and to work by recent artists and his own contemporaries (including Paul Cézanne, Matisse, and Picasso), thereby formulating a pattern of parallel, creative motivations similar to that outlined by Worringer. Although the word "abstraction" does not appear often, its occurrences are significant. At the start of an essay entitled "On the Question of

Form," Kandinsky referred to "the creative *spirit* (which could be called the abstract spirit)."[17] In its analysis of the various approaches to form, his argument particularly recalls Worringer's when it describes styles as expressive of cultural values,[18] with abstraction and realism on opposite sides of a cultural divide.[19] But then, in a kind of diplomatic and creative usurpation of the traditionalists' goals, Kandinsky extolled the expressive capacity of abstraction to communicate reality.[20] Variations on this point would often become a rallying cry of future abstractionists, so its appearance at this early moment is noteworthy. Kandinsky wanted to make abstraction competitive with other forms of art, particularly in the arena of representing reality. He concluded this portion of his argument with the following flourish: "Realism = Abstraction / Abstraction = Realism."[21] By incorporating into his definition the goals and methods of an already familiar and accepted form of art, Kandinsky attempted to render abstraction as similarly knowable, and to suggest that it was not such a wildly aberrant mode of working.

In 1913–14, at a time when Kandinsky had adopted a more consistently abstract approach in his work, he linked certain words and concepts to his enterprise, describing abstract painting as "pure" and "absolute,"[22] and stating that "chance" played almost no role in his art.[23] The term "abstraction" by itself must have become too relative for Kandinsky. Combining it with "absolute" made it more assertive and independent, comparable to Friedrich Wilhelm Nietzsche's and Richard Wagner's references to "absolute music" to describe compositions in which no association impinges on the purity of the musical experience.[24] By now, Kandinsky had begun to minimize the symbolic possibilities of his art, and had initiated a systematic elimination of all veiled references, intended or accidental.[25] His position had become unequivocal.

Malevich went through several phases with regard to the terminology he applied to his work. In 1916, he conceived of his art as "pure" and without any trace of the objects found in nature; his tone was strident as he boasted of having "destroyed the ring of the horizon and escaped from the circle of things . . . which confines the artist [from] the forms of nature."[26] During this decade, he rarely mentioned the word "abstraction," perhaps wishing to separate his Suprematism from the theories of Kandinsky and Worringer; instead, he used the term "non-objective."[27] But even as he banished from most of his paintings any references to the world, Malevich claimed to have invented a "New Realism" (a notion that would become a prevalent dogma of abstraction): "I have transformed myself into the zero of form and emerged from nothing to creation, that is, to Suprematism, to the new realism in painting, to objectless creation."[28] In the 1920s, the term "abstraction" often appeared in his writings in its conventional meaning, as when he envisioned "'something' abstract" emerging from a process by which a form "communes with the concrete thing."[29] By this somewhat mystical formulation, it would seem that his art is not so pure as first suggested, and that it was meant to have a relationship to the world of appearances or, as in *Suprematism (Sound Waves)*, 1917 (fig. 16), real but unseen things. And yet, the notion of something untouched by anecdotal experience is again indicated when Malevich described his abstract art as expressive of "pure feeling."[30]

As Mondrian was beginning to eliminate references to the observable world from his work in 1915, he used the words "abstract" and "abstraction" in their reductive sense, referring to the process of penetrating the "outward," recognizable form of an object and arriving at its "inward" essence: "When we show things in their outwardness

(as they *ordinarily* appear), *then* indeed we allow the human, the individual to manifest itself. But when we plastically express the inward (through the plastic form of the outward), then we come closer to manifesting the spiritual, therefore the divine, the universal."[31] By 1917, however, the idea of abstract form had become for him both a manifestation of and a path to a virtually "divine" purity. He condemned the expression of three-dimensional space as the enemy of abstraction and sought its "destruction."[32] By then, having shed the reservations of Kandinsky and Malevich, he accorded the word "abstraction" full stature as an art style.[33] In fact, Mondrian regarded abstraction as more than a conventional process and even spoke of its transformative powers,[34] which enabled him to go beyond realism to achieve an art of "superrealism."[35]

The great theoretical challenge facing the early pioneers of abstraction was to resolve the conflict between an abstract work of art being a product of sheer conceptualization and being a concretely perceived phenomenon. They wanted their art to avoid suggesting a world of dreams and the imagination, such as was found in Symbolism, or to be considered merely decorative. As an exploration of form, an abstraction might suggest a model of the world or might even be a channel by which the world could be understood,[36] but at the same time it would be perceived as a real object in the viewer's space.

Kandinsky, Malevich, and Mondrian were grappling with a new concept of art and a terminology for that innovation because each felt himself to be an explorer on the brink of an age that was gradually revealing itself. But whereas Malevich and Mondrian set out to find a style that was expressive of its time,[37] Kandinsky spoke of the abstract phenomenon in almost mystical terms: it simply "ripens" and appears.[38] He regarded traditional Western art at this time as largely incapable of expressing spiritual values, but revered tribal art and related his work to it as part of a Worringer-like continuum that joins diverse historical styles on the basis of their perceived "external similarity . . . founded on . . . a similarity of inner direction in an entire moral and spiritual milieu, . . . a similarity of 'inner mood.'" Such a correspondence, he proposed, "may account partially for our sympathy and affinity with and our comprehension of the work of primitives. Like ourselves, these pure artists sought to express only inner and essential feelings in their works."[39] Malevich admired religious icons for similar reasons ("My acquaintance with icon art convinced me that the point is not in the study of anatomy and perspective, that it's not in depicting nature in its own truth, but that it's in the sensing of art and artistic reality through emotions"[40]), but he found nothing to praise about "savage art." Perhaps consciously taking a position in opposition to the case made by Kandinsky, Malevich wrote that tribal art fails to manifest a "range of feelings," and that, indeed, it is "not . . . Art."[41] As was usual for him, Malevich was inconsistent in his arguments, for, although he admired Russian peasant art without reservation, his condemnation of tribal art included the observation that it had nothing to do with modern life.[42]

Like other artists before them, Kandinsky and Mondrian found certain natural analogies between painting and music. The notion of *ut pictura musica* evolved from a long past as a sidebar in aesthetics to assume a major role in support of an art dissociated from narrative concerns.[43] Music is the nearest to abstraction of all possible artistic models, for it can convey emotion by purely formal means, without any external references. Kandinsky recognized that music "is outwardly unfettered by nature, [and] needs no external form for its expression." He maintained that, through this formal language, it both manifests and touches the soul, and therefore "music is found to be the best teacher." The painter can only hope to achieve a similar expressiveness by emulating the compositional elements of music, such as tone color and rhythm. Hence, the "modern desire for rhythm in painting, for mathematical, abstract construction, for repeated notes of color, for setting colors in motion, and so on."[44] This emphasis on rhythm was very important to Mondrian, too, and came to dominate his concerns as his career unfolded.[45]

As a model for their art and as a source of terminology, architecture held a position of importance nearly equal to music for the new abstractionists. Kandinsky often used architectural metaphors in his writings, making reference, for example, to the "spiritual pyramid,"[46] and employing the words "construction" and "structure" to describe the formal composition and underlying organization of a picture.[47] As with the process of assembling a work of architecture, a painting is built from segments that only have significance in relation to the whole ensemble. In 1913, Kandinsky wrote that he aspired "to replace subject matter with construction," which "is the first step on the path that leads to pure art."[48]

Mondrian's interest in architecture began on a less theoretical level, as a pictorial subject that could be reduced to its basic rectilinear elements. One of the motifs that led him finally to pure abstraction was a church façade, from which he derived a planar composition of segments, as in *Composition 1916*, but without making any recognizable reference to the building's exterior as he had in an earlier series of works that includes *Church at Domburg*, 1910–11 (fig. 28). The façade offered a natural arrangement of horizontals and verticals, which eventually became the exclusive structural elements of Mondrian's pictorial vocabulary. The paintings he made based on church façades recall Monet's series devoted to the façade of Rouen Cathedral, the last of which were almost completely abstract. Like Kandinsky, Mondrian often used the verb "to construct" to describe his process, and also noted the architectural achievements of ancient cultures.[49] Both regarded architecture as a characteristic embodiment of a period's belief systems—much more so than painting and sculpture—and therefore a model for the other arts. Using an architectural metaphor, Mondrian stated that his most deeply held dream was for a "monument of Beauty."[50] Near the end of his life, he commented, "To move the picture into our surroundings and give it real existence has been my ideal since I came to abstract painting."[51] With this statement, Mondrian gained another rationalization for the reality or concreteness of the abstract object; once it is placed in an architectural context, the work of art simply exists in the world as a purveyor of the values that contributed to its construction.

Malevich too referred to "construction" in explaining his new abstract art,[52] which, together with his writings, helped set the stage for the first and most concerted effort to achieve contemporary monuments in the modern era: the Russian movement known as Constructivism, which began around 1918. With this movement, the verb "to construct," which so typifies the processes of the early pioneers of abstraction, was made the motto of an entire group of artists.

Abstraction was largely conceived by its progenitors as a rhetorical stand against the prevailing threat of materialistic concerns. In the last decades of the nineteenth century, Germany had become highly industrialized, and with that development came a growing embrace of materialistic values and of mechanistic and scientific explanations for how the world appears and behaves. But these positivist tendencies were accompanied by reactions against them by some German artists, writers, social critics, and philosophers, especially after the turn of the

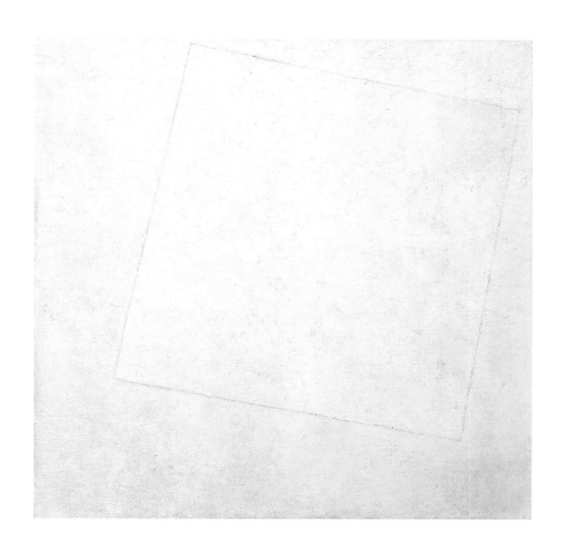

18. Kazimir Malevich, Suprematist
Composition: White on White, *1918.*
Oil on canvas, 31 ¼ x 31 ¼ inches (79.4 x
79.4 cm). The Museum of Modern Art,
New York, 1935.

19. Piet Mondrian, Tableau No. 2;
Composition VII, *1913. Oil on canvas,*
41 ⅛ x 44 ¾ inches (104.4 x 113.6 cm).
Solomon R. Guggenheim Museum,
New York 49.1228.

20. Piet Mondrian, Composition 1916,
1916. Oil on canvas, with wood strip at
bottom edge, 46 ⅞ x 29 ½ inches (119 x
75.1 cm). Solomon R. Guggenheim Museum,
New York 49.1229.

21. *Piet Mondrian,* Composition with
Grid 4 (Lozenge); Composition in
Black and Gray, *1919. Oil on canvas,*
23 ⅛ x 23 ⅛ inches (60 x 60 cm); lozenge,
axes (irregular) 33 ½ - 33 ¼ inches
(85 - 84.5 cm). Philadelphia Museum of
Art, The Louise and Walter Arensberg
Collection.

22. *Piet Mondrian,* Tableau 2;
Composition 2, *1922. Oil on canvas,*
21 ⅞ x 21 ⅛ inches (55.6 x 53.7 cm).
Solomon R. Guggenheim Museum,
New York 51.1309.

23. *Piet Mondrian,* Tableau No. IV,
Lozenge Composition with Red,
Gray, Blue, Yellow, and Black, *1925.*
Oil on canvas, 39 ½ x 39 ½ inches (100. 5 x
100. 5 cm); lozenge, axes (irregular)
56 ¼ - 56 inches (142. 8 - 142. 3 cm).
National Gallery of Art, Washington,
D.C., Gift of Herbert and Nannette
Rothschild 1971. 51. 1.

24. *Piet Mondrian,* Composition No. I;
Composition 1A, *1930. Oil on canvas,*
29 ⅛ x 29 ⅛ inches (75. 2 x 75. 2 cm);
lozenge, vertical axis 41 ⅛ inches (105 cm).
Solomon R. Guggenheim Museum,
New York, Hilla Rebay Collection
71. 1936 R96.

25. *Piet Mondrian*, Composition with
Yellow Lines, *1933. Oil on canvas,*
31 ½ x 31 ½ inches (80 x 80 cm); lozenge,
vertical axis 44 ½ inches (113 cm).
Haags Gemeentemuseum, The Hague.

26. *Piet Mondrian*, Composition No. I;
Composition, *1938–39. Oil on canvas,*
41 ⅟₁₆ x 40 ⅟₁₆ inches (105.2 x 102.3 cm).
Peggy Guggenheim Collection, Venice
76.2553 PG39.

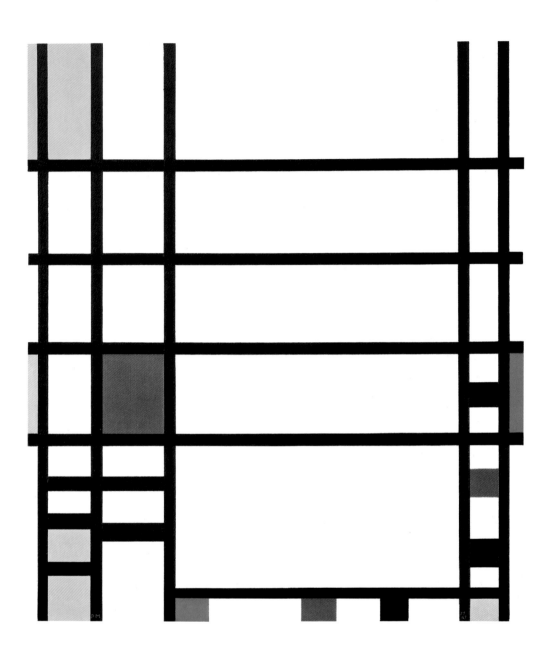

27. Piet Mondrian, Trafalgar Square,
*1939–43. Oil on canvas, 57 ¼ x 47 ¼ inches
(145.4 x 120 cm). The Museum of Modern
Art, New York, Gift of Mr. and Mrs.
William A. M. Burden, 1964.*

century. In Munich, from 1910, such opposition took the form of an exploration of alternative artistic and cultural values among a group of artists and intellectuals alienated from the social and political establishment. They rebelled not only against positivism and materialism but against the stultifying conventions and restrictions embodied in the bourgeoisie, commercialism, and naturalism. Abstraction was, in effect, a crusade against these positions, and against "low" cultural values, by advocates of "high" art. By turning inward and expressing what they found there, they sought to change the moral and cultural climate and thus transform society.[53]

Kandinsky was the most virulent among the abstractionists in his opposition to materialism, which he condemned for its suppression of spiritual concerns. Indeed, in an essay published in Russia in 1911, he wrote, "Our epoch is a time of tragic collision between matter and spirit and of the downfall of the purely material worldview."[54] But the obstacles preventing the triumph of the spirit seemed almost insurmountable: "During these mute and blind times men attribute a special and exclusive value to external success, for they judge them [the times] by outward results, thinking of material well-being. They hail technical advance, which can help nothing but the body. Real spiritual gains are undervalued or ignored."[55] His friend Franz Marc, in their *Blaue Reiter Almanac*, deplored how artists offering spiritual gifts to a materialistic society were rejected.[56] Kandinsky concluded that naturalistic art reinforces materialistic thinking, and thus there was a need for abstraction "to annihilate objective [reality]."[57] The vagaries of temporal form and "external beauty" could no longer be ends in themselves, however seductive.[58]

External reality could pose a problem for Mondrian as well, as an oft-repeated anecdote about him startlingly shows: it is said that when entering a restaurant, he sometimes made certain to avoid facing a window that would give him a view of the landscape.[59] To Mondrian, the outward forms of nature are merely deceptive appearances, the expression of which he considered too personal and subjective, without inner spirit—a distraction from the underlying pure reality.[60] However, he did welcome scientific progress when it moved human inquiry in the direction of universal thinking and objectivity,[61] but believed, like Kandinsky, that art could compete with science in penetrating beneath outward appearances and offering insight and knowledge of the world. More specifically, he viewed abstraction as the agent for accomplishing such exalted goals. In a revealing passage contrasting the individual with the universal, Mondrian stated that the "union" of the two "gave rise to the tragic" and that "the struggle of one against the other forms the tragedy of life. . . . Although the greatest tragedy is due to the inherently unequal dualism of spirit and nature, there is also tragedy in outward life." One can overcome the tragic only "through the merging of opposites into each other"—a "(final) unification" that is "far less possible in outward than in [inward] abstract life." Such a synthesis is likely in abstract art because "art is the plastic expression" of life and "can realize the union of opposites abstractly." But, Mondrian warns, "so long as art continues to use natural appearance as its plastic means, *its expression will emphasize the tragic*."[62]

Worringer had advocated the healing balm of abstraction to transcend the tribulations of ordinary life,[63] and Mondrian believed that he could provide similar transcendence by making art that expressed a "profound" vision of reality beyond appearance, thus redeeming mankind through the revelation of universal harmony.[64] Malevich, too, shared the belief that art can be a powerful antidote to the difficult circumstances of life. He claimed that something only

28. *Piet Mondrian,* Church at Domburg, *1910–11. Oil on canvas, 44 ¼ x 29 ½ inches (114 x 75 cm). Haags Gemeentemuseum, The Hague.*

becomes beautiful when it is expressed in art.[65] However, he distrusted the idealism of the ancient Greeks and Romans and the artists of the Renaissance, a "blind alley" that did not satisfactorily consider the realities of daily existence.[66] Their approach aestheticized reality, he declared, and "that moment when the idealization of form took hold of them should be considered the downfall of real art. For art should not proceed towards reduction, or simplification, but towards complexity."[67] Aligning himself with the goals of a progressive society, and momentarily imbued with the fervor of the Russian revolution and a faith in the future of humanity, Malevich was far more positive than Kandinsky or Mondrian about the benefits of science and technology and the future evolution of the economic conditions of humanity. And although all three expressed the utopian urge to overthrow prevailing values,[68] Malevich also distanced himself from traditional notions of art's spirituality, rejecting "all forms of heavenly bliss," and "all their representations by art workers" as "a lie concealing reality."[69] But his faith in the transformative, if not healing, powers of art was typologically similar to the belief, held by Kandinsky and Mondrian, of art's power to combat materialism with spirituality. In a world filled with lost innocence, rootless materialism, and insecurity, which all three artists regarded as the province of naturalistic art, they offered abstraction as an alternative.

For the most part, the struggle waged by the early abstractionists may be viewed as a rear-guard battle against the onrushing forces of modern life—especially the flood of changes brought about by developments in the fields of science, technology, and economics, and by the rise of the mass media (which established photography as the dominant mode of image making). These developments were robbing humanity of whatever inwardness and purity it may have had, and threatening the concept of a sublime unknown. To regain these qualities, the abstractionists focused on an inner, spiritual reality as the basis for an entirely new kind of art. In effect, their abstraction rejected the world and the body in favor of the spirit and the mind, although it did offer a new sensuous "body"—that of the work of art independent of the world of everyday reality. The ardent and ascetic ways of abstraction made for a sharp contrast to the variously worldly, world-weary, or decadent approaches that had flourished in France during the preceding two decades.

In the writings of Kandinsky and Mondrian, there were early indications of the role that the spiritual would play as a source of inspiration for abstract artists. Even before Kandinsky had begun making completely nonobjective works, he described art in terms of a crusade: "Art must march at the head of spiritual evolution."[70] Afterward, he ascribed the same role to his new style: "The force that propels the human spirit on the clear way forward and upward is the abstract spirit."[71] Finally, in what for him was a natural transition, he compared art to religion.[72] Mondrian was no less insistent on the spiritual role of art.[73] Long before his work became abstract, he noted the power of art "to provide a transition to the finer regions, which I call the spiritual realm."[74] Thus, it was only logical for him to "approach the spiritual in art" by employing "reality as little as possible," which is how "an abstract art came into being," he remarked in 1913–14.[75]

Both Kandinsky and Mondrian found significant reinforcement for their ideas in the teachings of Theosophy—a religious movement founded in New York in 1875 by Helena P. Blavatsky and Henry S. Olcott—and Anthroposophy, the offshoot of Theosophy developed by Rudolf Steiner in Germany. Their adherents, disenchanted with materialism, sought enlightenment through a synthesis of various

elements of mysticism, spiritualism, and esoteric philosophy. Kandinsky's interest in Theosophy, though short-lived, was concentrated around the time he was writing *Concerning the Spiritual in Art*, which shows signs of the movement's influence. In his treatise, Kandinsky wrote of a desire to emerge from "the nightmare of materialism" that "darkens the awakening soul"; of seeking, as the Theosophists did, "to approach the problem of the spirit by way of *inner* knowledge"; and of participating in a "spiritual revolution" through a new art that "give[s] free scope to the non-material strivings of the soul."[76] He even specifically credited the renewal of interest in abstraction to the increased interest in spiritual matters, and to "the forms of occultism, spiritualism, monism, the 'new' Christianity, theosophy, and religion in its broadest sense."[77] Mondrian joined the Dutch chapter of the Theosophical Society in 1909, while he was still painting in a figurative mode, and remained a lifelong member. In Theosophy he found ideas that reinforced his notion of a universal means of expression, and his preoccupation with achieving equilibrium out of the complementary dualities of spirit and matter and other corresponding oppositions, which eventually took form in his work as the juxtaposition of verticals and horizontals, white and black.[78]

The Theosophists often explained their concepts using metaphors based on symbolic notions of form and color. (They were influenced in their symbolic interpretations of color by the earlier color theories of Johann Wolfgang von Goethe and Arthur Schopenhauer.[79]) Blavatsky used a metaphor involving the colors of the spectrum to explain how the one eternal truth that had been given to man at the beginning of his existence had become adulterated, especially by the recent destructive effects of materialism, but that various elements of it were contained in all existing religions. Sixten Ringbom summed up the fundamental idea:

Blavatsky employs the image of the white ray of pure light (Theosophy) which has been diffracted into the different colours of the spectrum (the various religions and philosophies). It is now the task of the theosophists to reunite the different contending colours—each claiming to be the white ray—into the real, original white light of truth. This synthesis will be accomplished in the course of the twentieth century during which mankind will also gradually regain . . . those finer senses . . . which have been spoilt by rationalism and materialism.[80]

Theosophists Annie Besant and Charles W. Leadbeater, in a book entitled *Thought-Forms* (1905), expressed the view that form-giving represents the highest spiritual task, and proposed that a symbolic language of "thought-forms" should be invented to express spiritual concepts. Influenced by Goethe and Schopenhauer, they too believed that colors have inherent meanings, and that intuition (which they referred to as "clairvoyant observation") gives an individual an awareness of forms produced by thoughts and feelings, and of colors believed to reflect emotional states and changes.[81]

Kandinsky, Malevich, and Mondrian all described their art as a language, one within which each color may at times be used in a symbolic fashion. The fact that they differed in their color interpretations, however, indicates how subjective color symbolism is. For example, Kandinsky said that red is like blood, whereas Mondrian simply regarded red as an "outward" color; and although Malevich made no reference to a specific meaning for red, white represented infinity for him. To Mondrian, yellow and blue were more "inward" colors, but Kandinsky described blue as "heavenly" and yellow as strident.[82] While these artists all believed in abstraction as

29. *Vasily Kandinsky,* Painting with
White Border, *May 1913. Oil on canvas,
4 feet 7 ¼ inches x 6 feet 6 ⅛ inches (1. 4 x
2 m). Solomon R. Guggenheim Museum,
New York, Gift, Solomon R. Guggenheim
37. 245.*

the true path to the revelation of pure feeling (as music is capable of), they also struggled with the possibilities of conveying meaning without relying on conventional references. If they were going to restrict themselves to manipulating line, shape, and color, they would have to make a careful study of the inherent emotional and formal properties of those elements.

Whatever their differences, the statements of Kandinsky, Malevich, and Mondrian are all in accord about abstraction's potential for achieving freedom of expression, which became a rallying cry. Central to this notion was Henri Bergson's conviction that an individual must use intuition to attain any true knowledge of reality. Malevich claimed that, until his time, there had never been an unsullied use of the intuitive impulse in art; it had not been used without "utilitarian purpose" (that is, for narrative).[83] In Mondrian's terms, there is a "higher intuition"[84] that transcends the materialistic world. And for Kandinsky, pure intuition is "inner necessity," which is crucial to his entire approach. This subjectivist principle relies on the expression of feelings to convey a realm of experience unconnected to the surrounding world[85] and independent of the demands of representation. Mondrian—perhaps influenced by Kandinsky's writings—explained in 1913–14 that for an artist to render matter "differently from its visual appearance is . . . justified when [it] results from an inner feeling of necessity."[86] However, Kandinsky's emphasis on "inner necessity" may have been the point that Malevich disputed when he insisted that "in art there is a need for *truth*, not *sincerity*."[87]

The highest goal of this intuition or "inner necessity" was the expression of emotion. Malevich was insistent on this point: "Under Suprematism I understand the supremacy of pure feeling in creative art." He believed that the "visual phenomena of the objective world are, in themselves, meaningless" to the artist, whose mission is to find ways of expressing feeling through the fundamental elements of "non-objective representation." Malevich declared that "a blissful sense of liberating non-objectivity drew me forth into the 'desert,' where nothing is real except feeling." He saw art not as a battle against the forces of materialism, but as the expression of pure feeling in the "desert" of life's unforgiving environment.[88]

Mondrian also acknowledged the importance of emotion in art. But he regarded the "common emotions" as unworthy of attention and instead extolled "the emotion of beauty" and "aesthetic emotion," both of which have an abstract appearance.[89] Such concepts were intended to eliminate from art the physical manifestations of life—the "particularities . . . , which obscure pure reality"—and to emphasize "concrete, universal expression."[90] Mondrian did believe, however, that his inner feelings were symptomatic of the collective outlook of the times, but wanted to avoid a purely subjective statement.[91] His distaste for unbridled emotion might have been a reaction to the various forms of Expressionism practiced in Vienna and in Germany, which stressed the direct expression of personal feelings and a critique of contemporary society by manipulating and distorting—though not eliminating—the artist's traditional representational means. In contrast to the latter, Kandinsky, Mondrian, and Malevich sought to convey a different kind of feeling, which, while implicitly expressive of the times, would remain free of any explicit social context and thus unconstrained by conventional notions of reality. Theirs was the realm of transcendent emotions as opposed to the contextually angst-ridden ones of, for example, Ernst Ludwig Kirchner and Oskar Kokoschka.

Abstraction as a personal quest reached its supreme purpose and grandest claim in the artists' discussions of freedom. Mondrian analyzed all early twentieth-century art as evolving in this direction

and culminating in the unfettered application of pure colors and forms: "Once painting was freed from the imitation of nature, it automatically sought further freedom. It had liberated itself somewhat from natural color—and also to some extent from natural form; now the breaking of natural color and natural form had to follow."[92] Kandinsky, too, stressed that an artist's freeing of form to express inherent "vibration" results in the personal attainment of "spiritual freedom."[93] Malevich was consumed by a desire to liberate himself from objective reality (the representation of which, he noted, is best left to photography and cinema[94]); he envisioned this "circle of things" as a manacle around his neck,[95] which he likened to the "chains of capitalist slavery,"[96] from which he similarly sought escape.

With forms that are free of natural representation seemingly comes complete artistic freedom and an uninhibited spontaneity and immediacy.[97] Implied is the need for freedom *from* something, including the conditions of material culture and everyday existence.[98] Although these unrestricted conditions exist only in the artistic arena, such freedom also implies a certain degree of political freedom symbolized by the total lack of concern for the "circle of things." Hence, while it can be argued whether such freedom is possible, it is the yearning for it that is important to examine.

It is tempting to speculate that Kandinsky, Malevich, and Mondrian must have felt threatened by the world, individual governments, and daily events, and unable to cope (in the way described by Worringer about those who embrace abstraction). Their rejection of conventional forms and objective references to the external world was not just an aesthetic decision but a gesture of political defiance and revolt as well. Is there an unspoken anguish in this gesture? Though hardly apparent in the way that the German and Viennese Expressionists flaunted it, anguish perhaps underlies their creation of a seamless, abstract façade, and might explain the curious use of the word "tragedy" in statements by Kandinsky and Mondrian (a word never used by the Cubists). It has been pointed out that a Bergsonian assertion of freedom and intuition may in fact add little to an understanding of the world;[99] however, by declaring this freedom, the individual's self-confidence is bolstered, as is his or her faith that a culturally determined destiny is not inevitable or acceptable. With the unconstrained creation of works of art that seemingly have no reference to the surrounding world, the artist abolishes that destiny, and history itself.

The Subject
"What should replace the missing object?"[100] "The artist must have something to communicate."[101] These statements by Kandinsky form the crux of the dilemma for all abstractionists, and his articulation of this issue early in his career substantiates his pioneer status. From the start, abstractionists needed to define their position with regard to subject matter, with each artist proposing his or her own solution. While rejecting traditional notions of explicit subject matter, Kandinsky, Malevich, and Mondrian affirmed the existence of the subject in abstract art, especially in terms of its potential to express universal spiritual forces and the inner truth of things. In answer to the question "What do these works mean?" they would undoubtedly have said, "As much as possible." Instead of a pedestrian world view, the abstractionist lays claim to a global vision and an expansive range of meaning; anecdotal themes or perceptions of "objective reality" will not suffice.

And yet the early abstractionists were not completely free of traditional values, which resulted in a degree of ambiguity and contradiction within their theorizing. For instance, they still abided by

the notion of resemblance,[102] even if in their case it required truth to the portrayal of inner states of mind, ideas, or emotions. They were interested in life, but only in its unseeable or interior dimension. However, because their works have no apparent relationship to the field of appearances, the paintings must be recognized as extensions of metaphysical thought, giving a "picture of the world" by abstract means.[103] Metaphysics, dealing with the realm of life that underlies or transcends material existence, is at the heart of the abstractionists' purpose and strategy with regard to subject matter, and parallels the underlying religious spirit of so much early abstraction. However, abstractionists are not philosophers but creators of artworks, and it is through that means that they hope to achieve their most exalted goal.

By relying on his notion of "inner necessity," Kandinsky supported the existence of subject matter in his work. He believed that forms originate in authentic feelings, and are therefore filled with inherent content, and that a "form without content [that is, subject matter] is a sin against the spirit."[104] The word "spirit" was key for Kandinsky, and he conceived it in terms simultaneously abstract and concrete: the "life of the spirit may be graphically represented as a large acute-angled triangle"[105]—and triangular forms occur frequently in his work, as in *Painting with Black Arch*. But Kandinsky suggested that other subjects were within his purview, as well, including the evocation, if not delineation, of moods and feelings,[106] and even the "sounds of the universe."[107] On other occasions, he explained that it is the "inner sound" of each form that is depicted, and that his job consists of orchestrating or composing these sounds to create a picture. Although the subject usually remains unspecific, Kandinsky always insisted that *something* is being represented, and that he has given it an abstract appearance.

Kandinsky composed a system of veiled references "emerging unnoticed from the canvas and meant for the soul rather than the eye."[108] As has been noted, he indicated that there were degrees of abstraction in his works of 1910–14; correspondingly, one might say that the more abstract the image, the more veiled the subject matter. For example, consider the presence or absence of a descriptive title for a work, with all the expectations and assumptions it triggers. If Kandinsky gave a descriptive title to a painting in which he used fragmentary images from the world, one would conclude that the painting is apparently about a partially masked subject;[109] but if the title is not referential, then one might say that the subject has been more fully submerged. On all occasions, Kandinsky depended on the inherent suggestiveness of each form—especially its color(s)—to carry his content.[110] And he even raised the hidden to a transcendent level: "Speaking of the hidden by means of the hidden. Is this not content?"[111]

Kandinsky's attempts to explain the nature of content in abstract art resulted in part from his fear that abstraction might be perceived as descending to the level of "mere geometric decoration resembling something like a necktie or a carpet."[112] The hollowness that he ascribed to such geometric abstraction—with his highly pejorative description of "decoration"—was a stinging indictment by an artist who desperately wanted to "have something to communicate." Indeed, in protesting that the evocation of beauty could not suffice as the principal aim of abstract art, and maintaining that his veiled references served a spiritual function, Kandinsky was asserting the undecorative nature of abstract art. One should view the thorny issue of pictorial space in this regard. Logically, in order to achieve complete abstraction in his paintings, Kandinsky should have avoided suggesting any illusion of depth, which carries with it an

ambiguousness that contradicts the purity of the formal means. But, fearing that his work might become decoration if he made it completely flat—eliminating any sense of depth from the picture plane—he preferred to combine flatness and space to insure that "the ornamental" was avoided.[113]

Malevich was initially as ambivalent as Kandinsky about abstraction's subject matter, attaching referential titles to fully abstract work. But he held these qualms for only a brief time, after which he gave no thought to conventional subject matter except to rail against it as "vulgar," stressing that form was enough—*that* was his subject.[114] Nevertheless, in 1916 he used a metaphor of the human figure to describe his Suprematist square: "It is the face of the new art. / The square is a living, royal infant."[115] Malevich's analogy to a "royal infant" is perhaps even a reference to the Christ child. Recall, too, Malevich's frequent use of the cruciform composition—as in *Suprematism (Black Cross on Red Oval)*, 1921–27 (fig. 30)—which, as has often been noted, can be likened to the icon paintings he admired. Thus, even as he disavowed subject matter, Malevich appears to have maintained a connection to traditional religious themes, as Kandinsky had, by transforming them through the modern clothing of abstraction.

In 1918, Malevich went further in suggesting content for his art. For instance, he described a square as if it were the sign of a new age,[116] perhaps hoping to rival Kandinsky's spiritual triangle, which appeared frequently in his writings and art. For Malevich, the square is "a distant pointer to the aeroplane's path in space," and thereby a harbinger of mankind's future. In 1920, Malevich explained that the white square "evokes the establishment of world building as 'pure action,' as self-knowledge in a purely utilitarian perfection of 'all man.'"[117] In one sense, Malevich's references to the aerial nature of the square simply had to do with leaving behind the things of this earth and all that was suggested by them for a plane of "pure emotion." But his later evocation of this modern piece of machinery along with the onrush of references to "world building" and the "utilitarian" character of his enterprise hint at a shift in how he either understood or felt it necessary to explain the Suprematist mission. One wonders if both the challenge of Constructivism's practical ambitions starting in late 1919, and then the pressures of Russia's new revolutionary government, might have led Malevich to some of these statements. Why else would he have adjusted his earlier positions so as to emphasize the "purely utilitarian necessity,"[118] rather than the abstract purity of his project? This is not to say he had become a Constructivist, only that his theorizing had taken on a new tone. Also in 1920, Malevich began to use the term "abstraction," as when he declared that "Suprematist forms, as an abstraction, have achieved utilitarian perfection."[119] "Abstraction" is used in its traditional sense here, meaning "abstracted from," indicating that by 1920 Malevich was grounding his purity in an idealized notion of the practical.

In the work of Mondrian, the notion of subject matter is perhaps best approached by looking at his art as "a description of the world," a phrase used by Svetlana Alpers to characterize earlier Dutch art,[120] much of which was concerned with rendering the tangible world or "God's great plan"[121] of it. One could also say that Mondrian was engaged in depicting a transcendental vision of the world in very tangible form, and that he expressed his vision of "God's great plan" through various permutations of the horizontal-vertical cross, a universal symbol that can be understood as representing nearly every dichotomy that might exist in nature or human thought. By means of these configurations, he believed that he could create an analogy to underlying layers of reality, without recourse to superficial or anecdotal

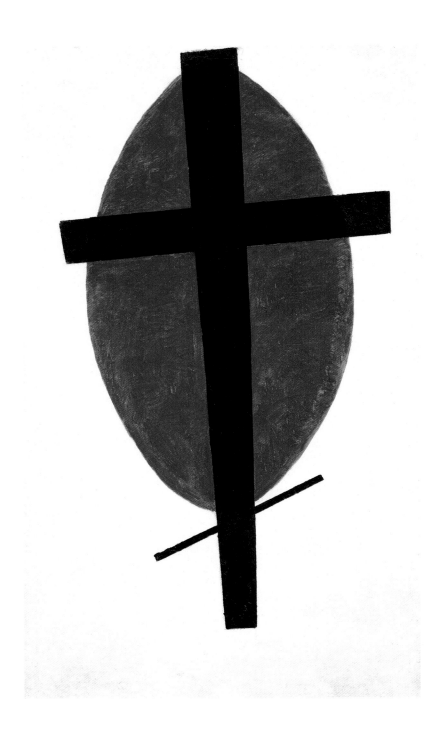

30. Kazimir Malevich, Suprematism
(Black Cross on Red Oval), *1921–27.*
Oil on canvas, 39 ½ x 23 ⅛ inches (100.5 x
60 cm). Stedelijk Museum, Amsterdam.

appearances. Where Mondrian showed greater insight than his colleagues was in emphasizing that abstraction's great innovation was its stylistic breakthrough, not its subject matter. He proclaimed that the artist "*wants* and *searches* for a style: this is his struggle."[122] Only after achieving that unique and effective style could the artist hope to communicate his elusive subject matter, that quarry described as the universal, the spiritual, or pure feeling. Kandinsky was not completely unaware of this issue,[123] but it was Mondrian who asserted that the discovery of a style was the true search of the abstract artist.

Immanence/Transcendence

Even though abstraction strove to transcend the everyday world, its flatness presented an obstacle to its complete independence. It has been explained that the development toward greater flatness, starting in the mid-nineteenth century, signified increasing modernity through a deliberate emulation of the flat appearance of "popular" art manifestations that are a part of everyday life.[124] Yet abstract works, though flat, completely avoid any depiction of anecdotal life in an overt, illusionistic form, thus asserting an independent existence. If both claims are true, then the abstractionist, in effect, claims immanence and transcendence in the same object—that is, the abstract work of art occupies a real presence in the space of the viewer even as it conveys a realm beyond the world of appearances.

Kandinsky's dictate that "art stand above nature"[125] is the key to abstraction's claims for its territorial sphere. Even as it may strive to evoke the deepest laws of nature, abstraction is ultimately intended as a form of emancipation from the world, and thus as a means of transcendence. The early abstractionists referred to myth in order to explain how such transcendence might occur. They believed, as tribal cultures had, that their acts of creation re-enacted those of the Creator, not merely symbolically but as a ritualistic act that has divine implications. Mircea Eliade wrote beautifully about this phenomenon in earlier cultures. According to their belief systems, he explained, ceremonies are based on godly precedents, and an act of creation "repeats the pre-eminent cosmogonic act, the Creation of the world."[126] At the ritual of creation, the protagonist operates in a kind of timeless vacuum, also understood as "sacred time,"[127] during which history is abolished.[128] An act of creation signifies "the passage from the nonmanifest to the manifest or . . . from chaos to cosmos."[129] Such sublime notions are typically the province of abstract artists.

Malevich was unequivocal on this point: "Art approaches creation as an end in itself."[130] Although he was referring here to art generally rather than to abstraction or even Suprematism, it was only with the attainment of his abstract style that he was emboldened to make such a statement. The creation myth as described by Eliade clearly underlies Malevich's concept. For instance, Malevich explained that whereas earlier historical art failed at authentic "creation,"[131] he could succeed because his forms have nothing to do with nature.[132] The great trap occurs because, when "pursuing the form of things, we cannot discover painting as an end in itself, the way to direct creation."[133] Since man is part of nature, he explained, man can create like nature, without imitating it.[134]

Declaring that "nature . . . inspires me, arousing in me the emotion that stimulates creation,"[135] Mondrian described an artistic process that partly corresponds to that put forth by Malevich in its emphasis on creation. From there, it was only a short step for him to undergo the transformation from creative artist to Creator, asserting that "Art must transcend reality—Art must transcend humanity. Otherwise it would be of no value to man."[136] Kandinsky made the analogy even

more directly: "The creation of works of art is the creation of the world."[137] Kandinsky and Mondrian, like Malevich, were making general statements about art, but all three of them pointed to their own abstract work as accomplishing these goals, unlike their contemporaries, who made no such claims.

The myth of creation provided those who believed in it with an extraordinary degree of the freedom that they desired. Unconstrained by time, society, and history—indeed, consciously seeking to demonstrate the absence of these boundaries in their art, and responding faithfully to their own instincts—these creators felt themselves capable of rich displays of self-assertion. They established themselves as players in a cosmic sense, with creation likened to Creation, and the artist likened to the Creator (and perhaps yearning for Him, too).

Just as Eliade described the place of creation as being a sacred "zone of absolute reality,"[138] the early abstractionists claimed that their paintings achieved a new kind of reality, and that they possessed an independent life and palpable presence that imparted a new dimension to the concept of realism. Now, as Georg Wilhelm Friedrich Hegel envisioned, the objective and subjective were harmonized,[139] as were immanence and transcendence. Immanuel Kant's concept of the "thing-in-itself" comes into play here, for there is an emphasis not on mere representation but on the siren song of sensuous attributes that one apprehends from the artwork. In this regard, the abstractionists' claims to realism were founded on the theory that nothing beyond the work is pertinent—that, rather than presenting images of reality, the work is a piece of reality itself. Yet its independence, with that implacable façade, defies our complete knowledge of it. Kant's "thing-in-itself" was an exquisitely sublime notion for the abstractionists in that the object is at once in our presence, seemingly knowable, but offers rewards beyond us. Kandinsky, Malevich, and Mondrian feared losing this bond between the finite qualities and infinite possibilities of the work of art, which might otherwise be simply decorative. If an artwork were both immanent and transcendent at once, it would achieve a kind of apotheosis of reality.

Mondrian's belief in this line of thinking was fundamental to his whole approach, which he termed "abstract-real" to link the two poles. He contended that the world's "rhythm" is present in his abstract paintings.[140] Similarly, Malevich believed that an "independent life of forms" resulted in a "new realism," and that "Suprematist forms will live, like all living forms of nature."[141] Kandinsky described his works as possessing "their own independent, intense life,"[142] and as "objective" and "independent" like nature.[143] In sum, the early abstractionists claimed that each of their works is a real, metaphysical/transcendental *something* beyond the bounds of history.

Early Abstraction in a Larger Context

The early twentieth century was a time when many artists all over Europe were taking extreme positions and forming movements. These groups were competing at the forefront of the avant-garde for the mantle of modernity. Grandiose claims were made in manifestos and exhibitions, both being equally important. Each movement was a kind of religious crusade, with materialism always the enemy. In this atmosphere, there was a need for new symbols to replace the outmoded ones. For example, in *The Blaue Reiter Almanac*, Marc wrote of being at the turning point from one epoch to another and referred to the "altar of a new spiritual religion" that would be established by the exponents of the new ideas, while Thomas von Hartmann envisioned the arrival of a "new Renaissance."[144]

Although Kandinsky, Malevich, and Mondrian never saw themselves as belonging to a movement called abstraction, each felt himself at the dawning of a new artistic age.[145] In *The Blaue Reiter Almanac*, Kandinsky wrote of the onrush of an "abstract spirit";[146] however, he saw this as being manifested by a shared content more than any similarity of style.[147] Mondrian also affirmed the spiritual nature of this abstract initiative,[148] but the group with which he was associated emphasized an external style, as is suggested by its name, De Stijl. While all of this group's members were purely abstract artists, as were the Suprematists, this was not true of Blaue Reiter. Abstraction, if not a movement per se, was described as having a leadership role, even in political matters. This view was taken not only by Malevich in revolutionary Russia, as would be expected, but by Mondrian, who said that abstraction was the "true socialism."[149] The degree of utopianism was such that they and other artists of the time believed abstraction capable of promoting changes in society.

In boasting of their innovation, the pioneer abstractionists generally denounced the art that preceded them, although Kandinsky's statements in this regard appear measured and even analytical compared to Malevich's invective. Kandinsky criticized the preceding period for its emphasis on the "external,"[150] whereas Malevich maintained that he was being tortured by the conventions of earlier thinking.[151] Both contended that a rupture in history had occurred, an abrupt break with the objective fixation found in other mediums.

Mondrian's language is dramatic, too. He placed his art "on the edge of an abyss,"[152] a phrase that suggests confronting an oppressive reality or entering a completely uncharted region.[153] For Mondrian, art had never before been at such a crossroads: "'To advance without interruption, eyes fixed upon a distant goal,' that is exactly what we have to do."[154] When he first set out on this mission, even sympathetic contemporaries did not understand the breakthrough proposed by this proponent of the new abstraction: in 1914, a Dutch Theosophical journal that commissioned his first essay on art and Theosophy rejected it as being outlandish.[155]

The early abstractionists faced the enormous hurdle of gaining public acceptance, without which they would remain marginalized.[156] Already, in Symbolist-dominated work, artists and writers had turned to private systems of meaning and to evocations of dreams, as if out of disdain for, and rejection by, the everyday world.[157] But the abstractionists had little desire to shock the bourgeoisie, even when they felt alienated from the public. Their ambition embraced all of society, for they were concerned with spiritual issues that might counterbalance the prevailing materialist milieu and offer a quasi-religious sense of deliverance from history. Nevertheless, the chasm between artist and audience could only grow wider when no overt subject matter was present at all. Kandinsky fluctuated in his approach to this problem but was always quite conscious of it, since he wanted an audience for his work.[158] He complained that few viewers looked at his work with "an open soul" or with a willingness to allow a painting to speak about its immaterial content;[159] instead, he said, viewers want to find literal meanings.[160] And yet, he did acknowledge the imprecise nature of abstract form, thereby implying that audiences would have difficulty.[161] He felt some responsibility to lead them,[162] and perhaps that was why he gave many of his works referential or evocative titles. Underlying Kandinsky's analysis was the fear that his audience's materialistic outlook was too firmly established for them to accept a purely abstract work,[163] a situation that would keep him alienated from if not ignored by the general public. But he continued to hope that the new, still vaguely

defined "abstract spirit" would find a willing populace with which to "make contact."[164]

Malevich generally took a more strident position. Although he regarded himself as part of the general political revolution, he seemed unable to put himself in the place of an audience new to this art, as Kandinsky, more generously, was able to do. Instead, Malevich spoke of the enemies of his art as "suppressors."[165]

Mondrian declared his ambivalence on this question: "Art is not made for anybody and is, at the same time, for everybody."[166] Elsewhere, while professing that his art belonged to the contemporary epoch and that abstraction was part of the mood of the times, he sadly concluded that the "true content" of his work was barely perceived.[167] As with Kandinsky, Mondrian contended that audiences were still too bound by conventional notions to be sensitive to "a more interiorized beauty."[168] In effect, even after the early abstractionists acknowledged their role in making an art that was problematic, they still blamed viewers for lacking the Bergsonian intuition necessary to perceive what they were expressing.

Modern France was a place where artists routinely still felt an ongoing connection with history. At the turn of the century, there was little sense of alienation within French intellectual life; it was the *belle époque*, and people felt relatively comfortable with their government and institutions.[169] Hence, French art of that period still centered around the traditions of figurative, landscape, and still-life painting. Although there was an avant-garde, led by the Symbolists and the Nabis, Parisian artists were not then filled with the kind of ideas characteristic of the abstractionists—ideas that a new era was dawning and that all earlier art was about to be overthrown. Nor were they inclined toward theorizing in quite the way the abstractionists did, or imagining that art could have religion's restorative powers. They simply carried out their innovations on the canvas, extending the boundaries of the traditional forms without breaking out of them. But Paris was not immune to foreign influences,[170] and indeed, many of its most notable innovators were expatriates.

Cubism was the invention of one such exile from Spain, Picasso, in collaboration with his French colleague Braque, in the first decade of the new century. This ground-breaking innovation developed as a logical outcome of the work of Cézanne, and represented an elaboration of the still-life tradition of painting that had come to prominence during the preceding century and a half. Cubism was a reasoned approach to the problem of rendering the three-dimensional world on a two-dimensional plane. It was an attempt to convey what Bergson would term the "relative" knowledge of a thing, which one could attain by moving around it in space, as opposed to the supposed "absolute" knowledge if the perceiver could somehow "enter into" the depicted object.[171] The latter was closer to the goal of pure abstraction, but Braque, Picasso, and their followers, no matter how abstract or hermetic their work appeared, remained in the real world and actual space, a world of everyday objects that even included such prosaic elements as newspapers, commercial lettering, and other fragments of daily existence, especially those that evoked café life. As has often been noted, Cubism was steadfastly realistic in the traditional sense rather than that claimed by Mondrian; the Cubists wanted their works to be "read" by the public.[172]

This desire for recognizable subject matter is perhaps what motivated Picasso to draw back from the remarkable extreme he had reached in *Tree-Landscape*, 1907 (fig. 31). Painted during the beginning phase of Cubism—six years before Mondrian's reductive abstractions of trees and buildings—this work so abstracts the formal pattern of a

tree that the source of the motif is virtually unrecognizable without the aid of the title. The painting, a predecessor of the sort of organic abstraction that developed during subsequent decades, could have led Picasso directly to nonobjective art at that moment, but he did not pursue this path of investigation. Cubism's concerns lay elsewhere.

In their early works, the Cubists offered viewers ambiguous clues to the subject matter of a painting. But even when the motif is more clearly evident in later works, a primary aesthetic conundrum for the viewer concerns whether an object or a fragment of flat printed material is actually attached to the canvas or is pictorially rendered. The Cubists did not devise illusionistic spaces or maintain a completely flat plane, but instead created what Joseph Masheck termed a *"pictorially veritable* space."[173] That is, by their actions on a canvas, they constantly reasserted that the flat picture plane could be modified, and that the work of art is an object in its own right. Whereas Kandinsky's use of line in the early 1910s is usually free and does not function as contour in any way, the Cubists' line often serves to define a scaffolding or grid in their Analytic Cubist works. And whether an area of color in a Cubist painting is meant to delineate an object or not, it always clearly asserts its real identity as paint on canvas. In contrast, juxtaposed areas of color in a painting by Kandinsky seem always to imply a certain degree of illusionistic depth.

When Futurism, pure abstraction, and other new approaches to art making began to emerge alongside Cubism, they all competed in their claims for best expressing the era's sense of modernity. The artists pursuing these approaches made it clear that they were not merely imitating the superficial world of appearances, but rather exploring an unseen realm of experience. The claims made for Cubism especially began to resemble those made for pure abstraction, including a sense of "freedom,"[174] a new kind of "artistic reality" distinct from traditional realism,[175] purity such as was found in music,[176] and even the expression of an "inner urge."[177] But the art of the Cubists was steeped in the current moment, whereas the abstractionists were seeking a timeless, universal expression of the human spirit.

Regardless of their professed aims, the early abstractionists could only have arrived at their stylistic solutions by way of French developments, especially Cubism. Cubism's increasingly shallow pictorial space set the stage for abstraction's planarity, and just as significant was its emphasis on an arrangement of formal elements derived from the natural world but submerged in an abstract composition. Mondrian was quite willing to acknowledge his debt to Cubism, a debt that was evident when he gradually reduced the motif of a tree or harbor pier to a composition of crossed vertical and horizontal marks. Nevertheless, he took pains to clarify the differences between himself and his French colleagues. He acknowledged that Cubism was a breakthrough[178] but qualified the extent of its influence on him, asserting that it was based on "earlier forms of beauty,"[179] while his own work, he said, was directed toward an audience "open to more interiorized beauty."[180] According to Mondrian, Cubism was most concerned with volume and naturalistic, three-dimensional space, and was thus "an *abstraction* but not *abstract*,"[181] whereas he wanted to eliminate any sense of volume from his paintings. As if to claim that he alone developed the abstract approach, Mondrian lumped Kandinsky with the Cubists and Futurists, perhaps because he was eager to establish his own credentials.[182]

Malevich, in his important essays "From Cubism and Futurism to Suprematism: The New Realism in Painting" (1916) and "On New Systems in Art" (1919), gave Cubism the credit for destroying the representation of the object. He noted, however, that Cubism

31. Pablo Picasso, Tree-Landscape, *summer 1907. Oil on canvas, 37 x 36 ¼ inches (94 x 93.7 cm). Musée Picasso, Paris.*

32. Pablo Picasso, The Dressing Table, *fall 1910. Oil on canvas, 24 x 18 ¼ inches (61 x 46.4 cm). Private collection.*

33. Georges Braque, Rio Tinto Factories at L'Estaque, *fall 1910. Oil on canvas, 25 ¼ x 21 ¼ inches (65 x 54 cm). Musée National d'Art Moderne, Centre Georges Pompidou, Paris, Gift of Mr. and Mrs. André Lefèvre.*

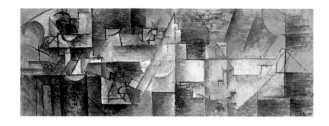

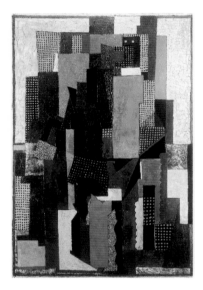

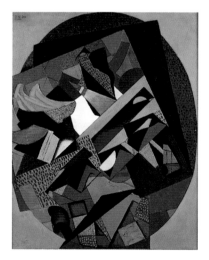

34. *Pablo Picasso,* Woman Lying on a Couch, *1910–11. Oil on canvas, 19 ⅛ x 51 ⅛ inches (49 x 130 cm). Private collection.*

35. *Pablo Picasso,* Man Leaning on a Table, *1915–16. Oil on canvas, 6 feet 6 ¼ inches x 4 feet 4 inches (2 x 1.32 m). Private collection.*

36. *Juan Gris,* Still Life, *1915. Oil on canvas, 45 ⅝ x 35 ½ inches (116 x 90 cm). Staatliche Museen, Preussischer Kulturbesitz, Nationalgalerie Berlin.*

remained aligned with the object, whereas Suprematism took the next step in eliminating the recognizable motif. Futurism was a more important point of departure for him,[183] because it revealed the dynamic energies of matter and form and because of its strident attitudes toward conventional society and art and its emphasis on intuitive methods.[184] Nevertheless, according to Malevich, Futurism, like Cubism, almost never dispensed with the object to become pure.

Mondrian and Malevich were more directly influenced by Cubism than Kandinsky, whose development was closely linked with Fauvism, but Kandinsky did recognize the importance of Cubism to the evolution of abstraction. Works by Braque and Picasso were included in exhibitions that he co-organized in 1910 and 1912; and among the works by French artists that he and Marc reproduced in *The Blaue Reiter Almanac* in 1912 were several Cubist paintings by Picasso.[185] In a letter that he wrote to Marc in 1911, while they were preparing the *Almanac,* Kandinsky gave his evaluation of Picasso's recent work: "He splits the subject up and scatters bits of it all over the picture; the picture consists of the confusion of the parts. . . . This decomposition is very interesting. But frankly 'false' as I see it. I'm really pleased with it as a sign of the enormous struggle toward the immaterial though."[186] On several occasions he wrote of his admiration for Cézanne and Matisse, but he noted that the latter was occasionally guilty of "conventional beauty," a concern with external materiality that, he said, was never true of Picasso.[187] Still, Kandinsky remarked that even as Cubism helped destroy materiality it remained paradoxically rooted in that state. For him, French innovations were a transition: Picasso, with his achievements in the area of form, and Matisse, in the area of color, were the "two great signposts pointing toward a great end."[188] The problem that could arise, he said, was if "conventional beauty" became a goal in itself;[189] in contrast, pure abstraction offered completely new and ongoing possibilities for elaboration.[190]

While Kandinsky, Malevich, and Mondrian were highly familiar with French developments, their own work, especially the abstract examples, was hardly known firsthand in Paris until well after World War I. It is true that Kandinsky had shown at the Salon d'Automne or the Salon des Indépendants every year from 1904 to 1912 except 1907, but three of his most abstract works, from the *Improvisation* series, were seen only in the 1912 exhibition.[191] The critics' responses to these were generally derogatory, with one condemning his paintings for being derivative of Odilon Redon[192] and another describing him as a wildly slashing "artichokist."[193] In a 1914 review of *Concerning the Spiritual in Art,* a French critic complained about Kandinsky's theoretical approach.[194] his was much more discerning, perhaps realizing that Kandinsky represented a threat to his claim that the "greatest names in modern painting . . . are French."[195] In 1912, he wrote that Kandinsky derived his art from Matisse but carried the instinctual approach "to an extreme,"[196] and in the following year related his work to the development of an "art of pure color"[197] by Robert Delaunay and his colleagues, whom he had already identified as moving toward "an entirely new art" of "pure painting."[198] But in a review of a 1913 exhibition, Apollinaire declared that Kandinsky had shorn himself of French influences altogether, and that he admired his work very much.[199] By 1921, a French critic named André de Ridder finally gave Kandinsky credit as an "initiator" of abstraction, and asserted that French art had not yet caught up[200]—although it might have been more accurate to state that French artists had still not shown much interest in it. Indeed, Kandinsky did not have a solo exhibition in Paris until 1929.[201]

Kandinsky's abstract works were not received much more positively

in Vienna, where Hans Tietze described him in 1914 as an unsuccessful Symbolist. But at least this critic termed the work "absolute,"[202] whereas Apollinaire did not discuss its abstractness. In 1919, when a German art magazine ran articles debating the merits of Kandinsky's achievement, another critic also credited him with addressing "the absolute."[203]

Mondrian's work was shown in the Salon des Indépendants of 1911, 1913, and 1914, the last of which included paintings that marked the beginning of his turn toward abstraction. In 1913, Apollinaire accurately called Mondrian's approach "highly abstract Cubism,"[204] recognizing that the work arose out of Cubism but departed further from the object. During the same period, a Dutch reviewer warned that "only emptiness would be the result" of such an ascetic style,[205] a criticism that would frequently be made against the work of later abstractionists as well. Mondrian moved back to Paris in 1919 (after staying in the Netherlands throughout World War I), and in 1921 his work—in his completely reductive, mature style—began to be shown by Léonce Rosenberg, a Parisian dealer who also arranged for the translation of his writings. But Daniel-Henry Kahnweiler, the Cubists' principal dealer and one of its chief theoreticians, condemned the art, castigating Mondrian for having never recognized that Cubism was an art of realism and therefore potentially understandable to the public.[206] Claiming to represent the views of the Cubist painters, Kahnweiler called Mondrian's art "purely ornamental."[207]

Malevich showed three of his Cubist-inspired works in Paris at the 1914 Salon des Indépendants, but was denounced as a fraud ("du chiqué").[208] It appears that the French preferred to see naïve Russian art, for that same salon was full of such work. Four of Malevich's Suprematist paintings were included in a large exhibition of Russian art in 1922 in Berlin, and were undoubtedly seen there by Maurice Raynal, who reviewed the show for a Parisian periodical. But he did not specifically refer to Malevich in his review, although he did write that the exhibition ought to be seen in Paris.[209] Malevich's achievement was still either so unknown or misunderstood in Paris that, in 1940–41, when Delaunay proposed a museum of nonobjective art and listed the artists whose work would be included, Malevich's name was not among them.[210]

The non-French pioneers of abstraction spoke a different language—both literally and figuratively—from their French counterparts. One might even say that they were marginalized in relation to French culture, which dominated European art of the period, but imagined that a modern alternative was possible. Abstraction was a means for artists outside France to create work that shared in a contemporary ethos without appearing to be derivative of Parisian art. It offered all artists, whether in Germany, Russia, or the Netherlands, a lightning rod that was at once the very height of forward, modern thinking and a counterthrust to French tradition. Unlike most late-nineteenth- and early twentieth-century French artists, whose art was founded on an empirical experience of daily life and on the connectedness of the object in its space, abstract artists glorified romanticism, spirituality, and individual imagination. They conceived of an art that would offer salvation from ordinary existence, or at least a reprieve from it. Rather than investigating secular life or posing as ironic dandies, abstractionists explored the possibilities of the artist as shaman. In keeping with these distinctions, critics and other commentators in the French capital spoke of art as a restorative that does not excite but calms the viewer,[211] in contrast to the abstractionists' vision of an art that triggers exalted emotions.

Abstractionists in Germany, Russia, and the Netherlands made a nearly complete break with the art traditions they inherited. French innovators, although they rebelled against the stultifying Salon system, never severed their links to their culture's visual tradition—hence the relationship of Cézanne's bathers and landscapes to those of Nicolas Poussin, or Cubist still lifes to those of Jean-Baptiste-Siméon Chardin. When Maurice Denis wrote that "a picture . . . is essentially a surface covered with colors arranged in a certain order,"[212] he stressed the act of applying paint to canvas because innovation in France grew out of artistic practice itself, whereas elsewhere changes were more often related to new ideas in literature or philosophy (as in Germany, where artistic evolution arose from the realm of Idealist philosophy).[213]

For the pioneer abstractionists, the appeal of Worringer's thesis must have been considerable, especially his proposal of a tradition to which abstraction belongs. Although Worringer ascribed the urge to abstraction to an essentially Northern outlook, his examples suggest a broader spectrum of interests that together contrast with the classical empathic tradition, which includes most French art. To a very great extent, intentionally or not, Kandinsky purveyed certain of Worringer's ideas directly to the art world; only a short time after the latter's book appeared in print, Kandinsky was declaring that his own new innovations were related to the creative spirit of various other periods and cultures. In effect, the abstractionists became the adherents of the previously unacknowledged tradition outlined by Worringer.

The desire among German, Russian, and Dutch artists to establish a new, non-French, practice called abstraction had its chauvinistic aspects, perhaps in response to French people's disdain for certain cultures beyond their nation's borders. The French were especially contemptuous of all things German, for the latter were linked in the French mind with the barbarism of the German military.[214] Nevertheless, it should be noted that starting in 1912, the theoretical territory of abstraction—specifically its emphasis on purity—was being promulgated in Paris by Apollinaire and Raynal.[215] The French were stressing the important distinctions between a decorative and a pure art,[216] just as Kandinsky had done. Perhaps reflecting the Parisian debate and its biases, Willard Huntington Wright, an American who was in Paris at the time, wrote that Kandinsky was a metaphysician and disparaged his art as merely "decorative."[217]

In December 1910, Roger Fry called Cubism "geometric abstraction,"[218] a designation that for its time was relatively accurate. Braque and Picasso had been making paintings in which they were rendering empty space in an increasingly solid manner, so as to equal whatever weight was suggested by objects, a trend that culminated in some of the most abstract of their Analytic Cubist canvases, including the former's *Rio Tinto Factories at L'Estaque*, 1910 (fig. 33), and the latter's *The Dressing Table*, 1910 (fig. 32) and *Woman Lying on a Couch*, 1910–11 (fig. 34). Despite the referential titles, these works appear to have been among the first almost completely abstract paintings, a continuation of Picasso's earlier exploration of abstraction in *Tree-Landscape*. Fry's comment suggests this conclusion, as does his statement of two years later that Cubism is "the abstract language of form—a visual music."[219] Elsewhere, too, the perception was that Braque and Picasso had developed an extreme position, as in a Spanish critic's 1912 description of Cubism as a "conceptual art, a spiritual abstraction."[220] However, the following year, Jean [Hans] Arp, who had already been exploring abstraction, accurately described Picasso's work as a "compromise . . . with the Absolute."[221]

Although the paintings of Braque and Picasso momentarily verged on complete abstraction, the two Cubists quickly retreated from their

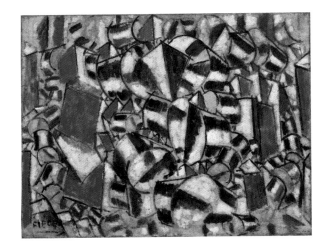

37. Fernand Léger, Contrast of Forms, 1913. Oil on burlap, 38⅞ x 49¼ inches (98.8 x 125 cm). Solomon R. Guggenheim Museum, New York, Gift, Solomon R. Guggenheim 38.345.

38. Henri Matisse, Le Bonheur de vivre, fall–winter 1905–06. Oil on canvas, 68½ x 93¾ inches (174 x 238.1 cm). The Barnes Foundation, Merion, Pennsylvania.

39. Henri Matisse, French Window at Collioure, fall 1914. Oil on canvas, 45⅞ x 35 inches (116.5 x 89 cm). Musée National d'Art Moderne, Centre Georges Pompidou, Paris.

advances of 1910. Perhaps they feared that they had gone in a direction that was too abstract (that is, decorative), a point of view generally supported by the contemporary Parisian art world.[222] In 1911, they began adding representational details and fragments of words to their Analytic Cubist compositions; then, in 1912, with the invention of collage, they introduced bits of the real world, thus reasserting even more strongly the referential nature of their enterprise. The general rationale, Braque explained, was "to come as close as possible to some kind of reality."[223] In later years, Picasso emphatically rejected abstraction, dismissing it as false. Whereas abstractionists "want to paint the invisible and the non-pictorial"[224] and eliminate all traces of the real world from their work, he asserted that the artist always starts with something from the world, which remains present in the work, even if "you remove all traces of reality."[225] In contrast, he believed, other Cubists also were against abandoning the representational basis of art. Albert Gleizes and Jean Metzinger, in their 1912 position paper on Cubism, seemed to have Kandinsky in mind when they wrote, "Let us admit that the reminiscence of natural forms cannot be absolutely banished; not yet. . . . An art cannot be raised to the level of pure effusion at the first step."[226] Writing in a similar vein in 1917, Braque extolled "the rule which corrects emotion."[227] And in 1924, Juan Gris was quite blunt in his declaration that "the only purpose of a picture is to achieve representation."[228]

The Cubist painters flirted with pure abstraction again in the mid-1910s, despite their stated positions. Gris's *Still Life*, 1915 (fig. 36), and Picasso's *Man Leaning on a Table*, 1915–16 (fig. 35), are instances in which these artists appear to have begun their works with an abstract structure. The painting by Gris is the closest he ever came to complete abstraction—so close that it is difficult to identify a representational motif in this work. Most Cubist paintings during this period—in the phase referred to as Synthetic Cubism—seem to have been conceived as arrangements of planar elements, with referential details added afterward.

Fernand Léger often stood apart from his Cubist colleagues. In 1913, for example, he briefly embraced abstraction in the series *Contrast of Forms* (fig. 37; see also Chronology). Some of these dynamic compositions seem to be entirely nonobjective, consisting of overlapping cylindrical, cubic, and planar elements in a play of alternating solids and voids, light and shadow. Léger also covered many areas of the canvas with passages of plain white paint that have no descriptive function, such as had only appeared in the work of Kandinsky by this date. The inclusion of recognizable subject matter was more important to the other Cubists at that time than it was to Léger, who in 1913 noted the crucial breakthrough by the Impressionists in minimizing the importance of the subject.[229] However, although Léger claimed that he and Delaunay were the first to free color from representation,[230] he continued to insist that a painter's task is to synthesize the representation of objects with their more abstract aesthetic character.[231] Léger's experiences during World War I led to an enthusiastic re-embrace of objects; however, his statement "Once I had got my teeth into that sort of reality I never let go of objects again" is misleading.[232] In fact, he continued to give thought to and occasionally to practice abstraction. In the mid-1920s, for instance, he became interested in applying decorative abstract panels within architectural settings,[233] just as had been the custom of the De Stijl group in the Netherlands.[234] Moreover, in 1931, he called abstraction "a dangerous game" that "must be played," declaring that it was the most important innovation of the preceding quarter century.[235]

Matisse was a primary influence on Kandinsky but seemed only barely to take notice of abstraction himself. By 1907, he had made the expressive potential of pure plastic elements central to his work.[236] Indeed, in the upper section of his great *Le Bonheur de vivre*, 1905–06 (fig. 38), the exuberant, free-floating passages of color anticipate whole compositions by Kandinsky of five years later. Like most of the Cubists, Matisse was primarily interested in using subject matter as a vehicle for exploring pictorial relationships that might border on the abstract. But it is always important to maintain a "measure of reality," he said in 1908.[237] This modest assertion of the need for a subject indicates the caution with which Matisse at times verged on pure abstraction, as in several works of 1914 and 1915. Without the title as a clue to its source, his *French Window at Collioure*, 1914 (fig. 39), for example, might be viewed as a study of planar fields of color aligned side by side on the picture plane. But after this momentary fling with pure abstraction, Matisse decisively turned away again, restoring more than just "a measure of reality" to his work. Many years later, in 1953, he titled a work *Abstract Panel Rooted in Reality* (Tate Gallery, London), implying that abstraction is acceptable if it has a tangible basis in the real world. (In fact, the work became known as *The Snail*.[238]) At about the same date, in 1952, he complained about contemporary artists who "depart from a void,"[239] which for him must have meant an intangible source.

Delaunay was one of the very few French artists to embrace the new tendency of abstraction from its earliest years. His work synthesized various aspects of Cézanne, Georges Seurat, Paul Signac, Fauvism, and Cubism. When Delaunay exhibited some of his *Simultaneous Windows* series, of 1910–13, in Zurich in 1912 (for example, fig. 40), Paul Klee, a colleague of Kandinsky, wrote admiringly that these were "the model of the autonomous painting, living without a natural motif, with an entirely abstract plastic existence."[240] In fact, such motifs were still visible in portions of the paintings, but, for the most part, the images of urban rooftops seen through a window seem to dissolve in a glow of light. Around 1912, Delaunay insisted that his subject was light and color fused into "la proportion harmonique" (harmonic proportion).[241] He gave his new method of painting the name "Simultanéisme," after French chemist Michel-Eugène Chevreul's "Law of the Simultaneous Contrasts of Color" (an 1839 treatise on the perceptual effects of juxtaposed colors), from which Delaunay developed his own research and theory of "the movement of colors." By this means, he sought to express the experience of viewing light effects over a period of time, shown in an instant, simultaneously. He asserted that simultaneity itself was both his subject and his pictorial invention.[242] "Color," he wrote, "is *form* and *subject*."[243] In 1924, perhaps eager to take credit as the initiator of pure abstraction, Delaunay explained that the title *Window* was simply intended to be evocative, and that in fact his pictures were abstract and without reference.[244] In 1939–40, echoing the language of other early abstractionists, he characterized his 1911–12 series *Window on the City* (for example, fig. 41) as concerned with "realism, but created and living realism, human realism."[245]

Perhaps Delaunay's greatest achievement in the area of pure abstraction is his most debated work—*First Disc* (fig. 43), in which he eliminated all apparent references to the visible world, instead offering a concrete representation of prismatic light effects. Although the date of this painting has long been given as 1912, it is more likely that it was made in 1913.[246] The fact that it was not shown until many years later supports one suggestion that it was a study for *Homage to Blériot*, 1914 (fig. 42).[247] The importance of pure painting for Delaunay was apparently short-lived, for even while creating such an abstract

40. Robert Delaunay, Simultaneous Windows (2nd motif, 1st Part), *1912. Oil on canvas, 21 ⅛ x 18 ¼ inches (54.9 x 45.9 cm). Solomon R. Guggenheim Museum, New York, Gift, Solomon R. Guggenheim 41.464A.*

41. Robert Delaunay, Window on the City No. 3, *1911–12. Oil on canvas, 44 ¾ x 51 ½ inches (113.7 x 130.8 cm). Solomon R. Guggenheim Museum, New York 47.878.*

42. Robert Delaunay, Homage to Blériot, *1914. Distemper on canvas, 8 feet 2 ⅛ inches x 8 feet 3 ¼ inches (2.51 x 2.52 m). Öffentliche Kunstsammlung Basel, Kunstmuseum.*

43. *Robert Delaunay,* First Disc, *1912.*
Oil on canvas, 53 inches (134.6 cm) in
diameter. Private collection, Switzerland.

work, he continued to paint ambitious canvases that are resolutely figurative, such as the two *Cardiff Team* paintings, 1912–13 (Stedelijk van Abbemuseum, Eindhoven, and Musée d'Art Moderne de la Ville de Paris).[248]

Unlike most of his French colleagues, Delaunay had direct contact with Kandinsky, and was probably influenced by the Russian artist's works exhibited at the 1911 and 1912 Salons des Indépendants in Paris.[249] In those same years, Delaunay showed in both Blaue Reiter exhibitions and corresponded with Kandinsky. In a letter he wrote early in 1912, after seeing a copy of *Concerning the Spiritual in Art*, Delaunay told Kandinsky that he wished he could read the treatise but could not because it had been published in German. Nevertheless, he declared that he and Kandinsky shared common concerns in the area of color and "pure painting," and seemed to suggest that they were both part of a gathering movement, although in Paris, too, there was still no public for such art.[250] Compared to Kandinsky, Delaunay was guided less by intuition than by his research into color theory. Later, writing after the war, Delaunay was clearly at pains to distinguish himself from characteristics that could be associated with Kandinsky's art. For him, in 1924, French art was "clear, live, visual . . . not mystic."[251] His abstraction was concerned with modern life and the rendering of its mood, discoveries, and sensations.

Apollinaire regarded Delaunay's innovative departure from Cubism as the first "pure painting,"[252] and he dubbed it Orphism, a term that he also applied to the work of such artists as Marcel Duchamp, František Kupka, Léger, and Francis Picabia.[253] Leaving aside Duchamp, these were the artists in Paris who gave abstraction a serious, if fleeting examination, whether through the vehicle of color, color theory, dynamic movement, or mysticism. Virginia Spate has speculated that Orphism as a movement declined due to the onset of World War I, which eroded faith in modernity, and due to the fact that Orphist abstraction was rapidly co-opted by the fashion world,[254] an association that would have been anathema to those who feared any decorative tendency in abstraction.

Kupka was a somewhat more isolated case of an abstract artist at work in Paris. He had no connection with Cubism during his formative years, his ideas having largely been developed during his studies in his native Prague and in Vienna[255] before he moved to Paris in 1896. His initial abstractions, which predate those of Delaunay, are all part of his *Verticals* series, and consist of loosely organized, rectangular patches of paint—as in *Nocturne*, 1911 (Museum des 20. Jahrhunderts, Vienna)—or a small number of narrow vertical rectangles—as in *Vertical Planes III*, 1912–13 (see Chronology). In the first painting of the series, *Mme Kupka among Verticals*, 1910–11 (fig. 44), Kupka playfully painted a figure peeking out from behind an abstract curtain, but it is the only one in the series that contains such a figural motif. However, some of the paintings in Kupka's next series, entitled *Amorpha*—such as *Amorpha, Fugue in Two Colors*, 1912 (fig. 45)—though long thought of as completely abstract, may have been loosely based on a figure and then transformed into an arrangement of colored forms.[256] Whatever their origins, the two *Amorpha* canvases shown in the Salon d'Automne in October 1912 and the two *Vertical Planes* paintings seen at the Salon des Indépendants the following year were the first purely abstract paintings exhibited in Paris.[257]

Kupka lived in the Parisian suburb of Puteaux, where he was a neighbor of Duchamp's brothers, Raymond Duchamp-Villon and Jacques Villon, and participated in discussions about Cubism that Villon held in his studio with his artist friends, including Roger de La Fresnaye, Albert Gleizes, Léger, Jean Metzinger, and Picabia.

44. František Kupka, Mme Kupka among Verticals, *1910–11. Oil on canvas, 53 ⅛ x 33 ⅛ inches (135.5 x 85.3 cm). The Museum of Modern Art, New York, Hillman Periodicals Fund, 1956.*

45. František Kupka, Amorpha, Fugue in Two Colors, *1912. Oil on canvas, 6 feet 11 ⅛ inches x 7 feet 2 ⅛ inches (2.11 x 2.2 m). Národní Galerie, Prague.*

46. *František Kupka*, Disks of Newton
(Study for "Fugue in Two Colors"), *1912.
Oil on canvas, 39 ½ x 29 inches (100.3 x
73.7 cm). Philadelphia Museum of Art,
The Louise and Walter Arensberg
Collection.*

47. *Constantin Brancusi*, Bird in Space,
*1923–24(?). Yellow marble on four-part
base of veined marble, limestone, and oak;
bird: 45 ¼ inches (116.2 cm) high,
14 ½ inches (36.8 cm) in circumference;
base: 53 ⅛ inches (135.6 cm) high.
Philadelphia Museum of Art, The Louise
and Walter Arensberg Collection.*

Collectively, they became known as the Puteaux group, and showed their work together at an exhibition in 1912 under the name Salon de la Section d'Or.[258] Kupka was also briefly considered a part of the Orphist movement,[259] and it is likely that his abstract oeuvre of 1911–12 influenced his colleagues, especially Delaunay.[260] In Kupka's *Disks of Newton (Study for "Fugue in Two Colors")*, 1912 (fig. 46), the hues of the spectrum are distributed among segments of concentric circles arranged in overlapping arrays—a highly organized composition that displays rhythms of color and form, but without the apparent sense of freedom in concurrent paintings by Kandinsky. Although this phase of Kupka's work seems closer to that of Delaunay—including Delaunay's research into color theory—Kupka's aesthetic ideas were allied with a rather un-French preoccupation with mysticism, metaphysics, and Theosophy; indeed, he was a practicing spiritualist.[261] His belief that art based on the abstract values of color and form could convey some universal idea beneath the surface of appearances paralleled the ideas of Kandinsky, whose *Concerning the Spiritual in Art* Kupka had read by 1913.[262]

Perhaps it was the example of Kandinsky's *Improvisations* at the 1912 Salon des Indépendants that led Kupka to a new kind of abstraction in the series entitled *Organization of Graphic Motifs*, 1912–13 (for example, fig. 48). These have the same atmosphere of infinite space, curvilinear organic shapes, and dynamism that were present in Kandinsky's paintings of the preceding year or so. But the two painters' theories differed markedly. Whereas the driving force in Kandinsky's creation of his most nonreferential works was "inner necessity," Kupka was concerned with bestowing "subjective form . . . on natural phenomena."[263] Thus, Kupka's fascination with astronomy led him toward an abstract style that appears to be the subjective rendering of cosmic space. Like Kandinsky, he imagined that his work might attain a divine level of creation, although his primary concern was the depiction of physical, heavenly space. Yet even as this impulse to depict the cosmos came to preoccupy many abstractionists during the 1920s, it faded from Kupka's work, and he became interested in calculated formulistic strategies.

One can argue that Constantin Brancusi's *Endless Column*, 1918 (fig. 52), a completely nonreferential form with a powerful physical presence, is the first important completely abstract sculpture. Brancusi compared it to the growth pattern of plants "that grow up straight and strong from the ground,"[264] but unlike his more typical *Bird in Space* sculptures (for example, fig. 47; see also Chronology) the connection of *Endless Column* to a specific source in nature appears to be more metaphorical than real. Brancusi arrived in Paris in 1904 and within a few years began developing a progressively simplified approach to sculpture, finding inspiration in African and Celtic sculptures and the culture of his native Romania. He came to know Apollinaire and several of the Cubists but remained outside that circle. Although most of his work is based on natural forms, he was driven by a desire to see behind surface appearances, believing that "what is real is not the external form but the essence of things. Starting from this truth it is impossible for anyone to express anything essentially real by imitating its exterior surface."[265] *Endless Column*'s abstract form is a projection of such a "real" essence. Its segmented configuration may have been inspired by the constantly repeated motifs of Gregorian chant, which Brancusi greatly enjoyed,[266] and its simple verticality expresses a strength that, he believed, transcends the limitations of architecture.[267] Indeed, regarding one version of *Endless Column*, Brancusi said he made it to "sustain the vault of heaven."[268] Such references reinforce the work's fundamental link to the concerns of

LOCALISATIONS DE MOBILES GRAPHIQUES.

48. *František Kupka*, Localization of
Graphic Mobiles, *1912–13. Oil on canvas,*
6 feet 6 ¼ inches x 6 feet 4 ⅜ inches
(2 x 1.94 m). Fundación Colección
Thyssen-Bornemisza, Madrid.

49. *Giacomo Balla,* Plastic Construction
of Noise and Speed, *1914–15,
reconstructed 1968. Construction of
aluminum and steel on painted wood
mount, 40 ⅛ x 46 ½ x 7 ⅞ inches (101. 8 x
118 x 20 cm). (Reconstruction no. 1 from an
edition of 9.) Hirshhorn Museum and
Sculpture Garden, Smithsonian Institution,
Washington, D.C., Gift of Joseph H.
Hirshhorn, 1972.*

50. *Gino Severini,* Sea = Dancer, *January
1914. Oil on canvas, 41 ½ x 33 ¹⁵/₁₆ inches
(105. 3 x 85.9 cm) including artist's painted
frame. Peggy Guggenheim Collection,
Venice 76. 2553 PG32.*

51. *Natalia Goncharova,* Cats (rayist
percep.[tion] in rose, black, and yellow),
*1913. Oil on canvas, 33 ¼ x 33 inches
(84. 4 x 83. 8 cm). Solomon R. Guggenheim
Museum, New York 57.1484.*

the early abstractionists, despite Brancusi's distaste for having his art
described as abstract. Around 1957, Brancusi explained: "They are
imbeciles who call my work abstract; that which they call abstract is
the most realist, because what is real is not the exterior form but the
idea, the essence of things."[269] In fact, *Endless Column* became the
model for a great deal of abstract sculpture throughout the century,
work consisting of repeated units of more or less identical elements.

Just as Delaunay, influenced by Cubism's dissolution of space,
created a purely abstract art based on interpenetrations of light and
color, so the Italian Futurists—primarily Giacomo Balla, Umberto
Boccioni, Carlo Carrà, Luigi Russolo, and Gino Severini—achieved a
similar transformation in some of their work. Their principal subject
matter was the dynamic sensation of motion conveyed by speeding
cars, trains, and airplanes, which for them signified modern life in all
its manifestations. "We choose to concentrate our attention on things
in motion," wrote Severini, "because our modern sensibility is
particularly qualified to grasp the idea of speed."[270] While the
Futurists defiantly rejected Cubism, their works depend on its
pictorial solutions, which suggest interpenetrating realms and lines of
force. And while they never identified themselves with abstraction,
their statements often draw upon its lexicon. In the second Futurist
manifesto (April 1910), they exhorted artists to break away from
traditional notions of studio art to "soar to the highest expressions of
the pictorial absolute."[271] About 1912–13, Balla began making fully
abstract works consisting of patterns of crossed diagonal lines, one of
the most fluid of which is *Abstract Speed + Sound,* 1913–14 (fig. 53).
Apparently influenced by Delaunay, he attempted in these paintings to
approximate the effects of light, sound, and movement, and to capture
the unstable, constantly changing images of speeding forms using
abstract means. Balla, together with his colleague Fortunato Depero,
described their process as finding the "abstract equivalents of all the
forms . . . of the universe, and then we . . . combine them . . . in order
to form plastic constructions."[272]

In 1914–15, Balla carried this approach into relief sculpture with his
Plastic Construction of Noise and Speed (fig. 49), again trying to create an
"abstract equivalent" of immaterial phenomena. Perhaps he used the
word "construction" in the title because it, better than "abstraction,"
places the emphasis on the independent existence of the resulting
composition and conveys the modern sensibility exalted in Futurist
thinking. Balla's manipulation of form in this work suggests the
geometric faceting of Léger's *Contrast of Forms* series translated into
sculpture. His subsequent abstract paintings have a harder, more rigid
appearance, consisting largely of pattern effects.

Severini, who lived in Paris from 1906 on, was also influenced by
French developments, specifically those of Delaunay and Léger.[273] His
series entitled *Spherical Expansion of Light,* 1913–14, makes use of
Léger-like cylindrical forms in an apparent elaboration of Delaunay's
ideas of light. In *Sea = Dancer,* 1914 (fig. 50), and other paintings that
he made on the theme of dance, Severini rendered balletic movements
through analogous color effects, in a manner that recalls Delaunay's
Simultaneity. The result is a radiant composition of colorful planes
organized by long diagonal force lines. Subsequently, Severini recoiled
from this degree of abstraction to become a kind of retardataire
Cubist, very much under the influence of Gris.

Futurism, with its feverish engagement with contemporary life,
exerted a powerful influence on many Russian artists. In 1911, Natalia
Goncharova and her companion Mikhail Larionov began painting in
an abstract style that they called Rayonism, which they launched
officially at an exhibition in 1913. Larionov described this "style of

52. Constantin Brancusi, Endless Column *(version I), 1918. Oak, 6 feet 8 inches x 9 ⅞ inches x 9 ⅞ inches (2.03 x .25 x .24 m). The Museum of Modern Art, New York, Gift of Mary Sisler, 1983.*

53. Giacomo Balla, Abstract Speed + Sound, *1913–14. Oil on board, 21 ½ x 30 ⅛ inches (54.5 x 76.5 cm) including artist's painted frame. Peggy Guggenheim Collection, Venice 76.2553 PG 31.*

painting independent of real forms" as a "synthesis of Cubism, Futurism, and Orphism."[274] These dynamic works, composed of dramatic force lines intersecting in constantly changing patterns, were more or less completely abstract, although the titles tend to have associative references, such as Goncharova's *Cats (rayist percep.{tion} in rose, black, and yellow)*, 1913 (fig. 51). Larionov also had a close association with Kandinsky (who intended to have a contribution from him in the never-finished second volume of *The Blaue Reiter Almanac*).[275]

By the mid-1910s, there were signs in England of a certain receptiveness to abstraction. Critic T. E. Hulme, who had been influenced by Worringer, gave an important lecture in 1914, in which he described "the new tendency towards abstraction."[276] And Fry delivered an influential lecture series at the Slade School of Fine Art, London, in 1913–14, entitled "The Appreciation of Design in the History of Art," in which he proposed that compositional principles had taken precedence over all other issues, including subject matter, in the history of art.[277] In this atmosphere was born the movement known as Vorticism, led by Percy Wyndham Lewis.

Like the Futurists, Lewis was wedded to the idea of expressing the most modern aspects of the machine age.[278] Although he acknowledged that Cubism provided him with a basic pictorial vocabulary, he derided Picasso for being insufficiently engaged with the modern world. Furthermore, he described Cubism as not going far enough in the direction of abstraction,[279] and therefore condemned it as having become irrelevant.[280] As for Matisse, Lewis found him to be too decorative.[281] Lewis's ambitions were in the area of abstraction, which he declared to be the foremost "new section."[282] He both praised and criticized the exemplar of this new direction in art, Kandinsky, whose work was known in London through exhibitions at the Allied Artists' Salons as early as 1909, and whose *Concerning the Spiritual in Art* appeared there in English translation in 1914.[283] Kandinsky, Lewis wrote, was "the only PURELY abstract painter in Europe," but was too "passive" in his approach and his work was too "lyrical" in appearance. Lewis also described Kandinsky's work as lacking resolution, thus implying that, like Cubism, it was a bankrupt direction.[284] He explained: "We must constantly strive to ENRICH abstraction till it is almost plain life."[285] The "plain life" referred to here connotes his absolute commitment to modern life and to the notion that the artwork must hold a concrete position in its midst.

Lewis's *Composition*, 1913 (fig. 56), exemplifies his approach to abstraction. Though apparently lacking a recognizable reference, the work has the hard, rectilinear surfaces one might associate with the machine age, and with the contemporaneous work of Léger. But like so many other abstractionists, Lewis was ambivalent in his intentions, no matter what he proclaimed in print. In subsequent works, he usually assigned referential titles, such as *Plan of War*, for example, thereby offering an aid to perplexed viewers. Clive Bell, who stressed the importance of "significant form" in the work of art, criticized Lewis's work as having become too involved with lifelike dramas "to the detriment of pure design."[286]

The context that made England, Germany, Italy, the Netherlands, and Russia fertile territory for abstraction seemed to apply in the United States as well. There was at once an absence of prevailing avant-garde tendencies in which to couch new experiments, and a hunger for a breakthrough. Thus, for instance, already in 1909, there was an exhibition of contemporary German art in Chicago, the catalogue for which included an essay on the influence of proto-Formalist Adolf von Hildebrand.[287] Also in Chicago, collector Arthur

54. Arthur Dove, Abstraction No. 3, *1910–11. Oil on wood, 9 x 10 ½ inches (22.9 x 26.7 cm). Private collection.*

55. Arthur Dove, Nature Symbolized No. 2, *ca. 1911. Pastel on paper, 18 x 21 ⅛ inches (45.8 x 55 cm). The Art Institute of Chicago, Alfred Stieglitz Collection 1949.533.*

56. *Percy Wyndham Lewis*, Composition,
1913. Pen, watercolor, and pencil on paper,
13 ½ x 10 ⅛ inches (34.3 x 26.5 cm). Tate
Gallery, London, Purchased 1949.

57. *Marsden Hartley*, The Aero, *1914.*
Oil on canvas, 39 ½ x 32 inches (100.3 x
81.3 cm). National Gallery of Art,
Washington, D.C., Andrew W. Mellon
Fund 1970.31.1.

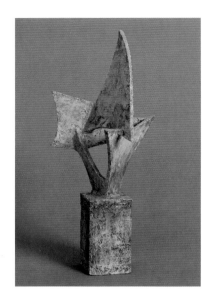

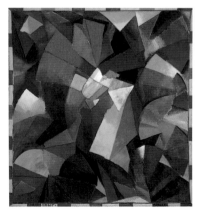

58. Max Weber, Air-Light-Shadow, 1915. Polychromed plaster, 28 ⅛ x 12 ¼ x 10 ⅜ inches (73.2 x 31.1 x 26.3 cm). The Museum of Modern Art, New York, Blanchette Rockefeller Fund, 1959.

59. Morgan Russell, Synchromy in Orange: To Form, 1913–14. Oil on canvas, 11 feet 3 inches x 10 feet 1 ½ inches (3.43 x 3.08 m). Albright-Knox Art Gallery, Buffalo, Gift of Seymour H. Knox, 1958.

Jerome Eddy, who acquired works by Kandinsky beginning in 1913, encouraged a fellow collector in New York, Edwin R. Campbell, to commission a suite of Kandinsky paintings.[288] Eddy wrote a book about modern art in which Kandinsky is named "the most extreme man . . . of the entire modern art movement."[289] Paraphrasing abstractionist thinking, Eddy called attention to the limits of Picasso's Cubism arising from its dangerously unemotional investigation beginning in the world of appearances.[290] In New York, in July 1912, Alfred Stieglitz published in his magazine *Camera Work* excerpts (translated into English) of Kandinsky's *Concerning the Spiritual in Art*, seven months after its original publication in Germany.[291] The enormously influential Stieglitz, apparently inspired by Kandinsky's ideas, declared that same year that abstraction was the art of the future.[292] He even purchased a work by Kandinsky in 1913 from the famed Armory Show in New York,[293] an exhibition that further propelled the American embrace of the latest aesthetic tendencies. The artists who were associated with Stieglitz and his gallery "291" in New York were the ones who, for the most part, advanced the cause of abstraction early in the century in America.

Arthur Dove studied in France with other Americans, and, shortly after his return to the United States in 1909, even before Stieglitz expressed interest in abstraction, he produced a series of six small paintings later entitled *Abstraction*, dated 1910–11 (for example, fig. 54). In their abbreviated approach to landscape details, these bear a strong relationship to the contemporaneous work of Kandinsky,[294] although the more likely sources are paintings by Cézanne and the Fauves. In 1911–12, Dove completed a series of ten pastels, which were exhibited without titles at his first solo exhibition at "291" in late February 1912. Of the ten works, which later became known as *The Ten Commandments*, one has been positively identified, and eight have been identified with relative certainty.[295] Three of the identified works bear the title *Nature Symbolized* (for example, fig. 55; see also Chronology), which is a good indication of Dove's approach. He had a profound, Romantic interest in nature and wanted to express an idea of it in his art, using abstract means as his vehicle. In a manner resembling the work of Balla, but preceding it, these pastels have an organic vitality based on the repetition of rhythmic curves.

Although Georgia O'Keeffe did most of her work in the postwar period, it is important to note that she was a part of the Stieglitz circle. Almost from the start of her mature career, O'Keeffe's art was based on natural motifs, no matter how completely abstract the paintings may appear. Indeed, she occasionally rendered such motifs in a way that seems to eliminate their connection to nature entirely.

Marsden Hartley learned of Kandinsky and *The Blaue Reiter Almanac* by July 1912, and two months later sent a copy to Stieglitz. In September 1912, Hartley also promised to obtain for Stieglitz a copy of *Concerning the Spiritual in Art*, apparently unaware that Stieglitz had already published excerpts of it in *Camera Work*.[296] The following year, Hartley visited Berlin and then Munich, where he met Kandinsky and Marc;[297] he even exhibited with these and other Blaue Reiter artists in the Erste Deutsche Herbstsalon (First German Autumn Salon) in Berlin in 1913.[298] Several of Hartley's paintings of 1912–14 show the clear impact of Kandinsky, especially in the overlapping, mountain-shaped triangles and the general sense of a natural world abstracted into geometric shapes. But Hartley combined this idiom with Cubism and a certain German Expressionist sensibility to produce, in the mid-1910s, an altogether original and at times completely abstract body of work, as in *The Aero*, 1914 (fig. 57). In subsequent decades, however, he discarded the abstract approach.

Max Weber is best known for his Cubistic paintings of 1913–15, which, for the most part, are quite derivative. Around this same time, however, he created a completely original abstract sculpture entitled *Air-Light-Shadow*, 1915 (fig. 58). Interpreted in the context of an essay by Weber entitled "The Fourth Dimension from a Plastic Point of View," published in a 1910 issue of *Camera Work*,[299] this sculpture appears to be a Futurist-style attempt to depict the physical concept of a fourth dimension with abstract means.

The Synchromists, a group of painters led by Stanton MacDonald-Wright and Morgan Russell, represented another American outpost of abstraction. These artists were responsible for creating an American approach to color that was derivative of the work of Delaunay, as can be seen in Russell's *Synchromy in Orange: To Form*, 1913–14 (fig. 59).[300] Compared to Delaunay, however, the Synchromists remained steadfastly abstract.[301]

War and Revolution

From the onset of World War I to the outbreak of the Russian Revolution, the enormous exchange of ideas that had recently taken place throughout the art world subsided somewhat, and the idea of abstraction established by its pioneers was at least temporarily eclipsed by new developments that arose in response to the war's tragic devastation. The massive numbers of dead produced a "new dimension" in history,[302] and a degree of reality that could only leave artists wondering how best to react, no matter what style of art they adhered to. Some maintained that a direct response was inadequate, anecdotes having little authentic value in the face of such events. Parisian writers Paul Dermée and Pierre Reverdy urged artists to ignore life altogether and work from their imaginations.[303] In fact, Malevich and Mondrian embarked on their paths of pure abstraction during this period, and no explicit evocation of death can be found in the work of the Cubists.

But other artists rebelled against the established values that had led to the catastrophe. The art movement known as Dada was born during World War I, largely of German parentage. It began in New York and Zurich, and then spread to other cities in Europe, including Berlin, Cologne, Paris, and Hannover. Its chief founders were Hugo Ball, Richard Huelsenbeck, and Tristan Tzara; and among its most prominent participants were Arp, Duchamp, Max Ernst, Picabia, and Kurt Schwitters. Dada was more a sensibility than an art style; its proponents attacked the conventional values of society, bourgeois appearances, and traditional expectations about the nature of art. It took the form of spontaneous actions and performances, along with art objects inspired by subconscious musings or chance events. All of these were meant to epitomize a rebellious, anarchistic approach, which, it was hoped, would reform the societal premises that had led to the cataclysmic war. According to Huelsenbeck, a German poet (and also, at the time, a medical student), "Dada" was at first a name for an abstract tendency.[304] He explained that "abstract art was for us tantamount to absolute horror. Naturalism was a psychological penetration of the motives of the bourgeois, in whom we saw our mortal enemy."[305] In other words, an abstract work of art contained an artist's horrified response to the war, whereas a representational work reflected the bourgeois morality that had triggered the horror. Ball, who started Cabaret Voltaire, the Dada meeting place in Zurich, was a German poet, musician, and theatrical producer. In a 1917 lecture, he lavishly praised Kandinsky for his spiritual stand in the face of rampant materialism, as well as for his free, anarchic approach.[306]

Years later, Arp wrote admiringly of Kandinsky's "breakthrough,"

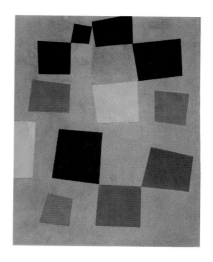

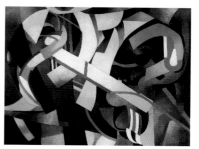

60. *Jean Arp*, Squares Arranged According to the Laws of Chance, *1917. Cut-and-pasted paper, ink, and bronze paint, 13 ⅛ x 10 ¼ inches (33.2 x 25.9 cm). The Museum of Modern Art, New York, Gift of Philip Johnson, 1970.*

61. *Francis Picabia*, Physical Culture, *1913. Oil on canvas, 35 ⅜ x 46 inches (89.9 x 116.8 cm). Philadelphia Museum of Art, The Louise and Walter Arensberg Collection.*

62. *Jean Arp (embroidery by Sophie Taeuber)*, Pathetische Symmetrie, *1916—17. Embroidery on linen, 10 15/16 x 7 1/16 inches (27.8 x 18 cm). Öffentliche Kunstsammlung Basel, Kunstmuseum.*

and asserted that both of them were motivated by a similar desire for "liberty."[307] Like Kandinsky and Mondrian, Arp believed that he could make life more bearable with his art—indeed, that he might transform the inherently "tragic existence" of humanity.[308] And like Mondrian, Arp sought in abstraction the most elemental essence of artistic form, and thus to eliminate from art the egotism of the individual.[309] In an essay on Cubism written in 1913, he examined the work of Picasso from the standpoint of a true abstractionist, arguing that Picasso, by retaining images of objective reality in his work, made a "dangerous compromise . . . with the Absolute."[310]

Purity, the sublime, and "an incommunicable absolute" were Arp's obsessions,[311] and around 1915, in collaboration with Sophie Taeuber (after they married in 1922, she became known as Sophie Taeuber-Arp), he arrived at a new way of exploring them by using an abstract mode and methods of chance. Taeuber's paintings, tapestry designs, and wood-carvings were based on a purely abstract grid format,[312] which Arp developed with her and on his own in a series of collages, paintings, and other works between 1915 and 1918, such as *Pathetische Symmetrie*, 1916–17 (fig. 62). In works such as *Squares Arranged According to the Laws of Chance*, 1917 (fig. 60), Arp allowed spontaneous actions to play a principal organizing role in determining the geometric composition. Just as Kandinsky brought to abstraction his interest in spirituality, Arp and Taeuber invested the new language of art with a kind of religious trust in pure chance.[313] In both cases, abstraction was imbued by its creators with something from outside the limited field of simple formal relationships. During these same years, Arp also created many works using curvilinear or biomorphic forms and explored the technique of automatic drawing. The latter, characterized by a Kandinsky-like free hand, gave full reign to the possibility of an abstract art based on unconscious inspiration.

Some of Dada's most antirational, freely inspired, playful works were produced by French artists who experimented for a brief time with abstraction, particularly Duchamp and Picabia, and the American-born Man Ray. Picabia's *Physical Culture*, 1913 (fig. 61), represents a science-fiction vision of abstraction, in which detached, seemingly nonreferential forms float in a container, surrounded by shadows. Similarly, there is a strong machinelike element to Duchamp's abstraction, as in *The Bride Stripped Bare by Her Bachelors, Even*, 1915–23 (fig. 63), in which a "bride" and her "suitors" are rendered as pseudo-mechanical forms. Duchamp's enormously influential series of "readymades" (ordinary or "found" objects exhibited as sculpture), such as *Bottlerack*, 1914 (see Chronology), acted as a stabwound not only to the general character and tradition of art but to the purely formal, nonreferential integrity of abstraction. Man Ray was an artist of diverse talents who delved occasionally into abstraction during the late 1910s. His *Boardwalk*, 1917 (fig. 64), which is less about spiritual than matter-of-fact physical forces, suggests a lighthearted approach to abstraction.

Although abstraction was already established as an expression of something modern, Dadaists were often ambivalent about it and some became altogether disillusioned with it. With their inherent general skepticism, they saw abstract art as a potential dead end, one more variation on the tired convention of traditional art objects. Ball, expressing the predictable concern that abstraction has little to do with life, worried in 1917 that it would become merely a "revival of the ornamental."[314] Tzara saw abstraction as Dada's connection to modern existence, but he wanted something more. In 1918, in the second Dada manifesto, he wrote, "Dada is the signboard of abstraction; advertising and business are also elements of poetry."[315] Hence, the practice of

63. Marcel Duchamp, The Bride Stripped Bare by Her Bachelors, Even (The Large Glass), *1915–23. Oil and lead wire on glass, 9 feet 1¼ inches x 5 feet 9⅛ inches (2.78 x 1.76 m). Philadelphia Museum of Art, Bequest of Katherine S. Dreier.*

64. Man Ray, Boardwalk, *1917. Oil, furniture handles, and cable wire on wood, 33⁷⁄₁₆ x 36¼ x 4½ inches (85.5 x 92 x 11.5 cm) including original frame. Staatsgalerie Stuttgart.*

65. Ivan Puni, Still Life: Relief with Hammer, *1914, restored 1920 by the artist. Gouache on cardboard, with hammer, 31¹⁵⁄₁₆ x 25⁹⁄₁₆ x 3⁹⁄₁₆ inches (80.5 x 65.5 x 9 cm). Private collection, Zurich.*

66. *Vladimir Tatlin*, Corner Relief,
1915, reconstructed 1979 by Martyn Chalk.
Wood, iron, and wire, 31 x 31 ½ x
27 ½ inches (78.5 x 80 x 70 cm). Courtesy
of Annely Juda Fine Art, London.

67. *Olga Rozanova*, Untitled (Green
Stripe), *1917–18. Oil on canvas,*
28 x 20 ⅞ inches (71 x 53 cm).
Rostovo-Yaroslavskij Arkhitekturno-
Khudozhestvennyj Muzej-Zapovednik,
Rostovo-Yaroslavskij, Russia.

68. Kurt Schwitters, Revolving, 1919.
Wood, metal, cord, cardboard, wool, wire,
leather, and oil on canvas, 48 ⅓ x 35 inches
(122.7 x 88.7 cm). The Museum of Modern
Art, New York, Advisory Committee Fund,
1968.

collage, with a strong emphasis on popular culture, assumed primacy in many Dadaists' oeuvres.

In Dada writings of this period, the word "abstract" often appears with reference to literary endeavors in an increasingly disparaging way. Huelsenbeck, in a 1920 text, "En Avant Dada," criticized an imaginary German poet for his dreamy escapism by calling him a "born abstractionist," and declared that Tzara, who "made Dadaism an abstract direction in art, . . . never really understood what it meant to make literature with a gun in hand."[316] However, while Huelsenbeck wanted an art that had the actuality of a "toothache" and embarked on "the road from yearning to the reality of little things," he acknowledged that "this road is abstract."[317] Abstraction, although it might at first have had the force of a horrified shout, had become an inadequate means of attacking contemporary culture. Whether in iconoclastic art objects, literary actions, performances, or demonstrations, the Dadaists were looking for something strong and direct.

Schwitters identified Dada with abstraction[318] but, using the technique of collage, added a more explicit degree of reality to his art than Kandinsky, Malevich, or Mondrian had. His *Revolving*, 1919 (fig. 68), like most of the works he made from 1918 on, is composed of materials that he found discarded in the streets. The refuse, though arranged into a composition that potentially transforms or even elevates it, continues to assert its original character. "The materials are not to be used logically in their objective relationships but only within the logic of the work of art," he wrote in 1921. "The more intensively the work of art destroys rational objective logic, the greater become the possibilities of artistic building"[319] (here the word "abstract" might be substituted for the word "artistic"). Just as Arp and Taeuber added the real element of chance to their abstract compositions, Schwitters imbued abstraction with both matter and content taken directly from life. In other words, these Dadaists, following the examples set by Kandinsky, Malevich, and Mondrian, were attempting to impart a degree of reality or realism to their forms of abstraction. The elimination of clear-cut distinctions between art and life became fundamental to the abstract work of many artists in Russia as well.

Malevich's followers in the Suprematist movement were at first predominantly engaged with pure abstraction, in 1915 and just after. Ivan Kliun and Olga Rozanova, like Malevich, tended to make compositions of severe geometric forms on flat, monochromatic backgrounds. Rozanova's *Untitled (Green Stripe)*, 1917–18 (fig. 67), typifies this approach (and is also an uncanny precedent for Barnett Newman's art later in the century). And several other Russians, who had extended Cubist practice to a purely abstract level, including Aleksandra Ekster and Liubov Popova, were making art that had little or no connection to daily life. However, the influence of Cubism in Russia took a new direction when Vladimir Tatlin, inspired by Picasso's wood reliefs, which he saw in Paris in 1913, made a series of reliefs in 1913–15 out of such materials as scrap metal, wood, glass, rope, and wire, sometimes combined with manufactured objects. These sculptures were completely abstract, and some of them—the *Corner Counter-Reliefs*, 1915 (for example, fig. 66; see also Chronology)—were site-specific, installed high in the corners of rooms. As Picasso had in his collages and constructions, Tatlin (and Schwitters soon after him) made use of signs of contemporary life in the form of its ordinary materials. But unlike Picasso, who had transformed such materials into recognizable images—a guitar, a wineglass, and so on—Tatlin was making assemblages of real materials shown as they were in real

space. His focus was on their inherent properties and constructive relationships, such as the rough, untreated surface of a work's metal plates and the tension of the ropes that hold them in place. However, this level of pure abstraction lasted only a short time in revolutionary Russia, where the notion of art as a utilitarian activity practiced by "artist-engineers" quickly took hold, with Tatlin as one of its foremost advocates.

In the comparative isolation of wartime Russia, many artists were creating new kinds of abstract art that had no connection with the spiritual aspects practiced by some, and more with the Dadaist blurring of distinctions between art and life. Although Kandinsky and Malevich continued to be important forces, the idealistic approach of these two was being challenged by younger artists led by Tatlin, who followed a more pragmatic approach within abstraction.[320] Ivan Puni started as a Cubist, became a Suprematist, and then made reliefs inspired by Tatlin's *Corner Counter-Reliefs*. Puni's *Still Life: Relief with Hammer*, 1914 (fig. 65), exemplifies the growing influence of Tatlin's approach among many Russian artists, who began using nontraditional materials and real objects to make abstract three-dimensional constructions. Like the actual hammer that Puni attached to a flat surface—a gesture that today seems to project a certain Dada insolence—these objects were often meant to symbolize elements of construction. Part of a general iconography of tools that flourished in Russia at that time,[321] they show the artists' concern with building a new society.

Writing in 1918, Freud described the survivors of World War I as having an "unmistakable tendency to put death aside, to eliminate it from life," but at the same time feeling an enormous sense of shame about the immorality demonstrated by the participants, even by those of ostensibly "the highest culture."[322] Carl Jung explained such failures as the result of people losing confidence in their own value.[323] In this regard, all the earlier notions of individual freedom and the Bergsonian belief in *élan vital* seemed to have been contradicted by the tragic circumstances of the war,[324] and that contradiction also undermined the spiritual premises of abstraction and its universal goals.

Of the three pioneers of abstraction, only the work and thinking of Mondrian gave an indication of the direction that abstraction would take in the postwar era. Early on, Mondrian had recognized the dangers of glorifying the individual, which he considered in 1918 to be an "Old World" concept.[325] But his antidote, embodied in his striving for the universal, was hardly a balm for the postwar generation. Perhaps the realm of eternal harmony belonged to the dead; it was certainly not a prospect for the living. Subsequent artists could accept the language of abstraction, but not its dogma. They sought to make it relevant to a new life situation.

After World War I, with its rampant destruction and the concomitant breakdown of established beliefs[1] and cultural forms, the French art world underwent its own upheaval. Cubism was in crisis in Paris, where various forms of representational art were ascendant and even Georges Braque, Juan Gris, and Pablo Picasso turned to classicizing figurative modes in the late 1910s and early 1920s. The adherents to styles based on representation included, in addition to the constant example of Henri Matisse, such artists as Raoul Dufy, Marie Laurencin, Aristide Maillol, Amedeo Modigliani, Jules Pascin, Chaim Soutine, and Maurice Utrillo, and many others whose work gained favor with a wider circle of admirers. Representation also held a central position in the art of the Surrealist painters—chiefly Salvador Dalí, Max Ernst, and René Magritte, and to a somewhat lesser extent, André Masson, Joan Miró, and Yves Tanguy—who used their canvases to present an alternative, dream version of reality. Despite Surrealism's often revolutionary rhetoric, the work itself was in some ways conservative, replacing Dada's anarchy and anti-art with Symbolist fantasy and pictorial technique. The trend toward verisimilitude was even stronger in Germany, where a reaction against Expressionism took form in a countermovement known as Neue Sachlichkeit (New Objectivity or New Realism), led by Otto Dix and George Grosz, as well as in related work by Max Beckmann.

While Piet Mondrian's concepts continued to have some applicability to abstract artists during this period, Vasily Kandinsky's and Kazimir Malevich's had little, although both tried to adapt to some extent. In this reactionary context, new converts to abstraction in the late 1910s and early 1920s were circumspect. For the most part, they rejected the transcendent approach of Kandinsky, Malevich, and Mondrian, instead developing an abstraction shaped by modern postwar attitudes, dominated by rationalism and technological progress. They also rejected individualism and subjectivity, which, however, came to dominate the Surrealist movement. In contrast to their predecessors' repudiation of the present in favor of eternal values in their art, these postwar abstract artists viewed the present as a time of possibility. Many of them banded together in collective groups and institutions— De Stijl in the Netherlands, the Bauhaus in Germany, and the Constructivists in Soviet Russia—united by utopian thinking and the hope that their active engagement with society and its problems would lead to a better future for all. The movement called Constructivism was appropriately named, especially in the period of extensive postwar reconstruction, providing artists a way of identifying their abstract efforts with everyday existence. While divorced from its original impetuses, abstraction—rather than figuration—still seemed best able to express the modern outlook. Nevertheless, despite the best efforts of many within these groups to maintain the energy and idealism of this renewed form of abstraction, Wilhelm Worringer wrote in 1927 that a spiritual art was now useless in society, and that expressionist art (he did not use the word "abstract" here) had become decorative.[2]

From Composition to Construction in Postwar Russia

Kandinsky's development of abstract composition as a pictorial strategy parallel to music was succeeded by an emphasis on construction in the thinking of a rising younger generation of abstract artists in Russia, who were influenced by principles of architecture and modern technology. After the October 1917 revolution, many of these younger avant-garde artists joined together to help create a collectivist utopia of the future, resulting in a dramatic transformation in the aesthetics of abstraction. They aligned themselves with the

new social institutions and embraced the latest materials and technologies, along with prevailing political ideology. Industry was especially valued as a force that might eliminate suffering and ugliness from society. Where possible, machine production was utilized for aesthetic effect; even if this led only to the look of geometry, its influence was pervasive, for it symbolized a progressive outlook.[3] Malevich declared that the revolution demanded a "philosophy of Contemporaneity."[4] However, his archrival Vladimir Tatlin better embodied that spirit. In his enormously influential *Counter-Reliefs* and *Corner Counter-Reliefs*, which were among the earliest abstract sculptures, Tatlin emphasized an art of industrially produced materials, stressing the purely formal relationships established by combinations of wire, glass, and steel. In a manifesto of 1920, which he cosigned, he attacked art that expressed individuality and sensuality, or that appeared to be decorative, and declared that the times called for artists to unite painting, sculpture, and architecture into a single entity. He praised iron and steel as "materials of modern Classicism, comparable in their severity with the marble of antiquity." These efforts to unite the arts would yield nothing less than the "creation of a new world."[5] Here, like the abstractionists before him, Tatlin revealed a Romantic outlook, although his was apparently more grounded in the real world.

The single work of art that best expresses Tatlin's utopian striving is his *Monument to the Third International*, 1920 (see fig. 69), which functioned symbolically as an emblem of the new government. It bears comparison to Constantin Brancusi's *Endless Column*, 1918 (fig. 52), although whether Tatlin knew this sculpture is not known. Both artists created works meant to suggest infinite verticality, a gesture of endless striving. Although the *Monument* was never built (its planned height of about 1,300 feet would have made it taller than the Eiffel Tower), Tatlin's model and drawings for it became renowned in Russia after being exhibited in St. Petersburg and Moscow in 1920. This is perhaps the first work of art that was entirely in accord with the conditions and possibilities of the modern age. Indeed, the machine aesthetic was clearly an influence on Tatlin's *Monument*, which in turn spurred an emphasis among Tatlin's contemporaries on the materiality of artworks over spiritual values. One wonders whether this phenomenon reflected a utopian wish to turn the horrific machinery of war into plowshares; certainly, to humanize and soften that fearful technology and to transform militaristic hardware into esteemed objects of machine-made beauty would have been among the highest achievements for an aesthetically minded utopian. So all-pervasive did the machine aesthetic become during the 1920s that soft curves were minimized, if not eliminated altogether, in hair styles and clothing in favor of angularity and straight lines. According to Modris Eksteins, curves were associated with the generation that produced the war, and ornamental architecture was rejected in the same spirit.[6] The abstraction embodied by Tatlin's *Monument* was the contemporary style that accorded with the new nation's utopian longings: it was to be machine-made, kinetic in its central section, and to consist primarily of a transparent armature. In its projected form as a functioning headquarters of a government agency, the *Monument* was to be a synthesis of sculpture and architecture, which would become a paramount concept of Constructivism in general.

Critic Nikolai Punin praised the *Monument*, at the model's first showing, as "the spiral . . . the line of movement of mankind liberated. With its heel set against the ground, it escapes from the ground and becomes a renunciation of all animal, earthly and low ambitions!"[7] This enthusiastic description strangely recalls Kandinsky's vision,

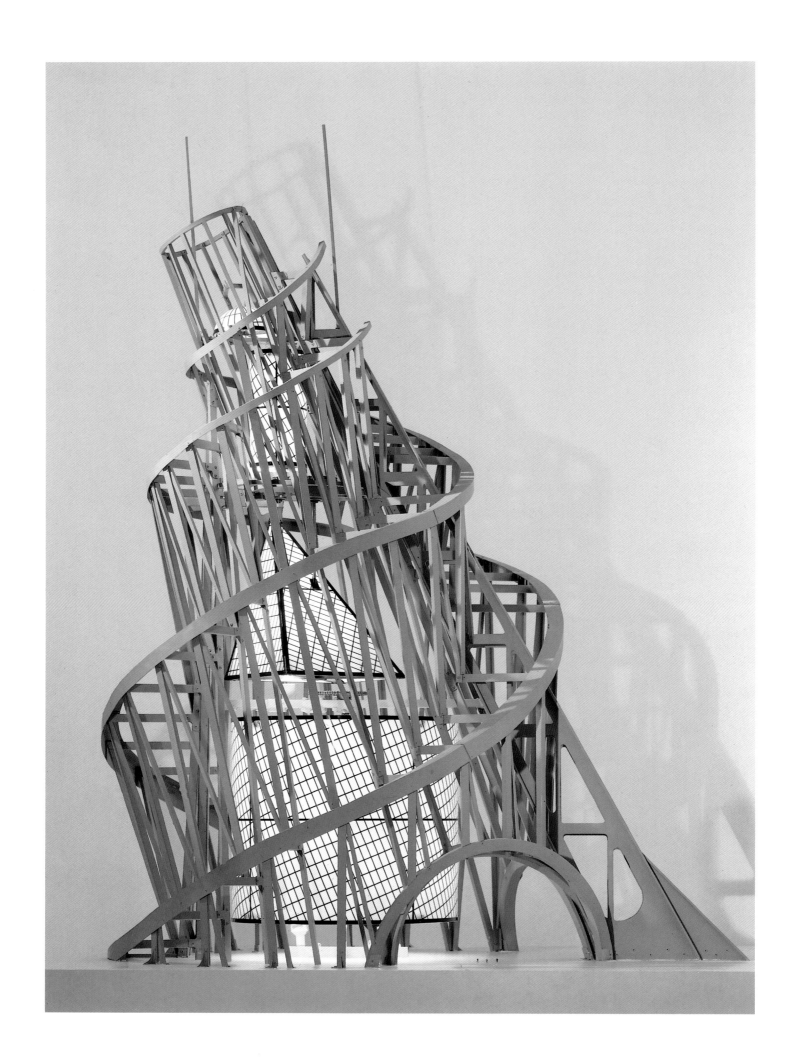

which he described in *Concerning the Spiritual in Art*, of a "spiritual pyramid" that would convey humanity upward, and ascribes to the *Monument* something simultaneously earthbound and transcendent. Punin goes on to say that Tatlin's sculpture does away with the figure for good, to be replaced by "the perfect monument,"[8] again echoing the earlier vocabulary and rationale of abstraction. In effect, Tatlin is simply leap-frogging history, modernizing the traditional device of the monument by employing industrial materials and the visual language of abstraction. However, his *Monument* still maintains one traditional element, for at the top it has a dedication, to "The Soviet of Workers' and Peasants' Deputies of the World."

One battleground between the old aesthetics of abstraction and the new was at the Institute of Artistic Culture (INKhUK), Moscow, which was founded in 1920 with Kandinsky as its director. Although Kandinsky's pre-eminence as the founder of abstract art was unchallenged, his academic position was tenuous. He had scant interest in politics,[9] and remained a painter at a time when there was tremendous fascination with the potential of industrial materials in art. But his influence could still be detected to some extent in works such as Nikolai Kolli's *The Red Wedge*, 1918 (fig. 70), and El Lissitzky's *Beat the Whites with the Red Wedge*, 1920 (fig. 71), abstract-symbolic narratives related to the 1918–20 civil war, in which the newly formed Red Army of the Bolsheviks (the "Reds") defeated the anti-Communist forces led by former imperial officers (the "Whites"). In the use of the wedge, which is a version of Kandinsky's aspiring triangle, and in the color symbolism, these artists applied what are now conventional practices of abstraction. Whereas Kandinsky had explored new strategies of composition, pictorial concerns were increasingly overtaken in the new abstraction by an emphasis on three-dimensional structure, as the younger generation proclaimed construction as their watchword.[10] And in contrast to Kandinsky and Malevich, who represented spiritual and mystical interests, this younger group was preoccupied with technological matters. Indeed, the word "Constructivism" effectively replaced the word "art," for they believed that only this word could adequately suggest a thoroughly modern outlook. With Tatlin and his colleagues at INKhUK, it was only a year before Kandinsky's views were seen as incompatible with the latest thinking, and he was forced to leave.

With Constructivism, Russian abstract art became a function of socially approved goals, and all that was utilitarian was celebrated. Constructivists hoped and expected to participate in the perfecting of the social and political organism. The Communist leaders' plans for a better world condemned individuality in favor of communal concerns and art that would engage the populace in the public arena; indeed, it was crucial that this abstract art be comprehensible to the public.[11] The very words "Constructivism" and "construct" perfectly embodied the new and impersonal approach, and were associated with architecture, an art form that exists in the real world rather than in a museum. Constructivism banished all traditional aesthetic notions, including beauty, and, finally, even "art" needed to be exposed as inappropriate to describe the endeavors of Constructivists. Hence, they announced its demise, as had the Dadaists before them. In Berlin in June 1920, at the First International Dada Fair, German Dadaists expressed their affinity with the Constructivist approach with a poster that proclaimed: "Art is dead. Long live Tatlin's new machine art."[12] And Constructivist ideologue Aleksei Gan wrote in 1921, "Death to Art . . . art is inextricably connected with theology, metaphysics and mysticism."[13] We can imagine why the Dadaists, who were among the first to embrace and then reject abstract principles, would applaud

70. Nikolai Kolli, The Red Wedge, *1918. Pencil, watercolor, and india ink on paper, 13 x 8 1/16 inches (33 x 20.5 cm). State Shchusev Museum, Moscow.*

71. El Lissitzky, Poster, Beat the Whites with the Red Wedge, *1920. Lithograph, 19 1/16 x 27 1/16 inches (49 x 69 cm). Lenin Library, Moscow.*

facing page:
69. Vladimir Tatlin (after), Model for "The Monument to the Third International," *1920, built 1983 by Smithsonian Institution Office of Exhibits Central and the Hirshhorn Museum and Sculpture Garden. Fiberglass, extruded aluminum, Plexiglas, and tape, with metal gears, electric motor, and lights, mounted on wood base; tower: 8 feet 9 inches x 5 feet 9 inches x 6 feet 8 inches (2.67 x 1.75 x 2.03 m); base: 1 foot 6 inches x 6 feet 3 inches x 7 feet (.46 x 1.9 x 2.13 m). Hirshhorn Museum and Sculpture Garden, Smithsonian Institution, Washington, D.C.*

72. Aleksandr Rodchenko, The Last Painting (Pure Red Color, Pure Yellow Color, and Pure Blue Color), 1921. Oil on canvas, three panels, 24 ⅛ x 20 ¾ inches (62.5 x 52.7 cm) each. A. M. Rodchenko and V. F. Stepanova Archive, Moscow.

73. Aleksandr Rodchenko, Dissipation of a Plane, 1921. Oil on canvas, 31 ⅛ x 27 ¾ inches (79 x 70.5 cm). A. M. Rodchenko and V. F. Stepanova Archive, Moscow.

74. Aleksandr Tyshler, Color-Dynamic Tension in Space: Front and Profile, 1924. Oil on canvas, 40 ⅛ x 40 ⅛ inches (102 x 102 cm). Collection of F. Syrkina, Moscow.

Tatlin's achievement, for it announced the demise of conventional conceptions and categorical aesthetic classifications.

In Moscow on September 18, 1921, the Constructivists held an exhibition entitled 5 x 5 = 25, which included paintings by five artists, intended as their final statements in that medium, which they considered obsolete. Among Aleksandr Rodchenko's five paintings were three monochromes, each painted in one of the primary colors, which he collectively titled *The Last Painting* (fig. 72). As he explained nearly twenty years later, "I reduced painting to its logical conclusion and exhibited three canvases: red, blue, and yellow. I affirmed: It's all over. Basic colors. Every plane is a plane, and there is to be no more representation."[14] For many Constructivists, painting had no authentic utilitarian value; and, moreover, as a manifestation of art in general, it could never truly be engaged with the conditions of life. These paintings by Rodchenko also mocked abstraction's recent goal of achieving a flat, objectlike existence by taking it to an extreme. Each of Rodchenko's monochromes, instead of enclosing a plane within a plane, as Malevich's *Suprematist Composition: White on White*, 1918 (fig. 18) does, is merely a simple, single layer of color. In contrast, objects that were "constructed"—that is, sculpture and architecture—existed in real space and were therefore part of life. Ironically, however, Rodchenko's *The Last Painting* proved to be an early example of a nearly century-long tradition of monochrome canvases.

The Constructivists' emphasis on the reality and utilitarian nature of their objects, in contrast to the apparent artificiality of most art,[15] recalls the ideas of the progenitors of abstraction, who believed that their works of art were independent, concrete manifestations, free of any representational function. In this, the early abstract principles helped liberate the Russians from the constraints of the art of the past and enabled them to try creating a systematic approach to the process of construction. In 1921, Rodchenko described the new situation of the painter who has dispensed with the content of a work by Kandinsky, and who has begun to explore painting, and art in general, as a person of science might: "What happens in architecture with the engineer happens in painting too. What is left is the problem itself, stripped of everything, without any mysticism."[16] This scientific approach is reflected in such works as Aleksandr Tyshler's *Color-Dynamic Tension in Space: Front and Profile*, 1924 (fig. 74). Rodchenko's "problem" concerns materials and their deployment based on a utilitarian notion of their characteristics. His linear sculpture *Hanging Construction*, 1920–21 (fig. 75)—his first mobile—and his painting *Dissipation of a Plane*, 1921 (fig. 73), exemplify the former Suprematist's departure from a fundamental premise of abstraction. In new Russian art, Rodchenko proposed, line would take the place of plane as the dominant element, but line that did not appear hand-drawn and thus would not express the style of a particular individual.[17]

Tyshler was one of a small group of artists known as "The Method (Projectionists)," who believed in the need for artists to make, rather than consumer goods, paintings and sculptures (constructions), which they regarded as "the most convincing form of expression (PROJECTIONS) of the METHOD of organization of materials."[18] In contrast, painting and drawing were to a large extent abandoned by many artists during this period in favor of "production art," such as designs for furniture, kiosks, textiles, clothing, posters, and other graphics. Thus, the use of flat, abstract forms can be seen more often in the design of political banners or in the applied arts from this period. In making such works, artists drew on the prehistory of abstraction in the form of abstract patterning from many centuries of the decorative arts, especially textiles produced by the artisans of

75. *Aleksandr Rodchenko,* Hanging
Construction, *1920–21, reconstructed 1973.*
Aluminum, 20.1 x 33 x 18 ½ inches (51 x
83.7 x 47 cm). Indiana University Art
Museum, Bloomington.

76. *El Lissitzky,* Proun 2 (Construction), *1920. Oil, paper, and metal on wood, 23 7/16 x 15 11/16 inches (59.5 x 39.8 cm). Philadelphia Museum of Art, A. E. Gallatin Collection.*

77. *Naum Gabo,* Kinetic Construction (Standing Wave), *winter 1919–20, reconstructed 1985. Metal rod with electric motor, 24 3/16 inches (61.5 cm) high. Tate Gallery, London.*

tribal cultures. The designation "artisan," with its emphasis on the mastery of a technical skill, might have pleased the Russian Constructivists. They also drew inspiration from some of the earliest twentieth-century works in the abstract mode, in particular textile designs (or related pieces) by Sophie Taeuber and Sonia Terk-Delaunay—such as the latter's *Tenture,* 1911 (Musée National d'Art Moderne, Centre Georges Pompidou, Paris), a patchwork of different fabrics stretched within a frame—and by Liubov Popova, Varvara Stepanova, and other Russian women in the late 1910s and early 1920s.

During the early 1920s, Constructivism became virtually the national aesthetic of the Soviet Union, practiced by hundreds of artists who de-emphasized painting or combined it with elements of sculpture and architecture. For example, in 1919, El Lissitzky began making abstract works that he later named *Proun,* explaining the series as "an interchange station between painting and architecture."[19] *Proun 2 (Construction),* 1920 (fig. 76), shows that Lissitzky's station is an ambiguous mechanistic realm in which the abstract rectilinear components seem to float and can be read as either two- or three-dimensional. Rather than maintaining the flat field of Malevich or Mondrian, he preferred to suggest a three-dimensional space in which a proscenium stage holds a group of abstract actor-forms.

In an essay of 1925, Lissitzky wrote that in the preceding years in Russia, "a lot of old rubbish was destroyed. . . . We dropped Abstraction off its sacred throne 'and spat on its altar' (Malevich 1915)."[20] While pointing to Malevich, this comment also recalls Franz Marc's reference to abstraction as the "new altar"; implied, however, is the creation of a different, still abstract, altar known as Constructivism. Lissitzky, who saw artists as social engineers, hoped through his art to build "a new manifold, yet unified image of man's nature."[21] This grandiose claim reverberates with the mysticism of the earlier abstractionists, even though Lissitzky would have denied it.

Hand in hand with these ideas and the utopian longings that they generated was the faith in a universal ideology. Collective visions demanded a new kind of man to serve society,[22] and Constructivists such as Lissitzky became obsessed with the myth of the individual who is totally at one with the conditions of society. The New Man had to sacrifice his individual happiness for the whole;[23] idiosyncrasy was despised in the name of objectivity.[24] But these brave, hopeful thoughts masked a deteriorating economic base and an increasingly corrosive political machinery, with all aspects of art and culture coming under tighter control by the State, and the avant-garde finding less and less favor as the decade wore on.

The brothers Naum Gabo and Antoine Pevsner, although they were contemporary with the first Constructivists, tended to distinguish their ideas from the tenets of Constructivism, particularly in their assertion in "The Realistic Manifesto" (1920) that "the realization of our perceptions of the world in the forms of space and time is the only aim of our pictorial and plastic art."[25] Nevertheless, Gabo's *Column,* ca. 1923 (fig. 78), is largely based on Tatlin's aesthetic of contemporary industrial materials and his synthesis of sculpture with architecture. But Gabo's earlier *Kinetic Construction (Standing Wave),* 1919–20 (fig. 77), was in several ways quite an original creation, most notably as one of the first electrically powered kinetic sculptures, and anticipated Rodchenko's emphasis on the power of line in the new art. Here, the single vibrating line in space is a perfect embodiment of the sculpted abstract form that might replace the plane of color.

Although at first Gabo maintained that he and his brother had rejected "abstraction," many years later he admitted that "abstraction"

78. *Naum Gabo,* Column, *ca. 1923.*
Perspex, wood, metal, and glass,
41 ⅛ inches (104.3 cm) high, 29 ½ inches
(75 cm) in diameter. Solomon R.
Guggenheim Museum, New York 55.1429.

79. *Ivan Kliun*, Spherical Composition, *1923. Oil on canvas, 25 ⅜ x 25 ⅜ inches (64.5 x 64.5 cm). Museum Ludwig, Cologne, Ludwig Collection.*

80. *Vladimir Stenberg*, Color Construction No. 12, *1920–21. Mixed media on canvas, 20 ½ x 17 ¹¹⁄₁₆ inches (52 x 45 cm). State Tretiakov Gallery, Moscow.*

81. *Paul Klee*, Alter Klang, *1925. Oil on cardboard, 14 ¹⁵⁄₁₆ inches x 14 ¹⁵⁄₁₆ inches (38 x 38 cm). Öffentliche Kunstsammlung Basel, Kunstmuseum, Bequest, Dr. h.c. Richard Doetsch-Benziger, 1960.*

and "construction" are virtually the same, and that he simply considered the former word undesirable.[26] Undoubtedly, the term's pejorative connotation had to do with whom abstraction was identified and therefore what it stood for—that is, it is more accurate to state that the Constructivists dispensed with the ideology of Kandinsky and Malevich rather than with an emphasis on the nonreferential work of art. Hence, abstraction as a movement, which was never unified and did not have its own manifesto in the 1910s, became orphaned in the 1920s in the Soviet Union (and in Europe generally) in favor of various Constructivist approaches.

At the beginning of the 1920s, there was considerable evidence that Malevich, too, was trying to adapt to the changed conditions of the art world. Having no support at INKhUK[27] must have been as demoralizing to him as it was to Kandinsky. In 1920, Malevich began to write about a modified form of individual artistic freedom that is "not . . . separate and outside the community,"[28] thus giving art no special place in society.[29] He dropped the term "Suprematism" from his vocabulary almost completely, except in correspondence abroad, and proceeded to act as if there was a single, united art front, which he imagined as having begun in Russia and spread across Europe.[30] When he tried to define that front, he termed it a "method" on one occasion,[31] or referred to the "non-objective" as if that were the tie binding the various movements.[32] Within a few years, the exalted forms of Malevich's "pure emotion" no longer appeared in his work. His painting reverted to a mannered figurative style, and he became increasingly involved in architectural theory and produced designs for theater costumes and textiles. But Malevich was not always able to suppress his earlier instincts, or to maintain his group identity. Even in the early 1920s he still distinguished himself as a "spiritual" person in contrast to those with an "objective consciousness," who wished to construct "a tower from which to observe the world."[33] Probably a reference to Tatlin's *Monument*, this statement basically reiterates the differences that existed earlier, and suggests that Malevich's conciliatory statements were token gestures. He condemned the "objective" approach as a threat to God, and defiantly announced that "God is Not Cast Down."[34] By the later 1920s, Malevich was again championing Suprematism,[35] perhaps because Constructivism had lost some of its force. In a letter of 1927 to Kurt Schwitters, he declared that, although the world might seem to have been "overgrown with Constructivism," the mechanical, automatonlike nature of which threatened art and humanity, the movement was "beginning to become an almost invisible phenomenon."[36]

Malevich's fellow Suprematists continued to place abstraction at the service of seemingly mystical or cosmic concerns, as exemplified in Ivan Kliun's *Spherical Composition*, 1923 (fig. 79). Others, not necessarily Suprematists—such as Vladimir Stenberg in his *Color Construction No. 12*, 1920–21 (fig. 80)—were also creating works that suggest an uncompromising approach to abstraction, even if the titles still imply a quasi-scientific, Constructivist approach. The saddest irony occurred when those Russians who had abandoned pure abstraction—or at least attempted to reinterpret it in the postrevolutionary context— were rejected by their own government, starting early in the 1920s.[37] After first tolerating these artists because they served the government's political objectives, Communist officials subsequently denounced such avant-garde practices. There had always been resistance to the avant-garde, but as the Soviet regime became more unified in its thinking and achieved complete control over institutional life, free artistic activity was little appreciated, and more overtly propagandistic figurative art was encouraged.[38]

The Bauhaus

Art in Germany between the wars was more diverse than in the Soviet Union, but the forces of a Constructivist-type outlook were powerfully represented and debated at the Bauhaus, a school founded in 1919 in Weimar by architect Walter Gropius. From the start the Bauhaus was devoted to examining all the arts as a single enterprise, based on principles of good design and a wide-ranging exploration of materials and techniques. The Bauhaus exemplified the academic approach to formal elements, which were to be measured and used with great calculation so as to produce harmonious results, harmony being synonymous with worthy design. This rational approach, based on functional aesthetics and a fastidious handling of color and the drawn line, came to dominate the Bauhaus after 1923 and resulted in often impersonal, rigorously geometric paintings and sculptures.

Abstraction was clearly the language of all aspects of the Bauhaus endeavor. However, the school's chief academician from 1919 to 1922, Johannes Itten, and its founding director, Gropius, held radically divergent views that reflected the differences that emerged between the pioneer abstractionists and the subsequent generation at the end of World War I. Gropius made architecture the school's primary focus in the pursuit of a universal language of form that would unite all the arts, embracing industrial processes and a methodology of design to create a modern utopia. His motto for the newly formed school was "Art and Technology—A New Unity." From the inception of the Bauhaus, Gropius's philosophy was vocally opposed by Itten, whose spiritual approach to art was based on individual experience and personal expression and who had little interest in linking art and industrial production.

Itten had the tacit support of the two best-known faculty members—Kandinsky, who joined the staff in June 1922, and Paul Klee, Kandinsky's Blaue Reiter colleague, who had been teaching there since January 1921. However, Kandinsky and Klee were not completely antagonistic to postwar interests. In his writings, Klee often made the processes of abstraction and construction synonymous, although, siding with Kandinsky and prewar aesthetics, he asserted that a painting should not be called a "Construction" but a "Composition."[39] His highest goal in seeking to harmonize the warring Bauhaus camps was to bring "architectonic and poetic painting into a fusion."[40] Yet Klee's art is only rarely completely abstract, the "poetic" being linked with a certain degree of referentiality—an approach that he described as "abstract with memories."[41] In one long wartime passage in his *Diaries*, dated 1915, Klee evoked the motives of the early abstractionists, whose approach came under siege at the Bauhaus and elsewhere a decade later:

One deserts the realm of the here and now to transfer one's activity into a realm of the yonder where total affirmation is possible.

 Abstraction.

 The cool Romanticism of this style without pathos is unheard of.

 The more horrible this world (as today, for instance) the more abstract our art, whereas a happy world brings forth an art of the here and now.

 Today is a transition from yesterday. In the great pit of forms lie broken fragments to some of which we still cling. They provide abstraction with its material. A junkyard of unauthentic elements for the creation of impure crystals.

 That is how it is today.

 But then: the whole crystal cluster once bled. I thought I was dying, war and death. But how can I die, I who am crystal?

 I, crystal.[42]

Like Kandinsky and Mondrian, Klee believed that his creations could be likened to those of the Creator, but that these "crystals" were loaded with the content of the times and were therefore "impure." He sublimated the inherent tumultuousness of the period—and his occasionally pathetic, romantic streak—in the vehicle of abstraction; as with Worringer, that style proved to be a salve for wartime experiences.

In his teachings, Klee was thorough and precise in defining the components of this abstract language and their implications. Each line and color has a "sound" (to employ Kandinsky's term), which must be carefully applied to the abstract composition as necessary. This approach is exemplified by his *Alter Klang*, 1925 (fig. 81), which, unlike the neutrality of a primary-hued Mondrian, displays a color harmony that is replete with "memories."

It was perhaps the spirit of the technologically oriented times as much as any internal force that caused Kandinsky to change his style, beginning about 1920, from free-form to a more overtly hard-edged, geometric type of abstraction. This transformation may have also been influenced by the art of his Russian colleagues, including Kliun, Malevich, and others, and their belief in a universal style based on geometric forms.[43] Kandinsky's new approach altered his art dramatically; it lost the raucous, uninhibited, and emotional qualities that had run rampant in his work, and became deliberate and at times dispassionate in tone. As in *White Cross*, 1922 (fig. 82), and *Composition 8*, 1923 (fig. 83), rectilinear forms, sharply drawn lines, and a more subdued palette characterized his work; the loosely drawn triangles of earlier were now rigorously geometric. During this period, Kandinsky also became more academic in his writing, especially in *Point and Line to Plane*, a treatise devoted to the study of formal elements.[44] Nevertheless, he remained deeply committed to the theoretical tenets of abstraction that he had promulgated earlier. In a 1925 essay on abstract art, he emphasized that the "resounding triad: Romantic, Germanic, Slavic" would be the basis for all future developments in abstraction.[45]

The conflict at the Bauhaus between Gropius and Itten lasted until early in 1923, when Itten left the school and was replaced by László Moholy-Nagy, a Hungarian who had been living in Berlin for two years and associating with Dadaists and Constructivists. Moholy-Nagy was a dedicated advocate of the Constructivist approach, believing that the artist should be a kind of anonymous fighter for a utopian vision. His approach to teaching was so systematic that a "science of form" became an essential statement of Bauhaus ideology in its day-to-day application.[46] The faculty and students of the Bauhaus, virtually all of whom believed that the language of art was universal, were dedicated to creating an academy of (abstract) form, which was also referred to as design by the more Constructivist-inclined. Moholy-Nagy himself was particularly interested in visual perception, and in the power of a consistent art language to affect the individual. He experimented with the abstract possibilities of photography (especially in his photograms, "light-compositions" made in the darkroom without a camera), and treated painting and sculpture as the specific province of nonobjectivity. Abstraction was the fundamental principle that underlay all of Moholy-Nagy's ideas, a belief that he reiterated in 1945 in an essay entitled "In Defense of Abstract Art," in which he declared it to be a "truly revolutionary act."[47]

Another important figure at the Bauhaus was Josef Albers, who, after teaching art in several schools, studied there from 1920 to 1923. He took part in various workshops, including furniture-making and stained glass, and then began teaching at the Bauhaus. From 1923,

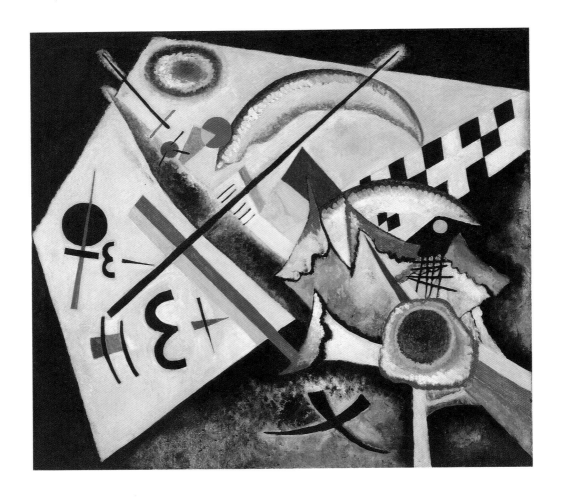

82. *Vasily Kandinsky,* White Cross,
January – June 1922. Oil on canvas,
39 ⅞ x 43 ½ inches (100.5 x 110.6 cm).
Peggy Guggenheim Collection, Venice
76.2553 PG 34.

83. *Vasily Kandinsky,* Composition 8,
July 1923. Oil on canvas, 4 feet 7 ⅛ inches x
6 feet 7 ⅛ inches (1.4 x 2.01 m). Solomon R.
Guggenheim Museum, New York, Gift,
Solomon R. Guggenheim 37.262.

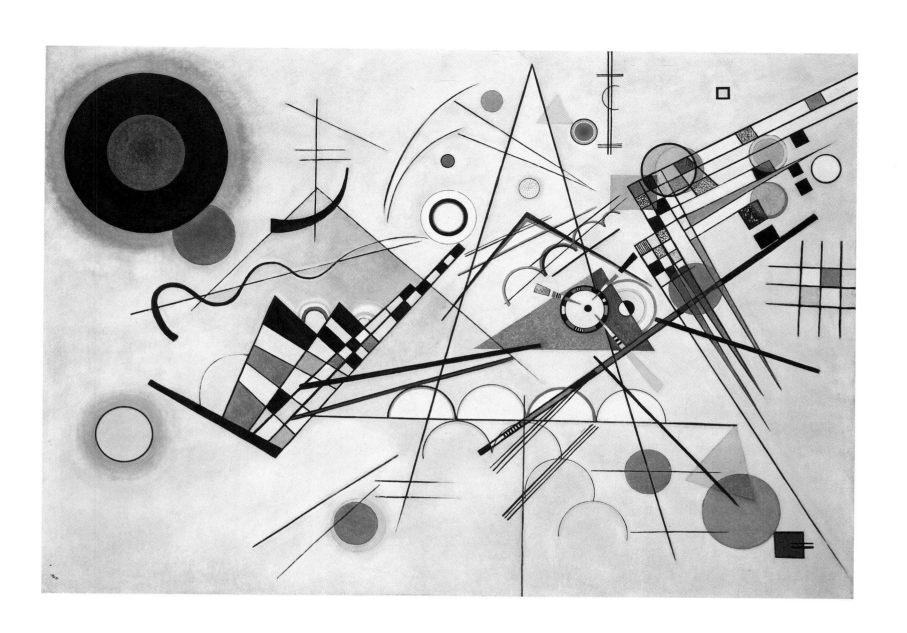

Albers and Moholy-Nagy each taught a component of the Preliminary Course, which gave students a solid foundation in Bauhaus principles. Albers gained full responsibility for the entire course when Moholy-Nagy resigned from the Bauhaus in January 1928, just before Gropius left to concentrate on his architectural commissions. Although both Albers and Moholy-Nagy focused on a new, objective approach to materials and the principles of construction, Moholy-Nagy stressed the spatial articulation of materials through "the fluctuating play of tensions and forces,"[48] while Albers emphasized the fundamental properties of materials, economy of form, and an understanding of optical phenomena, all taught in a systematic fashion.[49] Applying the modern principles of Bauhaus design to a variety of endeavors, Albers always pursued "technical and economical rather than esthetic considerations" and "counteract[ed] the exaggeration of individualism without hampering real individuality."[50]

Gropius's successor as director of the school was Hannes Meyer, a Swiss architect who had only been teaching at the Bauhaus for a year and whose extreme, functionalist approach completely undercut the role of art in favor of architecture and industrial production.[51] The new emphasis on trade specialization and practical applications reflected the growing economic depression and the political swing to the right in the national elections of the preceding autumn. Moholy-Nagy explained in his resignation letter that there was an absence of popular support for the school's ideas and activities,[52] but he might have specified political backing as well, for the German government saw no more useful value in these revolutionary artists than the Communist regime had in the Soviet Union. When he first began as an instructor at the Bauhaus, Moholy-Nagy had opposed Itten's intuitive approach to teaching and making art. But now, in complaining that the school was likely to be forced into becoming a trade school and that the artists there would lose their vital role and have to "fall in line,"[53] he reversed his position somewhat and reaffirmed the pre-eminence of art itself. Despite the marginalization of art that was occurring at the school, Klee stayed until 1931, and Kandinsky until the Bauhaus was dissolved by the National Socialists (Nazis) in 1933.

Right-wing political pressure had earlier forced the Bauhaus to move from Weimar to Dessau, where it reopened in spring 1925. But the fact that the Bauhaus began its existence in Weimar, at the seat of the national government, makes it easy to see in its history an indication of the postwar German mentality. Just as most of the artists involved with the school hoped to remain idealistic and to avoid partisan politics, the Weimar government had a kind of head-in-the-sand attitude about itself, its efficacy, and the future. Described as a period of "sober idealism,"[54] the Weimar period must also be remembered for its "utopianist self-delusion"[55] and "political impotence."[56] Similarly, while Bauhaus ideology sought to mesh man's inner and outer natures in the modern academy, it remained oblivious to the ultimately divisive and self-defeating context in which the debate over the role of art was held. And as the debate raged, the prevailing utopian dreams of the latest abstractionists lacked sufficient rootedness in the social and political realities of the time to be anything more than another romantic gasp of pathetic longing.

De Stijl

In 1917 in the Netherlands, a small group of artists and architects who shared certain ideas about geometric abstraction and utopian harmony formed the core of a movement around the Dutch term "de Stijl" (style). It became a loosely organized international movement, since its adherents never taught or exhibited together (as had contemporaneous groups in Russia and Germany) and were not all united by location: Mondrian returned from the Netherlands to Paris after World War I; Theo van Doesburg spent much time abroad, especially in Germany; and, although a handful of Dutch members remained in the Netherlands, at various times the group also included, however tangentially, Jean Arp, Lissitzky, Gino Severini, and others throughout Europe. De Stijl usually represented itself as a group interest through the vehicle of a magazine by that name, edited by van Doesburg and published primarily in Dutch.[57] Although a manifesto appeared in its November 1918 issue (in Dutch, French, German, and English),[58] *De Stijl* printed articles by or about a wide variety of artists, including Dadaists. One relatively consistent position from the first issues of the magazine was an emphasis on architecture, and a desired partnership between painters and sculptors within this medium. Painting was not considered merely decoration for architecture but an essential component in creating a harmonious, total environment. Collaboration between artists and architects was therefore a basic goal of De Stijl aesthetics, and the results of such collaborations achieved a rare degree of synthesis. As might be expected, De Stijl projected a good deal of utopian thinking, expressed as a call for universal values, a concern for morals,[59] and a vision of the world of the future transformed by beautiful surroundings and ethical behavior. This utopianism, more like that of the Bauhaus than that of the Russian Constructivists, was for the most part apolitical; rather than finding common ground with Socialists, for example, van Doesburg called Socialism "another form of bourgeois materialism."[60] Although the De Stijl movement never officially came to an end, it was effectively over after van Doesburg died in 1931 and the last issue of *De Stijl* appeared in 1932.

Mondrian and van Doesburg shared a vision of a universal art purified of individual concerns, a vision that continued to influence other artists for decades to come. The name "De Stijl" itself underscores Mondrian's belief that the struggle for a style was the crucial issue for modern artists. But Mondrian's Theosophical outlook was not shared by his colleagues, who tended to follow van Doesburg's embrace of Constructivist principles. Despite his affirmation of universal values, Mondrian indicated little enthusiasm for collective concerns and remained largely isolated in his personal life. Furthermore, he was always somewhat ambivalent about the close alliance of art and architecture that van Doesburg had envisioned,[61] although he did imagine the day when easel painting would disappear, its "plastic beauty" and color transferred to surrounding space, whether room interiors or architecture in general.[62] But this vision was less that of a Constructivist than an abstractionist who foresaw the possibility of his approach becoming spatial in the fullest sense. Mondrian created such a "sanctuary" in his own studio,[63] and in the proposed 1926 set design for Michel Seuphor's play *L'Ephémère est éternel* (fig. 84).

Van Doesburg was much influenced by the "absolute art" of Kandinsky and Mondrian during his formative years in the 1910s, but late in the decade he began to integrate his ideas about abstraction with the utopian thinking that was sweeping Europe.[64] In the first issue of *De Stijl* in 1917, he wrote, "As soon as the artists in the various branches of plastic art will have realized that they must speak a universal language, they will . . . serve a general principle far beyond the limitations of individuality. . . . Only by consistently following this principle can the new plastic beauty manifest itself in all objects as a style, born from a new relationship between the artist and society." In that same issue he wrote, "For the propagation of the beautiful, a spiritual group is more necessary than a social one"; and later he

declared that the machine was "a phenomenon of spiritual discipline 'par excellence.'"[65] His faith in the Constructivist outlook, with its affirmation of technology and collective efforts, came to dominate the De Stijl point of view, which he, more than anyone else, formulated. He dearly wanted to win the public over to this new position,[66] and was a tireless spokesman, traveling often between the art centers of the Netherlands, France, and Germany to promote his views. Perhaps better than any other figure of the 1920s, van Doesburg illustrates the ecumenical approach of the between-the-wars generation, representing a synthesis of Bauhaus, Constructivist, and Dadaist ideas. (In addition to his De Stijl activities, he wrote Dadaist poems and essays in the early 1920s under the pseudonym I. K. Bonset, and edited four issues of a Dadaist magazine in 1922–23.)

Given his admiration for Mondrian, it is not surprising that van Doesburg's paintings show the strong influence of his countryman in their reliance on an underlying perpendicular grid, primary colors, and an allover composition in place of Cubism's central focus.[67] Although he arrived at abstraction as Mondrian had, by simplifying a subject to a geometric expression of its component parts—a "pure" image stripped of subjective elements[68]—van Doesburg's paintings had none of the intended spiritual content of Mondrian's. And in 1925, after van Doesburg began making paintings based on a diagonal grid, departing from the exclusively horizontal-vertical axes established by Mondrian, the latter disapproved so strongly that he quit the De Stijl movement. Van Doesburg's greatest aspirations were in the area of architecture, which he believed could express the same "spiritual discipline" as the machine, both apparently being unsubjective, concrete, constructed manifestations of modern life.[69] Van Doesburg even suggested architecture as a "modern temple to be established in the future,"[70] but after the critical and practical failure of his interior design for the Café Aubette in Strasbourg (a collaboration with Arp and Taeuber-Arp) in 1928 (fig. 85; see also Chronology), he became disappointed with the model of architecture. That year he wrote, "Let the architect create for the public . . . the artist creates beyond the public. . . . constant values are only contained in 100% art. This is now my firm conviction."[71]

Van Doesburg was undoubtedly aware of Constructivism's loss of favor in the Soviet Union throughout the decade and the problems that the Bauhaus was having in Germany, so his sentiments here reflect more than just his personal situation. The mounting economic crisis belied artists' utopian hopes of government solving intractable social problems and exposed their theoretical views of art's role in improving life as falling far short of reality. As Klee warned in 1924, "the people are not with us."[72] It was always questionable whether the aspirations of such utopian groups were practical or would be welcomed, or if the sense of crisis would dissipate and peace be made permanent, or if individuals would consistently submit themselves to a group interest.[73] Moreover, their collective fantasies may have even played into the hands of Fascist governments.[74] By the 1930s, the principles of pure abstraction had been compromised more and more by political and social conditions, and abstract art had increasingly come to look— dare it be said?—decorative.

Reactions and Accommodations

As antagonistic as the French art world was toward metaphysics, it was almost equally resistant to calls for a utopian vision expressed through abstraction. With the exception of Delaunay's initial experiments with abstraction, František Kupka's early work, and a few other isolated examples, abstraction was hardly seen in Paris until the 1920s.

84. Piet Mondrian, Set design for L'Ephémère est éternel, 1926, model 1963. Painted wood, 21 x 30 ⅛ x 10 ⁷⁄₁₆ inches (53.3 x 76.5 x 26.5 cm). Stedelijk Van Abbemuseum, Eindhoven, The Netherlands.

85. Theo van Doesburg, Café Aubette, Strasbourg: Chromatic Solution for the Large Dance Hall, Wall Toward Kléber Place, 1927. Pencil, ink, silver paint, and gouache on paper, 18 ⅛ x 41 ⅜⁄₁₆ inches (46 x 105 cm). Rijksdienst Beeldende Kunst, The Hague.

86. *Fernand Léger,* Mural Painting.
*1924–25. Oil on canvas, 71 x 31⅝ inches
(180.2 x 80.2 cm). Solomon R. Guggenheim
Museum, New York 58.1507.*

87. *Charles-Edouard Jeanneret {Le
Corbusier},* Still Life with Pile of Plates.
*1920. Oil on canvas, 32 x 39¼ inches (81 x
100 cm). Öffentliche Kunstsammlung Basel,
Kunstmuseum, Gift, Dr. h.c. Raoul La
Roche 1963.*

Mondrian did not exhibit fully abstract works there until 1921, and Malevich not at all; and although three almost entirely abstract works by Kandinsky were shown in the 1912 Salon des Indépendants, he did not have a solo exhibition in Paris until 1929.[75] However, Cubism was itself under attack in this period, on charges of elitism and inaccessibility,[76] and, whereas abstraction might have earlier been attacked for the same reasons, it had been transformed in the Soviet Union into an art with at least a pretense to a functional and popular outlook. Meanwhile, the remaining Cubists, including Albert Gleizes, Fernand Léger, and Jacques Villon, were keeping up with the times by creating some compositions that verged on the purely abstract;[77] and by the late 1920s one critic even declared the Cubist style to be "a genuine architecture . . . capable of making us believe for a time in our freedom."[78] While the French recognized nonobjective art to be an extension of Cubism,[79] they were now adapting the dogma of this offshoot—its liberating quality and its connection to architecture— to their current endeavors. Other Cubists simply defected.

In the late 1910s and early 1920s, there was an unexpected turn to neoclassical subjects and a naturalistic style in the work of many avant-garde artists in Paris, of whom Picasso was one of the first. In the context of late Dada manifestations and abstractionist tendencies in central Europe, the manner appears retardataire, even if it does respond to the aforementioned criticisms of Cubism. In effect, this neoclassical phase was a defiantly aggressive attempt to counter abstraction and once more assert the laws of the French and Classical traditions at a time when the Parisian avant-garde was under siege. But the character of the gesture, which Mondrian described as putting "water in their wine,"[80] suggests that some Parisian artists had in effect yielded the mantle of modernity and the avant-garde to Amsterdam, Moscow, Weimar, and Zurich, at least for the moment.

Parisians had an opportunity to see abstract works by De Stijl artists at an exhibition at the Léonce Rosenberg Gallery in October– November 1923,[81] a show that had a significant impact on Léger, especially the De Stijl advocacy of abstract painting integrated within architecture.[82] By then, Léger had flirted with pure abstraction several times during the preceding decade, and after creating a fragmented synthesis of abstraction and figuration in *The City*, 1919 (Philadelphia Museum of Art), he painted a series of compositions in which the backgrounds are increasingly rectilinear and abstract, beginning with *The Mechanic*, 1920 (National Gallery of Canada, Ottawa). The dominant motifs in several of these works are mechanical elements, which Léger simplified almost beyond recognition, as in *Mechanical Element*, 1924 (Musée National d'Art Moderne, Centre Georges Pompidou, Paris), placing greater emphasis on their sculptural value than their representational identity. From 1924 to 1926, he envisioned a more completely abstract idiom in a series of seven purely geometric paintings either commissioned or intended as murals, and, to a lesser extent in paintings such as *The Baluster*, 1925 (Museum of Modern Art, New York).[83] In the mural paintings, such as *Mural Painting*, 1924–25 (fig. 86), Léger reached a level of abstraction that he had not previously attempted, and never would again.

The new direction in Léger's art was driven by an interest in seeking an appropriate site for pure abstract art. In a 1924 essay, he wrote that there are two types of "plastic expression: 1. *The art object*," including the discrete easel painting, and "2. *Ornamental art*, dependent on architecture," which he further explained as "a materialization in abstract, flat, colored surfaces" intended for architectural settings. Instead of condemning the latter as merely decorative—a qualm of

the early abstractionists—he embraced it, noting that these "colored surfaces" could serve to "distract man from his enormous and often disagreeable labors."[84] Such an interest in the utility of art and in the social conditions of workers, while in keeping with Léger's lifelong concerns, also reflected the tenor of the period; and, indeed, in 1923, he wrote of his desire to be "consistent with my own time."[85] In his essay on easel painting and decorative art, he described the degree to which the world was geometric and machine-oriented, and remarked on the close collaborative efforts between painters and architects in Germany, asserting, "Only there does the plastic life exist. It is nothing in Paris, and it will be nothing as long as the possibility of *illuminating the walls* is not recognized."[86]

Although several works from Léger's 1924–26 *Mural* series were shown briefly in architectural settings, none were installed permanently.[87] And as the decade came to a close, his interest in murals waned for several years (it revived in 1935 and continued until his death in 1955). In 1931, he reviewed these early attempts in an essay on abstraction, which he described as "the most important, the most interesting of the different plastic trends that have developed during the last twenty-five years." However, he declared that he had never involved himself totally in the "radical concept" of the De Stijl approach, for "the [neoplasticists] are the true purists." Their "pure abstraction, pushed by this new spirit to its outermost limits, is a dangerous game that must be played"—dangerous because of its lofty purity, its "desire for perfection and complete freedom that makes saints, heroes, and madmen." Although Léger made clear that this "extreme state" was not for him, he expressed a certain admiration for it, acknowledging that "it had to be done," and that, though it appeared frail next to the tumultuous dynamism of modern life, "it will stay."[88]

In the early 1930s, after Léger had for the time being lost interest in the collaborative ideal, Matisse was just arriving at the possibility. In his case, the painted murals he made for a gallery in the Barnes Foundation in Merion, Pennsylvania, in 1931–33 are not abstract, although he emphasized their "architectural" qualities. In 1934, Matisse announced that "at present, . . . public monuments decorated by . . . painters [are] the great problem." Although still steadfastly antagonistic to abstraction, he allowed that "in architectural painting . . . the human element has to be tempered, if not excluded."[89] Yet Matisse's murals were exceptions, for easel painting continued to be the principal medium for French artists during the 1920s, and their orientation remained predominantly figurative and representational, even when they were exploring elements of abstraction or—later in the decade—Surrealism.

The sense of order inherent in hard-edged or geometric abstraction and its connection to the modern machine age were the principal concerns of one group of Parisian artists, who called themselves, appropriately, Purists. Led by Amédée Ozenfant and architect/painter Charles-Edouard Jeanneret (who also used the name Le Corbusier), this movement simplified still-life subjects to a machinelike essence, as in Jeanneret's *Still Life with Pile of Plates*, 1920 (fig. 87). Although they generally argued against pure abstraction,[90] these artists passionately pursued a reductive approach in their art. Moreover, they attacked art that was too concerned with individuality,[91] and advocated a genuine embrace of modern life[92] and a striving for the purity of the anonymous, machine-made object,[93] all aspects of the Constructivist approach to abstraction. During the 1920s, Le Corbusier applied these painterly ideals to his architecture; and when he advocated, in 1923, an architecture founded on the stylistic and functional essentials

underlying all historical models,[94] he was summarizing one of the chief premises of early abstraction and formalism.

The newest abstractionist groups in Germany, the Netherlands, and the Soviet Union had abandoned their predecessors' belief in individual self-expression. But it was reaffirmed with great creative energy and artistic license in France in the mid-1920s by the Surrealists, those post-Dada radicals of the time who diverged from societal conventions and norms, and from the most recent traditions of the avant-garde—especially Cubism.[95] Although the Surrealists resembled the Constructivists in their desire to break down the barriers between art and life, their thinking shows much in common with the earlier abstractionists. André Breton, in the first of his Surrealist manifestos in 1924, expressed profound antagonism toward materialism and conventional logic, and stressed the need for personal freedom.[96] His position was that of the individual who lost faith during the postwar period and disparaged all utopian longings. That many of Kandinsky's basic concepts are present in Breton's words— "necessity," "freedom," art that will "aspire to a complete and radical reconstruction of society," "powers of the interior world"[97]—only confirms the degree to which the art world had been reconfigured. In November 1925, the Surrealists held their first exhibition, at the Galerie Pierre in Paris, with a catalogue text by Breton and Robert Desnos. Those participating were Arp, Giorgio de Chirico, Ernst, Klee, Man Ray, Masson, Miró, Picasso, and Pierre Roy.

Some Dadaists and Surrealists had a primarily investigative or playful approach to abstraction, as can be seen in their use of the medium of film to create abstract compositions. First, Marcel Duchamp, in *Rotary Glass Plate*, 1920, and then Hans Richter, in *Rhythm 21*, 1921, and Viking Eggeling, in *Diagonal-Symphony*, 1923–24, made films consisting of deadpan arrangements of decorative patterns put into motion. *Anemic Cinema*, 1926–27, which Duchamp made in collaboration with Marc Allégret and Man Ray, mocked this type of abstraction. It begins with an abstract image of a monotonously rotating spiral, followed by a rotating spiral of words; after these two alternate for a few minutes, a woman's face and other representational images are introduced as if to suggest more complex parallels. The always prescient Duchamp demonstrated the potential plenitude or anemia of each type of image, and how each is enhanced or denuded of meaning by being juxtaposed with other types. Here, Duchamp rendered meaning and meaninglessness as boring extremes, and the modes of making both as equally ridiculous. One wonders if part of his intention was to take Tatlin's exalted spiral down from its Constructivist altar.[98]

Schwitters was another Dadaist imbued with the values of early abstraction. His art was abstract, but he had the clear intention of making life visible in his subtle collages, cousins of the rectilinear paintings of Arp and Mondrian but consisting of discarded odds and ends. Schwitters's work is "concrete" in Arp's sense of the word, yet remains rooted in his vision of an abstract "absolute." The best example of this was Schwitters's most ambitious endeavor, *Der Merzbau* (fig. 88), an installation work resembling a building, begun in 1920 and completed in 1935, but destroyed in a 1943 bombing raid. In his essay "Merz" (1920), he quoted a description of what must be the earliest version of it, written by a critic named Christof Spengemann, as "a spiritual expression of the force that raises us up to the unthinkable: absolute art. This cathedral cannot be used . . . this is absolute architecture, it has an artistic meaning and no other."[99] Here, Schwitters related to both the first and the second wave of abstractionists—to the former, in their faith in a spiritual type of

88. *Kurt Schwitters,* Der Merzbau,
1933 state, reconstructed 1980–83 by Peter Bissegger. Wood, plaster, and plastic, 12 feet 10 ¼ inches x 19 feet ⅛ inch x 15 feet 1 ⅛ inches (3.93 x 5.8 x 4.6 m). Sprengel Museum, Hannover.

art, and to the latter in their view of architecture as the ultimate discipline. It is clear, however, that he rejected the functional Bauhaus and Constructivist approaches to art, which he opposed with his Dadaist impulse to defy conventional thinking, social norms, and rational, objective logic.

Schwitters used the nonsense word "merz" to refer to all his art activities after 1920 — which he described as a "composite" of many branches of contemporary art[100] — and used it as the title for a magazine that he founded in 1923. The first issue reported on Dadaist activities in the Netherlands, and the magazine continued to reflect Schwitters's internationalist outlook after he revised it in 1924 and renamed it *Nasci*. Indeed, in its coverage of the many directions of European abstraction during that period, *Nasci* may provide the best-informed account published to that date. A double issue from spring 1924, for which Schwitters had invited Lissitzky to collaborate as co-editor,[101] begins with the talismanic image of Malevich's *Black Square* and includes reproductions of works by Alexander Archipenko, Arp, Braque, Léger, Man Ray, Ludwig Mies van der Rohe, Mondrian, and Tatlin, along with the editors' own works; inexplicably, there was none by Kandinsky. However, this may have been the first time that a Suprematist work by Malevich was published in the West.

By the mid-1920s, several French and Swiss artists along with a few others, in part influenced by the work of Brancusi[102] and in deliberate contrast to recent geometric abstraction, were making abstract works composed of biomorphic forms. Among those who took this approach were Arp, Alexander Calder, Jean Hélion, and Joan Miró. Arp, after his initial experiments with abstraction during the 1910s, when he began to create compositions "arranged according to the laws of chance" (see fig. 60), devoted his career to biomorphic paintings, sculptures, and reliefs that have at least an indirect link to human forms or heavenly constellations, such as *Constellation with Five White Forms and Two Black, Variation III*, 1932 (fig. 89). Although his art usually maintains this connection to the world, it was extremely influential on others who created completely abstract work. In a similar vein, Arp's writings repeatedly emphasize various principles of early abstraction, including the need to suppress individual ego,[103] the belief that art should address the subject of "infinity,"[104] and the idea that the work of art mirrors the creations of nature.[105] In order to affirm the latter point, he used the adjective "concrete" to describe abstraction; his idea was that each work of abstract art is a materialization of organic growth, possessing a concrete reality.[106] Arp's utopian faith in art led to the claim that "concrete art wishes to transform the world . . . to render existence more tolerable"; otherwise, life is "tragic."[107] Such "concrete" art can be seen as a between-the-wars attempt to reinterpret the utopian vision of early abstraction, and it is not surprising that by 1939 Kandinsky had dispensed with the often unpopular word "abstract" in favor of "concrete," which he believed more aptly rendered the sense of "purity" found in music.[108]

In Miró's early career, during the 1910s, he was completely negative toward abstract art,[109] but he gradually modified his outlook under the influence of Cubism.[110] Then, in the mid-1920s, as he found his own original style, Miró became anti-Cubist and made paintings that are "absolutely detached from the outer world."[111] It was during the period of approximately 1925 to 1933, as a sometime participant in Surrealist manifestations, that Miró first made works that can be considered abstract, such as *Painting (The Red Spot)*, 1925 (fig. 90), *Untitled Painting*, 1927 (fig. 91), and *Painting*, 1927 (fig. 92). His untitled canvases of this period are without direct associations, but (typical of Miró)

89. Jean Arp, Constellation with
Five White Forms and Two Black,
Variation III, *1932. Oil on wood, 23 ⅝ x
29 ⅝ inches (60 x 75.2 cm). Solomon R.
Guggenheim Museum, New York 55.1437.*

90. *Joan Miró*, Painting (The Red Spot),
*1925. Oil on canvas, 57 ⁷⁄₁₀ x 44 ½ inches
(145 x 113 cm). Private collection.*

91. *Joan Miró*, Untitled Painting, *1927.
Aqueous medium on canvas, 44 ¼ x
57 ½ inches (113.7 x 146.1 cm). Philadelphia
Museum of Art, The Albert M. Greenfield
and Elizabeth M. Greenfield Collection.*

92. Joan Miró, Painting, *1927. Oil on canvas, 50 ¾ x 38 ¼ inches (129 x 97 cm). Musée National d'Art Moderne, Centre de Création Industrielle au Centre Georges Pompidou, Paris; formerly collection of Geneviève and Jean Masurel, donated in 1979 to the Musée d'Art Moderne Villeneuve d'Ascq; on deposit at the Musée d'Art Moderne de la Communauté Urbaine de Lille, Villeneuve d'Ascq, 1994.*

appear to be full of amorphous evocations of life forms, floating in the void of celestial space.

Though always antagonistic toward codified aesthetic theory, Miró did participate to some extent in abstraction's semantic debates and territorial infighting. For instance, in 1934 he corrected a dealer for giving one of his works from that year the title *Composition*, which he felt "evokes abstract things in a dogmatic or superficial sense." Perhaps he was thinking of the designation "construction," but, at any rate, he preferred the title *Painting*,[112] which he used for a series of works of 1933. He remarked in 1931 that the "only thing that interests me is the spirit itself,"[113] but he refused to join the Abstraction-Création group in Paris, which he later described as a "deserted house."[114] Miró stressed that his marks "correspond to a concrete representation of my mind . . . possess a profound reality, [yet] were not part of the real itself."[115] In other words, his work not only possesses content but is "concrete." Thus, Miró, who claimed to be beyond the fray, eagerly tried to seize abstraction's territory of "reality," which was seemingly its most fiercely fought-over battleground. In later years, he further elaborated the distinctions between his goals and those of various abstractionists, saying he hated "form for form's sake"[116] and geometric art, which, according to him, is "not the way to spiritual freedom."[117] With his desire for form containing content and for "spiritual freedom," it is not surprising that Miró admired Kandinsky and Mondrian.[118] What he despised was abstraction as practiced by the post–World War I groups. Yet he was a reluctant Surrealist; indeed, he was unwilling to align himself with any group at this time, and his own ideas seem to have had more in common with the thinking of the earlier generation.

Throughout Miró's career, there were just two periods during which he yielded to the temptations of complete abstraction: from 1925 to 1933, as mentioned earlier, and again in the early 1960s. These later abstract works are exemplified by a group of large blue canvases from 1961 (for example, fig. 93), which he described as being about "emptiness." This characterization is Miró's variant on the grand nothingness emphasized by most abstractionists. Making these paintings, said Miró, "was like preparing the celebration of a religious rite or entering a monastery. . . . These canvases are the culmination of everything I had tried to do up to then."[119] His allusion to a "religious rite" recalls Mircea Eliade's description of a creation rite among tribal cultures, with its connection to the underlying theory of early abstraction. But one must also consider the influence of the contemporaneous paintings of Yves Klein. Although it is possible to see the vast blue fields of Miró's 1961 paintings foreshadowed in his own earlier abstract work, one wonders if Miró saw Klein's paintings and then felt he had the license to create the series about which he had long dreamed but possibly lacked the courage to execute. Abstraction was regarded so negatively in Paris that the criticism might have been more than he was earlier able to face. In 1966, Miró wrote that when Kandinsky arrived in Paris in 1933 "all the painters politely refused to see him. . . . This great Prince of the Mind, this Great Lord, lived in extreme isolation."[120] Although in retrospect Miró was able to say, recalling Kandinsky's exhibitions in Paris at Galerie Zak beginning in 1929, that the Russian's "gouaches touched me to the bottom of my soul,"[121] he was at the time unwilling to acknowledge the achievement. In fact, the ethos that reigned in Paris in the late 1920s and 1930s maintained its hold on Miró. As late as 1970, speaking about being influenced by Abstract Expressionist art from the United States, he declared that he found it "hard to break away from" the School of Paris.[122]

93. Joan Miró, Blue II, *March 1961. Oil on canvas, 106 ¼ x 139 ¾ inches (270 x 355 cm). Musée National d'Art Moderne, Centre Georges Pompidou, Paris.*

94. *Alexander Calder*, Little Ball with
Counterweight, *1930. Painted sheet metal,
wire, and wood, 63 ¼ x 12 ½ x 12 ½ inches
(162 x 31.7 x 31.7 cm). Collection of Mrs.
Ruth Horwich, Chicago.*

95. *Alexander Calder*, Mobile, *ca. 1935.
Wood, wire, and string, 5 feet 5 inches x
6 feet 3 inches (1.65 x 1.91 m). Collection of
Irma and Norman Braman.*

96. Alexander Calder, Mobile, *1936(?).*
Wood, metal rods, and cord, 39 x 36 inches
(99 x 91.5 cm). Solomon R. Guggenheim
Museum, New York, Collection of Mary
Reynolds, Gift of her brother 54.1392.

The biomorphic branch of French Surrealism, which was its most abstract manifestation, flourished in the late 1920s and early 1930s, and it attracted Calder in 1930, during his fourth stay in Paris. He had already met Miró during a 1928 visit, and Man Ray in 1929. This time he became acquainted with Arp, Robert Delaunay, Hélion, Le Corbusier, Léger, van Doesburg, and, the most important for Calder, Mondrian. He wrote of his first visit to Mondrian's studio that fall: "This one visit gave me a shock that started things. Though I had heard the word 'modern' before, I did not consciously know or feel the term 'abstract.' So now, at thirty-two, I wanted to paint and work in the abstract."[123] But he employed the organic forms of Arp and Miró rather than the "colored rectangles" he had seen at Mondrian's studio, and began exploring ways to incorporate movement in his sculptures. While Rodchenko and Gabo had experimented with movement to animate their abstract forms, Calder made it into a brilliant career. In his earliest mobiles, the forms are abstract, without associations— small discs, balls, and cones attached to wire rods and arcs in delicate equilibrium, such as *Little Ball with Counterweight*, 1930 (fig. 94). In 1932, during his next stay in Paris, he met Duchamp, who came up with the name "mobile" for Calder's moving sculptures, and soon after that Arp coined the term "stabile" for the stationary ones.[124] Subsequently, Calder began making mobiles with numerous balls, various winglike or fish shapes, or small carved wooden forms in arrangements that often evoke celestial elements suspended or revolving in space (for example, figs. 95 and 96). This celestial theme had been taken up earlier by Kupka and by the group known as Tabu Dada during the late 1910s and 1920s, and was later adopted by Miró.

The Spread of Abstraction

Throughout the 1920s and 1930s, a wide range of abstract artists from many countries came to Paris. There, in 1929, Uruguayan artist Joaquín Torres-Garcia and Dutch-born critic Seuphor founded a group dedicated to abstraction, which they called Cercle et Carré (Circle and Square) and which was composed primarily of non-French individuals. It was the first time that abstraction, as a style, became the focal point of its own movement. Unlike the Constructivist, Bauhaus, and De Stijl tendencies, there were no utopian and/or political implications to abstraction for this group. Cercle et Carré published a review of the same name in 1930.

Cercle et Carré was quickly supplanted by another, more organized and more international group, Abstraction-Création, which began with an exhibition in Paris in 1930[125] and was officially founded at the start of the following year by Hélion, Auguste Herbin, and Georges Vantongerloo.[126] The first volume of the journal *Abstraction-Création* was published in 1932, and it continued annually through 1936.[127] To a great extent, Abstraction-Création was a locus for many of the now-disenfranchised Constructivists, for Dadaists from throughout Europe, as well as for such English artists as Barbara Hepworth and Ben Nicholson (who were members until 1935). Unlike the Constructivists, who had embraced abstraction as a fundamental style, language, or concept without much reference to it in their debates, the artists in this Paris-based association discussed and analyzed it at great length. In the 1935 issue of *Abstraction-Création*, they claimed that Paris was by then "the center of the movement," and presented a survey of the spread of support for abstraction there, listed by arrondissement.[128] In contrast to the Paris of preceding decades, when being an abstract artist meant being an outcast, abstraction became an acceptable or even a popular choice, perhaps in deliberate opposition to Surrealism. Illustrations of works by Calder, Delaunay, Gleizes, Hélion, and

97. Jean Hélion, Composition, April– May 1934. Oil on canvas, 56 ⅞ x 78 ¼ inches (144.3 x 199.8 cm). Solomon R. Guggenheim Museum, New York 61.1586.

98. *Henry Moore,* Mother and Child,
*1938. Elm, 30 ⅛ x 13 ⅞ x 15 ½ inches (77.2 x
35.2 x 39.2 cm). The Museum of Modern
Art, New York, Acquired through the
Lillie P. Bliss Bequest.*

Kupka, among others, appeared in the journal, and even works by Brancusi and Picasso were published in the 1935 issue.

More than Kandinsky or Malevich and their associates, it was the De Stijl group that most heavily influenced the 1930s tendencies of abstraction. The pages of *Abstraction-Création* show that the influence of Mondrian was overwhelming, and that he had produced a "school" of painting. However, Hélion softened the hard edges of De Stijl in his works and thereby produced an individual interpretation of the Dutch style, as can be seen in *Composition*, 1934 (fig. 97).

During this period, abstraction took hold in a significant way in England, which had for some time been influenced by a formalist approach among artists and critics (for example, in 1926 Roger Fry was still explaining that the work of art "is itself everything, its historical reference of no interest"[129]). Among its most notable English practitioners to emerge in the 1930s were Hepworth, Nicholson, and Henry Moore. This group well illustrates the clear and deliberate stylistic dichotomy that had developed within abstraction. Nicholson and Hepworth were both greatly influenced by their 1932 visit to Paris, where they met Arp, Brancusi, and Picasso. Nicholson, who also met Mondrian in 1933, belonged to the geometric branch of abstraction, whereas Hepworth and Moore were attracted to the "ovoid" tradition started by Brancusi and expanded by Arp and Miró (see fig. 98). This biomorphic strain might also be thought of as the Surrealists' style of abstraction.

In the United States, biomorphic abstraction first appeared in the late 1910s and early 1920s, in the work of Georgia O'Keeffe. But in the mid-1920s the geometric style found more converts there, culminating in 1936 in the establishment of the American Abstract Artists (AAA) group,[130] which was a kind of counterpart to Abstraction-Création. In fact, several Europeans showed in the first AAA exhibition in 1937, including Hélion, Léger, Moholy-Nagy, and Mondrian. The later work of Kandinsky and, even more so, Mondrian (who moved to New York in 1940) was particularly influential on the American abstractionists, influences that are apparent in the Americans' style of studied, harmonious balance, as in the work of such AAA members as Ilya Bolotowsky, Burgoyne Diller, Fritz Glarner, Carl Holty, Ad Reinhardt, and Charmion von Wiegand. Although the AAA was dominated by formal approaches—filtered through a synthesis of Russian and German Constructivism and a mannered academic Cubism—it admitted a broad range of abstract styles.

The weakest works created by artists in the Cercle et Carré, Abstraction-Création, and AAA groups were criticized by many as extreme examples of superficial symbolism, concrete and real yet uninflected, like an international traffic sign. The symbolic potential of abstraction has been acknowledged by many commentators. For example, Meyer Schapiro wrote that geometric forms have specific meanings, citing Walt Whitman's belief that God could be described as a square.[131] Another view was exemplified by Ernst Cassirer in *The Philosophy of Symbolic Forms*, published in 1929, wherein he proposed that "universal form" (which he notes is abstract) subsumes relatively complex meaning.[132] At issue was whether, in the words of Eric Voegelin, this abstract language is "an empirical body of signs or . . . a creative agency bestowing meaning on the world."[133] The debate was not settled by the abstractionists of any period, although one might generalize and say that the Constructivists and those pursuing geometric abstraction would have embraced the former position and that the pioneers of abstraction would have taken the latter. Artists working in a biomorphic mode would have been more likely to take the latter position too, and to think of art as a way of visualizing

otherwise unknowable phenomena, based on the premise that there is a "coincidence" of appearance between their forms and the subjects to which they indirectly allude. Alfred H. Barr, Jr. announced in 1936 in the catalogue to his Museum of Modern Art exhibition *Cubism and Abstract Art* that European biomorphic abstraction was ascendant and that geometric abstraction was in decline.[134] This assessment appears to have been based on the belief that geometric abstraction was settling into stale formulas, an art that could be too easily analyzed for its meaning, as if it were a collection of signs, whereas biomorphic abstraction held out the potential for creatively "bestowing meaning."

However, it was the cool, uninflected surface of geometric abstraction that came to be regarded as the epitome of Modernism and led to its widespread application in all fields of art and design in the 1930s, particularly the decorative arts, architecture, and two-dimensional graphic arts. Furthermore, the Bauhaus emphasis on functional and utilitarian design predominated. Abstraction became identified with a concern for design principles that could be used in any context, without suggesting a set of referents—it was, in other words, a universal language.

Architecture—*the* functional art form—which had been so admired by the early abstract artists, was itself influenced by abstraction in the 1920s, in the designs of the early proponents of what became known as the International Style. In 1929, Le Corbusier wrote admiringly of the Constructivists: "They are poets in steel and glass. Form *takes precedence* over function. . . . What emerges from Moscow is an enthusiastic declaration of faith in the architectural poem of the modern age."[135] Following the lead of the Constructivists and the Bauhaus, these modern architects used new materials and technologies to create spatial compositions that emphasize function, but, as Reyner Banham pointed out, their best works are "composed much as an Abstract painting might have been composed" and are "rich in the associations and symbolic values current in their time."[136] Whereas abstract painters and sculptors dealt with forms that have no clear meaning or use, architects could avoid empty formalism and proudly claim that "form follows function."[137] Karl Jaspers wrote that architecture became the art form of the epoch because the union of art and engineering seemed to serve both the elite class and the masses. If it did not permit a "transcendental aim to peep through," that was just as well, for utilitarian purposes better fit the period.[138]

During the 1930s, abstraction was thought of as the only new approach that offered art a future, and—in the Parisian sphere—as the challenger to Cubism and Surrealism.[139] It had become synonymous with the most avant-garde of art forms; yet, ironically, even as it was gaining recognition, its positive impact was diminishing, for its status as a movement was largely in the hands of the Abstraction-Création group and its mostly academic secondary artists. Mondrian, forced into the role of spokesman at this time, was asked to defend abstraction against various crimes, including being "excessively cerebral . . . purely ornamental . . . suitable at best to posters and advertising catalogues," and having replaced "emotion" with an "exercise in pure color and geometric designs."[140] Indeed, these accusations were often true of the Abstraction-Création group and its various offshoots, including those in the United States. There, in the mid-1930s, one critic declared that the age of abstraction was virtually at an end because the "decorative" effects of this style had yet to be joined to an expressive component;[141] and another described the term "abstract" as having become "derogatory," merely a "jeu d'ésprit," if not futile altogether.[142] In 1936, Barr wrote that abstraction had neared death some ten years earlier;[143] by viewing Mondrian as an offshoot of Picasso, he suggested that pure

abstraction had never really attained any significance on its own and that Cubism was still the paramount breakthrough.

One wonders whether Jaspers's general attacks on art, in the 1930s, had academic abstraction as its central focus. For him, art had become "unprincipled," a form of "entertainment"; he wrote that it was time for art to return to its traditional role, "to make transcendentalism perceptible. It may well be that the moment draws near when art will once again tell man what his God is and what he himself is. So long as we . . . have to contemplate the tragedy of man . . . because we have no truth of our own . . . we are failing to grasp our world."[144] Jaspers urged artists once again to address humanistic issues. Although Kandinsky and Mondrian had been concerned with some of these matters, their successors had failed to hold to this heritage.

The shortcomings of the second wave of abstractionists were conspicuous by the 1930s. During the preceding decade, they had sought to correct their forebears' failure to engage society and attract a public, but they themselves failed miserably. The governments on which they were dependent rejected them for not satisfactorily serving the needs of propaganda. So much for idealism; the artists had been hung out to dry. However, the failure was also inherent in their aesthetic mission, which appeared pedantic given the unassailably real and prevailing deprivation in society. Once abstract imagery had been devalued to the point of design by academic abstraction, the artists' work was left with little meaning in the context, and it became enervated and then floundered.

Early abstraction had been betrayed. If this now seemingly trivialized style was to be resuscitated, it had to be rejuvenated by the next generation's idealism. Even if it looked bankrupt at this point, abstraction remained the territory of those with exalted concepts and hopes. A revolutionary spirit was once again needed in a world filled with despair.

With parts of Europe in ruins after World War II, and many European artists having gone to the United States (including Max Ernst, Naum Gabo, Fernand Léger, Jacques Lipchitz, and Piet Mondrian), the center of the art world shifted to New York City. It is there that the story of abstraction resumes in earnest. Though most American artists were not touched directly by the war's devastation, they were no less disillusioned than their European counterparts. Having lived through the Depression and global war and witnessed the ravages of mankind's latest moral failures, they had lost faith in modern civilization. Utopianism had demanded a trust and passive optimism that most artists and intellectuals no longer shared. Alienation had eroded any sense of collective idealism, and American artists began to find their voice by exploring the self and celebrating personal freedom. In support of these views, they cited writings by Sigmund Freud and Carl Jung based on the fundamental idea that the truth of one's inner life holds sway over the dictates of reason.[1] They also found themselves increasingly caught up in the ideas of existentialism, which seemed to reflect their personal and social anxieties and reinforced their belief in individual freedom.[2]

The mood of artists in the United States after World War II recalls certain patterns of thinking during the initial phase of abstraction. Foremost among these was the perception of freedom being threatened, which was particularly strong in the repressive postwar atmosphere. Maintaining a resolute faith in reason or in the possibility of human perfectibility was difficult; the human condition—indeed, human dignity—needed propping up.[3] The tragic vision that Vasily Kandinsky and Mondrian had attempted to transcend through their art appeared to have been deeply embraced by a new generation of artists.

Among these young artists, there was a general loss of faith in the prevailing ideologies, and a tendency to view abstraction as a style of the past. In the early to mid-1940s, the artists of the then developing New York School were elaborating on Surrealist examples through an increasing awareness of all types of archaic art and primitivizing themes. Their work from this phase is a combination of figurative and abstract elements, richly allusive in the manner of André Masson, Matta [Roberto Sebastián Matta Echaurren],[4] and Joan Miró (though, of the entire New York group, only Willem de Kooning and Arshile Gorky achieved a sustained and fully realized voice working in this manner; see fig. 99). During the postwar period the term "abstraction" carried a negative connotation, implying an interwar movement that was too unambiguous and positivistic, untouched by events, antagonistic toward individuality, and unalterably wedded to pictorial laws, in contrast to Surrealism's celebration of ambiguity, imagination, and individual creative freedom.

Although the word "abstraction" was anathema to some, its stylistic force and underlying romantic outlook were fully in place among the New York School artists who became known as the Abstract Expressionists.[5] Only the early European abstractionists had held a comparable degree of faith in art. This new generation took seriously Karl Jaspers's call for artists to "make transcendentalism perceptible," reviving the waning concern for conveying serious, meaningful subject matter within an abstract vocabulary. In hindsight, it seems apparent that if the Americans had not come along to reattempt this synthesis, abstraction might have gone into permanent decline.

The one ideology that continued to attract artists and intellectuals during the 1930s and 1940s was Marxism, although it certainly did not enjoy official acceptance in the United States. Indeed, the House Committee on Un-American Activities was founded in 1938, by a vote

in Congress of 191 to 41, specifically to combat Communism and other influences considered antithetical to national interests. But the right-wing press had already been on the attack for several years. Among the actions regarded as particularly suspicious were declarations advocating absolute freedom, which Leon Trotsky had cited in 1938 to be the province of true art.[6] Fifteen years later, musician Artie Shaw said, "I am at a point today if someone says, 'Here is a committee for personal freedom,' I don't want any part of it. I don't know what these things mean anymore."[7] Art that was not Regionalist or anecdotally naïve was considered subversive. In this climate, an artist whose work showed signs of "foreign influences" might even be investigated. Artists subsidized by the Works Progress Administration (WPA)—two-thirds of whom were concentrated in New York City, which was regarded as "an almost alien outpost of foreign influences"[8]—were under attack as Communists.[9] To depart from conventional expressions of traditional American values was clearly risky, whether in the form of Social Realist tributes to class struggle and to unrestrained political freedom or Modernist displays of aesthetic freedom. Abstraction, with its foreign roots, was especially suspect.

The Great Debate
For advanced American artists of the late 1930s who wanted to escape the constraints of anecdotal and Regionalist practices, European art offered the choice of two seemingly disparate models, abstraction and Surrealism. In Europe, the schism between the two had developed into a "violent quarrel"[10] that had spread to the United States, so that, in 1942, when Peggy Guggenheim opened her New York gallery, Art of This Century, she wore one earring made by Yves Tanguy and another by Alexander Calder "in order to show my impartiality between surrealist and abstract art."[11] In 1944, however, Sidney Janis asserted that "the schism between the factions is not as insurmountable as their members believe."[12] About this bitterly divided time, Masson wrote that categories were for the "lower slopes of the mind."[13] Still, the issues proved divisive.

The debate was addressed in part in Alfred H. Barr, Jr.'s 1936 exhibition *Cubism and Abstract Art*, for his Francophile position favored Surrealism as a continuation of the School of Paris, while American abstraction was shut out of the exhibition altogether.[14] The formation of the American Abstract Artists (AAA) group exemplified the extreme position of abstraction in America. In its first exhibition, in 1937, AAA stressed that "a liberal interpretation would have to be placed upon the word 'abstract,'" and affirmed the group's broad internationalism, with its roots in the Abstraction-Création movement based in Paris and the Circle group in London.[15] Another strong influence on many AAA artists was the work of Stuart Davis, who in the late 1920s had developed a thoroughly American Cubist-derived version of abstraction based on a system of flat planes and geometric shapes usually combined with bits of lettering, words, or phrases. He explained that "a subject had its emotional reality fundamentally through our awareness of such planes and their spatial relationships."[16] Even in the face of the public's hostility toward abstraction between the wars, Davis maintained a strict adherence to his aesthetic principles. In 1939, he proclaimed: "Abstract art is here to stay because the progressive spirit it represents is here to stay. A free art cannot be destroyed without destroying the social freedoms it expresses."[17] Indeed, although AAA failed to attract Barr's enthusiasm, it should still be given credit for drawing enough serious attention to American abstraction that during the year 1938, as one magazine noted, abstract art flooded the galleries.[18]

99. *Arshile Gorky,* The Liver Is the
Cock's Comb, *1944. Oil on canvas,
7 feet 9 ½ inches x 12 feet 11 inches (2.37 x
3.94 m). Albright-Knox Art Gallery,
Buffalo, Gift of Seymour H. Knox, 1952.*

100. *Hans Hofmann,* Fantasia, *1943.
Oil, Duco, and casein on plywood, 51 ⁷⁄₁₆ x
36 ⁹⁄₁₆ inches (130.7 x 93.2 cm). University
Art Museum and Pacific Film Archive,
University of California at Berkeley,
Gift of the artist.*

The AAA group was concerned that the Surrealist glorification of individual sensibility might diminish an emphasis on unfettered plasticity.[19] It was no longer Kandinsky, Malevich, and Mondrian but the AAA and its counterparts in Europe who had come to epitomize abstraction and to represent its aesthetic positions. Hence, the emphasis on plasticity became a hallmark of the abstract approach. This extreme formalist outlook was maintained not only by many artists but also by curators and critics.[20] The increasingly influential critic Clement Greenberg, for example, railed against all forms of representational painting in recent art, especially Surrealism, which (except for automatism) he considered too literary. In a characteristically elitist remark, Greenberg suggested that Surrealism catered too much to popular taste, lowering instead of raising the sensibility of Everyman. The art that he favored, he archly stated, was "arduous."[21] As a champion of formalism, he even surpassed Roger Fry, who had left room for a link between art and life; for Greenberg, there was none.[22] Thus, the frequent characterization of abstraction by its enemies as an ivory-tower pastime is hardly surprising.[23] It was also attacked as "a symptom of cultural, even moral, decay,"[24] as Greenberg noted in one essay.

In 1937, in an essay called "The Nature of Abstract Art," art historian Meyer Schapiro challenged the strictly formalist, ahistorical view of abstraction perpetuated by Barr and others. After describing Barr's *Cubism and Abstract Art* as "the best that we have in English on the movements now grouped as abstract art," he condemned Barr for disregarding the fundamental notion that art is shaped by the conditions of the moment and the nature of the society in which it arises. Barr, he said, had erroneously attributed the development of abstract art entirely to the "exhaustion" of representational art, theorizing that, "out of boredom with 'painting facts,' the artists turned to abstract art as a pure aesthetic activity." Schapiro insisted that, on the contrary, such a "broad reaction against an existing art is possible only on the ground of its inadequacy to artists with new values and new ways of seeing," as a critique of existing conditions and an affirmation of freedom. And he completely rejected the notion that art is a purely aesthetic activity, "a 'pure art' unconditioned by experience."[25] Schapiro elaborated on the idea of abstract art as the domain of freedom in a talk in 1957, in which he proposed that the revolution in modern painting and sculpture introduced "a new liberty . . . a new sense of freedom and possibility." Recent abstract painting, he asserted, featured new approaches to "handling, processing, [and] surfacing" that emphasized "spontaneity or intense feeling" and "the freely made quality" of the work, and embodied an artist's profound realization of "freedom and deep engagement of the self."[26] In 1960, in a brief essay defending abstraction against some common misconceptions and criticisms, Schapiro concluded (with a shade of ambivalence): "Looking back to the past, one may regret that painting now is not broader and fails to touch enough in our lives. The same may be said of representation, which, on the whole, lags behind abstract art in inventiveness and conviction; today it is abstract painting that stimulates artists to a freer approach to visible nature and man . . . and has opened to [them] regions of feeling and perception unknown before."[27]

Abstraction was constantly under attack in the United States during the 1930s and early 1940s, its imminent demise a frequent topic of discussion.[28] Throughout the 1930s, abstraction was often identified with Communism,[29] in spite of the broad range of political views and affiliations among its adherents in the United States. Stylistically, American abstraction was criticized for what were perceived as its

numerous faults, including an arid, machine-made look and a pallid academicism. Although some commentators acknowledged that abstraction was suitable for "decorative" uses in architecture and design, they insisted that it did not meet the higher requirements of other forms of art.[30] When it was not being criticized for lacking expressiveness, abstract art was being described as too subjective.[31] Because it was seemingly without roots in a great tradition, some critics regarded it as incapable of the subtlety of representational art, and called for a return to both representation and subject matter in order to combat the sterility that they believed had permeated contemporary modes of expression.[32] One of them asked, "In avoiding life, can abstract painting live?"[33] Barr must have been responding to these discussions when he categorized a number of European artists as "Abstract Expressionists" in his 1936 exhibition, thereby showing that the idea of abstraction could be rescued by a synthesis with Expressionism.

In the mid-1940s, in this hostile environment, the AAA still managed to succeed in its goals of fostering abstraction and bringing it to public attention.[34] But with much of the work of its members dominated by formulaic geometry and pattern-making, the group's leaders harbored doubts about whether a place could be made within their approach for some degree of expression.[35] However, there were younger artists outside their group who were exploring more radical modes of abstraction in a search for expression beyond representational styles, and who realized that a fusion of expressive content and pictorial qualities was called for. Perhaps it was apparent by this early date that the young Abstract Expressionists might reinvent abstraction, and the AAA wanted to co-opt or at least include the upstarts' efforts within their own agenda. But despite the AAA's intention, it never attracted this new generation, although it continued to offer an organized base for abstract artists into the 1950s.

The New York School: Abstract Expressionism

Early twentieth-century abstraction began with the gestural work of Kandinsky and the quite different rectilinear paintings of Mondrian, followed by a similar contrast between the organic abstraction of Jean Arp and Miró and the geometrically inclined Constructivists. The pattern continued in the two branches of abstraction practiced in America during the 1950s and 1960s: the exuberant gestures of de Kooning, Franz Kline, Jackson Pollock, and other Action painters, and the relatively uninflected planes of color of the Field painters, including Josef Albers, Barnett Newman, Ad Reinhardt, Mark Rothko, and Clyfford Still.

Although de Kooning's paintings are rarely larger than human scale, he achieved an epic effect through the dramatic intimacy and muscular physicality of his brushstrokes. The freedom and energy of de Kooning's brushstrokes were anticipated in twentieth-century art only by Kandinsky. But whereas Kandinsky almost always gave his brushstrokes room to breathe, de Kooning treated space with a certain degree of ambiguity. In such works as *Painting*, 1948 (fig. 101), he only partially relieved the density of the massed black forms with a few glimpses of white "space" here and there. Soon after making this work, he began to focus on what became his primary activity as a painter— the elaboration of the drawn colored line inscribed with swaths of pigment. Each painting became the repository of gestures so numerous and densely layered, as in *Composition*, 1955 (fig. 102), that the painted surface obliterated any breathing space that may have been present in its earlier stages. Perhaps because a line constantly verges on description, some of the gestural painters of the New York School

occasionally left hints of a figurative subject in their compositions. De Kooning, in his works of the 1950s and 1960s, often maintained the sense of a centered configuration or even a recognizable figure, and in his *Woman* series of the early 1950s he made subject matter quite obvious. In fact, throughout his career de Kooning moved between pure abstraction, as in *Composition*, and obvious or apparent representation, as in *Palisades*, 1957 (fig. 103). But the paintings of his landscape series, to which *Palisades* belongs, are mostly subliminal in their references to landscape or any other sources. Such works are evocations of raucous urban or suburban energy in dynamic equilibrium, a counterpart to Mondrian's vision and, like Mondrian's works, essentially metaphysical. In the 1970s, in works such as *. . . Whose Name Was Writ in Water*, 1975 (fig. 104), and *Untitled* (fig. 121) and *Untitled I* (fig. 122), both 1977, de Kooning maintained his ambiguous approach to the density and buoyancy of his painted gestures.

Pollock and Hofmann also seemed to have been strongly influenced by the gestural work of Kandinsky. Their earliest drip paintings—for example, Hofmann's *Fantasia* (fig. 100) and Pollock's *Composition with Pouring II* (fig. 105), both 1943—exhibit the same free, highly personal, nondescriptive gesture and imprecise but atmospheric space evident in Kandinsky's work, along with a suggestion of Miró's often liquid line.[36] These American gesturalists stressed the physicality of the medium and the raw process of painting.

Process and improvisation were central to the working methods of both de Kooning and Pollock. But Pollock, with his drip technique, courted chance and spontaneous effects more than de Kooning did. Compared to the controlled fury of de Kooning's gestures, Pollock's line is more akin to a masterful accident of the hand, as in *Number 1, 1950 (Lavender Mist)* (fig. 106) and *Number 3* (fig. 120), both 1950. Although Pollock had dealt with the figure in the early 1940s and occasionally returned to it a decade later, there is almost never a shape hinted at or described in most of his mature works, which consist of linear "skeins"—densely woven, filamented lines and textures that overlap and interweave, as in *Number 13A: Arabesque*, 1948 (fig. 107) and *Lavender Mist*. In these works, Pollock stressed an allover compositional format in which space, or the possibility of visual penetration, appears to be invited and then denied.

Pollock began making large-scale paintings in the early 1940s,[37] a development that may reflect, in addition to his often-cited interest in Mexican murals, the interwar abstractionists' expansion of scale in order to achieve a fuller, environmental impact. This expansion of pure abstraction continued in the 1950s, when the Field painters created large paintings that consist chiefly of flat expanses of color, with a minimum of gesture and not even a hint of figuration, such as Newman's *The Word II*, 1954 (fig. 114). Indeed, the size of these works, often even larger than Pollock's, was a critical element in achieving the goals of these artists. With the scale of abstraction enlarged to epic proportions, the viewer is physically overwhelmed, compelled to enter the space of the picture and—the artists hoped—to experience firsthand a completely abstract world defined by the sensuous qualities of the painted surface, comparable to viewing the most dramatic effects of nature.

The Field painters, more than the gestural painters, were especially interested in expressing a sublime and/or tragic vision.[38] After making paintings incorporating imagery based on archetypal myths of the ancient Greeks and the North American Indians during the late 1930s and early 1940s, Newman, Rothko, and Still began using richly colored abstract shapes to evoke a more intense sensation of nothingness or

101. *Willem de Kooning,* Painting, *1948.*
Enamel and oil on canvas, 42 ⅛ x
56 ⅛ inches (108.3 x 142.5 cm). The Museum
of Modern Art, New York, Purchase, 1948.

102. *Willem de Kooning,* Composition,
1955. Oil, enamel, and charcoal on canvas,
6 feet 7 ⅛ inches x 5 feet 9 ⅛ inches (2.01 x
1.76 m). Solomon R. Guggenheim Museum,
New York 55.1419.

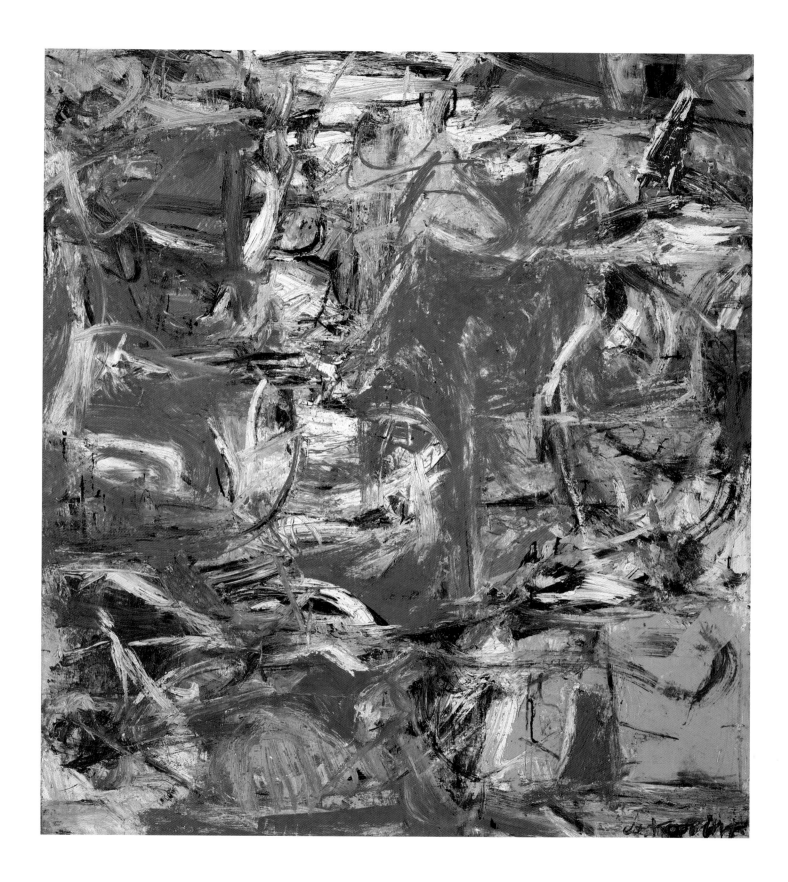

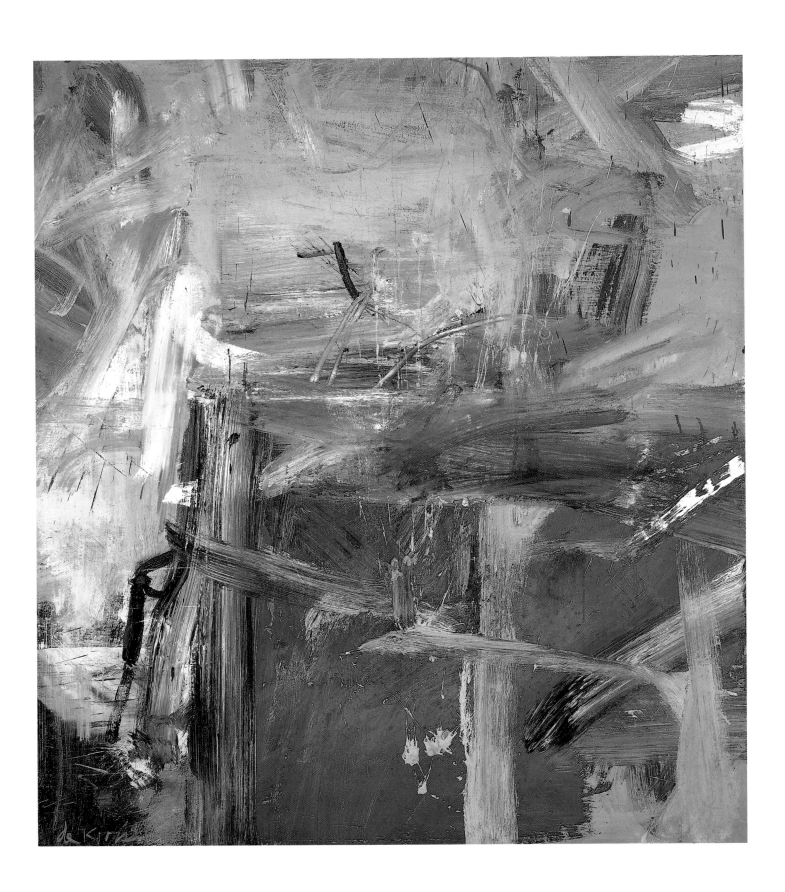

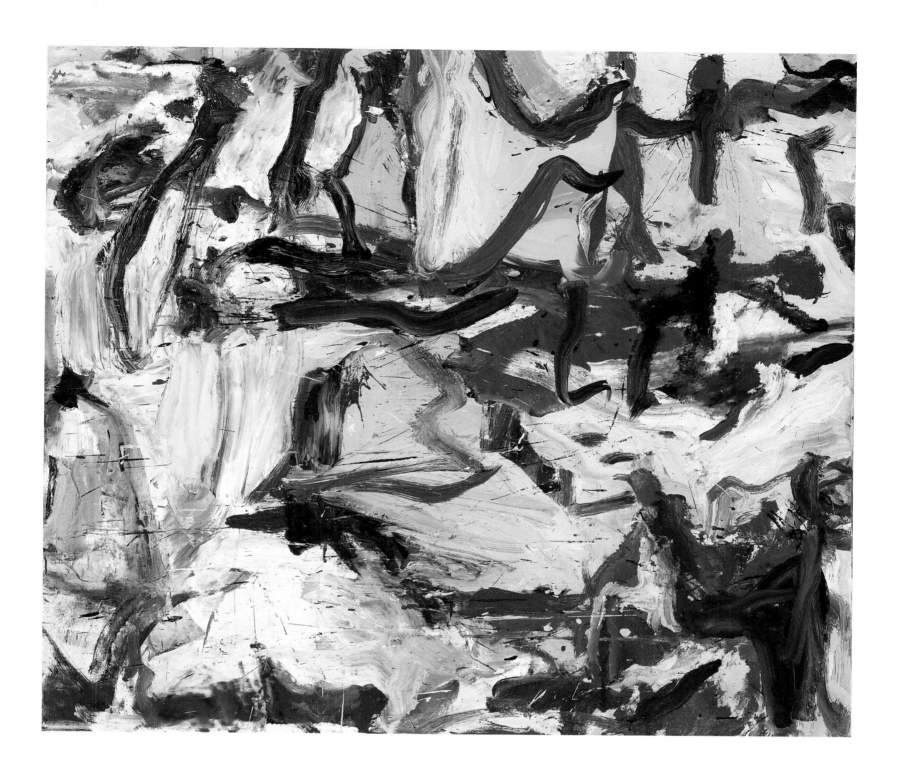

103. Willem de Kooning, Palisades,
1957. Oil on canvas, 6 feet 7 inches x
5 feet 9 inches (2 x 1.75 m). Collection of
Adriana and Robert Mnuchin.

104. Willem de Kooning, . . . Whose
Name Was Writ in Water, 1975. Oil on
canvas, 6 feet 4 ¼ inches x 7 feet 3 ¼ inches
(1.95 x 2.23 m). Solomon R. Guggenheim
Museum, New York, By exchange 80.2738.

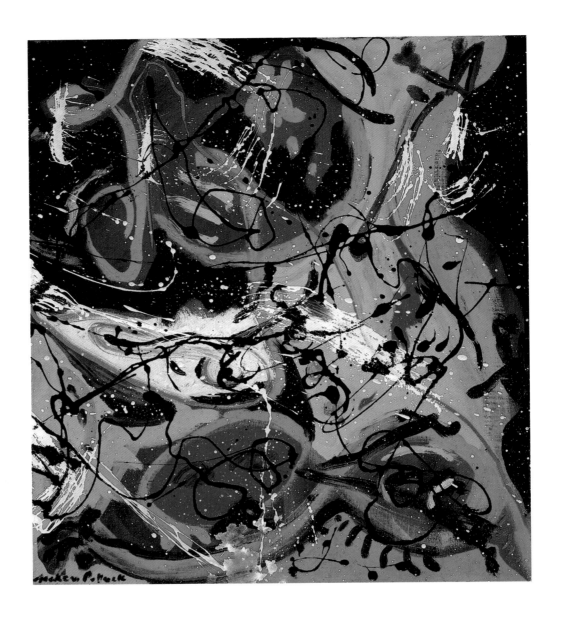

105. *Jackson Pollock,* Composition
with Pouring II, *1943. Oil on canvas,
25 ⅛ x 22 ⅛ inches (63.9 x 56.3 cm).
Hirshhorn Museum and Sculpture Garden,
Smithsonian Institution, Washington,
D.C., Gift of Joseph H. Hirshhorn, 1966.*

106. *Jackson Pollock,* Number 1, 1950
(Lavender Mist), *1950. Oil, enamel,
and aluminum paint on canvas,
7 feet 3 inches x 9 feet 10 inches (2.21 x
3 m). National Gallery of Art,
Washington, D.C., Ailsa Mellon Bruce
Fund 1976.37.1.*

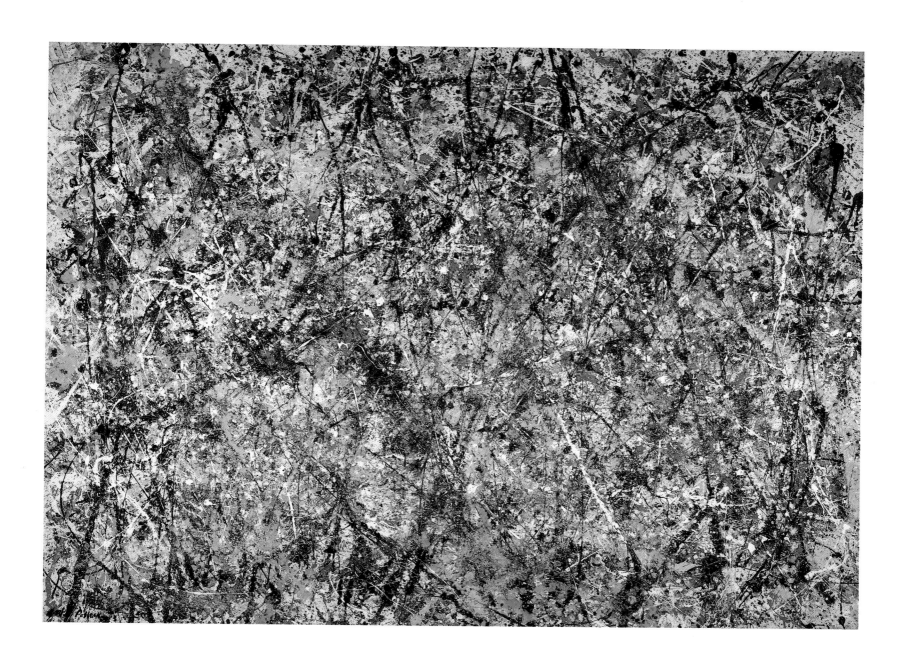

107. Jackson Pollock, Number 13A:
Arabesque, *1948. Oil and enamel on
canvas, 3 feet 1 ¼ inches x 9 feet 8 ½ inches
(.95 x 2.96 m). Yale University Art
Gallery, New Haven, Connecticut, Gift of
Richard Brown Baker, B.A. 1935.*

108. *Mark Rothko*, Slow Swirl by the Edge of the Sea, *1944. Oil on canvas, 6 feet 3 ⅛ inches x 7 feet ⅛ inch (1.91 x 2.15 m). The Museum of Modern Art, New York, Bequest of Mrs. Mark Rothko through The Mark Rothko Foundation, Inc., 1981.*

facing page:
109. *Franz Kline,* Siegfried, *1958. Oil on canvas, 8 feet 7 inches x 6 feet 9 inches (2.62 x 2.06 m). The Carnegie Museum of Art, Pittsburgh, Gift of the Friends of the Museum, 1959.*

infinity than had ever been painted. By the 1950s, their subject matter was no longer insinuated through symbols but was real and present in the space of the viewer, conveyed by a new pictorial language that relied entirely on color, line, and space.

Color was abandoned for a while by de Kooning, Adolph Gottlieb, Robert Motherwell, and Pollock during the period from the early 1940s to the early 1950s—and almost permanently by Kline (see fig. 109)— in favor of an ascetic black-and-white palette. Its stark, dramatic contrast, evoking the grim world of Hollywood film noir, seemed to deny sensuality in favor of an aggressively tragic vision. There is no desire to "entertain" by the use of color, or to please, as in the School of Paris. In an all-white painting such as *The Name II*, 1950 (fig. 115), Newman appears to have used whiteness less to convey infinity or purity than as something tough and raw, more a neutral tonality than a symbolic one, even if a certain symbolism is suggested by the tripartite composition. Indeed, any suggestion of infinite expansion is abruptly denied by Newman's treatment of the painting's left and right edges, which he deliberately left unpainted.

Rothko's evolution away from Surrealist-inspired imagery is similar to that of several of his colleagues, including Newman, Still, and, to a degree, Pollock, but somewhat more formally systematic, perhaps comparable to that of Mondrian. In the 1940s, after several years of figurative work, Rothko began painting mythic or totemic images of Surrealist inspiration against neutral fields (as in *Slow Swirl by the Edge of the Sea*, 1944, fig. 108), something like what Masson and Miró had been doing. Then, in the late 1940s, he eliminated all figurative references and all traces of line, with the abstract background or flat plane beyond the pictorial events in the foreground gradually becoming the entire subject matter of his art. A typical Rothko composition, such as *Blue over Orange*, 1956 (fig. 126), or *No. 207 (Red over Dark Blue on Dark Grey)*, 1961 (fig. 110), consists of two or three soft-edged rectangles of highly saturated color, stacked vertically, with the largest usually presented as the central focus and the other colors subtly balancing the dominant one, creating an atmosphere of weight and mystery. Rothko used a range of color, thinly painted and applied with great nuance, as in *White Band (No. 27)*, 1954 (fig. 111), giving his reductive compositions a vulnerable, even human, dimension, which is magnified by the blurred edges of his forms. The effect is theatrical, for Rothko was a master at creating a physical impact, and his evocation of infinity, or the sublime, is palpable.

Seeking an archetypal image in abstract terms, Newman reduced his compositional elements to a large field of uninflected color with a narrow vertical column (sometimes several) of another color interrupting it, as in *Onement I* (fig. 112) and *Onement II* (fig. 113), both 1948. By subsequently enlarging the scale of his paintings to epic proportions, he thought art could be made a vehicle of strong feeling,[39] exemplifying Motherwell's belief that American artists' passion for largeness of scale signifies a heroic impulse and a desire for the sublime. Unlike Rothko's, Newman's use of color, even when it creates a sense of vast, overwhelming space, still recalls works by Mondrian: a flat, dense, careful application, usually of primary hues. And, also unlike Rothko, Newman never gave up line as a basic component of his work, and said that drawing was crucial for him.[40] Indeed, the vertical "zip" that marks or delimits his fields of color, and which is the central element of his art, is a powerful expression of the drawn line, an emphatic and solitary gesture. Sometimes, though, he reduced it to nothing more than a narrow space between two adjacent rectangles, as in *Ulysses*, 1952 (fig. 116).

Still's mature paintings consist of great expanses of roughly textured,

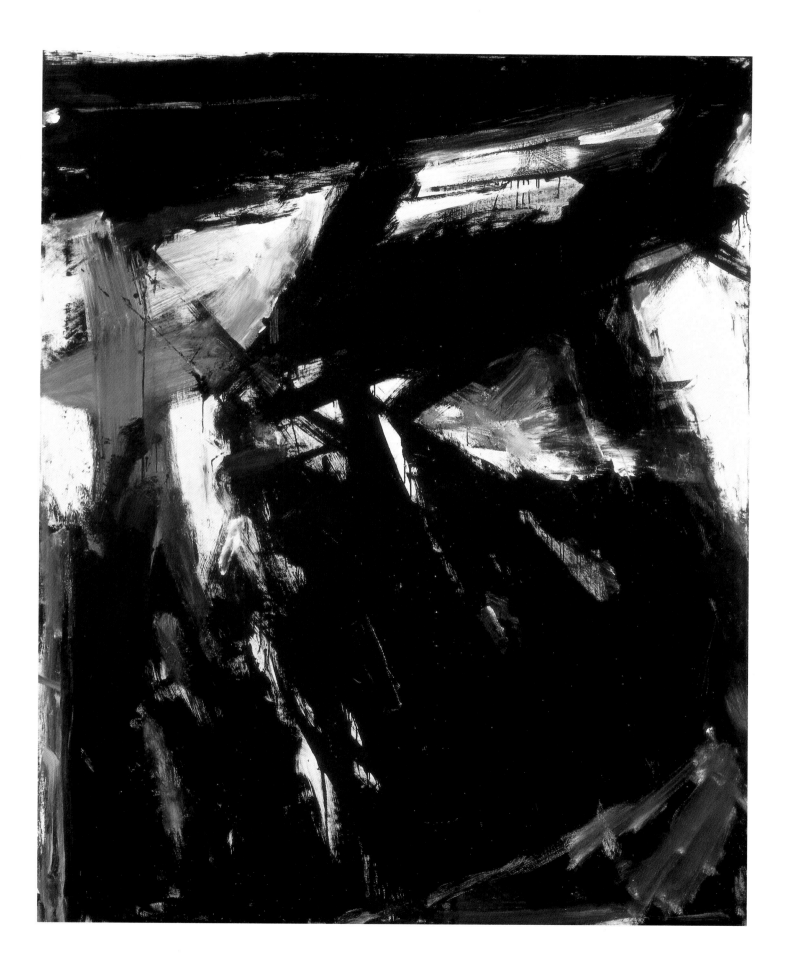

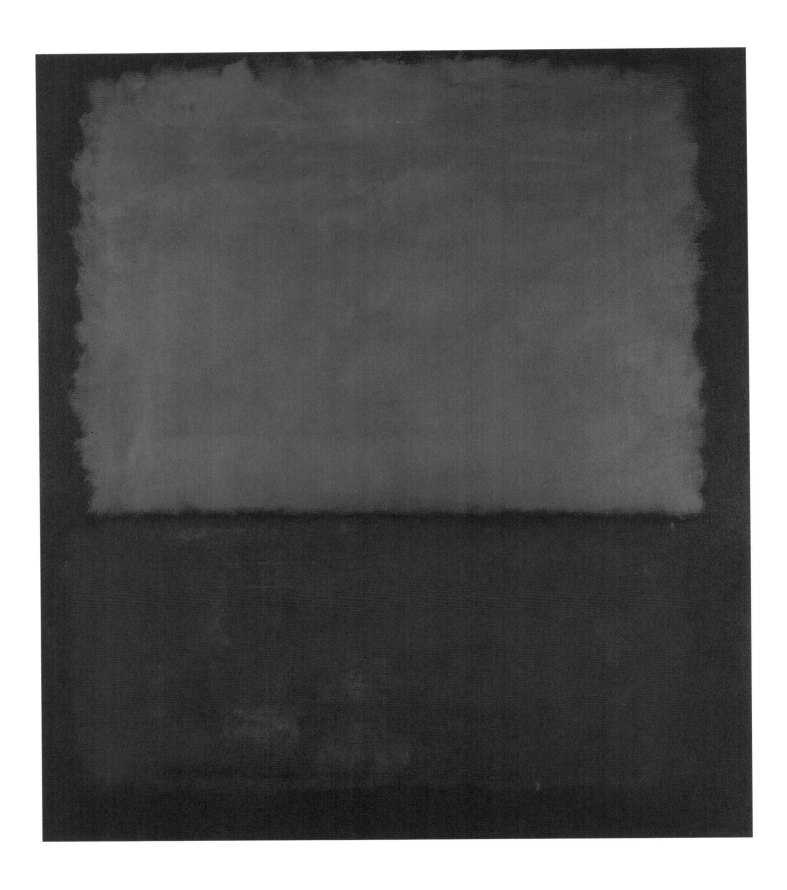

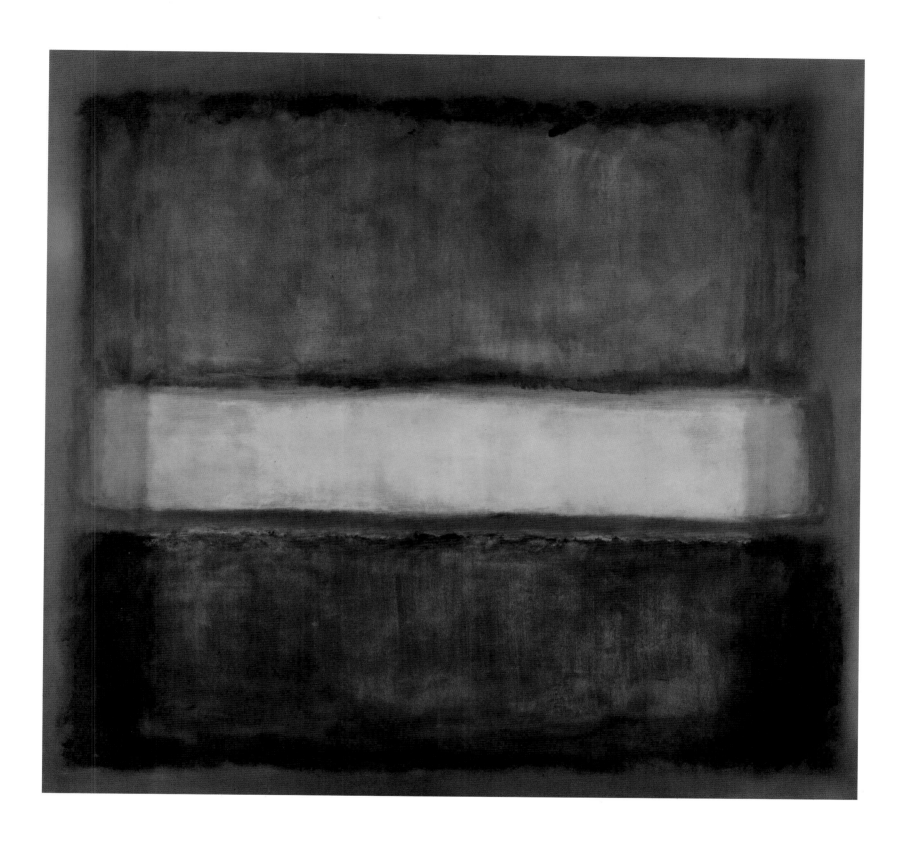

110. *Mark Rothko,* No. 207 (Red over
Dark Blue on Dark Grey)*, 1961. Oil on
canvas, 7 feet 8 ¼ inches x 6 feet 9 ⅛ inches
(2.36 x 2.06 m). University Art Museum
and Pacific Film Archive, University of
California at Berkeley.*

111. *Mark Rothko,* White Band (No. 27)*,
1954. Oil on canvas, 7 feet 2 ⅛ inches x
6 feet 9 inches (2.2 x 2.06 m). Private
collection.*

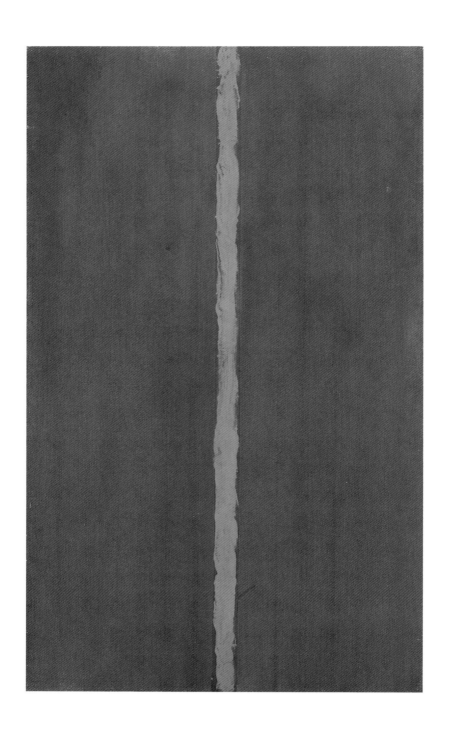

112. Barnett Newman, Onement I. *1948.*
Oil on masking tape and canvas, 27 ¼ x
16 ¼ inches (69.2 x 41.2 cm). The Museum
of Modern Art, New York, Gift of Annalee
Newman, 1992.

113. Barnett Newman. Onement II. *1948.*
Oil on canvas, 60 x 36 inches (152.4 x
91.4 cm). Wadsworth Atheneum, Hartford,
Connecticut, Gift of Mr. Tony Smith.

114. *Barnett Newman,* The Word II, *1954.*
Oil on canvas, 7 feet 6 ¼ inches x
5 feet 10 ¼ inches (2.29 x 1.78 m). Collection
of Ronnie and Samuel Heyman, New York.

115. *Barnett Newman,* The Name II, *1950.*
Magna and oil on canvas, 8 feet 8 inches x
7 feet 10 inches (2.64 x 2.39 m). National
Gallery of Art, Washington, D.C., Gift of
Annalee Newman, in Honor of the 50th
Anniversary of the National Gallery of
Art 1988.57.4.

following page:
116. *Barnett Newman,* Ulysses, *1952.*
Oil on canvas, 11 feet x 4 feet 2 inches
(3.35 x 1.27 m). The Menil Collection,
Houston.

thickly encrusted pigment of one color often violently interrupted by patches (or irregular streaks or jagged, mountainous forms) of one or two other colors, as in *1954*, 1954 (fig. 117), and *1957-D No. 1*, 1957 (fig. 118). These dramatic, sometimes nearly monochromatic works, like some by Newman and Rothko, are heroic evocations of space, but Still's motifs are more closely linked to elements of landscape.

In many ways, Abstract Expressionism represents the full flowering of abstraction. The abstract object gained a presence and force of reality through an enlargement of scale, and a poignancy through an emancipation of feeling. However, it is difficult not to see the Americans' aesthetics in the terms first given by Kandinsky. Like him, they expressed a degree of inner feeling and subjectivism through abstract forms, and their emphasis on the sublime effectively echoed Kandinsky's religious fervor. While the gestural painters' assertive, dynamic stance carried some of the overt romanticism of the early abstractionists, the approach of the Field painters is aptly characterized by Paul Klee's description of abstraction as "cool Romanticism."

Americans on Their Predecessors

By the 1940s, the impact of abstraction as epitomized by the AAA group began to change as Americans came into direct contact with the pioneering work of the early European abstractionists. Although the work of Kazimir Malevich remained almost unknown, the paintings of Kandinsky and Mondrian gained increased recognition around that time in New York. After Mondrian moved there in 1940, his exhibitions at the Sidney Janis Gallery and his strong influence on many members of the AAA made him a major force in American abstraction; his 1945 retrospective at the Museum of Modern Art, a year after his death, extended that influence and made his work more widely known. Kandinsky's art had become familiar in New York through the Museum of Non-Objective Painting, founded in 1939 by Solomon R. Guggenheim under the direction of his art advisor, Hilla Rebay. According to Dore Ashton, Gorky was a frequent visitor at that museum from the start and was especially affected by the works by Kandinsky he saw; and Pollock worked there briefly as a custodian.[41] A memorial exhibition of more than 200 of Kandinsky's works was organized there in 1945, and it had a major impact on New York artists.

Today, it seems obvious that Pollock's early pouring technique, as well as the contemporaneous drip paintings by Hofmann, were influenced by Kandinsky's freely painted lines. But among artists of the period, opinion was mixed on the art of that pioneer abstractionist. Motherwell once commented that no one except Gorky ever had a good word to say about Kandinsky, which of course was an exaggeration. Hofmann expressed great admiration for Kandinsky and for Mondrian (as well as for Klee and Miró),[42] and acknowledged a primary position for Kandinsky in the history of modern art.[43] Another admirer of Kandinsky was John Graham, a Russian-born artist who came to New York around 1920 and who knew and influenced many artists, including de Kooning, Gorky, Pollock, and David Smith. His book *System and Dialectics of Art* shows a deep knowledge and appreciation of Kandinsky's central ideas.[44] Smith, in a symposium at the Museum of Modern Art in 1952, acknowledged that his aesthetics were "influenced by Kandinsky, Mondrian, and Cubism."[45] Newman characterized Kandinsky's and Mondrian's ideas as seminal, and Miró and Mondrian as "the most original of the abstract European painters," but believed that his and his American colleagues' achievement was greater, as they had created "a truly

abstract world which can be discussed only in metaphysical terms."[46] He claimed that they, unlike the European painters, had given physical presence and reality to "abstract concepts" without any reference to the natural world,[47] thus surpassing the efforts of their aesthetic "fathers." Rothko found inspiration in the work of Surrealists such as Miró as well as that of the pioneers of early abstraction, and in 1945, two years before he began to articulate his mature style, he wrote, "I quarrel with surrealist and abstract art only as one quarrels with his father and mother; recognizing the inevitability and function of my roots, but insistent upon my dissension."[48]

The critics argued over the status and significance of the pioneers of abstraction. Greenberg complained that Kandinsky was too illusionistic in his approach,[49] while Harold Rosenberg, a well-known critic of the period who was unencumbered by Greenberg's formalist bias, recognized that abstraction contained something else besides its pictorial innovations. Rosenberg analyzed Mondrian's formalism, for example, as a rejection of "the tragedy of history" and, therefore, a sign of an advanced position in art.[50] Although Kandinsky's influence remained for the most part unacknowledged, it was often apparent in the language of the critics, as in James Johnson Sweeney's introductory essay for Pollock's first exhibition in 1943, where he wrote of the need for more artists to "paint from inner impulsion,"[51] recalling Kandinsky's exhortation to the artist to work from "inner necessity."

De Kooning acknowledged the importance of Kandinsky's art, but found his writing to be a "philosophical barricade."[52] Mondrian was a far more complicated issue for him, perhaps because both were Dutch. Although he described Mondrian as a "great merciless artist,"[53] and his painting as having "terrific tension,"[54] de Kooning could not identify with his hermetic and utopian nature.[55]

Motherwell was one of the few who seemed to be aware of the work of Malevich during this period. In 1944, he wrote that Malevich and Mondrian had made tremendously significant contributions to the history of modern art, but he also criticized their work for its formalist emphasis, which inhibited individual expression.[56]

The opinions of most Abstract Expressionists about the Bauhaus were completely negative. Both Rothko and de Kooning felt that its functional approach to design denied the human and spiritual dimension and eliminated the possibility of "high" art ideals in favor of a kind of "low" art aspiration. Hofmann also attacked the Bauhaus for its "confused" approach to fine and applied arts.[57] Newman despised anything "programmatic and doctrinaire,"[58] and was cynical about utopians.[59] Hence, he was caustic in his disapproval of the Bauhaus, describing its practitioners as designers of "screwdrivers, modernistic furniture, and bric-a-brac," for whom art was not an act of the "human spirit" but merely the means for the better manufacture of "automatic flapjack turners" and other such products.[60] Still was antagonistic toward the Bauhaus and its machine aesthetic, materialist outlook, and emphasis on architecture, and expressed his resentment against the former members of the Bauhaus who came to the United States and "dumped their authoritarian theology on our museums and educational institutions."[61] Belligerently asserting that the Bauhaus had "herded" earlier movements (presumably abstraction) "into a cool, universal Buchenwald,"[62] Still was perhaps the only member of the Abstract Expressionist group to express such extreme hatred of the German school and its followers.

The School of Paris retained enormous stature and significance in New York during this period, as indicated by Pollock's statement in 1944 that all of the important art of the past century had been produced in France.[63] Although Surrealism as a viable contemporary

117. *Clyfford Still, 1954, 1954. Oil on*
canvas, 9 feet 5 ½ inches x 13 feet (2.88 x
3.96 m). Albright-Knox Art Gallery,
Buffalo, Gift of Seymour H. Knox, 1957.

118. *Clyfford Still, 1957-D No. 1, 1957.*
Oil on canvas, 9 feet 5 ½ inches x
13 feet 3 inches (2.87 x 4.04 m).
Albright-Knox Art Gallery, Buffalo,
Gift of Seymour H. Knox, 1959.

alternative was generally in decline by the early 1950s, the Surrealists' practice of automatism was extraordinarily influential, popularized by Masson, Matta, and Miró. Automatism supplied the "creative principle" that artists were searching for,[64] because it was spontaneous, leading to art that originated in the subconscious and that represented states of feeling[65] (including a direct emotional response to the devastations of war[66]). Surrealism was a correction to abstraction's seemingly contentless approach, which Motherwell understood when he commented that the "strength of Arp, Masson, Miró, and Picasso lies in the great humanity of their formalism."[67] However, Motherwell also declared that "no Parisian is a sublime painter, nor a monumental one,"[68] although, of the painters he named, Miró probably came the closest and therefore exerted the greatest influence in the United States during the 1940s and early 1950s.[69] According to Ashton, even artists "such as de Kooning, who were never to embrace even the most abstract of surrealist notions, nevertheless showed their awareness of its impact in their work."[70] Motherwell reported that Greenberg hated Surrealism to such an extent that for a long time its influence on Pollock was underestimated.[71]

Newman acknowledged that, although the influence of Surrealism waned after World War II, it contributed to the revival of subject matter in American painting. But he criticized the dream worlds evoked by the Surrealists for being "mundane" and "never . . . transcendental," and attacked the Surrealist artists, with the exception of Miró, for failing to address the issue of plastic values.[72] He thus acknowledged the importance of Miró, but in 1947 singled out Miró's one weakness as remaining overly tied to the world of appearances.[73]

The historical breakthrough accomplished by Abstract Expressionism was its synthesis of a Surrealist concern for subject matter and abstraction's concern with a formal presence—Rothko's "father and mother." Still described such a synthesis being discussed in the 1940s, although it was the Bauhaus form of abstraction that was considered.[74] In 1944, Newman said that "compromise" might better express the relationship but a year later used the word "fusion" to describe the effect in Miró's art.[75] He also declared that American "art of the future will . . . be . . . abstract yet full of feeling,"[76] a characterization that properly acknowledges the absolute position of abstraction while indicating a desired modification of its course. It was in this context of rapprochement that Peggy Guggenheim donned each of her earrings.

On the Subject of Abstraction

The Abstract Expressionists, while not completely united in their thoughts on the general subject of abstraction, held some similar ideas and criticisms of it. Their chief complaint was that it is soulless. In 1945, Rothko repudiated the abstract artist's "denial of the anecdote," for he believed that art "is an anecdote of the spirit."[77] In 1951, Mark Tobey said, "We have tried to fit man into abstraction, but he does not fit."[78] The most vocal on this subject was de Kooning, who in 1951 described abstraction as the pastime of theoretical-minded types who purified form of its human dimension,[79] leaving out all the "drama, pain, anger, [and] love" that he was concerned with in his art. He felt that in their hands, abstraction did not allow for the uncertainty of life, while for him, "Nothing is positive about art."[80] This kind of dissociation of art from life had been noted by Motherwell in 1942 when he declared that the problem with Mondrian's art and abstraction in general was its lack of "contact with historical reality."[81]

Another severe reaction to abstraction concerned its apparently decorative purity. In this regard, the designation "geometric" was a particular curse for Newman,[82] who derided American abstractionists (undoubtedly the AAA geometricians) as "dull" and feared that an emphasis on geometry, purity, and form, such as had been practiced between the wars, would lead to empty formalism.[83] Rothko, too, felt that abstraction had become overly geometric, and he criticized any art or artistic process that might be dehumanized or that became chiefly concerned with design.[84] Years later, Philip Guston summarized the matter: "There is something ridiculous and miserly in the myth we inherit from abstract art. That painting is autonomous, pure and for itself, and therefore we habitually analyze its ingredients and define its limits. But painting *is* 'impure.' It is the adjustment of 'impurities' which forces painting's continuity."[85] For the young Americans, an art-for-art's-sake position was sterile and inappropriate; abstraction needed to evoke the powerful forces of life, of reality. "Art never seems to make me peaceful or pure,"[86] declared de Kooning, who believed that style is "a fraud," and that an artist fills space "with an attitude"[87]—an attitude of restless searching and spiritual independence, which gives an otherwise pure style its human dimension.

There were some in this new generation of abstractionists, however, who strove for purity in their work and shunned expression of any kind. Reinhardt, who as a member of AAA in the late 1930s and 1940s had worked in an energetically complex mode related to geometric abstraction, stripped it down by the early 1950s to ascetic cruciform arrangements of squares of similar colors, as in his *Abstract Painting*, 1960–66 (fig. 130), concentrating on what he described as "pure form, pure color, and pure monochrome."[88] He rejected "Expressionism" as early as 1957 and again later distanced himself from all "expressionist" labels.[89] Philip Pavia recalled that there had been a great struggle over the term "abstract expressionism" in 1952, when for about six months one was either an abstractionist or an expressionist, but not both.[90]

As a defining stylistic hallmark, though, "abstraction" had become an imprecise, general term, and remained in flux.[91] In 1951, de Kooning grudgingly allowed that "if I *do* paint abstract art, that's what abstract art means to me."[92] "Abstraction" was usually thought of by the Americans more as a language or style than as a movement, but one that they had made their own. There are numerous, increasingly positive expressions of this in their writings, such as David Smith's declaration in 1940 that abstraction "is the language of our time," Newman's in 1944 that abstraction "is the art of the future," and Gottlieb's in 1956 that "we are going to have perhaps a thousand years of non-representational art."[93] In 1959, Reinhardt made the point that abstraction was about fifty years old and had come to characterize the century. Rather than being a "'moment' or 'school' or 'ism' . . . it was a new idea or beginning, with limitless possibilities."[94]

Like Smith, Newman recognized abstraction as the "language"[95] or "style" of the times[96] and placed it at the forefront of future art. Perhaps distinguishing himself from his AAA contemporaries, Newman described "a difference between a purist art form and an art form used purely."[97] He wanted a "confrontation with abstraction,"[98] in order to create a "new type of abstract thought."[99] That is, he treated abstraction as a worthy tradition, stale but not debased, and saw himself as contributing to its future.

Although the paintings of Gorky are almost never completely abstract, he was a champion of the style and a great influence on his younger colleagues. Unlike the other major European immigrant artists, such as de Kooning and Rothko, Gorky had immersed himself in the ideas of the pioneer abstractionists. In 1947, he analyzed abstraction as having the potential to disclose views of infinite inner

realms, and said that "abstraction is . . . the probing vehicle, the progressive thrust toward higher civilization, . . . the emancipation of the mind." He even declared that abstract art "is at the root of all creativity."[100] Thus, for Gorky, abstraction was more than just a style—it was a process that led to the sublime.

Similarly transcendent notions seem to underlie the views of several of the Abstract Expressionists toward abstraction. Newman contrasted illusionistic art and its "overload of pseudo-scientific truths"[101] to the metaphysical truths[102] and pure expressions of feeling[103] in abstraction. By noting that his paintings have no beginning or end,[104] Pollock emphasized their evocation of eternity. This desire for a transcendent realm can also be found in the thinking of Still, for whom the sublime had been "a paramount consideration from my earliest student days,"[105] and Rothko, who declared that he sought "transcendental experiences," "miracles," and "revelation" in art.[106] Although Motherwell professed a dislike for the word "mysticism," he acknowledged it to be the true content of abstraction.[107] All of these artists wanted their paintings to embody otherwise unviewable phenomena, and used abstraction as the means toward that end. Newman described "the new painter" making use of metaphysical models,[108] as if his or her goal was to create on the canvas a world apart from the material reality of ordinary existence.[109] However, Reinhardt was an exception in this respect too, for even though his art resembles the others in some ways, he hardly ever referred to such transcendence in his statements and writings. Rather, he sought purity, as an antithesis to the apparent dissoluteness of daily life.[110] Among the Abstract Expressionists, the Field painters—the creators not of dynamically gestural paintings but of those consisting of vast planes saturated with color—were most intrigued by a Romantic vision of the Sublime, whereas most of the gestural painters explored a more "impure" realm. In discussions of their art, it was Newman who most often invoked images of a sublime realm driving his aesthetic thinking and, comparing his work to earlier examples of abstraction, suggested that his project was the most "exalted" of all.[111]

Most of the Abstract Expressionists made emotion the cornerstone of their art and believed that abstraction, despite their fears of its sterility,[112] held the key to the expression of raw feelings and even self-discovery.[113] Newman acknowledged the desire for self-exploration as the paramount subject of art, declaring that "the self, terrible and constant, is for me the subject matter of painting and sculpture."[114] Hofmann stated the matter in psychoanalytic terms, insisting that abstract art "means . . . to discover myself,"[115] and Pollock, too, maintained that "most modern painters work . . . from within."[116] Self-examination had, in part, replaced utopian ideals, as if the only viable subject for the artist in an apparently bankrupt society was the self. Although de Kooning only rarely mentioned emotion, his approach was dominated by life experiences and sensations, which are clearly reflected in his paintings and which he once characterized as "the melodrama of vulgarity"; indeed, the character of his abstract work epitomizes the expression of feeling.[117]

Motherwell asserted that the "emergence of abstract art is a sign that there are still men able to assert feeling in the world . . . no matter how irrational or absurd."[118] Emotion, being messy, romantic, and even "vulgar" (to use de Kooning's word), injected a new attitude into the ostensibly "empty" vessel of abstract art. The artists asserted that their works, rather than being anecdotal renderings of emotions, were the feelings themselves, real and present in the same space occupied by the viewer. In this regard, Pollock carefully explained that his art was not about the narration of feelings but was the

expression of them;[119] thus, his description of being "in" his painting[120] might be understood as evoking a state of high emotional excitement. Rothko, explaining why he made large paintings (for example, fig. 124), also described the sensation of being "in" the painting, and ascribed it to his desire "to be very intimate and human. To paint a small picture is to place yourself outside your experience, to look upon an experience . . . with a reducing glass. . . . However you paint the larger picture, you are in it."[121]

Rothko fervently wished his art to evoke the human condition, and even declared, "The only thing I care about is the expression of man's basic emotions: tragedy, ecstasy, doom."[122] These extremes of feeling are reflected in his colors, from the sunny yellows and oranges of many works from the 1950s to the somber blacks, browns, and grays that predominated in his last years, as in *Untitled (Black on Grey)*, 1970 (fig. 125). Kline and Hofmann talked about emotion as essential to their work, but did not describe it in any detail.[123]

Newman proclaimed the importance of feeling in his art repeatedly throughout his career,[124] and, as befitting the true abstractionist, acknowledged an admiration for music's pure expressiveness.[125] He was not interested, however, in ordinary feelings but in universal truths that he could summon from within the depths of his being. In the mid-1940s, he wrote, "The present painter [i.e., himself] is concerned not with his own feelings or with the mystery of his own personality" but instead was "attempting to dig into metaphysical secrets" in order to "catch the basic truth of life."[126] He spoke of emotions in art as being "absolute" and regarded each of his paintings as embodying a "specific and separate" emotion.[127] His description of creating "cathedrals" of feeling[128] recalls the aspirations of Malevich.

These artists' dedication to emotional freedom was rooted in the existential notion of living freely and actively in the present,[129] in accord with what Henri Bergson called the primacy of one's instincts. Early on, Gottlieb, Newman, and Rothko made use of the term "risk" to describe and perhaps dramatize their enterprise: "To us art is an adventure into an unknown world, which can be explored only by those willing to take risks."[130] Here, they were echoing an idea that André Breton had introduced five years earlier when he wrote, in an essay about Masson, "The taste for risk is undeniably the principal mechanism capable of carrying man forward to an unknown way."[131] In Newman's case, the celebration of this quality is extreme: "Risk is the high road to glory; of course, I hate the idea of glory, but . . ."[132] The notion of freedom discussed here—a state of being unconstrained by societal strictures—underscores that the project of abstraction continued to be idealist, if no longer utopian. Rothko stressed his aesthetic independence, explaining that the shapes in his paintings have "a passion for self-assertion" and attain an "internal freedom" that does not "conform with or . . . violate what is probable in the familiar world."[133] Still spoke of his commitment to the "unqualified act"[134] and of his desire for the "liberation of the spirit,"[135] but suggested a social aspect to all this, calling his work "a critique of values."[136] He used the word "emancipation" to describe the result of his endeavor,[137] but added a cautionary and even pedagogical note when he spoke of "the disciplines of freedom,"[138] a concept akin to the spontaneous yet disciplined expression in jazz improvisation.

Describing the emancipating possibilities of modern art, de Kooning said "I get freer."[139] Pollock, although he never specifically commented on this subject, offered the most absolute declaration when he said "I am nature,"[140] thus suggesting that spontaneous freedom is amoral and apolitical. Being completely detached from a program of requirements, abstract art was for these artists the ultimate—but not the only—

119. *Jackson Pollock,* Ocean Greyness,
1953. Oil on canvas, 4 feet 9 ¼ inches x
7 feet 6 ⅛ inches (1.47 x 2.29 m). Solomon
R. Guggenheim Museum, New York
54.1408.

120. *Jackson Pollock,* Number 3, *1950.*
Oil, enamel, and aluminum paint on
Masonite, 4 x 8 feet (1.22 x 2.44 m).
Private collection.

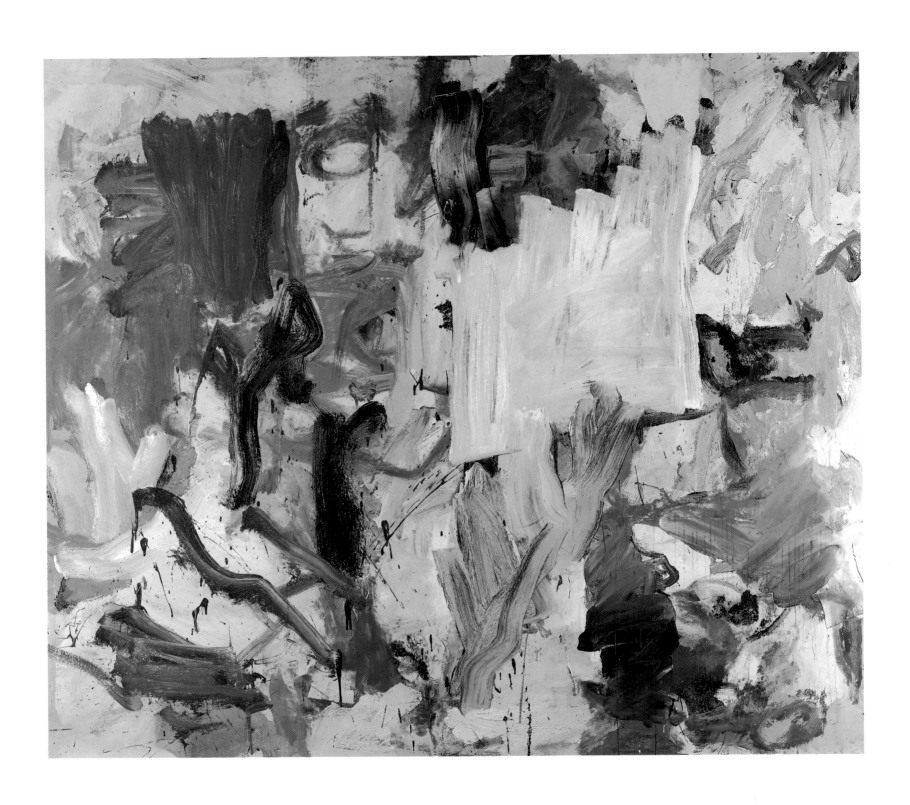

121. *Willem de Kooning,* Untitled,
1977. Oil on canvas, 6 feet 5 inches x
7 feet 4 inches (1.96 x 2.24 m). Collection of
Lyn and George Ross.

122. *Willem de Kooning,* Untitled I,
1977. Oil on canvas, 6 feet 5 inches x
7 feet 4 inches (1.96 x 2.24 m). Collection of
Adriana and Robert Mnuchin.

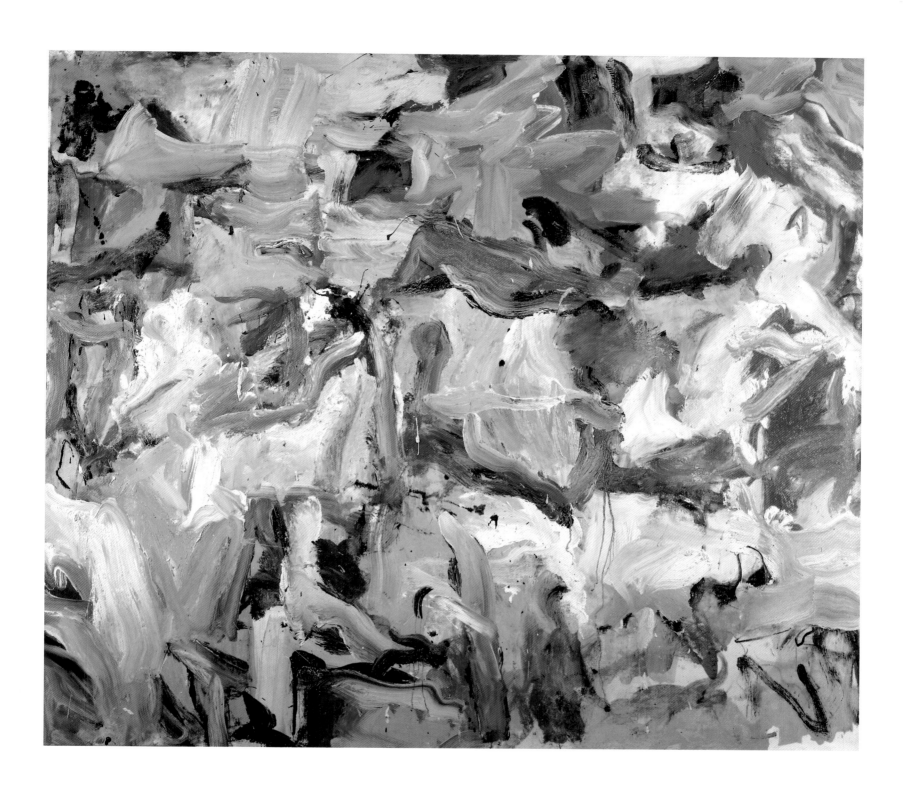

vehicle by which freedom of expression might be achieved. Because this freedom informed the process of making abstract art and the language of abstraction itself, they believed that it was evoked both by analogy and by actual fact.

In the American milieu, the idea of emotional freedom was linked to political freedom. "Art is born of freedom and liberty, and dies of constraint," wrote David Smith in an essay around 1940, in which he decried fascism's curtailment of artistic freedom, not only abroad but in America, where "outright fascists" and "political and cultural reactionaries" had threatened artists' ability to freely express emotions and ideas.[141] Artists had to fight against these tendencies by actively exploring the freedom offered by abstraction, which Smith saw as the true revolutionary art, and he believed that "the great majority of abstract artists are anti-fascist and socially conscious."[142] Newman declared that "if my work were properly understood, it would be the end of state capitalism and totalitarianism." According to him, his paintings offered a vision of an "open society . . . not of a closed institutional world."[143]

But society in the 1940s and 1950s did not appear open and welcoming to the Abstract Expressionists and other artists, who saw themselves cast in the roles of outsiders and social outcasts. Wilhelm Worringer's notion that abstract art arises out of the transcendental urge brought on by anxiety over the arbitrary conditions of life appears to apply to the Abstract Expressionists, given their feeling of alienation from modern life and their search for the sublime. Motherwell said that abstraction is meant to be used to "close the void" felt by the artist toward the modern world,[144] and described Kline as "a born abstract painter, since he could not . . . endure the tensions of modern life."[145] In 1949, writing to Rothko on the subject of their relationship to the public, Still lamented: "We are alone,"[146] echoing a similar complaint made earlier by Klee. Elsewhere, he typically justified this alienation as a moral position, declaring that society was a "sordid" place.[147] Both Reinhardt and Rothko used a similarly moral tone in complaints about the ethical deficiencies of their fellow citizens. Indeed, Rothko complained that the "people" were a cruel, "vulgar," and "impotent" lot altogether.[148] He acknowledged the discouraging response of contemporary audiences toward his work (an indifference that all the Abstract Expressionists experienced early in their careers), and described a clandestine existence for the abstract artist, whose activity essentially consists of destroying the "familiar identity of things."[149]

Gottlieb, too, linked abstraction to a position of being "at war with society." Like Rothko, there is a stridency and ill will in his words; he asserted that abstraction declares to the public: "You're stupid. We despise you. We don't *want* you to like us—or our art."[150] Earlier abstractionists had shown at least some desire to connect with society, but the American group seemed to embrace their position as outcasts, having seen that abstract art had failed anyway to attract an audience.

Did the bohemian—or Beat—pose accurately reflect the Abstract Expressionists' economic situation? Whether they attained financial success is a matter of contention among scholars. Lawrence Alloway reported that there was little such success (and that Serge Guilbaut's claim of the group supporting a conservative political agenda is false).[151] Analyzing the sale of works by the Abstract Expressionists during the early 1950s, Ashton wrote that "a few of the New York School painters were escaping from the egalitarian condition of poverty" and becoming "relatively 'successful,'" but there were still exhibitions where no works sold.[152] A recent essay by one art historian, however, supports the view that the apparently bohemian pose of the

group was a sham.[153] Motherwell, in a typically conflicted theoretical discussion of this issue, linked the striving for freedom on the part of his colleagues to the path of the working class, as if in revolutionary solidarity; but in the same essay, he declared that "as a conscious entity the working class does not exist." He finally concluded, regretfully, that the artist seeks to "transcend the social," and that artistic freedom is an individual rather than a collective matter.[154] It would appear that the absence of a public for abstract art inevitably separated its creators from the population at large.[155] Pining for an audience turned into an attack, which in no way would have been ameliorated by even a degree of financial success. Rothko, however, tried to make use of the public's "hostility . . . as a lever for true liberation."[156]

Paradoxically, while the Abstract Expressionists were intent on reversing what they saw as the pattern of arid abstraction that was their inheritance from the interwar generation, their formalist admirers failed to acknowledge that situation. The artists would never agree with Greenberg, the most influential of the critics, that their art was independent of context or meaningful intentions. To focus only on the objecthood of the work of art would appear too close to the abstraction of the 1930s, which they despised. The formalist thinker conceived art to be an analytical process, but the Abstract Expressionists were dreamers. They wanted to instill in their works something spiritually rich, vast, moral, important, and compelling. Unlike any formalist, Newman admired the art of the Northwest Coast Kwakiutl tribe for succeeding in making a shape "a living thing, a vehicle for an abstract thought-complex, a carrier of the awesome feelings [the artist] felt before the terror of the unknowable."[157] He announced a desire "to paint the impossible . . . the greatest painting that has ever been made,"[158] and, similarly, Reinhardt imagined making "the last painting anyone can paint."[159] These claims appear to be a deliberate corrective to Aleksandr Rodchenko's *The Last Painting*, 1921 (fig. 72), which he had intended to be the ultimate statement about painting and abstraction; the Americans wanted to resurrect the fields of art that Rodchenko believed had no future.

Americans on Subject Matter

The Abstract Expressionists rejected the formalist notion that abstraction is meaningless and proclaimed that their abstract art has subject matter.[160] This was a way not only to answer questions regarding the worth of that art but to potentially gain an audience. It was also a means by which they could take the middle road in the debate between abstraction and representation, maintaining an abstract style while also communicating something. They were grappling with the same issue as the pioneer abstractionists, who also wanted their art to be about something beyond formal essences. However, the question of what constituted subject matter remained a thorny problem for them.

The American artists referred to this problem often during the 1940s, at a time when their work was primarily influenced by Surrealism and was based on primitive and archaic myths. In turning to this kind of material, they were rejecting traditional anecdotal subjects founded on conventional values in favor of universal themes that gave authentic expression to man's basic emotions. In particular, totemic imagery from tribal cultures and prehistory abounded in their work at this time.[161]

Announcing their aesthetic beliefs on the pages of *The New York Times* in 1943, Gottlieb, Newman, and Rothko wrote, "We assert that the subject is crucial."[162] Speaking about Pollock in 1944, Motherwell said, "His principal problem is to discover what his true *subject* is."[163]

William Baziotes asserted in 1945 that, while he was painting, "there is always a subject that is uppermost in my mind,"[164] and Gorky wrote in 1947, "What to paint is as important as how to paint. Great art contains great topics."[165] Newman declared in 1945 that earlier abstraction had destroyed subject matter, and that the job of artists in his time and in the future was to discover a "new subject matter,"[166] one that would express all kinds of feeling with abstract means.[167] Reinhardt, who insisted that his art was "meaningless,"[168] was nearly alone among his colleagues on this issue. When Baziotes, David Hare, Motherwell, Rothko, and Still started a school in 1948, they gave it the unwieldy but specific, programmatic name "The Subjects of the Artist," indicating the importance of subject matter in their art.[169]

Starting in the late 1940s, the work of most New York School artists began to change in outward appearance, from the recognizably totemic images that they had been making to a more purely abstract art. When this occurred, a new explanation of subject matter was called for. In 1952, Rosenberg, a friend of these artists, described the new work that they were doing as the record of the process of its creation, and referred to the canvas as "an arena in which to act— rather than as a space in which to reproduce, re-design, analyze or 'express' an object, actual or imagined. What was to go on a canvas was not a picture but an event."[170] Dubbing such work "Action Painting," Rosenberg evoked the personal liberation and expression of self that are emphasized in early abstractionist theories and conveyed by Kandinsky's brushstrokes. But Rosenberg was claiming that for these artists the canvas was a site for glorious spectacle, on which an Act would occur, not merely an expression of feeling. "Such is not 'pure art,'" he declared, as if to say that earlier abstraction had failed. Indeed, "the new painting has broken every distinction between art and life."[171] It was another assertion that the highest forms of abstraction are not simply formalist but are engaged with reality. Rosenberg further explained that the Action painters undertook the "creation of private myths."[172] Rather than dealing with universal totemic imagery, each artist formulated his or her own iconic myth in terms of an individual abstract style. In the work of these artists, Rosenberg implied, subject matter had become folded into the very appearance of the abstract style that each artist chose to develop.[173]

Newman was probably the most articulate among the New York artists in discussing the "new subject matter." In 1947, his notion of "the ultimate subject matter of art" was "the defense of human dignity," but during the 1950s it shifted inward and by 1965 he expressed it as the exploration of "the self, terrible and constant."[174] He wrote admiringly of certain literary works in which there was a return to "epic" and "moral" themes. Although he warned that such topics had become "stylized" at times,[175] he aimed to communicate a subject that he variously termed "sublime," "transcendental," "religious," and "world-mystery."[176] He and his colleagues Gottlieb and Rothko asserted in their 1943 letter to the *Times* that "only that subject matter is valid which is tragic and timeless."[177] Whereas Kandinsky and Mondrian sought to avoid tragedy in their art, the bleak postwar mood and a concern with tragedy were among the most deeply felt and often-expressed subjects of the Abstract Expressionists.

While it might be argued that, in contrast to artists who pursued socially relevant themes in their work, the Abstract Expressionists were frightened of politically controversial subject matter and avoided it, they (and the critics who supported them) claimed that their tragic subject matter was proof of political engagement. They believed that they could communicate the ideas of absolute freedom

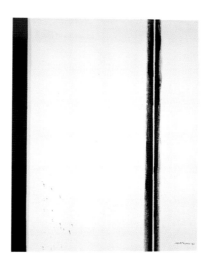

123. Barnett Newman, Fourth Station, *1960. Oil on canvas, 6 feet 6 inches x 5 feet ¼ inch (1.98 x 1.53 m). National Gallery of Art, Washington, D.C., Robert and Jane Meyerhoff Collection 1986.65.4.*

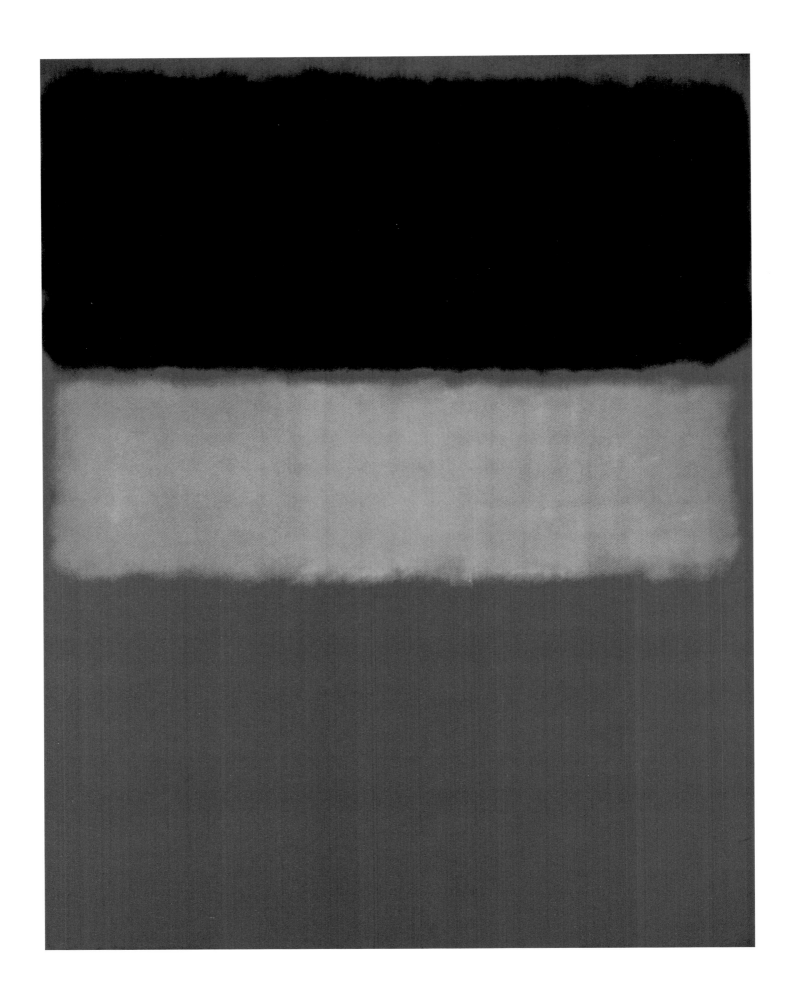

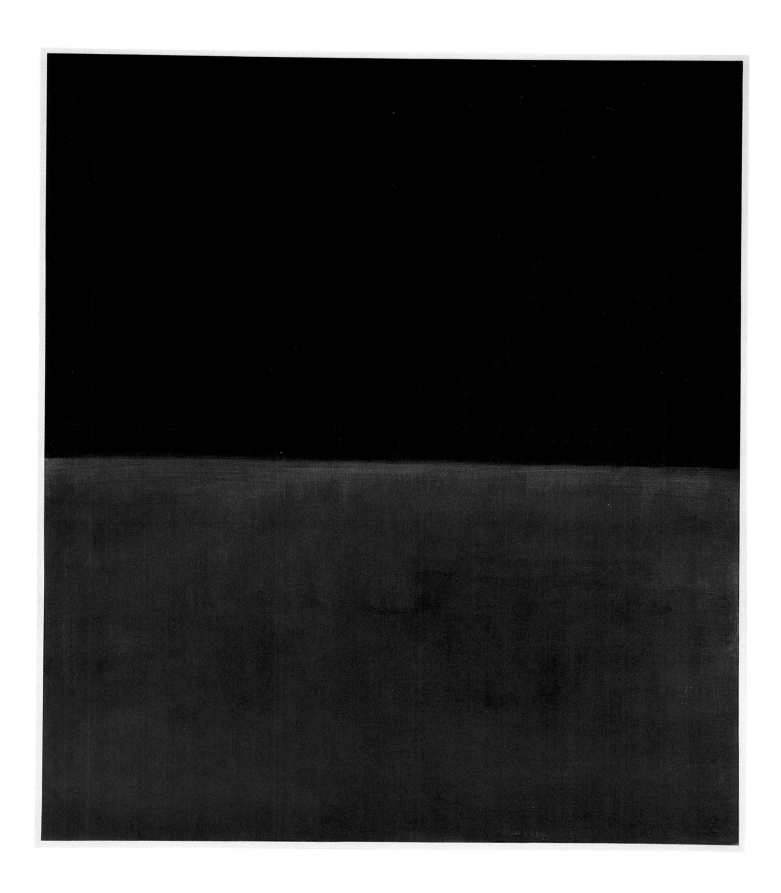

124. *Mark Rothko*, Black, Ochre,
Red over Red, *1957. Oil on canvas,*
8 feet 4 inches x 6 feet 10 ¼ inches (2.54 x
2.09 m). The Museum of Contemporary
Art, Los Angeles, The Panza Collection.

125. *Mark Rothko*, Untitled (Black
on Grey), *1970. Acrylic on canvas,*
6 feet 8 ⅛ inches x 5 feet 9 ⅛ inches (2.04 x
1.76 m). Solomon R. Guggenheim Museum,
New York, Gift, The Mark Rothko
Foundation, Inc. 86.3422.

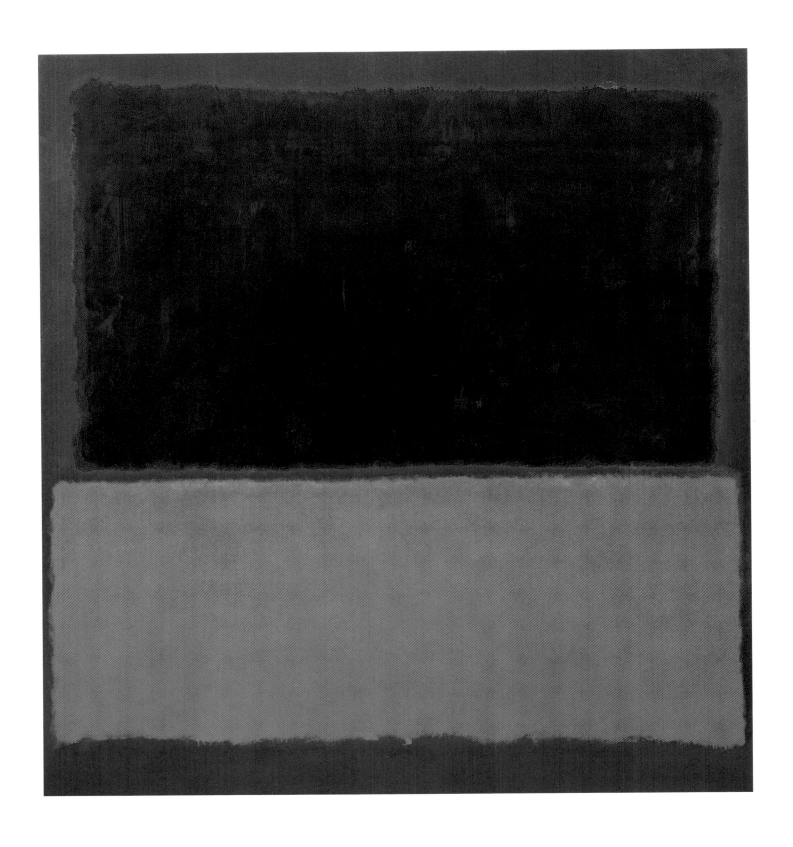

126. *Mark Rothko,* Blue over Orange,
*1956. Oil on canvas, 7 feet 2 inches x
6 feet 7 inches (2.18 x 2 m). Collection of
Ambassador and Mrs. Donald Blinken.*

127. *Barnett Newman,* Achilles, *1952.
Oil on canvas, 7 feet 11 ½ inches x
6 feet 7 ⅛ inches x 2 ¼ inches (2.42 x
2.01 x .06 m). National Gallery of Art,
Washington, D.C., Gift of Annalee
Newman, in Honor of the 50th
Anniversary of the National Gallery
of Art 1988.57.5.*

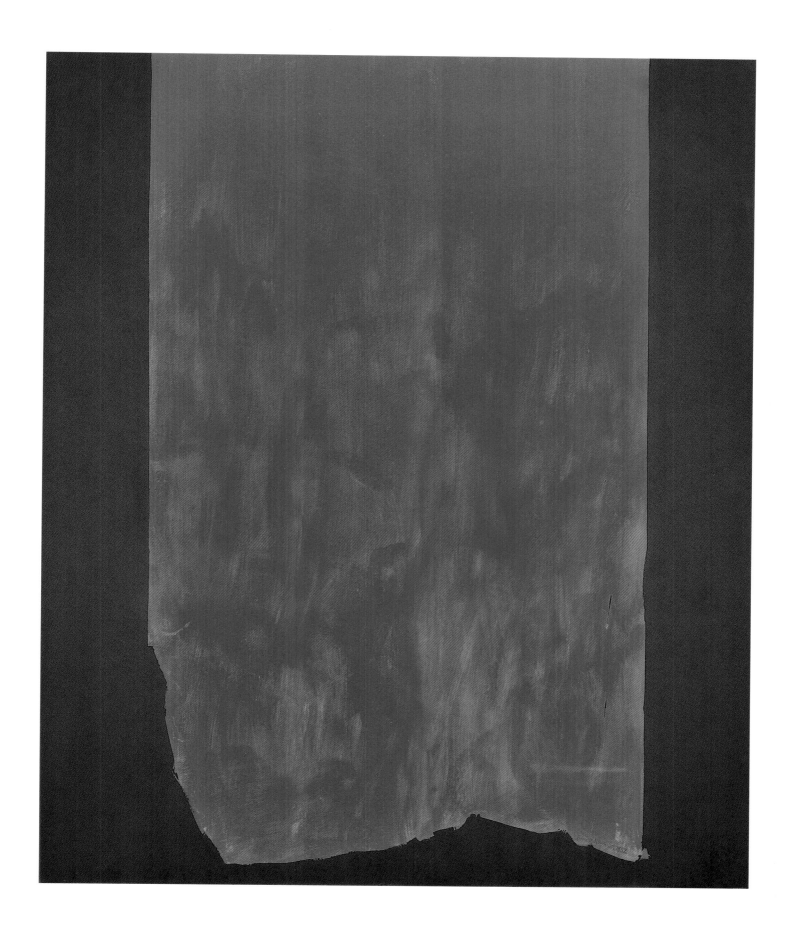

128. Nicolas de Staël, The Red Sky,
1952. Oil on canvas, 51 ½ x 64 ⅛ inches
(130. 8 x 162.9 cm). Walker Art Center,
Minneapolis, Gift of the T. B. Walker
Foundation, 1954.

129. Jean-Paul Riopelle, Painting, 1955.
Oil on canvas, 45 ⅜ x 28 ⁹/₁₆ inches (115.2 x
72.5 cm). Peggy Guggenheim Collection,
Venice 76.2553 PG187.

and moral commitment through their deep involvement in their art practice and the values represented by that activity.

During and after the 1950s, the same rhetoric regarding subject matter continued, but with greater specificity. Newman, describing the white line in *Fourth Station,* 1960 (fig. 123), from his series *Stations of the Cross*, called it an "abstract cry."[178] Sam Francis, a West Coast Abstract Expressionist (see fig. 131), also made reference to a religious context when he described his art as being a vehicle for contact with "the Holy Ghost."[179] Rothko believed that his paintings are expressions of religious feeling, declaring that "the people who weep before my pictures are having the same religious experience I had when I painted them";[180] and he addressed this belief directly in the series of paintings that he began in 1964 as a commission for a chapel at the Institute of Religion and Human Development at Rice University in Houston (and which were installed there posthumously in 1971). Around 1955, Reinhardt, having earlier separated himself from his New York colleagues by asserting the apparent meaninglessness of his art, described his work as evoking "spirituality . . . absoluteness . . . transcendence,"[181] thus implying a religious meaning in his use of a cruciform pattern in his black-on-black paintings.

Postwar European Abstraction

By the late 1940s, abstraction had become the lingua franca of European art, and in the 1950s and 1960s it became dominant. Kandinsky and Mondrian had both died in 1944, and in the following decade other modern masters—Arp, Georges Braque, Léger, Henri Matisse, Miró, Pablo Picasso—were in, or approaching, the period of their late styles. Of all the established art movements, only Surrealism maintained a sizable following, but many artists during the postwar period were exploring various modes of abstraction. In many ways the theories and practices of European artists at this time echoed recent developments in the United States. Hans Hartung, a German-French gestural painter, wrote in 1947 that "the painting called 'abstract' is not an 'ism' . . . nor a style, nor a 'period,' but an entirely new means of expression, another human language."[182] Proponents debated "lyrical versus concrete (systemic) abstraction,"[183] also called *abstraction chaud* (hot) and *abstraction froid* (cold). Although each camp had its adherents, a majority of European abstractionists during the late 1940s and 1950s seemed to favor the lyrical mode, including Nicolas de Staël (see fig. 128), Hartung, Serge Poliakoff, and Emil Schumacher. In general, they took an expressive, unstructured approach based on improvisation and rooted in earlier European practices, including the color application of the Fauves, the spatial and linear freedom of Kandinsky, and the spontaneous, graphic quality of the Surrealists, especially Miró and Matta.[184]

To describe this often gestural kind of painting, French critic Michel Tapié began using the term "Art Informel" (literally, "art without form") in 1950, and two years later, "Art Autre" ("art of another kind"). These terms refer to the work of, among others, French artists Jean Dubuffet, Jean Fautrier, Georges Mathieu (originator of the phrase "lyrical abstraction"), Henri Michaux, and Jean Riopelle; the Catalan Antoni Tàpies; and two German artists who had moved to Paris, Hartung and Wols [Wolgang Schulze]. In 1954, another French critic, Charles Estienne, introduced the term "Tachisme" to describe a style of painting that is similarly spontaneous and expressive, but characterized by signs or gestures in the form of blots or patches of color (*taches,* in French) rather than the more calligraphic lines of much Art Informel. However, the terms are often used interchangeably. Some artists, such as Mathieu and Riopelle, worked during this period

130. *Ad Reinhardt*, Abstract Painting,
*1960–66. Oil on canvas, 60 x 60 inches
(152.4 x 152.4 cm). Solomon R.
Guggenheim Museum, New York, By
exchange 93.4238.*

131. Sam Francis, Abstraction, *1954. Oil
on canvas, 6 feet 6 inches x 6 feet 1 ⅛ inches
(1.98 x 1.86 m). The Montreal Museum of
Fine Arts, Gift of Mr. and Mrs. Maurice
Corbeil and Gilles Corbeil.*

in a gestural idiom that paralleled the gestural Abstract Expressionists in the United States, including a version of the drip technique (see fig. 129). Others, such as Dubuffet and Fautrier, combined figurative and abstract elements to achieve a personal vocabulary of primitive images or ideographs emerging from heavily painted surfaces. In the late 1950s, Dubuffet often experimented with a completely abstract style in works consisting of accretions of unusual materials such as aluminum, sand, and pebbles, such as *The Substance of Stars*, 1959 (fig. 142). Rejecting traditional formalist values, these European artists shared a Surrealist-inspired reliance on unconscious invention to express the artist's inner world.

A closely related current during this period was the work of the CoBrA group, founded in 1948 in Paris—but with headquarters in Brussels—by Danish painter Asger Jorn and several associates from Belgium (including Cornelis van Beverloo, known as Corneille) and the Netherlands (Karel Appel and Constant Nieuwenhuis, known as Constant); the name CoBrA is an acronym of the initial letters of the capital cities Copenhagen, Brussels, and Amsterdam. The group was dedicated to experimentation and the free expression of the unconscious, and fiercely opposed what they regarded as tired traditions, including French academicism, geometric abstraction, and Surrealism. Jorn disdained theory and dogma to such an extent that he characterized the art that he and his fellow CoBrA members created as "an abstract art which does not believe in abstraction."[185] Indeed, they freely mixed figurative and abstract elements, like some of the practitioners of Art Informel, with a similar emphasis on primitive and archaic imagery but a more savage expressiveness, as in Jorn's *Untitled*, 1961 (fig. 132). They also incorporated unconscious gesture as an essential element of their art, like the Abstract Expressionists, but never worked on the large scale that the Americans did. In fact, most European abstractionists of this period made relatively small works.

The best-known practitioners of concrete abstraction or *abstraction froid*—the names given during this period to a geometric style based on a systematic, often mathematical approach—were Swiss artists Max Bill, Karl Gerstner, and Richard Lohse, but the category became broad enough to include much other nonobjective art, such as French artist François Morellet's work from the 1950s. The latter's often witty paintings explore quasi-scientific notions about a work's method of construction and surface properties. Some of them anticipate later American developments, including several pinstripe paintings of the early 1950s and a double-concentric pattern of 1956 (*From Yellow to Violet*, fig. 133) that foreshadow Frank Stella; grid works of 1958 that predate Stella and Agnes Martin; compositions of colored parallel lines that precede Gene Davis; and dot-and-dash compositions of 1960 that prefigure early works by Robert Irwin.

Certain southern Europeans—Alberto Burri and Lucio Fontana in Italy and Tàpies in Spain—broke with their abstractionist colleagues elsewhere in Europe by physically violating the surface of the canvas. Fontana first punctured a pattern of holes in the canvas of a monochrome painting in 1949, in one of his *Spatial Concept* series (fig. 141; see also Chronology), and made variations on this theme over several years; starting in 1958, he extended the idea further by slashing his painted canvases from one to more than two dozen times. Instead of maintaining the illusory space of traditional easel painting, Fontana rejected the notion of the canvas as merely the support for a picture, forcing the viewer to confront real space and consider the punctured canvas as the image. This concept was at the heart of his theory of *Spazialismo* (Spatialism), which focused on the material and metaphysical properties of space.[186] He had faith in a materialist,

132. Asger Jorn, Untitled, 1961. Oil on canvas, 38 ¼ x 51 ½ inches (98.5 x 130.8 cm). Albright-Knox Art Gallery, Buffalo, Gift of Seymour H. Knox, 1962.

*133. François Morellet, From Yellow
to Violet, 1956. Oil on canvas,
3 feet 7 ⁷⁄₁₆ inches x 7 feet 2 ⅛ inches
(1.1 x 2.2 m). Musée National d'Art
Moderne, Centre Georges Pompidou, Paris.*

*134. Piero Manzoni, Achrome, 1959.
Kaolin on canvas, 19 ⅝ x 25 ⅝ inches
(49.8 x 65.1 cm). Courtesy of Hirschl &
Adler Modern.*

utopian vision,[187] and hoped through the use of the world's newest
technologies, even television, to achieve a work of art that effectively
leapt beyond objecthood into the world. Burri, beginning in 1949,
created a series of collage constructions that he called *Sacchi* (Sacks;
see Chronology), made from worn burlap bags patched together and
mounted on stretchers, in which holes in the humble fabric are an
intrinsic part of each object. He continued this approach in works such
as *Composition*, 1953 (fig. 140). By combining formal composition with
random process and exploiting the power of common materials, Burri
bridged the generations of Art Informel and the later Arte Povera
movement in Italy. In 1954, Tàpies also began creating works in which
he collaged untreated discarded materials, including torn canvas, rags,
and string, but splashed them with scrawls and dribbles of paint like
random graffiti. With these desecrated picture planes and often the
poorest of materials, Burri, Fontana, and Tàpies created a tortured
form of abstraction.

Fontana's monochromes were the first of a wave of monochrome
paintings in Europe after World War II. Yves Klein painted his first in
1950;[188] Burri followed in 1951, with his series of pitch-black *Tars*;[189]
and, influenced by Fontana, Piero Manzoni began an important series
of monochromes in the mid-1950s. Working from familiar tenets of
earlier abstraction, these artists were seeking to eliminate the
simulation of reality as a guiding principle of art and to substitute the
idea of the work of art itself as an object of pure reality. Manzoni was
opposed not just to representational art but even to compositions of
abstract patterns of colors and forms, which he believed reduce a field
of "unlimited possibilities" to "a kind of receptacle into which
unnatural colors and artificial meanings have been forced. Why
shouldn't this receptacle be emptied?"[190] In 1957, he began painting
what he called "achromes," canvases covered in "colorless" white paint
and inflected only by texture (for example, fig. 134), where the white
is "not a sensation or a symbol or anything else" but merely "a white
surface that is simply a white surface and nothing else." The canvas
says nothing and explains nothing, and its nothingness is equivalent
to infinity, which, Manzoni said, "is vigorously monochrome." The
value of a picture, he declared, is "that it exists . . . ; being is all that
matters: two colors in harmony, or two shades of the same color,
already represent a relationship that is extraneous to the meaning of
the unique, limitless, absolutely dynamic surface."[191]

Klein was preoccupied with these same concerns, and around 1956,
after experimenting with various colors for his monochromes for
several years, began limiting the palette of his works to a single shade
of blue, which he called "International Klein Blue," as in *Untitled Blue
Monochrome (IKB 68)* and *Untitled Blue Monochrome (IKB 69)*, both 1961
(figs. 136 and 137); he even began referring to himself as "Yves le
monochrome."[192] Through the "depersonalization" of color, he wished
to eliminate all subjective emotion from his work, as Mondrian had,
and thus to become "acquainted with the immaterial."[193] He chose the
color blue because "blue has no dimensions, it is beyond dimensions,
whereas other colors are not. . . . All colors arouse specific associative
ideas, . . . while blue suggests at most the sea and sky, and they, after
all, are in actual, visible nature what is most abstract."[194]

In his writings, Klein sounded very much like the inheritor of early
abstractionist ideas, particularly in passages that describe his religious
faith (Rosicrucian),[195] his admiration for music and architecture, and
his goal of attaining in his art "the spiritual absolute."[196] He described
his subject as "space, pure spirit,"[197] but declared that, although
freedom is desirable, it needs to be tempered.[198] Constantly
emphasizing the "pure," and declaring line in any form to be

135. *Yves Klein*, Untitled Monogold
(Le Silence est d'or) (MG 10), *1960.*
Gold leaf on canvas, on plywood, 58¼ x
44⅞ inches (148 x 114 cm). Private
collection.

136. *Yves Klein*, Untitled Blue
Monochrome (IKB 68), *1961. Dry
pigment in synthetic resin on board,
6 feet 6 ⁷⁄₁₀ inches x 5 feet ¼ inch (1.99 x
1.53 m). Private collection.*

137. *Yves Klein*, Untitled Blue
Monochrome (IKB 69), *1961. Dry
pigment in synthetic resin on board,
6 feet 6 ⁷⁄₁₀ inches x 5 feet ¼ inch (1.99 x
1.53 m). Private collection.*

138. *Yves Klein*, Le Rose du Bleu,
1959–60. Sponges and dry pigment on
wood, 6 feet 6 ⁷⁄₁₆ inches x 5 feet ¼ inch
(1.99 x 1.53 m). Private collection.

139. *Yves Klein*, Requiem, *1960. Sponges,*
pebbles, and dry pigment in synthetic
resin on board, 6 feet 6 ⅛ inches x
5 feet 4 ⅞ inches x 5 ⅞ inches (1.99 x 1.65 x
.15 m). The Menil Collection, Houston.

140. Alberto Burri, Composition, 1953.
Oil, gold paint, and glue on burlap and
canvas, 33 ⅞ x 39 ½ inches (86 x 100.4 cm).
Solomon R. Guggenheim Museum, New
York 53.1364.

141. Lucio Fontana, Spatial Concept,
1949. Oil on paper, mounted on canvas,
39 ⅜ x 39 ⅜ inches (100 x 100 cm).
Kunstsammlung Nordrhein-Westfalen,
Düsseldorf.

142. *Jean Dubuffet*, The Substance
of Stars, *December 1959. Metal foil
on Masonite, 4 feet 11 inches x
6 feet 4 ½ inches (1.5 x 1.95 m).
Solomon R. Guggenheim Museum,
New York 74.2078.*

anathema,[199] Klein followed the example of Malevich, whom he mentioned at the conclusion of his essay "The Monochrome Adventure."[200] However, Klein boasted of being able to place the infinite before the viewer, unlike Malevich, whom he quoted as merely wanting to "represent infinity."[201]

The innovative surface treatments and unusual material effects of European abstract art during this period departed significantly from American practice. The typical approach of most Americans, with the exception of the pouring and dripping techniques of Hofmann and Pollock, was simply to apply paint to canvas using brushes, and occasionally a palette knife. But Manzoni applied cotton balls to his surfaces and Klein soaked sponges with pigment (see figs. 138 and 139). Fontana cut into the canvas surface, creating rhythmic, even elegant slashes that make the wall behind the canvas an integral part of the work. Burri worked with torn burlap as a support to create highly associative, fetishistic objects. Tàpies created layered, thickly textured surfaces that look like molten lava, as did Dubuffet in his brief period of abstraction. Working with the surface in such a direct and immediate fashion, these Europeans gave their work an enormously physical presence, as powerful as that of the Abstract Expressionists but different in character. The Europeans' paintings are generally less heroic in scale than the Americans', and are often more personal, vulnerable, and poetic. These tendencies, except in the matter of scale, continued in the work of the next generation in Europe, as in Joseph Beuys's *Tents in the Himalayas*, 1959 (fig. 143), with its highly expressive use of materials.

Other Directions in 1950s American Art

The pre-eminence of Abstract Expressionism during this period extended to the work of sculptors such as David Smith and a younger generation including John Chamberlain, Mark di Suvero, and Richard Stankiewicz. The expansion of scale and freedom of composition that marks their work was due in large part to their choice of making welded iron and steel sculpture often incorporating found objects rather than more traditional modeled, carved, or cast pieces. Smith was part of the generation of de Kooning and Pollock, but by the late 1950s his sculpture had become more geometric, hard-edged, and directly linked to Cubism and Constructivism, culminating in his *Zig* series, 1961–64, and his *Cubi* series, 1961–65. The *Zig* sculptures are composed of painted rectangles and circles of concave steel, while each *Cubi* consists of asymmetrically arranged stacks of burnished stainless-steel cubes and cylinders (see figs. 145 and 146). Smith was one of the few modern sculptors up to that point to put a painted finish on his work, a practice that he continued almost until his death in 1965. The introduction of bright, painted color added a new element to the vocabulary of abstract sculpture.

Chamberlain, in describing the revelation he experienced on first seeing Smith's sculpture, particularly noted its abstract quality: "It was the first piece of sculpture that I saw that was just itself. . . . it wasn't representing something. . . . It was just there by itself and that fascinated me."[202] Unlike Smith, however, Chamberlain eschewed geometric forms in favor of the chance, idiosyncratic shapes of discarded automobile parts, as in his *Dolores James*, 1962 (fig. 148). He also made color an integral element of his abstract sculpture.

An important younger member of the original generation of Abstract Expressionists was Helen Frankenthaler, a pioneer of the stain method of Color-field painting adopted by Morris Louis and Kenneth Noland. Frankenthaler's early work was influenced by Gorky and her other peers in New York, but she soon developed an original manner

143. Joseph Beuys, Tents in the Himalayas, *1959. Felt and stained gauze on paper, mounted on cardboard, 9 ⅝ x 15 ⅜ inches (24.5 x 39 cm) overall. Öffentliche Kunstsammlung Basel, Kunstmuseum, Emanuel Hoffmann Foundation, Permanent loan to the Museum für Gegenwartskunst.*

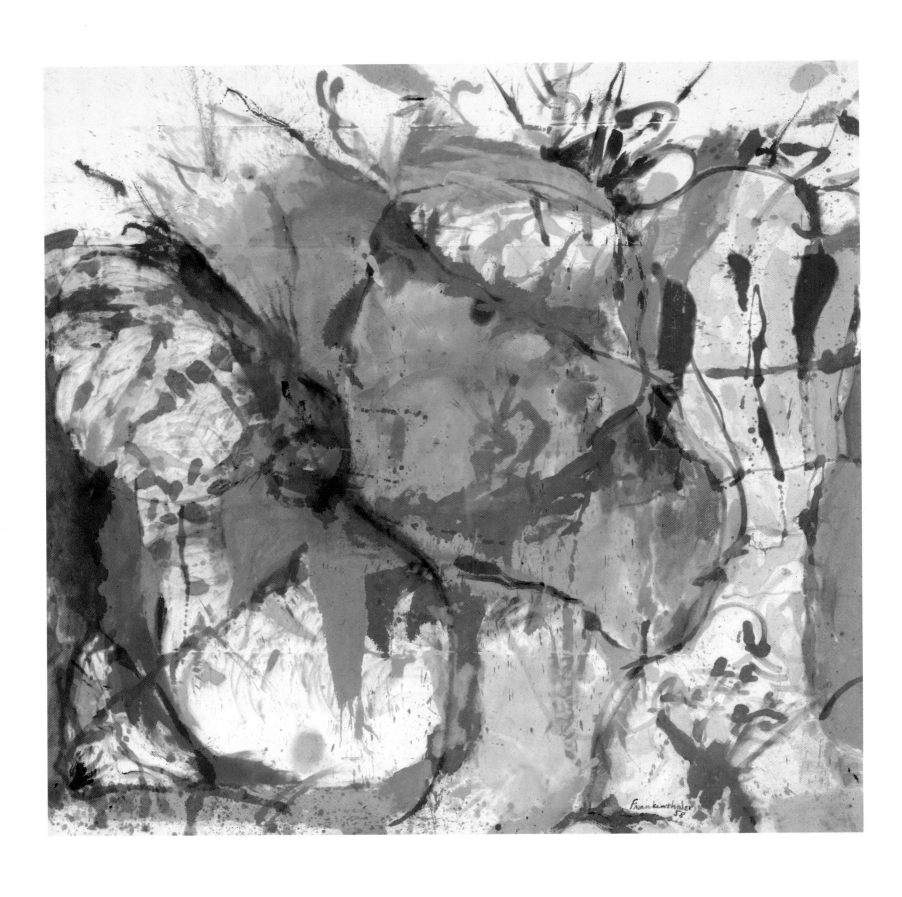

144. Helen Frankenthaler, Before
the Caves, 1958. Oil on canvas,
8 feet 6 ⅛ inches x 8 feet 8 ½ inches (2.6 x
2.65 m). University Art Museum and
Pacific Film Archive, University of
California at Berkeley, Anonymous Gift.

following three pages:
145. David Smith, Cubi XXVII, March
1965. Stainless steel, 9 feet 3 ⅛ inches x
7 feet 3 ¼ inches x 2 feet 10 inches (2.83 x
2.23 x .86 m). Solomon R. Guggenheim
Museum, New York, By exchange 67.1862.

146. David Smith, Cubi XVIII, 1964.
Stainless steel, 9 feet 7 ¼ inches x 5 feet x
1 foot 9 ¼ inches (2.94 x 1.52 x .55 m).
Museum of Fine Arts, Boston, Gift of
Susan W. and Stephen D. Paine.

147. David Smith, Two Circles IV, 1962.
Painted steel, 10 feet 4 inches x 5 feet x
2 feet 4 ½ inches (3.15 x 1.52 x .72 m).
Collection of Mr. and Mrs. David N.
Pincus.

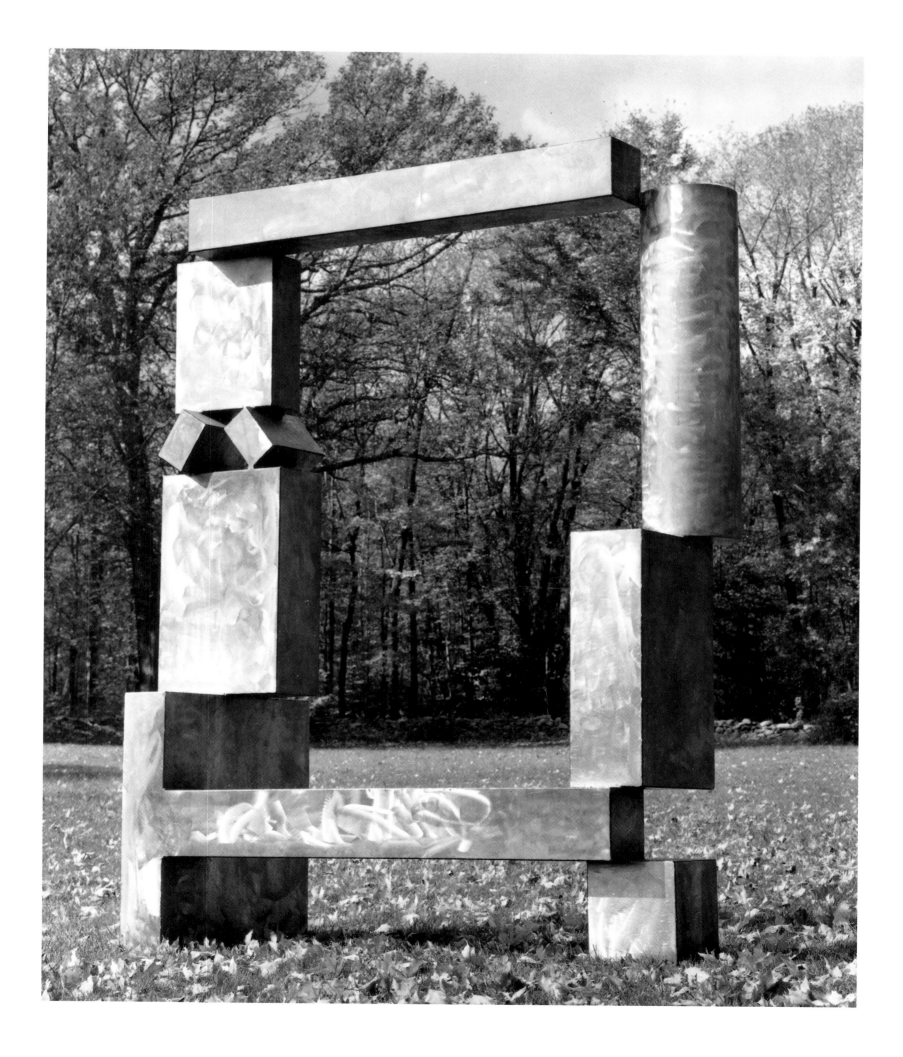

148. John Chamberlain, Dolores James, 1962. Welded and painted automobile parts, 6 feet 4 inches x 8 feet 1 inch x 3 feet 3 inches (1.93 x 2.46 x .99 m). Solomon R. Guggenheim Museum, New York 70.1925.

149. *Morris Louis,* Saraband, *1959.*
Acrylic resin on canvas, 8 feet 5 ¼ inches x
12 feet 5 inches (2.57 x 3.79 m). Solomon R.
Guggenheim Museum, New York 64.1685.

150. *Robert Rauschenberg,* Erased de
Kooning Drawing, *1953. Traces of ink*
and crayon on paper with mat and hand-
lettered (in ink) label in gold-leaf frame,
25 ¼ x 21 ¼ inches (64.1 x 55.3 cm).
Collection of the artist.

emphasizing biomorphic form, gesture, scale, and new methods of
color combination. Her style coalesced after she took over the process
of stain painting suggested by Pollock, staining unsized, unprimed
canvas by pouring pigment onto it, as in the enormously influential
Mountains and Sea, 1952 (see Chronology). Unlike the allover
compositions of Pollock, Frankenthaler's paintings consist of
extraordinarily liquid and veiled "images" of highly saturated color.
In many of Frankenthaler's works of the late 1950s, such as *Before the
Caves*, 1958 (fig. 144), these motifs are densely layered, sometimes
exploding with energy and exuberance.

Greenberg was a fervent supporter of the work that Frankenthaler,
Louis, and Noland were doing during this period, which he regarded
as a natural evolution from Abstract Expressionism toward a less
"heroic," more lyrical, and at the same time more rigorous form of
large-scale abstraction. Their breakthrough, he explained, was in
making the painted image completely congruent with the surface of
the canvas; with stains of color dissolving the picture plane, their
works are free from the interference of painterly effects.[203] Louis's work
ranges from lush, expansive color fields, as in his *Veil* series, 1957–60
(for example, fig. 149), to the more extreme abstractions of his *Unfurled*
series, 1960–61 (see Chronology), in which controlled diagonal flows
of pure color frame a large central area of virginal white unsized,
unprimed canvas. Richard Diebenkorn and Francis, contemporaries of
Frankenthaler on the West Coast, also developed lyrical variations on
Abstract Expressionist models.

Although Abstract Expressionism and developments associated with
it dominated the New York scene during the 1950s, there were at the
same time other noteworthy tendencies in American abstract art.
Albers and Reinhardt developed a rigorous offshoot of the geometric
abstraction promoted by the AAA group (some of whose exhibitions
Albers participated in). As practitioners of this American variation of
Concrete Art, which Alloway dubbed Systemic Art in the mid-1960s,
Albers and Reinhardt were forerunners of Minimalism.[204] They tried
to exclude content and signification from their art through an
uncompromising adherence to a rigorous geometric vocabulary,
machinelike precision, and calculated regularity, devoid of any
spontaneity. Reinhardt devoted himself to monochrome abstract
compositions using several almost imperceptibly differentiated shades
of a single color (see fig. 130), in which underlying geometric patterns
can be seen (with a degree of effort reminiscent of viewing
Rembrandt's chiaroscuro). Denying even this minimal possibility of
illusionistic space, Albers, in his *Homage to the Square* series, from 1950
on (for example, figs. 151 and 152; see also Chronology), repeatedly
employed a rigid composition of three or four concentric squares of
various carefully chosen hues, in order to explore the interaction of
different colors.[205] The work of these two American painters is similar
to that of their European peers in the obvious influence of Malevich's
monochrome approach, only cooler in tone. Reinhardt wanted an art
that was at once "formalist, escapist, sterile, inhuman, cold,
unemotional, empty, dogmatic, absolute, academic, purist."[206] Yet, he
viewed his austere abstract art as nevertheless capable of conveying
morality,[207] communicating honestly and directly, and offering a more
complete creative vision "related to personal wholeness and social order
because it is clear and without extra-esthetic elements."[208]

Unlike the Abstract Expressionists, Albers and Reinhardt held
abstraction in the highest regard. Reinhardt asserted unequivocally:

*The one art that is abstract and pure enough to have the one problem and
possibility in our time and timelessness, of the "one single grand original*

151. *Josef Albers,* Homage to the Square:
New Gate, *1951. Oil on Masonite, 24 x
24 inches (61 x 61 cm). The Josef and Anni
Albers Foundation.*

152. Josef Albers, Homage to the Square,
*1951. Oil on Masonite, 24 x 24 inches
(61 x 61 cm). The Josef and Anni Albers
Foundation.*

following two pages:
153. Robert Rauschenberg, White
Painting, *1951. Oil on canvas, two
panels, 6 x 8 feet (1.83 x 2.44 m) overall.
Collection of the artist.*

154. Ellsworth Kelly, White & Dark
Grey Panels, *1977. Oil on canvas,
8 feet 10 inches x 12 feet (2.69 x 3.66 m).
Private collection, New York.*

Reinhardt knew, though, that the power of abstraction had degenerated through the proliferation of mannered academic imitations,[210] and he feared that the original impetus and fundamental issues of abstraction were being misinterpreted to support attacks on these later, more academic manifestations of the style.[211] Still, the formalism occasionally ascribed to the works of the Abstract Expressionists applies more aptly to the paintings of Reinhardt and, especially, Albers.

"Hard-Edge Painting" is the term that Alloway adopted in 1959 "to refer to the new development which combined economy of form and neatness of surface with fullness of color, without continually raising memories of earlier geometric art."[212] Alloway explained that "forms are few in hard-edge and the surface immaculate. . . . The whole picture becomes the unit; forms extend the length of the painting or are restricted to two or three hues. The result of this sparseness is that the spatial effect of figures on a field is avoided."[213] Alloway cited Reinhardt as a practitioner of this new tendency, and linked him with Ellsworth Kelly, who devoted himself to painting abstract works consisting of flat, precisely bounded areas of vibrant, uninflected color. Kelly first experimented with reducing the painted image to a single monochrome panel from 1948 to 1954 while he was in Paris, where he found inspiration in the works of Arp, Constantin Brancusi, Miró, and late Matisse. In his work of the late 1950s and early 1960s, he continued to explore and refine his ideas about the interaction of color and shape (and in sculpture, mass), and his monochromes, multipanel works, and grid patterns of color (see figs. 157–60) anticipated Minimalist Art of the 1960s and 1970s. Kelly explained that he derived his imagery from his observation of details such as the shape of a window or a vaulted ceiling, or the negative space between objects, which he would isolate from its surroundings—"a fragment of the visual world with the third dimension removed."[214] However, the resulting works, such as *Dark Blue Curve*, 1995 (fig. 162), appear to be completely independent of their sources, which remain unrecognizable. Kelly acknowledged that his activity resulted in objects that, like some Asian ceramics, have shape as their dominant element. For him, "real meaning" resides only in "the thing seen,"[215] yet each work has the capacity to be viewed as a "mysterious object."[216]

Although Kelly has explained that in those early years in Paris he wanted to free himself of both figurative and abstract art in order to create these singular objects,[217] he was still grappling with the premises established by the early abstractionists. His emphasis on the creation of a "mysterious object" that would provide a "voluptuous experience"[218] echoes the transcendent notions of his predecessors. Moreover, his interest in the relationship of painting to architecture,[219] and his intention to reveal things that were previously unseen[220] also recall the aesthetic theories of the early abstractionists. But the importance that Kelly places on sources from the visual world and their transformation into voluptuous objects reveals the true nature of his approach as a synthesis of the French empirical and non-French abstractionist outlooks.

Unlike most of his American peers, and especially the Abstract Expressionists, Kelly wanted to eliminate even a hint of his own personality from his art.[221] He felt that with the making of such seemingly anonymous work he had achieved a "new freedom."[222]

155. Robert Rauschenberg, Untitled [matte black painting with *Asheville Citizen*]*, ca. 1952. Oil and newspaper on two separately stretched and joined canvases, 6 feet ¼ inch x 2 feet 4 ¼ inches (1.84 x .72 m) overall. Collection of the artist.*

156. Robert Rauschenberg, Estate, *1963. Oil and silkscreen ink on canvas, 8 feet x 5 feet 10 inches (2.44 x 1.78 m). Philadelphia Museum of Art, Gift of the Friends of the Philadelphia Museum of Art.*

157. *Ellsworth Kelly,* Painting for a
White Wall, *1952. Oil on canvas, five
panels, 23 ½ x 71 ½ inches (59.7 x 181.6 cm)
overall. Collection of the artist.*

158. *Ellsworth Kelly,* Train Landscape,
*1953. Oil on canvas, three panels, 44 x
44 inches (111.8 x 111.8 cm) overall.
Collection of the artist.*

159. Ellsworth Kelly, White Square, *1953.
Oil on wood, 43 ¼ x 43 ¼ inches (109.9 x
109.9 cm). Collection of the artist.*

160. Ellsworth Kelly, Broadway, *1958. Oil
on canvas, 6 feet 6 inches x 5 feet 9 inches
(1.98 x 1.75 m). Tate Gallery, London,
Presented by E. J. Power through the
Friends of the Tate Gallery, 1962.*

161. *Ellsworth Kelly,* Black Ripe, *1955.*
Oil on canvas, 63 ⅟₁₆ x 59 ⅛ inches (161.3 x
150.8 cm). Collection of Harry W. and
Mary Margaret Anderson.

162. *Ellsworth Kelly,* Dark Blue Curve,
1995. Oil on canvas, 3 feet 10 inches x
15 feet 10 inches (1.17 x 4.83 m). Private
collection.

163. Jasper Johns, Green Target, *1955. Encaustic on newspaper and cloth, over canvas, 60 x 60 inches (152.4 x 152.4 cm). The Museum of Modern Art, New York, Richard S. Zeisler Fund.*

164. Jasper Johns, Map, *1963. Encaustic and collage on canvas, 5 feet x 7 feet 9 inches (1.52 x 2.36 m). Private collection, New York.*

However, like Newman, Kelly never thought of himself as making geometric art, which to him is about composition; his art, he explained, is about the evocative and sensuous object. With their great masses of color, his paintings are comparable to Newman's sheer, open chromatic fields and since the early 1950s have been on a scale approaching that of works by the Abstract Expressionists.

When Robert Rauschenberg began seriously exploring the premises of abstraction as a student of Albers and friend of composer John Cage at Black Mountain College in the early 1950s, he was already familiar with the paintings of Newman and had, like him, given religious titles to some of his works. During this period, Rauschenberg produced first a series of all-white (1951), then all-black (1952–53), and finally all-red paintings (1953–54). The white monochromes (for example, fig. 153; see also Chronology) have a certain uninflected, deadpan quality that distinguishes them from the brooding canvases of Newman and Reinhardt. Rauschenberg described his white paintings in 1951, in a manner that echoes the quasi-mystical/religious philosophizing of the early abstractionists and shows the additional influence of Cage's Zen ideas:

They are not Art because they take you to a place in painting art has not been. . . .

They are large (1 white as 1 God) canvases organized and presented with the experience of time and presented with the innocence of a virgin. Dealing with the suspense, excitement, and body of an organic silence, the restriction and freedom of absence, the plastic fullness of nothing, the point a circle begins and ends. . . . It is completely irrelevant that I am making them— Today *is their creator.*[223]

Rauschenberg explained that these paintings were inspired by the "schooling" of Albers, but that instead of juxtaposing several colors in one work he was presenting one color at a time.[224] The subsequent black and red works have a different quality, for they have quite clearly been painted over torn and crushed newsprint, and some of them were laid face down over pebbles or gravel in order to adhere extra material to the painted surface.[225]

Rauschenberg's *Erased de Kooning Drawing*, 1953 (fig. 150), is one key to his intentions in these early 1950s series. After literally erasing a drawing that he had obtained for this purpose from the artist, he then presented the result as his own work of art. Adopting Cage's understanding of the term "nothing" (which the composer also called "Silence"),[226] Rauschenberg claimed that his *Erased de Kooning Drawing* and monochrome works are above all about "the fullness of nothing." They represent a psychological study of "willful submission of oneself to non-experience as an active form of experience."[227] Instead of fearing emptiness, there is a desire, in the words of Hans von Baeyer, to "domesticate the darkness."[228] In effect, Rauschenberg was attempting to find a way to create his own sensuous image of nothing.

Throughout the 1950s and early 1960s, Rauschenberg made a practice of juxtaposing abstract passages with representational images, an approach he first used in *Untitled {matte black painting with* Asheville Citizen}, ca. 1952 (fig. 155). In free-floating medleys, such as *Estate*, 1963 (fig. 156), the color patches appear to be particularly arbitrary and the juxtapositions seem to question abstraction at its core, a harbinger of Postmodern strategies.

Jasper Johns, an early friend of Rauschenberg, has worked with similar strategies throughout his career. For instance, by burying familiar mundane images within flat, often monochrome abstractions, such as *Green Target*, 1955 (fig. 163), and *Map*, 1963 (fig. 164), Johns

ironically commented on the proclaimed subject matter of Newman, Reinhardt, and others who employed monochrome. However, the work of Johns and Rauschenberg represents an important step in the growing tendency away from abstraction toward emphasizing the objecthood of art by insisting that the artwork should be regarded as a reality in itself. In 1974, Johns declared, "I like what I see to be real, or to be my idea of what is real. And I think I have a kind of resentment against illusion when I can recognize it. Also, a large part of my work has been involved with the painting as an object, as a real thing in itself."[229]

With hindsight, it seems evident that the evolution in Europe from the initial pioneering phase of abstraction to the between-the-wars period was repeated after a fashion in the United States. The vigorous self-expression, passionate aesthetic certainty, and heroic subject matter of the Abstract Expressionists were for the most part replaced in the 1960s by depersonalization, ambiguity, and cool restraint. Yet whereas European artists pursued this latter approach for utopian purposes, the new search in America concerned an independent object. Despite such changes, the next generation recognized that abstraction was still a language with limitless possibilities, still a domain of freedom.

By the 1960s, abstraction was moving away from the subjective and the expressive toward a cooler, more detached sensibility. Even the second-generation Abstract Expressionists tended to smooth out the rough edges and tone down the high emotions unleashed by many of their immediate predecessors. At first, most of the latest abstract paintings were ascetic, restricted to straight lines and a minimum of color, often with a palette limited to black and white, or monochrome; abstract sculpture followed the same lean approach. Among the artists who were important early practitioners of this new manifestation of pure abstraction were Agnes Martin and Frank Stella in painting, and Tony Smith in sculpture.

Stella started as a relatively painterly artist, but after moving to New York in 1958, at the age of twenty-two, he radically simplified his style over the course of a year until he had reduced it to the minimum, in the form of a black field with loosely parallel white stripes, as in *Delta*, 1958 (fig. 168). He refined this idea in several monochromatic series, beginning with his black paintings, which consist of symmetrical configurations of parallel black stripes of equal width, separated by narrow white lines of unpainted canvas, not unlike a pinstriped suit fabric, as in *Jill*, 1959 (fig. 169). In these works, Stella eliminated subject matter and illusionistic space by restricting himself to what he called "a regulated pattern"[1] that echoes the shape of the canvas and emphasizes the nature of the painting as a purely self-referential object. The entire content of the painting is the painting itself. The only point, according to Stella, is "the fact that you can see the whole idea without any confusion. . . . What you see is what you see."[2] It contains no veiled mystery, unlike the black paintings of Ad Reinhardt from 1955 to 1967, which are based on a "hidden" cruciform pattern. However, despite Stella's matter-of-fact intentions, his early stripe paintings have a powerful, magisterial presence. In subsequent series of the 1960s, Stella varied the shape of the canvas (from simple H forms to complex notched parallelograms), exploiting shape for pure visual impact and thus further emphasizing the painting as a unitary object with a single internally consistent idea. In 1960, he began painting shaped canvases in color—at first, a restrained monochrome of aluminum or copper (as in *Union Pacific*, 1960, fig. 170), adding various commercial and industrial colors in 1962, and using more than one at a time in 1963—and in 1966, he stopped deriving the colored forms strictly from the literal shape of the canvas. Stella's subsequent work, in a dazzling variety of series, has displayed a growing compositional complexity, as can be seen in *The Chase*, 1989 (fig. 171). High-key color and a vocabulary of forms derived from the tools of architectural drafting—including French curves, protractors, and templates[3]—have often been at the core of his increasingly dramatic art. In recent years, Stella has stressed a more spatial approach to abstraction, either literally in reliefs or illusionistically in paintings.

Stella's paintings from the late 1950s and early 1960s, along with Ellsworth Kelly's from the 1950s, represent the next major breakthrough in abstraction after Abstract Expressionism. Each of these works presents a single thoroughly abstract, unified form, with a flat, unnuanced clarity and a large scale that dramatizes its formal idea. Indeed, as physical objects, they transcend mere prettiness and decoration, and convey seriousness and presence.

Stella was extremely aware of the abstract art that preceded his, and was especially affected by Kazimir Malevich's *Suprematist Composition: White on White*, 1918 (fig. 18),[4] perhaps because purity was a pre-eminent issue for him.[5] Like the Constructivists, he emphasized that his way of working was "architectural" and had "a lot to do with building."[6] But Stella also compared himself to the

Abstract Expressionists, declaring that he wanted to be their "successor" in the tradition of "American abstractionists."[7] Some of Stella's early work, such as *Great Jones Street*, 1958 (fig. 165), contains a synthesis of certain elements from his favorite models: Barnett Newman's iconic "zip," Mark Rothko's moody atmosphere, Willem de Kooning's expressive linear composition, and the large scale used by all of them. As his art evolved, however, Stella eliminated all but the last element from his work, thus perpetuating the epic quality of his predecessors while diverging from their goals and approach in most other ways.

Although Martin's paintings of the early 1960s resemble Stella's in that they are monochromatic and filled with parallel lines or repeating shapes, hers have a delicate, ethereal quality. The pale colors were barely washed on, resulting in a luminous surface that seems to emanate light. Though arranged in strict grid patterns, as in *Night Sea*, 1963 (fig. 172), the hand-drawn graphite lines vary slightly in size and visual weight, and are regular but imprecise, like the edges of the stripes in Stella's early paintings. Yet whereas the effect of such variation is incidental in Stella's paintings (only perceptible from up close), in Martin's it is a paramount aspect of the aesthetic effect, so that what we see is a web of fragile lines applied with a gentle, personal touch. Unlike most of Stella's contemporaneous work, her six-foot-square format is of human scale, not larger than life.

With its subtle range of colors, Martin's palette, like Stella's in his early works, can be compared to the gradations within Malevich's palette. But the qualities in earlier abstraction that Martin most admired were anathema to Stella. She regarded her paintings as expressions of her feelings about the world, and revelations of what she referred to as a sublime realm.[8] Martin, who believed that abstraction enabled her to achieve a profound expression of herself,[9] admired the subjectivism of Abstract Expressionism. She described how its rejection of "objectivity" made "an authentic abstract art possible" and put it on the same pinnacle as music.[10] "It really *is* abstract. . . . You can really go off when you get out into the abstract!"[11] Her feeling of personal freedom in abstraction was exultant. However, despite her identification with the New York School artists, she also felt a certain kinship with Josef Albers,[12] whose systematic, ascetic approach separated him from most of his colleagues; her adherence to the grid is comparable to his to the square.

Like Stella's black paintings, Tony Smith's sculptures of the 1960s are large-scale, black abstract objects from which all decorative color and light have been eliminated. They range from stark black six-foot cubes, such as *Die*, 1962 (fig. 167), to the massive, asymmetrical *The Snake Is Out*, 1962 (fig. 166). A contemporary and friend of the Abstract Expressionists, Smith embraced monumental scale so as to give his work a majestic presence and heroic weight. Indeed, he sought to achieve a mysterious quality, and imagined art to be "something vast."[13]

Although Martin, Smith, and Stella did not share the same goals, they each gave abstraction an especially rigorous, economical appearance, as Kelly had been doing, and in many ways were precursors of Minimalism. In the work of Martin and Stella, the grid or arrangements of parallel lines replaced the seemingly random and exuberant gestures of Abstract Expressionism. They favored symmetry, an allover design, and regular graphic patterns, thus maintaining what Stella called a "nonrelational" arrangement of elements, which avoids a hierarchical composition with a central focus.[14] Smith's cube became a precedent for the subsequent generation of sculptors, a three-dimensional version of the deadpan, predictable, and thus knowable

165. Frank Stella, Great Jones Street, 1958. Enamel on canvas, two panels, 8 x 12 feet (2.44 x 3.66 m) overall. Collection of Irma and Norman Braman.

166. Tony Smith, The Snake Is Out, 1962. Painted steel, 15 feet x 23 feet 2 inches x 18 feet 10 inches (4.57 x 7.06 x 5.74 m). National Gallery of Art, Washington, D.C., Gift of the Tony Smith Estate and Patrons' Permanent Fund 1992.21.1.

grid. Monochrome—featured in the work of all three artists—reinforced this aesthetic by its inherent neutrality, and it became a prevalent approach in the 1960s and after.

The type of abstract art practiced by Martin and Stella can be described as "systemic," a term first used by Lawrence Alloway to refer "to paintings which consist of a single field of color, or to groups of such paintings," as well as "paintings based on modules . . . , with the grid either contained in a rectangle or expanding to take in parts of the surrounding space. . . . The field and the module (with its serial potential as an extendable grid) have in common a level of organization that precludes breaking the system," which, he explained, "is an organized whole, the parts of which demonstrate some regularities."[15] Such work thus appears predictable and neutral, the result of the artist's predetermined plan, having nothing to do with subjective needs or impulses. But, Alloway added, this method "does not exclude empirical modifications of a work in progress," for "a system is not antithetical to the values suggested by {the terms} humanist, organic, and process. On the contrary, while the artist is engaged with it, a system is a process; trial and error, instead of being incorporated into the painting, occur off the canvas."[16] Alloway found a precedent for this approach in the art and thought of Kelly and Reinhardt. Reinhardt apparently allowed for "no accidents or automatism"; a preconceived plan of attack was the source of all artistic decisions.[17] As Martin realized, Albers too was influential in the spread of this approach among the next generation.

Despite some clear associations, Stella, like Newman before him, dissociated himself from geometric artists. He felt that their work dealt exclusively with decorative patterns, whereas his stressed the character of the painted canvas as an object. Although he admitted that the artists of the Groupe de Recherche d'Art Visuel (GRAV) in Europe (of which François Morellet was a founding member) "actually painted all the patterns before I did—all the basic designs that are in my painting," Stella asserted that the way they painted was "not the way I did it" and thus "doesn't have anything to do with my painting." He regarded "all that European geometric painting" as "very dreary" and overly concerned with the relation of parts within a composition.[18]

Stella's adamant, oft-repeated assertion that his art is about nothing other than what the viewer sees, that it is entirely "pure painting,"[19] is the primary difference between him and the more romantic Smith and Martin. Stella emphasized the fundamental matters of art and rejected expressivity or symbolism.[20] In contrast, Smith denounced art that appears self-evident, which he compared to "a washing machine," and favored a certain "inscrutability."[21] Even his ostensibly neutral cube is loaded with content.[22] For Martin, the sense of infinity imparted by her grid is as important as its straightforward physical rendering. She described the grid as being about "elusive" things, comparable to the sea.[23] Where Martin's approach is lush, tied to the romantic outlook of the Abstract Expressionists, Stella's is deliberately cool,[24] and while he continued the tradition of nonobjectivity perpetuated by the Abstract Expressionists, he rejected their sensibility. Stella quickly achieved remarkable critical success, yet even though his strategy of painting was a grand culmination of the formalist approach outlined by Clement Greenberg, his work—especially the use of monochrome—was too extreme for that critic.[25] Nevertheless, he represented a new wave, and it was Stella, rather than any of the Greenberg-backed Color-field painters, or Kelly, Martin, or Tony Smith for that matter, who had the greatest influence on a group of artists who came to be known as the Minimalists.

167. *Tony Smith,* Die, *1962. Steel, 6 x 6 x
6 feet (1.83 x 1.83 x 1.83 m). (No. 2 from
an edition of 3.) Collection of Paula Cooper,
New York.*

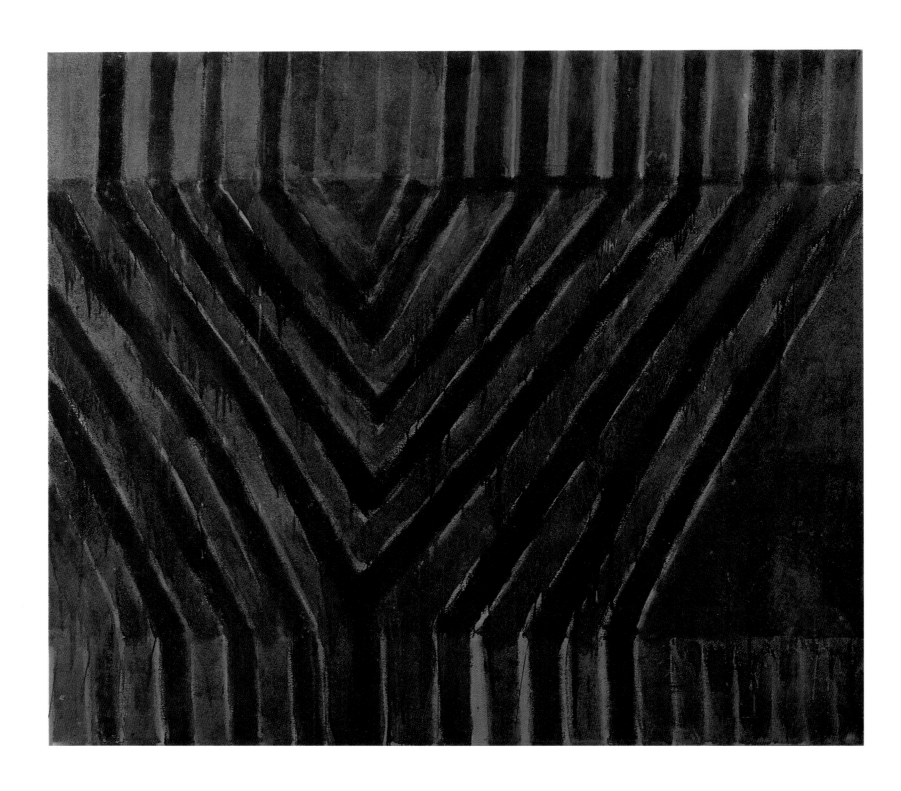

168. Frank Stella, Delta, 1958. Enamel on
canvas, 7 feet 1⅛ inches x 8 feet 1 inch
(2.17 x 2.46 m). Collection of the artist.

169. Frank Stella, Jill, 1959. Enamel on
canvas, 7 feet 6¼ inches x 6 feet 4¼ inches
(2.31 x 1.99 m). Albright-Knox Art
Gallery, Buffalo, Gift of Seymour H.
Knox, 1962.

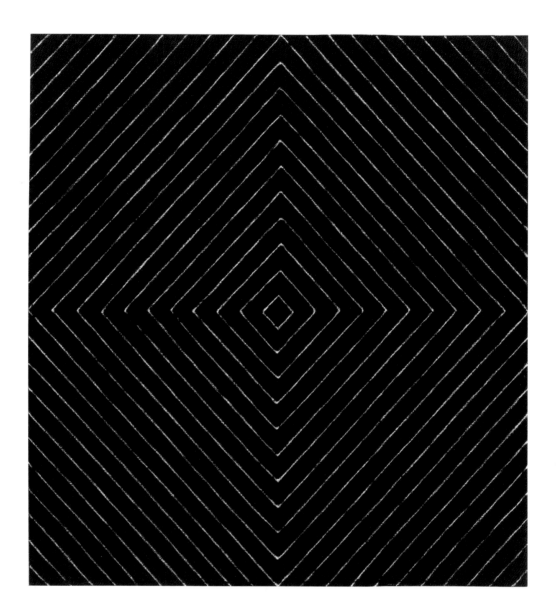

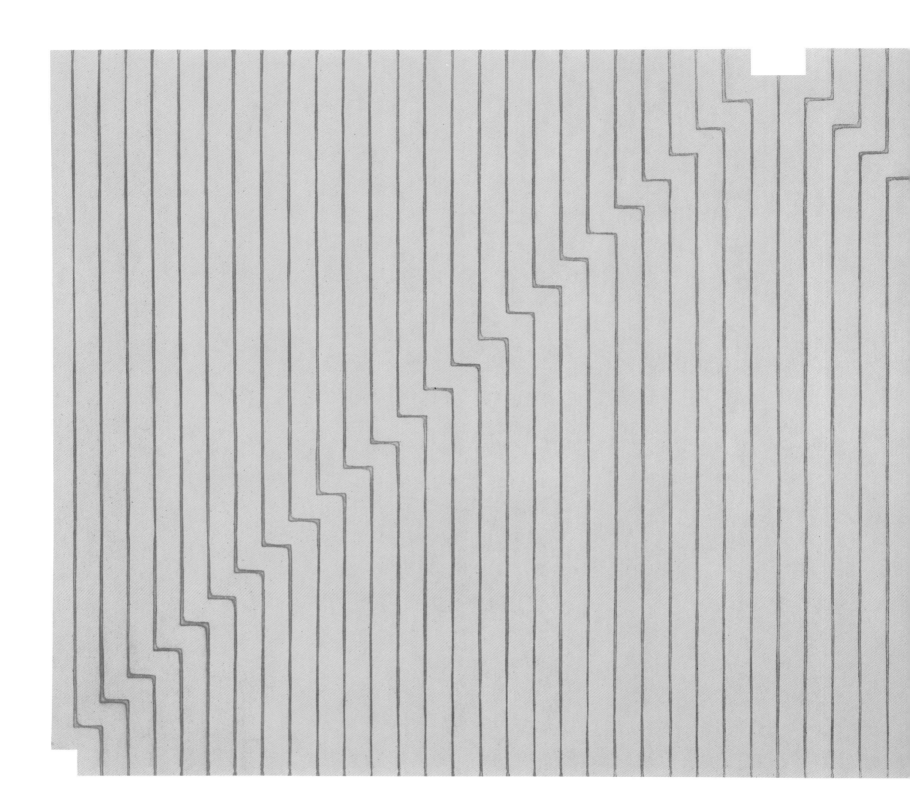

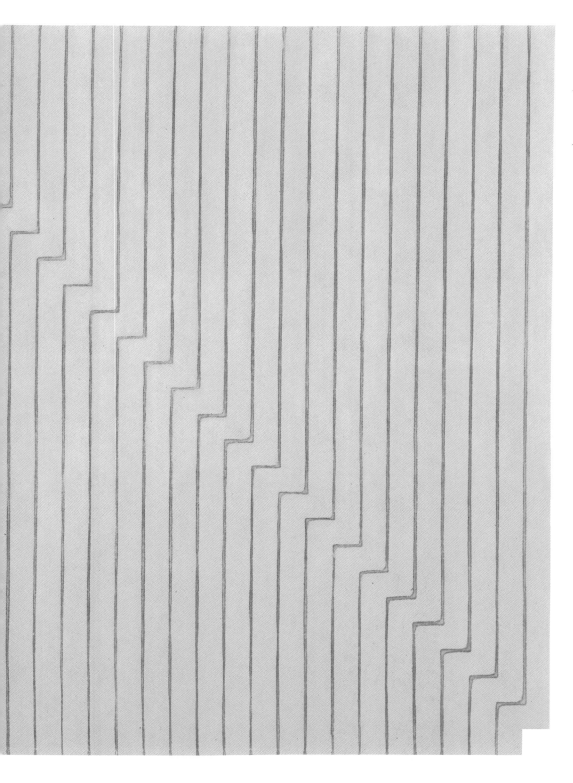

170. Frank Stella, Union Pacific,
1960. Aluminum paint on canvas,
6 feet 5 ¼ inches x 12 feet 5 inches
(1.96 x 3.78 m). Purchased with funds
from the Coffin Fine Arts Trust, Nathan
Emory Coffin Collection of the Des Moines
Art Center 1976.62.

following two pages:
171. Frank Stella, The Chase, *1989.*
Mixed media on etched aluminum
and magnesium, 8 feet 5 inches x
19 feet 1 ⅛ inches x 4 feet 2 ½ inches
(2.57 x 5.82 x 1.28 m). Private collection,
Chicago.

172. *Agnes Martin,* Night Sea, *1963. Oil
and gold leaf on canvas, 6 x 6 feet (1.83 x
1.83 m). Private collection, San Francisco.*

173. *Agnes Martin,* Leaf, *1965. Acrylic
and graphite on canvas, 6 x 6 feet (1.83 x
1.83 m). Collection of Mr. and Mrs.
Daniel W. Dietrich II.*

174. *Agnes Martin,* White Stone,
1965. Oil and graphite on canvas,
5 feet 11 ⅞ inches x 5 feet 11 ⅞ inches
(1.83 x 1.83 m). Solomon R. Guggenheim
Museum, New York, Gift, Mr. Robert
Elkon 69.1911.

175. *Agnes Martin,* Fiesta, *1985. Acrylic*
and pencil on canvas, 6 feet ⅟₁₆ inch x
6 feet ⅛ inch (1.83 x 1.83 m). Solomon R.
Guggenheim Museum, New York, Gift,
The American Art Foundation 92.4025.

176. Agnes Martin, Untitled No. 13, *1988.*
Acrylic and pencil on canvas, 6 x 6 feet
(1.83 x 1.83 m). Collection of Mr. and Mrs.
Robert Lehrman.

177. Carl Andre, Equivalent II, *1966*
(destroyed), refabricated 1969. Sand-lime
brick (original)/firebrick (refabrication),
120 units, 2 ½ x 4 ½ x 9 inches (6.4 x 11.4 x
22.9 cm) each, 5 inches x 1 foot 1 ½ inches x
15 feet (.13 x .34 x 4.57 m) overall.
Collection of the Grinstein Family.

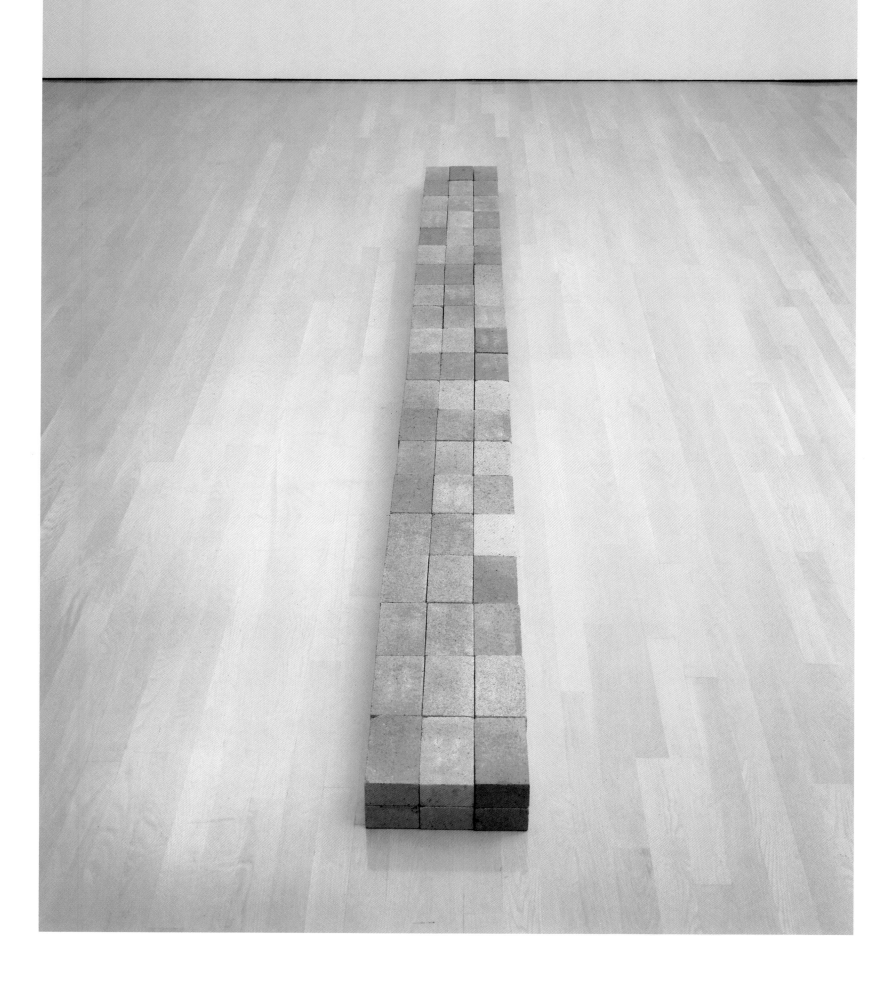

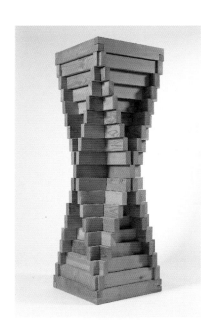

178. Carl Andre, Pyramid (Square Plan),
*1959 (destroyed), refabricated 1970. Wood,
seventy-four units, 2 x 4 x 31 inches (5.1 x
10.2 x 78.4 cm) each, 68 ⅛ x 31 x 31 inches
(174.9 x 78.7 x 78.7 cm) overall. Dallas
Museum of Art, General Acquisitions Fund
and matching funds from The 500, Inc.*

Minimalism

Minimalism is not so much a movement as a set of characteristics
associated with a group of abstract sculptors working in New York
City in the mid-1960s and after. The key breakthrough for this
sculptural initiative started with the friendship between Stella and
Carl Andre, who took the principles of Stella's new pictorial innovation
and applied them to sculpture. When Stella began to achieve renown
as a painter, Andre was a core member of the coterie that Stella
attracted around him (which included Dan Flavin by 1960, Donald
Judd by 1962, and later Sol LeWitt and Robert Morris[26]). Andre
became Stella's protégé, and described him as his last teacher[27]—a
teacher of the matter-of-fact, of the nonsymbolic,[28] who presented
things as they were, which in his paintings took the form of "stripes
[that] are the paths of brush on canvas."[29] Andre's materials were also
simple: at first, he used rectilinear beams and blocks of wood, sawed or
carved into equal units; then prefabricated Styrofoam beams,
commercial bricks (as in *Equivalent II*, 1966, fig. 177), and concrete
blocks; and finally, standardized metal squares. From the beginning of
Andre's career, in wood sculptures such as *Pyramid (Square Plan)*, 1959
(fig. 178), he learned to start making a work of art with an
"operation"—that is, taking a form and breaking it down "into
elements, and then combining them."[30] The resulting works, according
to Andre, have no one dominant point of view,[31] a notion similar to
Pollock's allover approach to painting. However, they are not
compositions with a sense of drama, but nonrelational "arrangements"
of identical, interchangeable parts.[32] This was the key concept of much
Minimal sculpture, as it had been the cornerstone of Stella's paintings.

Of earlier twentieth-century art, Andre admired Russian
Constructivism above all.[33] He found in it a precedent for his own, and
Stella's, practice of making works based on "the multiplication of the
qualities of the individual constituent elements," which are "identical,
discrete units" (in Stella's case, brushstrokes),[34] and letting the
materials dictate the form of each work. His interest in the
Constructivists suggests a parallel: just as the Russians "corrected" the
excesses of the early abstractionists, so Andre and his Minimalist
colleagues, by devoting themselves to creating neutral, inanimate
objects, countered the romantic inclinations of their predecessors.[35]
And in the spirit of the Constructivists, Andre rejected any
connotation of a spiritual dimension in his art.[36] However, although he
participated in the Art Workers Coalition (founded in 1969) and there
is a socially conscious aspect to his work (especially his choice of
common, accessible materials), he never followed the Constructivists'
lead in making art that served utopian or revolutionary political goals.

An equally important influence on Andre was the work of
Constantin Brancusi, whose *Endless Column*, 1918 (fig. 52), he
considered to be "the highest achievement . . . in European abstract
sculpture of the century."[37] In his early work Andre emulated
Brancusi's method of stacking "things (pedestals and bases) and also
structures (benches and arches and tables like those in [the]
Philadelphia [Museum of Art])."[38] But he began orienting his
sculptures horizontally, on the floor, in order to avoid frontality and
verticality, both of which he thought of as inherently figurative,[39] and
that low-lying orientation became the prevailing characteristic of his
art. "All I'm doing," Andre said of *Lever*, 1966 (fig. 182), his first floor
piece, consisting of a single row of 137 firebricks, "is putting the *Endless
Column* on the ground."[40] Soon after that he invented what has become
his signature format—a rectilinear arrangement of metal squares
(usually of a single material), held in place only by gravity, such as *144
Pieces of Zinc*, 1967 (fig. 180).

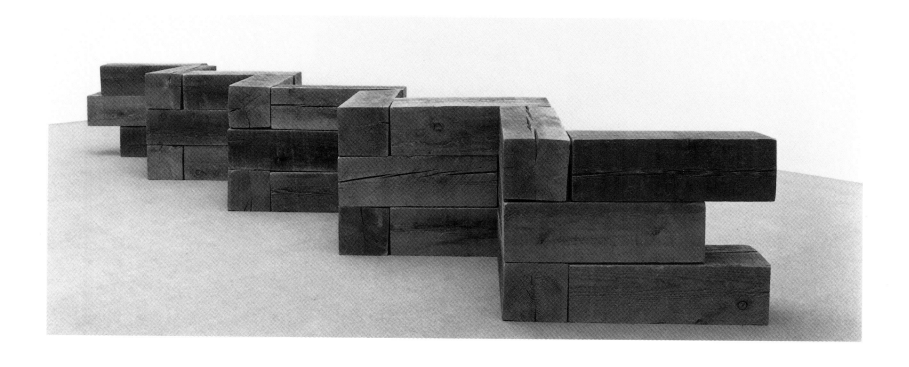

179. Carl Andre, Redan, *1964 (destroyed),
refabricated 1970. Wood, twenty-seven
units, 12 x 12 x 36 inches (30.5 x 30.5 x
91.4 cm) each, 36 inches x 42 inches x
20 feet 5 inches (.91 x 1.07 x 6.22 m)
overall. Art Gallery of Ontario, Toronto,
Purchased with assistance from the Women's
Committee Fund, 1971.*

180. *Carl Andre,* 144 Pieces of Zinc,
*1967. Zinc, 144 units, ⅛ inch x 12 inches x
12 inches (1 x 30.5 x 30.5 cm) each, ⅛ inch x
12 feet x 12 feet (.01 x 3.66 x 3.66 m)
overall. Milwaukee Art Museum,
Purchase, National Endowment for the
Arts Matching Funds.*

181. *Carl Andre,* The Way North, East,
South, and West (Uncarved Blocks),
*1975. Western red cedar, five units, 12 x
12 x 36 inches (30.4 x 30.4 x 91.4 cm)
each, 36 x 60 x 60 inches (91.4 x 152.4 x
152.4 cm) overall. Private collection,
New York.*

182. foreground: Carl Andre, Lever, 1966.
Firebrick, 137 units, 2 ½ x 4 ½ x 8 ⅞ inches
(6.4 x 11.4 x 22.5 cm) each, 4 ½ inches x
8 ⅞ inches x 29 feet ½ inch (.11 x .23 x
8.85 m) overall. The National Gallery of
Canada, Ottawa. Included in Carl Andre,
Solomon R. Guggenheim Museum, New
York, September 29–November 22, 1970;
shown with Well, 1964/1970 (left), and
Pyramid (Square Plan), 1959/1970.

183. Donald Judd, Untitled, 1965.
Perforated steel, 8 inches x 10 feet x
5 feet 6 inches (.2 x 3.05 x 1.68 m).
Solomon R. Guggenheim Museum,
New York, Panza Collection 91.3712.

The character of an Andre floor piece is abstract, but so literal and
deadpan, so lacking subjective affect, as to make the viewer conscious
of the surroundings and of being alone with him- or herself. Andre has
drawn an analogy between viewing the earth from an airplane and
"looking down" at his work.[41] Moreover, he invites the viewer to walk
on his floor pieces, to contemplate the physical experience of being
present in the room with it and engaging in that activity. Andre's floor
pieces are thus both modest and confrontational, coy and aggressive.

Like Stella, Andre admired the Abstract Expressionists and shared
their passion for large scale[42] and the concomitant "possibility of being
within the sculpture."[43] He believed that their "level of extraordinary
aspiration . . . makes art worth doing."[44] In contrast, he had only
contempt for Pop art, for what he described as painting "the ordinary
shit of our time,"[45] thus reintroducing the high/low distinction with
which the abstractionists always flirted.

In his wholehearted embrace of abstraction, Andre asserted in 1978
that "abstract art was morally superior to representational art."[46] This
claim implies that he believed that his personal mission was "morally
superior" and that his work, by being rooted in an ethical framework,
has some kind of elevated character. Like Wilhelm Worringer, Andre
believed that abstraction originated in the Neolithic period. And he
suggested that it arose then "for the same reason that we are doing it
now. The culture requires significant blankness because the emblems,
symbols, and signs which were adequate for the former method of
organising production are no longer efficient in carrying out the
current roles that we assign to them." What contemporary artists
needed, he said, was to reattain a similar "tabula rasa."[47] To create such
a neutral field, Andre relied on the format of a modular grid and,
usually, the restriction to monochrome (i.e., a single metal) in each
floor piece.

By 1964, following the principles established by Andre and Stella,
Judd began to assemble identical modular units—boxes that he had
metalworkers fabricate in galvanized iron at a factory—into abstract
sculptures that are extremely rigorous and project a tough, assertive
presence in the spaces they occupy. For the three preceding years,
using wood and sometimes metal pipe, he had been making simple,
usually symmetrical constructions (boxes, open frames, and ramps)
and had honed his approach to making abstract sculptures intended
merely as neutral objects. His two most characteristic formats are a
floor-to-ceiling stack of identical metal boxes (of galvanized iron,
stainless steel, copper, brass, or anodized aluminum) mounted on the
wall, such as Untitled, 1965 (fig. 186), and a horizontal row of similar
boxes suspended from a long square metal pipe attached to the wall,
such as To Susan Buckwalter, 1964 (fig. 185); however, in the late 1960s,
he began concentrating on large floor pieces (for example, fig. 183),
often permutations of an open box.

Traditional composition was anathema to Judd, perhaps because of
its representational connotations.[48] Specifically, he believed that its
"hierarchical structure" reflects a "larger idea of order and an
acceptance of a scheme which is exterior to the work of art."[49] His
works, like Andre's and Stella's, are nonrelational arrangements of
elements that avoid such hierarchical composition, and he too admired
Brancusi's Endless Column, especially for its monolithic quality and its
modular structure. In his vertical stacks, Judd also eliminated
sculpture's traditional reference to the human figure by taking the
work off the pedestal while keeping it upright.[50]

Judd wrote of his respect for the Russian abstractionists' "clear-
headedness" in separating art from nature[51] and singled out
Malevich for praise, particularly his accomplishment in giving

form and color an independent life,[52] but he distanced himself from the Constructivists. Judd disliked the hierarchical composition of geometric painting, a category in which he included the works of Mondrian (but not Malevich).[53] He criticized Mondrian's orthogonal, relational elements for appearing "anthropomorphic"—for example, lines in a T formation could suggest a torso with extended arms[54]—and therefore not being sufficiently abstract.[55] However, he expressed admiration for Henri Matisse, in particular for his use of grand scale, which he recognized as crucial to the Abstract Expressionists and to himself.[56]

Judd commended the New York School's approach to abstraction as a rejection of Mondrian's geometry and an embrace of Matisse's scale and Joan Miró's "indefinite space."[57] He believed that the movement's key figures were Newman, Jackson Pollock, Rothko, and Clyfford Still,[58] and that the expansive scale of their paintings,[59] along with the "wholeness" of each work (that is, its singleness or unity of form, which enables the viewer to apprehend it at once), were essential contributions to the development of abstraction.[60] Judd also regarded Albers's work as "intriguing," despite its small scale, for its variations on a theme.[61] However, Stella's ascetic approach to surface and space represented a breakthrough for Judd, as it had been for Andre, making Abstract Expressionism look "inadequate," like a "compromise."[62] According to Judd, the best and most advanced abstract painting, like Stella's, minimizes its illusionism as much as possible by emphasizing its flatness. In addition to Stella, he credited Gene Davis, Alfred Jensen, Kenneth Noland, and Jules Olitski with this achievement,[63] as well as Kelly and Yves Klein.[64]

Although Judd at times resisted identifying his art as abstract,[65] he asserted his place among abstract artists.[66] He set forth the great challenge for future abstraction—and specifically for himself—as the creation of "form that's neither geometric nor organic."[67] Suspicious of all claims of purity in art, Judd asserted that "there is no form that can be form without meaning, quality and feeling. . . . It's a contradiction to make a form that is meaningless. It's also impossible to express a feeling without a form. It couldn't be said or seen."[68] And he was "very uninterested {in} and very wary of the {geometric} style" until he realized that "it could be used in a non-Neo-Plastic way, an impure way, without the purity that geometric art seemed to have." He "always liked Mondrian," but Mondrian, "though really great, is too ideal and clean," and "Reinhardt is too." However, he praised Stella's black paintings as a new kind of "impure geometric art."[69] He wanted art that defied the usual categorical boundaries, works that could approach architecture,[70] and declared that the fertile territory of such art would reveal more and more diverse possibilities.[71] Although the work of Judd and other Minimalists was often celebrated in Europe, it was largely ignored or scorned in the United States, where it was misunderstood by the general populace and even rejected by the dean of formalist criticism, Greenberg. Judd, responding to this indifference and disapproval, moved to Marfa, a small town in Texas, in 1973 and set up a permanent installation of his work there, where his art would not be "subject to the ignorance of the public."[72]

Flavin, near the beginning of his career, began making abstract sculptures consisting of store-bought fluorescent light fixtures placed "at crucial junctures"[73] in rooms and other architectural spaces to create "situations" of suffused illumination, ranging from pure white or a single color to various combinations of colors. His series entitled *Monument for V. Tatlin* (for example, fig. 184) indicates the place of Russian Constructivism in his thinking. In 1964, describing the seventh work in this series, Flavin wrote:

184. Dan Flavin, Monument for V. Tatlin, 1964. Cool-white fluorescent light, 10 feet (3.05 m) high. (No. 4 from an edition of 5.) Collection of Dia Center for the Arts, New York.

185. *Donald Judd,* To Susan Buckwalter,
*1964. Lacquer on aluminum and
galvanized iron, 2 feet 6 inches x
12 feet 7 inches x 2 feet 6 inches (.76 x
3.84 x .76 m). Private collection,
San Francisco.*

This dramatic decoration has been founded on the young tradition of a plastic revolution which gripped Russian art only forty years ago. My joy is to try to build from that "incomplete" experience as I see fit. Monument 7 in cool white fluorescent light memorializes Vladimir Tatlin, the great revolutionary, who dreamed of art as science. It stands, a vibrantly aspiring order, in lieu of his last glider, which never left the ground.[74]

Flavin's frequent practice of orienting his arrangements of lights to articulate the space in a corner of a room carries Tatlin's *Corner Counter-Reliefs* a step further. According to Morris, Flavin's fellow Minimalist, Tatlin was "the first to free sculpture from representation and establish it as an autonomous form."[75] Flavin wanted to transform sculpture into a synthesis of the material and the immaterial, with light as the transforming medium, quietly inhabiting space in the corner of a room. His goal, as he described it, was "to combine traditions of painting and sculpture in architecture with acts of electric light defining space."[76] But the light effects that he has created are as sensuous as a painting by Rothko. Moreover, his description of his work as "dramatic decoration" brings the term decoration back to its architectural context and rescues it from its traditional low status among abstractionists.

Although at first Flavin thought of his work in romantic terms relating to the spiritual and the sublime, it did not take him long to arrive at a cooler, more literal view, no doubt influenced by his contact with Stella. Flavin's first fluorescent piece, *Diagonal* (fig. 188), which he made around 1963, consists of a single eight-foot "gold" fluorescent tube arranged diagonally on a wall. He titled his diagram for the work *"the diagonal of personal ecstasy (the diagonal of May 25, 1963)"* and compared the resulting piece to Brancusi's *Endless Column*, which to him "was like some imposing archaic mythologic totem risen directly skyward."[77] Flavin saw his *Diagonal* as a contemporary totem that, "as common light repeated effulgently across anyone's wall, had the potential of becoming a modern technological fetish."[78] However, by 1967, without diminishing his sense of the beauty and sensuousness of his works, he was emphasizing their literal physical presence as objects. It became clear to him that "the physical fluorescent tube has never dissolved or disappeared by entering the physical field of its own light. . . . At first sight, it appeared to do that . . . but . . . [t]he physical fact of the tube as object in place prevailed whether switched on or off."[79]

Morris was a mainstay of the Minimalist group from 1963, the year both he and Judd had solo shows at the Green Gallery in New York, until 1968, when he changed his approach to making sculpture and helped initiate the Post-Minimalist trend—one of the many surprising turns he has taken in his career. As a Minimalist sculptor, Morris was noted for the unitary forms that he made from industrial materials. Essentially, he viewed Minimalist sculpture as the three-dimensional successor to Abstract Expressionist painting, both of which stressed, he said, "immediacy and . . . overwhelming presence."[80] In his view, this ambitious period in the history of abstraction was undone in the late 1960s by the "political unrest and disbelief in United States political actions," which undermined the confidence of American abstractionists.[81]

LeWitt began his career in the early 1960s making geometric painted reliefs (which he called "wall structures") and freestanding constructions, then concentrated in the mid-1960s on what he called "open modular cubic structures,"[82] and turned in 1968 to planning abstract wall drawings to be executed by others, thus exemplifying the evolution from Minimalist art to Conceptual art during that decade.

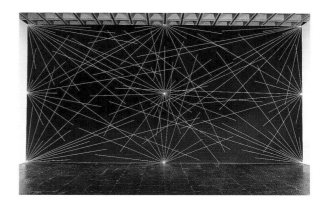

187. Sol LeWitt, Fourth wall of A six-inch (15 cm) grid covering each of the four black walls. White lines to points on the grids. 1st wall: 24 lines from the center; 2nd wall: 12 lines from the midpoint of each of the sides; 3rd wall: 12 lines from each corner; 4th wall: 24 lines from the center, 12 lines from the midpoint of each of the sides, 12 lines from each corner, *1976. White crayon lines and black graphite grid on black walls, dimensions variable. Whitney Museum of American Art, New York, Purchase, with funds from the Gilman Foundation, Inc.*

facing page:
186. Donald Judd, Untitled, *1965. Galvanized iron, seven units, 9 x 40 x 30 inches (22.9 x 101.6 x 76.2 cm) each, spaced 9 inches (22.9 cm) apart; 9 feet (2.74 m) high overall. Moderna Museet, Stockholm.*

The drawings are based on simple repetitive systems (grids, parallels, crisscrossing lines, concentric circles and arcs) applied directly to a white wall surface, using black graphite alone (for example, fig 187; see also Chronology) or red, yellow, and blue. (LeWitt later began a series of wall paintings, using an expanded palette of colors.) By having someone else execute the drawings according to his predetermined instructions, he eliminated the subjective gesture from abstraction altogether and underscored the idea embodied by the work. His wall drawings emphasize their existence in the viewer's actual space in the same way that Andre's pieces do on the horizontal plane. LeWitt wanted "to do a work that was as two-dimensional as possible," to make the lines "become, as much as possible, a part of the wall surface, visually,"[83] in order to create what he termed an "absolute relationship" between the work of art and its location.[84] By making the drawing congruent with the wall surface, LeWitt dematerialized the abstract "object," illustrating a characteristic aspect of Minimalist aesthetics.

Conceptual art was essentially an extension of Minimalism, for it took the art object based on a preconceived idea to the point where the concept itself became the work of art. LeWitt wrote extensively about Conceptual art, which in 1967 he defined as art that is intended "to engage the mind of the viewer, rather than his eye or emotions."[85] In creating such work, he wrote, "all of the planning and decisions are made beforehand and the execution is a perfunctory affair. The idea becomes a machine that makes the art."[86] He envisioned the artist producing pure information, engaged in an enterprise comparable to that of a physicist.[87] However, the information is complex and sometimes contradictory, for Conceptual art is "intuitive" and "purposeless," constructed on a foundation of "conclusions that logic cannot reach" but that "should be followed absolutely and logically" in formulating a work of art. In his view, Conceptual artists are therefore "mystics rather than rationalists."[88]

Rationalism—which favors reason over sense perceptions as a source of knowledge—was rejected by the Minimalists as a basis for their art. They were interested only in the viewer's aesthetic experience of perceiving the literal, physical reality of the object and its existence in his or her actual space. This unmediated experience of the literal object was the point of art, they believed, not the revelation of human sentiments or universal truths. In an early article on Minimalism, Barbara Rose wrote, "There is no wish to transcend the physical for either the metaphysical or the metaphoric. The thing, thus, is presumably not supposed to 'mean' anything other than what it is."[89] For the Minimalists, to do otherwise—to depict or represent—would be to falsify reality. Yet they denied that their new kind of art was reductive; it just "doesn't have what the old work had," explained Judd.[90] "A shape, a volume, a color, a surface, is something itself. It shouldn't be concealed as part of a fairly different whole."[91] What the Minimalists were interested in was a unified gestalt that would be perceived immediately as a single object, which Judd described simply as "the thing as a whole, its quality as a whole."[92] But iconic form was not the goal of Judd and his fellow artists,[93] for they did not want a work of theirs to be perceived only as a geometric form or pattern.

Another way in which their new abstract art differed from "the old work" was its machine-made anonymity, for the Minimalists considered handmade sculpture too subjective and personal. They used prefabricated materials or had their works fabricated in a machine shop or factory and favored unconventional-looking metals and new industrial materials, such as anodized aluminum, Plexiglas, and fluorescent tubes.[94] By taking advantage of recent technological innovations (as the Constructivists had earlier), they could diminish any suggestion in their art of the traditional forms and values that they rejected. Judd noted that the "objectivity" of his materials conveys to the viewer the idea that his works "aren't obviously art,"[95] an idea exemplified by such works as his *Untitled*, 1965 (fig. 190), which is made of galvanized steel.

Extending the earlier abstractionists' notion of the reality of abstract art, the Minimalists wanted their works to be taken as part of the environment in which they were presented, as real as any everyday object. Hence, the elimination of supports and frames from wall works and bases from sculpture. Andre's floor-bound works exemplify the extreme of this approach. He explained that he wanted to make artworks that would avoid conventional aesthetic attention, even to the point of being ignored.[96] Through the work's simplicity or neutrality, its lack of internal relationships, the artist could draw attention away from the work itself to encourage the viewer to focus on its relationship to the surrounding environment. Andre, Flavin, and LeWitt expanded the scale and even the structure of the abstract work of art so as to encompass the space in which the work is placed, enveloping the viewer and establishing an "absolute relationship" between the work and its site. With this formulation, the earlier abstractionists' idea of an "absolute" art was given a new definition. Modern sculpture, according to Andre, had evolved from "sculpture as form" to "sculpture as structure" and finally to "sculpture as place."[97]

Andre wanted his abstract art to reflect the industrialized nature of society,[98] and frequently emphasized the strictly material basis of his work: "I just like . . . the different properties of matter, the different forms of matter, different elements, different materials. . . . I don't want to disguise it at all, I don't want to make something else out of it. . . . By nature, I am a materialist."[99] But he wanted to reveal something new about the prefabricated materials he presented, to use "the materials of society in a way that society does not use them."[100] He accomplished this in his floor pieces in part by subjecting them to the conditions of the environment in which they are presented—that is, being walked on by viewers—and thus each of the works becomes a "record of everything that's happened to it."[101]

Despite his emphasis on the objective materiality of his works, Andre has occasionally described them as more than just inert objects. In 1970, he admitted to a degree of subjectivity in his art: "I submit to the properties of my materials out of a kind of reflection of my own temperament."[102] In 1972, he suggested that art exists to provide a certain "peace and happiness,"[103] and in 1978, he attributed "a kind of political statement" to his work,[104] recalling Newman's faith that his act of creative freedom was a political act that resulted in an abstract work of art. Earlier, in the mid-1960s, Andre referred to his use of "anaxial symmetry," in which "any part can replace any other part," as a way to approximate "the symmetry of the heavens."[105] In striving to emulate the perfection of nature in this way, he was fulfilling what he regarded as art's goal: "to provide intimations of the perfect."[106] He has even compared his work to "a tree, or a rock, or a mountain or an ocean,"[107] thus identifying it as more a product of nature than an artifact of culture. Andre regarded culture as an inimical influence on art, and described Minimal art as resulting from the artist's attempt to "rid himself of the burden, the cultural over-burden that stands shadowing and eclipsing art."[108] What is finally left after this process of emptying, according to Andre, is a "blankness,"[109] a nothingness that is full in the abstract sense, that has as its appearance the monochrome sculpture.

Judd eschewed such a notion of nothingness. When he made a form,

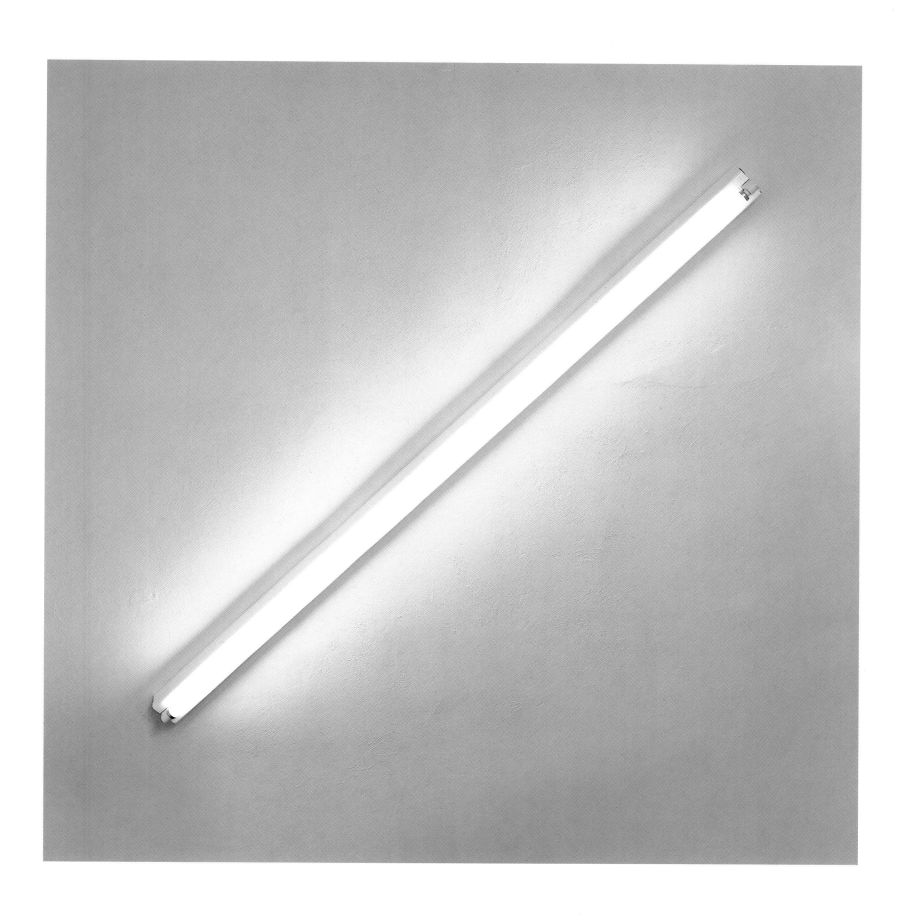

188. *Dan Flavin,* Diagonal, *ca. 1963.*
Fluorescent light, 8 feet (2.44 m) long.
Collection of Mr. and Mrs. Keith L. Sachs,
Philadelphia.

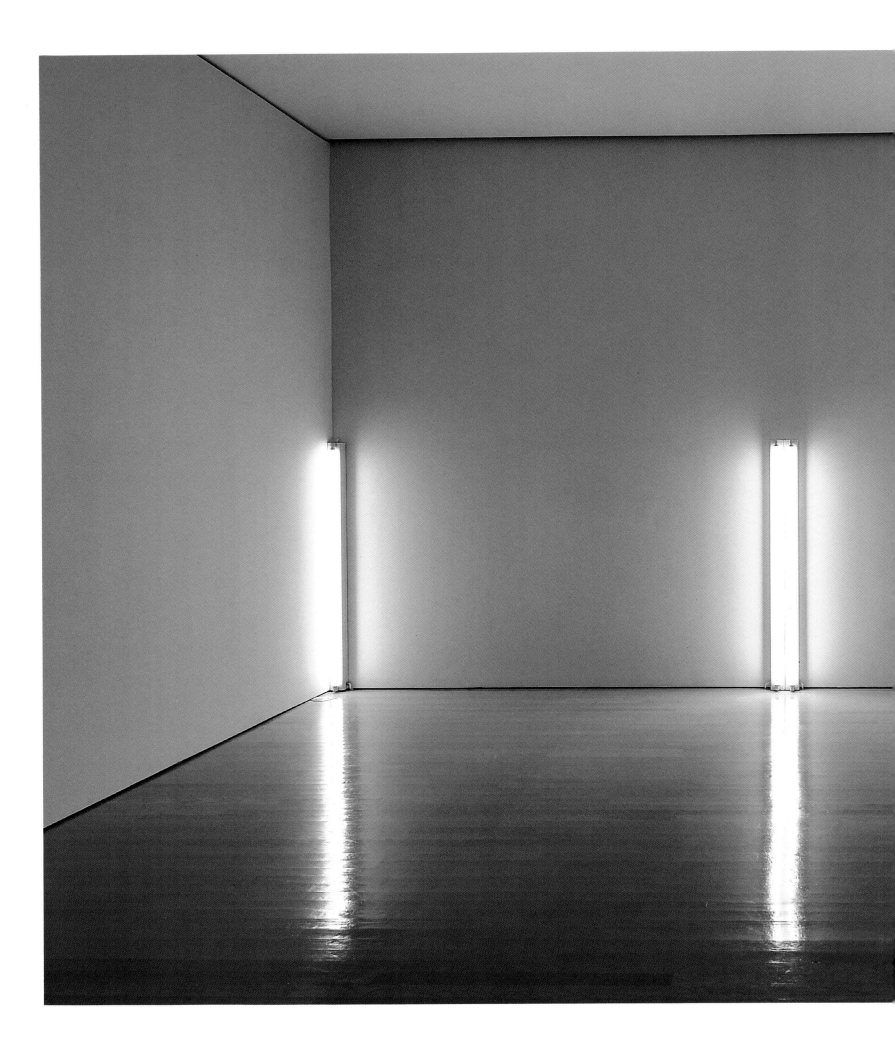

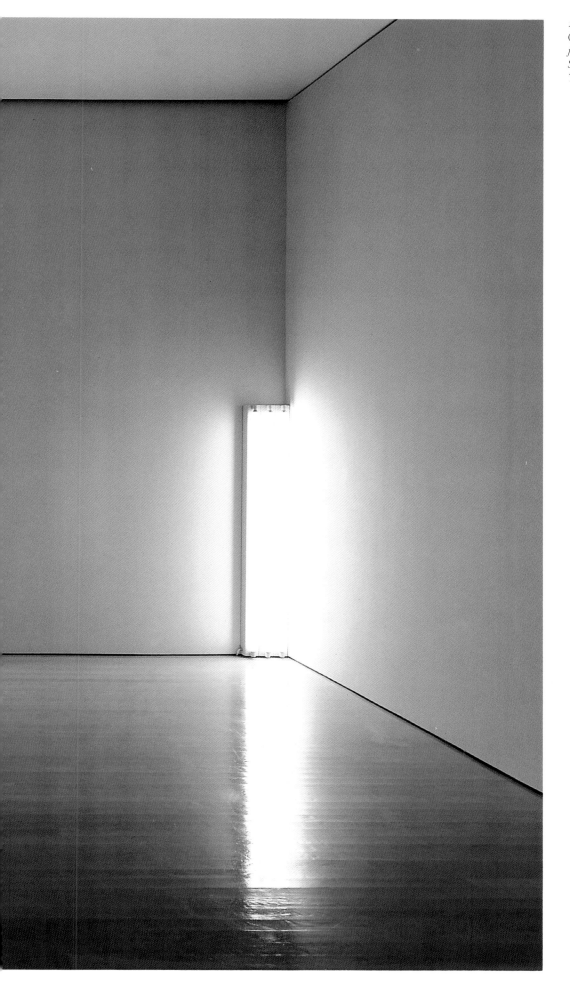

189. *Dan Flavin,* the nominal three
(to William of Ockham), *1963. Daylight
fluorescent light, 6 feet (1.83 m) high.
Solomon R. Guggenheim Museum, New
York, Panza Collection 91.3698.*

190. *Donald Judd*, Untitled, *1965.*
Lacquer on galvanized steel,
1 foot 2 ⁹⁄₁₀ inches x 6 feet 4 ⁷⁄₁₀ inches x
2 feet 1 ⅛ inches (.37 x 1.95 x .65 m).
Walker Art Center, Minneapolis,
Harold D. Field Memorial Acquisition,
1966.

191. Robert Mangold, X Series Central Diagonal 2, *1968. Acrylic and black pencil on Masonite, plywood, and metal, 4 feet 1/16 inch x 8 feet 1/4 inch (1.23 x 2.46 m). Solomon R. Guggenheim Museum, New York, Gift, Donald Droll 69.1886.a,.b.*

it always carried a feeling that arose out of the particular circumstances of its creation; at the same time, it embodied its inherent "meaning, quality and feeling." In fact, said Judd, "embodiment is the central effort in art, the way it gets made, very much something out of nothing."[110] This type of discussion is hardly surprising for the abstractionist hungry to ascribe some kind of subject matter, if not intent, to the ostensibly empty vehicle of his or her abstract work of art. Indeed, following a now familiar pattern, LeWitt, in addition to pointing out the mystical component of Conceptual art, related his art to a form of freedom, and suggested that his work was a "protest."[111] These departures from the strict adherence to literal objecthood indicate intentions that contradict the usual characterization of the Minimalists as making work that is blank, neutral, and mechanical—what Donald Kuspit, writing about contemporary abstract art in the late 1970s, referred to as a "purge of the metaphysical by the physical, the obscurely connoted by the obviously denoted, the illusion of the essential by the really essential."[112] However, LeWitt declared that the artist's role is "asocial and apolitical," and that making art is an "opportunity to pursue a pure line of work . . . which disregards society"; and he derided artists' attempts at "political content" in their art as "pretty embarrassing . . . a delusion and a sentimentality."[113]

During the 1960s in New York, especially among Minimalist sculptors, there was a significant tendency to believe that "painting was . . . dead"[114] (echoing Nietzsche's assertion in 1882 that God was dead), although it was more of an ideological stance than a reality. Indeed, there were some painters whose literal approach, restrained or monochrome palettes, and occasional use of a grid or manipulation of geometric shapes connected them to the prevailing Minimalist aesthetic, even if their work only occasionally matched the ambitious scale of the sculptures. They were also friendly with some of the Minimalist sculptors, including Flavin and LeWitt. Only loosely affiliated with each other, and not always in complete agreement, these painters all started with the actual painted surface as their subject, however much they varied in the formal elements of their work. This approach, often called Minimal painting, is exemplified by the work of Robert Mangold, Brice Marden, and Robert Ryman.

Of the three, Ryman has always pursued the most literal approach, emphasizing painting's material components by adhering almost entirely to a single format—the monochrome white square—for almost thirty years. Within this consistent structure, Ryman has explored the nuances of varying the application of paint on different supports of different sizes (though rarely at the large scale of the Abstract Expressionists) and the details of attaching it to the wall. His use of white is personal in feeling, and results in paintings that are often luminous with the glow of reflected light. Indeed, he has acknowledged the influence not of Malevich but of Paul Cézanne, Matisse, and Rothko.[115] But unlike the veiled mystery of works by Rothko, Ryman's paintings evoke a tranquil, almost domestic intimacy. The fact that he was a student of jazz pianist Lenny Tristano when he first arrived in New York helps explain Ryman's especially subtle and experiential approach to painting.

Ryman conceives of his work not as "abstract," "concrete," or "nonobjective" art[116] but as an art of the real, of "outward" rather than "inward" expression,[117] and has compared it to that of Mondrian, whom he considers "a realist painter" like himself.[118] Ryman's notion of realism is comparable to the literal sense of presence of Minimalist sculpture: "With realism there is no picture . . . there is no story. And there is no myth. And there is no illusion, above all. So lines are

real, and the space is real, the surface is real and there is an interaction between the painting and the wall plane, unlike with abstraction and representation."[119] In some works, such as *Institute*, 1981 (fig. 193), Ryman has emphasized the visibility of the aluminum or steel fasteners that he uses to attach each painting to the wall, as if such a detail is "excruciatingly significant, *the* telling 'gesture' of the work," as Kuspit described it.[120] Thus, Ryman is not concerned with pattern, but with making abstraction tangible. He finds a "certain beauty"[121] in the essentials of a painting and the details of its presentation as a wall-bound object, and has even spoken of the emotional quality of his work: "I would say that the poetry of painting has to do with feeling. It should be a kind of revelation, even a reverent experience. You come away feeling delight. . . . I think that's what art is, if it can convey that feeling."[122]

Mangold has focused more on composition in his works than on their surface qualities. He began his career in the early 1960s making hard-edged abstract paintings using curvilinear shapes, then created objectlike monochromes with "windows" cut out of them, and in 1966 started to make paintings with shaped canvases in which linear geometric shapes drawn on the surface play off the form of the support, as in *X Series Central Diagonal 2*, 1968 (fig. 191). Realizing the importance of the combination of "formal and psychological things that the line does and the way it affects how you read something,"[123] Mangold exploited these properties to create subtle compositions of geometric abstraction on a modest scale, often in warm monochromes of quiet earth tones. He had at one time thought that design considerations were the extent of the abstractionist project, but Abstract Expressionism revealed to him the vast, untapped possibilities inherent in the abstract approach.[124]

For many years, Marden's basic format was a monochrome rectangle—or two or three monochrome panels in different colors presented as a single rectangle—for which he used a mixture of beeswax and oil paint applied with a fine sense of touch, as in *Paris Painting*, 1969 (fig. 192). Each color is rich but subdued, chosen for some private association: "I begin work with some vague color idea; a memory of a space, a color presence, a color I think I have seen."[125] The resulting paintings are abstractions that evoke atmospheric space, and simmer with understated emotion, the creations of a romantic sensibility tempered by Minimalist control. That combination of control and emotion is what Marden loves about Francisco Zurbarán's paintings, which he described as "very coldly executed yet very passionate."[126] Marden does not share Stella's aesthetic of formalist literalism. He interpreted Stella's axiom "What you see is what you see" as "This is nothing more than what there is," and responded, "Well, there is more than that." Although, when interviewed in 1986, Marden expressed some doubt about the spiritual content of abstraction, he said that he would "like to believe that there could be some kind of transcendence. . . . I would rather keep it open and say that there are magical, spiritual possibilities in painting rather than be cynical about it. . . . If there isn't a belief that you can really do something, then you're just making furniture."[127]

During the years dominated by Minimalist thinking, abstract painters who were interested in spiritual or emotional possibilities, or in anything beyond the literalness of pure painting, confronted challenges not faced by the sculptors. Whereas Minimalist sculpture—because of its inherent material literalism, which emphasizes the work's objecthood and makes it easy for the artist to avoid illusionism—fulfilled the tenets of formalist thinking that had been championed by a succession of critics, including Reinhardt (who

192. Brice Marden, Paris Painting, *1969. Oil and wax on canvas, two panels, 6 feet ⅛ inch x 2 feet (1.83 x .61 m), and 6 feet ⅛ inch x 2 feet ⅛ inch (1.83 x .61 m). Solomon R. Guggenheim Museum, New York, Panza Collection 91.3783.a,.b.*

193. *Robert Ryman,* Institute, *1981. Oil on
linen, with metal fasteners, 63 x 60 inches
(160 x 152.4 cm). Private collection.*

194. *Robert Ryman,* Media, *1981. Oil on
aluminum, 59 ¼ x 59 ¼ inches (151.8 x
151.8 cm). Collection of Mr. and Mrs.
Thomas Dittmer, Chicago.*

195. *Robert Ryman,* Winsor 34, *1966.*
Oil on linen, 62 ½ x 62 ½ inches (158.8 x
158.8 cm). Courtesy of The Greenwich
Collection Ltd.

196. *Robert Ryman,* J. Green, *1968.*
Acrylic on paper, six sections,
approximately 41 ¼ x 28 inches (104.8 x
71.1 cm) each, 6 feet 10 ½ inches x 7 feet
(2.1 x 2.13 m) overall. Solomon R.
Guggenheim Museum, New York, Panza
Collection 91.3846.a –.f.

197. Robert Ryman, Lenox, 1971. Enamelac
on cotton, 60 x 60 inches (152.4 x 152.4 cm).
Solomon R. Guggenheim Museum, New
York, Panza Collection 91.3856.

198. Robert Ryman, Associate, 1981.
Oil on aluminum, 59 ¼ x 58 inches (151.8 x
147.3 cm). Seattle Art Museum, Gift of
Mrs. Corydon Wagner.

199. Robert Ryman, Sector, *1981. Oil on aluminum, with fiberglass bands, 59 ¼ x 59 ¼ inches (151.8 x 151.8 cm). Collection of Ralph and Helyn Goldenberg.*

200. Robert Ryman, Range, *1983. Oil and Enamelac on fiberglass panel, with aluminum, 51 ¼ x 47 ¼ inches (131.4 x 121.3 cm). Collection of Mrs. Hannelore B. Schulhof.*

201. *Robert Ryman,* Alternate, *1988.*
Lascaux acrylic on Lumasite with
kraft paper and steel, 47 ½ x 48 inches
(120.7 x 122 cm). Collection of Henry S.
McNeil, Jr., Philadelphia.

had condemned the "transcendental nonsense" of the Abstract Expressionists[128]), such painters found formalism insufficient for their needs. They wanted to explore the territory of an underlying reality that the Abstract Expressionists had opened up.

Post-Minimalist Sculpture

Coinciding with the high point of Minimalist sculpture, starting in the mid-1960s, some artists who are often referred to as Post-Minimalists were making a different kind of abstract sculpture. Though grounded in Minimalist aesthetics, they were freer in their treatment of materials and their occasional use of systemic elements and emphasized the processes and personal actions involved in making their works. They claimed as their aesthetic territory a synthesis of the improvisation and high emotion of the Abstract Expressionists and the literalism of the Minimalists. Within that territory some Post-Minimalists, reacting against certain elements of Minimalist practice, gave rein to more sensual impulses and exploited the tactile and visceral qualities of their often nontraditional materials; these artists included Eva Hesse, Martin Puryear, and (in his early work) Richard Serra. Others, such as Richard Long and Robert Smithson, took the Minimalist notion of extending the sculptural object into its surrounding space and made it part of the landscape, sometimes on a monumental scale, or brought the raw material of nature indoors. Serra, working with large slabs of metal, began to make sculptures that redefined the relationship of the artwork to its environment and to its viewer, and was soon creating site-specific sculptures outdoors as well as in. Other artists, such as Robert Irwin, transformed the notion of the sculptural object in a gallery setting by dematerializing the object and its environment.

Hesse was a pioneer of eccentric forms who also respected structural regularity, and frequently integrated the two in her work. Even in her sculptures based on the grid or a modular composition of repeated units characteristic of Minimal art, she rejected the Minimalists' geometric contours and hard surfaces in favor of a more organic approach, using such untraditional materials as latex, rubberized cheesecloth, and rope. Hesse undercut the diagrammatic look of a grid composition by maintaining a handmade quality in her treatment of the surface, whether in a sculpture, such as *Sans II*, 1968 (fig. 205), or a drawing, and at the end of her brief career abandoned structural regularity entirely in works consisting of tangled skeins of rope, string, and wire combined with fiberglass or latex. (Her mature work dates from 1965 to her early death in 1970.) Many of her sculptures are dangling forms in which the tug of gravity has been made palpable, as in *Untitled (Rope Piece)*, 1970 (fig. 204). There is an almost Surrealist biomorphism in other works, such as *Tori*, 1969 (fig. 206), a floor sculpture that consists of a cluster of nine similar fiberglass forms with an anthropomorphic quality.

In *Accession II*, 1969 (fig. 202), one of a group of works that evoke a highly charged eroticism,[129] there appears to be a joking reference to the feminine "box," as well as an interpretation of Meret Oppenheim's fur-covered teacup (fig. 203) in abstract form. Hesse admired Claes Oldenburg's soft sculptures for the eroticism that was central to them, an eroticism that she noted was abstract, since Oldenburg evoked the erotic through the "pure sensation" of his materials rather than any "direct association with the objects depicted."[130] By exploiting similar visual-tactile qualities, Hesse found ways to evoke the stimuli of erotic sensations through abstract forms, thereby conveying the pure emotion that other abstractionists had described as their subject matter.

"The decorative is the only art sin,"[131] Hesse once declared, echoing

202. Eva Hesse, Accession II, *completed 1969. Galvanized steel and plastic tubing, 30 ¼ x 30 ¼ x 30 ¼ inches (78.1 x 78.1 x 78.1 cm). The Detroit Institute of Arts, Founders Society Purchase, Friends of Modern Art Fund and Miscellaneous Gifts Fund.*

203. Meret Oppenheim, Object (Le Déjeuner en fourrure), *1936. Fur-covered cup, saucer, and spoon; cup: 4 ⅜ inches (10.9 cm) in diameter; saucer: 9 ⅜ inches (23.7 cm) in diameter; spoon: 8 inches (20.2 cm) long; 2 ⅞ inches (7.3 cm) high overall. The Museum of Modern Art, New York, Purchase, 1946.*

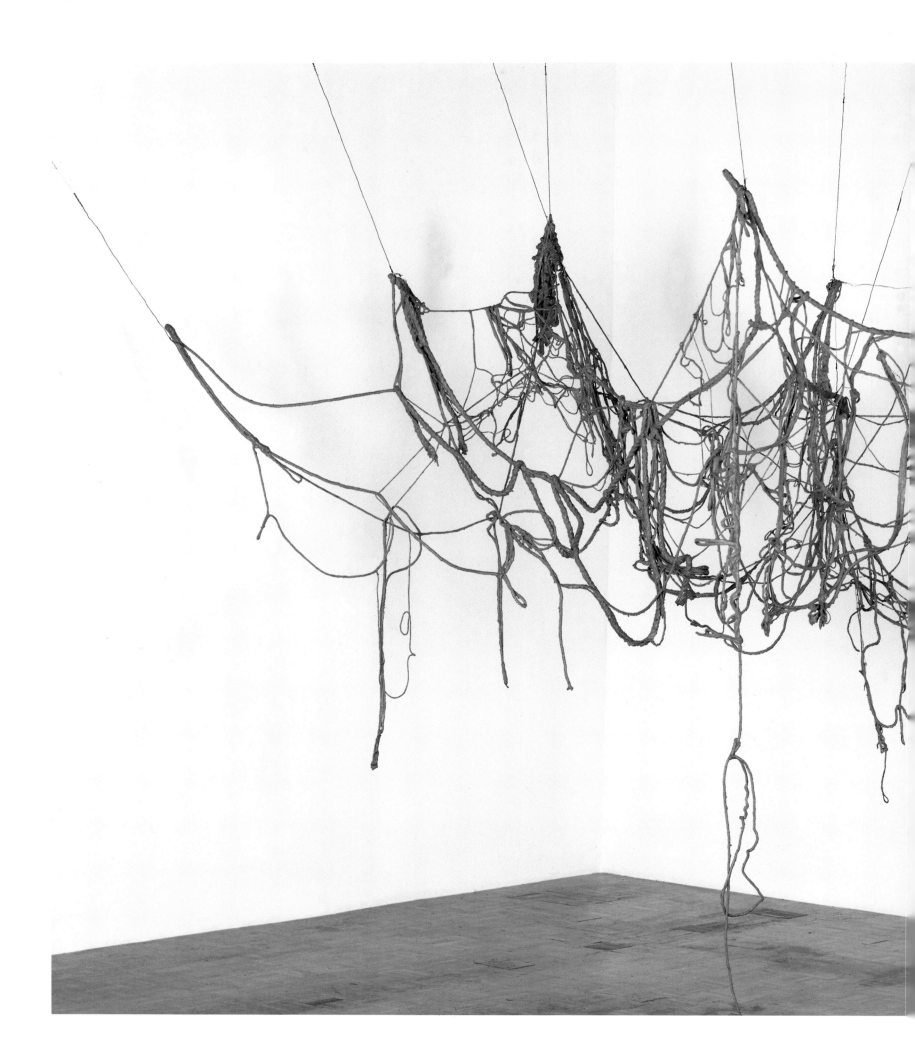

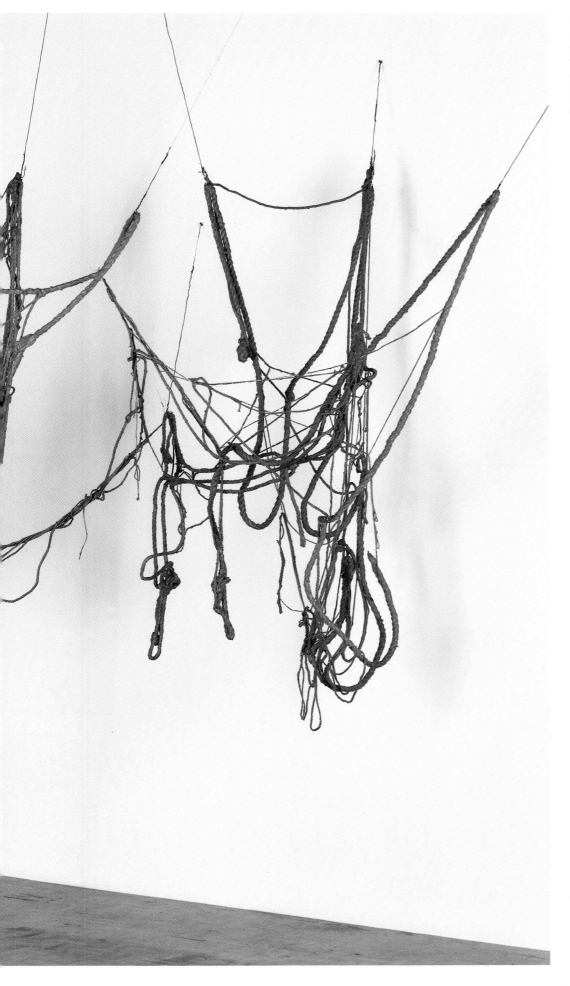

204. Eva Hesse, Untitled (Rope Piece),
1970. Latex over rope, string, and wire, two
strands, dimensions variable. Whitney
Museum of American Art, New York,
Purchase, with funds from Eli and Edythe
L. Broad, the Mrs. Percy Uris Purchase
Fund, and the Painting and Sculpture
Committee.

205. *Eva Hesse,* Sans II, *1968. Fiberglass and polyester resin, 3 feet 2 inches x 14 feet 2 ¼ inches x 6 ⅛ inches (.97 x 4.34 x .16 m). Whitney Museum of American Art, New York, Purchase, with funds from Ethelyn and Lester H. Honig and the Albert A. List Family.*

206. *Eva Hesse,* Tori, *1969. Fiberglass over wire mesh, nine units, 30 x 12 ½ x 11 ¼ inches (76.2 x 31.8 x 28.6 cm) to 47 x 17 x 15 inches (119.4 x 43.2 x 38.1 cm) each. Philadelphia Museum of Art, Purchased with funds contributed by Mr. and Mrs. Leonard Korman, Mr. and Mrs. Keith Sachs, Marion Boulton Stroud, Mr. and Mrs. Bayard T. Storey, and various funds.*

207. *Eva Hesse*, Hang-Up. *1965–66.
Acrylic on cloth over wood, and acrylic
on cord over steel tube, 6 feet x 7 feet x
6 feet 6 inches (1.83 x 2.13 x 1.98 m). The
Art Institute of Chicago, Gift of Arthur
Keating and Mr. and Mrs. Edward Morris
by exchange.*

the view of earlier abstractionists. In describing her art, she referred to the forms she created as "abstract objects" that are "detached but intimate, personal," objects that are "not symbols for something else."[132] Her use of pliable, often loosely hanging materials reinforces this sense of an interior realm, but she frequently exaggerated the eccentricity of her forms in order to express what she regarded as "the absurdity of extreme feeling."[133] She felt that she had succeeded in conveying this in *Hang-Up*, 1965–66 (fig. 207), which she described as "the most ridiculous structure I have ever made and that is why it is really good. It has the kind of depth or soul or absurdity or life or meaning or feeling or intellect that I want to get." She explained her notion of absurdity as having to do with "contradictions and oppositions. . . . order versus chaos, stringy versus mass, huge versus small, and I try to find the most absurd opposites or extreme opposites." For Hesse, although the process of making a sculpture involved "only the abstract qualities"—materials, form, size, scale, positioning—these did not constitute the "totality of the image." She insisted that "art and life are inseparable. If I can name the content . . . it's the total absurdity of life."[134]

A year before she died, Hesse wrote of being driven to reach another kind of art, which she described as "non art, non connotive, non anthropomorphic, non geometric, non nothing, everything, but of another kind, vision, sort" and of striving to accomplish this "through total risk, freedom, discipline."[135] Hesse's words reiterated the element of risk in the project of abstraction. She recognized, as the Abstract Expressionists had, that only by taking risks can an artist attain freedom, and that freedom must be accompanied by discipline. "Chaos can be as structured as non-chaos," she declared. "That we know from Jackson Pollock."[136] Hesse had a firm sense of discipline, which she had learned from the same teacher that Robert Rauschenberg had studied with: Albers, one of the toughest taskmasters of abstraction.

Puryear's work possesses the simple clarity of Minimalist form but contains within it the implied criticism that Minimalism cultivates neutrality and an industrial aesthetic at the expense of a human dimension. Influenced by traditional West African and Scandinavian woodworking techniques, which he learned during a stint in the Peace Corps in Sierra Leone from 1964 to 1966 and a visit to Sweden from 1966 to 1968, Puryear's approach to sculpture emphasizes natural materials and handcrafted poetic abstract forms. His wood relief of roughly parallel lines, *Some Tales*, 1975–77 (fig. 208), displays these characteristics as well as a deliberate, loose-limbed imprecision, which appears frequently in his work, and which contrasts dramatically with the grids of much Minimalist art. Through surprising juxtapositions and the manipulation of materials, Puryear creates elusively metaphorical Post-Minimalist structures. *Night and Day*, 1984 (fig. 209), consists of a ten-foot-long pine beam over which is suspended a semicircular wire arc that he has bisected by painting half of it white and the other half black. *Sanctum*, 1985 (fig. 210), a massive biomorphic form made of pine and tar-covered wire mesh, is simultaneously playful and ominous.

Serra, who began his career in 1967 making rubber-and-neon hanging works (such as *Belts*, 1966–67, fig. 211) that have much in common with Hesse's hanging pieces in their implied critique of Minimalist sculpture, soon adopted lead as his material of choice to make sculptures of greater clarity and weight. These became part of an ongoing series intended to manifest certain specific actions, based on a list of verbs that he wrote down in 1967 and 1968. The first work in the series consists of lead splashed in a molten state along the base of a gallery wall, a sheet of lead torn into ribbons and scattered on the

208. *Martin Puryear,* Some Tales,
*1975–77. Ash and yellow pine,
approximately 30 feet (9.14 m) long.
Panza Collection.*

209. Martin Puryear, Night and Day,
1984. Painted pine and wire,
6 feet 11 ½ inches x 9 feet 10 ½ inches x
5 inches (2.12 x 3.01 x .13 m). The Patsy R.
and Raymond D. Nasher Collection,
Dallas.

210. Martin Puryear, Sanctum, 1985.
Pine, wire mesh, and tar, 6 feet 4 inches x
9 feet 1 inch x 7 feet 3 inches (1.93 x 2.77 x
2.21 m). Whitney Museum of American
Art, New York, Purchase, with funds from
the Painting and Sculpture Committee.

211. *Richard Serra,* Belts, *1966–67. Vulcanized rubber, neon tubes, and neon transformer, 7 feet x 24 feet x 1 foot 8 inches (2.13 x 7.32 x .51 m) overall. Solomon R. Guggenheim Museum, New York, Panza Collection 91.3863.*

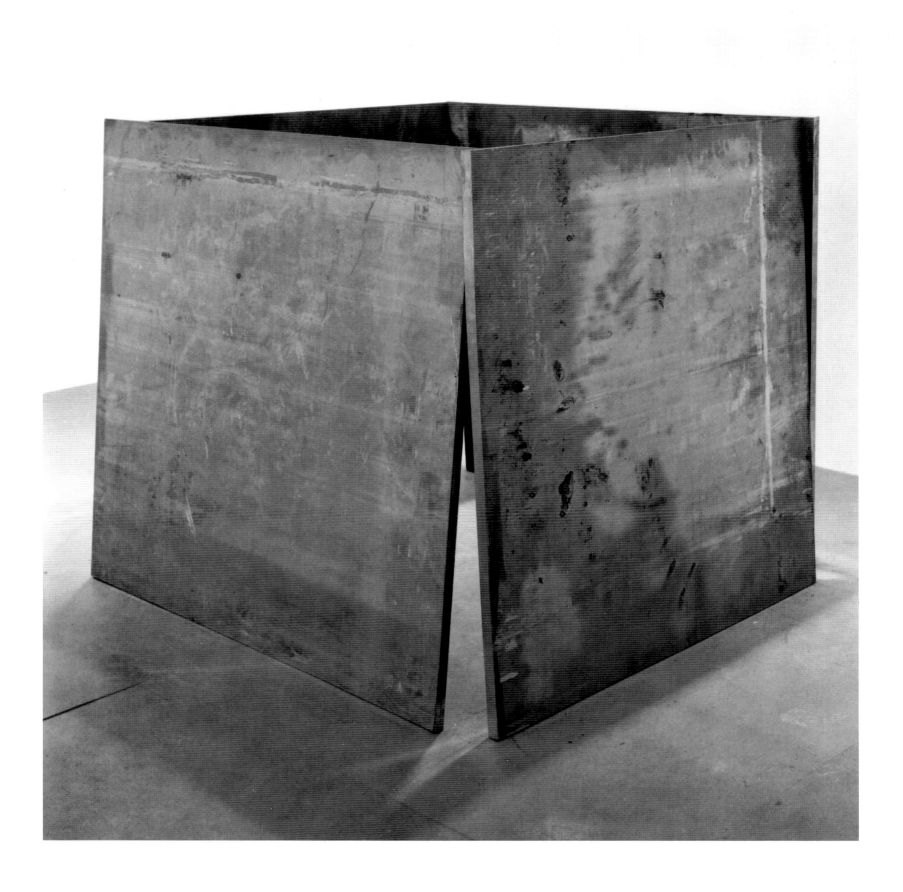

floor, and a thin square of lead pinned to a wall only by the force of a steel pipe propped against it. The verb "to prop" inspired more works from Serra, such as *One Ton Prop (House of Cards)*, 1969 (fig. 212), a loose cubic structure of four four-foot-square slabs of lead precariously propped together at the upper corners and held in place only by gravity. In these prop works, Serra articulated what became his signature style, which is characterized by the regularity of form, economy of means, and use of monochrome and industrial materials typical of Minimalist works, but with even greater physicality and a deeper focus on the relationship between the sculpture and its surroundings. Serra found the literal qualities and the emphatic geometry basic to Minimalism insufficient for his own work, for he felt that the Minimalists "left no room for doubt, no room for anxiety, no room for anything that would not substantiate a general proposition."[137] By introducing a potential element of danger through the "notion of collapse in the early lead props,"[138] he created a constant state of tension in the work, giving it emotional weight and establishing a new relationship between sculpture and viewer.

What he had also discovered in making *One Ton Prop (House of Cards)* was that "it was not exclusively the properties of the material which interested me" but its sculptural character, for "it had volume, weight, mass, a core and one could walk around it."[139] Even more than Andre and Flavin, Serra made the viewer's active participation with an abstract sculpture central to his approach. Within a few years, he was making sculptures with "larger scale and larger masses" that viewers could "enter into" and "go through," and that "dissolved into the sculptural field which is experienced in time,"[140] such as *Five Plates, Two Poles*, 1971–85 (fig. 215). The scale and disposition of forms in these works is such that, according to Serra, no work can be grasped as a single gestalt but can only be comprehended as a series of perceptions gained through the physical experience of the sculpture and its context over time.[141] What Serra's work has in common with Andre's is, as Serra has described it, the sculpture establishing "coordinates to your body that you understand when you walk through it."[142] But whereas Andre imagines the possibility of his floor pieces being virtually invisible in a space, Serra hopes that viewers will perceive how each of his site-specific works "declares" itself and "change[s] the description of a space."[143] For Serra, this condition is a "behavioral space in which the viewer interacts with the sculpture in *its* context."[144]

In making most of his sculptures, Serra does not begin with an a priori idea, as the Minimalists did, but lets the particular features of the landscape or interior space determine the placement and character of the work's elements, as the sloping terrain did in the disposition of the low concrete walls of *Shift*, 1970–72 (fig. 213). However, he does not try to make these site-specific works "fit" into their surroundings, for that would be a betrayal of his art.[145] He has explained the process as follows:

The scale, size and location of site-specific works are determined by the topography of the site, whether it be urban or landscape or architectural enclosure. The works become part of the site and restructure both conceptually and perceptually the organization of the site. My works never decorate, illustrate or depict a site.

The specificity of site-oriented works means that they are conceived for, dependent upon and inseparable from their location.[146]

Pollock's "non-compositional overallness" was an important influence on Serra's early works,[147] and Newman's use of enormous scale was a revelation for its sense of space and mass unfolding over time.[148] Like

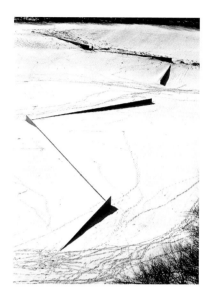

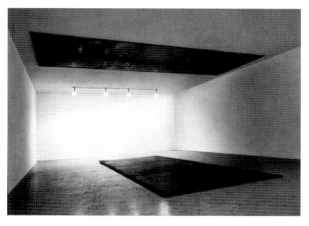

213. Richard Serra, Shift, King City, Ontario, 1970–72. Concrete, six units, 5 feet x 90 feet x 8 inches (1.52 x 27.43 x .2 m); 5 feet x 240 feet x 8 inches (1.52 x 73.15 x .2 m); 5 feet x 150 feet x 8 inches (1.52 x 45.72 x .2 m); 5 feet x 120 feet x 8 inches (1.52 x 36.58 x .2 m); 5 feet x 105 feet x 8 inches (1.52 x 32 x .2 m); and 5 feet x 110 feet x 8 inches (1.52 x 33.53 x .2 m); 815 feet (248.41 m) long overall. Collection of Roger Davidson, Toronto.

214. Richard Serra, Delineator, 1974–75. Steel, two plates, 1 inch x 10 feet x 26 feet (.02 x 3.04 x 7.92 m) each. Collection of the artist and Ace Gallery, Venice, California.

facing page:
212. Richard Serra, One Ton Prop (House of Cards), 1969. Lead antimony, four plates, 48 x 48 x 1 inches (122 x 122 x 2.5 cm) each. The Museum of Modern Art, New York, Gift of the Grinstein Family, 1986.

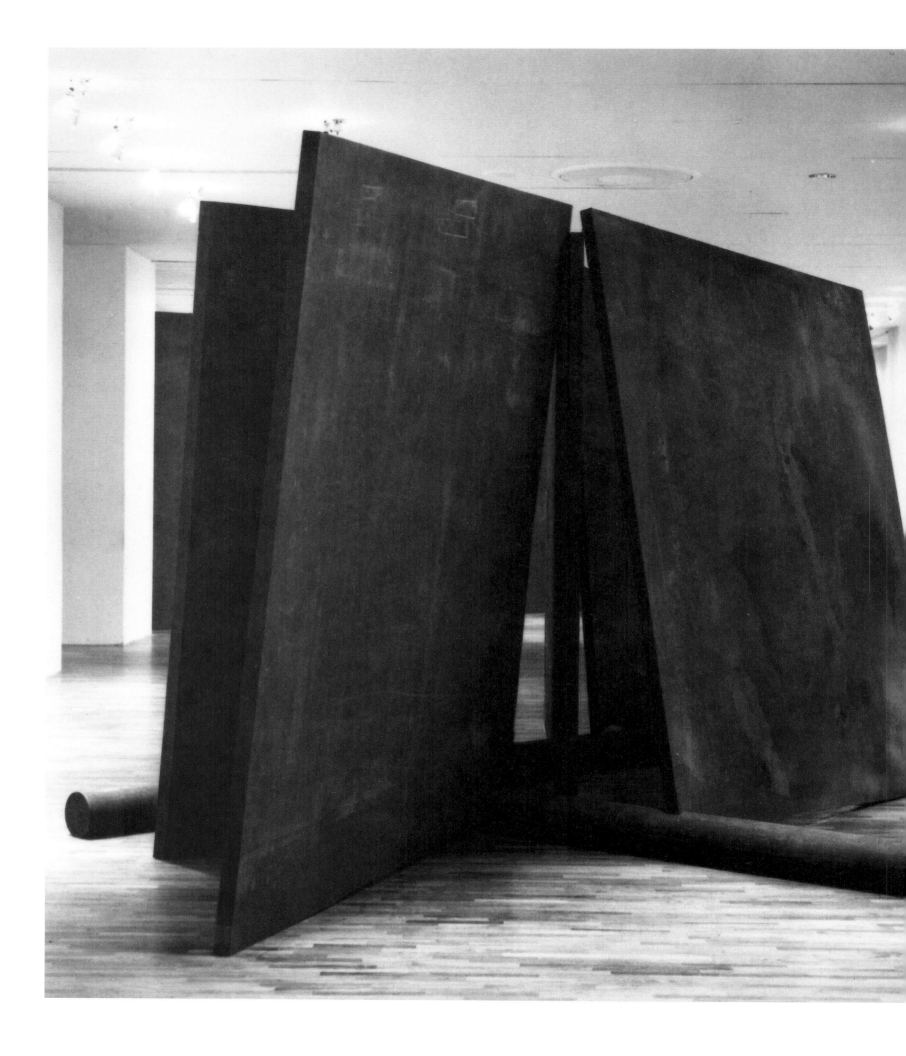

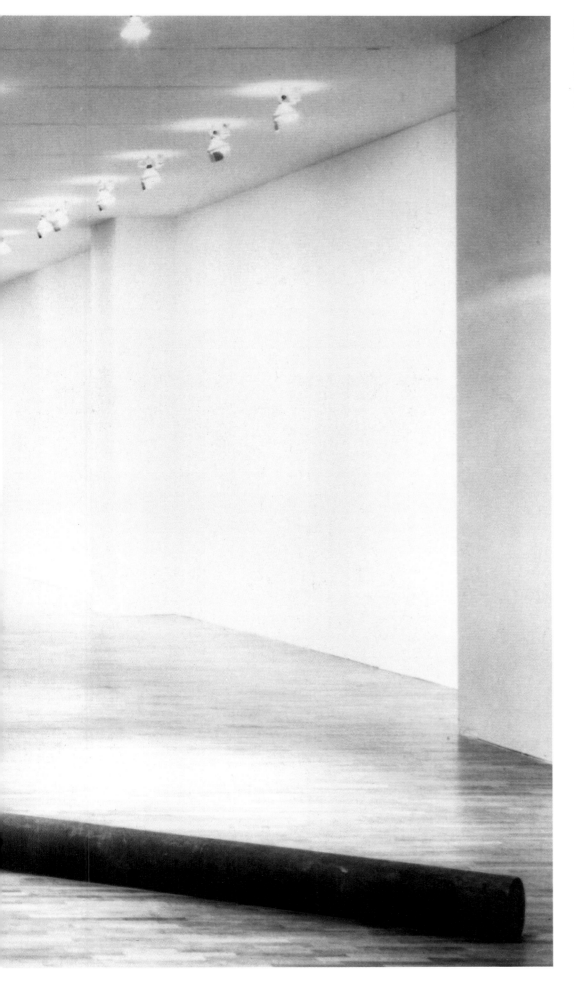

215. *Richard Serra*, Five Plates, Two Poles, *1971–85. Hot-rolled steel; five plates, 8 feet x 8 feet x 2 inches (2.44 x 2.44 x .05 m) each; two poles, 12 feet 6 inches (3.81 m) long, 7 inches (.18 m) in diameter each; 8 feet x 23 feet x 18 feet (2.44 x 7.01 x 5.49 m) overall. Collection of the artist.*

others in this generation of abstractionists, he also admired the work of Brancusi and Malevich. Serra declared that although Brancusi's *Endless Column* influenced many of the Minimalists, he "was more interested in Brancusi's open pieces, like the *Gate of the Kiss*."[149] The cross image in several paintings by Malevich is comparable to the basic configuration of Serra's *Delineator*, 1974–75 (fig. 214),[150] in which two steel plates extend Malevich's flat painted form into three-dimensional space. This cruciform structure can be entered by viewers, though with a certain amount of trepidation over its stability.

In his sculptures and drawings, Serra follows the neutral monochrome approach that was adopted by so many abstract artists in the 1950s and 1960s, and which he chose in order to avoid "allusions to nature."[151] He has always been uncompromising in his adherence to abstraction, but feels some ambivalence about being tied to its historical tradition. When Serra was laboring in 1974 over his first drawing on linen, applying Paintstick with his fingers to make a large black trapezoid, he impulsively wrote on the wall next to it "Abstract Slavery," which became the title of the work (Kröller-Müller Museum, Otterlo). He later said of this moment: "The labor that went into covering the surface was a kind of slavery. Also, if you involve yourself in the quest of abstraction, and you take that tradition on as a primary concern that you want to understand and know, it implies a subjugation, or a kind of slavery, to a historical convention. To be involved with the convention of abstraction means to a degree to be victimized by it. That is the reason for the title. . . . I still think I'm involved in that concept."[152]

Serra considers his forms "ambiguous, indeterminable, unknowable,"[153] as any abstractionist must. For Serra, as for others before him, the freedom of abstract art lies precisely in its uselessness, its lack of any explicit utilitarian function.[154] Because "there is no socially shared metaphysic,"[155] he sees no point to symbolism: "The interesting thing about abstract art is that given the basic position one assumes and the kind of experience one needs to have, the work remains free, in that it doesn't need to serve any ideological premise. . . . There's a real trend now to demean abstract art as not being socially relevant. . . . I don't [feel] that art needs any justification outside of itself."[156] In defending his interest in making completely "nonutilitarian, nonfunctional" abstract sculpture, Serra acknowledged that "there is no audience" for such an activity. He contrasted it with "art as commercial enterprise," which he condemned for its simplemindedness and venal materialism, recalling the early abstractionists' attacks on materialism. He wrote scathingly of the "big audience for products which give people what they want and supposedly need, and which do not attempt to give them more than they understand. Marketing is based on this premise. . . . [T]he more one betrays one's language to commercial interests the greater the possibility that those in authority will reward one's efforts."[157]

Starting in the late 1960s, several artists realized that the Minimalist approach to sculpture opened the way for an abstract work of art to have a reciprocal relationship with the space in which it is located, and took this concept further, creating art at specific outdoor sites by manipulating part of the terrain. One of the pioneers of this kind of work was Smithson. In 1968, he organized a show with the title *Earthworks*, consisting of photographic documentation of various interventions that he and other artists had made in remote locales. Two years later, he created a monumental earthwork that he called *Spiral Jetty* (fig. 216) by moving six thousand tons of earth in Utah's Great Salt Lake to form an enormous raised spiral, which he planned as a temporary intrusion in the landscape, to be eroded and swallowed

up by the water after several years. (It is now under water.) Morris aptly described such works as "essentially a continuation of Abstract Expressionism's impulse for grandeur fused to Minimalism's emblematic forms."[158] They are radical extensions of the relationship between artwork and environment established by Andre in his floor sculptures, Flavin in his light installations, and LeWitt in his wall drawings; the earliest ones preceded Serra's first site-specific sculptures at outdoor urban sites by only a year or two.

In the mid-1960s, before creating his first earthwork, Smithson had been making machine-tooled Minimal sculptures using steel and aluminum, although he asserted that these are "not really Minimal" but "more related to crystallized notions about abstraction."[159] Within a few years he was extending his ideas about abstraction into the landscape, creating geometric compositions on a vast scale in outdoor settings. He also brought the raw materials from outdoors into the gallery, placing them in industrial-metal containers of his own design, thus creating a synthesis of organic abstraction and Minimalism. Smithson called his earthworks "abstract geology."[160] The effect, like that of ancient burial mounds or the megaliths at Stonehenge, was to assert the legacy and authority of abstract art as handed down from the distant past.

Smithson regarded his earthworks and his gallery pieces as belonging to two different categories: site and nonsite. He described the work that he called the "site" as "the physical, raw reality—the earth or the ground that we are really not aware of when we are in an interior room," and its complement (the gallery pieces) as "the land [transferred] indoors, to the non-site, which is an abstract container."[161] When Smithson moved indoors, as in his *Eight-Part Piece (Cayuga Salt Mine Project)*, 1969 (fig. 219), he brought with him that sense of "abstract geology," as if providing artifacts for domestic contemplation. *Eight-Part Piece* consists of eight mirrors laid out in a row on top of a long flat pile of rock salt taken from the Cayuga Salt Mine, with nine smaller piles of the rock salt almost covering the mirrors' adjacent edges (and the space in between) and flanking each end of the row.

Beginning in the mid-1960s, Smithson used the word "crystalline" to indicate a particular kind of abstraction, "rooted in crystal structure" and based on a concern with the elements of matter itself. At first this led him to create works based on "grids and planes and empty surfaces," as in his *Enantiomorphic Chambers*, 1965 (fig. 217), a sculpture of painted steel and mirror,[162] and to admire the Minimal sculptures of Flavin, Judd, LeWitt, and Morris.[163] During this period he also expressed admiration for the "Ultramoderne" architecture of the 1930s, with its façades resembling "topographic maps or interminable landscapes,"[164] but criticized de Kooning, Pollock, and Frank Lloyd Wright for their biomorphic abstraction, which he considered too expressive and anthropomorphic and therefore not sufficiently abstract.[165] Soon Smithson "began to see the grid as a kind of mental construct of physical matter," and in a proposal for the Dallas–Fort Worth Airport in 1966 "was dealing with grids superimposed on large land masses, so that the inklings of the earthworks were there."[166] With his earthworks and nonsites, he created a dialectic "between the organic and the crystalline,"[167] and even found echoes of "abstract geology" in Pollock's work (describing Pollock's "deposits of paint" in terms of "layers and crusts" and "splashes of marine sediments").[168]

Smithson asserted that, whereas the representational artist deals with human history, he was interested in "time on a geological scale . . . the great extent of time which has gone into the sculpting

of matter."[169] But he did not believe that art "was supposed to be on some eternal plane, free from the experiences of the world."[170] He criticized pure abstraction for pretending to be free of time and independent of nature.[171] Rather than "imposing an abstraction" on a site in making his earthworks, he said that he became involved in the processes of nature and thus felt a part of nature.[172] In a 1970 interview, Smithson discussed how Wilhelm Worringer, in *Abstraction and Empathy*, identified abstraction as arising out of the tendency of some artists "to exclude the whole problem of nature and just dwell on abstract mental images of flat planes and empty void spaces and grids and single lines and stripes, that sort of thing."[173] Smithson elaborated on this in his last published essay (published five months before his death in 1973):

"The primal artistic impulse," says Worringer, "has nothing to do with the renderings of nature." Yet, throughout his book he refers to "crystalline forms of inanimate matter." Geometry strikes me as a "rendering" of inanimate matter. What are the lattices and grids of pure abstraction, if not renderings and representations of a reduced order of nature? Abstraction is a representation of nature devoid of "realism" based on mental or conceptual reduction. There is no escaping nature through abstract representation; abstraction brings one closer to physical structures within nature itself. But this does not mean a renewed confidence in nature, it simply means that abstraction is no cause for faith. Abstraction can only be valid if it accepts nature's dialectic.[174]

He made it clear that his work was "not involved with nature, in the classical sense,"[175] for he was concerned with the disorder and chaos of nature as it occurs over time. But as an artist who took on "the persona of a geologic agent,"[176] he felt engaged with, not estranged from, nature. Smithson's form of abstraction was thus never "devoid of 'realism.'"

Long has, since 1967, made site-specific arrangements of stones and other natural materials in remote locations and in gallery spaces. Unlike Smithson's, his interventions in the landscape are delicate and unobtrusive and do not permanently alter the terrain: he has trimmed the flowers in a meadow to make an X-shaped depression in it or, more commonly, gathered stones or branches into a row, a circle, or some other geometric pattern during the course of one of his frequent walks in the wilderness. Some of his indoor pieces, such as *Carrara Line*, 1985 (fig. 220), are similar arrangements of rocks that he has collected during such walks, but conceived for the site of a gallery floor. In recent years, Long has also used mud to make geometric drawings improvised directly on walls, using mud, such as *River Avon Mud Circle*, 1986 (fig. 218). Whether indoors or out, these works are manifestations of the chaos of nature subjected to the human invention of geometry. Though a great admirer of Andre's floor pieces, Long rejected the industrial materials and technology that Andre embraced. Even in the artificial space of a gallery, Long's sculptures are paeans to nature.

Long has described his work as "abstract art laid down in the real spaces of the world,"[177] and finds in that a "link with primordial art,"[178] a connection made earlier by Kandinsky and others. Using only the materials of nature, he leaves the mark of his presence in wilderness areas the way prehistoric peoples once did. His sculptures are about that primordial connection to the earth, experienced directly. "My art," he says, "is the essence of my experience, not a representation of it."[179]

While Long and Smithson brought abstraction out of the studio and

216. Robert Smithson, Spiral Jetty, *Great Salt Lake, Utah, April 1970. Rocks, earth, and salt crystals, 1500 feet (457.2 m) long. Estate of Robert Smithson, Courtesy of John Weber Gallery, New York.*

217. Robert Smithson, Enantiomorphic Chambers, *1965. Steel and mirrors, two chambers, 34 x 34 x 34 inches (86.4 x 86.4 x 86.4 cm) each. Estate of Robert Smithson, Courtesy of John Weber Gallery, New York.*

218. Richard Long, River Avon Mud Circle, *1986. Mud on wall, 17 feet 4 inches (5.3 m) in diameter. Included in* Richard Long, *Solomon R. Guggenheim Museum, New York, September 12–November 30, 1986.*

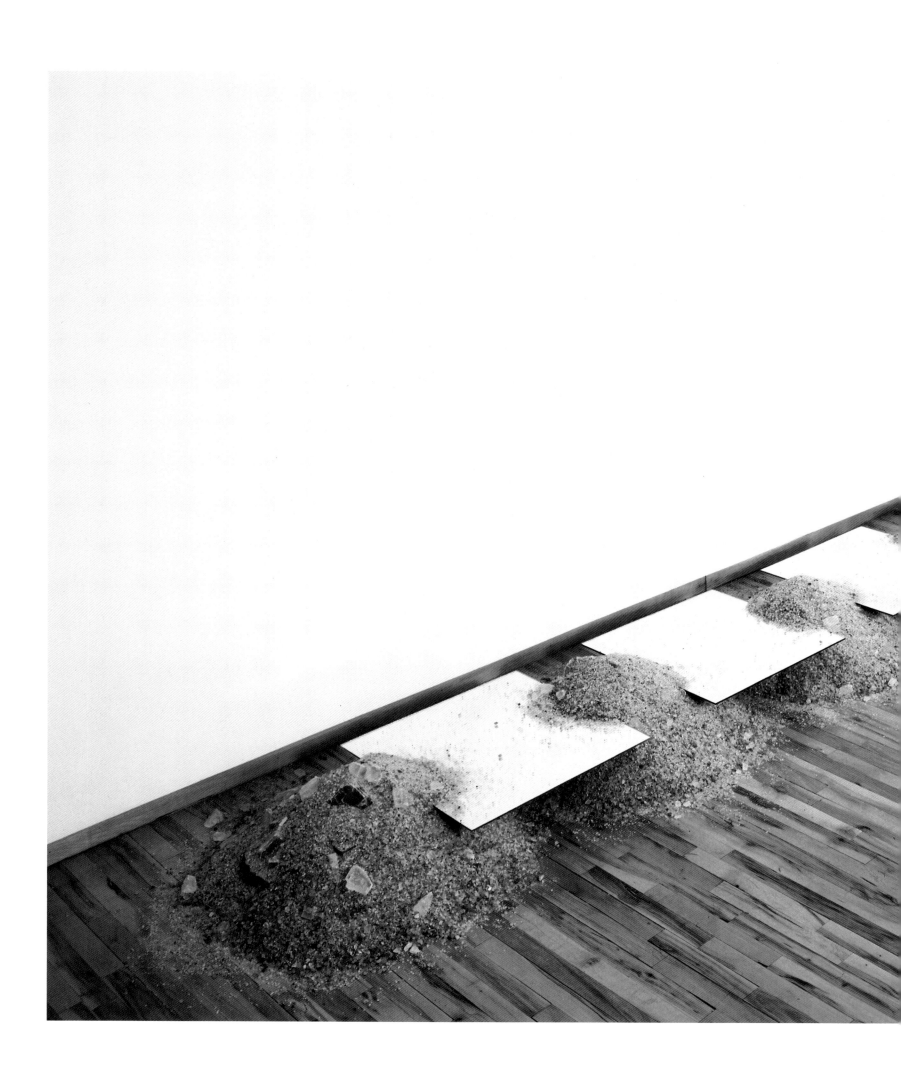

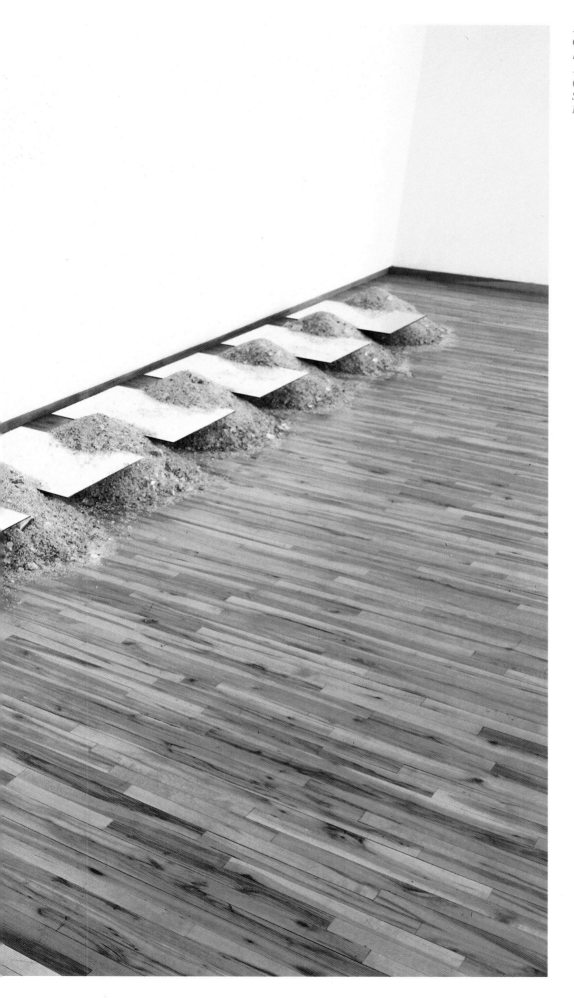

219. *Robert Smithson*, Eight-Part Piece
(Cayuga Salt Mine Project), *1969.*
Rock, salt, and mirrors, approximately
11 inches x 2 feet 6 inches x 30 feet
(.27 x .76 x 9.14 m). Estate of Robert
Smithson, Courtesy of John Weber Gallery,
New York.

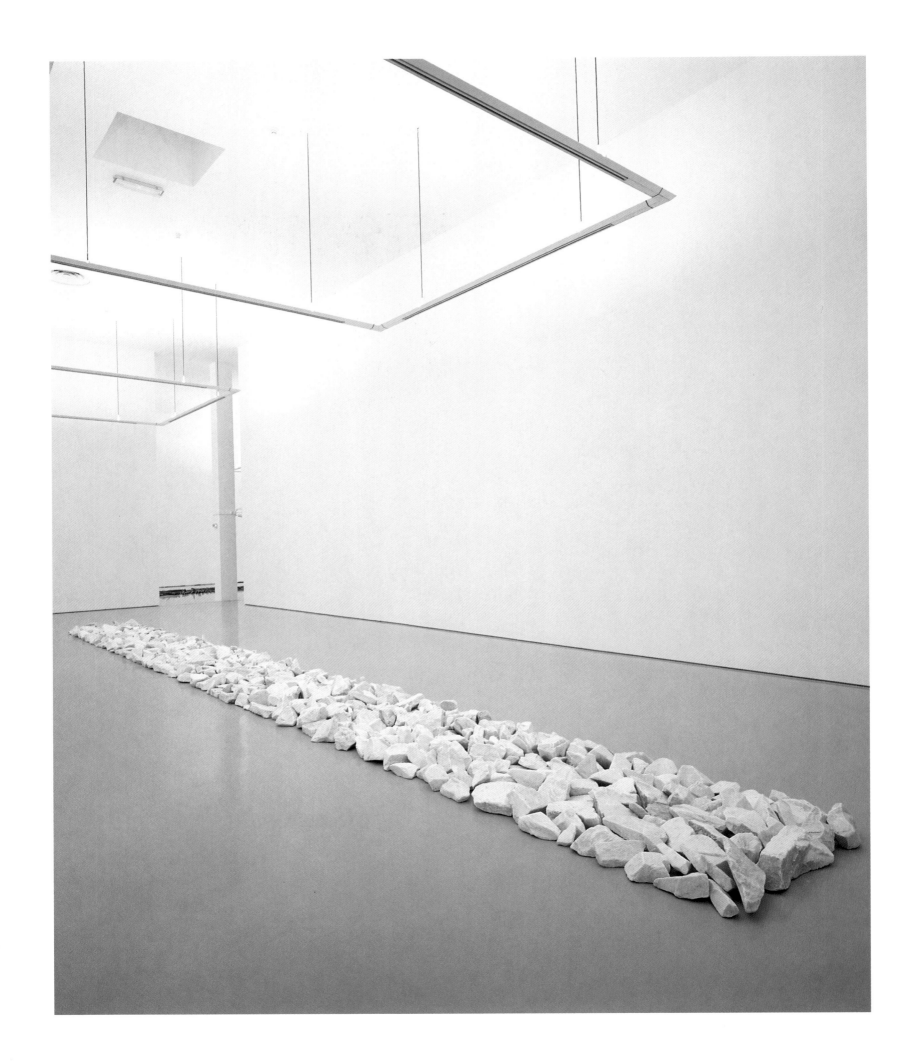

into the landscape, such artists as Robert Irwin, Maria Nordman, and James Turrell—part of the so-called West Coast space and light movement—gave abstraction a new dimension within a gallery setting. Irwin began his career in the late 1950s as an Abstract Expressionist painter before developing a more reductive style, which led in 1964–66 to his seemingly monochrome "dot paintings" (in which he applied pinprick-size red and green dots over the surface of a bright white ground). He followed these in 1966–67 with reliefs consisting of an aluminum disk painted white and illuminated with several spotlights to create a pattern of overlapping circular shadows behind it (for example, fig. 221), blurring the distinctions between solid objects and immaterial effects. This use of light to dematerialize the object, challenging the viewer's perceptions and assumptions about real space, became Irwin's predominant theme. In 1970, he expanded on his exploration of this theme so that each work would encompass the entire space of a room in a gallery or museum, installing large panels of fabric scrim that transform the viewer's spatial context and experience, as in *Scrim Veil—Black Rectangle—Natural Light, Whitney Museum of American Art, New York*, 1977 (fig. 222). The effect breaks down the barriers between art and life, or suggests that life—a mysterious element here—might be beheld through the veil of art. As Irwin has described it:

That scrim material . . . tended to affect the space as a kind of defocusing element. It's very hard to focus on that material: it sets up an ambiguity that makes everything do one of two things: either become ambiguous or razor sharp by comparison. Where a corner is will be very hard and extra clear, but where there's just surface will be very ambiguous. So that everything in that installation conspired to skew one's expectations, to raise some and lower others, so that your perceptual mechanism became tilted, and you perceived the room as you otherwise might not have. And that was all that was there. There was nothing else besides that.[180]

In the early 1980s, Irwin began to apply his ideas to spaces outside the museum or gallery, making site-specific installations in public outdoor locations using a wide range of materials, from plantings and light fixtures to chain-link fencing.

Irwin conceives of abstraction as a vehicle for a "humanistic search"[181] that leads the viewer to a greater awareness of his or her being. "What I'm really trying to do with these things is draw their attention to . . . looking at and seeing all of those things that have been going on all along but which previously have been too incidental or too meaningless to really seriously enter into our visual structure, our picture of the world."[182] The viewer's perceptual experience is Irwin's subject matter, and thus in his works abstraction gains a foothold in the world.[183] Irwin has commented that his installation works cannot really be documented, for, he asks, "How can you photograph a 'state of being'?"[184] This is a question that no Minimalist is likely to raise.

Postmodernism and Beyond

In the mid-1960s, abstraction began to attract the attention of artists who wanted to call into question its basic premises, including purity of form independent of the world of appearances, compositional unity and balance, universality, and unfettered creative freedom. The latter was attacked as an impossibility on the grounds that no art can ever completely evade worldly referents[185] and no artist can remain free of the influence of his or her cultural milieu. With these criticisms, abstraction once more faced being considered mere decoration, lacking in any meaning.[186] Beginning in the 1970s, many artists were

221. Robert Irwin, Untitled, 1965–67. Acrylic automobile lacquers sprayed on aluminum disk, with metal tube and floodlights; disk: 60 inches (152.4 cm) in diameter. Walker Art Center, Minneapolis, Purchased with matching grant from Museum Purchase Plan, the National Endowment for the Arts and Art Center Acquisition Fund, 1968.

222. Robert Irwin, Scrim Veil—Black Rectangle—Natural Light, Whitney Museum of American Art, New York, 1977. Cloth, metal, and wood, 12 feet x 114 feet x 4 feet 1 inch (3.66 x 34.75 x 1.24 m). Whitney Museum of American Art, Gift of the artist. Included in Robert Irwin, Whitney Museum of American Art, New York, April 16–May 29, 1977.

facing page:
220. Richard Long, Carrara Line, 1985. Marble stones, 4 feet 5 ¼ inches x 46 feet 11 inches (1.35 x 14.3 m). Solomon R. Guggenheim Museum, New York, Panza Collection, Extended loan.

223. *Nam June Paik,* Zen for TV, *1963–75. Television set modified to show only a vertical line, 26 ⅛ x 12 ⁷⁄₁₆ x 15 ¾ inches (67 x 49 x 40 cm). Museum Moderner Kunst Stiftung Ludwig, Vienna, formerly Collection Hahn, Cologne.*

224. *Andy Warhol,* Five Deaths Seventeen Times in Black and White, *1963. Silkscreen ink on synthetic polymer paint on canvas, two panels, 8 feet 7 ¼ inches x 6 feet 10 ¼ inches (2.62 x 2.09 m) each. Öffentliche Kunstsammlung Basel, Kunstmuseum.*

influenced by certain developments linked to Conceptual art and Structuralist philosophy, and this skepticism became more widespread, part of a trend now commonly referred to as Postmodernism.

Some antecedents for this critical attitude can be seen in many works from the late 1950s and 1960s. Jasper Johns's *White Flag* (Collection of the artist) and *Green Target* (fig. 163), both 1955, by doubling as monochrome abstractions and literally meaningful patterns, eroded the notion of abstraction's purity of form; and Nam June Paik's *Zen for TV,* 1963–75 (fig. 223), mocked Newman's "zip" by reducing it to a test pattern on a television monitor. Despite Andy Warhol's adherence to figurative subjects, Judd regarded his work as basically abstract, subverting subject matter by treating it "simply as 'over-all' painting of repeated elements."[187] Warhol at times even combined figurative images with pure abstraction, as in his grid-format diptych *Five Deaths Seventeen Times in Black and White,* 1963 (fig. 224), which consists of an image of a newspaper photo of a car wreck (in which five people died) repeated seventeen times, juxtaposed with a single black monochrome abstraction. When Tom Wesselmann included an abstract canvas amidst the clutter of a bathroom in one of his assemblages, *Still Life #20,* 1962 (fig. 225), the abstract work of art was further reduced in significance. On the West Coast, Joe Goode and Ed Ruscha also tweaked abstraction in such works as *Milk Bottle Painting (Two-Part Blue),* 1961–62 (fig. 226), in which Goode juxtaposed a bottle with a monochrome rectangle, and *ACE,* 1962 (fig. 227), Ruscha's superimposition of the word "ACE" on a bland monochrome field. Each juxtaposition represented an attack on the transcendent status of pure abstraction, for the addition of a banal word or object was a manifestation of the "low" on a sublime field of "high" art. European artists, too, were engaged in showing the diminished value of abstraction. For example, Sigmar Polke's *Moderne Kunst,* 1968 (fig. 228), is an "homage" to abstraction as the style of the century, but as a hollow recollection of its former glory; and Jean Tinguely's *Le Soulier de Madame Lacasse* (Öffentliche Kunstsammlung Basel, Kunstmuseum), 1960, consists of a machine shaking a blue orb, a farcical reference to the art of Klein. What these works proposed is that abstraction's time had passed and that it had become a fossil that could now be subjected to parody, or at least to an examination of its premises and its pretensions to inherent meaning.

One of the most fascinating and perplexing Postmodern artists is Gerhard Richter, whose work embodies the ambivalence that has often characterized contemporary abstraction and whose explanations of his motives have often been contradictory. His oeuvre consists of beautiful realistic landscapes and figurative paintings and some of the most moving, and equally beautiful, large-scale abstractions of the last two decades. Richter's mature oeuvre began with a series of works that he called "photo paintings," based—like Warhol's—on pre-existing black-and-white photographic images that he enlarged and projected onto canvas, and then painted using a palette of white and several shades of gray, often made to look streaked or slightly blurred. He thus preserved the photos' relationship to reality and at the same time gave them a somewhat abstract quality; by relying on ready-made sources (until 1966, when he began using his own), he avoided conveying any personal meaning. Richter's subjects during this period included family snapshots, airplanes, cars, animals, nudes, doors, curtains, and, beginning in 1968, landscapes, seascapes, and aerial views of cities and mountains. Although a few of these paintings are in color, he chose gray as the tonality of most of them, he says, because of its apparent neutrality, for no other hue better expresses "nothing."[188] In 1966, while continuing to make his gray photo paintings, Richter began a series

based on color charts, consisting of gridlike arrangements of monochrome rectangles or squares of various colors (fig. 229). (He returned to this series in 1971 and 1973–74.) At this time, Richter disliked the way in which abstraction was held in "pious" regard by its adherents,[189] and was especially contemptuous of their theories of color, which he attacked with the random color combinations of his "color chart" paintings. "Colors match the same way as the right bingo numbers will," he explained.[190] He continued to deflate the possibility of meaning in representational painting as well, as demonstrated by his sequence of photo paintings of composers, scientists, poets, playwrights, and novelists, *Forty-eight Portraits*, 1971–72 (fig. 230), which are deliberate clichés, like the banal black-and-white photos of professors in a school's graduating-class yearbook.

Richter described how the gray photo paintings and the color-chart canvases became insufficient statements for him, and that in order "to survive" he needed to turn to something more extreme.[191] In 1976–77, he began to make broadly gestural, apparently spontaneous abstract paintings—dizzyingly complex layered compositions of veils, streaks, and particles of bright color that look as if they were produced by machine.[192] Both impersonal and expressive at once, and often very large, these works suggest a bravura approach to Abstract Expressionism. This type of abstraction seemed to free Richter to pursue a much more personal and liberated expression; according to him, these paintings represent "my presence, my reality, my problems, my difficulties and contradictions,"[193] as well as his own "psychic structure."[194] He continued to make large abstract paintings in this style during the 1980s (see figs. 231–33).

In the early 1980s, Richter painted a series of smoothly realistic vanitas images of skulls or burning candles, and another, larger series of landscapes in color, to which he has repeatedly returned. In a 1972 interview, in answer to a question about his preference for landscapes at that time, Richter said, "I wanted to paint something beautiful,"[195] and in a 1985 interview he declared that his landscapes represent a "yearning for a whole and simple life."[196] A year later, however, he confessed that he now found that yearning pathetic, yet he painted such landscapes in order to demonstrate that humanity projects beauty onto nature, a practice that he considers full of "stupidity" and even "mendacious."[197]

Richter's practice of utilizing several different stylistic approaches, sometimes concurrently, has always elicited confused responses from his critics, including the accusation of cynicism, which Richter denies.[198] Rather, he simply refuses to be wed to any one system, perhaps out of a frequently stated distaste for ideology of any kind.[199] But in his heart, Richter seems an abstractionist par excellence, even if in practice he has at times exhibited a kind of postmodern doubt and has not devoted himself to abstraction exclusively.

Many of Richter's statements about art echo the views of early abstractionists. He admits to sharing some of the attitudes of a still-present romantic outlook,[200] and to yearning after "lost qualities for a better world."[201] He believes that art has a quasi-religious mission, with a "moral function" to affect society[202] that has become more vital than ever in the modern era: "Now that we do not have priests and philosophers anymore, artists are the most important people in the world."[203] What they offer through their art, Richter asserted, is "a possible explanation of the inexplicable, or at least a way of dealing with it. . . . Art is the highest form of hope."[204] He has also described art as "the highest longing for truth and happiness and love" and "the most perfect form of humanity."[205]

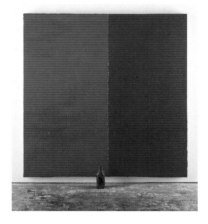

225. *Tom Wesselmann,* Still Life #20, *1962. Paint, paper, wood, light bulb, switch, and other materials, 41 x 48 x 5 ½ inches (104.1 x 121.9 x 14 cm). Albright-Knox Art Gallery, Buffalo, Gift of Seymour H. Knox, 1962.*

226. *Joe Goode,* Milk Bottle Painting (Two-Part Blue), *1961–62. Oil on canvas, and oil on glass milk bottle, 68 ½ x 66 inches (174 x 167.6 cm). Courtesy of the artist.*

227. *Edward Ruscha,* ACE, *1962. Oil on canvas, 5 feet 11 ⅛ inches x 5 feet 6 ¾ inches (1.81 x 1.7 m). Museum of Contemporary Art, San Diego, Museum purchase in memory of Lois Person Osborn.*

Moderne Kunst

228. *Sigmar Polke*, Moderne Kunst, *1968. Acrylic on canvas, 59 ⅛ x 49 ⅛ inches (150 x 125 cm). Private collection, Berlin.*

229. *Gerhard Richter,* Untitled (139/3 Farbtafeln), *1966. Lacquer on canvas, 27 ½ x 25 ½ inches (70 x 65 cm). Collection of Susan and Lewis Manilow, Chicago.*

230. *Gerhard Richter,* Forty-eight Portraits, *1971–72. Oil on canvas, forty-eight panels, 27 ½ x 21 ½ inches (70 x 55 cm) each. Museum Ludwig, Cologne.*

Not surprisingly, Richter has great admiration for many of his abstract predecessors. He saw paintings by Lucio Fontana and Pollock in the 1958 Documenta exhibition in Kassel, and was moved by the "unashamedness" of their work, in which he saw "radical" truthfulness and "liberation," the freedom to express "a completely different and new content."[206] He has stated his admiration for the work of Minimalists Andre, Flavin, LeWitt, and Ryman, but has criticized the work of Stella as decorative,[207] and has dismissed all formalist art as "empty aesthetics."[208] In a fascinating passage in his notes, Richter related Mondrian and Pollock to Donatello, Grünewald, and Rembrandt, all of whom dealt with the subjects of "despair and helplessness."[209] However, he has seemed to take contradictory positions on the utopian aspirations of abstract art, at times rejecting them[210]—perhaps because of the failures of the interwar generation— and then accepting them as necessary and inevitable.[211] In 1973, he wrote of his own abstract paintings as a rejection of the need for ideology, truth, freedom, and meaning and described Mondrian's imposition of geometric order on the infinite chaos of life as a political response to life's meaninglessness: "the question about the meaning of life is ridiculous and ascription of meaning inhuman — I realize that I cannot explain it after all. But from that point of view a picture by Mondrian is not constructivist, but political."[212]

For Richter, the most important characteristic of abstraction is its deliberate lack of meaning. He has contrasted his embrace of an abstraction without meaningful subject matter to the approach of Newman and Rothko, for whom subject matter was essential.[213] Abstract art, according to Richter, provides "a better possibility of approaching what is non-visual and incomprehensible, because it portrays 'nothing' directly visually, with all the means available to art."[214] But he asserted that "the infinite number of never-to-be-realized possibilities, the boundlessness and utter and complete meaninglessness" are "hopeful,"[215] a notion that may reflect his yearning for a divine state of bliss. Richter even quoted Cage's statement "I have nothing to say and I am saying it,"[216] and then turned it into his own mantra: "I know nothing, can do nothing, understand nothing, know nothing, nothing."[217]

Although he has rejected explicit subject matter and meaning, Richter strains for a profound and emotional sense of content in his abstractions.[218] These paintings, which represent what he called "fictitious models"—because "they illustrate a reality that we can neither see nor describe, but whose existence we can infer" and which "we describe with negative concepts: un-known, in-conceivable, in-finite"[219]—are "parables . . . of . . . a possible form of social relations."[220] If so, the paintings work as embodiments, not symbols. As such, Richter said, "The abstract is more real, the other [his landscapes] more a dream."[221]

If Richter's diverse and often contradictory statements do not comprise a program—unlike those of the early abstractionists— his ideas exemplify the postmodern dilemma. Though at moments disdainful of the high aspirations of his predecessors, he has not jettisoned these ideals, much less the heroic scale and look of their work. And what can he offer as a substitute? Richter is still filled with ambivalence, his refusal to be pigeonholed reflecting the uncertainty and transitional nature of the current era.

Richter's practice of treating abstraction as just one style among several available to him established a precedent for other artists uncomfortable with the abstract orthodoxy. Although irony is not something with which Richter is comfortable,[222] his approach suggests that outlook,[223] an irony that has been inherent in the

231. Gerhard Richter, November, *1989.*
Oil on canvas, two panels, 10 feet 6 inches x
13 feet 1 ½ inches (3.2 x 4 m) overall.
The Saint Louis Art Museum, Purchase:
Funds given by Dr. and Mrs. Alvin R.
Frank and Pulitzer Publishing Company
Foundation.

232. *Gerhard Richter,* December, *1989.*
Oil on canvas, two panels, 10 feet 6 inches x
13 feet 1 ½ inches (3.2 x 4 m) overall.
The Saint Louis Art Museum, Purchase:
Funds given by Mr. and Mrs. Donald L.
Bryant, Jr., Mrs. Francis A. Mesker,
George and Aurelia Schlapp, and Museum
Purchase; Mr. and Mrs. John E. Simon,
Estate of Mrs. Edith Rabushka in memory
of Hyman and Edith Rabushka,
by exchange.

233. *Gerhard Richter,* January, *1989.*
Oil on canvas, two panels, 10 feet 6 inches x
13 feet 1 ½ inches (3.2 x 4 m) overall.
The Saint Louis Art Museum, Purchase:
Funds given by Mr. and Mrs. James E.
Scheithorst, Mrs. Henry L. Freund and the
Henry L. and Natalie Edison Freund
Charitable Trust; Alice P. Francis,
by exchange.

234. *Daniel Buren,* 120 Paintings, *1990
(detail). Acrylic on canvas, fifteen panels,
66 ⅛ x 51 ⁹⁄₁₆ inches (168 x 132 cm) each.
C.A.P.C. Musée d'Art Contemporain de
Bordeaux. Included in* Daniel Buren,
C.A.P.C. Musée d'Art Contemporain de
Bordeaux, *June 30 –December 30, 1990.*

gathering tendency from the late 1960s on to critique the fundamental
attitudes of abstraction.

Several artists loosely associated with Conceptualism challenged the
tenets of abstraction during a period overlapping and subsequent to
Minimalism, perhaps encouraged in part by the views of European
Marxists who held abstraction in contempt because it failed to deal
with the inequalities of life and thus, they believed, had no bearing on
reality.[224] The career of French installation artist Daniel Buren, from
the late 1960s on, has consisted of using an abstract pattern of stripes
woven or printed onto a support as a vehicle for restructuring the
viewer's experience of various public spaces. In these site-specific
installations, Buren calls attention to subtextual aspects of locale in
terms of its physical and functional characteristics, and prevents the
stripes from serving a purely abstract function. In installations such as
120 Paintings, 1990 (fig. 234), Buren has mocked the possibility of
spiritual content in an abstract composition of parallel lines. German
artists Imi Knoebel and Blinky Palermo have further referenced and
deconstructed the forms of abstraction, leaving it far drier than
Minimalist painters and sculptors in America. Other artists have
violated the purity of abstraction by making what Joan Simon has
referred to as "abstractions that are worldly in reference and
appearance,"[225] an apt description of one of the fundamental changes
effected in this mode by artists in the late twentieth century. In
general, what we see here is a rejection of abstraction due to its
perceived social irrelevance, and a dismissal of its heroes as a
misguided, perhaps pitiable, group of dreamers.

The Marxist critique also challenges the idea that abstract art, or
indeed any art, can change society.[226] According to this view, the work
of art, as a valued product of materialist culture, is hardly in a position
to correct or improve civilization or to elevate spiritual consciousness;
rather, it is seen as affirming societies' institutions and concerns.[227]

A further critique leveled at abstraction is that it denies the insights
of language, and absents itself from realms in which words are the
crucial purveyors of content.[228] Abstraction has also been accused of
"aridness," and its claims to universality and absolute truth[229] have
been attacked for denying the diversity of the contemporary world.

Another idea explored by Postmodernists during the 1970s and 1980s
is that abstraction is a cohesive entity, a veritable school, with a largely
closed visual and philosophical system. Paradoxically, abstraction
achieved the status of an established movement for the first time in
the century at the same time that it came under extreme duress. The
titles of essays such as "Deconstructing Abstraction," "After the Fall,"
and "Concentric Collapse Awaiting Annealment" and books such as
Endgame all indicate its perceived demise.[230]

The artist who has written most extensively about these matters is
Peter Halley, whose Day-Glo abstractions are intended as reflections
of our social and cultural condition and a rejection of Modernist cant.
These paintings, such as *Two Cells with Circulating Conduit*, 1985
(fig. 235), are geometric compositions that consist of rectilinear shapes
in combinations intended to resemble prisons, factories, and battery
cells. He has described them in explicitly anti-Modernist terms: "The
paintings are a critique of idealist modernism. In the 'color' field is
placed a jail. The misty space of Rothko is walled up. . . . The 'stucco'
texture is a reminiscence of motel ceilings. . . . The Day-Glo paint is a
signifier of 'low-budget mysticism.' It is the afterglow of radiation."[231]
Halley regards the colors and forms in his paintings, though abstract,
as representing specific aspects of the real world, a far cry from the
spiritual or metaphysical aspirations of the early abstractionists. "The
view of modernism that I grew up with," he explained, "was that it

was spiritual, it was about a kind of purity and Emersonian transcendentalism, and that it had a very linear history. Feeling less and less comfortable with that, I decided that for me modernism was really about skepticism, doubt, and questioning . . . —things that we now say are part of a post-modern sensibility."[232] At once, Halley seeks to undermine the apparent neutrality of geometric abstraction[233] and to locate and uncover its veiled meanings, especially its potential to maintain and even glorify societal values.[234] Although he devotes considerable energy to placing himself in relation to the pivotal artists of abstraction, Halley has said that his work is not really abstract but, rather, "diagrammatic," signifying the deliberate manner in which he uses formal schema to represent social conditions.[235]

Unlike Halley, whose approach can be characterized as seriously respectful if deconstructive with regard to abstraction, other artists put more distance between themselves and their early Modernist models. Annette Lemieux, in her painting *Black Mass*, 1991 (fig. 236), presented a photographic image of a demonstration by Chinese workers carrying placards that she altered to represent multiples of Malevich's black square. The work's tone seems ironic and even sarcastic, implying the uselessness of Malevich's iconic image for these marchers. The abstract icon in Jonathan Borofsky's *Green Space Painting with Chattering Man at 2,841,789*, 1983 (fig. 237), is equally dysfunctional. Several of Alan McCollum's assemblages, such as *Ten Plaster Surrogates*, 1989 (fig. 238), consist of banal black square multiples, which he calls "plaster surrogates,"[236] that similarly cheapen Malevich's "pure feeling" and mock a hallowed image of abstraction. Borofsky, Lemieux, McCollum, and other contemporary artists trivialize the transcendent object by juxtaposing it with banalities of everyday life or merely placing it in a mass-culture context.

Another aspect of this paradoxical approach to abstraction is several artists' simulation of abstraction. This strategy takes two forms: either the incorporation of images or stylistic aspects of earlier abstract models for a new purpose, or the wholesale appropriation of selected earlier works. Halley adopted a hard-edge geometric style reminiscent of early Modernist and mid-century American geometric painting and applied it to his cell-and-conduit imagery, which he has often described as having "taken Newman's zip and made it into plumbing."[237] Ross Bleckner has borrowed Op art's patterns of stripes and added ribbons, flowers, birds, or other memorial images that allude to the era of AIDS, as in *Circle of Us*, 1987 (fig. 239). Appropriationists attempt to subvert established notions of Modernism through the ironic practice of copying earlier works and presenting them as their own "original" art. Sherrie Levine does this with her precise renderings of paintings by Braque, Marden, and other male artists, and Mike Bidlo has taken on Picasso, Pollock, and other modern masters. Most viewers are nonplussed by these literal restatements of earlier works, which, lacking the intent or soul of the precedents,[238] seem thoroughly cynical. Kuspit wrote of appropriationist abstraction "harshly criticizing itself for its youthful illusions."[239] Indeed, most simulators or appropriators of abstraction seem not to want to do away with abstraction but to reform the initial impetus. Many of these artists may be mourning the lost goals of abstraction, or expressing a nostalgia for its concerns. Substantiating this analysis, Levine has described her work as concerned with "the uneasy death of modernism" and has said, "We like to imagine the future as a place where people loved abstraction before they encountered sentimentality."[240]

Attacking earlier abstraction's striving for balance and unity of composition, many Postmodern artists deliberately cultivate

235. Peter Halley, Two Cells with Circulating Conduit, *1985. Day-Glo acrylic and Roll-a-tex on canvas, 5 feet 3 inches x 9 feet (1.6 x 2.14 m). Collection of B. Z. + Michael Schwartz.*

236. Annette Lemieux, Black Mass, *1991. Latex, acrylic medium, gesso, and oil on canvas, 8 feet x 8 feet 9 inches (2.44 x 2.67 m). Collection of Emily Fisher Landau, New York.*

237. Jonathan Borofsky, Green Space Painting with Chattering Man at 2,841,789, *1983. Acrylic on canvas, with aluminum, wood, Bondo, electric motor, speaker, and floodlights; canvas: 9 feet 4 inches x 6 feet (2.85 x 1.83 m); man: 7 feet 1 inch x 3 feet x 2 feet (2.1 x .58 x .33 m). The Rivendell Collection, On permanent loan to the Center for Curatorial Studies, Bard College, Annandale-on-Hudson, New York.*

238. Allan McCollum, Ten Plaster Surrogates, *1989. Enamel on Hydrocal, dimensions variable. Courtesy of John Weber Gallery, New York.*

disequilibrium or awkwardness in their works. Johns had mastered such a deconstructivist approach in his so-called crosshatch works of the 1970s and early 1980s, and it has been continued by others during the last fifteen years. Described by American painter David Row as the "abandonment of a Kantian ideal [and] the introduction of a fractured quality," this approach produces "a sense of the provisional, and the legitimacy of subjective interpretation."[241] This subjectivity can be seen in Row's own work, such as *Split Infinitive*, 1990 (fig. 240). While earlier abstraction was not always particularly objective, these latest abstractionists pledge that their art is subject to, and should reflect, real-life circumstances.[242] Kuspit has noted that artists such as Hans Federle, Knoebel, and Mangold create abstract compositions in which the very attainment of equilibrium seems to be the struggled-after but never-to-be-realized content of the work. A sense of desperation fills these failed attempts at harmony, as wholeness is today beyond the capacity of the creator[243]—a wholeness that is never absent in Mondrian's canvases.

Nevertheless, in numerous disparate ways, Postmodern artists suggest a future for abstraction. Christian Eckart, for example, has declared: "Art . . . has been and continues to be a struggle in the name of Life against the cynicism, pessimism and despairs of the strategies of negation and nihilism."[244] Other artists seek to make abstraction that embodies or reflects certain aspects of the real world rather than some artificial notion of "purity"[245]—for example, Halley, who wants "to interject into the ideal world of geometric art some traces of [the] social landscape."[246] Even Stella, that paradigm of formalism, is cursed with a related aspiration, as he revealed in his recent lectures on the need for abstract painting to move beyond the dead-end of Mondrian to a "new kind of pictoriality," which he subsequently explained as the creation of "space that is not compromised by decoration or illustration."[247] However, such assertions of the need to inject abstract art with life begin to have a familiar and perhaps hollow ring. In 1969, Herbert Marcuse declared that "art cannot become reality," and that the "antiart of today is condemned to remain art, no matter how 'anti' it strives to be. [It is] incapable of bridging the gap between Art and reality."[248]

Conclusion

Today, looking back over the past ninety years, and forward into the future, it is important to acknowledge both the successes and failures of abstract art, and to try to understand their significance.

When, after more than one hundred years as the dominant influence in Western art, French art was rivaled by abstraction, the concerns and traditions of several non-French cultures emerged subliminally but triumphantly through this previously unimaginable, thoroughly modern style. And after the initial art movements of the early twentieth century had played themselves out, abstraction remained fresh and viable and became the defining approach of this century. Moreover, it is a fully international art style, not bound by local narrative or language, and so relatively unchauvinistic as to be considered "universal."

The development of abstraction is comparable in certain respects to this century's remarkable developments in almost every other area of human endeavor. Just as many aspects of life have been profoundly altered by advances in science and technology, so too have the visual arts been thoroughly transformed by abstraction. Indeed, nearly every field of art—painting, sculpture, architecture, design, and photography—has been powerfully influenced by it. Abstraction has

inspired new visions of beauty that are variously intense, exciting, explosive, serene, or utterly quiet.

The best abstract art can even provide the viewer with a transcendent experience simply through the contemplation of the sensuous appearance of its materials, forms, and colors. This literal approach presumes a kind of extreme realism, positing the physical character of the work of art as an end in itself. Truth to appearance has been supplanted, then, by truth to one's medium and sensations. The creator of the abstract object has total control over the look of the finished object, and might imagine that this freedom of production represents complete personal liberty. Moreover, because of its unfettered nature, abstraction has a powerful capacity for liberating an individual's self-expression.

Even in periods when abstraction has tended to be steadfastly literal, it has retained certain aspects of Romanticism, though not in their original form. Many abstractionists have succeeded in presenting a new kind of subject matter in art, replacing religious themes with the ineffable and the sublime, or traditional subjective expression with an equally expressive formal language. Although each abstract work may appear unspecific or even hermetic, the abstract artist suggests that through it an unseen or unseeable realm can be embodied and given presence. It is a premise of this method that, when it is successful, an abstract language is achieved in which form and content are one, and that form, if skillfully rendered, can carry with it specific meaning. Indeed, abstraction has proved to have a remarkable and renewable capacity to absorb meanings, ideologies, and intentions. Each artist aspires on some level to create an individual style through which personal beliefs or a sense of self may be conveyed. While abstraction is thus an art of the mind or the spirit, the body has not been completely eliminated from this kind of art. Rather, it has become transmuted into the abstract work itself.

To carry out their work, it seems, abstractionists must reject history, in the sense of such elements as specific periods and anecdotal incidents and events, in order to concentrate on heightened emotions. And yet many abstractionists have not wished to dispense with such great subjects of the past as anguish, eros, mortality, humor, nature, frailty, horror, evil, joy, and other primal human dimensions. Abstraction has enabled the artist to address such weighty subjects in a new way, or at least to examine them in a modern context.

The successful abstract work of art, it can be argued, succeeds on many of these counts, and so it is no wonder that abstraction has been and continues to be an extremely attractive option for young artists, and one that is stubbornly clung to. Each generation's success has been to keep abstraction alive and of the moment—modern, in other words—and to keep it from degenerating into mere decoration. This can only be achieved by artists who confront the issues of abstraction in the context of their own time, and who determine just what their concerns ought to be. If Worringer's analysis is correct, however, this viability may only signal the enduring alienation and pessimism of the century. Perhaps, though, abstraction has so satisfactorily answered the call for a style that is of its time that artists will continue to be attracted by its possibilities as long as the modern outlook endures. One of abstraction's triumphs, then, is to have become a tradition— one that is a vehicle through which innovation is continuously possible, as the still-life and landscape genres have been.

For each of the successes, however, there is an attendant failure to the enterprise of abstraction. By taking the position that form is the only necessary component of art, abstract artists have courted condemnation for making art that is irrelevant, decorative, or

239. Ross Bleckner, Circle of Us, *1987. Oil on canvas, 9 x 6 feet (2.74 x 1.83 m). Private collection.*

240. David Row, Split Infinitive, *1990. Oil on canvas, 7 feet 2 inches x 9 feet 8 inches (2.18 x 2.95 m). Courtesy of André Emmerich Gallery, New York.*

superficial, characterizations that are not entirely untrue. Perhaps that is why so many members of each succeeding generation of abstractionists has tried hard to imbue their forms with meaning, especially meaning connected to life. Abstractionists anxious to suggest such a dimension have frequently assigned poetic titles to their works, going against a trend by some among their ranks to leave works untitled, and undermining the notion that the content of abstract art is completely formal. How much support is there, then, for abstraction that is thoroughly pure?

It is easy enough—perhaps too easy—to regard abstractionists as a band of individuals motivated by escapism, foolish utopianism, or pessimism, and so alienated, or solipsistically concerned only with the self, that they expunge from their art all remnants of the outside world. The notion that abstraction offers an artist complete personal freedom is illusory in the context of the real world, where one is never free from the conditions of life. If abstractionists ignore history, goes the argument, then they are truly "irrelevant."[249] When abstraction is held to be comparable to, say, the airplane or computer for its profound contribution to civilization, the counterargument is that the spiritual and material conditions of life have only been marginally or superficially affected by those inventions, with—sad to say—the human condition remaining essentially unchanged. To the claim of an apotheosis in art comes the counterclaim that no one cares.

An obvious problem for abstraction is how to find an audience and connect with it, perhaps by triggering an instinctive or intuitive response, as most music does. However, such art may be too demanding for contemporary viewers, who are not often willing to make the effort. Abstractionists must deal with the public's skepticism or lack of interest when confronted with the forbidding appearance of their art, which seems so independent, self-contained, and, too often, hermetic. The paradox is that if their art were popular, their self-proclaimed condition of freedom could be compromised or co-opted. Thus, if they are condemned to remain unpopular, artists must decide whether they can live with that situation.

The fundamental issues of abstraction seem to have remained more or less constant, following the leap from figurative versions of an abstract vision, such as Worringer discussed, to the full-blown nonobjective work produced by its early twentieth-century pioneers. Within a very short time, these artists developed certain basic formal options—spontaneous gesture, geometric composition, iconic form, and monochrome—that are still the primary strategies used by abstract artists. Many of the changes that have occurred have been incremental, modifications made by different artists as a result of variations in individual expression and cultural context. The most significant recent changes have occurred with abstraction's move to large scale, and from traditional mediums to unusual materials and such hybrid practices as installation art.

If there is little progress per se in the evolution of the essentials of abstraction, what might one say is its future as the century comes to an end? The question itself reflects the now-discredited notion that progress is inherent in the history of modern art, which some critics and art historians (Greenberg and Michael Fried foremost among them) have formulated as a series of continually evolving solutions to formal problems. Therefore, to the question posed, one might reasonably respond that abstraction's future lies in artists continuing to find it a useful method of expressing all sorts of ideas. And yet, at this moment art is so oriented to social issues that such a rarefied style again seems superfluous. But if it is still with us, practiced by some and held up by others as an aesthetic against which to rebel, then its

basic premises must still have some relevance. Oddly enough, in the current art climate, abstraction might find a public that is relieved to escape art concerned with social and political issues. Moreover, there is by now a certain legibility to the language of abstraction, since it became firmly established in painting and sculpture and has come to permeate so many other areas.

Abstraction's immediate future will in part be determined by the critiques of it made by the current generation. Thus, if no artist feels the need to work in an idiom that provides freedom from the concerns and images of the material world, it will cease to be championed. If art based solely on the sensuous effect of formal elements is considered insufficient for an audience that demands cultural relevance, then perhaps artists will bend abstraction to new uses, if it survives at all. If abstract art's implication of a harmonious universe, in which the individual is unthreatened, is seen to be false or self-indulgent, then the style will have no bearing on contemporary thinking. In this age that celebrates diversity, a variety of quirky individual approaches might be preferred to the homogeneity of abstraction's "universal" language (a language that is also often identified with the white male power elite, when that group's viewpoint is frequently considered suspect). One might now ask whether such universality is worth seeking, or even possible, in an era when an artist's work may not be understood by viewers unfamiliar with his or her origins. Abstraction is in the category of "high art," which claims a privileged position in society. Since all similar "high" manifestations have lately been discredited, or simply overwhelmed by popular culture, abstraction can hardly expect a different fate.

The appearance now of a publication devoted to abstraction might therefore be regarded as an act of nostalgia, in an age that dismisses the emotional, personal experiences that most abstract artists so value. When the self-indulgence of social "irrelevance" is guarded against, and alienation is considered a weakness, an art about Nothing will be considered boring, and an art that values exaltation will be seen as eccentric.

Abstraction may be threatened, too, by the loss of its moral force, with its chief younger exponents themselves expressing ambivalence. Whenever abstraction has lost its sense of conviction and its sense of risk, it has become academic. And it courts demise when its existence as a tradition becomes too hidebound, for it survives best as a cause. A successful abstract work has to be imbued with emotion and have that sense of risk, and still look convincing. It remains to be seen if such work will continue to be created.

Notes

Introduction

1. Alfred H. Barr, Jr., *Cubism and Abstract Art*, exh. cat. (New York: Museum of Modern Art, 1936; reprint, New York: Arno Press, 1966), p. 19.

2. Eva Hesse, artist's statement (1969), in *Art in Process IV*, exh. cat. (New York: Finch College Museum of Art, 1969); reprinted in *Eva Hesse: A Memorial Exhibition*, exh. cat. (New York: Solomon R. Guggenheim Museum, 1972), unpaginated.

3. Piet Mondrian, "Reply [to the editors of *Cahiers d'art*]," *Cahiers d'art* (1931); reprinted as "On Abstract Art," trans. Harry Holtzman and Martin James, *The League Quarterly* 19, no. 1 (spring 1947), p. 7.

4. Michael Fried, *Absorption and Theatricality: Painting and Beholder in the Age of Diderot* (Berkeley: University of California Press, 1980), p. 81.

5. Ibid., pp. 74, 90.

6. Ibid., pp. 103–04.

7. Ibid., pp. 92–93.

8. One of the most influential books that assisted artists of the pre-Modern era in this task was by Swiss scientist Johann Kaspar Lavater, *Physiognomical Fragments for the Promotion of the Knowledge and Love of Mankind* (1775–78; 1802), which analyzed aspects of human character in terms of physical idiosyncrasies (Lorenz Eitner, ed., *Neoclassicism and Romanticism 1750–1850*, Sources and Documents in the History of Art, ed. H. W. Janson [Englewood Cliffs, N.J.: Prentice-Hall, 1970], vol. 1, pp. 86–88).

9. For a brief survey of the issue of style, see Meyer Schapiro, "Style," in A. L. Kroker, ed., *Anthropology Today* (Chicago: University of Chicago Press, 1953); reprinted in Morris Philipson and Paul T. Gudel, eds., *Aesthetics Today* (rev. ed.; New York: New American Library, 1980), pp. 137–71. See also Nelson Goodman, "The Status of Style," in *Ways of Worldmaking* (Indianapolis: Hackett, 1978), pp. 23–40; Jules David Prown, "Style as Evidence," *Winterthur Portfolio* 15, no. 3 (fall 1980), pp. 197–210; Rudolf Arnheim, "Style as a Gestalt Problem," *Journal of Aesthetics and Art Criticism* 39, no. 3 (spring 1981), pp. 281–89; Willibald Sauerländer, "From Stilus to Style: Reflections on the Fate of a Notion," *Art History* 6, no. 3 (September 1983), pp. 253–70; Arnold Hauser, *The Philosophy of Art History* (New York: Alfred A. Knopf, 1959), pp. 207–36; and David Summers, "'Form,' Nineteenth Century Metaphysics and the Problem of Art Historical Description," *Critical Inquiry* 15, no. 2 (winter 1989), pp. 372–406.

10. Donald B. Kuspit, "The Illusion of the Absolute in Abstract Art," *Art Journal* 31, no. 1 (fall 1971), p. 28.

Chapter 1

1. See Wassily [Vasily] Kandinsky, "Reminiscences" (1913), reprinted in Robert L. Herbert, ed., *Modern Artists on Art: Ten Unabridged Essays*, trans. Eugenia Herbert (Englewood Cliffs, N.J.: Prentice-Hall, 1964), p. 26. Robert L. Herbert later corrected the long-standing English-language mistranslation of Monet's *meules de blé* as "haystacks"; they are in fact "stacks of wheat" or "grainstacks" and, he pointed out, can be seen to represent "the farmer's wealth," thereby suggesting a deeper content than previously assumed (Herbert, "Method and Meaning in Monet," *Art in America* 67, no. 5 [September 1979], pp. 106–07).

2. For more on Monet in relation to abstraction, see Clement Greenberg, "The Later Monet," in Greenberg, *Art and Culture: Critical Essays* (Boston: Beacon Press, 1961), pp. 37–45; and William Seitz, "Monet and Abstract Painting," *College Art Journal* 16, no. 1 (fall 1956), pp. 34–46; both reprinted in Charles F. Stuckey, ed., *Monet: A Retrospective*, exh. cat. (New York: Hugh Lauter Levin Associates, 1985), pp. 367–81. For more on the relation of Impressionism to abstraction, see Meyer Schapiro, "Nature of Abstract Art," *The Marxist Quarterly* 1, no. 1 (January–March 1937), pp. 77–98; reprinted in Schapiro, *Modern Art: Nineteenth and Twentieth Centuries: Selected Papers* (New York: George Braziller, 1978), pp. 185–211.

3. Robert L. Herbert, *Impressionism: Art, Leisure, and Parisian Society* (New Haven: Yale University Press, 1988), p. xiv.

4. Albert Boime, *The Academy and French Painting in the Nineteenth Century* (London: Phaidon, 1971), pp. 166–84.

5. Paul Cézanne emphasized that the source of his art was rooted in perceptions about nature: "I simply must produce after nature," he wrote in a letter to his son Paul (Aix, October 13, 1906), excerpted in Herschel B. Chipp, ed., *Theories of Modern Art: A Source Book by Artists and Critics* (Berkeley: University of California Press, 1968), p. 23.

6. Ibid.

7. Paul Gauguin, letter to Emile Schuffenecker (Pont Aven, August 14, 1888), excerpted in ibid., p. 60.

8. Gauguin describing his *Self-Portrait, Les Misérables* of 1888, in a letter to Schuffenecker (Quimperlé, October 8, 1888), excerpted in Chipp, ed., *Theories of Modern Art*, p. 67.

9. For more on Gauguin's place regarding abstraction, see Mark A. Cheetham, *The Rhetoric of Purity: Essentialist Theory and the Advent of Abstract Painting* (Cambridge: Cambridge University Press, 1991), especially pp. 1–39; and Cheetham, "Mystical Memories: Gauguin's Neoplatonism and 'Abstraction' in Late-Nineteenth-Century French Painting," *Art Journal* 46, no. 1 (spring 1987), pp. 15–21.

10. In a letter to Emile Bernard (Arles, first half of October 1888), excerpted in Chipp, ed., *Theories of Modern Art*, p. 40, van Gogh referred to his "abstract studies." A little more than a year later, in a letter to Bernard (St. Rémy, beginning of December 1889), excerpted in *Theories of Modern Art*, pp. 44–45, he reflected that "abstraction" had seemed to him "a charming path," but that it was "enchanted ground," and that "one soon finds oneself up against a stone wall." Finally, he wrote, "I'm afraid abstractions would make me soft."

11. In a letter to his brother, Theo van Gogh (Arles, [ca. August 1888]), excerpted in Chipp, ed., *Theories of Modern Art*, p. 35, van Gogh wrote: "Why do I understand the musician better, why do I see the *raison d'être* of his abstractions better?"

12. See, for example, his discussion of the formal effects of color in letters to Bernard (Arles, second half of June 1888 and August 1888), excerpted in Chipp, ed., *Theories of Modern Art*, pp. 32–34.

13. Jean Moréas, quoted in Peter Vergo, Introduction, in *Abstraction: Towards a New Art: Painting 1910–20*, exh. cat. (London: Tate Gallery, 1980), p. 19.

14. For one essay on this subject, see Sigfried Giedion, "The Roots of Symbolic Expression," in Gyorgy Kepes, ed., *The Visual Arts Today* (Middletown, Conn.: Wesleyan University Press, 1960), pp. 24–33.

15. August Endell, quoted in Peg Weiss, *Kandinsky in Munich: The Formative Jugendstil Years* (Princeton: Princeton University Press, 1979), p. 25; for further discussion of Endell, see pp. 34–40. To Endell's sentiments may be added those of Leo Tolstoy who, in his famous essay "What Is Art?" of 1898, emphasized that "art . . . must be . . . the infection by one man of another or of others, with the feelings experienced by the artist," adding that "ornaments" of all cultures, though "despised" in traditional art circles, should be "esteemed far above exceptional, pretentious, pictures and sculptures" (Tolstoy, *What Is Art? and Essays on Art*, trans. Aylmer Maude, World's Classics [London: Oxford University Press, 1930; 1969], p. 247).

16. See Weiss, *Kandinsky in Munich*, pp. 43–47.

17. Maurice Denis, "Definition of Neotraditionism" (1890), excerpted in Chipp, ed., *Theories of Modern Art*, p. 94. For the precedents of this statement, see Joseph Masheck, "The Carpet Paradigm: Critical Prolegomena to a Theory of Flatness," *Arts Magazine* 51, no. 1 (September 1976), p. 93. For further background, consult H. R. Rookmaaker, *Synthetist Art Theories: Genesis and Nature of the Ideas on Art of Gauguin and His Circle* (Amsterdam: Swets and Zeitlinger, 1959).

18. Denis, "Subjective and Objective Deformation" (1909), excerpted in Chipp, ed., *Theories of Modern Art*, p. 106.

19. Dennis Farr, *English Art 1870–1940* (Oxford: Oxford University Press, 1978), pp. 3–20.

20. See Masheck, "Carpet Paradigm," pp. 85–86.

21. Whistler, "Ten o'Clock" (London, 1885), quoted in Farr, *English Art*, pp. 17–18.

22. For a summary of the Arts and Crafts movement as it relates to the development of abstraction, see Weiss, *Kandinsky in Munich*, pp. 7–10.

23. This point was made by Roger Fry in 1910; see Jacqueline V. Falkenheim, *Roger Fry and the Beginnings of Formalist Art Criticism* (Ann Arbor, Mich.: U.M.I. Research Press, 1980), p. 10.

24. Henry van de Velde, quoted in George Heard Hamilton, *Painting and Sculpture in Europe 1880–1940* (3rd rev. ed.; New York: Penguin Books, 1983), p. 133.

25. Karsten Harries, *The Bavarian Rococo Church: Between Faith and Aestheticism* (New Haven: Yale University Press, 1983), p. 252.

26. Ibid., p. 254. Harries further relates the quality of "presence"—Immanuel Kant's term for a quality of art that is so self-sufficient it exists outside the present time, reality, and even history—to abstraction (p. 253).

27. Masheck, "Carpet Paradigm," passim; and Masheck, "Raw Art: 'Primitive' Authenticity and German Expression," *RES* 4 (fall 1982), pp. 92–117.

28. Albert Aurier, a Symbolist spokesman, wrote in 1891 that the ideal work of art would be: "'Decorative' . . . nothing other than a manifestation of art at once subjective, synthetic, symbolist and idealist. . . . [D]ecorative painting is . . . the true art of painting" (quoted in Robert Goldwater, *Symbolism*

[New York: Harper and Row, Icon Editions, 1979], pp. 183–84).

29. Falkenheim, *Roger Fry*, pp. 50–52; Peter Selz, *German Expressionist Painting* (Berkeley: University of California Press, 1957; 1974), pp. 3–11; and Hamilton, *Painting and Sculpture in Europe*, p. 181.

30. Adolf von Hildebrand, *The Problem of Form in Painting and Sculpture* (1893), ed. and trans. Max Meyer and Robert Morris Ogden (rev. ed.; New York: G. E. Stechert, 1907; 1945), p. 12.

31. Clive Bell, in *Art* (New York: Frederick A. Stokes, n.d. [1914]), p. 8, wrote, "Lines and colours combined in a particular way, certain forms and relations of forms, stir our aesthetic emotions. These relations and combinations of lines and colours, these aesthetically moving forms, I call 'Significant Form'; and 'Significant Form' is the one quality common to all works of visual art." In the Preface (p. viii), Bell acknowledged his debt to Fry in formulating his ideas.

32. Falkenheim, *Roger Fry*, p. 96.

33. Beverly H. Twitchell, *Cézanne and Formalism in Bloomsbury* (Ann Arbor, Mich.: U.M.I. Research Press, 1987), p. 3.

34. Ibid., pp. 20, 27.

35. On the notion of the object as object, see Kant's discussion of the "thing-in-itself" and the limits of received information provided by objects, in his *Critique of Pure Reason*, trans. Norman Kemp Smith (London: Macmillan, 1933), pp. 27, 74, 86–87.

36. Of the rich literature on this subject see, for example, Klaus Lankheit, "Die Frühromantik und die Grundlagen der 'gegenstandslosen' Malerei," *Neue Heidelberger Jahrbücher* (Neue Folge, 1951), pp. 55–90; Harries, *The Meaning of Modern Art: A Philosophical Interpretation*, Northwestern University Studies in Phenomenology and Existential Philosophy (Evanston, Ill.: Northwestern University Press, 1968), pp. 104–06; Franzepp Würtenburger, *Malerei und Musik: Die Geschichte des Verhaltens zweier Künste zueinander – dargestellt nach den Quellen im Zeitraum von Leonardo da Vinci bis John Cage* (Frankfurt: Peter Lang, 1979); Peter Vergo, "Music and Abstract Painting: Kandinsky, Goethe and Schoenberg," in *Towards a New Art: Essays on the Background to Abstract Art, 1910–20*, exh. cat. (London: Tate Gallery, 1980), pp. 41–63; Lynn Gamwell, *Cubist Criticism*, Studies in the Fine Arts: Criticism, no. 5 (Ann Arbor, Mich.: U.M.I. Research Press, 1980), pp. 168–69, n. 22; Staatsgalerie Stuttgart, *Vom Klang der Bilder: Die*

Musik in der Kunst des 20. Jahrhunderts, ed. Karin V. Maur, exh. cat. (Munich: Prestel Verlag, 1985); and Andrew Kagan, "Ut Pictura Musica, I: To 1860," *Arts Magazine* 60 (May 1986), pp. 86–91. Harries notes that, in addition to Kant, Arthur Schopenhauer also posited music as an ideal method for the expression of spiritual states; moreover, Kant even mentioned the word "abstraction" in relation to the admired art form of music (Harries, *Meaning of Modern Art*, p. 106). In Paris and throughout Europe, Richard Wagner was a highly regarded figure, in particular for his expression, epitomized in the operatic *Gesamtkunstwerk*, of another reality than the everyday. For more on this phenomenon, see Modris Eksteins, *Rites of Spring: The Great War and the Birth of the Modern Age* (Boston: Houghton Mifflin, 1989), pp. 77–78. For a discussion of the cult of Ludwig van Beethoven in France, see Kermit S. Champa, *The Rise of Landscape in France: Corot to Monet*, exh. cat. (Manchester, N.H.: Currier Gallery of Art, 1991), pp. 31–41.

37. For the development of this phenomenon in German literature, see Neil H. Donahue, "Spatial Form in Modern German Prose: The Tradition of Abstraction in Prose from Hugo von Hofmannsthal's *Ein Brief* (1902) to Thomas Mann's *Doctor Faustus* (1947)," Ph.D. diss., Rutgers University, 1987, p. 72. Regarding the French Parnassians of the 1860s (Charles Baudelaire, Paul Verlaine, et al.) and their creation of a "pure" poetry, see Roland N. Stromberg, *European Intellectual History Since 1789* (2nd ed.; Englewood Cliffs, N.J.: Prentice-Hall, 1975), p. 211.

38. John H. Randall, Jr., *The Making of the Modern Mind: A Survey of the Intellectual Background of the Present Age* (New York: Columbia University Press, 1976), p. 389.

39. Ibid., pp. 389–426.

40. Harries, *Meaning of Modern Art*, p. 52.

41. Stromberg, *European Intellectual History*, pp. 39, 41–42, 47.

42. Tim Threlfall, *Piet Mondrian: His Life's Work and Evolution, 1872 to 1944* (New York: Garland, 1988), pp. 126–27; and Terry Eagleton, *The Ideology of the Aesthetic* (Oxford: Basil Blackwell, 1990), pp. 1–172.

43. H. Stuart Hughes, *Consciousness and Society: The Reorientation of European Social Thought 1890–1930* (New York: Alfred A. Knopf, 1958), pp. 29–66.

44. Stromberg, *European Intellectual History*, pp. 204–06.

45. For an introduction to these cults and their influence, see Gwendolyn Bays, *The Orphic Vision* (Lincoln: University of Nebraska Press, 1965), pp. 31–67.

46. For an expanded discussion of this subject, see Robert Rosenblum, *Modern Painting and the Northern Romantic Tradition: Friedrich to Rothko* (New York: Harper and Row, Icon Editions, 1975).

47. Bernard Susser, *The Grammar of Modern Ideology* (London: Routledge, 1988), pp. 16–17.

48. Linda Dalrymple Henderson, "X Rays and the Quest for Invisible Reality in the Art of Kupka, Duchamp, and the Cubists," *Art Journal* 47, no. 4 (winter 1988), pp. 323–40; see also Henderson, *The Fourth Dimension and Non-Euclidian Geometry in Modern Art* (Princeton: Princeton University Press, 1983).

49. Franklin L. Baumer, *Modern European Thought* (New York: Macmillan, 1977), p. 466; Hughes, *Consciousness and Society*, pp. 183–91; and Vergo, Introduction, in *Abstraction: Towards a New Art*, p. 14.

50. Henderson, "X Rays," pp. 325–26, passim; the phrase is taken from the title of a contemporary article on the subject by Carl Snyder, "The World Beyond Our Senses," *Harpers Monthly Magazine* 107 (June 1903), p. 119. For more on the relationship between transcendental ideas and the advances of science, see Stromberg, *European Intellectual History*, pp. 195–200. In addition to Henderson's publications, the rich literature on the relationship of science to modern art includes John Adkins Richardson, *Modern Art and Scientific Thought* (Urbana: University of Illinois Press, 1971); Paul C. Vitz and Arnold B. Glimcher, *Modern Art and Modern Science: The Parallel Analyses of Vision* (New York: Praeger, 1984); C. H. Waddington, *Behind Appearance: A Study of the Relations Between Painting and the Natural Sciences in This Century* (Cambridge, Mass.: M.I.T. Press, 1970); David R. Topper and John H. Holloway, "Interrelationships Between the Visual Arts, Science and Technology: A Bibliography," *Leonardo* 13, no. 1 (1980), pp. 29–33; and Topper and Holloway, "Interrelationships of the Arts, Sciences and Technology: A Bibliographic Update," *Leonardo* 18, no. 3 (1985), pp. 197–200.

51. Robert Martin Adams, *NIL: Episodes in the Literary Conquest of Void During the Nineteenth Century* (New York: Oxford University Press, 1966); and Eliot Hearst, "Psychology and Nothing," *American Scientist* 79, no. 5 (September–October 1991), pp. 432–43.

52. For an early example of art criticism that emphasizes viewer response, see Bell, *Art*, especially pp. 3–37.

53. Harries, *Meaning of Modern Art*, p. 53.

54. Hughes, *Consciousness and Society*, p. 39; and Baumer, *Modern European Thought*, p. 499.

55. Fred Dallmayr, *Margins of Political Discourse*, SUNY Series in Contemporary Continental Philosophy, ed. Dennis J. Schmidt (Albany: State University of New York Press, 1989), pp. 41–42.

56. Stromberg, *European Intellectual History*, p. 181.

57. Horace M. Kallen, *Art and Freedom* (New York: Duell, Sloan and Pearce, 1942), vol. 2, p. 605; and James M. Thompson, ed., *Twentieth-Century Theories of Art* (Ottawa: Carleton University Press, 1990), pp. 1–17.

58. The literature on Henri Bergson is vast. My understanding has been enhanced by Kallen, *Art and Freedom*, vol. 2, pp. 690–703; Thomas A. Goudge, Introduction, in Henri Bergson, *An Introduction to Metaphysics* (1903), trans. T. E. Hulme (reprint; New York: Liberal Arts Press, 1955), pp. 10–12; Joseph Chiari, *Twentieth-Century French Thought: From Bergson to Lévi-Strauss* (New York: Gordian Press, 1975), pp. 28–59; Stromberg, *European Intellectual History*, pp. 190–94; Vergo, Introduction, in *Abstraction: Towards a New Art*, p. 17; and Hughes, *Consciousness and Society*, pp. 35–38, 57–59, 63–66, 105–07, 113–25.

59. Bergson, *Introduction to Metaphysics*, p. 23.

60. Hughes, *Consciousness and Society*, p. 105.

61. Ibid.

62. It has often been debated whether Bergsonian thought, with its devaluation of science, could have had any influence at all on Cubism. For discussions of this issue, see Yve-Alain Bois, *Painting as Model* (Cambridge, Mass.: M.I.T. Press, 1990), pp. 67, 281, n. 13; Vergo, Introduction, in *Abstraction: Towards a New Art*, p. 17; Robert Mark Antliff, "Bergson and Cubism: A Reassessment," *Art Journal* 47, no. 4 (winter 1988), pp. 341–49; Christopher Gray, *Cubist Aesthetic Theories* (Baltimore: Johns Hopkins Press, 1953), pp. 65, 69–71, 85–88, 95–96, 160, 163–64, 166; Virginia Spate, *Orphism: The Evolution of Non-Figurative Painting in Paris, 1910–1914*, Oxford Studies in the History of Art and Architecture (Oxford: Clarendon Press, 1979), pp. 19–21; and Ivor Davies, "Western European Art Forms Influenced by

Nietzsche and Bergson before 1914, Particularly Italian Futurism and French Orphism," *Art International* 19, no. 3 (March 20, 1975), pp. 49–55.

63. Hughes, *Consciousness and Society*, p. 287.

64. See the reference to Guillaume Apollinaire's statements in this regard in Threlfall, *Piet Mondrian*, p. 198. Maurice Raynal also called Cubism a "*pure* painting" in 1912 (Masheck, "Carpet Paradigm," p. 101).

65. Magdalena Dabrowski, *Contrasts of Form: Geometric Abstract Art, 1910–1980*, exh. cat. (New York: Museum of Modern Art, 1985), p. 17. The rich literature on this subject includes Robert Delaunay, *Du Cubisme à l'art abstrait*, ed. Pierre Francastel (Paris: S.E.V.P.E.N., 1957); Alfred H. Barr, Jr., *Cubism and Abstract Art*, exh. cat. (New York: Museum of Modern Art, 1936); Rosenblum, *Cubism and Twentieth-Century Art* (Englewood Cliffs, N.J.: Prentice-Hall; New York: Harry N. Abrams, 1976); Christopher Green, *Cubism and Its Enemies: Modern Movements and Reaction in French Art, 1916–1928* (New Haven: Yale University Press, 1987); and Green, "Cubism and the Possibility of Abstract Art," in *Essays on the Background to Abstract Art, 1910–20*, pp. 156–77.

66. For a discussion of these artists (August Endell, Adolf Hölzel, and Hermann Obrist) see Weiss, *Kandinsky in Munich*, pp. 28–47.

67. Wilhelm Worringer, *Abstraction and Empathy: A Contribution to the Psychology of Style* (1908; 2nd ed., 1910), trans. Michael Bullock (New York: International Universities Press, 1963).

68. Ibid., p. 4.

69. Ibid., p. 9.

70. Ibid., p. 24.

71. Ibid., p. 46.

72. Worringer was nevertheless aware of parallel interests among contemporary artists and others concerned with abstraction as well as the growing impact of his book upon them. See his Foreword to the first edition (1908) and especially to the second (1910) edition (ibid., pp. xiii–xv).

73. Ibid., pp. 16–17.

74. Worringer's influence on literature is discussed in Donahue, "Spatial Form," and in Joseph Frank, *The Widening Gyre: Crisis and Mastery in Modern Literature* (New Brunswick, N.J.: Rutgers University Press, 1963), pp. 50–58.

Chapter 2

1. Edouard Roditi, "Interview with Gabrièle Münter," *Arts Magazine* 34, no. 4 (January 1960), p. 39.

2. For many years, it was thought that a watercolor of 1910 was Vasily Kandinsky's first purely abstract work, but this has long since been discounted; see Rose-Carol Washton Long, *Kandinsky: The Development of an Abstract Style* (Oxford: Clarendon Press, 1980), p. 157, n. 17. In letters Kandinsky wrote to Alfred H. Barr, Jr. and Hilla Rebay in 1936 and 1937, he dated his first wholly abstract oil paintings to 1911, but it has been difficult to ascertain which one was the first. Kandinsky's letters to Barr—which have not been published—are in the Alfred H. Barr, Jr. Papers at the Museum of Modern Art, New York. Kandinsky's letters to Rebay are in the Hilla von Rebay Foundation Archive at the Solomon R. Guggenheim Museum, New York; many of them are quoted and discussed in Angelica Zander Rudenstine, *The Guggenheim Museum Collection: Paintings 1880–1945*, 2 vols. (New York: Solomon R. Guggenheim Foundation, 1976).

3. Kandinsky, letter to Barr (June 22, 1936), Museum of Modern Art, New York; and Kandinsky, letter to Hilla Rebay (December 16, 1936 and January 16, 1937), Solomon R. Guggenheim Museum, New York; quoted and discussed in Rudenstine, *Guggenheim Museum Collection*, vol. 1, pp. 274–77.

4. Kandinsky, quoted in Rudenstine, *Guggenheim Museum Collection*, vol. 1, p. 275. That Kandinsky alluded to the period of 1911 is deduced from the fact that in the previous sentence he referred to a "first 'abstract' painting . . . in Moscow," which he dated to 1911 in his letter to Rebay (January 16, 1937).

5. In *Kandinsky*, pp. 134–36, Long disputed whether *Black Lines* is as lacking in reference as Kandinsky asserted.

6. Kandinsky, letter to Rebay (January 16, 1937), excerpted in Rudenstine, *Guggenheim Museum Collection*, vol. 1, pp. 275–76.

7. Wassily [Vasily] Kandinsky, *Concerning the Spiritual in Art and Painting in Particular* (1912), trans. Michael Sadler with Francis Golffing, Michael Harrison, and Ferdinand Ostertag, Documents of Modern Art, no. 5 (New York: George Wittenborn, 1947), p. 48. The 1947 Wittenborn edition incorporates revisions made by Kandinsky in 1914.

8. Some of Kandinsky's work was shown at Vladimir Izdebsky's first

"International Salon" exhibition, which opened in Odessa in 1909 and traveled to Kiev, St. Petersburg, and Riga in 1910. In December 1910, fifty-two of his paintings were shown at Izdebsky's second "International Salon" exhibition in Odessa. See Long, *Kandinsky*, pp. 166–67, n. 206; and Jelena Hahl-Koch, "Kandinsky's Role in the Russian Avant-Garde," in Stephanie Barron and Maurice Tuchman, eds., *The Avant-Garde in Russia 1910–1930: New Perspectives*, exh. cat. (Cambridge, Mass.: M.I.T. Press, 1980), p. 393. In February 1911, his article "Whither the 'New' Art?" was published in *Odesskie novosti* (*Odessa News*); a translation by John E. Bowlt is in Kenneth C. Lindsay and Peter Vergo, eds., *Kandinsky: Complete Writings on Art*, 2 vols. (Boston: G. K. Hall, 1982), vol. 1, p. 103. In Ekatarinoslav, he exhibited with the Art and Theater Society in 1910 and in a contemporary painting show in 1912.

9. For David Burliuk's many ties to Kazimir Malevich, see Katherine S. Dreier, *Burliuk* (New York: Wittenborn, 1944), pp. 53, 61, 69–70, 85; and *Kazimir Malevich 1878–1935*, exh. cat. (Amsterdam: Stedelijk Museum; Moscow: U.S.S.R. Ministry of Culture, 1988), pp. 74, 76.

10. A critic named Konstantin Umansky made this remark in *New Art in Russia* (Pottsdam/Munich, 1920), pp. 20, 22; quoted in Hahl-Koch, "Kandinsky's Role in the Russian Avant-Garde," p. 84.

11. Kirk Varnedoe has noted in Malevich's work an illusion of forms flying over a field. For a discussion of the "modernity of the overhead view" and the impact of aerial photography on the work of Malevich, see Varnedoe's *A Fine Disregard: What Makes Modern Art Modern* (New York: Harry N. Abrams, 1990), pp. 252–56.

12. Rainer Crone was perhaps the first to suggest that the central "square" in the stage sketches for *Victory Over the Sun* is in fact a vertical rectangle; see his "Zum Suprematismus—Kasimir Malevic, Velimir Chlebnikov und Nicolai Lobacevskij," *Wallfraf-Richartz-Jahrbuch* 40 (1978), p. 144. Yve-Alain Bois, in "The Definitive Malevich," *The Journal of Art* 3, no. 2 (November 1990), p. 11, quoted Donald Judd's assertion that Malevich, because his "square" shapes as well as his canvases in his Suprematist works are not precisely geometric, is not a geometric painter.

13. There is some debate about the date of Piet Mondrian's first purely abstract work. For a discussion of 1916, see Joop P. Joosten, "Abstraction and Compositional Innovation," *Artforum* 11,

no. 8 (April 1973), pp. 55–56; for 1917, see Robert P. Welsh, "The Birth of De Stijl, Part I: Piet Mondrian, The Subject Matter of Abstraction," *Artforum* 11, no. 8 (April 1973), p. 53; and Bois, *Painting as Model* (Cambridge, Mass.: M.I.T. Press, 1990), p. 106.

14. Kandinsky, *Concerning the Spiritual*, pp. 47–49.

15. Ibid., p. 51.

16. Ibid., p. 66.

17. Kandinsky, "On the Question of Form," in Kandinsky and Franz Marc, eds., *The Blaue Reiter Almanac* (1912), trans. Henning Falkenstein with Manug Terzian and Gertrude Hinderlie, Documents of Twentieth-Century Art (New York: Viking, 1974), p. 147.

18. Ibid., pp. 150–51.

19. Ibid., p. 158.

20. Ibid., p. 165.

21. Ibid.

22. Kandinsky first used the word "absolute" in his "Reminiscences" (1913), reprinted in Robert L. Herbert, ed., *Modern Artists on Art: Ten Unabridged Essays*, trans. Eugenia Herbert (Englewood Cliffs, N.J.: Prentice-Hall, 1964), p. 40, nn. 10, 42. The words "absolute" and "pure" appear in the text to his (undelivered) Cologne lecture of 1914; see Lindsay and Vergo, eds., *Kandinsky: Complete Writings*, vol. 1, p. 393.

23. Kandinsky, letter to Arthur Jerome Eddy (1914), reprinted in Lindsay and Vergo, eds., *Kandinsky: Complete Writings*, vol. 1, p. 405.

24. See the entry for the word "Absolut" in Grimm's *Deutsches Wörterbuch* (Leipzig: S. Hirzel Verlag, 1983), vol. 1, p. 960.

25. Kandinsky, "Abstract Painting," *Kronick von hedendaagsche Kunst en Kultur* (April 1936); reprinted in Lindsay and Vergo, eds., *Kandinsky: Complete Writings*, vol. 2, p. 785.

26. Malevich, "From Cubism and Futurism to Suprematism: The New Realism in Painting" (1916), reprinted in Malevich, *Essays on Art 1915–1933*, ed. Troels Andersen, trans. Xenia Glowacki-Prus and Arnold McMillin (London: Rapp & Whiting; Chester Springs, Pa.: Dufour Editions, 1968), vol. 1, p. 19.

27. Malevich, "On New Systems in Art" (1919), reprinted in Malevich, *Essays on Art*, vol. 1, p. 100.

28. Malevich, "From Cubism and Futurism to Suprematism," p. 37; see also pp. 33, 38.

29. Malevich, "Non-Objectivity" (1922), in Malevich, *Essays on Art 1915–1933*, ed. Andersen, trans. Glowacki-Prus and Edmund T. Little (Copenhagen: Borgen, 1976), vol. 3: *The World as Non-Objectivity: Unpublished Writings 1922–25*, p. 35.

30. Malevich, "Suprematism" (1927), reprinted in Herschel B. Chipp, ed., *Theories of Modern Art: A Source Book by Artists and Critics* (Berkeley: University of California Press, 1968), p. 341.

31. Mondrian, letter to Augusta de Meester-Obreen (ca. February 1915), quoted in Martin S. James, "Piet Mondrian: Art and Theory to 1917," in Harry Holtzman and Martin S. James, eds., *The New Art—The New Life, The Collected Writings of Piet Mondrian*, trans. Holtzman and James {hereafter referred to as *Collected Writings of Mondrian*] (Boston: G.K. Hall, 1986), p. 15.

32. Mondrian, "Piet Mondrian: Writings," ed. Holtzman, *Tracks* 3, nos. 1–2 (spring 1977), p. 22.

33. Mondrian, "The New Plastic in Painting" (1917), reprinted in *Collected Writings of Mondrian*, pp. 31–35.

34. Ibid., p. 32.

35. Mondrian, "On Abstract Art: Reply by Piet Mondrian" (1931), trans. Holtzman and James, *The League Quarterly* 19, no. 1 (spring 1947), p. 8. Mondrian would remain constantly ambivalent about "the natural," which he alternately sought to transform or negate in favor of the neutrality given by geometric form; see his "Plastic Art and Pure Plastic Art" (1937), reprinted in Chipp, ed., *Theories of Modern Art*, p. 351.

36. For George Berkeley's use of the word "abstract" in philosophy, see Willis Doney, ed., *Berkeley on Abstraction and Abstract Ideas* (New York: Garland, 1989). For a general discussion of the concept in philosophy, see Hubert G. Alexander, *The Language and Logic of Philosophy* (Albuquerque: University of New Mexico Press, 1972), pp. 107–28, 233–38.

37. Mondrian described the "rationality" of an art form in terms of its being "an art for our time"; see his "New Plastic in Painting," p. 41. Malevich wanted a "philosophy of contemporaneity" ("New Systems in Art," p. 117) and an art based on "forms which correspond to modern life ("From Cubism and Futurism to Suprematism," p. 22).

38. Kandinsky, "Question of Form," p. 147.

39. Kandinsky, *Concerning the Spiritual*, pp. 23–24.

40. Malevich, "Fragments from 'Chapters from an Artist's Autobiography'" (1933), trans. Alan Upchurch, *October*, no. 34 (fall 1985), p. 44; and in a revised translation in *Malevich*, exh. cat. (Washington, D.C.: National Gallery of Art, 1990), p. 174.

41. Malevich, "From Cubism and Futurism to Suprematism," p. 20.

42. Ibid., p. 26.

43. The comparison of painting to music can be documented to have entered the general area of Modernist discussion with the publication of the article "Ut Pictura Musica" by Louis Viardot in the premiere issue of the *Gazette des Beaux-Arts* (January 1859); see Andrew Kagan, "Ut Pictura Musica, I: to 1860," *Arts Magazine* 60 (May 1986), pp. 86–91. Karsten Harries has pointed out that the Latin phrase *ut pictura musica* in fact translates to mean "As is painting, so is music" or "Music is like painting" (conversation with Denise McColgan in New Haven, May 15, 1992). Writers on art, however, in using the phrase as an obvious allusion to Homer's famous simile *ut pictura poesis*, understood it to mean "As is music, so is painting" or "Painting is like music," in the same way that writers on art since the Renaissance had transformed the original meaning of *ut pictura poesis* (literally "as is painting, so is poetry") to "as is poetry, so is painting," which better served their purposes; see Rensselaer W. Lee, *Ut Pictura Poesis: The Humanistic Theory of Painting* (New York: W. W. Norton, 1967), p. 3.

44. Kandinsky, *Concerning the Spiritual*, p. 40; see also pp. 46–52.

45. Mondrian compared the rhythmic qualities of his painting to those found in American jazz; see his "On Abstract Art," p. 8.

46. Kandinsky, *Concerning the Spiritual*, pp. 39–40; see also p. 31 regarding the spiritual triangle.

47. For instance, see ibid., pp. 73, 77; Kandinsky, "Question of Form," p. 186; and Kandinsky, letter to Eddy (1914), reprinted in Lindsay and Vergo, eds., *Kandinsky: Complete Writings*, vol. 1, p. 406. See also Long, *Kandinsky*, p. 48.

48. Kandinsky, "Painting as Pure Art" (1913), reprinted in Lindsay and Vergo, eds., *Kandinsky: Complete Writings*, vol. 1, p. 353.

49. Mondrian, letter to H. P. Bremmer (January 1914), quoted in James, "Piet Mondrian," pp. 14–15.

50. Ibid.

51. Mondrian, statement (ca. 1943), reprinted in Chipp, ed., *Theories of Modern Art*, p. 363.

52. In 1916, Malevich wrote, "The forms of Suprematism are already proof of the construction of forms from nothing, discovered by intuitive reason"; see his "From Cubism and Futurism to Suprematism," p. 33. He wrote two essays on the relationship of abstract painting to architecture in the 1920s: "Notes on Architecture" (written in 1924 but first published in 1978) and "Painting and the Problem of Architecture" (1928), both reprinted in *Kazimir Malevich 1878–1935*, pp. 113–25, 126–32.

53. For discussions of these trends in Europe at that time, see Horace M. Kallen, *Art and Freedom* (New York: Duell, Sloan and Pearce, 1942), vol. 2, p. 826; H. Stuart Hughes, *Consciousness and Society: The Reorientation of European Social Thought 1890–1930* (New York: Alfred A. Knopf, 1958), pp. 33–66; Roland N. Stromberg, *European Intellectual History Since 1789* (2nd ed.; Englewood Cliffs, N.J.: Prentice-Hall, 1975), pp. 172–232; and Peg Weiss, *Kandinsky in Munich: The Formative Jugendstil Years* (Princeton: Princeton University Press, 1979), p. 9.

54. Kandinsky, "Whither the 'New' Art?," p. 103. In September 1910, he had referred to the same condition of "the collision of the spiritual with the material" in his artist's statement in the catalogue of the second exhibition of the *Neue Künstlervereinigung München*, reprinted in Lindsay and Vergo, eds., *Kandinsky: Complete Writings*, vol. 1, p. 82.

55. Kandinsky, *Concerning the Spiritual*, p. 28.

56. Franz Marc, "Spiritual Treasures," in Kandinsky and Marc, eds., *Blaue Reiter Almanac*, pp. 55–60.

57. Kandinsky, "Question of Form," p. 164.

58. Ibid., p. 149, and Kandinsky, *Concerning the Spiritual*, p. 26, n. 3.

59. Nelly van Doesburg, "Some Memories of Mondrian," in *Piet Mondrian, 1872–1944: Centennial Exhibition*, exh. cat. (New York: Solomon R. Guggenheim Museum, 1971), p. 71.

60. For instance, Mondrian objected to Futurism for being "excessively concerned with human sensations," in his letter to Bremmer (January 1914), quoted in James, "Piet Mondrian," p. 15; see also the opening lines of his "New Plastic in Painting," p. 28.

61. Mondrian, "Plastic Art," p. 351.

62. Mondrian, "New Plastic in Painting," pp. 52–53.

63. For a discussion of Worringer's *Abstraction and Empathy: A Contribution to the Psychology of Style* and how it posited abstraction as a "transcendent" solution to man's sense of "homelessness," offering stability and timelessness, see Karsten Harries, *The Meaning of Modern Art: A Philosophical Interpretation*, Northwestern University Studies in Phenomenology and Existential Philosophy (Evanston, Ill.: Northwestern University Press, 1968), pp. 69–70.

64. Ibid., pp. 28–29.

65. Malevich, "Artist's Autobiography," pp. 43–44.

66. Malevich, "New Systems in Art," pp. 117–19, and "From Cubism and Futurism to Suprematism," p. 22.

67. Malevich, "From Cubism and Futurism to Suprematism," p. 22.

68. Kandinsky's "utopian protest" is discussed in Donald B. Kuspit, "Utopian Protest in Early Abstract Art," *Art Journal* 29, no. 4 (summer 1970), pp. 430–37.

69. Malevich, "New Systems in Art," p. 118.

70. Kandinsky, "Content and Form" (1910–11), reprinted in Lindsay and Vergo, eds., *Kandinsky: Complete Writings*, vol. 1, p. 89.

71. Kandinsky, "Question of Form," p. 149.

72. Kandinsky said that "Art is like religion in many respects"; see his "Reminiscences," p. 39.

73. See Mondrian, notes from sketchbooks (ca. 1913–14), quoted in James, "Piet Mondrian," p. 18; and Mondrian, "New Plastic in Painting," p. 50. Years later, Mondrian noted that since life is so imperfect, the need for art is even greater, to "reconcile us"; see his "On Abstract Art," p. 7.

74. Mondrian, letter to Israel Querido (1909), quoted in James, "Piet Mondrian," p. 14.

75. Mondrian, notes from sketchbooks (ca. 1913–14), quoted in James, "Piet Mondrian," p. 17.

76. Kandinsky, *Concerning the Spiritual*, pp. 24, 32–33. For a complete account of Kandinsky's interest in Theosophy, see Sixten Ringbom, "Art in 'The Epoch of the Great Spiritual': Occult Elements in the Early Theory of Abstract Painting," *Journal of the Warburg and Courtauld Institutes* 29 (1966), pp. 386–418. Ringbom was the first to closely analyze the influence of Theosophy upon

Kandinsky. Others have suggested that the influence was not so overriding. For a summary of various positions on the subject, see Long, *Kandinsky*, pp. 16, 160, nn. 27–31; see also Weiss, *Kandinsky in Munich*, pp. 5–6, 20–21, 23, 156–58, n. 16. For a critique of both Ringbom and Long on this subject, see Jelena Hahl-Koch, *Kandinsky*, trans. Karin Brown, Ralph Harratz, and Katharine Harrison (New York: Rizzoli, 1993), pp. 28–29, 177–79, 386–87. Kandinsky apparently attended lectures by Rudolf Steiner in 1907–08; for this and other information about Kandinsky's interest in Steiner, see Hahl-Koch, *Kandinsky*, pp. 28, 177, 386.

77. Kandinsky, "Whither the 'New' Art?," p. 101.

78. For the influence of Theosophy on Mondrian, see Robert P. Welsh, "Mondrian and Theosophy," in *Centennial Exhibition*, pp. 35–51; and Nelly van Doesburg, "Some Memories of Mondrian," p. 72. For Mondrian's interest in Steiner, see Tim Threlfall, *Piet Mondrian: His Life's Work and Evolution, 1872 to 1944* (New York: Garland, 1988), pp. 214–16.

79. According to Hahl-Koch (*Kandinsky*, p. 193), Kandinsky owned a copy of Schopenhauer's *Theory of Colors*.

80. Ringbom, *The Sounding Cosmos: A Study in the Spiritualism of Kandinsky and the Genesis of Abstract Painting* (Abo, Finland: Abo Academi, 1970), pp. 57–58. He cites Blavatsky's book *The Key to Philosophy* (1893) as the source for his discussion in this passage.

81. Ibid., pp. 55–56. For more on the ideas in *Thought-Forms*, see ibid., pp. 36–37, 62–63, 83–90. Annie Besant and C. W. Leadbeater, *Thought-Forms* (London: Theosophical Publishing Society, 1905), was published in German as *Gedankenformen* (Leipzig: Theosophisches Verlagshaus, 1908).

82. These references to Kandinsky's color symbolism are from Kandinsky, *Concerning the Spiritual*, pp. 44, 58; see also pp. 44–47, 57–63, 69–70. For Mondrian's, see Mondrian, "New Plastic in Painting," p. 36. For Malevich's, see Malevich, "Non-Objective Creation and Suprematism" (1919), and his "Suprematism: Thirty-four Drawings" (1920), reprinted in Malevich, *Essays on Art*, vol. 1, pp. 121, 125.

83. Malevich, "From Cubism and Futurism to Suprematism," p. 31.

84. Mondrian, letter to Bremmer (January 1914), quoted in James, "Piet Mondrian," p. 14.

85. Kandinsky, "Question of Form," pp. 169, 201; and his *Concerning the Spiritual*, pp. 45, 47, 50–54, 71–73, 75.

86. Mondrian, notes from sketchbooks (ca. 1913–14), quoted in James, "Piet Mondrian," p. 17.

87. Malevich, "From Cubism and Futurism to Suprematism," p. 19.

88. Malevich, "Suprematism," pp. 341–42.

89. Mondrian, "New Plastic in Painting," p. 28.

90. Mondrian, "Toward the True Vision of Reality" (1941), reprinted in *Collected Writings of Mondrian*, p. 338; and "[An Interview with Mondrian]" (1943), reprinted in ibid., p. 356.

91. Mondrian asserted that "the artist's spirit is part of the general spirit of the times," but also that "man's one-sided way of thinking is grossly erroneous"; see "Plastic Art," pp. 350–51, and his notes from sketchbooks (ca. 1913–14), quoted in James, "Piet Mondrian," p. 17. Mondrian's train of thought, with its emphasis on art—specifically abstract art—expressing the collective feeling of an age seems strikingly similar to Worringer's thesis.

92. Mondrian, "New Plastic in Painting," p. 63.

93. Kandinsky, *Concerning the Spiritual*, p. 74.

94. Malevich, "New Systems in Art," pp. 92–93.

95. Malevich, "From Cubism and Futurism to Suprematism," p. 19.

96. Malevich, "The Problems of Art and the Role of Its Suppressors" (1918), reprinted in Malevich, *Essays on Art*, vol. 1, p. 49. For more on this point, see also his "From Cubism and Futurism to Suprematism," p. 40.

97. Kuspit, "Utopian Protest," pp. 430–37. For another discussion of these issues and their mythic place in modern art, see Harries, *Meaning of Modern Art*, pp. 95–108, 159.

98. Harries, *Meaning of Modern Art*, pp. 67–68.

99. Hughes, *Consciousness and Society*, pp. 120–21.

100. Kandinsky, "Reminiscences," p. 32.

101. Kandinsky, *Concerning the Spiritual*, p. 75.

102. Ibid., p. 74.

103. For a discussion of metaphysics in this regard, see Anthony Quinton, *The Nature of Things* (London: Routledge; Boston: Kegan Paul, 1973), pp. 235–37.

104. Kandinsky, "On the Artist," exh. brochure (Stockholm: Gummeson's, 1916); trans. Ann-Kristin Stervd, reprinted in Lindsay and Vergo, eds., *Kandinsky: Complete Writings*, vol. 1, p. 417. See also Kandinsky's "Question of Form," where he emphasized that "Form is the outer expression of the inner content" (p. 149); and his "Reminiscences," where he stated, "I could never bring myself to use a form which developed out of the application of logic—not purely from *feeling* within me" (p. 32), and "I felt more and more clearly that it is not a question in art of the 'formal' but of an inner wish (=content) which imperatively determines the formal" (p. 35).

105. Kandinsky, *Concerning the Spiritual*, p. 27.

106. See, for instance, ibid., p. 24; and Kandinsky, letter to Eddy (1914), reprinted in Lindsay and Vergo, eds., *Kandinsky: Complete Writings*, vol. 1, p. 403.

107. Kandinsky, "Whither the 'New' Art?," p. 102.

108. Kandinsky, *Concerning the Spiritual*, p. 73.

109. Kandinsky discussed residual forms in ibid., p. 49.

110. Kandinsky described the presence of "veiled or bared" forms in his work; see ibid., p. 51. For a full discussion of this subject, see Rose-Carol Washton Long, "Kandinsky and Abstraction: The Role of the Hidden Image," *Artforum* 10, no. 10 (June 1972), pp. 42–49; Long, "Kandinsky's Abstract Style: The Veiling of Apocalyptic Folk Imagery," *Art Journal* 34, no. 3 (spring 1975), pp. 217–27; and Long, *Kandinsky*, pp. 65–74.

111. Kandinsky, artist's statement, in *Neue Künstlervereinigung München* (1910), reprinted in Lindsay and Vergo, eds., *Kandinsky: Complete Writings*, vol. 1, p. 82.

112. Kandinsky, *Concerning the Spiritual*, p. 69; see also pp. 68, 72, and his "Reminiscences," p. 32.

113. Kandinsky, "Cologne Lecture," p. 397.

114. Malevich, "From Cubism and Futurism to Suprematism," pp. 25, 34.

115. Ibid., p. 38.

116. Malevich wrote "Clean the squares of the remains of the past" and "We declare our time to be the square of our age," in "To the New Image," vol. 1, p. 51; and he described the square as "the absolute expression of modernity" in "New Systems in Art," p. 83.

117. Malevich, "Suprematism: Thirty-four Drawings," pp. 123, 127.

118. Ibid., p. 124.

119. Ibid.

120. Svetlana Alpers, *The Art of Describing: Dutch Art in the Seventeenth Century* (Chicago: University of Chicago Press, 1983), p. 8. For a discussion of Mondrian, see also p. 258, n. 23.

121. Ibid., p. 9.

122. Mondrian, "New Plastic in Painting," p. 32.

123. Kandinsky, "Question of Form," p. 151.

124. T. J. Clark, *The Painting of Modern Life: Paris in the Art of Manet and His Followers* (New York: Alfred A. Knopf, 1985), p. 13.

125. Kandinsky, *Concerning the Spiritual*, p. 73.

126. Mircea Eliade, *The Myth of the Eternal Return, or Cosmos and History*, trans. Willard R. Trask, Bollingen Series 46 (Princeton: Princeton University Press, 1974), p. 18.

127. Ibid., p. 21.

128. Ibid., pp. 35, 76.

129. Ibid., p. 18.

130. Malevich, "From Cubism and Futurism to Suprematism," p. 19.

131. Ibid., p. 26.

132. Ibid., p. 24.

133. Ibid., p. 28.

134. Ibid., pp. 24–25. Elsewhere, Malevich stated, "We cannot conquer nature, for man is nature"; see his "New Systems in Art," p. 87.

135. Mondrian, letter to Bremmer (January 1914), quoted in James, "Piet Mondrian," p. 14.

136. Mondrian, notes from sketchbooks (ca. 1913–14), quoted in James, "Piet Mondrian," p. 17.

137. Kandinsky, "Reminiscences," p. 35.

138. Eliade, *Eternal Return*, p. 17.

139. See Threlfall, *Piet Mondrian*, p. 290.

140. Mondrian, "On Abstract Art," p. 7; and "New Plastic in Painting," pp. 34–35.

141. Malevich, "From Cubism and Futurism to Suprematism," pp. 32, 38.

142. Kandinsky, "Autobiographical Note/Postscript" (1913), reprinted in Lindsay and Vergo, eds., *Kandinsky: Complete Writings*, vol. 1, p. 345.

143. Kandinsky, "Reminiscences," p. 40, n. 10.

144. Marc, "The 'Savages' of Germany," in Kandinsky and Marc, eds., *Blaue Reiter Almanac*, p. 64; and Thomas von Hartmann, "On Anarchy in Music," in ibid., p. 118. Also, Hugo Ball, the Dadaist, called Kandinsky a "prophet of renaissance"; see Klaus Lankheit, "A History of the Almanac," in ibid., p. 33. And Kandinsky compared his own missionary zeal to that of Christianity; see his "Reminiscences," p. 41. Malevich, in characteristically defiant fashion, said that Suprematism "*spat on the altar of* [Futurism's] *art*"; see his "From Cubism and Futurism to Suprematism," p. 27.

145. None of them ever wrote about abstraction as a movement, but Worringer's text certainly provided the terminology and theoretical basis for such a notion, and much of the conceptual foundations and claims were parallel, if not the same. For a discussion of the possible influence of Worringer on Kandinsky, see Weiss, *Kandinsky in Munich*, p. 159, n. 25; and Hahl-Koch, *Kandinsky*, p. 193.

146. Kandinsky, "Question of Form," pp. 147, 151.

147. Ibid., pp. 149–54.

148. Mondrian referred to "the advancing culture of the spirit" and to an allied "*abstract . . . expression*"; see his "New Plastic in Painting," pp. 29, 30, respectively.

149. Mondrian, "New Plastic in Painting," p. 57, n. k.

150. Kandinsky, statement, in *The Battle for Art: An Answer to the Protest of German Artists* (1911), reprinted in Lindsay and Vergo, eds., *Kandinsky: Complete Writings*, vol. 1, p. 107.

151. Malevich spoke of academicism as "that torture chamber of the Inquisition"; see his "From Cubism and Futurism to Suprematism," p. 39. He expressed similar sentiments on pp. 19, 21, 26, 28, 37, 40. He also especially denounced "idealism"; see ibid., pp. 21–22, 40.

152. Mondrian, "On Abstract Art," p. 7.

153. For a discussion of Mondrian's sense of mission, see James, "Piet Mondrian," p. 19.

154. Mondrian, "On Abstract Art," p. 8.

155. This incident is described in James, "Piet Mondrian," p. 15.

156. The "cultural revival" in Munich did not assuage the deep sense of alienation generally felt by artists and intellectuals during this period; see Hughes, *Consciousness and Society*, pp. 42–53.

157. For a general survey of this European tendency, see Stromberg, *European Intellectual Theory*, pp. 207–15.

158. Kandinsky, "Content and Form," p. 87.

159. Kandinsky, "Reminiscences," p. 29, n. 7.

160. Kandinsky, *Concerning the Spiritual*, p. 70.

161. Ibid., p. 48.

162. Kandinsky, "Reminiscences," p. 42.

163. Kandinsky, "Abstract Painting," *Kroniek von hedendaagsche Kunst en Kultuur* (1936); reprinted in Lindsay and Vergo, eds., *Kandinsky: Complete Writings*, vol. 2, p. 786.

164. Kandinsky, "Question of Form," p. 147.

165. See Malevich, "The Problems of Art and the Role of Its Suppressors," in Malevich, *Essays on Art*, vol. 1, pp. 49–50.

166. Mondrian, "Plastic Art," p. 352.

167. Mondrian, "On Abstract Art," p. 7.

168. Ibid.

169. Hughes, *Consciousness and Society*, pp. 53–59.

170. Just before and after World War I, Paris suffered from a degree of intellectual lethargy and passivity, and there were fads for various cultures, including that of Russia; see Modris Eksteins, *Rites of Spring: The Great War and the Birth of the Modern Age* (Boston: Houghton Mifflin, 1989), pp. 44–50.

171. Henri Bergson, *An Introduction to Metaphysics* (1903), trans. T. E. Hulme (reprint; New York: Liberal Arts Press, 1955), p. 21.

172. Daniel-Henry Kahnweiler said of the Cubists, "These painters were not abstract artists, they were realists. . . . They wanted people to be able to 'read' their pictures. It was this which Mondrian did not understand about Cubism." Kahnweiler, "Daniel-Henry Kahnweiler Reviews Cubism," eds. Barbara Balensweig and Virginia Wangberg, *The League Quarterly* 20, no. 4 (summer 1949), p. 15. Pierre Reverdy wrote that one aim of Cubism was "pleasing the public" and that it was "an art of great reality." See his "On Cubism," *Nord-Sud* (1917); trans. Edward F. Fry, in Fry, *Cubism* (New York: McGraw-Hill, 1966), p. 145.

173. Masheck, "Carpet Paradigm," p. 100.

174. Maurice Raynal, *Anthologie de la peinture en France de 1906 à nos jours* (1927), quoted in Christopher Green,

Cubism and Its Enemies: Modern Movements and Reaction in French Art, 1916–1928 (New Haven: Yale University Press, 1987), p. 159.

175. Reverdy stated that "the art of today is an art of great reality. But it must be understood *artistic reality* and not *realism*; the latter is the genre which is the most opposed to us"; see his "On Cubism," p. iv.

176. Apollinaire, "The Cubist Painters" (1913), excerpted in Chipp, ed., *Theories of Modern Art*, p. 222.

177. Kahnweiler, "The Rise of Cubism" (1915), excerpted in Chipp, ed., *Theories of Modern Art*, p. 250.

178. Mondrian, "On Abstract Art," p. 7.

179. Mondrian, letter to Bremmer (January 1914), quoted in James, "Piet Mondrian," p.15.

180. Mondrian, "On Abstract Art," p. 7.

181. Mondrian, letter to James Johnson Sweeney (May 24, [1943]), facsimile published in *Piet Mondrian: The Earlier Years*, exh. cat. (New York: Solomon R. Guggenheim Museum, 1957), unpaginated; see also Mondrian, "Plastic Art," p. 359; and his statement (ca. 1943), reprinted in Chipp, ed., *Theories of Modern Art*, p. 364.

182. Mondrian, "New Plastic in Painting," p. 37; and Threlfall, *Piet Mondrian*, p. 198. Of all the Cubists, Mondrian felt the greatest affinity with Fernand Léger, whose "homogeneous forms with tense curved lines rhythmically composed" bear a strong relationship to his own work; see Mondrian, "New Plastic in Painting," p. 64.

183. Malevich, "From Cubism and Futurism to Suprematism," pp. 33–37; and "New Systems in Art," pp. 94–102, 109–18.

184. Malevich, "From Cubism and Futurism to Suprematism," p. 30.

185. In addition to illustrations of works by Jean Arp, Paul Cézanne, Paul Gauguin, Paul Klee, Alfred Kubin, August Macke, Marc, Henri Matisse, Gabriele Münter, Pablo Picasso, Henri Rousseau, Arnold Schönberg, and Vincent van Gogh, *The Blaue Reiter Almanac* included a wide range of nontraditional art, including children's drawings, fairy tale illustrations, and African and Mexican sculpture. The purpose of this range of art was to indicate a unifying impetus for art created throughout various periods and locales.

186. Kandinsky, letter to Marc (October 2, 1911), reprinted in Lankheit, ed., *Wassily Kandinsky, Franz Marc,*

Briefwechsel (Munich and Zurich, 1983), pp. 61ff, and quoted in Hahl-Koch, *Kandinsky*, p. 196.

187. Kandinsky, *Concerning the Spiritual*, pp. 36, 39.

188. Ibid., p. 39.

189. Ibid.

190. See ibid., pp. 71–72, where Kandinsky discussed both the modern dance of Isadora Duncan and painting in terms of abstraction's potential. See also Kandinsky, "Abstract Painting" (1936), reprinted in Lindsay and Vergo, eds., *Kandinsky: Complete Writings*, vol. 2, p. 789, where he explained that "the abstract painter derives his 'stimulus' not from some part or other of nature, but from nature as a whole, from its multiplicity of manifestations, which accumulate within him and lead him to the work of art. . . . Abstract form is broader, freer, and richer in content than 'objective' [form]."

191. Hans K. Roethel and Jean K. Benjamin, *Kandinsky: Catalogue Raisonné of the Oil Paintings*, 2 vols. (Ithaca, N.Y.: Cornell University Press, 1982–84), vol. 1, cat. nos. 427–29.

192. "Le Salon des Indépendants, Salle XVII, Hommage à Picasso du cubisme," *Gil Blas* (1912); quoted in Christian Derouet and Jessica Boissel, *Kandinsky: Oeuvres de Vassily Kandinsky (1866–1944), Collections du Musée National d'Art Moderne* (Paris: Centre Georges Pompidou, Musée National d'Art Moderne, 1984), p. 80.

193. Tabarant, "Salon des Indépendants" (review), *Le Siècle* (1912); quoted in Derouet and Boissel, *Kandinsky*, p. 80.

194. Marcel Herbert, "Les Arts et les artistes – sur Kandinsky," *La Société Nouvelle – Revue internationale* (1914); quoted in Derouet and Boissel, *Kandinsky*, p. 80.

195. Apollinaire, "Modern Painting," *Der Sturm* (1913); reprinted in Leroy C. Breunig, ed., *Apollinaire on Art: Essays and Reviews 1902–1918*, trans. Susan Suleiman, Documents of Twentieth-Century Art (New York: Viking, 1972), p. 267.

196. Apollinaire, "The Salon des Indépendants" (review), *L'Intransigeant* (1912); reprinted in Breunig, ed., *Apollinaire on Art*, p. 214.

197. Apollinaire, "Modern Painting," p. 270.

198. Apollinaire, "The Beginnings of Cubism," *Le Temps* (1912); reprinted in Breunig, ed., *Apollinaire on Art*, p. 219.

199. Apollinaire, "Review of the First German Autumn Salon, Berlin," *Les Soirées de Paris* (1913); reprinted in Breunig, ed., *Apollinaire on Art*, p. 338. For more on Apollinaire's evaluation of Kandinsky, see his article "For Kandinsky," *Der Sturm* (1913); reprinted in ibid., p. 277.

200. André de Ridder, *Sélection* (1921); quoted in Derouet and Boissel, *Kandinsky*, p. 160.

201. In 1929, a show of Kandinsky's watercolors was held at the Galerie Zak in Paris.

202. Hans Tietze, "Kandinsky, Klänge," *Die Graphischen Künste* 37 (1914), pp. 15–16. This is a review of Kandinsky's *Klänge*, an illustrated book of prose poems.

203. Herbert Kühn, "Kandinsky: Für," *Das Kunstblatt* 3, no. 6 (1919), p. 178.

204. Apollinaire, "Through the Salon des Indépendants," *L'Intransigeant* (1913); reprinted in Breunig, ed., *Apollinaire on Art*, p. 289.

205. Steenhoff, review, quoted in Threlfall, *Piet Mondrian*, p. 216.

206. See note 172 above.

207. Kahnweiler, "Kahnweiler Reviews Cubism," p. 15.

208. Arthur Cravan, "L'Exposition des Indépendants," *Maintenant* (1914); quoted in Jean Hubert-Martin, "Casimir Malevitch: Fonder une ère nouvelle," in *Malevitch*, exh. cat. (Paris: Centre Georges Pompidou, Musée National d'Art Moderne, 1978), p. 13.

209. Raynal, "Les Arts," *L'Intransigeant* (November 1, 1922), p. 2. The degree of Malevich's anonymity is further shown in Louis Reau's 1922 book about Russian art: *L'Art russe de Pierre le Grand à nos jours* (Paris: Henri Laurens, 1922). More recently, in a 1989 account of Parisian artistic life between 1914 and 1925, the author does not even mention Malevich or Mondrian: Kenneth E. Silver, *Esprit de Corps: The Art of the Parisian Avant-Garde and the First World War, 1914–1925* (Princeton: Princeton University Press, 1989).

210. Robert Delaunay, *Du Cubisme à l'art abstrait*, ed. Pierre Francastel (Paris: S.E.V.P.E.N., 1957), pp. 240–41.

211. For example, there is Matisse's famous explanation of the aims of his art: "What I dream of is an art of balance, of purity and serenity devoid of troubling or depressing subject matter, an art which might be for every mental worker, be he businessman or writer, like an appeasing influence, like a mental soother, something like a good armchair in which to rest from physical fatigue." Matisse, "Notes of a Painter" (1908), reprinted in Chipp, ed., *Theories of Modern Art*, p. 135. Another example is the following statement by Léger: "The work of art should not participate in the battle [for the individual's leisure and freedom]; on the contrary, it should be the resting place after the strife of your daily struggles, in an atmosphere of calm and relaxation." Léger, "Color in the World," *Europe* (1938); reprinted in Léger, *Functions of Painting*, ed. Edward F. Fry, trans. Alexandra Anderson, Documents of Twentieth-Century Art (New York: Viking, 1973), p. 130.

212. Maurice Denis, "Définition du Néo-traditionnisme" (1890), quoted in George Heard Hamilton, *Painting and Sculpture in Europe 1880–1940* (3rd rev. ed.; New York: Penguin Books, 1983), p. 107.

213. See Dora Vallier, *Abstract Art*, trans. Jonathan Griffin (New York: Orion Press, 1970), pp. 11–18.

214. Silver, *Esprit de Corps*, pp. 6–8, 92–93.

215. Raynal wrote, "What finer idea can there be than this conception of a *pure* painting." Raynal, "L'Exposition de *La Section d'Or*," *La Section d'Or* (1912); quoted in Masheck, "Carpet Paradigm," p. 101.

216. For a discussion of the uses of "decoration" among the Cubist artists and writers of the time, see Gamwell, *Cubist Criticism*, pp. 16, 28–30, 48, 64–65, 92–93. Apollinaire had been disdainful of an exhibition of decorative arts in Munich in 1910; see Masheck, "Raw Art: Primitive Authenticity and German Expressionism," *Res* 4 (fall 1982), p. 114, n. 104.

217. Willard Huntington Wright, *Modern Painting: Its Tendency and Meaning* (New York: John Lane; London: John Lane, Bodley Head, 1915), pp. 308, 311.

218. Roger Fry, "Art: The Post-Impressionists — II," *The Nation* (1910); quoted in Marilyn McCully, ed., *A Picasso Anthology: Documents, Criticism, Reminiscences* (London: Arts Council of Great Britain and Thames and Hudson, 1981), p. 79.

219. Roger Fry, "The French Group," in Grafton Galleries, *Second Post-Impressionist Exhibition of English, French and Russian Artists*, exh. cat. (1912); quoted in McCully, ed., *Picasso Anthology*, p. 86.

220. Josep Junoy, "Picasso's Art," *Arte y Artistas* (1912); trans. Miguel Sobré, quoted in McCully, ed., *Picasso Anthology*, p. 88.

221. Arp and L. H. Neitzel, "The Cubists," trans. David Britt, in *Neue französische Malerei* (1913); quoted in McCully, *Picasso Anthology*, p. 101.

222. For a concise account of this development, see Green, *Cubism and Its Enemies*, pp. 221–23.

223. Braque, quoted in Vallier, "Braque, la peinture et nous," *Cahiers d'art* (1954); reprinted in Vallier, *Georges Braque* (Basel: Editions Beyeler, 1968), unpaginated [p. 11].

224. Picasso, interview with Marius de Zayas (1923), quoted in Green, *Cubism and Its Enemies*, p. 231.

225. Picasso, quoted in Christian Zervos, "Conversation avec Picasso," *Cahiers d'art* (1935); reprinted in Dore Ashton, ed., *Picasso on Art: A Selection of Views*, Documents of Twentieth-Century Art (New York: Viking, 1972), p. 9; similar assertions by Picasso are on pp. 36, 66.

226. Albert Gleizes and Jean Metzinger, "Cubism," trans. Edward F. Fry, in Fry, *Cubism*, p. 106.

227. Georges Braque, "Pensées et réflexions sur la peinture," *Nord-Sud* (1917); quoted in Silver, *Esprit de Corps*, p. 106.

228. Juan Gris, "On the Possibilities of Painting" (lecture delivered to the Société des Etudes Philosophiques et Scientifiques at the Sorbonne, 1924), quoted in Green, *Cubism and Its Enemies*, p. 223.

229. Léger, "The Origins of Painting and Its Representational Value," *Montjoie!* (1913); reprinted in Léger, *Functions of Painting*, p. 4.

230. See Léger, "Art and the People," *Arts de France* (1946); reprinted in Léger, *Functions of Painting*, p. 147. See also his "Modern Architecture and Color," in *American Abstract Artists* (1946); trans. George L. K. Morris, reprinted in *Functions of Painting*, p. 150.

231. See Léger, "Contemporary Achievements in Painting," *Soirées de Paris* (1914); reprinted in Léger, *Functions of Painting*, p. 14. See also his "Notes on Contemporary Plastic Life," *Kunstblatt* (1923); reprinted in *Functions of Painting*, p. 26.

232. Léger, quoted in Douglas Cooper, *Fernand Léger et le nouvel espace*, trans. François Lachenal (Geneva: Editions des Trois Collines, 1949), pp. 74–75.

233. See Green, *Cubism and Its Enemies*, pp. 239–42.

234. In 1931, Léger gave credit to "the northern artists" who created Neoplasticism. See Léger, "Abstract Art," *Cahiers d'art* (1931); reprinted in Léger, *Functions of Painting*, p. 82.

235. Ibid., p. 83.

236. In an interview with Apollinaire (1907), Matisse remarked, "When difficulties stopped me in my work I said to myself: 'I have colors, a canvas, and I must express myself with purity, even though I do it in the briefest manner by putting down, for instance, four or five spots of color or drawing four or five lines which have a plastic expression'"; quoted in Jack D. Flam, ed., *Matisse on Art* (New York: E.P. Dutton, 1978), p. 32.

237. In "Notes of a Painter" (1908), Matisse reflected that the artist "must have the humility of mind to believe that he has painted only what he has seen. . . . Those who work in a preconceived style, deliberately turning their backs on nature, miss the truth. An artist must recognize, when he is reasoning, that his picture is an artifice; but when he is painting, he should feel that he has copied nature. And even when he departs from nature, he must do it with the conviction that it is only to interpret her more fully"; reprinted in Flam, ed., *Matisse on Art*, p. 3. See also Matisse, "Statements to Tériade, 1936," reprinted in *Matisse on Art*, p. 74.

238. This work is also known as *The Chromatic Composition*; see Jack Cowart et al., *Henri Matisse: Paper Cut-Outs* (St. Louis: St. Louis Art Museum; Detroit: Detroit Institute of Arts, 1977), p. 244.

239. Matisse, interview with André Verdet (1952), reprinted in Flam, ed., *Matisse on Art*, p. 147.

240. Paul Klee, "Die Ausstellung des 'Modernen Bundes' im Kunsthaus Zürich," *Die Alpen* (1912); quoted in Spate, *Orphism*, p. 35.

241. Delaunay, *Du Cubisme*, p. 160. See also Delaunay's letters to August Macke and Kandinsky from 1912, excerpted in Chipp, ed., *Theories of Modern Art*, pp. 317–19.

242. Spate, *Orphism*, p. 198; Delaunay, *Du Cubisme*, pp. 108–09; and Delaunay, "Light" (1912), reprinted in Arthur A. Cohen, ed., *The New Art of Color: The Writings of Robert and Sonia Delaunay*, trans. David Shapiro and Cohen, Documents of Twentieth-Century Art (New York: Viking, 1978), p. 83. This essay was translated into German by Klee for publication in *Der Sturm* 3, nos. 144–45 (1913).

243. Delaunay, *Du Cubisme*, p. 67.

244. Ibid., p. 97.

245. Ibid., p. 63.

246. See Spate, *Orphism*, p. 377; and Long, *Kandinsky*, p. 157, n. 18.

247. Sherry A. Buckberrough, *Robert Delaunay: The Discovery of Simultaneity*, Studies in Fine Arts: The Avant-Garde, no. 21 (Ann Arbor, Mich.: U.M.I. Research Press, 1982), p. 226.

248. Ibid., pp. 161–79.

249. Long, *Kandinsky*, pp. 138–40; and Spate, *Orphism*, pp. 194–95.

250. Delaunay, letter to Kandinsky (early spring 1912), reprinted in Cohen, ed., *New Art of Color*, pp. 113–14.

251. Delaunay, "Painting Is, by Nature, a Luminous Language" (ca. 1924), reprinted in Cohen, ed., *New Art of Color*, p. 103. Ivor Davies noted that in a letter of 1912 to Kandinsky's colleague August Macke, Delaunay emphasized his dependence on "'observations in nature of its luminous essense,'" which Davies pointed out, "is unlike the geometrical metaphysical or spiritual starting point of the German group"; see Davies, "Western European Art Forms Influenced by Nietzsche and Bergson before 1914, Particularly Italian Futurism and French Orphism," *Art International* 19, no. 3 (March 20, 1975), pp. 51–52.

252. Apollinaire, "The Cubist Painters," p. 222.

253. John Golding, *Cubism: A History and an Analysis 1907–1914* (2nd ed.; Boston: Boston Book and Art Shop, 1968), pp. 38–39; and Spate, *Orphism*, p. 38.

254. Spate, *Orphism*, p. 47.

255. Green, *Cubism and Its Enemies*, pp. 226–28.

256. A dancing female figure may be the source for *Amorpha, Fugue in Two Colors*; see Long, *Kandinsky*, pp. 143–44; and Green, "Cubism and the Possibility of Abstract Art," in *Essays on the Background to Abstract Art, 1910–20*, p. 173.

257. Spate, *Orphism*, p. 85.

258. Golding, *Cubism*, pp. 29–32; and Green, "Possibility of Abstract Art," p. 172. Delaunay participated in the discussions but not the exhibition (Hamilton, *Painting and Sculpture in Europe*, p. 261).

259. Spate, *Orphism*, pp. 37–38.

260. Spate, *Orphism*, pp. 194–95; and Long, *Kandinsky*, p. 139.

261. Ashton, *A Reading of Modern Art* (Cleveland: The Press of Case Western Reserve University, 1969), p. 23; Linda Dalrymple Henderson, "X Rays and the Quest for Invisible Reality in the Art of Kupka, Duchamp, and the Cubists," *Art Journal* 47, no. 4 (winter 1988), pp. 87–91.

262. According to personal notes by František Kupka, he had discovered Kandinsky's book by July 1913; see *František Kupka 1871–1957: A Retrospective*, exh. cat. (New York: Solomon R. Guggenheim Museum, 1975), p. 311.

263. Kupka, "Creation—The Basic Problem in Painting," *La Vie des Lettres* (1921); quoted in Ludmila Vachtova, *František Kupka: Pioneer of Abstract Art*, trans. Zdenek Lederer (London: Thames and Hudson, 1968), p. 285. See also statements by Kupka, in "To Create! A Question of Principle in Painting," *La Vie des lettres* (1921); quoted in Green, *Cubism and Its Enemies*, pp. 227–28.

264. Constantin Brancusi, conversation with Malvina Hoffmann (1938), quoted in Ionel Jianou, *Brancusi* (New York: Tudor, 1963), p. 58.

265. Brancusi, quoted in *Brancusi*, exh. cat. (New York: Brummer Gallery, 1926), unpaginated.

266. Carola Giedion-Welcker, *Constantin Brancusi*, trans. Maria Jolas and Anne Leroy (New York: George Braziller, 1959), p. 33.

267. Radu Varia, *Brancusi*, trans. Mary Vadouyer (New York: Rizzoli, 1986), p. 265.

268. Brancusi, quoted in ibid.

269. Brancusi, "Aphorisms," excerpted in Chipp, ed., *Theories of Modern Art*, p. 365. See also Varia, *Brancusi*, p. 256.

270. From the catalogue of Severini's exhibition at the Marlborough Gallery, London (1913); quoted in Joshua C. Taylor, *Futurism* (New York: Museum of Modern Art, 1961), p. 13.

271. "Futurist Painting: Technical Manifesto" (April 11, 1910), reprinted in E. Coen, *Boccioni*, exh. cat. (New York: Metropolitan Museum of Art, 1988), p. 231.

272. Giacomo Balla and Fortunato Depero, *The Futurist Reconstruction of the Universe* (1915), quoted in Margit Rowell, *The Planar Dimension: Europe, 1912–1932*, exh. cat. (New York: Solomon R. Guggenheim Museum, 1979), p. 17.

273. Buckberrough, *Robert Delaunay*, pp. 222–23.

274. Mikhail Larionov, quoted in Camilla Gray, *The Russian Experiment in Art, 1863–1922* (2nd. rev. ed.; London: Thames and Hudson, 1986), p. 138.

275. See Magdalena Dabrowski, *Contrasts of Form: Geometric Abstract Art, 1910–1980*, exh. cat. (New York: Museum of Modern Art, 1985), p. 27.

276. T. E. Hulme, "Modern Art and Its Philosophy" lecture delivered in London (1914), quoted in Richard Cork, *Vorticism and Abstract Art in the First Machine Age*, 2 vols. (Berkeley: University of California Press, 1976), vol. 1, p. xxi; for a discussion of this lecture and of Worringer, see vol. 1, pp. 139–42.

277. Cork, *Vorticism and Abstract Art*, vol. 1, p. 57.

278. See Percy Wyndham Lewis, "A Review of Contemporary Art," *Blast*, no. 2 (July 1915), where he introduced the word "Vorticism" (p. 38). In this review, he stated that "in our time it is natural that an artist should wish to endow his 'bonhomme' when he makes one in the grip of an heroic emotion, with something of the fatality, grandeur and efficiency of a machine" (p. 43) and "In any heroic, that is, energetic representations of men today, this reflection of the immense power of machines will be reflected" (p. 44). Regarding Severini's influence on Lewis, see Cork, *Vorticism and Abstract Art*, vol. 1, p. 130.

279. Ibid.

280. Lewis declared that "the whole of the modern movement, then, is, we maintain, under a cloud. That cloud is the exquisite and accomplished, but discouraged, sentimental and inactive, personality of Picasso. We must disinculpate ourselves of Picasso at once"; see Cork, *Vorticism and Abstract Art*, vol. 1, p. 41.

281. Ibid.

282. Ibid., p. 46.

283. Ibid., pp. 214–16.

284. Lewis, "Review of Contemporary Art," p. 40; see Cork, *Vorticism and Abstract Art*, vol. 1, p. 283. T. E. Hulme described Kandinsky's abstraction as "rather dilletante [sic]" and "as a kind of romantic heresy"; see his "Modern Art III—The London Group," *The New Age* (1914); quoted in Cork, *Vorticism and Abstraction*, vol. 1, p. 214.

285. Lewis, "Review of Contemporary Art," p. 40.

286. Clive Bell, "Post-Impressionist and Futurist Exhibition, Doré Galleries, London" (review), *The Nation* (1913); quoted in Cork, *Vorticism and Abstract Art*, vol. 1, p. 126.

287. Paul Clemen, "Contemporary German Art," in *Exhibition of Contemporary German Art, 1909*, exh. cat. (Chicago: Art Institute of Chicago, 1909), p. 31.

288. The *Panels for Edwin R. Campbell, Nos. 1–4*, 1914, are now in the collection of the Museum of Modern Art, New York.

289. Eddy, *Cubists and Post Impressionism* (Chicago: A. C. McClurg, 1914), p. 115.

290. Ibid., pp. 98–101.

291. William Innes Homer, *Alfred Stieglitz and the American Avant-Garde* (Boston: New York Graphic Society, 1977), p. 75.

292. Ibid.

293. Ibid., p. 170. The work purchased was *Improvisation No. 27*, 1912, now in The Alfred Stieglitz Collection, The Metropolitan Museum of Art, New York.

294. See Ann Lee Morgan, *Arthur Dove: Life and Work, with a Catalogue Raisonné*, An American Art Journal/Kennedy Galleries Book (Newark: University of Delaware Press; London: Associated University Presses, 1984), pp. 40–43. For more on these works, see also Sasha M. Newman, *Arthur Dove and Duncan Phillips: Artist and Patron*, exh. cat. (Washington, D.C.: Phillips Collection; New York: George Braziller, 1981), pp. 27–29, 56; Andrew Dickson White and Alan R. Solomon, *Arthur G. Dove 1880–1946: A Retrospective Exhibition*, exh. cat. (Ithaca, N.Y.: Cornell University Press, 1954), pp. 6–7, 16, cat. nos. 3–4; and Long, *Kandinsky*, p. 157, n. 19.

295. See Morgan, *Arthur Dove*, pp. 43–44, and Homer, "Identifying Arthur Dove's 'The Ten Commandments,'" *American Art Journal* 12 (summer 1980), pp. 21–32.

296. Homer, *Alfred Stieglitz*, pp. 160–63, 286–87, nn. 93–94, 98.

297. Ibid., pp. 161–63; Barbara Haskell, *Marsden Hartley*, exh. cat. (New York: Whitney Museum of American Art and New York University Press, 1980), pp. 29–31, 187–88; and Gail R. Scott, *Marsden Hartley* (New York: Abbeville Press, 1988), pp. 44–49, 166.

298. Haskell, *Marsden Hartley*, p. 188; Scott, *Marsden Hartley*, p. 166.

299. *Camera Work*, no. 31 (July 1910), p. 51; reprinted in *Max Weber: The Cubist Decade, 1910–1920*, exh. cat. (Atlanta: High Museum of Art, 1991), p. 95.

300. The degree of Delaunay's influence has been debated. See Gail Levin, *Synchromism and American Color Abstraction, 1910–1925*, exh. cat. (New York: Whitney Museum of American

Art and George Braziller, 1978), pp. 14, 18–19. Levin suggested that the Synchromists may have known the work of Kupka in 1911–12 (pp. 17–18).

301. For a discussion of the relationship of American to European art during the first decades of the century, see Ashton, *The New York School: A Cultural Reckoning* (2nd ed.; London: Penguin Books, 1985), pp. 8–14. Certainly, many other artists might be mentioned as significant in establishing abstraction in the United States in the second decade of the century, including, for example, Patrick Henry Bruce, Manierre Dawson, and Alfred Maurer.

302. George L. Mosse, *Fallen Soldiers: Reshaping the Memory of the World Wars* (New York: Oxford University Press, 1990), p. 3.

303. Green, *Cubism and Its Enemies*, p. 25.

304. Richard Huelsenbeck, "En Avant Dada: A History of Dadaism" (1920), trans. Ralph Manheim, in Robert Motherwell, ed., *The Dada Painters and Poets: An Anthology* (2nd ed.; Cambridge, Mass.: The Belknap Press of Harvard University Press, 1981), pp. 24, 32. Huelsenbeck also said, "Dada was to be a rallying point for abstract energies" (p. 24).

305. Ibid., p. 24.

306. See Hugo Ball, "Kandinsky" (lecture delivered at Galerie Dada), Zurich, 1917; trans. Christopher Middleton, in Ball, *Flight Out of Time; A Dada Diary*, ed. John Elderfield, trans. Ann Raimes (New York: Viking, 1974), pp. 222–34.

307. Arp, "Kandinsky" (1948), in *Arp on Arp: Poems, Essays, Memories*, ed. Marcel Jean. Joachim Neugroschel, Documents of Twentieth-Century Art (New York: Viking, 1969), p. 228.

308. Arp, "Concrete Art" (1947), in *On My Way: Poetry and Essays 1912 . . . 1947*, ed. Robert Motherwell, trans. Ralph Manheim, Documents of Modern Art (New York: Wittenborn, Schultz, 1948), p. 72.

309. Ibid., p. 70; see also Arp, "Dadaland," in *Arp on Arp*, p. 232.

310. Arp and Neitzel, "The Cubists," p. 101.

311. Arp and Camille Bryon, "Conversation at Meudon" (1955), in *Arp on Arp*, p. 339. Related concerns are discussed in Arp, "And So the Circle Closed" (1948), in *Arp on Arp*, p. 246, and in Arp and Neitzel, "The Cubists," p. 101.

312. Arp, "Collages" (1955), in *Arp on Arp*, p. 328.

313. Arp believed that chance was a path to an otherwise "inaccessible order" in the world, and that use of it resulted in "pure life." Arp, "Signposts" (1950), in *Arp on Arp*, pp. 232, 246.

314. Ball, diary entry (May 19, 1917), in Ball, *Flight Out of Time*, pp. 114–15.

315. Tristan Tzara, quoted in Motherwell, ed., *Dada Painters and Poets*, p. 78.

316. Huelsenbeck, "En Avant Dada," p. 28.

317. Ibid., pp. 26, 37.

318. Kurt Schwitters, "Merz" (1920), *Der Ararat* (1921); reprinted in Motherwell, ed., *Dada Painters and Poets*, p. 60.

319. Ibid., p. 62.

320. See John Milner, *Vladimir Tatlin and the Russian Avant-Garde* (New Haven: Yale University Press, 1983), pp. 99ff.

321. For instance, in Poland, Wladyslaw Strzeminski created *Tools and Products of Industry*, 1919–20; it is illustrated in *The Great Utopia: The Russian and Soviet Avant-Garde, 1915–1932*, exh. cat. (New York: Solomon R. Guggenheim Museum, 1992), cat. no. 82.

322. Sigmund Freud, *Reflections on War and Death*, trans. A. A. Brill and Alfred B. Kuttner (New York: Moffat, Yard, 1918), pp. 17, 41.

323. See Franklin Baumer, *Modern European Thought* (New York: Macmillan, 1977), p. 404.

324. The postwar reaction to Bergson in France is discussed in Silver, *Esprit de Corps*, pp. 209, 216–18, 322–23.

325. See the "De Stijl Manifesto" (1918), reprinted in *Collected Writings of Mondrian*, p. 24. Article 2 states: "The war is destroying the old world and its content: domination by the individual in every area."

Chapter 3

1. Peter Fuller refers to the "disappearance of God" during the postwar period; see his essay "Beyond the Veil, Stars and Stripes?," Art & Design Profile 3: *Abstract Art and the Rediscovery of the Spiritual*, Art & Design 3, nos. 5–6 (1987), p. 72.

2. Wilhelm Worringer, "Art Questions of the Day," *The Monthly Criterion* 6, no. 2 (August 1927), pp. 107–08.

3. See Norbert Lynton, "The New Age," in *Towards a New Art: Essays on the Background to Abstract Art, 1910–20* (London: Tate Gallery, 1980), pp. 14–18.

4. Kazimir Malevich, "On New Systems in Art" (1919), reprinted in Malevich, *Essays on Art 1915–1933*, ed. Troels

Andersen, trans. Xenia Glowacki-Prus and Arnold McMillin (London: Rapp & Whiting; Chester Springs, Pa.: Dufour Editions, 1968), vol. 1, p. 117.

5. Vladimir Tatlin, T. Shapiro, I. Meyerzon, and Pavel Vinogradov, "The Work Ahead of Us" (1920), reprinted in Stephen Bann, ed., *The Tradition of Constructivism* (New York: Viking, 1974), p. 14.

6. Modris Eksteins, *Rites of Spring: The Great War and the Birth of the Modern Age* (Boston: Houghton Mifflin, 1989), p. 259.

7. Nikolai Punin, quoted in John Milner, *Russian Revolutionary Art* (London: Oresko Books, 1979), p. 24.

8. Punin, "On the Town," in *Vladimir Tatlin*, exh. cat. (Stockholm: Moderna Museet, 1968), p. 56.

9. See Edouard Roditi, "Interview with Gabrièle Münter," *Arts Magazine* 34, no. 4 (January 1960), p. 40.

10. This transition is discussed by Magdalena Dabrowski in her *The Russian Contribution to Modernism: "Construction" as Realization of Innovative Aesthetic Concepts of the Russian Avant-Garde* (New York: Institute of Fine Arts, 1990), p. 78.

11. Apparently, the necessity for an accessible art was so obvious that as early as 1922, in France, Louis Reau had already observed that Russian officials wanted an art that was "compréhensible aux ouvriers et aux paysans" (comprehensible to workers and peasants). See Reau, *L'Art russe de Pierre le Grand à nos jours* (Paris: Henri Laurens, 1922), p. 265.

12. The slogan read: "Die Kunst ist tot/Es lebe die neue Maschinenkunst Tatlins"; see *Art into Life: Russian Constructivism 1914–1932*, exh. cat. (Seattle: Henry Art Gallery, University of Washington; New York: Rizzoli, 1990), pp. 212, 215. See also Milner, *Russian Revolutionary Art*, p. 25.

13. See Milner, *Vladimir Tatlin and the Russian Avant-Garde* (New Haven: Yale University Press, 1983), p. 195.

14. Aleksandr Rodchenko, "Working with Maiakovskii" (1939), quoted in *Art into Life*, p. 47.

15. See Dabrowski, *Russian Contribution*, pp. 15–16; and Milner, *Russian Revolutionary Art*, pp. 22, 43.

16. Rodchenko, quoted in Selim O. Khan-Magomedov, *Rodchenko: The Complete Work*, ed. Vieri Guilici (Cambridge, Mass.: M.I.T. Press, 1987), p. 84.

17. Rodchenko, "The Line" (1920–21), *Arts Magazine* 47, no. 7 (May–June 1973), pp. 50–52.

18. *First Discussional Exhibition of Organizations of Active Revolutionary Art*, exh. cat. (Moscow, 1924), quoted in *Art into Life*, p. 36.

19. El Lissitzky and Hans [Jean] Arp, *Die Kunstismen, 1914–1924* (Zurich: Eugen Rentsch Verlag, 1925), p. xi; quoted in *The Great Utopia: The Russian and Soviet Avant-Garde, 1915–1932*, exh. cat. (New York: Solomon R. Guggenheim Museum, 1992), p. 270. See also Kestatis Paul Zygas, *Form Follows Form: Source Imagery of Constructivist Architecture 1917–1925* (Ann Arbor, Mich.: U.M.I. Research Press, 1981), p. 63.

20. Lissitzky, "A. and Pangeometry," reprinted in Larissa A. Zhadova, *Malevich: Suprematism and Revolution in Russian Art 1910–1930* (London: Thames and Hudson, 1982), p. 336.

21. Ibid.

22. George L. Mosse, *The Crisis of German Ideology: Intellectual Origins of the Third Reich* (New York: Grosset & Dunlap, 1964), p. 166.

23. See Franklin L. Baumer, *Modern European Thought* (New York: Macmillan, 1977), p. 409.

24. Karl Jaspers, *Man in the Modern Age* (London: George Routledge & Sons, 1933), pp. 47–48.

25. Naum Gabo and Antoine Pevsner, "The Realistic Manifesto" (1920), reprinted in *Art into Life*, p. 62.

26. See Herbert Read and Leslie Martin, *Gabo: Constructions, Sculpture, Paintings, Drawings, Engravings* (Cambridge, Mass.: Harvard University Press, 1957), pp. 156, 162, 165. Gabo, in his later years, preferred, like Kandinsky, the term "absolute" rather than "abstract"; see Gabo, "Sculpture: Carving and Construction in Space" (1937), reprinted in Chipp, ed., *Theories of Modern Art*, pp. 330, 336.

27. Malevich, "A Letter from Malevich to the Dutch Artists" (1922), in Malevich, *Essays on Art*, vol. 1, p. 255, n. 62.

28. Malevich, "The Question of Imitative Art," in Malevich, *Essays on Art*, vol. 1, p. 165.

29. Ibid., p. 174.

30. Malevich referred, in 1919, to "Russia. The International Bureau of International Art." See Malevich, *Essays on Art 1915–1933*, ed. Troels Andersen, trans. Xenia Hoffmann (Copenhagen: Borgen, 1978), vol. 4: *The Artist, Infinity,*

Suprematism: Unpublished Writings 1913–33, p. 223. Three years later, he opened a letter with the salutation "Dear comrade innovators in Holland!" ("Letter to Dutch Artists," p. 183), and around the same time referred to a single united community of artists ("Imitative Art," pp. 177–78).

31. Malevich, "Imitative Art," p. 176.

32. Malevich, "Letter to Dutch Artists," p. 187.

33. Malevich, "God Is Not Cast Down," in Malevich, *Essays on Art*, vol. 1, pp. 210–11.

34. Ibid., pp. 188–223, n. 255.

35. Malevich, "Suprematism," in Malevich, *Essays on Art*, vol 4, pp. 144–57.

36. Malevich, "Letter to Schwitters," in Malevich, *Essays on Art*, vol. 4, p. 160.

37. See John E. Bowlt, Introduction, in *Russian Art of the Avant-Garde: Theory and Criticism* (New York: Thames and Hudson, 1988), pp. xxxvii–xl.

38. For more on the relationship between the avant-garde and the Communist Soviet regime, see *Art into Life*, p. 228.

39. Paul Klee, *On Modern Art*, trans. Paul Findlay (London: Faber and Faber, 1966), p. 43.

40. Klee, *The Diaries of Paul Klee*, ed. Felix Klee (Berkeley: University of California Press, 1968), p. 125. Although this entry is dated 1902, it now seems clear, thanks to the work of Christian Geelhaar, that the *Diaries* were written retrospectively; see Geelhaar, *Paul Klee: Schriften, Rezensionen und Aufsätze* (Cologne: DuMont, 1976).

41. Klee, *Diaries*, p. 313.

42. Ibid.

43. See Rose-Carol Washton Long, "Expressionism, Abstraction and the Search for Utopia in Germany," in Maurice Tuchman with Judi Freeman, eds., *The Spiritual in Art: Abstract Painting 1890–1985*, exh. cat. (Los Angeles: Los Angeles County Museum of Art; New York: Abbeville Press, 1986), p. 214.

44. Vasily Kandinsky, *Punkt und Linie zu Fläche: Beitrag zur Analyse der malerischen Elemente*, eds. Walter Gropius and László Moholy-Nagy (Munich: Albert Langen, 1926); published in English as *Point and Line to Plane: Contribution to the Analysis of the Pictorial Elements*, trans. Howard Dearstyne and Hilla Rebay (New York: Museum of Non-Objective Painting, 1947).

45. Kandinsky, "Abstract Art" (1925), reprinted in Kenneth C. Lindsay and Peter Vergo, eds., *Kandinsky: Complete Writings on Art*, 2 vols. (Boston: G. K. Hall, 1982), vol. 2, p. 514.

46. Joseph Harris Caton, *The Utopian Vision of Moholy-Nagy: Technology, Society, and the Avant-Garde* (Ann Arbor, Mich.: U.M.I. Research Press, 1984), pp. 26–38.

47. Moholy-Nagy, quoted in Richard Kostelanetz, ed., *Moholy-Nagy* (New York: Praeger, 1970), p. 45.

48. Moholy-Nagy, quoted in Herbert Bayer, Walter Gropius, and Ise Gropius, eds., *Bauhaus 1919–1928* (New York: Museum of Modern Art, 1938); quoted in Gillian Naylor, *The Bauhaus Reassessed* (New York: E. P. Dutton, 1985), p. 146.

49. See Hans Wingler, *The Bauhaus* (Cambridge, Mass.: M.I.T. Press, 1984), pp. 430, 504.

50. Josef Albers, "Creative Education" (1928), reprinted in ibid., p. 143.

51. See Naylor, *Bauhaus Reassessed*, pp. 165–72.

52. Moholy-Nagy, "Letter of Resignation from the Bauhaus," reprinted in Bann, ed., *Tradition of Constructivism*, p. 136.

53. Ibid., pp. 136–37.

54. Peter Gay, *Weimar Culture: The Outsider as Insider* (New York: Harper and Row, 1968), p. 122.

55. Dagmar Barnouw, *Weimar Intellectuals and the Threat of Modernity* (Bloomington: University of Indiana Press, 1988), p. 4.

56. Gay, *Weimar Culture*, p. 144. See also Walter Laqueur, *Weimar: A Cultural History 1918–1933* (New York: Putnam, 1974), pp. 174–80.

57. See Robert P. Welsh, "De Stijl: A Reintroduction," in Mildred Friedman, ed., *De Stijl, 1917–1931: Visions of Utopia*, exh. cat. (Minneapolis: Walker Art Center; New York: Abbeville Press, 1982), pp. 17–43.

58. Paul Overy, *De Stijl* (New York: E. P. Dutton, 1969), p. 83.

59. See Hans L. C. Jaffé, Introduction, in Friedman, ed., *De Stijl*, p. 14.

60. Welsh, "Reintroduction," p. 43.

61. Nelly van Doesburg, "Some Memories of Mondrian," in *Piet Mondrian, 1872–1944: Centennial Exhibition*, exh. cat. (New York: Solomon R. Guggenheim Museum, 1971), p. 72.

62. See "Mondrian's Paris Atelier 1926–1931," in Friedman, ed., *De Stijl*, p. 81.

63. Ibid., p. 82.

64. For a discussion of Theo van Doesburg's early career, see Allan Doig, *Theo van Doesburg: Painting into Architecture, Theory into Practice* (Cambridge: Cambridge University Press, 1986), pp. 2–5, 11; and Carel Blotkamp, "Theo van Doesburg," in *De Stijl: The Formative Years, 1917–1922*, trans. Charlotte I. Loeb and Arthur L. Loeb (Cambridge, Mass.: M.I.T. Press, 1982), p. 8.

65. Theo van Doesburg, *De Stijl* (1917); quoted in Overy, *De Stijl*, pp. 14, 90; and Evert van Straaten, *Theo van Doesburg: Painter and Architect* (The Hague: S.D.U. Publications, 1988), p. 19.

66. Theo van Doesburg, *Principles of Neo-Plastic Art*, trans. Janet Seligman (New York: New York Graphic Society, 1968), pp. 2, 4.

67. This compositional strategy is discussed in Christopher Green, *Cubism and Its Enemies: Modern Movements and Reaction in French Art, 1916–1928* (New Haven: Yale University Press, 1987), p. 225.

68. Van Doesburg, *Principles*, pp. 14–15.

69. See Doig, *Theo van Doesburg*, p. 134.

70. Theo van Doesburg, quoted in van Straaten, *Theo van Doesburg: Painter and Architect*, p. 13.

71. Theo van Doesburg, letter to Adolphe Behne (November 7, 1928), quoted in Ulrich Condrads and H. G. Sperlich, *The Architecture of Fantasy: Utopian Building and Planning in Modern Times*, trans., ed., and expanded by Christiane Crasemann Collins and George R. Collins (New York: Frederick A. Praeger, 1962), p. 155; also quoted in Nancy J. Troy, "The Abstract Environment of De Stijl," in Friedman, ed., *De Stijl*, p. 189.

72. Klee, *On Modern Art*, p. 55.

73. See Jaspers, *Man in the Modern Age*, p. 9.

74. This idea is proposed by Egbert Krispyn in his essay "Literature and De Stijl," in Francis Bulhof, ed., *Nijhoff, Van Ostaijen, De Stijl: Modernism in the Netherlands and Belgium in the First Quarter of the Twentieth Century* (The Hague: Martinus Nijhoff, 1976), pp. 63–64.

75. For a more complete account of these three artists' Parisian exhibition histories, see chapter 2 of this volume, pp. 42–43.

76. See Green, *Cubism and Its Enemies*, pp. 143–44.

77. Ibid., pp. 85–87, 221.

78. Maurice Raynal, *Anthologie de la peinture en France de 1906 à nos jours* (1927), quoted in Green, *Cubism and Its Enemies*, p. 159; see also p. 87.

79. Green, *Cubism and Its Enemies*, p. 221.

80. Piet Mondrian, "Letter to J. J. P. Oud" (Paris, December 1921), quoted in Green, *Cubism and Its Enemies*, p. 62.

81. See Green, *Cubism and Its Enemies*, p. 93.

82. For a summary of Fernand Léger's reaction at this time to De Stijl and its principles, see Angelica Zander Rudenstine, *The Guggenheim Museum Collection: Paintings 1880–1945* (New York: Solomon R. Guggenheim Museum, 1976), vol. 2, pp. 469–73.

83. Ruth Krueger Ann Meyer, "Fernand Léger's Mural Paintings," Ph.D. diss., University of Minnesota, 1980, p. 139.

84. Léger, "The Machine Aesthetic II: The Manufactured Object, the Artisan, and the Artist" (1924), in Léger, *Functions of Painting*, ed. Edward F. Fry, trans. Alexandra Anderson, Documents of Twentieth-Century Art (New York: Viking, 1973), p. 64.

85. Léger, "Notes on the Mechanical Element" (1923), in Léger, *Functions of Painting*, p. 30.

86. Léger, "Machine Aesthetic II," p. 63.

87. See Meyer, "Fernand Léger's Mural Paintings," pp. 134–45, 162.

88. Léger, "Abstract Art" (1931), in Léger, *Functions of Painting*, pp. 82–83.

89. Henri Matisse, letter to Alexander Romm (February 14, 1934), reprinted in Jack D. Flam, ed., *Matisse on Art* (New York: Phaidon, 1973), pp. 68–69.

90. Green, *Cubism and Its Enemies*, p. 222; see also Amédée Ozenfant, *Foundations of Modern Art*, trans. John Rodker (New York: Dover, 1952), pp. 91, 124.

91. Ozenfant and Charles-Edouard Jeanneret, "Après le Cubisme," quoted in Kenneth E. Silver, *Esprit de Corps: The Art of the Parisian Avant-Garde and the First World War, 1914–1925* (Princeton: Princeton University Press, 1989), p. 229.

92. See Green, *Cubism and Its Enemies*, p. 89.

93. Ozenfant and Jeanneret, "Après le Cubisme," quoted in Silver, *Esprit de Corps*, p. 230.

94. Le Corbusier [Charles-Edouard Jeanneret], *Towards a New Architecture,*

trans. Frederick Etchells (New York: Dover, 1986), pp. 25–26, 29–31.

95. Green, *Cubism and Its Enemies*, p. 106.

96. André Breton, *Manifestoes of Surrealism*, trans. Richard Seaver and Helen R. Lane (Ann Arbor, Mich.: University of Michigan Press, 1969), pp. 3–6. In 1925, Breton declared, "We are not utopians"; quoted in James M. Thompson, ed., *Twentieth-Century Theories of Art* (Ottawa: Carleton University Press, 1990), p. 227.

97. Breton and Diego Rivera, "Manifesto: Towards a Free Revolutionary Art," trans. Dwight Macdonald, *Partisan Review* 6, no. 1 (fall 1938), pp. 49–51.

98. Marcel Duchamp's friend Constantin Brancusi made a drawing entitled *Portrait for James Joyce*, ca. 1928, in which the writer is depicted as a circular piece of cardboard with a spiral in the center.

99. Christof Spengemann, quoted in Kurt Schwitters, "Merz" (1920), *Der Ararat* (1921); trans. Ralph Manheim, in Robert Motherwell, ed., *The Dada Painters and Poets: An Anthology* (2nd ed.; Cambridge, Mass.: The Belknap Press of Harvard University Press, 1981), pp. 61–62.

100. Ibid., p. 62.

101. *Nasci* 2, nos. 8–9 (April–July 1924), eds. Schwitters and Lissitzky. For more information on *Nasci*, see John Elderfield, *Kurt Schwitters* (New York: Thames and Hudson, 1985), pp. 133–34.

102. Besides the sculpture of Brancusi, see also his drawings of the 1920s (illustrated in Radu Varia, *Brancusi*, trans. Mary Vadouyer [New York: Rizzoli, 1986], pp. 89–93).

103. Jean Arp, *On My Way: Poetry and Essays 1912 . . . 1947*, ed. Robert Motherwell, trans. Ralph Manheim, Documents of Modern Art (New York: Wittenborn, Schultz, 1948), pp. 70, 72.

104. Arp, *Arp on Arp: Poems, Essays, Memories*, ed. Marcel Jean, trans. Joachim Neugroschel, Documents of Twentieth-Century Art (New York: Viking, 1969), p. 273.

105. Arp, *On My Way*, pp. 70, 72.

106. See Harriett Watts, "Arp, Kandinsky, and the Legacy of Jakob Böhme," in Tuchman and Freeman, eds., *The Spiritual in Art*, pp. 239–44.

107. Arp, "Abstract Art, Concrete Art" (ca. 1942), reprinted in Chipp, ed., *Theories of Modern Art*, p. 391; see also Arp, *Arp on Arp*, pp. 246, 282, 315.

108. Kandinsky, "Abstract and Concrete Art," *London Bulletin* (May 1939); reprinted in Lindsay and Vergo, eds., *Kandinsky: Complete Writings*, vol. 2, p. 841.

109. See Joan Miró, letter to J. F. Ràfols (Mondroig, August 11, 1918), reprinted in Margit Rowell, ed., *Joan Miró: Selected Writings and Interviews*, trans. Paul Auster and Patricia Mathews (Boston: G. K. Hall, 1986), p. 57.

110. See Miró's letters to Ràfols (Mondroig, August 21, 1919 and July 25, 1920), reprinted in Rowell, ed., *Joan Miró*, pp. 63, 74.

111. Miró, letter to Michel Leiris (Montroig, August 10, 1924), reprinted in Rowell, ed., *Joan Miró*, p. 86. See also Francesc Trabal, "A Conversation with Joan Miró," *La Publicitat* (1928); reprinted in Rowell, ed., *Joan Miró*, p. 95.

112. Miró, letter to Pierre Matisse (Barcelona, February 7, 1934), reprinted in Rowell, ed., *Joan Miró*, p. 124.

113. Francisco Melgar, "Spanish Artists in Paris: Juan [sic] Miró," *Ahora* (1931); reprinted in Rowell, ed., *Joan Miró*, p. 116.

114. Georges Duthuit, "Where Are You Going, Miró?," *Cahiers d'art* (1936); reprinted in Rowell, ed., *Joan Miró*, pp. 150–51.

115. Ibid.

116. James Johnson Sweeney, "Joan Miró; Comment and Interview," *Partisan Review* (1948); reprinted in Rowell, ed., *Joan Miró*, p. 207.

117. Rafael Santos Torroella, "Miró Advises Our Young Painters," *Correo Literario* (1951); reprinted in Rowell, ed., *Joan Miró*, p. 226.

118. Ibid. See also Miró, letter to Nina Kandinsky (January 19, 1966), in *XXe Siècle* (1966); reprinted in Rowell, ed., *Joan Miró*, p. 273.

119. Rosamond Bernier, "Comments by Joan Miró," *L'Oeil* (1961); reprinted in Rowell, ed., *Joan Miró*, pp. 258–59.

120. Miró, letter to Nina Kandinsky (January 19, 1966), p. 273.

121. Ibid.

122. Miró, interview with Rowell (Paris, April 20, 1970), in Rowell, ed., *Joan Miró*, p. 279.

123. Alexander Calder, *Calder: An Autobiography with Pictures* (New York: Pantheon Books, 1966), p. 113.

124. Ibid., pp. 127, 130.

125. Michel Seuphor claimed to have organized the first international

exhibition of abstract art at Galerie 23, Paris, in 1930; see Seuphor, *L'Art abstrait. Ses Origines, ses premiers maîtres* (Paris: Maeght, 1949), p. 26.

126. *Abstraction-Création Art Non-Figuratif* (reprints of *Abstraction-Création*, nos. 1–5, 1932–36; New York: Arno Press, 1968), no. 4 (1935), p. 3.

127. Ibid. See also Seuphor, *L'Art abstrait, Vol. II: 1918–1938* (Paris: Maeght, 1972), pp. 60, 97; and Seuphor, "To Set the Compass," and Elderfield, "The Paris–New York Axis: Geometric Abstract Painting," in *Geometric Abstraction: 1926–1942* (Dallas: Dallas Museum of Fine Arts, 1972), unpaginated [pp. 9–28, 30–65].

128. *Abstraction-Création Art Non-Figuratif*, no. 4 (1935), p. 3.

129. Roger Fry, "Some Questions in Esthetics," *Transformations: Critical and Speculative Essays in Art* (1958); quoted in Judith Wechsler, ed., *Cézanne in Perspective* (Englewood Cliffs, N.J.: Prentice-Hall, 1975), p. 10.

130. Meetings among artists began in 1935, but it was not until 1937 that the AAA group coalesced ideologically. See Susan C. Larsen, "The Quest for an American Abstract Tradition, 1927–44," in John R. Lane and Susan C. Larsen, eds., *Abstract Painting and Sculpture in America 1927–1944*, exh. cat. (Pittsburgh: Carnegie Institute, Pittsburgh Museum of Art; New York: Harry N. Abrams, 1983), pp. 35–39.

131. Meyer Schapiro, "On the Humanity of Abstract Painting" (1960), reprinted in Schapiro, *Modern Art: Nineteenth and Twentieth Centuries, Selected Papers* (New York: George Braziller, 1978), p. 230.

132. Ernst Cassirer, *The Philosophy of Symbolic Forms*, trans. Ralph Manheim (New Haven: Yale University Press, 1957), vol. 3: *The Phenomenology of Knowledge*, p. 114.

133. Eric Voegelin, quoted in Fred Dallmayr, *Margins of Political Discourse*, SUNY Series in Contemporary Continental Philosophy, ed. Dennis J. Schmidt (Albany: State University of New York Press, 1989), p. 75.

134. Alfred H. Barr, Jr., *Cubism and Abstract Art*, exh. cat. (New York: Museum of Modern Art, 1936), p. 200.

135. Le Corbusier, letter to the editors of *Decorative Art*, in C. Geoffrey Holme and Shirley B. Wainwright, eds., *Decorative Art — 1929*, eds. (London: The Studio, 1929), p. 4.

136. See Reyner Banham, *Theory and Design in the First Machine Age* (New York: Frederick A. Praeger, 1960), pp. 320–25.

137. Ludwig Mies van der Rohe said that form for itself as an aim was not acceptable; see Philip C. Johnson, *Mies van der Rohe*, exh. cat. (New York: Museum of Modern Art, 1947), pp. 183–84.

138. Jaspers, *Man in the Modern Age*, p. 147.

139. Green, *Cubism and Its Enemies*, p. 138.

140. Mondrian, "De l'art abstrait: Réponse de Piet Mondrian," *Cahiers d'art* (1931); reprinted as "Cubism and Neo-Plastic," in *Collected Writings of Mondrian*, pp. 236–41.

141. Walter Abell, *Magazine of Art* (December 1935), p. 735. Regarding American attacks on the expressiveness of abstraction, see Richard William Lizza, "The American Abstract Artists: Thirties' Geometric Abstraction as Precursor to Forties' Expressive Abstraction," Ph.D. diss., Florida State University School of Visual Arts, 1985, pp. 164ff.

142. Sweeney, *Plastic Redirections in Twentieth Century Painting* (Chicago: University of Chicago Press, 1934), p. 39.

143. Barr, *Cubism and Abstract Art*, p. 9.

144. Jaspers, *Man in the Modern Age*, pp. 149–50.

Chapter 4

1. David Smith asserted that Sigmund Freud had the greatest single influence on theories of art at that time. See Smith, "Abstract Art," *The New York Artist* 1, no. 2 (April 1940), pp. 6, 15. For more on this subject, see Stephen Polcari, *Abstract Expressionism and the Modern Experience* (Cambridge: Cambridge University Press, 1991), pp. 43–44, 47; Dore Ashton, *New York School* (New York: Viking, 1973; Penguin Books, 1979), pp. 36–37, 86, 123–24; and Irving Sandler, *The Triumph of American Painting: A History of Abstract Expressionism* (New York: Praeger, 1970), pp. 22–23, 98.

2. See Sandler, *Triumph of American Painting*, p. 98, and Ashton, *New York School*, p. 174.

3. Polcari, *Abstract Expressionism and the Modern Experience*, p. 17.

4. Matta was especially influential on artists in New York, as he lived there from 1939 to 1948, producing work that presented a contemporary rethinking of Surrealist art.

5. See Robert Rosenblum, *Modern Painting and the Northern Romantic Tradition: Friedrich to Rothko* (New York: Harper and Row, 1975), pp. 196ff.

6. See Serge Guilbaut, *How New York Stole the Idea of Modern Art: Abstract Expressionism, Freedom and the Cold War*, trans. Arthur Goldhammer (Chicago: University of Chicago Press, 1983), pp. 30–31.

7. Artie Shaw, quoted in Robert Vaughn, *Only Victims: A Study of Show Business Blacklisting* (New York: Putnam, 1972), p. 182.

8. Ashton, *New York School*, pp. 47, 49.

9. See Vaughn, *Only Victims*, pp. 37, 50.

10. The phrase is Henry Moore's, from his essay "The Sculptor Speaks" (1937), excerpted in Herschel B. Chipp, ed., *Theories of Modern Art: A Source Book by Artists and Critics* (Berkeley: University of California Press, 1968), p. 597.

11. Peggy Guggenheim, quoted in Ashton, *New York School*, p. 118.

12. Sidney Janis, *Abstract and Surrealist Art in America* (New York: Reynal and Hitchcock, 1944), p. 89.

13. André Masson, "A Crisis of the Imaginary," *Magazine of Art* 39, no. 1 (January 1946), p. 22.

14. In his Preface to the exhibition catalogue, Alfred H. Barr, Jr. claimed that he devoted the show to European abstract art because there had been a large exhibition of American abstract art at the Whitney Museum just a year earlier; see Ashton, *New York School*, pp. 59–60. On how the AAA group was viewed by Barr, see Richard William Lizza, "The American Abstract Artists: Thirties' Geometric Abstraction as Precursor to Forties' Expressive Abstraction," Ph.D. diss., Florida State University School of Visual Arts, 1985, pp. 164ff.

15. Ashton, *New York School*, p. 76. According to Dennis Farr, the Circle group coalesced around Naum Gabo, architect J. L. Martin, and Ben Nicholson, who joined together in 1935 to produce a book that would reflect the modern outlook of contemporary painters, sculptors, architects, and others involved in the arts (*English Art 1870–1940* [Oxford: Oxford University Press, 1978], p. 288). *Circle: International Survey of Constructive Art* was published in 1937, with contributions by, among others, Marcel Breuer, Barbara Hepworth, Le Corbusier, Piet Mondrian, Moore, Lewis Mumford, Herbert Read, and Jan Tschichold.

16. Stuart Davis, quoted in James Johnson Sweeney, *Stuart Davis*, exh. cat. (New York: Museum of Modern Art, 1945), p. 17.

17. Davis, "Abstract Painting Today," in Francis V. O'Connor, ed., *Art in the Millions* (Greenwich, Conn.: New York Graphic Society, 1973); quoted in P. Andrew Spahr, *Abstract Sculpture in America 1930–1970* (New York: American Federation of Arts, 1991), p. 9.

18. [Forbes Watson?], "The Modernists," *American Magazine of Art* 31, no. 12 (December 1938), p. 711.

19. See statement by Harry Holtzman (1938), quoted in Sandler, *Triumph of American Painting*, p. 26, n. 27.

20. While not explicitly following such a bias, Barr's exhibition reflected this position. See Susan Noyes Platt, "Modernism, Formalism, and Politics: The 'Cubism and Abstract Art' Exhibition of 1936 at the Museum of Modern Art," *Art Journal* 47, no. 4 (winter 1988), pp. 285–86.

21. Clement Greenberg, "Surrealist Painting," *The Nation* 159, no. 7 (August 12, 1944), pp. 192–93.

22. See Leo Steinberg, *Other Criteria: Confrontations with Twentieth Century Art* (New York: Oxford University Press, 1972), p. 65.

23. See Ashton, *New York School*, p. 57.

24. See Greenberg, "Abstract and Representational," *Arts Digest* 29, no. 3 (November 1, 1954), p. 6.

25. Meyer Schapiro, "The Nature of Abstract Art" (1937), reprinted in Schapiro, *Modern Art: Nineteenth and Twentieth Centuries, Selected Papers* (New York: George Braziller, 1978), pp. 187–90, 192, 195–96. For a summary of Schapiro's ideas, see Guilbaut, *How New York Stole the Idea of Modern Art*, pp. 24–26.

26. Schapiro, "Recent Abstract Painting" (1957), reprinted in Schapiro, *Modern Art*, pp. 216–18. This text was originally delivered as an address on "The Liberating Quality of Avant-Garde Art" on April 5, 1957.

27. Schapiro, "On the Humanity of Abstract Painting" (1960), reprinted in Schapiro, *Modern Art*, p. 232.

28. See, for example, George L. K. Morris and Lincoln Kirstein, "Life or Death for Abstract Art?," *American Magazine of Art* 36, no. 3 (March 1943), pp. 111, 117–19.

29. See William Schack, "On Abstract Sculpture," *American Magazine of Art* 27, no. 11 (November 1934), p. 582. See also [Watson?], "The Modernists," p. 711, in which abstraction is called an "academism of the left."

30. See Schack, "On Abstract Sculpture," p. 581; and Walter Abell, "The Limits of Abstraction," *American Magazine of Art* 28, no. 12 (December 1935), p. 735.

31. See Abell, "Limits of Abstraction," pp. 735–40.

32. One of these was Walter Abell, as in his essay "Form Through Representation," *American Magazine of Art* 29, no. 5 (May 1936), pp. 304–06.

33. Theodore Sizer, "Can Abstract Painting Live?," *American Magazine of Art* 31, no. 3 (March 1938), p. 186.

34. One 1946 article suggested that the "dark horse of abstraction has swept into the lead" vis-à-vis representational forms of art: Milton W. Brown, "After Three Years," *American Magazine of Art* 39, no. 4 (April 1946), p. 138.

35. Morris, "The American Abstract Artists: A Chronicle 1936–56," in *The World of Abstract Art* (New York: George Wittenborn, 1957), p. 141.

36. See Ashton, *The Unknown Shore: A View of Contemporary Art* (Boston: Little, Brown, 1962), p. 28.

37. The question of who was the first to make such large mural-scale paintings has often been debated. Jackson Pollock painted *Mural* (7 feet 11 ¾ inches x 19 feet 9 ¼ inches) in 1943; Clyfford Still was perhaps the first to paint large, mostly monochrome mural paintings, such as *1948-E* (6 feet 10 inches x 5 feet 9 inches), 1948. See "Field Notes: An Interview" (discussion between Michael Auping and Lawrence Alloway, September 26, 1986), in Auping, *Abstract Expressionism: The Critical Developments*, exh. cat. (New York: Harry N. Abrams; Buffalo: Albright-Knox Art Gallery, 1987), pp. 131–32.

38. Most notably, Mark Rothko and Barnett Newman, but Still also indicated a significant interest in representing the sublime; see statement by Still in *Clyfford Still*, exh. cat. (Philadelphia: Institute of Contemporary Art, University of Pennsylvania, 1963); quoted in Maurice Tuchman, ed., *New York School: The First Generation, Paintings of the 1940s and 1950s*, exh. cat. (Los Angeles: Los Angeles County Museum of Art, 1965), p. 32.

39. See Thomas B. Hess, *Barnett Newman* (New York: Walker, 1969), p. 39.

40. Dorothy Gees Seckler, "Frontiers of Space" (interview with Newman), *Art in America* 50, no. 2 (summer 1962), pp. 86–87.

41. Ashton, *New York School*, p. 113.

42. Ibid., p. 83.

43. See Cynthia Goodman, *Hans Hofmann* (New York: Abbeville Press; Berkeley: University Art Museum, 1986), pp. 55–56.

44. John Graham, *System and Dialectics of Art* (Baltimore: Johns Hopkins Press, 1971), pp. 5, 63.

45. Smith, "The New Sculpture," in Garnett McCoy, ed., *David Smith* (New York: Praeger, 1973), p. 82.

46. Newman, "Response to Clement Greenberg" (1947), reprinted in Hess, *Barnett Newman*, p. 37.

47. Ibid.

48. Rothko, "Personal Statement," in *A Painting Prophecy—1950*, exh. cat. (Washington, D.C.: David Porter Gallery, 1950); quoted in Ashton, *About Rothko* (New York: Oxford University Press, 1983), pp. 90–91.

49. See Ashton, *New York School*, p. 159.

50. Harold Rosenberg, *Art on the Edge: Creators and Situations* (New York: Macmillan, 1975), pp. 40–42.

51. James Johnson Sweeney, quoted in Ashton, *About Rothko*, p. 82.

52. Willem de Kooning, statement, in "What Abstract Art Means to Me: Statements by Six American Artists," *The Museum of Modern Art Bulletin* 18, no. 3 (spring 1951), p. 7.

53. Ibid.

54. Rosenberg, "Interview with Willem de Kooning," *Art News* 71, no. 5 (September 1972), p. 56.

55. De Kooning, "Content Is a Glimpse . . . ," *Location* 1, no. 1 (spring 1963), p. 46.

56. Motherwell, "The Modern Painter's World," *DYN* 1, no. 6 (November 1944), p. 13.

57. Hans Hofmann, *Search for the Real and Other Essays*, ed. Sarah T. Weeks and Bartlett H. Hayes, Jr. (Cambridge, Mass.: M.I.T. Press, 1948), p. 47.

58. Newman, "The True Revolution Is Anarchist!," in Peter Kropotkin, *Memoirs of a Revolutionist* (New York: Horizon, 1968), p. x.

59. Newman, "A Conversation," in John P. O'Neill, ed., *Barnett Newman: Selected Writings and Interviews* (New York: Knopf, 1990), p. 275.

60. Newman, "Open Letter to William A. M. Burden" (June 7, 1954), reprinted in O'Neill, ed., *Selected Writings and Interviews*, pp. 39–40.

61. Still, quoted in, *Clyfford Still*, exh. cat. (New York: Metropolitan Museum of Art, 1979), p. 54; see also pp. 50, 56.

62. Still, quoted in *Clyfford Still: Thirty-three Paintings in the Albright-Knox Art Gallery*, exh. cat. (Buffalo: Buffalo Fine Arts Academy, 1966), p. 16.

63. "Jackson Pollock" (interview, February 1944), *Arts and Architecture*; reprinted in Tuchman, ed., *New York School*, p. 25.

64. Sidney Simon, "Concerning the Beginnings of the New York School 1939–1943" (interview with Motherwell) *Art International* 11, no. 6 (summer 1967), p. 23.

65. This point was noted by Pollock in "Jackson Pollock" (interview), reprinted in Tuchman, ed., *New York School*, p. 25.

66. See Motherwell, "Modern Painter's World," p. 12.

67. Ibid., p. 14.

68. Motherwell, "Beginnings of New York School," p. 23.

69. See Gail Levin, "Miró, Kandinsky, and the Genesis of Abstract Expressionism," in Robert Carleton Hobbs and Levin, eds., *Abstract Expressionism: The Formative Years*, exh. cat. (New York: Whitney Museum of American Art, 1978), pp. 27–40.

70. Ashton, *New York School*, p. 98.

71. Max Kozloff, "An Interview with Robert Motherwell," *Artforum* 4, no. 1 (September 1965), p. 33.

72. Newman, "Surrealism and the War" and "Plasmic Image," in O'Neill, ed., *Selected Writings and Interviews*, pp. 94–95, 140, 152, 154–55. For more on the relationship of Surrealism to Abstract Expressionism, see Polcari, *Abstract Expressionism*, pp. 23–27.

73. Newman, "Response to Clement Greenberg," p. 37.

74. *Clyfford Still*, exh. cat. (San Francisco: San Francisco Museum of Modern Art, 1976), p. 112.

75. Newman, "On Modern Art: Inquiry and Confirmation" (1944), in O'Neill, ed., *Selected Writings and Interviews*, p. 150, and "Plasmic Image," p. 69.

76. Newman, "On Modern Art," p. 69.

77. From Rothko's statement in the catalogue for a group exhibition at the David Porter Gallery, Washington, D.C. (1945), quoted in Ashton, *About Rothko*, p. 91.

78. Mark Tobey, quoted in William C. Seitz, "Abstract Expressionist Painting in America," Ph.D. diss., Princeton University, 1955, p. 281. Tobey also said,

"I have no use for impersonality. The prophet is never abstract." Quoted in Selden Rodman, *Conversations with Artists* (New York: Devin-Adair, 1957), p. 2. One wonders, though, if Tobey, like some of his colleagues, only saw abstraction as a geometric language.

79. See de Kooning, statement, in "What Abstract Art Means to Me," pp. 4–6.

80. De Kooning, quoted in Edy de Wilde, *De Kooning*, exh. cat. (Amsterdam: Stedelijk Museum, 1968), pp. 7–9. See also Hess, *Willem de Kooning*, exh. cat. (New York: Museum of Modern Art, 1968), p. 47. De Kooning also disliked abstraction for its similarity to Asian art, with its ethereal sense of beauty, and for having too many strictures that prevented him from being "free" ("What Abstract Art Means to Me," pp. 6–7).

81. Motherwell, quoted in Sandler, *Triumph of American Painting*, p. 30.

82. Newman, statement, in *The New American Painting: As Shown in Eight European Countries 1958–1959*, exh. cat. (New York: Museum of Modern Art, 1959), p. 60.

83. Newman, "Plasmic Image," pp. 148–49, 151, 155. See also Newman, "Letter to John Gordon, January 7, 1962," in O'Neill, ed., *Selected Writings and Interviews*, p. 221. Newman even mentioned Roger Fry and Clive Bell as purveyors of the "propaganda for plastic form" (Newman, "Plasmic Image," pp. 148–49).

84. See Ashton, *About Rothko*, pp. 91, 103, 131.

85. P. G. Pavia and Sandler, eds., "The Philadelphia Panel" (edited transcription of a March 1960 panel discussion), *It Is*, no. 5 (spring 1960), p. 38.

86. De Kooning, statement, in "What Abstract Art Means to Me," p. 7.

87. De Kooning, quoted in Hess, *Willem de Kooning*, pp. 15–16.

88. Ad Reinhardt, "Twelve Rules for a New Academy," *Art News* 56, no. 3 (May 1957), p. 38.

89. Ibid.

90. Reinhardt, "Ad Reinhardt on His Art," *Studio International* 174, no. 895 (December 1967), p. 266. When Reinhardt had a retrospective at Betty Parsons Gallery in 1960, he called it "twenty-five years of abstract art." (Reinhardt, letter to Thomas Merton [1960], in Joseph Masheck, ed., "Five Unpublished Letters from Ad Reinhardt to Thomas Merton and Two in Return," *Artforum*, 17, no. 4 [December 1978],

p. 25). Moreover, he once referred to himself as the "Dean of Abstract Art" (Reinhardt, undated letter to Merton, in Masheck, ed., "Five Unpublished Letters," p. 27). See also John Gruen, *The Party's Over Now* (New York: Viking, 1972), p. 270.

91. In the mid-1940s, Motherwell had carefully distinguished between abstract and nonobjective art, but in 1951 included Klee and Miró, whose work is more referential, with himself as practitioners of abstraction. See Motherwell, "Art Chronicle: II. Painters' Objects," *Partisan Review* 11, no. 1 (winter 1944), p. 94, and his statement in "What Abstract Art Means to Me," p. 12.

92. De Kooning, statement, in "What Abstract Art Means to Me," p. 8.

93. Smith, "Abstract Art," p. 15; Newman, review of the 15th-anniversary exhibition at the Museum of Modern Art, New York, *La Revista Belga* (November 1944); reprinted in O'Neill, ed., *Selected Writings and Interviews*, p. 70; and Adolph Gottlieb, quoted in Rodman, *Conversations with Artists*, p. 87.

94. Reinhardt, quoted in Sandler, ed., "Is There a New Academy? Part I," *Art News* 58, no. 4 (summer 1959), p. 35.

95. See Newman, review (November 1944), in O'Neill, ed., *Selected Writings and Interviews*, p. 70, and "Plasmic Image," p. 141.

96. Statements by Newman in *The Ideographic Picture*, exh. cat. (New York: Betty Parsons Gallery, 1947); quoted in Tuchman, ed., *New York School*, p. 22.

97. Newman, "Plasmic Image," p. 140.

98. Newman, letter to the editor, *Art News* 67, no. 4 (summer 1968), p. 8.

99. Newman, "Plasmic Image," p. 142.

100. Gorky, letter to his sister Vartoosh (February 17, 1947), in "The Letters of Arshile Gorky: To Vartoosh, Moorad and Karlen Mooradian," *Ararat* (special issue on Arshile Gorky) 12, no. 4 (fall 1971), p. 40.

101. Newman, in *The Ideographic Picture*, quoted in Tuchman, ed., *New York School*, p. 22.

102. See Newman, statement (1947–48), quoted in Hess, *Barnett Newman*, p. 37.

103. See Newman, review, (November 1944), in O'Neill, ed., *Selected Writings and Interviews*, p. 70, "Plasmic Image," p. 141, and statement (1950), in *Selected Writings and Interviews*, p. 178.

104. See "The Talk of the Town," *The New Yorker* 26, no. 24 (August 5, 1950), p. 16.

105. Still, statement, in *Clyfford Still* (University of Pennsylvania, Institute of Contemporary Art), p. 8; quoted in Tuchman, ed., *New York School*, p. 32.

106. Rothko, "The Romantics Were Prompted," *Possibilities I* (1947–48); quoted in Seitz, *Abstract Expressionist Painting*, p. 282.

107. Motherwell, statement, in "What Abstract Art Means to Me," p. 13.

108. See Newman, "The Plasmic Image," p. 147. In the same essay (p. 151), Newman named the members of this "American Renaissance" as Gorky, Gottlieb, S. W. Hayter, and Rothko. For more regarding Newman's views on metaphysics, see his "Response to Clement Greenberg," p. 163, and *The Ideographic Picture*, quoted in Tuchman, ed., *New York School*, p. 22.

109. See David Craven, "Abstract Expressionism, Automatism and the Age of Automation," *Art History* 13, no. 1 (March 1990), p. 90; and Karsten Harries, *The Meaning of Modern Art: A Philosophical Interpretation*, Northwestern University Studies in Phenomenology and Existential Philosophy (Evanston, Ill.: Northwestern University Press, 1968), pp. 36–40.

110. See statements by Reinhardt in "Panel: All-over Painting," *It Is*, no. 2 (fall 1958), pp. 76–77; Mary Fuller, "An Ad Reinhardt Monologue," *Artforum* 9, no. 2 (October 1970), p. 38; John I. H. Bauer, ed., *The New Decade*, exh. cat. (New York: Whitney Museum of American Art, 1955), p. 73; and Reinhardt, "Art-as-Art," *Art International* 6, no. 10 (December 20, 1962), p. 37.

111. Newman, "The Sublime Is Now," in "The Ides of Art: Six Opinions on What Is Sublime in Art?," *The Tiger's Eye* 1, no. 6 (December 1948), pp. 52–53; he specifically mentioned Mondrian as not being sufficiently sublime. See also Newman, "Plasmic Image," pp. 142, 147, 164.

112. Gottlieb warned, in 1950, that "we are approaching an academy version of abstract painting"; quoted in Bernard Karpel, Motherwell, and Reinhardt, eds., *Modern Artists in America* (New York: Wittenborn, Schultz, 1951), p. 10.

113. Of course, Reinhardt was not in agreement on this point, and denied the place of emotion in his art. See ibid., p. 15, and "Black" (transcript of a panel discussion), *Arts Canada* 24 (October 1967), pp. 8, 13.

114. Newman, statement, in *Exhibition of the United States of America*, exh. cat. (São Paulo Bienal, 1965); reprinted in

O'Neill, ed., *Selected Writings and Interviews*, p. 187. Newman further emphasized the place of the self in the hierarchy of key issues that the artist faces when he asserted that "the defense of human dignity is the ultimate subject matter of art"; first quoted in Teresa Zarnower, Preface, in *Six Gouaches*, exh. cat. (New York: Art of This Century, 1947), unpaginated; and also quoted in Lawrence Alloway, *Barnett Newman: The Stations of the Cross: lema sabachthani*, exh. cat. (New York: Solomon R. Guggenheim Museum, 1966), p. 35.

115. Hofmann, quoted in "Artists' Sessions at Studio 35" (1950), ed. Robert Goodnough; reprinted in Karpel, Motherwell, and Reinhardt, eds., *Modern Artists in America*, p. 10.

116. William Wright, "An Interview with Jackson Pollock" (1950), reprinted in Francis V. O'Connor, *Jackson Pollock*, exh. cat. (New York: Museum of Modern Art, 1967), p. 79.

117. De Kooning's immersion in "the melodrama of vulgarity" ("What Abstract Art Means to Me," p. 7) was a clear indication of his interest in emotion, though hardly in the "exalted" category described by Newman. In "Content Is a Glimpse . . . " (p. 47), de Kooning did specify emotion as central to his paintings, and said that they were about sensations experienced in the world; when he referred to the "attitude" that a painting is filled with (Hess, *Willem de Kooning*, p. 16), that, too, was an acknowledgment of sensibility and emotion.

118. Motherwell, statement, in "What Abstract Art Means to Me," p. 12. In this same text, Motherwell declared that "one of the most striking aspects of abstract art's appearance was her nakedness, an art stripped bare," thus emphasizing, with a nod to Marcel Duchamp, the capacity of an abstract picture to evoke the naked feelings of its creator.

119. Pollock made this point in *Jackson Pollock* (1951), a film by Hans Namuth and Paul Falkenberg on the artist; excerpted in Chipp, ed., *Theories of Modern Art*, p. 548.

120. "When I am *in* my painting, I'm not aware of what I'm doing. It is only after a sort of 'get acquainted' period that I see what I have been about." Pollock, "My Painting," *Possibilities I* (1947–48); excerpted in Chipp, ed., *Theories of Modern Art,* pp. 546–48.

121. Rothko, "A Symposium on How to Combine Architecture, Painting, and Sculpture," *Interiors* 110, no. 10 (May 1951), p. 104.

122. Rothko, quoted in Rodman, *Conversations with Artists*, p. 93.

123. See, for example, ibid., pp. 20, 105. For Hofmann's interest in the subject of emotion, see also Irma B. Jaffe, "A Conversation with Hans Hofmann," *Artforum* 9, no. 5 (January 1971), p. 35.

124. See, for instance, Newman, "The Sublime Is Now," p. 53; Newman, review (November 1944), in O'Neill, ed., *Selected Writings and Interviews*, p. 69; Newman, statement (1950), in *Selected Writings and Interviews*, p. 178; and Newman, "Interview with Emile de Antonio" (1970), in *Selected Writings and Interviews*, p. 305. A related watchword in Newman's lexicon was "passion," which he referred to as being the source of his activity; see Seckler, "Frontiers of Space," p. 86.

125. See Newman, "Painting and Prose" (1945), in O'Neill, ed., *Selected Writings and Interviews*, pp. 88–89.

126. Newman, quoted in Hess, *Barnett Newman*, p. 37.

127. Newman, statement (1950), in O'Neill, ed., *Selected Writings and Interviews*, p. 178.

128. Newman, "The Sublime Is Now," p. 53.

129. Existentialism, especially as articulated by Jean-Paul Sartre, was much discussed by American intellectuals at this time. For Existentialism's principal tenets and proponents, see Joseph Chiari, *Twentieth-Century French Thought: From Bergson to Lévi-Strauss* (New York: Gordian Press, 1975), pp. 29, 86, 93, 96–98, 101–04, 109–10, 112, 123.

130. Gottlieb, Newman, and Rothko, letter to Edward Alden Jewell, art editor of *The New York Times* (June 7, 1943), published in Jewell's column "The Realm of Art: A New Platform and Other Matters," *The New York Times* (June 13, 1943), p. x9; excerpted in Chipp, ed., *Theories of Modern Art*, p. 545, and Ashton, *New York School*, p. 128.

131. André Breton, "Prestige of André Masson," *Minotaure* (1939); quoted in Ashton, *New York School*, p. 115.

132. Newman, quoted in Hess, *Barnett Newman*, p. 68.

133. Rothko, "The Romantics Were Prompted," p. 84.

134. Still, quoted in Ashton, *The Unknown Shore*, p. 28.

135. Still, quoted in *Clyfford Still* (Albright-Knox Art Gallery), p. 17. He also discussed creating "a world of emancipation for myself" and praised

the school he helped start, called The Subjects of the Artist, for being "a center of free activity" (*Clyfford Still*, San Francisco Museum of Art, pp. 113, 123).

136. Still, quoted in *Clyfford Still* (San Francisco Museum of Art), p. 115.

137. Ibid., p. 123; see also *Clyfford Still* (Albright-Knox Art Gallery), p. 17.

138. Still, quoted in *Clyfford Still* (Albright-Knox Art Gallery), p. 13.

139. De Kooning, "Content Is a Glimpse . . . ," p. 48.

140. Bruce Glaser, [ed.], "Jackson Pollock: An Interview with Lee Krasner," *Arts Magazine* 41, no. 6 (April 1967), p. 38.

141. Smith, "Modern Sculpture and Society" (ca. 1940), in McCoy, ed., *David Smith*, p. 41.

142. Smith, quoted in Introduction, in McCoy, ed., *David Smith*, p. 22.

143. Newman, "Interview with Emile de Antonio" (1970), in O'Neill, ed., *Selected Writings and Interviews*, pp. 307–08.

144. Motherwell, statement, in "What Abstract Art Means to Me," p. 13. See also Motherwell, "On the Humanism of Abstraction" (1970), reprinted in *Tracks: A Journal of Artists' Writings* 1, no. 1 (November 1974), p. 10.

145. Motherwell, quoted in *Franz Kline: The Color Abstractions*, exh. cat. (Washington, D.C.: Phillips Collection, 1979), p. 43.

146. Still, quoted in O'Neill, ed., *Clyfford Still*, p. 27.

147. *Clyfford Still* (San Francisco Museum of Art), pp. 115–16.

148. Rothko, statement, in "The Ides of Art: The Attitudes of Ten Artists on Their Art and Contemporaneousness," *The Tiger's Eye* 1, no. 2 (December 1947), p. 44; quoted in Tuchman, ed., *New York School*, p. 14.

149. Ibid., p. 84.

150. Rothko, quoted in Rodman, *Conversations with Artists*, p. 89.

151. Auping and Alloway, "Field Notes: An Interview," p. 130.

152. Ashton, *New York School*, pp. 211, 215, 218.

153. Bradford R. Collins, "*Life* Magazine and the Abstract Expressionists, 1948–51: A Historiographic Study of a Late Bohemian Enterprise," *Art Bulletin* 73, no. 2 (June 1991), pp. 283–308.

154. Motherwell, "Modern Painter's World," pp. 10–11, 14.

155. Schack wrote in 1934 ("On Abstract Sculpture," p. 581) that abstraction was meaningless to its American audience, a situation that has continued to the present day.

156. Rothko, "The Romantics Were Prompted," p. 84.

157. Newman, statement, in *The Ideographic Picture*, quoted in Tuchman, ed., *New York School*, p. 22.

158. Newman, "A Conversation," in O'Neill, ed., *Selected Writings and Interviews*, pp. 278–79.

159. Phyllisann Kallick, "An Interview with Ad Reinhardt," *Studio International* 174, no. 895 (December 1967), p. 272.

160. Even the cofounder of the Guggenheim Museum, Hilla Rebay, asserted that "'non-objective' art has no 'meaning,'" according to Ashton, *New York School*, p. 111.

161. For more on this subject, see Robert Carleton Hobbs, "Early Abstract Expressionism: A Concern with the Unknown Within," in Hobbs and Levin, eds., *Abstract Expressionism*, pp. 10–15.

162. Gottlieb, Newman, and Rothko, letter to *The New York Times*, excerpted in Chipp, ed., *Theories of Modern Art*, p. 545, and Ashton, *New York School*, p. 128.

163. Motherwell, "Painters' Objects," quoted in Tuchman, ed., *New York School*, p. 21.

164. Baziotes, quoted in Tuchman, ed., *New York School*, p. 10.

165. Gorky, letter to his sister Vartoosh (November 24, 1947), reprinted in "Letters of Arshile Gorky," p. 42.

166. Newman, "Painting and Prose," in O'Neill, ed., *Selected Writings and Interviews*, p. 91.

167. Newman, review, (November 1944), in O'Neill, ed., *Selected Writings and Interviews*, p. 70; see also Newman, "Plasmic Image," p. 143, and Newman, "The Sublime Is Now," p. 53.

168. Reinhardt, quoted in Fuller, "Ad Reinhardt Monologue," p. 38.

169. Newman, though not a founding member, joined them soon after to lecture there. The school is discussed in Ashton, *New York School*, p. 196, and in Kozloff, "An Interview with Motherwell," p. 37.

170. Harold Rosenberg, "The American Action Painters," *Art News* 51, no. 8 (December 1952), p. 22.

171. Ibid., p. 23.

172. Ibid., p. 48.

173. See Kate Linker, "Abstraction: Form

as Meaning," in *Individuals: A Selected History of Contemporary Art 1945–1986*, exh. cat. (Los Angeles: Los Angeles Museum of Contemporary Art, 1986), p. 35.

174. Newman, statement (1947), quoted in Alloway, *Barnett Newman: Stations*, p. 35; and statement (1965), in *Exhibition of United States*, reprinted in O'Neill, ed., *Selected Writings and Interviews*, p. 187.

175. Newman, "Painting and Prose," p. 90.

176. Newman, "Plasmic Image," p. 140.

177. Gottlieb, Newman, Rothko, letter to *The New York Times*, excerpted in Chipp, ed., *Theories of Modern Art*, p. 545, and Ashton, *New York School*, p. 128. For Newman on tragedy, see also Newman, "The Sublime Is Now," p. 52, and Newman, "Plasmic Image," p. 140. For Rothko on tragedy, see also Rodman, *Conversations with Artists*, p. 93.

178. Newman, quoted in "Unanswerable Question," *Newsweek* (May 9, 1966), p. 100; also quoted in "The Fourteen Stations of the Cross, 1956–1966," in O'Neill, ed., *Selected Writings and Interviews*, p. 189.

179. Sam Francis, quoted in *Sam Francis: Works on Paper, A Survey 1948–1979*, exh. cat. (Boston: Institute of Contemporary Art, 1979), unpaginated.

180. Rothko, quoted in Rodman, *Conversations with Artists*, p. 94.

181. Reinhardt, statement (n.d.), in Bauer, *The New Decade*, p. 73.

182. Hans Hartung, quoted in *Art Since Mid-Century: The New Internationalism* (Greenwich, Conn.: New York Graphic Society, 1971), vol. 1: *Abstract Art*, p. 154.

183. Jan van der Marck, "François Morellet or the Problem of Taking Art Seriously," in Albright-Knox Art Gallery, *François Morellet: Systems*, exh. cat. (Buffalo: Buffalo Fine Arts Academy, 1984), p. 11.

184. Summaries of postwar European abstraction can be found in *Art Since Mid-Century*, vol. 1: *Abstract Art*; Association des Amis du Musée d'Art Moderne de Saint Etienne, *L'Art en Europe, Les années decisives: 1945–1953* (Geneva: Editions d'Art Albert Skira, 1987); Nello Ponte, *Modern Painting: Contemporary Trends*, trans. James Emmons (Geneva: Editions d'Art Albert Skira, 1960), pp. 107–24; Guilbaut, "Postwar Painting Games: The Rough and the Slick," in Guilbaut, ed., *Reconstructing Modernism: Art in New York, Paris, and Montreal 1945–64* (Cambridge, Mass.: M.I.T. Press, 1990),

pp. 30–84; Alloway, Introduction, in *Art in Western Europe: The Postwar Years 1945–1955*, exh. cat. (Des Moines: Des Moines Art Center, 1978), pp. 5–18; and Aldo Pellegrini, *New Tendencies in Art*, trans. Robin Carson (New York: Crown, 1966), pp. 49–76. In a 1950 roundup of abstract art in France, French critic Pierre Descargues expressed the opinion that the work of Kandinsky was superior to that of contemporary French abstractionists; see Descargues, quoted in "Painting in Paris: A Discussion of Contemporary Trends by Six French Critics," *American Magazine of Art* 43, no. 5 (May 1950), p. 170.

185. Asger Jorn, quoted in *Art Since Mid-Century: The New Internationalism* (Greenwich, Conn.: New York Graphic Society, 1971), vol. 2: *Figurative Art*, p. 150.

186. See van der Marck and Enrico Crispolti, *Lucio Fontana* (Milan: Archivio Lucio Fontana, 1974), vol. 1, pp. 146–48.

187. For Lucio Fontana's view of art as a progressive force, see Fontana, "Technical Manifesto," *Ark, Journal of the Royal College of Art*, no. 24 (1959), pp. 5–7. (Though dated here as 1947, all other Fontana sources give the date of the "Technical Manifesto" as 1951.) See also Fontana, "Proposal for a Charter Spatial Movement," in Guido Ballo, *Lucio Fontana* (New York: Praeger, 1971), p. 208. Fontana noted that art was a matter of "spirit" and "intuition" ("Fourth Spatial Art Manifesto," in Ballo, *Lucio Fontana*, p. 225) and that representational art would in time be merely a "farce" ("Technical Manifesto of Spatialism," in Ballo, *Lucio Fontana*, p. 228).

188. Reproduced in *Yves Klein 1928–1962: A Retrospective*, exh. cat. (Houston: Institute for the Arts, Rice University; New York: Arts Publisher, 1982), pl. 1. Note that the untitled watercolor of 1954, pl. 2, closely resembles Malevich's initial monochrome conceived as a stage setting.

189. See Emily Braun, ed., *Italian Art in the Twentieth Century: Painting and Sculpture 1900–1988* (Munich: Prestel Verlag; London: Royal Academy of Arts, 1989), p. 427.

190. Piero Manzoni, "Libera Dimensione," *Azimuth* (1960); reprinted as "Free Dimension," in *Piero Manzoni: Paintings, Reliefs and Objects*, exh. cat. (London: Tate Gallery, 1974), p. 46.

191. Ibid., pp. 46–47. Manzoni preferred the term "absolute" to "abstract"; see Manzoni, "For the Discovery of a Zone

of Images," in *Piero Manzoni: Paintings, Reliefs and Objects*, p. 17.

192. Kynaston McShine, "Yves Klein," in *Yves Klein*, exh. cat. (New York: Jewish Museum, 1967), p. 7.

193. Yves Klein, "The Monochrome Adventure," in *Yves Klein 1928–1962*, p. 224.

194. Klein, lecture delivered at the Sorbonne, Paris (1959), excerpted in the exhibition catalogue for a retrospective at Gimpel Fils in 1973; and reprinted in Jacques Caumont and Jennifer Gough-Cooper, eds., *Yves Klein: Selected Writings* (London: Tate Gallery, 1974).

195. See Thomas McEvilley, "Yves Klein and Rosicrucianism," in *Yves Klein 1928–1962*, pp. 239–54; and Klein, *Le Dépassement de la problématique de l'art* (Paris: Montbliart, 1959), pp. 19–21, 29–30.

196. Klien, quoted in Descargues, "Yves Klein," in *Yves Klein* (Jewish Museum), p. 22. Like Manzoni, Klein rarely used the term "abstract," instead referring to his art as "absolute," as he did in "Monochrome Adventure," p. 224.

197. Klein, "Monochrome Adventure," p. 224.

198. Klein exalted that he was "truly free," yet a few pages later he warned that freedom can be "dangerous," in ibid., pp. 220, 223.

199. Klein refused "the transient psychology of the linear," in ibid., p. 224.

200. Ibid.

201. Ibid. See also Descargues, "Yves Klein," p. 18.

202. Chamberlain, quoted in Diane Waldman, *John Chamberlain: A Retrospective Exhibition*, exh. cat. (New York: Solomon R. Guggenheim Museum, 1971), p. 15.

203. Greenberg, "Post Painterly Abstraction," in *Post Painterly Abstraction*, exh. cat. (Los Angeles: Los Angeles County Museum of Art, 1964), unpaginated.

204. See Yve-Alain Bois, "The Limit of Almost," in Museum of Contemporary Art, Los Angeles, and Museum of Modern Art, New York, *Ad Reinhardt*, exh. cat. (New York: Rizzoli, 1991), p. 11. For a general discussion of Alloway's concept, see his Introduction, in *Systemic Painting*, exh. cat. (New York: Solomon R. Guggenheim Museum, 1966), pp. 11–21.

205. Josef Albers wrote of "the square as a stage on which colors play as actors influencing each other"; quoted in Lucy R. Lippard, "Homage to the Square,"

Art in America 55, no. 4 (July–August 1967), p. 52.

206. "Ad Reinhardt on his Art" (from a talk delivered at the Institute of Contemporary Art, London, 1964), *Studio International* 174, no. 895 (December 1967), p. 266.

207. See Reinhardt, "The Moral Content of Abstract Art" (lecture delivered September 29, 1959), *The Journal of Art* 4, no. 6 (June–August, 1991), p. 27. In a cartoon of 1946 (reproduced in Guilbaut, *How New York Stole the Idea of Modern Art*, fig. 14), Reinhardt showed a young man called "abstract art" successfully combatting the forces of sin and even banality.

208. Reinhardt, statement, in *Recent Abstract Paintings by Ad Reinhardt*, exh. cat. (New York: Betty Parsons Gallery, 1948); quoted in Tuchman, ed., *New York School*, p. 27.

209. Reinhardt, "Art-as-Art," p. 37. Albers was pithier but equally emphatic: "For me, abstraction is real, probably more real than nature" and "[A]bstraction is nearer to my heart," quoted in Katherine Kuh, *The Artist's Voice, Talks with Seventeen Artists* (New York: Harper and Row, 1960), p. 11.

210. See Bois, "The Limit of Almost," p. 17.

211. Reinhardt, "The Next Revolution in Art: Art as Dogma, Part II," *Art International* 8, no. 2 (March 20, 1964) p. 57. See also Karpel, Motherwell, and Reinhardt, "A Statement," in Karpel, Motherwell, and Reinhardt, eds., *Modern Artists in America*, p. 7.

212. Alloway, Introduction, in *Systemic Painting*, p. 14.

213. Alloway, "Systemic Painting," in *Systemic Painting*, p. 45.

214. Ellsworth Kelly, quoted in Elizabeth C. Baker, *Ellsworth Kelly: Recent Paintings and Sculptures*, exh. cat. (New York: Metropolitan Museum of Art, 1979), p. 7.

215. Kelly, quoted in Diane Upright, *Ellsworth Kelly: Works on Paper*, exh. cat. (New York: Harry N. Abrams; Fort Worth: Fort Worth Art Museum, 1987), p. 7.

216. Kelly, quoted in Richard H. Axsom, *The Prints of Ellsworth Kelly: A Catalogue Raisonné 1949–1985* (New York: Hudson Hills Press and American Federation of Arts, 1987), p. 32.

217. See Upright, *Ellsworth Kelly*, p. 9.

218. Kelly, quoted in ibid.

219. See Patterson Sims and Emily Rauh Pulitzer, *Ellsworth Kelly: Sculpture*, exh.

cat. (New York: Whitney Museum of American Art, 1982), p. 18.

220. Baker, *Ellsworth Kelly*, p. 8.

221. Ibid., p. 7.

222. Kelly, "Notes from 1969," in *Ellsworth Kelly*, exh. cat. (Amsterdam: Stedelijk Museum, 1980), p. 30.

223. Robert Rauschenberg, letter to Betty Parsons (1951), quoted in Roni Feinstein, "The Early Work of Robert Rauschenberg: The White Paintings, the Black Paintings, and the Elemental Sculpture," *Arts Magazine* 61, no. 1 (September 1986), p. 28.

224. Barbara Rose, *An Interview with Robert Rauschenberg* (New York: Vintage Books, 1987), pp. 23, 37–38.

225. Ibid., p. 36.

226. John Cage first delivered his "Lecture on Nothing" at the Artists' Club in New York in 1949; see Cage, *Silence* (Cambridge, Mass.: M.I.T. Press, 1961), p. ix. Rauschenberg's White Paintings preceded Cage's silent composition *4' 33"*, a point that Cage noted in his article "On Robert Rauschenberg, Artist and His Work," *Metro* (1961); quoted in Walter Hopps, *Robert Rauschenberg: The Early 1950s*, exh. cat. (Houston: The Menil Collection and Houston Fine Art Press, 1991), p. 71, n. 3. Rauschenberg's relationship to Cage is discussed in *Robert Rauschenberg*, exh. cat. (Washington, D.C.: National Collection of Fine Arts, Smithsonian Institution, 1976), p. 3, and Feinstein, "The Early Work," p. 30.

227. Robert Martin Adams, *NIL: Episodes in the Literary Conquest of Void During the Nineteenth Century* (New York: Oxford University Press, 1966), p. 3.

228. Hans von Baeyer, quoted in Eliot Hearst, "Psychology and Nothing," *American Scientist* 79, no. 5 (September–October 1991), p. 441.

229. Jasper Johns, quoted in David Sylvester, "Interview," in *Jasper Johns Drawings*, exh. cat. (London: Arts Council of Great Britain, 1974), pp. 15–16.

Chapter 5

1. Robert Rosenblum, *Frank Stella* (New York: Penguin Books, 1971), p. 57.

2. Bruce Glaser, "Questions to Stella and Judd," ed. Lucy Lippard, *Art News* 65, no. 5 (September 1966), p. 61.

3. See Richard Meier, *Frank Stella: Shards* (New York: Peterborough Press, 1983), unpaginated [p. 3].

4. See Maurice Tuchman, "The Russian Avant-Garde and the Contemporary

Artist," in Stephanie Barron and Maurice Tuchman, eds., *The Avant-Garde in Russia 1910–1930: New Perpectives*, exh. cat. (Cambridge, Mass.: M.I.T. Press, 1980), pp. 119–20.

5. Glaser, "Questions to Stella and Judd," p. 61.

6. See William Rubin, *Frank Stella*, exh. cat. (New York: Museum of Modern Art, 1970), pp. 46, 60, 70.

7. Avis Berman, "Artist's Dialogue: A Conversation with Frank Stella," *Architectural Digest* 40, no. 9 (September 1983), p. 78.

8. *Agnes Martin Paintings and Drawings 1957–1975*, exh. cat. (London: Arts Council of Great Britain, 1977), p. 19.

9. Agnes Martin, notes, in Hermann Kern, ed., *Agnes Martin*, exh. cat. (Munich: Kunstraum, 1973), p. 37.

10. Martin, statement, in "The '60s in Abstract: Thirteen Statements and an Essay," *Art in America* 71, no. 9 (October 1983), p. 132; and John Gruen, "Agnes Martin: 'Everything, Everything Is About Feeling . . . Feeling and Recognition,'" *Art News* 75, no. 7 (September 1976), p. 93.

11. Martin, quoted in Gruen, "Agnes Martin," p. 93.

12. Martin, notes, in Kern, ed., *Agnes Martin*, p. 66.

13. Samuel Wagstaff, Jr., "Talking with Tony Smith," *Artforum* 5, no. 4 (December 1966), pp. 17–18.

14. See Frank Stella, statement, in Rosenblum, *Frank Stella*, p. 57; and Glaser, "Questions to Stella and Judd," p. 61.

15. Lawrence Alloway, Introduction, in *Systemic Painting*, exh. cat. (New York: Solomon R. Guggenheim Museum, 1966), p. 19.

16. Ibid.

17. Ibid., p. 15.

18. Glaser, "Questions to Stella and Judd," p. 55.

19. Ibid., pp. 59, 61.

20. See statement by Carl Andre on this aspect of Stella's work, in Dorothy C. Miller, ed., *Sixteen Americans*, exh. cat. (New York: Museum of Modern Art, 1959), p. 76.

21. Wagstaff, "Talking with Tony Smith," p. 18.

22. See Smith, statement, quoted in Lippard, "Homage to the Square," *Art in America* 55, no. 4 (July–August 1967), p. 53.

23. See, for instance, Gruen, "Agnes Martin," p. 94.

24. Stella, however, denied that his art was cold, and even compared it to Rothko's. See Emile De Antonio and Mitch Tuchman, *Painters Painting* (New York: Abbeville, 1984), p. 144.

25. Discussed by Thierry de Duve, "The Monochrome and the Blank Canvas," in Serge Guilbaut, ed., *Reconstructing Modernism: Art in New York, Paris, and Montreal 1945–64* (Cambridge, Mass.: M.I.T. Press, 1990), pp. 246–48, 266.

26. Irving Sandler, *American Art of the 1960s* (New York: Harper and Row, 1988), p. 277, n. 7.

27. Phyllis Tuchman, "An Interview with Carl Andre," *Artforum* 8, no. 10 (June 1970), p. 67.

28. Andrea Gould, "Dialogue with Carl Andre," *Arts Magazine* 48, no. 8 (May 1974), p. 27.

29. Carl Andre, quoted in David Bourdon, "A Redefinition of Sculpture," in *Carl Andre Sculpture 1959–1977*, exh. cat. (New York: Jaap Rietman, 1978), p. 18.

30. Achille Bonita Oliva, "Carl Andre," *Domus*, no. 515 (October 1972), p. 51.

31. Phyllis Tuchman, "Interview with Carl Andre," p. 57.

32. Ibid.

33. See Andre and Hollis Frampton, *Twelve Dialogues 1962–1963*, ed. Benjamin H. D. Buchloh (Halifax: Press of the Nova Scotia College of Art and Design; New York: New York University Press, 1980), p. 34. For Andre's interest in Aleksandr Rodchenko and Vladimir Tatlin, see "Carl Andre" (interview, December 1968), *Avalanche*, no. 1 (fall 1970), p. 26. In contrast to his positive view of Constructivism, he thought of the Bauhaus as "backward"; see "Carl Andre on His Sculpture, II," *Art Monthly*, no. 17 (1978), p. 8.

34. Andre and Frampton, *Twelve Dialogues*, p. 37.

35. Andre considered Paul Cézanne to have acted similarly as an antidote to Impressionism, especially in terms of Cézanne's utilization of his brushstroke as a building block: "Cézanne is a Constructivist and Renoir is not. Cézanne's brushstroke is the atom of which his paintings are composed. Renoir's stroke by comparison is miasmic, a mist among mists." Andre and Frampton, *Twelve Dialogues*, p. 37.

36. Irmeline Lebeer, "Carl Andre," *Art Vivant*, no. 50 (June 1974), p. 13.

37. Andre, quoted in Grace Glueck, "The Twentieth-Century Artists Most Admired by Other Artists," *Art News* 76, no. 9 (November 1977), p. 80.

38. Phyllis Tuchman, "Interview with Carl Andre," p. 55.

39. See Bonita Oliva, "Carl Andre," pp. 51–52.

40. Andre, quoted in David Bourdon, "The Razed Sites of Carl Andre," *Artforum* 5, no. 2 (October 1966), p. 15.

41. "Carl Andre on His Sculpture, II," p. 9.

42. Phyllis Tuchman, "Interview with Carl Andre," p. 57.

43. Andre, quoted in Bonita Oliva, "Carl Andre," p. 52.

44. "Statements by Sculptors," *Art Journal* 35, no. 2 (winter 1975–76), p. 127. However, Andre found the efforts of the second-generation Abstract Expressionists to be a "fiasco"; see "Carl Andre on His Sculpture," *Art Monthly*, no. 16 (1978), p. 6.

45. Andre and Frampton, *Twelve Dialogues*, p. 88.

46. "Carl Andre on His Sculpture," p. 6.

47. "Carl Andre on His Sculpture II," p. 10.

48. Glaser, "Questions to Stella and Judd," p. 58.

49. Donald Judd, quoted in Roberta Smith, "Donald Judd," in *Donald Judd*, exh. cat. (Ottawa: National Gallery of Canada, 1975), p. 11.

50. John Coplans, "Don Judd: An Interview," in *Don Judd*, exh. cat. (Pasadena, Calif.: Pasadena Art Museum, 1971), pp. 30–32.

51. Judd, "On Russian Art and Its Relation to My Work," in Judd, *Complete Writings: 1975–1986* (Eindhoven: Van Abbemuseum, 1987), p. 14. See also comments by Judd, quoted in Martin Friedman, "Echoes of De Stijl," in Mildred Friedman, ed., *De Stijl, 1917–1931: Visions of Utopia*, exh. cat. (Minneapolis: Walker Art Center; New York: Abbeville Press, 1982), p. 211. With reservations, Judd expressed "admiration" for Kandinsky, especially his *Composition VII*, 1913. See Judd, "The Current Scene," *Arts Magazine* (1963); reprinted in Judd, *Complete Writings: 1959–1975* (Halifax: Press of the Novia Scotia College of Art and Design; New York: New York University Press, 1975), pp. 76–77.

52. Judd, "Malevich: Independent Form, Color, Surface," *Art in America* 62, no. 2 (March–April 1974); reprinted in Judd, *Complete Writings: 1959–1975*, p. 214.

53. Ibid., p. 212.

54. Judd, conversation with Sandler, in Sandler, *American Art of the 1960s*, p. 72.

55. Judd, "Malevich," p. 215.

56. Judd, quoted in "Eight Statements" (interviews by Jean-Claude Lebensztejn), *Art in America* 63, no. 4 (July–August 1975), pp. 71–72.

57. Judd, "Abstract Expressionism," in Judd, *Complete Writings: 1975–1986*, p. 39.

58. Ibid., pp. 40, 42, 45.

59. Comment by Judd in Jeanne Siegel, "Around Barnett Newman," *Art News* 70, no. 6 (October 1971), p. 45.

60. Judd, "Specific Objects," *Arts Yearbook 8: Contemporary Sculpture* (New York: Art Digest, 1965), p. 77.

61. Judd, "In the Galleries" *Arts Magazine* (December 1959); reprinted in Judd, *Complete Writings: 1959–1975*, p. 7.

62. Judd, "In the Galleries" *Arts Magazine* (September 1962); reprinted in Judd, *Complete Writings: 1959–1975*, p. 57.

63. Ibid.

64. Judd, "Malevich," p. 214.

65. Judd, "Complaints: Part I," *Studio International* (1969); reprinted in Judd, *Complete Writings: 1959–1975*, p. 197.

66. Judd, "New York City—A World Art Center," *Envoy* (1962); reprinted in Judd, *Complete Writings: 1959–1975*, p. 63.

67. Judd, quoted in Lippard, "Homage to the Square," p. 56.

68. Judd, "Art and Architecture" (lecture delivered at the Yale School of Art and Architecture, New Haven, September 20, 1983), in Judd, *Complete Writings: 1975–1986*, p. 31.

69. Coplans, "Don Judd: An Interview," p. 21.

70. See Judd, "In Defense of My Work," in Judd, *Complete Writings: 1975–1986*, p. 9.

71. Judd, "In the Galleries," *Arts Magazine* (December 1959); reprinted in Judd, *Complete Writings: 1959–1975*, p. 6; and Judd, "In the Galleries," *Arts Magazine* (September 1962); reprinted in *Complete Writings: 1959–1975*, p. 57.

72. Judd, "In Defense of My Work," p. 9.

73. Dan Flavin, ". . . in Daylight or Cool White: An Autobiographical Sketch," *Artforum* 4, no. 4 (December 1965), p. 24.

74. Flavin, "The Artists Say: Dan Flavin," *Art Voices* 4, no. 3 (summer 1965), p. 72.

75. Robert Morris, "Notes on Sculpture," *Artforum* (1966); reprinted in Gregory Battcock, ed., *Minimal Art: A Critical Anthology* (New York: E. P. Dutton, 1968), p. 224.

76. Flavin, ". . . in Daylight or Cool White," p. 24.

77. Ibid.

78. Ibid.

79. Flavin, "Some Other Comments," *Artforum* 6, no. 4 (December 1967), p. 28.

80. Morris, "American Quartet," *Art in America* (1981); reprinted in Morris, *Continuous Project Altered Daily: The Writings of Robert Morris* (Cambridge, Mass.: M.I.T. Press, 1993), p. 240.

81. Ibid., p. 245.

82. Sol LeWitt, "Illustrations: Works by Sol LeWitt, 1962–1977, with His Commentaries," in *Sol LeWitt*, exh. cat. (New York: Museum of Modern Art, 1978), p. 62.

83. Lewitt, quoted in "Documentation, Conceptual Art: Weiner, Buren, Bochner, LeWitt," *Arts Magazine* 44, no. 6 (April 1970), p. 45.

84. LeWitt, "Drawing Series 1968 (Fours)," *Studio International* 177 (April 1969), p. 189.

85. LeWitt, "Paragraphs on Conceptual Art," *Artforum* 6, no. 10 (summer 1967), p. 83; reprinted in *Sol LeWitt*, exh. cat. (The Hague: Haags Gemeentemuseum, 1970), p. 57.

86. LeWitt, "Paragraphs on Conceptual Art," p. 80.

87. See Anna Nosei Weber and Otto Hahn, eds., "La Sfida del Sistema," *Metro*, no. 14 (June 1968), p. 45.

88. LeWitt, "Sentences on Conceptual Art" (1969), in *Sol LeWitt* (Haags Gemeentemuseum), p. 60. See also LeWitt, "Paragraphs on Conceptual Art," p. 80.

89. Barbara Rose, "ABC Art," *Art in America* 53, no. 5 (October–November 1965), p. 66.

90. Judd, quoted in Kynaston McShine, *Primary Structures*, exh. cat. (New York: Jewish Museum, 1966), unpaginated. See also Glaser, "Questions to Stella and Judd," pp. 59–60.

91. Judd, quoted in "Portfolio: Four Sculptors: Don Judd," *Perspecta*, no. 11 (1967), p. 44.

92. Judd, "Specific Objects," p. 187.

93. See Coplans, "Don Judd: An Interview," p. 32.

94. As Judd wrote in 1965, "Most of the work involves new materials, either recent inventions or things not used before in art. Little was done until lately with the wide range of industrial products. Almost nothing has been done with industrial techniques. . . . Art could be mass-produced, and possibilities otherwise unavailable . . . could be used." Judd, "Specific Objects," p. 187.

95. Ibid.

96. See *Carl Andre*, exh. cat. (The Hague: Haags Gemeentemuseum, 1969), p. 5.

97. Andre, quoted in Bourdon, "The Razed Sites of Carl Andre," p. 15, and in *Carl Andre* (Haags Gemeentemuseum), p. 38.

98. See "Carl Andre and His Sculpture," pp. 5, 8.

99. Phyllis Tuchman, "Interview with Andre," pp. 55, 60. For more on Andre's materialism, see Lebeer, "Carl Andre," p. 13.

100. Andre, quoted in *Carl Andre* (Haags Gemeentemuseum), p. 6.

101. Ibid., p. 5.

102. Phyllis Tuchman, "Interview with Andre," p. 59.

103. Bonita Oliva, "Carl Andre," p. 52.

104. Andre, quoted in *Carl Andre*, exh. cat. (London: Whitechapel Art Gallery, 1978), unpaginated.

105. Andre, quoted in Rose, "ABC Art," p. 67, and Phyllis Tuchman, "Interview with Carl Andre," p. 57.

106. Andre and Frampton, *Twelve Dialogues*, p. 88.

107. *Carl Andre* (Whitechapel Art Gallery), unpaginated [p. 14].

108. Phyllis Tuchman, "Interview with Carl Andre," p. 59.

109. Ibid.

110. Judd, "Art and Architecture," p. 31.

111. Weber and Hahn, eds., "La Sfida del Sistema," p. 45.

112. Donald B. Kuspit, "Authoritarian Abstraction," *Journal of Aesthetics and Art Criticism* 36, no. 1 (fall 1977), p. 26.

113. LeWitt, quoted in Weber and Hahn, eds., "La Sfida del Sistema," pp. 44–45.

114. Robert Ryman, in Maurice Poirier and Jane Necol, "The '60s in Abstract: Thirteen Statements and an Essay," *Art in America* 71, no. 9 (October 1983), p. 123.

115. Ibid.

116. Ibid., p. 59.

117. Ryman, "On Painting" (lecture delivered at the Solomon R. Guggenheim Museum, New York, January 9, 1991), in Christel Sauer and Urs Raussmüller, *Robert Ryman*, exh. cat. (Paris: Espace d'Art Contemporain; Schaffhausen: Hallen für Neue Kunst, 1991), p. 59.

118. Ibid., p. 61.

119. Ibid.

120. Kuspit, "Red Desert and Arctic Dreams," *Art in America* 77, no. 3 (March 1989), p. 123.

121. Ryman and Raussmüller, "A Talk in Ryman's Studio," in *Robert Ryman: Versions*, exh. cat. (Schaffhausen: Hallen für Neue Kunst; New York: Pace Gallery, 1992), p. 35.

122. Ryman, statement, in Poirier and Necal, "The '60s in Abstract," p. 124.

123. Robert Mangold, interview with Robin White, in *View* (Oakland: Crown Point Press, 1978), p. 17.

124. Mangold, "A Talk on December 5, 1992, in New York," in Sauer and Raussmüller, *Robert Mangold* (Paris: Espace d'Art Contemporain; Schaffhausen: Hallen für Neue Kunst, 1993), p. 59.

125. Brice Marden, quoted in Carl Andre, "New in New York," *Arts Magazine* 41, no. 7 (May 1967), p. 50.

126. Marden, statement, in Poirier and Necal, "The '60s in Abstract," p. 122.

127. "Brice Marden: Interview with Robert Storr on October 24, 1986," in Rosemarie Schwarzwälder, ed., *Abstrakte Malerei aus Amerika und Europa/Abstract Painting of America and Europe* (Vienna: Galerie Nächst St. Stephan, 1988), pp. 71–73.

128. Ad Reinhardt, "Art-as-Art," *Art International* 6, no. 10 (December 20, 1962), p. 14.

129. Lippard discussed the possibility of abstraction gaining erotic overtones in "Eros Presumptive," *The Hudson Review* 20, no. 1 (spring 1967), pp. 91–99.

130. Robert Pincus-Witten, "Eva Hesse: More Light on the Transition from Post-Minimalism to the Sublime," in *Eva Hesse: A Memorial Exhibition*, exh. cat. (New York: Solomon R. Guggenheim Museum, 1972), unpaginated; reprinted in Pincus-Witten, *Postminimalism* (New York: Out of London Press, 1977), p. 52.

131. Eva Hesse, quoted in Pincus-Witten, "Eva Hesse: More Light," in Pincus-Witten, *Postminimalism*, p. 62.

132. Hesse, quoted in Helen A. Cooper, *Eva Hesse: A Retrospective*, exh. cat. (New

Haven: Yale University Press with Yale University Art Gallery, 1992), p. 42.

133. Ibid.

134. Cindy Nemser, "An Interview with Eva Hesse," *Artforum* 8, no. 9 (May 1970), pp. 59–60.

135. Hesse, quoted in Cooper, *Eva Hesse*, p. 102.

136. Hesse, quoted in "Fling, Dribble and Drip," *Life* 68, no. 7 (February 27, 1970), p. 66. Hesse also discussed the importance of Pollock to her in Nemser, "Interview with Eva Hesse," p. 59.

137. "Interview: Richard Serra and Bernard Lamarche-Vadel" (May 1980), reprinted in *Richard Serra: Interviews, etc. 1970–1980* (Yonkers, N.Y.: Hudson River Museum, 1980), p. 135.

138. Ibid.

139. Richard Serra, interview with Victoria von Flemming (1977), quoted in Clara Weyergraf, "From 'Trough Pieces' to 'Terminal': Study of a Development," in *Richard Serra: Works 1966–77*, exh. cat. (Bochum, Germany: Galerie M, 1978), p. 207. In moving Minimalist abstraction into a more complex relationship with three-dimensional space, Serra was influenced by Robert Smithson, whom he met in New York around 1966–67; see "Serra and Lamarche-Vadel," p. 135.

140. Serra, "Rigging," *Cover* (1980); reprinted in *Serra: Interviews, etc.*, p. 120.

141. Serra, "St. John's Rotary Arc," *Artforum* (1980); reprinted in *Serra: Interviews, etc.*, p. 161.

142. Serra, "Sight Point '71–'75/Delineator '74–'76" (radio interview with Liza Béar), *Art in America* 64, no. 3 (May–June 1976), p. 84. For further discussion of this aspect of Serra's work as it relates to abstraction, see Rosalind E. Krauss, *Richard Serra*, exh. cat. (New York: Museum of Modern Art, 1986), pp. 22–24, 32–35, 37.

143. "Conversazione con Richard Serra a Milano/In Support of 'Tilted Arc,'" *Domus* 662 (June 1985), pp. 76–77; and Serra, "Rigging," p. 128.

144. Serra, quoted in Kenneth Baker, "Vectors of Viewer Response," *Artforum* 25, no. 1 (September 1986), p. 103.

145. See Serra, "Rigging," in *Serra: Interviews, etc.*, pp. 128–29.

146. Serra, *"Tilted Arc* Destroyed," *Art in America* 77, no. 5 (May 1989), p. 41.

147. Ibid., p. 40.

148. Serra, interview with Nicholas Serota and David Sylvester (May 27, 1992), in *Richard Serra: Weight and*

Measure, exh. cat. (London: Tate Gallery, 1992), pp. 23, 25.

149. Krauss, *Richard Serra*, p. 21. For more on Serra's opinion of Constantin Brancusi, see Harriet Senie, "The Right Stuff," *Art News* 83, no. 3 (March 1984), p. 55.

150. Krauss, *Richard Serra*, p. 28. For Serra on the art of the Russian Constructivists, see "Serra and Lamarche-Vadel," p. 145.

151. Serra, "Notes on Drawing," in Ernst-Gerhard Guse, ed., *Richard Serra* (New York: Rizzoli, 1987), p. 67.

152. Serra, interview with the author, 1991.

153. Serra, "St. John's Rotary Arc," p. 161.

154. "To deprive art of its uselessness is to make other than art. I am interested in sculpture which is nonutilitarian, non-functional. Any use is a misuse." Serra, "Rigging," p. 128.

155. Ibid.

156. Serra, "Sight Point/Delineator," p. 63.

157. Serra, "Extended Notes from Sight Point Road" (1985), in *Richard Serra: Recent Sculpture in Europe 1977–1985* (Bochum, Germany: Galerie M, 1985); reprinted in Serra, *Writings, Interviews* (Chicago: University of Chicago Press, 1994), p. 171.

158. Morris, "American Quartet," *Art in America* 69, no. 10 (December 1981), p. 96.

159. Moira Roth, "Robert Smithson on Duchamp" (interview), *Artforum* (1973); reprinted in Nancy Holt, ed., *The Writings of Robert Smithson* (New York: New York University Press, 1979), p. 197.

160. Smithson, "A Sedimentation of the Mind: Earth Projects," *Artforum* (1968); reprinted in Holt, ed., *Writings of Smithson*, p. 82.

161. Smithson, "Earth (Symposium at White Museum, Cornell University)" (February 6, 1969), reprinted in Holt, ed., *Writings of Smithson*, p. 160.

162. Paul Cummings, "Interview with Robert Smithson for Archives of American Art/Smithsonian Institution" (July 14 and 19, 1972), reprinted in Holt, ed., *Writings of Smithson*, p. 149.

163. Smithson, "Entropy and the New Monuments," *Artforum* (1966); reprinted in Holt, ed., *Writings of Smithson*, pp. 12–17. See also "Donald Judd," in *Seven Sculptors*, exh. cat. (Philadelphia: Philadelphia Institute of Contemporary Art, 1965); reprinted in *Writings of Smithson*, pp. 21–23.

164. Smithson, "Ultramoderne," *Arts Magazine* (1967); reprinted in Holt, ed., *Writings of Smithson*, p. 49.

165. Smithson, "Quasi-Infinities and the Waning of Space," *Arts Magazine* (1966); reprinted in Holt, ed., *Writings of Smithson*, p. 33; and Cummings, "Interview with Smithson," pp. 146–47.

166. Cummings, "Interview with Smithson," pp. 149, 152.

167. Ibid., p. 151.

168. Smithson, "Sedimentation of the Mind," p. 89.

169. "Discussions with Heizer, Oppenheim, Smithson," *Avalanche* (1970); reprinted in Holt, ed., *Writings of Smithson*, p. 175.

170. Bruce Kurtz, "Conversation with Robert Smithson on April 22, 1972," *The Fox II* (1975); reprinted in Holt, ed., *Writings of Smithson*, p. 200.

171. Alison Sky, "Entropy Made Visible" (interview with Smithson), *On Site* (1973); reprinted in Holt, ed., *Writings of Smithson*, p. 190.

172. Kurtz, "Conversation with Smithson," p. 202; Gianni Pettena, "Conversation in Salt Lake City" (interview with Smithson), *Domus* (1972); reprinted in Holt, ed., *Writings of Smithson*, p. 187; and Cummings, "Interview with Smithson," p. 154.

173. Cummings, "Interview with Smithson," p. 154.

174. Smithson, "Frederick Law Olmsted and the Dialectical Landscape," *Artforum* (1973); reprinted in Holt, ed., *Writings of Smithson*, pp. 121–22.

175. "Discussions with Heizer, Oppenheim, Smithson," p. 177.

176. Smithson, quoted in Pettena, "Conversation in Salt Lake City," p. 187.

177. Richard Long, "Words After the Fact" (1982), reprinted in R. H. Fuchs, *Richard Long*, exh. cat. (London: Thames and Hudson; New York: Solomon R. Guggenheim Museum, 1986), p. 236.

178. Long, "Interview with Bruno Corà," in Fondazione Amelio, *Terrae Motus* (Naples: Electa, 1984), p. 89.

179. Long, *Touchstones* (Bristol: Arnolfini, 1983), unpaginated.

180. Robert Irwin, quoted in Lawrence Weschler, *Seeing Is Forgetting the Name of the Thing One Sees: A Life of Contemporary Artist Robert Irwin* (Berkeley: University of California Press, 1982), p. 152.

181. Irwin, quoted in Frederick S. Wight, *Transparency, Reflection, Light, Space: Four Artists*, exh. cat. (Los Angeles: U.C.L.A. Art Galleries, 1971), p. 12.

182. Irwin, quoted in Weschler, *Seeing Is Forgetting*, p. 183.

183. See *Robert Irwin*, exh. cat. (New York: Whitney Museum of American Art, 1977), pp. 29, 31.

184. Jan Butterfield, "The State of the Real" (interview with Irwin), *Arts Magazine* 46, no. 8 (summer 1972), p. 48.

185. See Thomas McEvilley, "Heads It's Form, Tails It's Not Content," *Artforum* 21, no. 3 (November 1982), pp. 50–61; and Thomas Crow, "The Return of Hank Herron," in David Joselit and Elisabeth Sussman, eds., *Endgame: Reference and Simulation in Recent Painting and Sculpture*, exh. cat. (Boston: Institute of Contemporary Art; Cambridge, Mass.: M.I.T. Press, 1986), p. 15.

186. See Kuspit, *"Fin de Siècle* Abstraction: The Ambiguous Re-Turn Inwards," *Tema Celeste*, no. 34 (January–March 1992), p. 54.

187. D.J. [Donald Judd], "New York Exhibitions: In the Galleries: Andy Warhol," *Arts Magazine* 37, no. 4 (January 1963), p. 49.

188. Gerhard Richter, letter to Edy de Wilde (February 23, 1975), reprinted in *Gerhard Richter*, exh. cat. (London: Tate Gallery, 1991), p. 112.

189. Benjamin H.D. Buchloh, "Interview with Gerhard Richter," trans. Stephen P. Duffy, in Roald Nasgaard, *Gerhard Richter Paintings*, exh. cat. (Chicago: Museum of Contemporary Art; Toronto: Art Gallery of Ontario; London: Thames and Hudson, 1988), p. 19.

190. Richter, quoted in Klaus Honnef, "Richter's Painting: Between Art and Reality," trans. Gerda Garabédian, in *Gerhard Richter*, exh. cat. (Venice: Venice Biennale, 1972), p. 15.

191. Dorothy Dietrich, "Gerhard Richter: An Interview," *The Print Collectors Newsletter* 16, no. 4 (September–October, 1985), p. 131.

192. For a discussion of how these paintings are made, see I. Michael Danoff, "An Introduction to the Work of Gerhard Richter," in Nasgaard, *Gerhard Richter*, p. 12.

193. Dietrich, "Richter: An Interview," p. 128.

194. *Gerhard Richter 1988–89*, exh. cat. (Rotterdam: Museum Boymans-van Beuningen, 1989), p. 13.

195. Richter, interview with Rolf Gunther Dienst, trans. Gerda Garabédian, in *Gerhard Richter* (Venice Biennale), p. 19.

196. Dietrich, "Richter: An Interview," p. 128.

197. Richter, entry in "Notes 1966–1990" (1986), reprinted in *Gerhard Richter* (Tate Gallery), p. 117.

198. Buchloh, "Interview with Richter," p. 21.

199. For example, see *Gerhard Richter 1988–89*, p. 11.

200. See Richter's remarks from "Interview with L. Leeber," quoted in Jean-Pierre Criqui, "Three Impromptus in the Art of Gerhard Richter," trans. Stephen Sartarelli, *Parkett*, no. 35 (March 1993), p. 38.

201. Buchloh, "Interview with Richter," p. 25.

202. Peter Sager, "Gespräch mit Gerhard Richter," *Das Kunstwerk* 25 (July 1972), p. 27. Richter also speaks of painting as "a moral action," in *Gerhard Richter 1988–89*, p. 13.

203. Richter, quoted in *Gerhard Richter* (Tate Gallery), p. 109.

204. Richter, statement, in *Documenta 7* (Kassel: Documenta, 1982), vol. 1, pp. 84–85; quoted in Nasgaard, "The Abstract Paintings," in Nasgaard, *Gerhard Richter*, p. 107.

205. Richter, "Notes" (September 21, 1984), quoted in Nasgaard, "The Abstract Paintings."

206. Buchloh, "Interview with Richter," p. 15.

207. Ibid., p. 19.

208. Richter, entry in "Notes" (March 18, 1986), reprinted in *Gerhard Richter* (Tate Gallery), p. 117.

209. Richter, entry in "Notes" (January 27, 1983), reprinted in *Gerhard Richter* (Tate Gallery), p. 113.

210. Richter, entry in "Notes" (May 13, 1983), reprinted in *Gerhard Richter* (Tate Gallery), p. 114.

211. Richter, entries in "Notes" (March 28, 1986 and January 13, 1988), reprinted in *Gerhard Richter* (Tate Gallery), pp. 118, 120.

212. Richter, letter to Jean-Christophe Amman (February 24, 1973), reprinted in *Gerhard Richter* (Tate Gallery), p. 110.

213. Richter, entry in "Notes" (May 18, 1985), reprinted in *Gerhard Richter* (Tate Gallery), p. 116.

214. Richter, statement, in *Documenta 7*; reprinted in *Gerhard Richter* (Tate Gallery), p. 112.

215. Richter, letter to Amman (February 24, 1973), p. 110. Richter also says "Nothing helps me, no ideas, no rule, no belief to show me the way, no image of the future, no construction to give me superior sense" (Nasgaard, "Abstract Painting," p. 107).

216. Richter, entry in "Notes" (November 13, 1985), quoted in *Gerhard Richter* (Tate Gallery), p. 116.

217. Richter, quoted in Danoff, Introduction, in Nasgaard, *Gerhard Richter*, p. 9.

218. Buchloh, "Interview with Richter," p. 24.

219. Richter, statement, in *Documenta 7*; reprinted in *Gerhard Richter* (Tate Gallery), p. 112.

220. Ibid., p. 29.

221. Richter, quoted in Danoff, Introduction, in Nasgaard, *Gerhard Richter*, p. 13.

222. Dietrich, "Richter: An Interview," p. 131.

223. Discussed by Saul Ostrow, in "Strategies for a New Abstraction," *Tema Celeste*, nos. 32–33 (fall 1991), p. 70; and Stephen Ellis, in "After the Fall," *Tema Celeste*, no. 34 (January–March 1992), p. 59.

224. See Herbert Marcuse, "Art as a Form of Reality," in *On the Future of Art*, exh. cat. (New York: Solomon R. Guggenheim Museum and Viking, 1970), pp. 123–34.

225. Joan Simon, "Readymade Abstraction/Abstraction's Realities," in *Abstraction in Question*, exh. cat. (Sarasota: John and Mable Ringling Museum of Art, 1989), p. 19.

226. For instance, see "Helmut Federle: Interview with Bernhard Bürgi on December 26, 1986," in Schwarzwälder, *Abstrakte Malerei*, p. 144.

227. See Marcuse, "Art as a Form of Reality," pp. 125–27.

228. See W. J. T. Mitchell, "*Ut Pictura Theoria*: Abstract Painting and the Repression of Language," *Critical Inquiry* 15, no. 2 (winter 1989), pp. 349–54.

229. See "Artists' Statements: David Diao," in *Conceptual Abstraction* (New York: Sidney Janis Gallery, 1991), unpaginated [p. 23]; "Helmut Federle: Interview with Bernhard Bürgi," p. 140; and Stephen Westfall, quoted in Jeanne Siegel, "The Artist/Critic of the Eighties, Part One: Peter Halley and Stephen Westfall," *Arts Magazine* 60, no. 1 (September 1985), p. 77.

230. Oliver Mosset, "Deconstructing Abstraction," *Tema Celeste*, nos. 32–33 (fall 1991), p. 78; Ellis, "After the Fall," pp. 56–59; Archie Rand, "Concentric Collapse Awaiting Annealment," *Tema Celeste*, no. 34 (January–March 1992), pp. 90–91; Joselit and Sussman, eds., *Endgame*.

231. Peter Halley, "Notes on the Paintings" (1982), in Halley, *Collected Writings 1981–87* (Venice, Calif.: Lapis Press, 1991), p. 23.

232. "Peter Halley" (interview), in David A. Ross, *American Art of the Late 80s*, exh. cat. (Boston: Institute of Contemporary Art and Museum of Fine Arts, 1988), p. 96.

233. See Halley, "The Crisis in Geometry" (1984), in Halley, *Collected Writings*, pp. 75–81.

234. See Crow, "Return of Hank Herron," in Joselit and Sussman, eds., *Endgame*, pp. 15–16.

235. Siegel, "The Artist/Critic," p. 73.

236. Craig Owens, "Allan McCollum: Repetition and Difference," *Art in America* 71, no. 8 (September 1983), p. 130.

237. Ibid., p. 64.

238. See Sussman, "The Last Picture Show," in Joselit and Sussman, eds., *Endgame*, pp. 56–64.

239. Kuspit, "*Fin de Siècle* Abstraction," p. 55.

240. Sherrie Levine, artist's statement, in *Conceptual Abstraction*, exh. cat. (New York: Sidney Janis Gallery, 1991), unpaginated [p. 26].

241. David Row, "A Conversation with Demetrio Paparoni," *Tema Celeste*, no. 34 (January–March 1992), p. 95.

242. For a fuller discussion of the Postmodern approach to abstraction, see my *Critiques of Pure Abstraction* (New York: Independent Curators Incorporated, 1995), pp. 9–22.

243. Kuspit, "The Abstract Self-Object," in Schwarzwälder, *Abstrakte Malerei*, pp. 47–51.

244. Christian Eckart, quoted in *Conceptual Abstraction*, unpaginated.

245. See, for example, statements by Valerie Jaudon, Richard Kalina, and Shirley Kaneda in *Conceptual Abstraction*, unpaginated [pp. 24–25]; Halley, *Collected Writings*, pp. 21, 25; and Demetrio Paparoni, "The Orange and Its Juice: Abstraction between Reality and Pretense," *Tema Celeste*, nos. 32–33 (fall 1991), p. 64.

246. Halley, "The Crisis in Geometry," p. 75.

247. Stella, *Working Space* (Cambridge, Mass.: Harvard University Press, 1986), pp. 1, 5.

248. Marcuse, "Art as a Form of Reality," p. 131.

249. See Kuspit, "The Illusion of the Absolute in Abstract Art," *Art Journal* 31, no. 1 (fall 1971), p. 29.

Chronology

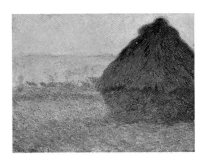

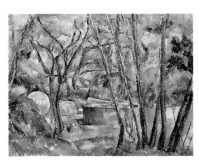

Claude Monet, Grainstack (Sunset)*, 1891. Oil on canvas, 28 ⅛ x 36 ½ inches (73.3 x 92.6 cm). Museum of Fine Arts, Boston, Juliana Cheney Edwards Collection.*

Paul Cézanne, Well: Millstone and Cistern under Trees*, 1892. Oil on canvas, 25 ⅝ x 31 ⅞ inches (65 x 81 cm). The Barnes Foundation, Merion, Pennsylvania.*

Henry van de Velde, Abstract Plant Composition*, 1892–93. Oil pastel, 18 ½ x 19 ¼ inches (47 x 49 cm). Kröller-Müller Museum, Otterlo, The Netherlands.*

Please note that in the chronology the following abbreviations are used for authors' names.

I.B.: Ivy Barsky
R.B.: Rebecca Butterfield
D.M.: Denise McColgan

Claude Monet
(b. 1840, Paris; d. 1926, Giverny, France)
Grainstack (Sunset), 1891

In the late 1880s, Claude Monet began to make several series of paintings that depict a single motif under varying atmospheric conditions. These landmark works opened the way to the dissolution of Western painting's traditional referent: a recognizable subject.

Grainstack (Sunset), 1891, is one of a group of fifteen *Grainstack* paintings (see also fig. 3). (In other series, Monet depicted poplars, views of the Seine, Rouen Cathedral, and water lilies.) Returning repeatedly to the same motif, Monet focused less on the object itself than on the ephemeral phenomena surrounding it. In *Grainstack (Sunset)*, for example, Monet painted the stack with the light behind it, thus flattening its volume and surrounding it with a luminous halo. The emblematic simplicity of the subject lends weight to the structure and coloristic depth of the shadows and the hushed, shimmering quality of the crimson-gold light. Ultimately, the subject of this painting is the glory of light.

Monet said that he aspired "desperately" to capture "'instantaneity,' the envelope [of light] above all, the same light spreading everywhere."[1] His series paintings came to be seen as transcending earthly experience. Octave Mirbeau, a critic who knew Monet well, claimed that they represent "the illumination of the states of consciousness of the planet, and the supersensible forms of our thoughts."[2]

By the mid-1880s, Impressionism had come to be seen by many as the stale, superficial rendering of innocuous subjects. For its reliance on objective reality, it was considered to be at the apex of a materialist approach to painting. Though an exponent of Impressionism, Monet was mostly excluded from this criticism, because of his work's perceived affinity with that of the emerging Symbolists,[3] who sought to portray not the world around them, but the world within them, in visual and literary language that transcends empirical experience and logical communication. Monet's appeal to the Symbolists lay in his determination to make permanent the transitory—to capture what they called "the eternal," rather than celebrating transitoriness itself—in works that gave precedence to ephemeral effects over the object's intrinsic materiality.

Significantly, Vasily Kandinsky claimed that his development as an abstractionist was influenced in part by viewing a Monet *Grainstack* in 1896 and being astonished not to recognize an object in the work.[4] (D.M.)

1. Claude Monet, letter to Gustave Geffroy (October 7, 1890), in Daniel Wildenstein, *Claude Monet: Biographie et catalogue raisonné* (Lausanne: La Bibliothèque des Arts, 1979), vol. 3, p. 258 (letter no. 1076).
2. Octave Mirbeau, "Claude Monet," *L'Art dans les deux mondes* (1891), quoted in Richard Shiff, "The End of Impressionism: A Study of Theories in Artistic Expression," *The Art Quarterly* 1, no. 4 (autumn 1978), p. 373.
3. Ibid., p. 368.
4. Although it is impossible to verify the specific *Grainstack* painting seen by Kandinsky, it seems likely that it was *Grainstack at Sunset* or one very similar to it. See Hans K. Roethel and Jelena Hahl-Koch, eds., *Kandinsky: Die Gesammelten Schriften* (Bern: Benteli, 1980), vol. 1, pp. 151–52, n. 24. See also Rosenthal in this volume, p. 5.

Paul Cézanne
(b. 1839, Aix-en-Provence; d. 1906, Aix-en-Provence)
Well: Millstone and Cistern under Trees, 1892

Paul Cézanne is often considered the "father" of modern art, for he was the first artist to systematically break down observed form to examine the nature of his own seeing. His advice to the young artist Emile Bernard to "deal with nature as cylinders, spheres, cones"[1] indicates how Cézanne rendered in paint on canvas what he saw before his eyes. Although in this respect Cézanne was a master of objective pictorial analysis, the impetus for this approach arose from a deeply subjective need to capture the complex whole of his perceived experience, a goal he felt constantly eluded his grasp. In the month before his death, Cézanne lamented to his son that he still strove with difficulty to attain his highest aim in painting, "the realization [*réalisation*] of my feelings. . . . to achieve the intensity my senses feel."[2]

For Cézanne, all form vibrates with a transfixing energy—whether shifting and amorphous, as the sweeping sky; inanimate and still, as silent rocks; emanating with gracious vitality, as a tall, stately tree; or pulsing with the brightness of man-made materials, as the artificial flowers he came to prefer to paint. He believed all forms of creation to be separate but connected, a wholeness that he experienced in bursts of epiphany, which he desired somehow to capture and hold through his painting.

Well: Millstone and Cistern under Trees, 1892, exemplifies the abstracting tendencies of Cézanne's work that so influenced later artists. The painting depicts a scene deep within a forest that Cézanne had known since a child, on the slope of his beloved Mont Sainte-Victoire, near Aix-en-Provence. A clearing reveals an ancient cistern and, to its left, an abandoned millstone, both framed by overarching trees.[3] Brilliant sunshine streams into the scene, spreading radiance that shifts the greens and browns of the wood to resplendent shades of purple, blue, raw sienna, orange, and red.

While the cistern and millstone attract our attention, the primary subject of this painting is the resonant array of individual entities that merge in a web of subtle relationships. The traditional distinction between foreground, middle ground, and background is blurred. The pattern of tree trunks and spreading branches dominates the surface and prevents our eyes from delving deeper, and Cézanne's extraordinary *passage*—his unique maneuvering of deft, parallel strokes between things—reconciles solid forms with the surrounding space, which is itself not empty but filled with ephemeralities such as light, shadow, and elusive, fleeting color. Perspective splays out, locking our gaze in the multileveled network of color and form. By transforming both depth and surface, Cézanne defused any traditional reading of pictorial space.

In the period in which it was made, Cézanne's work was quietly iconoclastic, for it transcended the banal conventions of academic art to reveal undiscovered truths of the act of seeing. It began to topple the structural behemoth of perspective, which had been dominant since the Renaissance, and broke ground for the fragmentation of form and the re-invention of pictorial space brought about by the Cubists soon after. (D.M.)

1. Paul Cézanne, letter to Emile Bernard (April 15, 1904), in John Rewald, ed., *Paul Cézanne: Letters*, trans. Seymour Hacker (rev. ed.; New York: Hacker Art Books, 1984), p. 296. This is Cézanne's most famous—and most frequently misquoted and misinterpreted—statement (see George Heard Hamilton, *Painting and Sculpture in Europe: 1880–1940*, Pelican History of Art [Harmondsworth, England: Penguin, 1972, 1979], p. 531, n. 34).
2. Cézanne, letter to Paul Cézanne (September 8, 1906), in Rewald, ed., *Paul Cézanne: Letters*, p. 322. With regard to Cézanne's *réalisation*, see Kurt Badt, *The Art of Cézanne*, trans. Sheila Ann Ogilvie (London: Faber and Faber, 1965), pp. 195–228.
3. Joseph J. Rishel discusses in detail the exact location of this scene, in *Great French Paintings from the Barnes Foundation: Impressionist, Post-Impressionist, and Early Modern* (New York: Alfred A. Knopf; Merion, Pa.: Lincoln University Press, 1993), pp. 128–31.

Henry van de Velde
(b. 1863, Antwerp; d. 1957, Zurich)
Abstract Plant Composition, 1892–93

The work of Henry van de Velde exemplifies the melding of art, architecture, and design that characterized the rise of Art Nouveau at the end of the nineteenth century, and embodies both the vitalist drive of the style and its propulsion toward Modernist abstraction. Van de

Velde gained international recognition in Paris in 1895, when he showed furnished interiors at Siegfried Bing's infamous exhibition *La Maison de l'Art Nouveau*, which gave the movement its name, and was subsequently acclaimed in Germany, where a receptive environment fostered the growth of his ideas. Although he began as a painter, van de Velde was inspired in the late 1880s by the theories of William Morris—the British Arts and Crafts reformer who expounded the artist's responsibility to meet social needs—and came to wield widespread influence as an architect, designer, theoretician, and educator. The system of instruction he introduced at the famous Weimar Kunstgewerbeschule (School of Arts and Crafts), where he was the director from 1901 to 1914, was the direct inspiration for the methods of the Bauhaus—the legendary academy of Modernist art, architecture, and design— into which the school was incorporated in 1919.

Abstract Plant Composition, 1892–93, is an early testament to van de Velde's desire to move beyond the decorative handling of plant life, an objective that he shared with other proponents of Art Nouveau. Here, the subject of organic growth has become an abstract condensation of swelling form and sweeping line. The emphatic coloration with opposing hues and the strong, flowing line of the burgeoning shapes convey a powerful sense of fecundity. While completing the painting, van de Velde turned it upside-down[1] (in reverse, a flower, stem, and leaves are discernible), an act that underscores the abstracting aims of the artist.

From experiments in abstract ornament such as this, van de Velde arrived at his "construction principle" (*Konstruktionsprinzip*) and declared, "A line is a force, active in the same way as all elemental forces. . . . it derives its force from the energy of the one who drew it."[2] He interpreted pure line as precise, expressive power and unequivocally emancipated it from any subservience to representation. This understanding, van de Velde believed, should be "the basis of the new ornament"[3]—ornament that was to serve not as appended decoration to an object, but rather as "the animating inflection of [the object's] purpose or function."[4] Van de Velde applied this principle to design and architecture in the conception of total environments (generally referred to as *Gesamtkunstwerk* [totalizing work of art]), as in the 1902 interior of the Folkwang Museum in Hagen, Germany. (D.M.)

1. Susan M. Canning, *Henry van de Velde (1863–1957): Paintings and Drawings*, ed. J. F.

Buyck, exh. cat. (Antwerp: Koninklijk Museum voor Schone Kunsten; Otterlo: Kröller-Müller Museum, 1988), pp. 186–87.
2. Henry van de Velde, *Kunstgewerbliche Laienpredigten* (Leipzig: Hermann Seemann Nachfolger, [1902]), pp. 188–89; reprinted in Hans Curjel, ed., *Henry van de Velde: Zum Neuen Stil.* (Munich: R. Piper, 1955), pp. 130–31 (author's translation).
3. Van de Velde, in Curjel, ed., *Henry van de Velde*, p. 131 (author's translation).
4. P. Morton Shand, Introduction to "Henry van de Velde: Extracts from his Memoirs: 1891–1901," *The Architectural Review* 112, no. 669 (September 1952), p. 144.

Pablo Picasso
(b. 1881, Málaga, Spain; d. 1973, Mougins, France)
Girl with a Mandolin (Fanny Tellier), late spring 1910

Cubism was born of a creative dialogue between Pablo Picasso and Georges Braque. It was initiated by the former's painting *Les Demoiselles d'Avignon*, 1907, and continued through 1914, demolishing the traditional, illusionistic representation of space, with lasting repercussions.[1] The Cubists sought to encapsulate in their paintings the artist's perceptual and conceptual experience of visual phenomena. In works such as Picasso's *Girl with a Mandolin (Fanny Tellier)*, 1910, the objects depicted and all relationships among them were subject to the artist's analysis and reconstitution. Guillaume Apollinaire, the movement's foremost spokesperson, claimed Cubist works to be "more cerebral than sensual." Cubist painters, he continued, aimed "not at an art of imitation, but at an art of conception, which tends to rise to the height of creation."[2] The style acquired its name from critic Louis Vauxcelles's 1908 description of Braque as an artist who "reduces everything . . . to cubes";[3] by 1911, the term had attained widespread usage.[4]

Cubism built on Paul Cézanne's impassioned determination to unify discrete objects into total epiphanic *réalisations*. But whereas Cézanne's art is one of reverent, patient construction— with masses simplified into their volumetric essences, the painting's structure intensified by tilted and compacted perspectives, and the negative space between objects transformed into connective tissue through the deft and subtle brushwork of the artist's *passage*—Cubism blasted into the object head-on, exploding its constituent parts into fragments, and simultaneously showing multiple viewpoints normally accessible only over time.

Girl with a Mandolin portrays the model Fanny Tellier in three-quarter length, with her head bowed toward the stringed instrument as she

plays, nude, against a background of dissolving cubic volumes. Like other relatively early Cubist paintings, it is nearly monochromatic, composed of delicate shades of taupe, gray, and white. It has been defined as a key composition in the development of Cubism; here, Picasso began to move from the depiction of the figure as a cohesive collection of faceted volumes toward the shattering of his subject's integral, closed form.[5] This is primarily evident in the face of the sitter. The remainder of the body is rendered in volumetric facets combined with smoothly modeled and simplified depictions of portions of the arms, the left breast, and the middle torso. We are shown the faceted right shoulder of the three-quarter-turned body, which with conventional perspective would be lost from view. The mandolin's form dissolves at the points of greatest vibration—over the upper frets where the sitter's fingers press and at the hollow opening where she plucks the strings. The figure merges with her environment.

While Cubism toppled the precepts of traditional perspective, it remained wedded to the depiction of objects, which ultimately distinguishes its practitioners from those later artists who followed a purely nonobjective vision. (D.M.)

1. Scholars divide the Cubist works of Picasso and Braque into two periods, the Analytic Cubist paintings of 1907 to 1912, which are characterized by the analysis of objects through the shattering of form into faceted planes of color in painted compositions of limited palette, generally blues, browns, greens, grays, and ochers; and the Synthetic Cubist compositions of 1913 to the early 1920s, distinguished by the use of collage in addition to paint and featuring flat, collagelike painted forms, brighter colors, and ornamental patterns.
2. Guillaume Apollinaire, *The Cubist Painters: Aesthetic Meditations* (1913), trans. Lionel Abel, Documents of Modern Art (New York: Wittenborn, Schultz, 1949), pp. 14, 17.
3. Louis Vauxcelles, "Exposition Braque. Chez Kahnweiler, 28 rue Vignon," *Gil Blas*, November 14, 1908; reprinted in English in Edward F. Fry, *Cubism* (New York: Oxford University Press, 1966, 1978), p. 50. Apollinaire claimed that Henri Matisse invented the term in a pejorative remark in 1908 (*The Cubist Painters*, p. 16); however, Matisse himself later denied this.
4. Fry, *Cubism*, p. 51.
5. Pierre Daix, *Picasso: The Cubist Years, 1907–1916*, trans. Dorothy S. Blair (Boston: New York Graphic Society, 1979), pp. 68, 247–48.

Vasily Kandinsky
(b. 1866, Moscow; d. 1944, Neuilly-sur-Seine, France)
Composition IV, 1911

Although other artists also experimented with abstraction early in this century, Vasily Kandinsky was the first to develop a consistent nonobjective approach in practice and theory. *Composition IV*, 1911, is one of the first

Pablo Picasso, Girl with a Mandolin (Fanny Tellier), *late spring 1910. Oil on canvas, 39 ½ x 29 inches (100.3 x 73.6 cm). The Museum of Modern Art, New York, Nelson A. Rockefeller Bequest, 1979.*

Vasily Kandinsky, Composition IV, *1911. Oil on canvas, 5 feet 2 ⅛ inches x 8 feet 2 ⅛ inches (1.6 x 2.51 m). Kunstsammlung Nordrhein-Westfalen, Düsseldorf.*

fully realized embodiments of his abstract ideals.

Kandinsky was deeply concerned by what he perceived as a spiritual malaise in Western society, which he believed was due to the increasing dominance of materialist values. He came to see abstraction as a path to human liberation from the glorification of materialism and the status quo implicit in traditional realism. Through his art, he wished to foster "higher" states of feeling related to the viewer's awareness of the inner, creative life force that he believed pervades the cosmos. In his influential 1912 treatise *Concerning the Spiritual in Art*, he identified the manifestation of this force within the artist as an "inner necessity," which he defined as the interior impulse that motivates the artist to create.[1] By cultivating an active relationship with this factor, the artist would be led to convey the "inner sound" or spiritual content of objects and phenomena in the world. Successful artworks would possess a *Klang* (resonance, vibration) that would allow a true communication between artist and viewer.

According to Kandinsky, the nature of this communication has to do with feelings, but with feelings beyond mere sensations or common emotions such as "fear, joy, and grief";[2] rather, it evokes "finer feelings, as yet unnamed . . . finer emotions for which we have no words."[3] Through abstraction, Kandinsky envisioned that a gradual shift would be made in viewers' sensibilities, processes of thought, and nuances of feeling. It would instigate a quickening of human consciousness that would ultimately change the world.[4]

Composition IV is the fourth of only ten works by Kandinsky with the title *Composition* (see also fig. 6). The word possessed mystical overtones for him, and he considered the *Compositions* his most subtle and complex creations, the products of his most discriminating faculties.[5] A relatively early work (the last *Composition* dates from 1939), *Composition IV* is not a purely abstract painting. Kandinsky believed that abstraction had to be introduced in stages to the world, for in that way it could be gradually accepted and its meaning fully understood.[6]

Although *Composition IV*'s symbolic referents are deliberately obscure, a schematic analysis written by Kandinsky, as well as several drawings and watercolors and a related painting, allow its components to be deciphered.[7] Kandinsky intended the painting to produce "a very bright effect."[8] In the middle rises a high, rounded mountain, colored a deep, royal blue, which in Kandinsky's iconography generally symbolizes spiritual aspiration. Atop

the mountain stands a castle, depicted in outline only; its emptiness perhaps signifies the expectation of occupation and thereby the possibility of spiritual attainment. Before the mountain stand three Cossacks, recognizable by their high red hats and a lilac-colored saber held by the figure on the left. Two of the Cossacks grasp tall lances, which extend upward to bisect the composition. The bifurcated structure of the composition manifests Kandinsky's apocalyptic vision of the passing away of a world of destruction and the creation of a new, spiritual realm.[9] To the left of the painting is a scene of chaos and confusion, to the right reign peace and harmony. The emphatic hooked and tangled black lines on the upper-left side of the painting describe a battle scene, with the Cossack horsemen raising saber and lances high above their red hats in sweeping, violent gestures. In the lower left, little blue boats, their rows of oars extended into patterns of parallel black lines, surge on a massive, jagged wave edged in black. Above the boats floats an incongruous, misshapen ovoid in dull, muddied colors that might reflect the fear and panic of the boats' inhabitants.[10] Immediately to its right, however, rises a rainbow, a symbol of hope. It forms a bridge to the blue mountain and arches over what appears to be a small sun emerging from darkness. In contrast to the left side of the composition, the right contains what Kandinsky called "light-cold-sweet colors,"[11] which coalesce as in a sky after a violent rainstorm. At the upper right, two tall, robed figures stand atop a shimmering gold mountain, like saintly monarchs presiding over a peaceful kingdom. Below, in the valley, lie two reclining figures with elongated and seemingly weightless forms. Suggesting paradisal bliss, they symbolize redemption.[12] Their faces are painted rose and blue, the colors of love and spiritual devotion, as is the cloudlike mass that wafts up to them from below.[13]

Composition IV represents what Kandinsky described, in apocalyptic terms, as "the modern movement," where "the inner content of the work of art" participates in one or both of the following processes: "1) the destruction of the soulless material life of the nineteenth century," and "2) the building-up of the spiritual-intellectual life of the twentieth century." Through its nonlinear narrative, which defies a fixed or logical reading, Kandinsky believed the viewer's "finer feelings" would be aroused. "Only through freedom," Kandinsky wrote, "can what is to come be received."[14] (D.M.)

1. Wassily [Vasily] Kandinsky, *Concerning the Spiritual in Art: and Painting in Particular* (1912),

trans. Michael Sadler, Francis Golffing, Michael Harrison, and Ferdinand Ostertag, Documents of Modern Art (New York: George Wittenborn, 1947; Hastings-on-Hudson, N.Y.: Morgan Press, 1972), pp. 52–54, passim. The 1947 English translation of Kandinsky's text was the first to include Kandinsky's notes and his modifications to the original text; these were to have been incorporated into the third German edition, of 1914, but this edition failed to materialize because of World War I.

2. Ibid., p. 24.

3. Kandinsky, *Über das Geistige in der Kunst* (1912) (10th ed.; Bern: Benteli, 1952), p. 23 (author's translation).

4. While Kandinsky felt that abstraction was the essential artistic vehicle to convey the "living spirit," he answered the question "Must we then altogether abandon representation and work solely in abstraction?" with the statement "There is no 'must' in art, because art is always free," and continued to emphasize the "infallible guide . . . of *the principle of internal necessity*" (Kandinsky, *Concerning the Spiritual in Art*, pp. 50–52, his emphasis). Kandinsky believed, for example, that Henri Rousseau's naïve realism was clearly born of "inner necessity," and claimed that it is equally valid as spiritual sustenance because it conveys a distinct "inner sound" that mitigates its material aspect. See Kandinsky, "On the Question of Form" (1912), in Kenneth C. Lindsay and Peter Vergo, eds., *Kandinsky: Collected Writings on Art* (New York: Da Capo Press, 1994), pp. 242–45, 252.

5. Kandinsky divided his paintings into three categories: "Impressions," which he described as "direct impression[s] of nature, expressed in purely pictorial form"; "Improvisations," which are "largely unconscious, spontaneous expression[s] of inner character, non-material nature"; and "Compositions," which are "expression[s] of a slowly-formed inner feeling, tested and worked over repeatedly. . . . Reason, consciousness, purpose, play an overwhelming part. But of calculation nothing appears: only feeling" (Kandinsky, *Concerning the Spiritual in Art*, p. 77).

6. Although Kandinsky stated that he painted his first nonobjective pictures in 1911, for many years scholars identified and published a watercolor signed and dated 1910 (now in the collection of the Musée National d'Art Moderne, Centre Georges Pompidou, Paris) as the artist's first abstract watercolor (see also Rosenthal in this volume, p. 11.). This evaluation has long since been overturned and the work given a designation of *Untitled* and a date of 1913 (see Vivian Endicott Barnett, *Kandinsky Watercolours: Catalogue Raisonné, Volume I, 1900–1921* [Ithaca, N.Y.: Cornell University Press; New York: Solomon R. Guggenheim Foundation, 1992], p. 191, cat. no. 365).

7. For this description of *Composition IV*, I am indebted to the detailed analysis of the painting and its related works by Magdalena Dabrowski in *Kandinsky: Compositions*, exh. cat. (New York: Museum of Modern Art, 1995), pp. 31–34.

8. Kandinsky, "Composition 4" (from "Reminiscences/Three Pictures," 1913), in Lindsay and Vergo, eds., *Kandinsky: Collected Writings on Art*, p. 384.

9. This is one of the earliest examples of a bifurcated structure representing the two realms in Kandinsky's oeuvre. Kandinsky used Christian themes and apocalyptic imagery (derived from the biblical Revelation of Saint John the Divine) increasingly from 1909 to 1914. See Rose-Carol Washton Long, *Kandinsky: The Development of an Abstract Style* (New York: Oxford University Press, 1980), pp. 74–75.

10. It is likely that the floating shape represents a "thought-form" (see Rosenthal in this volume, p. 34). Kandinsky owned the German edition of *Thought-Forms*, by Theosophists Annie Besant and Charles W. Leadbeater, which was published in 1908. The thought-form above the boats in *Composition IV* bears similarities to those produced by shipwreck victims, as described and reproduced in *Thought-Forms* (1901; Wheaton, Ill.: Theosophical Publishing House, 1986), pp. 47–49,

fig. 30. Kandinsky revealed his interest in thought-forms in *Concerning the Spiritual in Art*: "Thought, which although a product of the spirit can be defined with exact science, is matter, but of fine and not coarse substance" (p. 29, n. 4). For a recent discussion of Kandinsky's interest in and use of thought-forms, see Sixten Ringbom, "Transcending the Visible: The Generation of the Abstract Pioneers," in Maurice Tuchman and Judi Freeman, *The Spiritual in Art: Abstract Painting 1890–1985*, exh. cat. (Los Angeles: Los Angeles County Museum of Art; New York: Abbeville Press, 1986), pp. 134–37.

11. Kandinsky, "Composition 4," p. 383.

12. Dabrowski, pp. 45, 58–59, n. 176. Dabrowski refers the reader to Rose-Carol Washton Long, "Kandinsky's Vision of Utopia as a Garden of Love," *Art Journal* 43, no. 1 (spring 1983), pp. 50–60.

13. This shape also may be interpreted as a thought-form. On the color blue, see Kandinsky, *Concerning the Spiritual in Art*, pp. 58–60. See also Besant and Leadbeater, *Thought-Forms*, frontispiece (color chart). Besant and Leadbeater's color chart indicates that blue is the color of spirituality and devotion and that rose is the color of affection. The thought-form of love and devotion in *Composition IV* is similar to one in Kandinsky's *Lady in Moscow*, 1912; see Ringbom, "Transcending the Visible," pp. 140–43.

14. Kandinsky, "On the Question of Form," pp. 256–57.

Arthur Dove

(b. 1880, Canandaigua, New York;
d. 1946, Huntington, New York)
Nature Symbolized No. 3: Steeple and Trees, 1911–12

Arthur Dove was one of only a few American artists who made significant advances in abstraction before 1913, when European Modernism was introduced to the American public at the Armory Show in New York. Like most of the other early American abstractionists, Dove was a regular member of the group surrounding photographer Alfred Stieglitz, who exhibited work by European and American avant-garde artists at his Photo-Secession Galleries in New York (better known as "291," from its address at 291 Fifth Avenue), which he directed from 1907 through 1917. It was here that Dove had his first solo exhibition, in late February 1912.[1] *Nature Symbolized No. 3: Steeple and Trees*, 1911–12, is one of ten large-scale pastels that formed the core of the exhibition (see also fig. 55). Originally shown without titles, this group of pastels became known collectively as *The Ten Commandments*, a name (probably given by Stieglitz) that christened the works as signposts of a new and revolutionary set of artistic values heralding the future of avant-garde American painting. They are thought to be "probably the earliest sustained statement in an abstract idiom by any American painter."[2]

From 1907 to 1909, Dove lived in Europe, traveling to Italy, Spain, and France and developing friendships with a group of American artists living in Paris. After returning to the United

States, Dove retreated to the woods of upstate New York and began to break from representational form, completing six remarkable small abstractions, known simply as *Abstraction Nos. 1–6*, in 1910–11 (for example, fig. 54). From the beginning, Dove's abstracting processes were inspired by the direct experience of the natural world, as these oil studies indicate. No matter how abstract Dove's works became, nature remained his point of reference for the rest of his life.

Nature Symbolized No. 3, like the first of Dove's abstract studies, *Abstraction No. 1*, has a steeple shape at the center of the canvas, surrounded by a hilly landscape. In the later work, however, Dove took the abstracting process further, simplifying the forms and intensifying the colors to create a strong and definitive statement. At the center of the composition are two steeples— one white with a triangular opening and the other taller, cropped at the top, and colored a deep red-violet. They rise from the midst of a stylized terrain of pointed trees, rendered as attenuated cones, and polygonal hills, radiating out in facets like parasols. Both trees and hills are painted in a wide range of greens as well as various shades of white tinged from gold to pale green. Describing his working method soon after completing *The Ten Commandments*, Dove said that he first began to paint from nature, then concentrated on the painted form itself, with "dependence upon the object (representation) disappearing. . . . After working for some time in this way," he explained, "I . . . not only began to think subjectively but also to remember certain sensations purely through their form and color."[3] The rhythm, harmony, and vitality that Dove intuited from the landscape are thus presented in *Nature Symbolized No. 3* in a distilled and intensified form.

Although Dove exhibited works in group shows after 1912, his second solo exhibition did not take place until 1926. Despite the advent of American Scene painting, Dove remained committed to abstraction, though he was no less concerned with the human condition than the social realist artists. Nourished by a deepening interest in Eastern religions and Theosophy,[4] Dove developed a more focused abstract vision, becoming absorbed with giving form to the unseen energies of life and growth. His abstractions were inspired by nature's *own* abstraction; as he wrote in a poem of 1925, "works of nature are abstract/They do not lean on other things for meaning."[5] (D.M.)

1. The exhibition subsequently traveled to the W. Scott Thurber Galleries in Chicago, and was the first modern art exhibition to be held in that

city. Dove's reputation grew after Arthur Jerome Eddy purchased a pastel from the exhibition— *Based on Leaf Forms and Spaces*, 1911–12—and reproduced it in his book *Cubists and Post-Impressionism* (Chicago: A. C. McClurg, 1914, 1919). See Sasha M. Newman, *Arthur Dove and Duncan Phillips: Artist and Patron*, exh. cat. (Washington, D.C.: The Phillips Collection; New York: George Braziller, 1981), p. 56.

2. William Innes Homer, "Identifying Arthur Dove's 'The Ten Commandments,'" *American Art Journal* 12, no. 3 (summer 1980), p. 21.

3. Arthur Dove, letter to Eddy (October 3, 1913), The Stieglitz Archive, Collection of American Literature, Beinecke Rare Book and Manuscript Library, Yale University, New Haven, Conn.; quoted in Eddy, *Cubists and Post-Impressionism* (1919), p. 48, and in Newman, *Arthur Dove and Duncan Phillips*, p. 28.

4. See Sherrye Cohn, "Arthur Dove and Theosophy: Visions of a Transcendental Reality," *Arts Magazine* 58, no. 1 (September 1983), pp. 86–91.

5. Dove, "A Way to Look at Things," in *Seven Americans*, exh. cat. (New York: Anderson Galleries, 1925), unpaginated; reprinted in Newman, *Arthur Dove and Duncan Phillips*, p. 28.

František Kupka

(b. 1871, Opočno, Eastern Bohemia;
d. 1957, Puteaux, France)
Vertical Planes III, 1912–13

František Kupka is distinguished as the first artist to publicly exhibit large-scale, fully developed abstract paintings. At the 1912 Salon d'Automne in Paris, Kupka presented two works from his *Amorpha* series, including the almost seven-foot-square *Amorpha, Fugue in Two Colors*, 1912 (fig. 45), and several months later, at the spring 1913 Salon des Indépendants, he showed two *Vertical Planes* paintings, including *Vertical Planes III*, 1912–13, which measures six-and-one-half feet high and four feet wide. The significance of both works in the history of abstraction was underscored by Alfred H. Barr, Jr. in the catalogue to the historic 1936 exhibition *Cubism and Abstract Art* at the Museum of Modern Art, New York: "Within a year's time Kupka had painted what are probably the first geometrical curvilinear and the first rectilinear pure abstractions in modern art. In comparison with these conclusive and carefully considered achievements the slightly earlier abstractions of [Vasily] Kandinsky and [Mikhail] Larionov seem tentative."[1]

How did Kupka arrive at such a radical vision? After receiving a traditional academic training in Prague and Vienna, he settled permanently in Paris in 1896 and earned a living as an illustrator while developing his painting under the influence of Neo-Impressionism, Symbolism, Art Nouveau, and the Fauves. When Cubism emerged, Kupka maintained his distance, although he mingled with many artists in the Cubist orbit. (As a result of these friendships, his work is often identified with Orphism, yet from the start Kupka denied this designation

Arthur Dove, Nature Symbolized No. 3: Steeple and Trees, *1911–12. Pastel on board, mounted on wood, 18 x 21 ½ inches (45.7 x 54.6 cm). Terra Foundation for the Arts, Chicago, Daniel J. Terra Collection 1992.33.*

František Kupka, Vertical Planes III, *1912–13. Oil on canvas, 6 feet 6 ¼ inches x 3 feet 10 ⁷⁄₁₆ inches (2 x 1.18 m). National Gallery, Prague.*

Robert Delaunay, Simultaneous Contrasts: Sun and Moon, *1913 (dated 1912 on painting). Oil on canvas, 53 inches (134.5 cm) in diameter. The Museum of Modern Art, New York, Mrs. Simon Guggenheim Fund, 1954.*

and fiercely maintained his independence from that group.)

Kupka's detachment from Parisian Cubism, which was fundamentally French positivist in character,[2] can be understood in terms of the conflict that had long informed the artist's creative identity—between his academic training, which was grounded in scientific principles applied to observable reality, and his personal experiences, dating from childhood, of occult phenomena. These experiences had introduced him to levels of perception that fell outside the realm of rational explanation. Although Cubism shattered the appearances of things, it nevertheless maintained a reference to observable reality and an analysis of perception that tended to emphasize the intellectual and the conceptual, and inevitably, Kupka's passionate feeling and mystical fascination remained at odds with that approach.

Kupka's concerns were essentially metaphysical. His interest lay far beyond the physical, and far beyond the portrayal of abstract ideas through figurative allegories, the approach he had employed before his earliest experiments with abstraction around 1910. On the first page of his 1910–11 notebook, he wrote, "Formerly I was seeking to give form to an idea; now I am seeking the idea which corresponds to the form."[3] Instead of searching for an appropriate form to correspond to an idea, in other words, he now allowed form to evolve and reveal to him the idea.

Vertical Planes III resulted from a revelation—which unfolded through many studies and preliminary works[4]—of the idea of verticality in its most abstract sense. In contrast to the square format, arabesque shapes, and bright red-and-blue palette of *Amorpha, Fugue in Two Colors,* the painting is a tall, cool-colored, rectilinear composition. Here, vertical planes are disposed in a blue-gray space that is entirely unrelated to the phenomenal world. Slightly to the left of center of the composition is a purple rectangle, its top disappearing beyond the edge of the painting. Hanging to its right are two smaller, overlapping rectangles; the shape at the back is a brilliant white and the one in front a dark steel-blue. The three rectangles define the surface of the painting, yet at the same time seem to float, motionless, in the atmosphere of the pictorial space. The flat, tall rectangles at either side of the painting accentuate this spatial ambiguity. They serve as an enframing device that firmly anchors the composition, yet they also participate in its spatial play. Like a rectilinear, modern version of trompe-l'oeil

Renaissance drapery, they enclose the obscure mysteries of the central space and the ambiguities of the forms it contains as though presenting a glimpse into another world. During the same period in which he executed *Vertical Planes III,* Kupka reflected on the nature of rectilinear composition: "A rectilinear order appears as the most energetic, abstract, elegant, absolute order . . . Profound and silent, a vertical plane helps the whole concept of space to emerge."[5]

Despite Kupka's exceptional achievements in abstract painting, the influence of his theories remained limited during his lifetime. *Creation in the Visual Arts,* a treatise he wrote around 1912–13, at the time of his breakthrough to abstraction, was not published until a decade later, and then only in Czech; it was published in the original French in 1989.[6] Yet in artistic practice, as *Vertical Planes III* unequivocally demonstrates, Kupka was clearly among the foremost originators in the evolution of Modernist abstraction. (D.M.)

1. Alfred H. Barr, Jr., *Cubism and Abstract Art,* exh. cat. (New York: Museum of Modern Art, 1936), pp. 73–74.
2. Margit Rowell, "František Kupka: A Metaphysics of Abstraction," in *František Kupka, 1871–1957: A Retrospective,* exh. cat. (New York: Solomon R. Guggenheim Foundation, 1975), p. 48.
3. František Kupka, quoted in Rowell, *František Kupka,* p. 76. Rowell points out the influence of Goethe in this thought, and suggests that the statement echoes a description of Goethe's ideas written by Theosophist Rudolf Steiner.
4. Virginia Spate, in *Orphism: The Evolution of Non-Figurative Painting in Paris 1910–1914* (Oxford: Clarendon Press, 1979), p. 155, explained how *Vertical Planes I* evolved from earlier compositions incorporating smaller planes in arrangements akin to musical scales. The abstract quality of music—and its ability to communicate through immaterial form—was an important inspiration for Kupka's abstraction (p. 153).
5. Kupka, quoted in Rowell, *František Kupka,* p. 188.
6. *Tvoreni v umeni vytvarnem* (Prague: Editions Manes, 1923). *La Création dans les arts plastiques* (Paris: Editions Cercle d'Art, 1989).

Robert Delaunay

(b. 1885, Paris; d. 1941, Montpellier, France)
Simultaneous Contrasts: Sun and Moon, 1913

Although Robert Delaunay maintained that his work was based on direct observation, the primary subject of his paintings is an extremely abstract manifestation—light. After extended study, Delaunay concluded that light's powerful, paradoxical reality—its ubiquitous presence and infinite energy, despite its utter immateriality—could never be fully conveyed in paint, but could only be revealed through color. Delaunay referred to this method of revealing light through color as "Simultanéisme" (Simultaneity). From

1912 on, Simultaneity was the guiding principle of his art, whether he worked in a figurative or nonrepresentational mode.

Delaunay's influential 1912 essay "Light," his first published formulation of Simultaneity, was inspired by his readings of color theory, most notably those of Michel-Eugène Chevreul and Ogden Rood. In it, he observed that "Light in Nature creates movement of colors. The movement is provided by the relationships *of uneven measures,* of color contrasts among themselves and [it] constitutes *Reality.* This reality is endowed with *Depth* (we see as far as the stars), and thus becomes *rhythmic Simultaneity.*"[1] As Delaunay used the term, "Simultaneity" refers to both the generation and the manifestation of an intense visual experience that is marked by a sensation of brilliance and pulsating movement caused by the perception of precisely juxtaposed contrasting colors. In such a condensed arrangement of proportional relationships between carefully selected hues, Delaunay believed, linear movement disappears and time frames collapse; what is evoked is a suspended moment that seems to repeat itself endlessly in color rhythms.

The cosmic implications of Simultaneity are nowhere better exemplified than in *Simultaneous Contrasts: Sun and Moon,* 1913, one of twelve oil paintings known collectively as the *Circular Form* series. This group of works, which were exhibited at the 1913 Erster Deutscher Herbstsalon in Berlin, marked the first time that Delaunay allowed his pre-occupation with simultaneous color to overtake completely any aspiration to render objects descriptively. The title *Simultaneous Contrasts: Sun and Moon* indicates that Delaunay's primary concern was the abstract energy radiated by the two heavenly spheres, not the appearance of the spheres themselves. Delaunay described his activity as "painting the sun, which is nothing but painting,"[2] thus equating the sun, a symbol of light, with the artistic act itself.

Simultaneous Contrasts: Sun and Moon depicts the opposing realms of the firmament, lorded over by the orbs of day and night. The sun, on the upper right, is a white-hot body that erupts in a multitude of color wheels, generously painted in thick swashes and dabs. Color contrasts—such as purple against orange and red against green—animate the field. Against this fiery ebullience, the lunar realm, at the lower left, is a still, almost spectral image. The moon, a white ellipse tinged with pink, shines cold and serene. Floating in a calm sea of blues, it is surrounded by a halo of

pale green and protected by a double mandorla of diaphanous red-orange and violet. The viewer is stimulated into active response by the vivid color contrasts of the solar realm and drawn into dreamy enchantment by the silvery tonalities of the moon's domain. The painting's circular format underscores the radiating patterns of light that pour forth from the two spheres, creating a swirling universe that endlessly turns in upon itself.

Delaunay remained committed to Simultaneity throughout his life, both in his artistic practice and in his influential writings. Ultimately, his pursuit of "pure painting"[3] was intimately connected to a passionate desire to ameliorate the human condition. The "light" at the heart of his theories may be seen as the light of human consciousness.[4] "Our comprehension is *correlative* with our *perception. Let us try to see*," the artist implored.[5] (D.M.)

1. Robert Delaunay, "Light" (1912), in Gustav Vriesen and Max Imdahl, *Robert Delaunay: Light and Color* (New York: Harry N. Abrams, 1967), p. 9 (the original French text, entitled "La Lumière," appears on p. 8). First published in German (trans. Paul Klee), in *Der Sturm* 3, nos. 144–45 (January 1913), pp. 225f.
2. Delaunay, quoted in Virginia Spate, *Orphism: The Evolution of Non-Figurative Painting in Paris 1910–1914* (Oxford: Clarendon Press, 1979), p. 377.
3. The phrase "pure painting" (*peinture pure*) seems to have originated in the dialogue between Delaunay and Guillaume Apollinaire. See Delaunay, "Réalité, peinture pure," *Soirées de Paris*, December 1912; and Apollinaire, *The Cubist Painters: Aesthetic Meditations* (1913), trans. Lionel Abel, Documents of Modern Art (New York: Wittenborn, Schultz, 1949), p. 12. Apollinaire edited the journal in which Delaunay's essay appeared, and Delaunay reviewed Apollinaire's *Cubist Painters* before its publication.
4. Spate, in *Orphism*, wrote eloquently of this aspect of Delaunay's art.
5. Delaunay, "Light," p. 9.

Fernand Léger
(b. 1881, Argentan, France; d. 1955, Gif-sur-Yvette, France)
Contrast of Forms, 1913

Fernand Léger's *Contrast of Forms* series (see also fig. 37) represents a crucial breakthrough in the artist's concentrated investigation into abstraction. A central member of the Parisian avant-garde, Léger had begun experimenting with abstraction before 1910, producing paintings related to the Analytic Cubist works of Georges Braque and Pablo Picasso. He was also involved with the Puteaux Group, a circle of artists, including Marcel Duchamp, Raymond Duchamp-Villon, and Jacques Villon, among others, whose investigations were influenced by the theories of philosopher Henri Bergson. More concerned with pure, nonfigurative abstraction than the Analytic Cubists, the Puteaux artists were interested in the analogies

between art, mathematics, and music. Their work was fundamentally antiscientific and concerned with intuitive experience. Léger was also familiar with the Italian Futurist movement and the Russian avant-garde, and throughout the prewar period engaged in a sustained dialogue with Robert Delaunay.

Although his earliest Cubist paintings contain figurative elements, they evolved toward greater abstraction. In the *Contrast of Forms* series, Léger temporarily jettisoned not only the figure and recognizable landscape features but subject matter altogether, and achieved a style of painting that is exclusively about dynamism and dissonance.

In a 1913 essay, Léger proclaimed: "The relationships among volumes, lines, and colors will prove to be the springboard for all the work of recent years and for all the influence exerted on artistic circles both in France and abroad. From now on, everything can converge toward an intense realism obtained by purely dynamic means. Pictorial contrasts used in their purest sense (complementary colors, lines, and forms) are henceforth the structural basis of modern pictures."[1] In *Contrast of Forms*, 1913, reproduced here, the unprimed burlap produces a robust texture that accentuates the contrasts that Léger had been striving to achieve. The literal contrast of forms—of tubular elements juxtaposed with flat planes and the picture plane—and the contrast of pure, undiluted colors contribute to the dynamism he had been seeking to convey since beginning to work in an abstract mode.

Léger's explorations in pure abstraction were sporadic and short-lived. Serving in the French army during World War I, he was motivated by this profoundly distressing experience to rethink his use of nonobjectivity. He resolved that the move away from experience and reality was inappropriate both personally and socially, and subsequently returned to figurative subjects, although he revisited abstraction briefly in his mid-1920s mural compositions. (I.B.)

1. Fernand Léger, "The Origins of Painting and Its Representational Value" (1913), in Léger, *Functions of Painting*, ed. Edward F. Fry, trans. Alexandra Anderson (New York: Viking Press, 1973), p. 7.

Mikhail Larionov
(b. 1882, Tiraspol, Ukraine; d. 1964, Paris)
Red and Blue Rayonism, 1913

While working in a neo-primitivist style derived from an interest in Russian peasant art, Natalia Goncharova and Mikhail Larionov began to formulate a new approach that came to be known as

Rayonism.[1] Larionov's first Rayonist paintings date from late 1911, but it was not until 1913 that he and Goncharova issued a manifesto and exhibited their Rayonist works. The style was based on theories of time and space—including the notion of a "fourth dimension"— that were being developed concurrently by mathematicians, philosophers, and physicists.

Larionov's Rayonist paintings represent rays of light that seem to emanate from objects and disintegrating shapes. Evident in *Red and Blue Rayonism*, 1913, is the primary importance of color (in stark contrast to contemporary Analytic Cubist works' limited palette of restrained colors) and the dynamism of the seemingly abstract forms. The textured paint surface lends depth to the composition. As the shafts of light intersect with one another, they describe new plastic configurations in space, objectifying the intangible space that exists between objects in the world.

In their Rayonist manifesto, Goncharova and Larionov wrote: "Long live the style of rayonist painting that we created—free from concrete forms, existing and developing according to painterly laws! . . . The objects that we see in life play no role here."[2] Although they each made only a few Rayonist paintings, and both abandoned the style by 1914, their invention was critically important as the link between Russian neo-primitivism and nonobjective painting. (I.B.)

1. The movement is also known as Luchism.
2. Goncharova and Larionov, "Rayonists and Futurists: A Manifesto" (1913), in John E. Bowlt, ed., *Russian Art of the Avant-Garde: Theory and Criticism, 1902–1934*, Documents of Twentieth-Century Art (New York: Viking Press, 1976), p. 90. The manifesto was first published in the catalogue to the exhibition *Donkey's Tail*, which was held in Moscow in 1913.

Percy Wyndham Lewis
(b. 1882, near Amherst, Nova Scotia; d. 1957, London)
Composition, 1913

Percy Wyndham Lewis became familiar with French Cubism as early as 1908. Although his work was immersed in the Cubist idiom through 1911, he rigorously criticized the movement as being imitative and static and for promoting art that, while formally engaged, had no connection to real life. His opinion of Italian Futurism was similarly ambivalent. While he decried the movement in his writings, he found an affinity with Futurism's artistic vitality and radical politics, and his paintings of the 1910s display a formal resemblance to works by Futurist artists.

The Vorticist movement grew out of Lewis's curious relationship with the English avant-garde. Briefly associated

Fernand Léger, Contrast of Forms, *1913. Oil on burlap, 51 ½ x 38 ½ inches (130.8 x 97.8 cm). Philadelphia Museum of Art, The Louise and Walter Arensberg Collection.*

Mikhail Larionov, Red and Blue Rayonism, *1913. Oil on canvas, 20 ¹¹/₁₆ x 30 ⁹/₁₆ inches (52.5 x 78.5 cm). Bashkirian Museum of Fine Arts, Ufa.*

Percy Wyndham Lewis, Composition, *1913. Pen, watercolor, and pencil on paper, 13 ½ x 10 ⅜ inches (34.3 x 26.5 cm). Tate Gallery, London, Purchased 1949.*

Marsden Hartley, The Aero, *1914. Oil on canvas, 39 ½ x 32 inches (100.3 x 81.3 cm). National Gallery of Art, Washington, D.C., Andrew W. Mellon Fund 1970.31.1.*

Stanton MacDonald-Wright, Abstraction on Spectrum (Organization, 5), *1914–17. Oil on canvas, 30 ⅛ x 24 ¼ inches (76.5 x 61.4 cm). Purchased with funds from the Coffin Fine Arts Trust, Nathan Emory Coffin Collection of the Des Moines Art Center 1962.21.*

Marsden Hartley

(b. 1877, Lewiston, Maine; d. 1943, Ellsworth, Maine)
The Aero, 1914

The Aero, 1914, exemplifies Marsden Hartley's distinct abstract style.

with the Bloomsbury group (including Clive Bell and Roger Fry), Lewis joined Fry's Omega Workshops in early 1913. In a matter of months, he broke with the Workshops over Fry's art-for-art's-sake stance, which Lewis felt marginalized art and prevented it from interacting with life. He strongly believed that an artwork's integrity or quality is not compromised by ideological content, and felt that the work's formal aspects and ideological stance should act in concert. With Frederick Etchells and others, Lewis formed a splinter group in opposition to the Bloomsbury circle. Ezra Pound, who joined Lewis's group, invented the term Vorticism, suggesting that art should be the vortex around which the energies of life revolve.

The Vorticists claimed abstraction to be the matrix in which art and life meet. In the first issue of *Blast*, the movement's journal, published in 1914, Lewis pronounced: "The moment the Plastic is impoverished for the Idea, we get out of direct contact with these intuitive waves of power, that only play on the rich surfaces where life is crowded and abundant. We must constantly strive to ENRICH abstraction till it is almost plain life, or rather to get deeply enough immersed in material life to experience the shaping power amongst its vibrations, and to accentuate and perpetuate these."[1]

Lewis's absorption of Cubism and Futurism is evident in *Composition*, 1913. The painting contains stylistic elements of these movements, inflected by an almost obsessive restraint and control, and shows his interest in both primitive art and the rhythmic aspect of machines. Lewis believed all abstraction to be fundamentally representational because of its basis in experience of the physical world. By 1920, Lewis explained later, "the geometrics which had interested me so exclusively before, I now felt were bleak and empty. They wanted *filling*. They were still as much present to my mind as ever, but submerged in the coloured vegetation, the flesh and blood, that is life."[2] After that, he painted fewer works, but he explored a deeper synthesis of figurative and abstract elements in many of them. (I.B.)

1. Percy Wyndham Lewis, *Blast*, no. 1 (June 20, 1914).
2. [Percy] Wyndham Lewis, *Rude Assignment: A Narrative of My Career Up-to-Date* (London, 1950), p. 129; quoted in Richard Cork, *Wyndham Lewis: The Twenties*, exh. cat. (London: Anthony d'Offay, 1984), unpaginated.

Among the first American artists to experiment with abstraction, Hartley developed his highly original, emblematic approach while living in Europe from 1912 to 1915. He had established himself as an exhibiting artist at Alfred Stieglitz's avant-garde gallery "291" in New York with a solo exhibition there in 1909. After seeing a large show of works by Pablo Picasso at the same gallery two years later, Hartley—who was then working in a Fauvist style—began to experiment with abstract techniques.

Hartley, wishing to experience firsthand the art of Picasso, as well as that of Paul Cézanne and Henri Matisse, moved to Paris in April 1912. There, he quickly became part of the artistic community and a member of the circle surrounding Gertrude Stein. Yet only a few months later he became more interested in developments in Germany after learning about the Munich-based Vasily Kandinsky and his Blaue Reiter group. While Hartley had shown interest in the spiritual insight and mystic revelation before his exposure to the Blaue Reiter,[1] the German avant-garde affirmed this inclination and galvanized Hartley to embody the spiritual in abstract form. Hartley wrote enthusiastically to Stieglitz about an article he had come across that described Kandinsky as a "neo-primitive" who believed that the artist's search for "the inner soul" would result in an "unnaturalistic, anti-materialistic" art.[2] Soon after, he purchased Kandinsky's treatise *Concerning the Spiritual in Art*, as well as *The Blaue Reiter Almanac*, the compilation of art and ideas edited by Kandinsky and Franz Marc. Hartley clearly felt a strong affinity for the intuitive approaches, spiritual inspiration, and mystical leanings of the German group. By mid-November 1912, he described himself as painting "intuitive abstractions," for which, he explained, his "first impulses came from the new suggestion of Kandinsky's book the *Spiritual in Art*."[3] Feeling compelled to pursue his work in a German setting, Hartley moved to Berlin in May 1913.

In the catalogue to a 1914 exhibition at "291," Hartley described his art as having no "intellectual motives—only visionary ones. . . . Its only idea and ideal is life itself, sensations and emotions drawn out of great and simple things. . . . out of the spirit substance in all things."[4] Returning to Berlin after a four-month sojourn in New York that he made in conjunction with the exhibition, Hartley began to develop his unique style. With war brewing, everything Hartley looked upon became charged

with intensified associative meaning, and his work underwent an extreme simplification of form. As in *The Aero*, it became emblematic, characterized by bold, elemental motifs, pure and uninflected color, and densely packed compositions.

Manned flight was a new, glorious achievement at the time Hartley painted *The Aero*, and the airplane was an important element in Germany's armament program.[5] Hartley wrote to Stieglitz: "I have one canvas 'Extase d'aeroplane' . . . It is my notion of the possible ecstasy or soul state of an aeroplane if it could have one."[6] Is it the airplane's "soul" or animating force that is symbolized by the bright-red fireball with wings that dominates the composition? Splayed out behind this amazing form are vibrant patterns. The stripes and waves in Imperial gold and the German national colors— red, black, and white—and the checkerboard areas of red and green are all reminiscent of flags or pennants raised in a ceremony or used to signal directions at the beginning of a flight. Dispersed throughout the composition are a variety of smaller motifs with similar coloration—concentric circles, suggesting military symbols emblazoned on helmets and airplanes; circles within rectangles; miniature lollipoplike shapes; and, at the lower right, a red cross. The ground of the painting is a flat aluminum-gray, similar in color to the metal body of an airplane. The frame is painted in zones of color and patterns that complement the composition, intensifying the painting's exploding energy and exuberant effect.

Hartley's multilayered, emblematic abstraction anticipated later American developments, such as the vigorous semiotic style of Stuart Davis and the enigmatic use of cultural signs in the work of Jasper Johns. (D.M.)

1. Hartley's mystical interests and spiritual concerns are discussed in Gail Levin, "Marsden Hartley and Mysticism," *Arts Magazine* 60, no. 3 (November 1985), pp. 16–21; and in Patricia McDonnell, "'Dictated by Life': Spirituality in the Art of Marsden Hartley and Wassily Kandinsky, 1910–1915," *Archives of American Art Journal* 29, nos. 1–2 (1989), pp. 27–34.
2. M. T. H. Sadler, "After Gauguin," *Rhythm, Art, Music, Literature* 1 (spring 1912), pp. 23–24; quoted in Gail Levin, "Marsden Hartley and the European Avant-Garde," *Arts Magazine* 54, no. 1 (September 1979), p. 158.
3. Marsden Hartley, letter to Alfred Stieglitz (mid-November 1912), The Alfred Stieglitz Archives, Collection of American Literature, Beinecke Rare Book and Manuscript Library, Yale University, New Haven, Conn.; quoted in Gail Levin, "Marsden Hartley, Kandinsky, and Der Blaue Reiter," *Arts Magazine* 52, no. 3 (November 1977), p. 156.
4. Hartley, statement (1914), in Gail R. Scott, ed., *On Art: By Marsden Hartley* (New York: Horizon Press, 1982), p. 62.
5. Gail Levin suggested that *The Aero* might

commemorate the much-publicized Zeppelin disaster of October 1913. See Levin, "Hidden Symbolism in Marsden Hartley's Military Pictures," *Arts Magazine* 54, no. 2 (October 1979), p. 158.
6. Hartley, quoted in Roxana Barry, "The Age of Blood and Iron: Marsden Hartley in Berlin," *Arts Magazine* 54, no. 2 (October 1979), p. 168; Barry provided no source for the quote. Gail R. Scott paraphrased what seems to be the same letter, describing it as undated and suggesting that it was written in May or June 1913 (*Marsden Hartley* [New York: Abbeville, 1988], pp. 49, 158, n. 29).

Stanton MacDonald-Wright

(b. 1890, Charlottesville, Virginia; d. 1973, Pacific Palisades, California)
Abstraction on Spectrum (Organization, 5), 1914–17

After moving to Paris from the United States in 1907, Stanton MacDonald-Wright studied at the Sorbonne, Ecole des Beaux-Arts, and Académie Julian. In 1912, in a color-theory class taught by Ernest Percyval Tudor-Hart, who had developed an analogic system of color and music, MacDonald-Wright met Morgan Russell, a fellow American. Together, the two artists developed a theory of painting they called Synchromism.

MacDonald-Wright's *Abstraction on Spectrum (Organization, 5)*, 1914–17, exemplifies Synchromist theories. With its fanning, spectral applications of color, its gradations of pure, strong tones laid down in oval and spherical shapes, and the absence of recognizable images, the painting resembles the work of Kupka and Orphist paintings by Robert Delaunay and Sonia Delaunay-Terk. Yet, despite such formal parallels, MacDonald-Wright and Russell made every effort to distinguish themselves from the Europeans working in a similar manner. The Synchromists wanted to explore form through color, to create paintings based on sculptural solidity interpreted in two dimensions and expressed through a knowledge of color properties. MacDonald-Wright said, "I strive to divest my art of all anecdote and illustration, and to purify it to the point where the emotions of the spectator will be wholly aesthetic, as when listening to good music."[1] MacDonald-Wright returned to the United States in 1916 and had a solo exhibition of his work at Alfred Stieglitz's New York gallery "291" the following year. Although he abandoned Synchromist painting in 1919, his influence on the development of American color abstraction was considerable. (I.B.)

1. Stanton MacDonald-Wright, statement, in *Forum Exhibition of Modern American Painters*, exh. cat. (New York: Anderson Galleries, 1916), pp. 13–25; reprinted in Herschel B. Chipp, ed., *Theories of Modern Art: A Source Book by Artists and Critics* (Berkeley: University of California Press, 1968), p. 320.

Gino Severini

(b. 1883, Cortona, Italy; d. 1966, Paris)
Sea = Dancer, January 1914

The rebellious group of Italian poets and artists who called themselves Futurists celebrated urban life, industry, and the technology of the machine. Begun as a literary and social movement by poet and propagandist Filippo Tommaso Marinetti, Futurism was announced in his 1909 manifesto, which glorified violent conflict, mechanical energy, light, and speed. Futurism soon embraced the other arts, and the first Futurist painters' manifesto, written by Giacomo Balla, Umberto Boccioni, Carlo Carrà, Luigi Russolo, and Gino Severini, was issued in 1910.

Severini's *Sea = Dancer*, 1914, exemplifies the Futurists' consuming interest in the mechanics and power of movement. This nearly Pointillist, mosaiclike musing on particular properties of color is filled with spherical, cubic, and angular forms set in motion. In his treatment of the work's ostensible—but abstracted—subject matter (the sea), Severini depicted in paint a vision of a universe consisting only of dynamics.

The influence of Cubism in *Sea = Dancer* is undeniable, yet the painting's Divisionist brushstrokes seem to communicate a more energetic agitation than is found in Cubist works. In the year prior to the execution of this painting, Severini wrote, "We choose to concentrate our attention on the things in motion, because our modern sensibility is particularly qualified to grasp the idea of speed."[1] Indeed, in Severini's visualization of his equation in which the sea equals a dancer, the viewer can almost hear the speedy motion of molecules and sense the resultant energy. For the most part, Futurist artists retained figurative subject matter, based on their belief that art can never completely transcend the physical world. (I.B.)

1. Gino Severini, statement (1913), quoted in George Heard Hamilton, *Painting and Sculpture in Europe: 1880–1940* (3rd ed.; Harmondsworth, England: Penguin, 1967, 1987), p. 280.

Marcel Duchamp

(b. 1887, Blainville, France; d. 1968, Paris)
Bottlerack, 1914

Marcel Duchamp transferred the act of abstraction from the realm of the senses to the domain of the mind. In works such as *Bottlerack*, 1914, the artist's abstracting process was manifested not as a sensuous embodiment produced by hand, but rather as the willful, conceptual transformation of a given object.

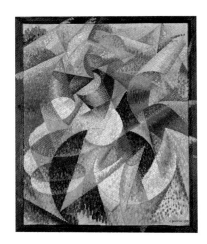

Duchamp had ventured into abstraction with *Nude Descending a Staircase* (No. 2), 1912, a study of human movement rendered in a Cubo-Futurist style. The painting gained him international notoriety when it was exhibited at the 1913 Armory Show in New York. That same year, however, Duchamp abandoned painting in favor of more cerebral avenues of artistic endeavor. *Bottlerack* was among the first of the "readymades" he began to make around this time. Purchasing an item common to French households—an iron rack designed for drying bottles—Duchamp inscribed it and presented it, provocatively, as a finished work of art.[1]

The mundane objects that Duchamp presented as readymades were displaced into the aesthetic realm through their selection by the artist, their subsequent removal from their usual function and surroundings, and their re-presentation as an artwork, christened with his inscription. The procedure, Duchamp later explained, gave him the freedom to "reduce the idea of aesthetic consideration to the choice of the mind, not to the ability or cleverness of the hand, which I objected to in many paintings of my generation."[2] Realizing that the profound simplicity of the readymades' execution made them open to degradation by indiscriminate repetition, Duchamp "decided to limit the production of 'readymades' to a small number yearly" soon after their inception.[3]

In his undated notes, sandwiched between ruminations on the idea that "in general the picture is the apparition of an appearance," Duchamp set down the directive to "redo literal nominalism," a sequence of thought that reflects his transition from painting images to renaming existing objects.[4] Duchamp's contribution to the history of twentieth-century art cannot be overestimated. By making the mind paramount over the eye, he opened up the vast, shifting territory where the verbal and visual intersect. In challenging accepted frames of reference, systems of knowledge, and epistemological assumptions in a brilliantly teasing way, Duchamp cleared a path for the fervent, iconoclastic investigation of art and aesthetic response that fueled later movements such as Dada, Pop, Minimalism, Conceptualism, and many manifestations of Postmodernism.[5] Because he located the truth of perception in consciousness rather than vision and gave pre-eminence to the abstracting act within the mind itself, Duchamp was this century's premier conceptual artist. (D.M.)

1. The term "readymade" was first used in 1915, after Duchamp had moved to the United States. The

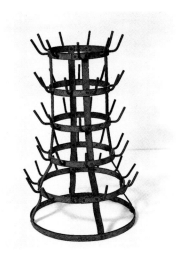

Gino Severini, Sea = Dancer, *January 1914. Oil on canvas, 41 1/4 x 33 11/16 inches (105.3 x 85.9 cm) including artist's painted frame. Peggy Guggenheim Collection, Venice 76.2553 PG32.*

Marcel Duchamp, Bottlerack, *1914, fourth version 1961. Readymade (galvanized iron), 25 1/4 inches (64.8 cm) high. Collection of Robert Rauschenberg, Courtesy of The Menil Collection, Houston.*

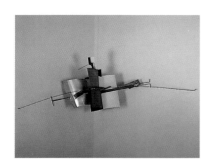

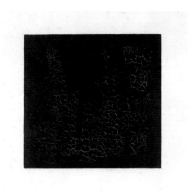

Vladimir Tatlin, Complex Corner Relief, *1915, reconstructed 1994 by Martyn Chalk. Iron, aluminum, zinc, and other mediums, 30 11/16 x 59 13/16 x 29 15/16 inches (78 x 152 x 76 cm). Courtesy of Annely Juda Fine Art, London.*

Kazimir Malevich, Black Square, *1915. Oil on canvas, 31 3/16 x 31 3/16 inches (79.2 x 79.5 cm). State Tretiakov Gallery, Moscow.*

artist later claimed that he did not intend his readymades to be works of art; he said of *Bicycle Wheel*, 1915, in which he fastened a bicycle wheel to a chair stool, that it was "just a distraction." See Pierre Cabanne, *Dialogues with Marcel Duchamp*, trans. Ron Padgett, Documents of Twentieth-Century Art (New York: Viking, 1971), p. 47.
2. Duchamp, unpublished interview with Harriet, Sidney, and Carroll Janis, 1953; quoted in Anne d'Harnoncourt and Kynaston McShine, eds., *Marcel Duchamp*, exh. cat. (New York: Museum of Modern Art, 1973), p. 275, n. 106.
3. Duchamp, "Apropos of 'Readymades'" (talk delivered at the Museum of Modern Art, New York, October 19, 1961), in Michel Sanouillet and Elmer Peterson, eds., *Salt Seller: The Writings of Marcel Duchamp (Marchand du Sel)* (New York: Oxford University Press, 1973), p. 142.
4. *Marcel Duchamp, Notes*, ed. and trans. Paul Matisse, Documents of Twentieth-Century Art (Boston: G. K. Hall, 1983), unpaginated, nn. 250–51.
5. For a recent assessment of the relationship between Duchamp and the development of abstract painting, see Joseph Masheck, "Duchamp in the Abstract," *Art Press*, no. 178 (March 1993), pp. E6–E16.

Vladimir Tatlin

(b. 1885, Moscow; d. 1953, Moscow)
Complex Corner Relief, 1915

With works such as *Complex Corner Relief*, 1915, Vladimir Tatlin prepared the ground for Soviet Constructivism, a movement that dominated Russian avant-garde art from the early 1920s. Traveling to Paris in 1913, Tatlin made repeated visits to Pablo Picasso's studio, where he saw Cubist assemblages that incorporated objects into the painting surface. From the language of these Cubist works, he developed his own early reliefs. While assimilating Picasso's example, however, Tatlin ventured further into the realm of abstraction. He divested his work of any reference to the world, concentrating on pure, abstract form that signifies nothing but itself. Tatlin also pushed Picasso's use of nontraditional art mediums into a passionate investigation of industrial materials. In the work illustrated here, he used iron, aluminum, and zinc. Employing their intrinsic properties of malleability and tensile strength, Tatlin bent, cut, shaped, and combined these metals to arrive at the work's bold and powerful forms.

By suspending *Complex Corner Relief* in a corner, with wires that connect the work to its environment, Tatlin subverted the essentially planar principle of traditional relief. In this and other of Tatlin's *Corner Counter-Reliefs*, the contemporary critic S. K. Isakov explained, "it is 'tension' and 'strain' that are in the foreground. That is why the artist called them 'counter-reliefs'. A 'counter-attack' as a response to an ordinary attack must exceed it in its energy. 'Counter-reliefs' are reliefs with a particularly pronounced tension."[1] The sculpture's location played on the traditional Russian

conception of corners as highly energized spaces—in Russian homes, family icons were hung and worshipped in the "beautiful corner." This "sacred" placement lends the work a distinct air of delicate mystery and iconicity, despite its overtly material-based concerns.[2]

In a 1920 manifesto, Tatlin and three associates—I. Meyerzon, T. Shapiro, and Pavel Vinogradov—explained their approach to artistic creation: "'materials, volume and construction' were accepted as our foundation." They declared a "distrust of the eye" and a need to "place sensual impressions under control."[3] Shedding the traditional role of the artist as a creator of beauty inspired by a source beyond the rational mind, they became heroic investigators of real, current materials arriving at physical solutions to artistic and—by extension—social problems. They believed that modern matter—especially materials produced by new technologies—could provide the appropriate medium with which to approach the questions being posed by the postrevolutionary order. Their functionalist approach to making art differed radically from the intuitive methods of Kazimir Malevich and the Suprematists, and this ideological rift came to a head at the 1915 exhibition *o.10* in St. Petersburg, which included *Complex Corner Relief* and eleven other works by Tatlin, along with Suprematist paintings by Malevich.

Tatlin's multifaceted oeuvre included designs for socially useful architecture. His mammoth *Monument to the Third International*, 1920 (fig. 69)—his most famous, although unrealized, work— was designed as a government building for the Communist International. A rising double spiral of iron containing rotating glass rooms, it represents the culmination of his goal of "uniting purely artistic forms with utilitarian intentions." His design is a prime example of what Tatlin described as "models which stimulate us to inventions in . . . creating a new world,"[4] an ideal that Tatlin first embodied in open-ended, nonrepresentational works such as *Complex Corner Relief*. (D.M.)

1. S. K. Isakov, "On Tatlin's Counter Reliefs" (1915), in Larissa Alekseevna Zhadova, ed., *Tatlin* (New York: Rizzoli, 1984), pp. 334–35.
2. Tatlin worked as an icon painter in his youth and would have been especially conscious of the association of corners with religious icons. In addition, a great exhibition of icons took place in Moscow in 1913, when Tatlin first began his relief sculptures. On Tatlin and icons, see Christina Lodder, *Russian Constructivism* (New Haven, Conn.: Yale University Press, 1983), pp. 11–13; and John Milner, *Vladimir Tatlin and the Russian Avant-Garde* (New Haven, Conn.: Yale University Press, 1983), p. 8.
3. I. Meyerzon, T. Shapiro, Vladimir Tatlin, and Pavel Vinogradov, "The Work Ahead of Us" (1920),

in Stephen Bann, ed., *The Tradition of Constructivism* (New York: Viking, 1974), pp. 12–14. This short manifesto was produced at the time that Tatlin was building a model of his *Monument to the Third International*, which was exhibited in 1920 to coincide with the meeting of the Eighth Congress of Soviets. The cosigners, two of whom were his students, helped him in the construction.
4. Ibid., p. 14.

Kazimir Malevich

(b. 1878, Kiev; d. 1935, Leningrad)
Black Square, 1915

In the opening sentence of his treatise "Suprematism," Kazimir Malevich proclaimed: "Under Suprematism I understand the supremacy of pure feeling in creative art."[1] The key to Malevich's Suprematist abstractions lies in this statement, and in understanding the subtle, difficult meaning of "pure feeling." Malevich explained that "from the standpoint of the Suprematist, the appearances of objective nature are in themselves meaningless; feeling is what is essential . . . totally independent of the environment from which it arises."[2] Feeling, he believed, has ultimate value over the material world, and pure feeling, which develops independently of objects, can be represented only by nonobjective art. Speaking of his earliest Suprematist works, Malevich claimed that "the black quadrilateral on the white field was the first form in which objectless feeling came to be expressed."[3]

To Malevich, everyday consciousness is governed by a relentlessly causal habit of thinking, which is deeply embedded in language and culture and which always focuses on a goal to be overcome or an end to be reached. This approach to the world, he claimed, is reinforced by a pervasive materialism, which throws people into an endless cycle of acquisition and accumulation. In a 1913 manifesto, Malevich pledged to "destroy the antiquated movement of thought according to the law of causality, the toothless, common sense, the 'symmetrical logic.'"[4] Believing that academic art's verisimilitude exacerbated the condition, he sought to obliterate through Suprematist art the constraints of causal thinking and a pre-occupation with objects.

Malevich likened the process of arriving at Suprematist consciousness to a spiritual journey, invoking the image of a religious mystic traveling through the desert, where revelation occurs: "The ascent to the objectless heights of art is difficult and torturous . . . but nevertheless rewarding . . . the familiar . . . is left further and further behind. . . . the outlines of the objective world fall further and further away . . . and it continues step by step, until finally the world of objective ideas—'everything we had loved—and lived by'—is lost

from sight. No more 'likeness of reality,' no more idealistic images—nothing but a desert! But this desert is filled with the spirit of objectless feeling which pervades everything. . . . the joyous feeling of liberating objectlessness dragged me forth into the desert, where nothing is real except feeling . . . —and so feeling became the substance of my life."[5] The experience of "objectlessness" is given form in Malevich's *Black Square*, 1915. He explained: "The quadrilateral = feeling, the white field = the nothingness outside of this feeling."[6] This "nothingness" is not a void but rather the white plenitude of infinity, the ever-existing source from which forms and feelings evolve.[7] The quadrilateral, which Malevich described as a symbol of modernity, evokes the mystical tradition of the square as the condensation of spirit into matter (just as the triangle is the symbol of transcendent divinity).[8] At the 1915 exhibition *0.10*, Malevich underscored the spiritual associations of his painting, when he hung *Black Square* high in a corner, surrounded by other intimate and meditative Suprematist paintings, in a position traditionally reserved in the Russian home for religious icons.

Malevich considered Suprematist feeling to be the sacred locus of life, the wellspring of vital being that must be protected ferociously from the everyday. Consequently, to preserve the domain of freedom it embodies, art had to remain nonutilitarian. Through the nonreferential forms of *Black Square* and subsequent Suprematist works, Malevich sought to free the mind from the mundane dimensions to which it was accustomed, evoking a creative consciousness and the experience of pure feeling. (D.M.)

1. Kazimir Malevich, "Suprematism," in *The Non-Objective World*, trans. Howard Dearstyne (Chicago: Paul Theobald, 1959), p. 67. (The treatise was first published in German in 1927.) Malevich introduced Suprematism in 1915, in a brochure entitled "From Cubism to Suprematism: The New Realism in Painting," which accompanied the exhibition *0.10* in Petrograd the same year. See Troels Andersen, ed., *K. S. Malevich: Essays on Art 1915–1933*, trans. Xenia Glowacki-Prus and Arnold McMillin (Copenhagen: Borgen, 1968), vol. 1, pp. 19–41.
2. Malevich, "Suprematismus," in *Die Gegenstandslose Welt*, ed. Hans M. Wingler, trans. Alexander von Riesen, Neue Bauhausbucher (Mainz: Florian Kupferberg, 1980), p. 65 (author's translation). The original Russian text, which Malevich gave to von Riesen, has never been found.
3. Malevich, "Suprematism," p. 74 (author's translation). While this work is commonly known by the title *Black Square*, the more accurate translation of the Russian word *chetyreugolnik* is "quadrilateral." Thus, the title suggests Malevich's system of cosmic geometry as flexible and unfolding rather than absolute and finite. See Jean-Claude Marcadé, "K. S. Malevich: From 'Black Quadrilateral' (1913) to 'White on White' (1917), From the Eclipse of Objects to the Liberation of Space," in Stephanie Barron and Maurice Tuchman, eds., *The Avant-Garde in Russia, 1910–1930: New*

Perspectives, exh. cat. (Cambridge, Mass.: MIT Press, 1980), pp. 20–24.
4. The First All-Russian Congress of Poets of the Future, "During the Last Seven Days" (1913), in Charlotte Douglas, *Swans of Other Worlds: Kazimir Malevich and the Origins of Abstraction in Russia*, Studies in the Fine Arts: The Avant-Garde, No. 2 (Ann Arbor: UMI Research Press, 1980), p. 36.
5. Malevich, "Suprematism," p. 68, with modifications from "Suprematismus," p. 66 (author's translation).
6. Malevich, "Suprematismus," p. 74 (author's translation). Malevich continues the mystical and philosophical tradition of equating "nothingness" with the source of all creation. The Dearstyne translation is misleading in rendering the German "Nichts" ("nothingness") as "void," which implies absence.
7. In "Non-Objective Creation and Suprematism" (1919), Malevich described "white" as "the true real conception of infinity," ending the essay with a call to "Sail forth! The white, free chasm, infinity is before us." See Andersen, ed., *K.S. Malevich*, vol. 1, pp. 121–22.
8. Malevich described the quadrilateral as "the form of modernity. In it four points triumph over three points." Unpublished manuscript, quoted in Marcadé, "K. S. Malevich," p. 21. Marcadé pointed out that the triangle is the traditional symbol of divinity. The interpretation of Malevich's use of the quadrilateral as a symbol of the material manifestation of divine substance would be entirely in keeping with his well-documented spiritual interests, which were characterized by a mystical and Theosophical approach to religious and metaphysical questions. See Linda Dalrymple Henderson, *The Fourth Dimension and Non-Euclidean Geometry in Modern Art* (Princeton: Princeton University Press, 1983), p. 281, n. 165; Patricia Railing, *From Science of Art to Systems of Art: On Russian Abstract Art and Language 1910/20 and Other Essays* (Forest Row, England: Artists Bookworks, 1989).

Ivan Puni

(b. 1894, Kuokalla, Russia; d. 1956, Paris)
Relief with White Ball, 1915

Relief with White Ball, 1915, illustrates Ivan Puni's contribution to early twentieth-century nonobjective art in Russia.[1] The work is one of a series of reliefs produced in 1915—called "pictorial sculptures" by Puni—that mark his total rejection of illusionism and his embrace of nonobjectivity. While emphasizing the concrete, physical reality of the wooden drawer and metal ball that comprise *Relief with White Ball*, Puni treated them as elements in an abstract design. He explained his choice of materials and the nonreferential quality of the composition: "Buttons are more elegant than minuets and madonnas, iron is more beautiful than gold or silver . . . the supreme expression of beauty is a drawer with a ball. Art is only good if it signifies nothing, represents nothing, has neither content nor meaning."[2]

Puni's relief synthesizes aesthetic and philosophical aspects of Vladimir Tatlin's constructions and Kazimir Malevich's Suprematist paintings. The crack running near the lower edge of the drawer, the uneven brushstrokes, the crumbling paint on the ball, and the three-dimensional configuration all

point to Tatlin's emphasis on texture, the conjunction of materials, and the relationship of the artwork to its surrounding space. The physical elements of the relief are unified in an abstract composition of geometric forms and stark color contrasts—flat trapezoids of black and green and a white sphere—that removes them, like the nonreferential shapes in Malevich's paintings, from the mundane world of needs and desires. Puni's work is distinguished from that of Malevich and Tatlin, however, by his inclusion of whole concrete objects treated as abstract elements.

Relief with White Ball was first shown in December 1915, in the exhibition *0.10* in Petrograd. Puni and his wife, artist Kseniia Boguslavskaia, financed and organized the exhibition, which consisted of works by fourteen avant-garde artists, including Malevich and Tatlin. The avowed intention of the *0.10* artists was to reduce art to the "zero point of forms." They saw their work as a turning point in art history: whereas the art of the past had been concerned with mimicking objects from the natural world, the art of the future would be nonobjective and autonomous. In general, the artists shared a utopian belief in the new art's power to change the world. In a manifesto explaining the theoretical underpinnings of their *0.10* works, Boguslavskaia and Puni made one of the earliest declarations concerning a totally autonomous art: "A picture is a new conception of abstracted, real elements, deprived of meaning."[3] By "depriving" his works of meaning, Puni hoped to liberate his art from the mundane world of commodities and to give it a concrete reality of its own. (R.B.)

1. Ivan Puni changed his name to Jean Pougny after emigrating to Paris in 1924.
2. Puni, quoted in *Jean Pougny*, exh. cat. (Paris: Musée d'Art Moderne de la Ville de Paris, 1993), p. 89 (author's translation).
3. Boguslavskaia and Puni, "Suprematist Manifesto," quoted in Stephanie Barron and Maurice Tuchman, eds., *The Avant-Garde in Russia, 1910–1930: New Perspectives*, exh. cat. (Cambridge, Mass.: MIT Press, 1980), p. 227.

Francis Picabia

(b. 1879, Paris; d. 1953, Paris)
Music Is Like Painting, 1916

Like many French Modernists, Francis Picabia began his painting career by mastering Impressionism, but after garnering a substantial reputation as an Impressionist painter, abandoned it for more avant-garde territory. In 1911, he became associated with the Puteaux group, a loose association of Cubists that included Marcel Duchamp, Raymond Duchamp-Villon, Albert Gleizes, Fernand Léger, Jean Metzinger, and Jacques Villon, among others. In

Ivan Puni, Relief with White Ball, *1915. Metal and wood, painted with oil, 13 ⅜ x 20 ⅒ x 4 ¼ inches (34 x 51 x 12 cm). Musée National d'Art Moderne, Centre Georges Pompidou, Paris.*

Francis Picabia, Music Is Like Painting, *1916. India ink, gouache, and watercolor on cardboard, 48 x 26 inches (122 x 66 cm). Private collection.*

Jean Arp, Squares Arranged According to the Laws of Chance*, 1917. Cut-and-pasted paper, ink, and bronze paint, 13 ⅛ x 10 ¼ inches (33.2 x 25.9 cm). The Museum of Modern Art, New York, Gift of Philip Johnson, 1970.*

Piet Mondrian, Composition in Color B*, 1917. Oil on canvas, 19 ⅞ x 17 ⅛ inches (50 x 44.7 cm). Kröller-Müller Museum, Otterlo, The Netherlands.*

1912, the poet Guillaume Apollinaire invented the term Orphism to describe works by these artists that were included in the *Section d'Or* exhibition in Paris. The Puteaux group discussed such topics as non-Euclidean geometry and the fourth dimension, and translated the dark Cubist palette of close-toned hues into more colorful abstractions.

Many important impulses coalesced in Picabia's work of this period. In 1908, he met Gabrielle Buffet, and the two married the following year. A music student trained in Berlin, Buffet believed in the Symbolist notion that direct correspondences exist between colors and forms, rhythms, sounds, and emotional experiences. Picabia held similar beliefs. The discs in Robert Delaunay's paintings, current theories of the analogy between abstract painting and music, a friendship with Marcel Duchamp, and discussions of science and math all contributed to Picabia's experiments with abstraction. But above all, Picabia's abstract works with contrasting colors and movement, such as *Music Is Like Painting*, 1916, were inspired by the artist's experience of the 1913 Armory Show, on which occasion he traveled to New York and was introduced to Alfred Stieglitz's circle at the gallery "291."

Music Is Like Painting is a prismatic, almost scientific painting, and recalls Delaunay's Orphist works and the experiments of the American Synchromists. The colored lines resemble patterns of light and sound, which suggest that the composition could be a sensorial record of an external reality.

Picabia is best known as an important practitioner of Dada, first in New York and then in Zurich and Paris. Although he moved freely among styles throughout his long career, including lengthy periods devoted to figuration, Picabia's thoughtful experiments in the early 1910s were among the first serious considerations of abstraction in France. (I.B.)

Jean Arp

(b. 1887, Strasbourg; d. 1966, Basel)
Squares Arranged According to the Laws of Chance, 1917

Jean Arp experimented with a form of abstraction based on Cubism as early as 1910,[1] but he began to concentrate on geometric abstraction in collaboration with his future wife, Sophie Taeuber, after they met in Zurich in 1915, and introduced into his work what the Dadaists called the "laws of chance." After ripping up and discarding a drawing that had frustrated him, Arp was struck by the pattern it made on the floor. In this remarkable chance encounter, created through nominal personal interjection, he decided that he had produced the unconscious form of expression that he had been looking for. He continued to make collages of torn squares scattered on a paper ground, in an approach similar to that of Tristan Tzara, a fellow Zurich Dadaist, who cut words from a newspaper, shook them up in a paper bag, and randomly arranged them to create a poem. Of the works made during this period, Arp has said: "My collages were made entirely of paper, and neither drawn nor painted. They were not speculative—I was haunted by the idea of doing something absolute. Cubism introduced perspective into its papiers collés, whereas I used paper to construct my plastic realities."[2]

Squares Arranged According to the Laws of Chance, 1917, exemplifies the dichotomy between order and chance in Dada's creative process. The squares of the collage fall roughly within an implied grid, but deviate from it enough to suggest tension, chaos, and disorder. Of this and other similar collages, Arp wrote: "These works are constructed with lines, surfaces, shapes, and colors. They seek to reach beyond human values and attain the infinite and the eternal. They are a denial of man's egoism."[3] Arp and Taeuber attempted to suppress the mark of the individual hand as much as possible in their works of this period, and preferred to use "humble" materials such as paper rather than paint and canvas.

Despite their connection to automatism and unconscious chance gestures, Arp's collages of this period also fit into the early history of geometric abstraction. Arp continued to make abstract works, but later turned to biomorphic forms, making sculptural reliefs based on organic shapes rather than the horizontal and vertical lines of his early works. (I.B.)

1. Arp later destroyed these early abstract works.
2. "Conversation at Meudon" (1955), in Arp, *Arp on Arp*, trans. Joachim Neugroschel (New York: Viking, 1972), p. 337.
3. Arp, statement (1915), in Herschel B. Chipp, ed., *Theories of Modern Art: A Source Book by Artists and Critics* (Berkeley: University of California Press, 1968), pp. 390–91.

Piet Mondrian

(b. 1872, Amersfoort, The Netherlands; d. 1944, New York City)
Composition in Color B, 1917

Composition in Color B, 1917, one of Piet Mondrian's first fully abstract works,[1] represents the inception of his use of pure abstraction in the service of his ideals. Mondrian was a member of De Stijl, a group of artists, designers, and architects founded in the Netherlands in 1917. The group's members shared a belief in art's potential for social redemption, and developed an aesthetic approach, called Neo-Plasticism, that was to be the means by which social transformation would be enacted. Devoid of historical references, De Stijl works are clean and geometric in form with spare and simplified applications of color. The group's compositional approach—whether in painting, architecture, or furniture design—emphasized the analysis of components into individual parts and their subsequent synthesis into a harmonious whole. Thus, the work served as a model for De Stijl's utopian vision of human society, in which the free individual would contribute toward the formation of a thriving, collective whole.[2]

Before arriving at pure abstraction, Mondrian had painted in various figurative modes. His attitude toward the depiction of the world changed, however, when he first encountered Cubism in 1911 and was struck by its breakdown of three-dimensional forms. Fueled by his interest in Hegelian dialectics and Theosophy's investigation of the duality of spirit and matter, he examined intensely the reconciliation of opposites and attempted to merge subjective and objective approaches to making meaningful art. He believed that the subjective approach, in the form of figuration and materialism, had to be transmuted into a more objective approach, which is necessarily abstract because it seeks to transcend particularities to reach a universalizing consciousness. His aim was the "direct creation of universal beauty," which arises from the inherent relationships between forms.[3] Through abstraction, Mondrian sought to capture these relationships, "the rhythm of life . . . in its most intense and eternal aspect."[4]

In *Composition in Color B*, Mondrian manifested these charged relationships through visual elements that he "purified" into irreducible absolutes of perpendiculars and primary colors. Discrete planes of red, yellow, and blue overlap bars of black and one another. The entire dialogue is suspended in a white spatial field. Mondrian never abandoned this basic schema, but began to integrate his compositional components even more to achieve a complete dissolution of the figure/ground dichotomy.

Mondrian's work represents the disciplined distillation of a crystalline order, intuited in the world and revealed by refined material means. While his abstract paintings often seem hermetic, they are actually quite humane in purpose. Mondrian

saw painting's function as a step in evolution, "to reconcile us with the imperfect life we know." He envisioned with optimism a time when art could be "cast into the 'abyss,'" its aims of social renewal having been fulfilled: "Art will be transformed, will be realized, first in our palpable environment, later in society . . . in our whole life which will then become 'truly human.'"[5] *Composition in Color B* and subsequent works are Mondrian's votive offerings toward this utopian ideal. (D.M.)

1. The painting was first exhibited as part of a triptych arrangement, along with *Composition with Colors A* and *Composition with Lines*, both 1917. (See the photograph of the installation reproduced in John Milner, *Mondrian* [London: Phaidon, 1992], p. 130.) Together, these works are generally thought to be Mondrian's first truly abstract works. However, Robert P. Welsh sees them as the last of the artist's "abstracted" works, because they share features with other paintings that can be traced to a visible source. See Welsh, "The Birth of De Stijl, Part I; Piet Mondrian: The Subject Matter of Abstraction," *Artforum* 11, no. 8 (April 1973), p. 53.
2. Paul Overy, *De Stijl* (London: Thames and Hudson, 1991), p. 9. See also Yve-Alain Bois, "The De Stijl Idea," in *Painting as Model* (Cambridge, Mass.: MIT Press, 1990), pp. 101–22.
3. Piet Mondrian, "Plastic Art and Pure Plastic Art" (1936), in *The New Art—The New Life: The Collected Writings of Piet Mondrian*, ed. and trans. Harry Holtzman and Martin S. James, Documents of Twentieth-Century Art (Boston: G. K. Hall, 1986), p. 289.
4. Mondrian, "On Abstract Art" (1930), in *The New Art—The New Life*, p. 238.
5. Ibid., p. 239.

Olga Rozanova

(b. 1886, Melenki, Russia; d. 1918, Moscow)
Untitled (Green Stripe), 1917–18

In its painterliness and palette, Olga Rozanova's *Untitled (Green Stripe)*, 1917–18, is quite different from works by her Russian contemporaries. The charged, light-filled, cream-colored ground of the canvas is bisected by a single painterly green stripe that pulsates with energy, in a composition that anticipates the work of Barnett Newman and like-minded American painters of the 1950s. Despite the aesthetic singularity of her work, Rozanova shared the artistic agenda and ideology characteristic of the Russian avant-garde.

From 1911, Rozanova lived in St. Petersburg and participated in all the major avant-garde exhibitions, including *0.10* in 1915. From 1910 to 1914, she was an active member of the Union of Youth, an association of artists that sponsored exhibitions and performances. Working in a Russian Futurist mode, she illustrated several books of poetry and was closely associated with the literary avant-garde, most of whom were interested in breaking down traditional syntax. Her work recalls the "lines of force" of the

Italian Futurists and the Rayonist paintings of her compatriots Natalia Goncharova and Mikhail Larionov. Influenced by Kazimir Malevich's collages, Rozanova experimented in the Cubist idiom from 1913 to 1914. At that time, she wrote, "servile repetition of nature's models can never express all her fullness. It is time, at long last, to acknowledge this and to declare frankly, once and for all, that other ways, other methods of expressing the World are needed."[1]

Immediately after Malevich introduced the Suprematist movement in 1915, Rozanova executed her first nonobjective paintings. By 1917, she had adopted a Constructivist approach and her interest in activating the pictorial space through light became primary. *Untitled (Green Stripe)* was a formal departure from the more expressionist paintings and collage book designs that had preceded it. Rozanova wrote of transforming art through abstraction: "We propose to liberate painting from its subservience to the ready-made forms of reality and to make it first and foremost a creative, not reproductive art . . . The aesthetic value of an abstract picture lies in the completeness of its painterly content."[2]

Rozanova was an avid supporter of the 1917 Revolution and immersed herself in the social and artistic activities associated with it. Although her premature death ended an active and inspired endeavor, plans she had devised to reorganize the structure of museums of industrial art were carried out posthumously. (I.B.)

1. Olga Rozanova, "The Bases of the New Creation and the Reasons Why It Is Misunderstood" (1913), in John E. Bowlt, ed., *Russian Art of the Avant-Garde: Theory and Criticism, 1902–1934*, Documents of Twentieth-Century Art (New York: Viking Press, 1976), pp. 102–10.
2. Rozanova, statement (1919), in M. N. Yablonskaya, *Women Artists of Russia's New Age 1900–1935* (London: Thames and Hudson, 1990), p. 97.

Liubov Popova

(b. 1889, Ivanovskoe, near Moscow; d. 1924, Moscow)
Painterly Architectonic, 1918

Liubov Popova's goal as a painter was not the depiction of existing realities but the construction of new ones out of pure pictorial space. Her *Painterly Architectonics*, which range in date from 1916 to 1918, were her first paintings devoid of figurative references. In the work illustrated here, brilliant planes of shining white, black, blue, maroon, and rose slide in a diagonal movement toward the center of the canvas. Planes intersect and pass through one another, at times subtly transformed by the process. Other planes merge, dissolving in an ethereal white light. The complex

interlocking and interpenetration of the glistening sheets makes it difficult to read depth, to know where each plane is located in relation to the others. With the absence of traditional perspective, the viewer is thrown into an unfamiliar visual experience.

Popova rejected the course of traditional art, which, she said, relied on "a) illusionism, b) literariness, c) emotion [and] d) recognition."[1] She arrived at her unique style after closely absorbing the lessons of two artists with distinctly different approaches— Kazimir Malevich, whose Suprematist paintings of nonfigurative elements floating on white grounds were intended to inspire feeling and shift the viewer's consciousness, and Vladimir Tatlin, who concentrated on the formal properties of common, concrete materials to create new sculptural and, ultimately, social realities. Synthesizing these two influences, Popova asserted that nonobjective art consists of "construction," where "the surface is maintained, but the form is volumetric." She sought to achieve this through what she described as the "architectonics" of "painterly space, line, color, energetics [and] texture."[2] The forms in *Painterly Architectonic* seem to shift with a delicate, perpetual movement according to Popova's own pictorial rules, the spatial paradox and shimmering coloration ceaselessly animating the painting.

As a teacher in postrevolutionary art institutions and as a member of art associations influential in cultural policy making, Popova remained dedicated to abstraction. She expanded her artistic investigations into more directly utilitarian uses,[3] making startling innovations in costume and set design for theatrical productions, as well as advances in textile and industrial design for factory-generated goods. Popova's swift and original development, which passed from works inspired by Cubism and Futurism to the Russian Suprematist, Constructivist, and Productivist groups, brought her to an early, courageous maturity that was abruptly ended by her untimely death. (D.M.)

1. Liubov Popova, statement, in *Tenth State Exhibition: Non-Objective Creation and Suprematism*, exh. cat. (Moscow, 1919), p. 22; reprinted in Dmitri V. Sarabianov and Natalia L. Adaskina, *Popova*, trans. Marian Schwartz (New York: Harry N. Abrams, 1990), p. 347.
2. Ibid.
3. Although Popova formally denounced pure painting in a group statement with fellow Productivists at the Institute of Artistic Culture in Moscow in November 1921, her activities suggest that she nevertheless pursued it privately. See George Peck and Lilly Wei, "Liubov Popova: Interpretations of Space," *Art in America* 70, no. 9 (October 1982), pp. 102–03.

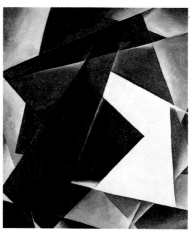

Olga Rozanova, Untitled (Green Stripe), *1917–18. Oil on canvas, 28 x 20 ⅞ inches (71 x 53 cm). Rostovo-Yaroslavskij Arkhitekturno-Khudozhestvennyj Muzej-Zapovednik, Rostovo-Yaroslavskij, Russia.*

Liubov Popova, Painterly Architectonic, *1918. Oil on canvas, 41 ⁵⁄₁₆ x 35 ⁵⁄₁₆ inches (105.5 x 89 cm). Uzbekistan State Museum of Fine Arts, Tashkent.*

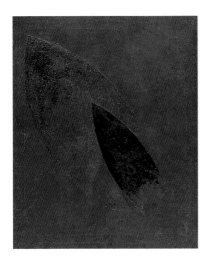

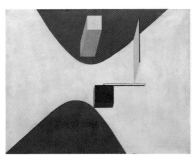

Aleksandr Rodchenko, Black on Black, *1918. Oil on canvas, 33 ¼ x 26 ⅜ inches (84.5 x 67 cm). State Russian Museum, St. Petersburg.*

El Lissitzky, Proun P23 No. 6, *1919. Oil on canvas, 20 ½ x 30 ¼ inches (52 x 77 cm). Property of Dessau Trust.*

Kurt Schwitters, Revolving, *1919. Wood, metal, cord, cardboard, wool, wire, leather, and oil on canvas, 48 ⅛ x 35 inches (122.7 x 88.7 cm). The Museum of Modern Art, New York, Advisory Committee Fund, 1968.*

Aleksandr Rodchenko

(b. 1891, St. Petersburg; d. 1956, Moscow)
Black on Black, 1918

Unlike his Russian compatriot Kazimir Malevich, who viewed art as part of a transcendent "higher order," Aleksandr Rodchenko believed that art is a part of everyday life. His investigations into abstraction did not evolve from the gradual honing of figurative elements, as had many other artists'. Rodchenko viewed the artist as an engineer or worker whose concerns are materials and geometric form. In the postrevolutionary period, Russian artists shared a newfound optimism regarding the possibility of using their work to effect social transformations. Rodchenko participated in this dialogue, and, in works such as *Black on Black*, 1918, used his painting to explore material aspects that might bear on social reconstruction.

In his *Black on Black* series, Rodchenko explored the nuances that result from the interaction of closely valued hues. The series, which was exhibited at the 1919 Tenth State Exhibition, titled *Non-Objective Creation and Suprematism*, in Moscow, plays off Malevich's famous *White on White* series of 1917–18. In contrast to the mystical and transcendent associations of Malevich's paintings, Rodchenko's series manifests the artist's concern with the materiality of paint. In the catalogue for the exhibition, Rodchenko wrote:

Don't look back, but go forever onwards.
 The world will be enriched by the innovators in painting.
 Objects died yesterday. We live in abstract spiritual creativity.
 We are the founders of non-objectivity.
 Of colors as such.
 Of tone as such.
 We glorify aloud the revolution as the sole motor of life.

Until 1920, painterly issues such as color, tone, and materials prevailed in Rodchenko's art. His investigations into the process of making a painting, which were so central to the *Black on Black* series, were abandoned with astonishing speed. By 1920, line had become the focus of his experiments, and he renounced painterly concerns for those of material construction. In 1921, Rodchenko exhibited *The Last Painting* (fig. 72)—three monochrome paintings: one red, one blue, one yellow—and proclaimed the death of easel painting. He and his wife, artist Varvara Stepanova, rejected painting altogether in that year and committed themselves to "production art" such as photography, typography, posters, books, textiles, cinema, and theater. (I.B.)

El Lissitzky

(b. 1890, Pochinok, Russia; d. 1941, Shchodnia, Russia)
Proun P23 No. 6, 1919

Abstraction first appeared in El Lissitzky's work in the compositions he called prouns, a series he began in 1919 and continued through the mid-1920s. An acronym derived from the Russian phrase *proekt utverzhdeniia novogo* (project of the affirmation of the new), "proun," Lissitzky explained, was "the name we have given to a station on the road towards constructing a new form. It grows on earth fertilized by the corpses of the picture and its artist."[1] With these lines, written in the wake of the 1917 Revolution, Lissitzky declared the death of traditional art as defined by the academy, the court, and bourgeois society, and of the artist's attendant role. Prouns represented the formation of a new society in which the artist would be an active participant.

Lissitzky's "new form" of art required an abstract approach. Only in this radical way, he explained, could truly innovative forms be discovered. Because representation, by definition, is based on existing forms, it had little value in his project. Lissitzky's shift to nonobjective art was influenced by Kazimir Malevich. In the prouns, Lissitzky combined the imaginative principles of Malevich's Suprematism and a more direct encounter with the social contingencies of contemporary reality.

Lissitzky characterized his prouns as a "way station between painting and architecture," and said that he treated the canvas "as a building site."[2] He drew on his training as an architect-engineer and applied his sophisticated knowledge of three-dimensional rendering to expand Malevich's essentially planar art into works about space and volume, as in *Proun P23 No. 6*, 1919. Two large hyperbolas of red, positioned in an asymmetrical arrangement at the top and bottom of the canvas, define the central white space. A group of boxlike volumes are situated on this ground: touching the bottom field of red is a black cube, upon which rests a long, horizontal bar connected to an upright broad white slab, which touches the second hyperbola. From within this top field rises a tall, cream-colored rectangular form. The volumes relate to one another because of their proximity, yet each is depicted according to a different system of three-dimensional representation. The apparent disjunction that arises from the absence of a unitary system of perspective seems to "bend" the space that the shapes inhabit. With its intriguing grouping of forms, the

composition evokes the idea of advanced avenues of technological exchange and a sense of futuristic community.

Lissitzky resisted any confining definition of his prouns: "I cannot define absolutely what 'Proun' is, for this work is not yet finished. . . . My aim . . . is not to represent, but to form something independent of any conditioning factor."[3] The prouns afforded Lissitzky limitless freedom to explore the forms of his imagination, and they remained an inexhaustible source of ideas throughout his life. (D.M.)

1. El Lissitzky, "PROUNS" (1920–21), in *El Lissitzky*, exh. cat. (Cologne: Galerie Gmurzynska, 1976), p. 60.
2. Lissitzky, "The Film of El's Life" (1928), in Sophie Lissitzky-Küppers, ed., *El Lissitzky: Life, Letters, Texts*, trans. Helene Aldwinckle and Mary Whittall (rev. ed.; London: Thames and Hudson, 1980), p. 329.
3. Lissitzky, "From a Letter" (1925), in ibid., p. 358.

Kurt Schwitters

(b. 1887, Hannover; d. 1948, Kendal, England)
Revolving, 1919

After earlier experiments in abstract painting, Kurt Schwitters embraced collage and assemblage as his premier medium by 1919. From this point on, Schwitters called all his creative activities by the word "merz."[1] He took the term from an early collage entitled *Merzbild* (now destroyed), which contained a fragment of an advertisement in which the letters "merz" (from the word "commerz") appeared. A poet as well as a painter, Schwitters was attracted to this word for its pleasing sound and affective associations. It rhymes with *Herz* (heart) as well as *Schmerz* (pain), for example, and is found in the verb *ausmerzen* (to weed out). Thus it alludes to the essence of Schwitters's merz works, which he formed from society's discarded material scraps.[2]

Revolving, 1919, an early merz work, demonstrates how Schwitters used the detritus of everyday life—cutaway lids of tin cans, discarded wheels, leftover wire netting, and so on—to create arrangements that carry new meanings.[3] The dominant themes of *Revolving* are movement and harmony in circular form. Generous washes of paint in blue and gold-toned ocher and taupe unite the various elements into a balanced, rhythmic whole. On the reverse side of the work, Schwitters marked the alternate title *Kosmische Kreise* (cosmic circles),[4] which suggests that the color scheme may be seen as an allusion to the blue and gold traditionally used to represent the heavenly firmament in Western religious painting. The title also reflects Schwitters's conviction that elements of the sacred are to be found

in the most lowly matter of earthly existence.

While the word merz and Schwitters's imagery invite allusive poetic play, Schwitters continually emphasized the abstract and autonomous quality of his art. Although the works' components came from the world, they derive their primary meaning from their role within the composition and not as referents back to the world. Schwitters stated: "The pictures—*Merzmalerei*—are abstract works of art. . . . it is unimportant whether the used materials have previously been shaped for some purpose or not. The wheel of a baby carriage, the wire net, string and cotton are all factors on a par with paint. The artist creates by choosing, dividing, and de-forming the materials."[5] Schwitters explained that through abstraction he sought to eliminate unnecessary obstacles between the moment of personal inspiration and its artistic manifestation: "Merz-Painting aspires to produce an immediate expression by shortening the path between intuition and the moment the work of art becomes visible."[6] Schwitters's desire to keep alive the energy of the initial spark of imagination derived from his passionate conviction that art is an unstoppable, burgeoning force similar to, and not in imitation of, that of nature. He felt that its process should be cultivated respectfully to foster its inherent freedom and vitality. The artist holds a serious responsibility to display a discriminating intelligence in the presence of complete artistic liberty: "Merz stands for freedom from all fetters, for the sake of artistic creation not lack of restraint, but the product of strict artistic discipline."[7] *Revolving* heralded the abundant abstract production that continued throughout Schwitters's life, from two-dimensional surfaces to the three environmental sculptures he called *Merzbauen* (for example, fig. 88)— continually evolving architectural fantasies built up from the mundane and incidental substantialities of his life. (D.M.)

1. While the term encompasses Schwitters's poems as well as his collages and assemblages, it does not refer to the naturalistic portraits and landscapes that he continued to produce—partly for income, partly for "sentimental pleasure," and partly as a counterbalance to his abstractions—throughout his life. See Werner Schmalenbach, *Kurt Schwitters* (New York: Harry N. Abrams, ca. 1967), p. 76; and John Elderfield, *Kurt Schwitters* (London: Thames and Hudson, 1985), pp. 215–19.
2. On Schwitters's invention of the term merz, see Schmalenbach, *Kurt Schwitters*, p. 93. Merz also sounds like the German word for the month of March—*März*—which connotes spring and thus fertility and rebirth; this association is apt, as Schwitters's merz works draw on civilization's garbage and give it new life.
3. On the physical and formal construction of *Revolving*, see Elderfield, *Kurt Schwitters*, pp. 52–54.
4. Schmalenbach, *Kurt Schwitters*, p. 248, n. 108.
5. Schwitters, "Die Merzmalerei," *Der Zweeman* 1, no. 1 (November 1919), p. 18; published in English as "Merz-Painting," in Rose-Carol Washton Long, *German Expressionism: Documents from the End of the Wilhelmine Empire to the Rise of National Socialism*, Documents of Twentieth-Century Art (New York: G. K. Hall, 1993), p. 278. By "de-forming" (*entformen*), Schwitters meant to suggest the transformation from one state to another (see Schmalenbach, *Kurt Schwitters*, p. 247, n. 30a; and Elderfield, *Kurt Schwitters*, p. 237).
6. Ibid.
7. Schwitters, "Merz" (1921), trans. Ralph Manheim, in Robert Motherwell, ed., *The Dada Painters and Poets: An Anthology* (Cambridge, Mass.: Belknap Press, 1981), p. 59.

Naum Gabo
(b. 1890, Briansk, Russia; d. 1977, Waterbury, Connecticut)
Column, ca. 1923

In *Column*, ca. 1923, Naum Gabo eschewed traditional sculpture's solid, massed forms, using interlocking vertical and horizontal planes to demarcate space and imply volume. The transparent planes expose the work's core and allow its overall structure to be seen from any vantage point. This visual clarity mirrors the work's formal clarity, which derives from a unifying mathematical system that determined the radius of the bases in relation to the dimensions of the vertical element. In *Column*, Gabo came closest to a goal he established early in his career: to fuse the architectural with the sculptural. In "The Realistic Manifesto" of 1920, which he wrote with his brother, Antoine Pevsner, Gabo proclaimed: "The realization of our perceptions of the world in the forms of space and time is the only aim of our pictorial and plastic art. . . . We construct our work as the universe constructs its own, as the engineer constructs his bridges, as the mathematician his formula of the orbits."[1]

While studying medicine and science in Munich, Gabo read works by philosopher Henri Bergson and attended lectures by art historian and theorist Heinrich Wölfflin. In 1914, at the outbreak of war, he moved to Norway, where he began to make sculptural reliefs of heads constructed from flat planes, in a manner similar to that of Italian Futurist Umberto Boccioni's work of the same period. Born Naum Pevsner, he changed his name to distinguish himself from his brother before returning to Russia with him in 1917 in order to support the Revolution. Gabo became an active member of the Russian avant-garde, and soon made the transition to pure abstraction. His approach was more closely aligned with Kazimir Malevich's relentless commitment to the transcendent power of art than to Vladimir Tatlin's Constructivist stance,

yet he shared with Tatlin a belief in the idealistic power of architectural form. In "The Realistic Manifesto," he wrote, "No new artistic system will withstand the pressure of a growing new culture until the very foundation of Art will be erected on the real laws of Life."[2] In works like *Column*, Gabo saw the potential of his sculptural forms being translated into an architectural language of public monuments.

Gabo left Russia for Germany in 1922, and it was there that he made many of his Constructivist sculptures, including *Column*. In 1932, as a result of the Nazi rise to power, he moved to Paris, where he took part in the Abstraction-Création group with Jean Arp, Albert Gleizes, and František Kupka, among others. He settled in London in 1936, and three years later, with his wife, American painter Miriam Israels, moved to Cornwall, where they befriended the artistic community there, including Barbara Hepworth and Ben Nicholson. Gabo was thus a link in the international history of abstraction. (I.B.)

1. Naum Gabo and Antoine Pevsner, "The Realistic Manifesto" (1920), in *Gabo* (Cambridge, Mass.: Harvard University Press, 1957), pp. 451–52.
2. Ibid.

László Moholy-Nagy
(b. 1895, Borsod, Hungary; d. 1946, Chicago)
Light-Space Modulator, 1923–30

The kinetic sculpture *Light-Space Modulator*, 1923–30, represents László Moholy-Nagy's investigation of form through light. The year before beginning the project, Moholy-Nagy had experimented with photograms, a type of cameraless photography in which objects placed on light-sensitive paper are exposed to light to form an image from the trace of the object's shape. With *Light-Space Modulator*, Moholy-Nagy's experiment took shape in an apparatus of aluminum, plastic, glass, and chrome-plated surfaces. The parts are variously solid, transparent, or perforated, and are driven by an electric motor and a series of chain belts. As light is transmitted through the moving apparatus, it is diffracted into overlapping and interacting beams, which create shadows in a constant state of flux. Stylistically, the work resembles Russian Constructivist assemblages, especially Vladimir Tatlin's *Monument to the Third International*, 1920 (fig. 69). Originally devised as a stage prop, the work is one of the most important objects in the history of the intersection of art and technology.

Moholy-Nagy completed *Light-Space Modulator* in 1930, with the help of engineer István Sebök and technician Otto Ball. Later that year, after showing

Naum Gabo, Column, *ca. 1923. Perspex, wood, metal, and glass, 41 ⅛ inches (104.3 cm) high, 29 ½ inches (75 cm) in diameter. Solomon R. Guggenheim Museum, New York 55.1429.*

László Moholy-Nagy, Light-Space Modulator, *1923–30. Steel, plastic, wood, electric motor, and other mediums, 59 ½ x 27 ½ x 27 ½ inches (151.1 x 69.9 x 69.9 cm). Busch-Reisinger Museum, Harvard University Art Museums, Cambridge, Massachusetts, Gift of Sibyl Moholy-Nagy.*

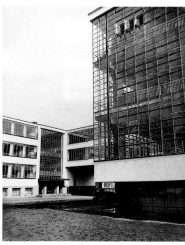

Constantin Brancusi, Bird in Space, *1924. Polished bronze on marble base; sculpture: 50 ¼ inches (127.8 cm) high, 17 ¾ inches (45 cm) in circumference; base: 6 ¼ inches (16 cm) high. Philadelphia Museum of Art, The Louise and Walter Arensberg Collection.*

Walter Gropius, Bauhaus buildings, Dessau, 1926.

the work at the Werkbund exhibition in Paris, he developed a film with his future wife, Sibyl Pietzsch, in which *Light-Space Modulator* is the central element. *Light Display: Black and White and Gray* recorded the abstract play created as light was projected through the sculpture onto walls and ceilings.

Like many other artists of his generation, Moholy-Nagy harbored utopian beliefs in the transformative power of art. In his writings, he often expressed these beliefs, and occasionally addressed the specific importance of abstraction: "I believed that abstract art not only registers contemporary problems, but projects a desirable future order, unhampered by any secondary meaning, which the customary departure from nature usually involves because of its inevitable connotations. Abstract art . . . creates new types of spatial relationships, new forms, new visual laws . . . as the visual counterpart to a more purposeful cooperative human society."[1]

A professor at the German Bauhaus from 1923 to 1928, Moholy-Nagy became the director of the New Bauhaus in Chicago after emigrating there in 1937. Although the school closed within a year, Moholy-Nagy's influence continued to be felt in the United States through the school he then founded, the Chicago Institute of Design. (I.B.)

1. László Moholy-Nagy, "Abstract of an Artist" (1944), quoted in Krisztina Passuth, *Moholy-Nagy* (London: Thames and Hudson, 1985), p. 364.

Constantin Brancusi
(b. 1876, Hobitza, Romania; d. 1957, Paris)
Bird in Space, 1924

Bird in Space, 1924, exemplifies Constantin Brancusi's lifelong desire to express the essential nature of things through abstract form. "What is real," he said, "is not the external form, but the essence of things. Starting from this truth it is impossible for anyone to express anything essentially real by imitating its exterior surface."[1] In the sleek, soaring silhouette of this sculpture, the concept of "bird" has been reduced to the essential gesture of upward flight, which, in Brancusi's pantheistic philosophy, signifies freedom and spirituality.

Bird in Space evokes both the material and spiritual realms, illustrating Brancusi's belief that harmony exists between the two. The play of light over the shiny bronze surface seems to dissolve the sculpture's mass, making it appear weightless and insubstantial. As it shimmers and gleams, *Bird in Space* seems to transcend its earthbound state. Yet at the same time, the highly polished surface incorporates its immediate environment by giving back

distorted reflections of the viewer and the surrounding space. The base that Brancusi made for this sculpture—now missing—was composed of three pieces. With the largest and most rough-hewn element on the bottom and the smallest, most refined one at the top, it emphasized the sculpture's upward thrust and symbolized the transition between the everyday world and a more ethereal one.

From approximately 1908 until the early 1950s, Brancusi sculpted forty-one birds in three series. *Birds in Space* (see also fig. 47), the last and most abstract series, was inspired by Romanian mythology and modern technology. The yellowish tone of the bronze alloy that Brancusi chose for *Bird in Space* alludes to the golden color of the *Maiastra*—a divine sunbird personifying light and vision in Romanian folklore—while also connoting nobility and preciousness. As the elegant, streamlined shape of this bird suggests, Brancusi was fascinated by the smooth precision of industrial forms, particularly those associated with the nascent aviation industry. By laboriously polishing his sculptures by hand, he effaced all traces of his touch and produced an impersonal, pristine surface similar to that of machine-crafted objects.

Ironically, the affinity of Brancusi's sculptures with industrial objects caused problems for the artist when he brought a version of *Bird in Space* to the United States in 1926 for an exhibition in New York. Unappreciative of its radical abstraction, United States customs officials refused to accept it as a work of art and insisted that it was subject to import duty as a "commercial" object. Finally, after a celebrated two-year court battle, the United States Supreme Court ruled that *Bird in Space* was in fact a work of art—one that reflected new, abstract trends. (R.B.)

1. Constantin Brancusi, quoted by P. Morand in an essay in the catalogue of the 1926 Brancusi exhibition at the Brummer Gallery, New York; also quoted in Athena T. Spear, *Brancusi's Birds* (New York: New York University Press, 1969), p. 37.

Walter Gropius
(b. 1883, Berlin; d. 1969, Boston)
Bauhaus buildings, Dessau, 1926

In its geometric simplicity, lack of historicist reference, asymmetrical layout, and radical use of modern materials (such as glass screen walls and a reinforced-concrete frame), Walter Gropius's design for the Bauhaus buildings in Dessau embodies the abstract conception of architecture that came to be known as the International Style. The buildings also symbolize the guiding credo of the Bauhaus, a school

of art, architecture, and design founded by Gropius in 1919. In the "Manifesto of the Bauhaus," he declared: "*The ultimate aim of all of creative activity is the building!* . . . Let us together desire, conceive and create the new building of the future, which will combine everything—architecture *and* sculpture *and* painting—in a *single form* which will one day rise towards the heavens from the hands of a million workers as the crystalline symbol of a new and coming faith."[1]

Gropius's manifesto declaration was both literal and metaphorical. He exploited the associative meanings that the word "building" (*Bau* in German) evokes in relation to both architecture and man's spiritual development,[2] and therefore the manifesto can be read not only as an assertion of architecture's primacy but also as an exhortation to spiritual elevation through artistic community. Gropius's vision was inspired by the medieval cathedral, the subject of a woodcut by Lyonel Feininger that accompanied the school's manifesto. By bringing together the creative labor of artists, artisans, and thinkers to serve the spiritual and social needs of the community, Gropius sought to implement the secular equivalent of cathedral construction.

As the Bauhaus evolved from a school of applied arts with an esoteric, fine-art philosophy to become the first school of modern design,[3] it began to foster the pragmatic application of artistic practice to the objects and spaces of modern daily living—from the design of a teapot to the plans of a building. Determining form by bringing functional need and aesthetic consideration into balance was the central tenet of the school's teaching, and is exemplified by Gropius's buildings.

All students entering the Bauhaus were required to complete the *Vorkurs*, which formed the core of the school's education. A preliminary course, it was designed to free the students of received assumptions and enable them to bring fresh insight and original thinking to the solution of artistic problems. Developed by Johannes Itten, an abstract painter with mystical leanings, the course emphasized spontaneity and freedom of expression, offering both theoretical and direct approaches to the study of pure form through exercises in two- and three-dimensional structure, color, material, and texture; life-drawing classes; and intensive analysis of the composition of Old Master artworks. Vasily Kandinsky and Paul Klee contributed to the course when they joined the faculty in the early 1920s. Academic dogma and historical allusion were shunned, and problems

were solved using a nonimitative, abstract approach. As the 1920s progressed and Gropius became increasingly convinced of the social necessity of the union of art and technology, the *Vorkurs* was adapted to reflect this new vision. Emphasis was placed more on rational analysis and an aesthetic derived from the machine than on intuitive reasoning and personal expression.[4] László Moholy-Nagy replaced Itten as the workshop teacher in 1923, and five years later, the position was assumed by Josef Albers.

Although the Bauhaus was dissolved under Nazi pressure in 1933, its principles continued to be disseminated. Many former students and faculty members such as Albers, Max Bill, Marcel Breuer, Gropius, and Moholy-Nagy left Germany, and most emigrated to England or the United States and joined prominent teaching institutions. As a result, Bauhaus methods of studying abstract form have become firmly entrenched in the curricula of art schools on both sides of the Atlantic. (D.M.)

1. Walter Gropius, "Manifesto of the Bauhaus" (1919), in Frank Whitford, *Bauhaus* (London: Thames and Hudson, 1984), p. 202. For the German original, see Hans M. Wingler, *The Bauhaus: Weimar, Dessau, Berlin, Chicago* (Cambridge, Mass.: MIT Press, 1979), p. 31.
2. For the associative meanings of *Bau*, see Whitford, *Bauhaus*, p. 29.
3. From 1926, the Bauhaus assumed the subtitle Hochschule für Gestaltung (institute of design). Classes in "free painting"—painting with no applied function—were offered beginning in 1927.
4. Robert Welsh points out that the early Bauhaus teachers approached abstraction as a "metaphysical quest," whereas the younger generation viewed it more as an "epistemological exercise." See Welsh, "Abstraction and the Bauhaus," *Artforum* 8, no. 7 (March 1970), p. 49.

Theo van Doesburg

(b. 1883, Utrecht, The Netherlands; d. 1931, Davos, Switzerland)
L'Aubette, Strasbourg, 1927

The utopian vision of De Stijl—the movement founded by Theo van Doesburg with several other artists and architects in 1917—found expression in an aesthetic principle based on the interaction of vertical and horizontal elements. With this approach, De Stijl artists, architects, and designers sought to represent primary oppositions such as activity and stasis, sky and earth, and male and female. (Later, diagonal elements were also introduced into De Stijl compositions.) Their method arose from the post–World War I need for a universal language that would erase the distinctions between art and life, thereby granting art the ability to effect social change. With the decoration of the café-restaurant complex L'Aubette (see also fig. 85), van Doesburg and his collaborators, Jean Arp and Sophie

Taeuber-Arp, used the built environment as the format for their utopian art, in a design that placed patrons within the equivalent of a De Stijl painting.

Arp, Taeuber-Arp, and van Doesburg made every effort to transform the space—which was designed by Jacques François Blondel in the 1760s to serve as a military headquarters—into the ultimate De Stijl environment, so that patrons would benefit from the utopian promises that paintings could only tangentially convey. Their design used clean, smooth materials such as iron, mirror glass, and aluminum; planar divisions of space; and a color scheme that resembled the paintings of the De Stijl movement (with black lines and blocks of primary colors).

For the tea room and the stained-glass windows of L'Aubette, Taeuber-Arp executed abstract, rectilinear designs. The café's staircase perhaps best interpreted the transformation of a De Stijl painting into a plastic environment. Designed by van Doesburg with a color scheme by Arp, it incorporated a stepped balustrade with vertical bands of color. Since the ceilings were treated in a similar way, with low-relief panels of color, no hierarchy was imposed between parts of the building. Doors and windows were extended to the ceilings, fostering the visual continuum of spaces and allowing the maximum amount of light to enter the rooms. L'Aubette marked the apex as well as the finale for De Stijl, but until his death van Doesburg continued to focus his unflagging energies on advancing the cause of abstraction. (I.B.)

Joan Miró

(b. 1893, Barcelona; d. 1983, Palma de Mallorca)
Untitled Painting, 1927

In the paintings he made during the early 1920s, Joan Miró searched for ways to combine his own fanciful inner vision of the world with elements of observed reality. Works such as *Catalan Landscape (The Hunter)*, 1923–24, his poetic, somewhat nostalgic reflection inspired by a summer spent in his native Montroig, marked an important transition toward abstraction. This painting's imagery is schematized, but much of it can be deciphered, and although Miró cast off all vestiges of perspective that had lingered in prior paintings, the work's two bands of color wash still distinguish the division in the landscape between land and sky.

In 1922, Miró began a friendship with André Masson, through whom he was introduced to many of the Surrealist artists and poets. Miró shared the

Surrealists' interest in "primitive" thinking and forms, and his work—with its biomorphic imagery floating freely in a controlled space—had stylistic similarities to that of Jean Arp, Alexander Calder, and Masson. Miró joined the Surrealist group in 1924 and by the following year had embraced its love of accident and chance. The open-ended automatism of the Surrealist project led to his spare, enigmatic works of the next few years.

Untitled Painting, 1927, is one of a group of abstract compositions featuring an elusive arrangement of calligraphic lines, dots, and white paint on a beige or light-brown ground (see also fig. 92). In the paintings of this period, Miró was not seeking pure, objectless abstraction, as some of his contemporaries were. In fact, he protested against nonobjectivity and refused to join the Abstraction-Création group in Paris in 1931. In a 1936 interview, he said, "Have you ever heard of greater nonsense than the aims of the Abstractionist group? And they invite me to share their deserted house as if the signs that I transcribe on canvas, at the moment when they correspond to a concrete representation of my mind, were not profoundly real, and did not belong essentially to the world of reality! As a matter of fact, I am attaching more and more importance to the subject matter of my work."[1] Miró created a visual vocabulary of abstract forms that vividly express his personal, complex relationship to the observed world. (I.B.)

1. Georges Duthuit, "Où allez-vous Miró?" (interview with Miró), *Cahiers d'art* 11, nos. 8–10 (1936), p. 261; published in English in James Johnson Sweeney, *Joan Miró*, exh. cat. (New York: Museum of Modern Art, 1941); reprinted in Herschel B. Chipp, ed., *Theories of Modern Art: A Source Book by Artists and Critics* (Berkeley: University of California Press, 1968), p. 431.

Georgia O'Keeffe

(b. 1887, Sun Prairie, Wisconsin; d. 1986, Santa Fe)
Black Abstraction, 1927

A major figure of American Modernism, Georgia O'Keeffe was part of the circle of artists—including Charles Demuth, Arthur Dove, Marsden Hartley, John Marin, and Paul Strand—who gathered around "291," the New York gallery directed by photographer Alfred Stieglitz. Having studied at the Art Institute of Chicago and the Art Students League in New York, and with Arthur Wesley Dow at Columbia College (also in New York), O'Keeffe took teaching jobs in various parts of the United States between 1912 and 1918, when she returned to New York. She had her first exhibition at "291" in 1916, and she and Stieglitz married in 1924.

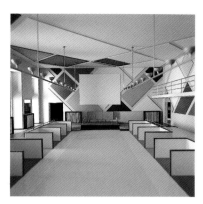

Theo van Doesburg, Café Aubette, Strasbourg: Model of the Large Dance Hall, *1927, reconstructed 1988. Wood, Perspex, and metal, 19 ¼₆ x 41 ¹¹⁄₁₆ x 59 ¼ inches (49.5 x 105.9 x 151.7 cm). Rijksdienst Beeldende Kunst, The Hague.*

Joan Miró, Untitled Painting, *1927. Aqueous medium on canvas, 44 ¾ x 57 ½ inches (113.7 x 146.1 cm). Philadelphia Museum of Art, The Albert M. Greenfield and Elizabeth M. Greenfield Collection.*

Georgia O'Keeffe, Black Abstraction, *1927. Oil on canvas, 30 x 40 ¼ inches (76.2 x 102.2 cm). The Metropolitan Museum of Art, New York, The Alfred Stieglitz Collection, 1969.*

César Domela, Neoplastic Relief Number 7, *1929. Oil on wood, with metal, 18 x 22 ½ inches (45.7 x 57.2 cm). Philadelphia Museum of Art, A. E. Gallatin Collection.*

Ludwig Mies van der Rohe, German Pavilion, International Exposition, Barcelona, 1929 (demolished later that year, reconstructed 1986).

O'Keeffe was dedicated to abstractions of nature or personal experience, and most of her work is founded on figurative subjects. She said, "The abstraction is often the most definite form for the intangible thing in myself that I can only clarify in paint."[1] O'Keeffe was influenced by Vasily Kandinsky's seminal 1912 treatise *Concerning the Spiritual in Art,* and sought to portray in her work the metaphysical aspects of nature, as he prescribed. Exploring nature's regenerative qualities, she imbued her compositions with an exceptional organic vitality. In 1916, as O'Keeffe began to simplify forms to their radical cores, she made a group of monochrome charcoal drawings that can be seen as evidence of her early search for essences. O'Keeffe's next prolonged phase of abstraction came around 1926, after she had gradually re-introduced color into her work. Although she used the same reductive process of her earlier abstractions, these more elaborate paintings, such as *Black Abstraction,* 1927, are clearly derived from nature. In place of the biomorphic elements of the earlier works, there is an emphasis on line—for example, the austere *Black Abstraction*'s primary compositional elements are a tiny sphere and a line. The tension between the two forms results in a highly charged composition, and the black-and-white palette of the work heightens its drama. Like O'Keeffe's other abstractions, the figurative source of *Black Abstraction* is thoroughly obscured, but it is thought to be based on the artist's experience of waking up in an anesthetic haze after surgery. (I.B.)

1. Georgia O'Keeffe, quoted in Patterson Sims, *Georgia O'Keeffe,* exh. cat. (New York: Whitney Museum of American Art, 1981), p. 19.

César Domela
(b. 1900, Amsterdam)
Neoplastic Relief Number 7, 1929

César Domela's art encompasses Modernist practice in various forms, including painting, sculpture, drawing, collage, photography, and design. Domela moved to Switzerland in 1919 to pursue landscape painting but fell headlong into abstraction in the early 1920s, when he came into contact with Russian Constructivism, and in 1924, after meeting Piet Mondrian and Theo van Doesburg in Paris, he became a member of the De Stijl group. His paintings from these years reflect the group's Neo-Plastic aesthetic, particularly that of Mondrian. Domela departed from De Stijl's strict adherence to the diametric opposition of vertical and horizontal elements, however, by introducing diagonal orientations into his compositions.

Neoplastic Relief Number 7, 1929, exemplifies Domela's breakthrough of the same year, when he shifted from flat paintings to works in relief that combine different materials. Its palette of primary colors and vocabulary of geometric forms conform to De Stijl conventions, but the composition's diagonal alignment within its rectangular frame shows just how far Domela had departed from Mondrian's rigid ideas. In an even more pronounced digression, the work plays with illusions of depth and space: the raised metal elements extend beyond the edges of the wooden support and lift away from the surface to create shadows on its painted surface.

Domela's evolution away from De Stijl can be credited, in part, to contacts that he developed with artists in Germany, such as Willi Baumeister, László Moholy-Nagy, and Kurt Schwitters. After moving to Berlin in 1927, he became acquainted with the close study of formal properties inherent in industrial materials, which was the hallmark of the Bauhaus approach, and began incorporating into his reliefs a multiplicity of elements, including glass, plastic, and wire mesh. For all of their Neo-Plastic characteristics, Domela's reliefs derived equally from the artist's lifelong interest in Taoist philosophy. Rather than imposing a preconceived design, he allowed the composition to emerge from the "natural order" inherent in the particular forms and materials that he used. (I.B.)

Ludwig Mies van der Rohe
(b. 1886, Aachen, Germany; d. 1969, Chicago)
German Pavilion, International Exposition, Barcelona, 1929

While abstract paintings and sculptures are characterized by their lack of observable referents and reliance on internal logic, abstraction in architecture is exemplified by the pure forms of the International Style. Works of this school demonstrate a Modernist focus on the present, which precludes imitation of historical precedents and naturalistic details. Ludwig Mies van der Rohe's German Pavilion for the 1929 International Exhibition in Barcelona (commonly known as the Barcelona Pavilion) has been hailed consistently as the aesthetic epitome of the International Style.

Henry-Russell Hitchcock and Philip Johnson defined the International Style in 1932, in their book of the same name.[1] They applied the term to buildings of the most advanced architects of the 1920s—Walter Gropius, Le Corbusier, J. J. P. Oud, and Mies van der Rohe—

using a name that referred to the coincidence of similar aspirations among architects of different countries. Hitchcock and Johnson identified three tendencies common to the work of the International Style architects: an emphasis on free-flowing space rather than traditional architecture's solid masses; the use of asymmetry and repetition to achieve equilibrium in place of traditional axial symmetry; and a distinct lack of applied ornament and a corresponding accentuation of the intrinsic qualities of both natural and man-made materials.[2] All of these factors presupposed an overriding functionalism; that is, the building's function was regarded as taking precedence over its symbolic role in determining its final form. In sum, the International Style embodied a radically abstract rather than imitative architectural vision.

The Barcelona Pavilion is perhaps the purest example of these qualities. Because it was planned as a temporary structure serving a ceremonial rather than utilitarian function, its architect could develop purely artistic ideas unimpeded by long-term practical considerations. The low, horizontal building is situated on an elevated terrace of light-colored stone, and the flat roof of the one-story structure is supported by slender, chrome-plated pillars. Inside, free-standing walls, intersecting at right angles, are arranged asymmetrically to create an open flow of space amenable to movement as well as discovery: as one advances through the pavilion, the walls seem to become sliding planes that reflect, expand onto, and contract from beckoning vistas. The rich, reflective surfaces capture natural light from the outside. Shining chrome and slabs of polished marble of opulent color join various types of glass—some transparent, others bottle green, translucent gray, or etched to produce a misty whiteness. A large reflecting pool in front of the building is lined in green glass and sparkles with the sun's light. A second, more intimate pool, lined in black glass and surrounded on three sides by walls of green Tinian marble, is located at the opposite end of the pavilion in a partly enclosed area.

At the center of the pavilion is an austerely majestic space, defined by a large wall constructed of onyx dorée, a rare golden marble with dark-gold to white veins. In front of this wall Mies van der Rohe placed two chairs, designed as a pair of royal thrones to accommodate the King and Queen of Spain for the ceremonial opening of the pavilion.[3] With curved metal frames and large rectangular cushions covered in white leather, the chairs are paeans to

abstract simplicity. Later known as the Barcelona Chair, the design has been widely reproduced.

Johnson has claimed that nowhere in recent history was architecture more affected by painting than in the 1920s.[4] To be sure, the Barcelona Pavilion shares important similarities with modern abstract painting, in its lack of historicist or naturalistic imitation, its emphasis on the active modulation of light, and its radical use of planar elements to create dynamic space. As the influence of Mies van der Rohe's style grew, however, its economy— specifically, the refined and delicate balance of proportions (an idea expressed in his famous dictum "Maximum effect with a minimum of means"[5])—became easily debased. As the twentieth century progressed, weak and uninspired imitations of the International Style were built, and the style evolved into an institutional architecture of faceless forms, cold geometry, and dehumanizing proportions. In its original manifestation, however, as the Barcelona Pavilion demonstrates, the style's abstracting sensibility represents a paring down of material in order to reveal subtle richnesses and to achieve a dignity of expression that resonates with human feeling and experience. (D.M.)

1. Henry-Russell Hitchcock and Philip Johnson, *The International Style* (1932; New York: W. W. Norton, 1966). Hitchcock and Johnson expanded on their ideas in their landmark 1932 exhibition, *Modern Architecture: International Exhibition*, at the Museum of Modern Art, New York.
2. Ibid., p. 13, passim.
3. Franz Schulze, *Mies van der Rohe: A Critical Biography* (Chicago: University of Chicago Press, 1985), p. 159. My description of the pavilion is especially indebted to Schulze and to Johnson, *Mies van der Rohe* (1947) (3rd ed.; New York: Museum of Modern Art, 1978).
4. Johnson, *Mies van der Rohe*, p. 21.
5. Mies van der Rohe, statement, *G*, no. 2 (September 1923); quoted in Schulze, *Mies van der Rohe*, p. 107.

Le Corbusier {Charles-Edouard Jeanneret}
(b. 1887, La Chaux-de-Fonds, Switzerland; d. 1965, Roquebrune, France)
Villa Savoye, Poissy, 1929–31

In the early twentieth century, enthusiasm for pure form and the language of collage permeated critical developments in both the visual arts and architecture. The work of Le Corbusier, perhaps more than any other practitioner of the time, embodies this cross-fertilization of ideas. An architect, painter, and theorist, he founded the Purist movement with Amédée Ozenfant in 1918 (see fig. 87). Although it depended heavily on Cubism's flattening of pictorial space and investigation of the dichotomy between

transparent and opaque forms, Purism was meant to be a more sober and refined means of expression than the earlier style. Le Corbusier and Ozenfant wrote: "Purism strives for an art free of conventions which will utilize plastic constants and address itself above all to the universal properties of the senses and mind."[1] Heralding their movement as "the new spirit" in art, from 1920 to 1925 they published a journal entitled *L'Esprit nouveau* in which they propounded classical principles of order, a sentiment echoed throughout French society in response to the ravages of World War I.

Le Corbusier's buildings evolved from this ethos of classical purity, but were equally informed by the aesthetics of modern technology. In his renowned 1923 book *Vers une architecture*, a collection of essays originally published in *L'Esprit nouveau*, Le Corbusier celebrated the idea of the architect as engineer, glorifying steamships, airplanes, and automobiles as perfect illustrations of the relation of form to function. From the 1920s on, his claim that "the house is a machine for living in" was repeatedly given expression in his designs. The Villa Savoye in Poissy, 1929–31, is the clearest summation of Le Corbusier's architectural ideas.

A collage of intersecting and overlapping geometric forms, the Villa Savoye exemplifies the application in architecture of abstract principles explored in modern painting. Supported by slim columns, the building is lifted from the ground and appears to float in the air. Its flat-roofed garden terrace introduces nature into the living environment and preserves the clarity of the building's geometric form. Le Corbusier employed a free plan, placing the structural load on the skeletal frame of the building so that interior wall configurations could be determined exclusively by spatial requirements. Its spiral staircase and system of interior ramps embody Le Corbusier's notion of the house as a machine. The horizontal ribbon windows unify the interior and exterior spaces and reveal the building's interior composition.

These principles formed the bedrock of Le Corbusier's architecture, which, along with works by Walter Gropius, Ludwig Mies van der Rohe, and J. J. P. Oud, established the International Style. Shortly after completing the Villa Savoye, Le Corbusier turned to urban planning, public housing, and civic architecture, producing some of the most significant architectural and planning projects of the twentieth century. (I.B.)

1. Charles-Edouard Jeanneret and Amédée Ozenfant, "Purism" (1920), in Robert L.

Herbert, ed., *Modern Artists on Art* (New York: Prentice Hall, 1964), p. 73.

Auguste Herbin
(b. 1882, Quiévy, France; d. 1960, Paris)
Spiral, 1933

Auguste Herbin's evolution as an abstract artist owes much to the atmosphere of Paris in the early twentieth century. Having settled in that city in 1903, Herbin initially worked in a Fauvist mode, painting portraits and landscapes in bright, unnatural colors, but he soon gravitated toward a style clearly reflecting the lessons of Paul Cézanne. In 1909, he took an atelier in the Bateau-Lavoir, home to the studios of Georges Braque, Juan Gris, and Pablo Picasso, and shortly thereafter his art assumed a decidedly Cubist orientation. He was not strictly a follower, however, for even his more derivative compositions reveal a penchant for geometric pattern and bright color, which were atypical of Cubism.

By the late 1910s and early 1920s, Herbin's paintings had developed into dense mosaics of geometric shapes that suggest an affinity with the patterns of Eastern art. During the following decade, like most artists in postwar Paris, Herbin succumbed to the call for a "return to order," and he began to employ a figurative, vaguely classical mode of representation. But in 1931, he became a founding member of the artists' group Abstraction-Création. Drawing a parallel between free thought and free form, the group defended abstract art against the reactionary cultural politics of countries such as Germany and Russia, which had forced many avant-garde artists to flee to Paris for refuge. International in scope, Abstraction-Création encompassed many diverse approaches to abstraction. Its organizing committee included Jean Arp, Albert Gleizes, Jean Hélion, František Kupka, and Georges Vantongerloo.

Herbin's *Spiral*, 1933, is a distillation of Abstraction-Création's principles and myriad other influences. Composed of arabesque lines, solid colors, and flat shapes, it reflects an interest in natural form but remains resolutely nonobjective, like the biomorphic abstractions of Arp and Vasily Kandinsky. Its harmony of complementary colors results from Herbin's evolving interest in juxtaposing different hues and tones to produce the effects of positive and negative space.

In the 1940s, Herbin's art shifted once again toward geometric abstraction, becoming wholly based upon a vocabulary of spheres, triangles, and squares. He maintained this hard-edged

Le Corbusier, Villa Savoye, Poissy, 1929–31.

Auguste Herbin, Spiral, *1933. Oil on canvas, 37 1/16 x 28 3/4 inches (95 x 73 cm). Collection of Denis Kilian, Paris.*

Jean Hélion, Equilibre, *1933–34. Oil on canvas, 38 ⅜ x 51 ⅛ inches (97.4 x 131.2 cm). Peggy Guggenheim Collection, Venice 76.2553 PG44.*

Alexander Calder, A Universe, *1934. Painted iron pipe, wire, and wood, with string and motor, 40 ½ inches (102.9 cm) high. The Museum of Modern Art, New York, Gift of Abby Aldrich Rockefeller (by exchange), 1934.*

Ben Nicholson, White Relief, *1935. Oil on board, 40 x 65 ½ inches (101.6 x 166.4 cm). Tate Gallery, London, Purchased with assistance from the Contemporary Art Society, 1955.*

geometric style—which prefigured late twentieth-century geometric abstractions—through the end of his career. (I.B.)

Jean Hélion

(b. 1904, Couterne, France; d. 1987, Paris)
Equilibre, 1933–34

When Jean Hélion began painting in the early 1920s, he worked in a figurative mode, but like many painters of the period, he became more concerned with the autonomy of forms and their liberation from references to nature. Subject matter eventually disappeared from his work, and in 1929, he exhibited his first abstract work. His goal was to make paintings completely divorced from objects in the real world. In 1929–30, Hélion was greatly influenced by Theo van Doesburg's Neo-Plastic paintings composed of strictly vertical and horizontal lines and pure colors, and in 1930, he signed van Doesburg's manifesto "Art Concret." By the end of the following year, however, he had rejected these rigid ideas and began to introduce curves into his paintings as well as mixed colors. He admired artists such as Jean Arp, Fernand Léger, and Piet Mondrian, who he believed invested spirituality in their abstract forms. In 1931, together with Arp, Albert Gleizes, Auguste Herbin, František Kupka, and Georges Vantongerloo, among others, he helped found the group Abstraction-Création, which supported the principles of pure abstraction. In 1933–34, Hélion moved from paintings composed of a single form outlined in black and began to paint larger canvases containing multiple elements with an emphasis on balance and harmony. *Equilibre*, 1933–34, features a bipartite structure, with the right half of the composition consisting of mostly rectilinear forms and the left half combining them with curves. All of the shapes are precisely rendered in red, orange, black, gray, or ivory against an off-white ground. Hélion returned to figuration following World War II, dissatisfied with the isolation he felt in abstraction and sharing the widespread postwar desire for human content in painting. (I.B.)

Alexander Calder

(b. 1898, Lawnton, Pennsylvania; d. 1976, New York City)
A Universe, 1934

After attaining a degree in engineering, Alexander Calder studied at the Art Students League in New York from 1923 to 1926. He began his career as a painter, and made his first sculpture in 1925. In the following years, he produced a large group of humorous

figurative wire sculptures based on the theme of the circus. In 1926, he went to Paris for the first time and from 1928 on divided his time between there and the United States. In Paris, he met avant-garde artists such as Joan Miró, Theo van Doesburg, and members of the Russian Constructivist and Surrealist movements. The year 1930 brought two seminal moments in Calder's career: he visited Piet Mondrian's studio and abandoned his figurative wire sculptures for abstract constructions.

Calder claimed that he discovered the word "abstract" in Mondrian's studio and described his visit there as a shock. Yet many other factors that came into play during this period seem equally to explain the transition to abstraction that occurred in his work. In 1931, he was persuaded by Jean Arp and Jean Hélion to join the Abstraction-Création group, which supported nonobjectivity, even though his own work combined the purely abstract with Surrealist biomorphic abstraction.

In *A Universe*, 1934, a work informed by the artist's engineering skills in its balanced construction of cantilevers and suspended wires, Calder combined all of these influences. Like many of his works from the early 1930s, the sculpture employs the theme of the planets and their rotations. His vocabulary of forms and hues, which he limited to spheres and ovoids and to primary colors and black, recalls that of Miró. The motorized system that propels the spheres is evidence of Calder's consuming interest in motion. This concern is seen also in Calder's best-known works, the mobiles that he began making in the early 1930s, in which motion finds expression not in mechanics but in more organic means (see figs. 94–96). (I.B.)

Ben Nicholson

(b. 1894, Denham, England; d. 1982, London)
White Relief, 1935

Along with sculptors Barbara Hepworth and Henry Moore, Ben Nicholson was one of the first practitioners of abstract art in England. *White Relief*, 1935, illustrates Nicholson's Modernist concerns: the purely formal qualities of line, shape, and color are emphasized; the work is autonomous and self-referential, without any visible connection to the external world; and its nonillusionistic space, literal depth, and smooth surfaces suggest the artist's respect for the inherent qualities of his materials and an honest and direct expression of his artistic ideas.

Although Nicholson worked primarily as a painter throughout his

long career, in 1934 he began to carve reliefs in wood. He painted each of his earliest reliefs in a few muted colors—browns, grays, ochers—but in 1935 shifted to white only, as he thought that this would enable him to concentrate purely on form. In the 1930s, white was a significant part of the new aesthetics of purity, as exemplified by International Style architecture and contemporaneous interior design.

White Relief displays the paradox common to much geometric abstraction: as a three-dimensional object producing a play of real light and space, the work stresses its own materiality, grounding it in the real world, yet the absence of external references in the work was intended to suggest an otherworldly realm. This aspect of the object was underscored by Nicholson's use of white, for in addition to its traditional evocations of simplicity and purity, white also suggests light, which has long been associated with spirituality. In 1934, Nicholson said: "As I see it, painting and religious experience are the same thing, and what we are all searching for is the understanding and realisation of infinity—an idea which is complete, with no beginning, no end, and therefore giving to all things for all time."[1]

Nicholson saw his white reliefs as an expression of the "constructive idea." While Russian Constructivism emphasized the investigation of the properties of materials and the potential for art's practical application, the English proponents of Constructivism wanted to unify painting, sculpture, architecture, and life, believing all areas of life and nature to rely on a series of common forms.[2] Nicholson claimed abstract art to be a potent part of everyday life, as could be seen in its influence on contemporary architecture and design. For him, abstraction symbolized freedom and universality: "I think that so far from being a limited expression, understood by a few, abstract art is a powerful, unlimited and universal language. Within the means of abstract expression there are immense possibilities and it is a language with a power peculiar to itself."[3] (R.B.)

1. Ben Nicholson, statement, in Herbert Read, ed., *Unit One* (London: Cassell, 1934), p. 89; reprinted in Maurice de Sausmarez, ed., *Ben Nicholson* (London: Studio International, 1969), p. 31.
2. Jeremy Lewison, *Ben Nicholson* (New York: Rizzoli, 1991), p. 17.
3. Nicholson, "Notes on Abstract Art," *Horizon* 4, no. 22 (October 1941); revised and reprinted in Herbert Read, ed., *Ben Nicholson* (London: Lund Humphries, 1948); excerpted in de Sausmarez, ed., *Ben Nicholson*, p. 34.

Barbara Hepworth

(b. 1903, Wakefield, England; d. 1975, St. Ives, Cornwall, England)
Two Segments and Sphere, 1935–36

In the late 1920s, Barbara Hepworth's sculpture began to move toward nonobjectivity. In her nearly abstract work of the early 1930s, she often incorporated an incised line that delineates a profile or an eye, deliberately reinforcing the work's figuration. She first pierced the mass of a sculpture in *Pierced Form*, 1931 (now destroyed), also known as *Abstraction*. Dramatically breaking with the tradition of the closed sculptural form, this piercing, which was later adopted by Henry Moore, yielded a newly liberated practice. In 1931, Hepworth met Ben Nicholson, her future husband, and in the following two years they traveled to Paris, where they visited the studios of Jean Arp and Sophie Taeuber-Arp, Constantin Brancusi, Georges Braque, Jean Hélion, Piet Mondrian, and Pablo Picasso, all of whom informed their thinking about abstraction. In Paris, they also joined the group Abstraction-Création. Along with Moore and the critic Herbert Read, Hepworth and Nicholson became the British link to a community of international abstract artists.

In 1934, Hepworth began making completely abstract sculptures with no explicit reference to natural forms. Instead, she aimed to infuse the formal geometry of her sculptures with nature. She was interested in the spatial tension between forms, a concern that is fundamental to *Two Segments and Sphere*, 1935–36. This sculpture also testifies to her use of a limited vocabulary of primary forms (such as the sphere and the ovoid) and her allegiance to the beauty of materials. (I.B.)

Matta [Roberto Sebastián Matta Echaurren]

(b. 1911, Santiago, Chile)
Invasion of the Night, 1941

Invasion of the Night, 1941, is an example of what Matta called his "psychological morphologies" or "inscapes," works that convey the artist's belief that "reality can only be represented in a state of perpetual transformation."[1] By adding the word "psychological" to "morphology," which means the study of the evolution of forms, Matta described the mutating objects in his paintings as metaphors for changing psychic states. *Invasion of the Night* contains the acidic colors, abstract forms, and ambiguous definition of space typical of these works. The writhing shapes evoke a variety of organic entities, such as volcanoes, male and female genitals, blood, flames, and microscopic organisms. The gelatinous space seems to be as solid as the organic forms that sink, float, and melt within it, obscuring any reading of depth in the painting.

Matta moved to Paris from Chile in 1933, and a few years later began to associate with the Surrealist circle. Sharing the Surrealists' belief that the subconscious mind is the source of all human creativity, Matta adopted the group's practice of automatism. He approached his canvas without having conceived the painting's subject matter or composition and let ideas flow, uncontrolled, from his subconscious. In making a painting, he generally poured or rubbed onto his support thin washes of pigment, which he smeared with his hand or a cloth before using a brush to define individual forms. Like most of the Surrealists, Matta preferred biomorphic shapes, although he took them to a much greater degree of abstraction than other artists. He felt that the associations that they can suggest to the viewer are nearly limitless. Matta's psychological morphologies were also influenced by the highly personal, fantastic perspectives on Latin American nature found in the poetry of the Comte de Lautréamont and Gabriela Mistral, as can be seen in *Invasion of the Night*'s nightmarish landscape of molten skies that devour the earth and its mutant organisms.

During the 1940s, Matta's emphasis on abstraction, violent emotion, and evocative colors and forms played a key role in the development of American Abstract Expressionism. Matta lived in New York from 1939 to 1948, and, more than any of the other Surrealists who took refuge in the United States during World War II, was responsible for introducing Abstract Expressionist artists to automatism. Matta's psychological morphologies attracted the budding Abstract Expressionists, who found inspiration in the works' visual analogies of the artist's conscious and subconscious states, their evocation of conflicts between opposing forces, and their use of abstraction to convey content that was personally and socially meaningful. Matta's emphasis on the utopian, international, and moral dimensions of art were also extremely influential. He believed that the objective of all art, including abstraction, is not to create beauty, but rather to "show man in his social situation, to show how he lives."[2] (R.B.)

1. Matta, *Matta, Entretiens Morphologiques: Notebook No. 1, 1936–1944*, ed. Germana Ferrari (London:

Sistan, 1987), p. 11; quoted in Valerie Fletcher, *Crosscurrents of Modernism: Four Latin American Pioneers* (Washington, D.C.: Hirshhorn Museum and Sculpture Garden, in association with Smithsonian Institution Press, 1992), p. 241.
2. Matta, "An Invitation to Artists," in *Matta: The Logic of Hallucination*, exh. cat. (London: Arts Council of Great Britain, 1984), p. 1.

Jean Fautrier

(b. 1898, Paris; d. 1964, Châtenay-Malabry, France)
Oradour-sur-Glane, 1945

As a child, Jean Fautrier moved from France to London, where he was exposed to the paintings of J. M. W. Turner at the Tate Gallery. This proved to be a formative experience, for Turner's work, with its paint swirling turbulently across the canvas and forms that dissolve into passages of color, would be a touchstone for Fautrier throughout his career.

Fautrier returned to France in 1917, and in the period following World War I he painted figurative compositions in a coarse, expressionist style, with a palette ranging from earth-toned to more brightly colored oils. By the early 1930s, Fautrier developed a more abstract language based on scrawled lines and washes of luminous color. He also began to explore a method that involved gluing layers of paper to the canvas to create a textured, porous ground for thick applications of paint. This technique paved the way for the emergence of his distinct style.

Fautrier's *Hostage* paintings represented a breakthrough in his work. Begun in 1942, the series was inspired by the horrors of Nazi atrocities in France. *Oradour-sur-Glane*, 1945, a seminal painting in the series, commemorates the destruction of a small rural community during the war. A collage of paint, dry pigment, paper, and canvas, the composition contains in its scumbled, rocky surface the discreet likeness of a human face with rough-hewn features. The work's volcanic quality, which led André Malraux to characterize the *Hostage* series as "a hieroglyph of pain,"[1] serves as a metaphor for the obliteration of the village.

With their emphasis on material over form, the *Hostage* paintings established Fautrier as a pioneer of Art Informel. Often characterized as a relative of American Abstract Expressionism, Art Informel encompassed the meditative and ethereal paintings of Fautrier and the more aggressive works of Jean Dubuffet, the style's other primary exponent. (I.B.)

1. André Malraux, Preface, in *Otages*, exh. cat. (Paris: Galerie René Drouin, 1945), unpaginated.

Barbara Hepworth, Two Segments and Sphere*, 1935–36. White marble, 12 inches (30.5 cm) high. Private collection.*

Matta, Invasion of the Night*, 1941. Oil on canvas, 38 x 60 ⅛ inches (96.5 x 152.7 cm). San Francisco Museum of Modern Art, Bequest of Jacqueline Marie Onslow-Ford.*

Jean Fautrier, Oradour-sur-Glane*, 1945. Oil, water-based paint, and dry pigment on paper, mounted on canvas, 57 ⅛ x 44 ⅛ inches (145 x 112.7 cm). The Menil Collection, Houston.*

Isamu Noguchi, Humpty Dumpty, *1946. Ribbon slate, 58 ¾ inches (149.2 cm) high. Whitney Museum of American Art, New York, Purchase.*

Lee Krasner, Noon, *1946. Oil on linen, 24 x 30 inches (61 x 76.2 cm). Private collection.*

Willem de Kooning, Painting, *1948. Enamel and oil on canvas, 42 ⅛ x 56 ⅛ inches (108.3 x 142.5 cm). The Museum of Modern Art, New York, Purchase, 1948.*

Isamu Noguchi
(b. 1904, Los Angeles; d. 1988, New York City)
Humpty Dumpty, 1946

Isamu Noguchi was born to an American mother and a Japanese father, and amalgamated in his work the influences of these two cultures. After spending his childhood in Japan, Noguchi returned to the United States in 1917, and in the early 1920s decided to become a sculptor. Although his early work was rooted in classical figuration, his attitude toward representational sculpture soon began to change.

In 1927, Noguchi traveled to Paris, where he became Constantin Brancusi's studio assistant for two years. This was a seminal experience for the younger artist. In Brancusi's studio, he mastered the techniques of carving natural materials, which would become his primary method. Also, he proclaimed, "It became self-evident to me that in abstraction lay the expression of the age."[1] The reduction of natural forms to their essential structure in Brancusi's sculptures became an important element of Noguchi's art. Yet throughout his career, Noguchi deviated from his teacher's purest abstraction and experimented with a variety of forms.

In the 1930s, when social realism prevailed in American art, Noguchi became interested in the broader implications of art, but while pursuing landscape-architecture projects and embarking on functional object designs, he maintained his commitment to the communicative power of abstraction. After he was voluntarily incarcerated at an Arizona detention camp for Japanese-Americans, Noguchi's work began to reflect the anxiety of the period. It also manifested the influence of the Surrealist artists who had escaped wartime Europe and settled in New York. Noguchi's works of the mid- to late 1940s, such as *Humpty Dumpty*, 1946, were carved from inexpensive thin marble or slate slabs used for building façades. They recall Yves Tanguy's dry landscapes, Pablo Picasso's Surrealist-inspired figures of the 1930s, and Noguchi's own constructivist pieces of the late 1920s. *Humpty Dumpty* consists of interlocking biomorphic planar forms reminiscent of Surrealist painting. The sculpture also reflects the delicate balance of the human condition in the postwar period and a highly personal investigation of the artist's transcultural sources. Noguchi said: "The essence of sculpture is for me the perception of space, the continuum of our existence. . . . If I say that growth is the constant transfusion of human meaning into the encroaching void, then how great is our need today when our knowledge of the universe has filled space with energy, driving us toward a greater chaos and new equilibriums."[2] (I.B.)

1. Isamu Noguchi, quoted in Sam Hunter, *Isamu Noguchi* (New York: Abbeville, 1978), p. 33.
2. Noguchi, quoted in Henry Geldzahler, *Isamu Noguchi: What Is Sculpture?*, exh. cat. (New York: P.S.1, Institute for Art and Urban Resources, 1986).

Lee Krasner
(b. 1908, New York City; d. 1984, New York City)
Noon, 1946

Influenced by the work of European Modernists including Henri Matisse, Joan Miró, Piet Mondrian, and Pablo Picasso, which she saw at the Museum of Modern Art in New York, Lee Krasner began painting in a completely abstract style prior to World War II. She also adopted the grid framework and Fauvist color of Hans Hofmann, her teacher at the Art Students League. As her painting continued to develop, however, Krasner became one of the boldest and most thoughtful American interpreters of European abstraction.

Like other first-generation Abstract Expressionists, such as her husband, Jackson Pollock, Krasner was concerned with the physical act of painting, yet her art tends to be more ordered and deliberate than that of her peers. Krasner's distinct approach first became evident in compositions such as *Noon*, 1946. The work is part of her *Little Image* series—paintings with dense, allover patterns of rhythmically organized opaque brushstrokes. The small, mosaiclike divisions of these canvases replaced the large, geometric shapes of earlier paintings such as *Blue Square*, 1939–43, and emphasize the works' frontality, shallow depth, and tight-knit gestural energy. Although *Noon* evokes Pollock's skeins of dripped paint, Krasner's works are hardly the result of the expansive, improvisational style used by Pollock. Rather, they derived from a powerful but thoughtfully controlled use of gesture, reined in by the easel-size canvas and gridded structure that the artist imposed as constraints.

Abstraction remained a lifelong investigation for Krasner. In the 1950s, her work assumed a more calligraphic or hieroglyphic style. In 1953, she began to cut up many of her previous paintings, using the parts as collage elements for new compositions. The later works are more expansive, monumental, and looser in handling than works such as *Noon*. (I.B.)

Willem de Kooning
(b. 1904, Rotterdam)
Painting, 1948

Willem de Kooning never approached abstraction with the zeal of some of his contemporaries, although he was influenced by both Arshile Gorky and the Cubists and was fully acquainted with the abstractions of his compatriot Piet Mondrian. De Kooning made figurative works during the 1930s and 1940s, like many of his peers in the United States. He moved toward abstraction beginning in the early 1940s, and at his first solo exhibition in 1948 he showed his black-and-white abstractions of the few previous years. But after returning to figurative works with his *Woman* series in the early 1950s, he then oscillated between figuration and abstraction, aggravating the New York art world, which was fervently embroiled in a debate over the two. Rather than supporting a dogmatic commitment to a style, de Kooning's art made a case for a move toward painting with complete freedom.

De Kooning attained a fluidity in *Painting*, 1948, sometimes even allowing the enamel housepaint to run. The spontaneous action of the brushwork produced an extremely charged composition, which is suffused with organic imagery without referring to natural objects with any specificity. Some parts of the canvas are densely filled with energetic visual incident, while others contain spaces that allow for visual respite. Jagged, brittle lines of white paint hover above the more solid infrastructure of the picture.

De Kooning's interest in Cubism is especially apparent in this work, in its sense of flatness and shallow space. His paintings also evoke the automatism of the Surrealists, although he maintained an underlying order in his work. However, the loose, gestural painterly execution and absence of recognizable objects in *Painting* identify this work as part of the movement referred to by Harold Rosenberg as Action painting. (I.B.)

Hans Hartung
(b. 1904, Leipzig, Germany; d. 1989, Antibes, France)
T50 Painting 8, 1950

T50 Painting 8, 1950, is characteristic of the style developed by Hans Hartung in the 1940s. The painting is completely abstract, containing a combination of broad swaths of color and gestural marks reminiscent of calligraphy. While Hartung was a pioneer of European Art Informel, his statement that he wanted to "act on canvas" earned him comparisons to American Abstract Expressionist artists. Although

his simple compositions and the intense energy of his brushstrokes are reminiscent of paintings by Adolph Gottlieb and Franz Kline, his stylistic development owed more to his early interests in German Expressionism and the work of Vasily Kandinsky.

Hartung was an abstract artist almost from the very beginning of his career, having experimented with free form in drawings as early as 1922. After emigrating to Paris in the 1930s to escape Nazi oppression, he began to explore variations on Cubism and Surrealism, but then settled on a vocabulary of linear and gestural forms, offset against washes of diffuse color. Along with Jean Fautrier, Wols, and other artists associated with Art Informel, Hartung pursued a style that was intended to liberate French painting from hard-edged geometric abstraction. In the 1960s, Hartung gravitated toward Color-field painting, only to revert to large-scale gestural works in the 1970s and through the end of his life. (I.B.)

Jackson Pollock
(b. 1912, Cody, Wyoming; d. 1956, The Springs, New York)
Number 1, 1950 (Lavender Mist), 1950

The networks of lines in Jackson Pollock's drip paintings from 1947 through 1950, such as *Number 1, 1950 (Lavender Mist)*, 1950, inscribe the visceral aspects of the artist's being at the moment of each work's creation. Executed at an intense level of concentration, they record the flow of the artist's psychic energy and physical movement in complex webs of poured and strewn lines, splattered puddles, and coalesced pools of paint. Pollock stated in 1950, "Today painters do not have to go to a subject matter outside of themselves. . . . They work from within."[1] He wanted to convey in his paintings the vital impulses of his mind and body, untouched by the filtering process of everyday consciousness and the socialized world, seeking to collapse the time lag between impulse and execution. He explained, "When I am *in* my painting, I'm not aware of what I'm doing. It is only after a sort of 'get acquainted' period that I see what I have been about. I have no fears about making changes, destroying the image, etc., because the painting has a life of its own."[2]
Lavender Mist is one of Pollock's largest works, and is perhaps his most masterful solution to the quest of making paintings imbued with vital energy. It consists of layered skeins of paint in pink, blue, black, white, off-white, and silver, delicately built up to produce a complex texture and subtle

depth. In describing this work, E. A. Carmean, Jr. stated that Pollock went beyond the "molecularization" of the painting surface typical of his works of this period, achieving an astonishing "pulverization of its allover fabric."[3] In creating his paintings, Pollock approached the work from above, laying the canvas on the floor and working around and into it from all four sides. He used both fine and industrial paint, and often added materials to the painted surface, including sand and cigarette butts, as well as other studio detritus.

Pollock's handprints appear at the far left and upper right of *Lavender Mist*. An uncommon feature in the artist's paintings, the handprints are something of a telling gesture, for as the 1950s progressed, Pollock began to re-introduce figuration into his work. This has been interpreted as a response to critics likening his paintings to "decorative wallpaper." Yet a more profound explanation for Pollock's abandonment of pure abstraction is that the process of his heroic nonobjectivity demanded too much dissolution of the self, producing an uncomfortable sense of alienation in the artist, who was more prone to attempt to "anchor" his insecurities.[4] In light of this, the handprints seem to be a poignant, ghostly gesture, an attempt to "hold on." (D.M.)

1. Jackson Pollock, quoted in William Wright, "An Interview with Jackson Pollock" (1950), in Ellen H. Johnson, ed., *American Artists on Art: From 1940 to 1980* (New York: Harper and Row, 1982), p. 5.
2. Pollock, "My Painting," *Possibilities* 1 (winter 1947–48); reprinted in Johnson, ed., *American Artists on Art*, p. 4.
3. E. A. Carmean, Jr., "Jackson Pollock: Classic Paintings of 1950," in Carmean, Eliza E. Rathbone, and Thomas B. Hess, *American Art at Mid-Century: The Subjects of the Artist*, exh. cat. (Washington, D.C.: National Gallery of Art, 1978), p. 130. Carmean carefully analyzed *Lavender Mist* in this essay.
4. Brian O'Doherty, *American Masters: The Voice and the Myth* (New York: Random House, 1973), p. 107.

Barnett Newman
(b. 1905, New York City; d. 1970, New York City)
Vir Heroicus Sublimis, 1950–51

Barnett Newman's austere technique, as seen in *Vir Heroicus Sublimis*, 1950–51, points to his antipathy toward the notion of abstract artworks as beautiful objects, subject to the vagaries of personal taste, just as his renunciation of references to natural imagery points to his desire to free art from the contingencies of everyday life. The painting's clearly defined lines accent and energize the large expanse of flat, unmodulated color and echo the framing edges. He suppressed all sensual qualities by applying paint with

a roller, eliminating texture, personal touch, and expressivity. Newman believed that art must be abstract because it is about "pure" ideas and metaphysical concerns, not about the world of physical appearances. He was a great admirer and active promoter of archaic and tribal art, particularly that of Northwest Coast Indian societies, because art in these cultures was purposeful rather than utilitarian or decorative, serving an integral function in religious and daily life. In his catalogue foreword for *The Ideographic Picture*, a 1947 exhibition that he organized and in which he participated, he explained what he saw as the congruence between the aims of tribal and modern artists. He wrote, "The abstract shape [that the Kwakiutl artist] used, his entire plastic language, was directed by a ritualistic will toward metaphysical understanding. . . . To him a shape was a living thing, a vehicle for an abstract thought-complex, a carrier of the awesome feelings he felt before the terror of the unknowable. . . . Spontaneous, and emerging from several points, there has arisen during the war years a new force in American painting that is the modern counterpart of the primitive art impulse."[1]

The title of this work—which means Heroic Sublime Man—relates to Newman's belief that the "first man was an artist," and that his first speech, his first marks, were symbols of his courageous efforts to confront and understand the unknown.[2] All of these meanings are compressed into his economical stripe or "zip" paintings (see also figs. 112–16, and 123). The "zip" can be read as a metaphor for a human being, assertively upright and individual amidst the surrounding chaos. It also represents the "first man's" original, poetic outcry against the void, and his first—artistic—mark. Noting Newman's interest in the Kabbala, a tradition of Jewish mysticism, art historian Thomas B. Hess saw the "zips" as re-enactments of the divine creative gesture: through an act of division and separation, an image is created from the nothingness of the void.[3] Although Newman was Abstract Expressionism's most thoughtful and prolific polemicist and shared the group's desire to infuse abstract art with significant spiritual content, his paintings, unlike those of his colleagues, were generally not well received in the 1950s. However, they were enthusiastically praised by a younger generation of abstractionists in the 1960s who embraced their extreme formal reductivism while largely ignoring their metaphysical meanings. (R.B.)

1. Barnett Newman, "The Ideographic Picture" (1947), in John P. O'Neill, ed., *Barnett Newman:*

Hans Hartung, T50 Painting 8, *1950. Oil on canvas, 38 ⅛ x 57 ½ inches (96.8 x 146.1 cm). Solomon R. Guggenheim Museum, New York 54.1367.*

Jackson Pollock, Number 1, 1950 (Lavender Mist)*, 1950. Oil, enamel, and aluminum paint on canvas, 7 feet 3 inches x 9 feet 10 inches (2.21 x 3 m). National Gallery of Art, Washington, D.C., Ailsa Mellon Bruce Fund 1976.37.1.*

Barnett Newman, Vir Heroicus Sublimis, *1950–51. Oil on canvas, 7 feet 11 ⅜ inches x 17 feet 9 ¼ inches (2.42 x 5.14 m). The Museum of Modern Art, New York, Gift of Mr. and Mrs. Ben Heller, 1969.*

Robert Rauschenberg, White Painting, *1951. Oil on canvas, two panels, 6 x 8 feet (1.83 x 2.44 m) overall. Collection of the artist.*

Helen Frankenthaler, Mountains and Sea, *1952. Oil on canvas, 7 feet 2 ⅛ inches x 9 feet 9 ¼ inches (2.2 x 2.98 m). Collection of the artist, on extended loan to the National Gallery of Art, Washington, D.C.*

Alberto Burri, Sack 5 P, *1953. Oil and burlap, 59 x 51 ⅛ inches (150 x 129.9 cm). Fondazione Palazzo Albizzini, Collezione Burri, Città di Castello.*

Selected Writings and Interviews (New York: Alfred A. Knopf, 1990), p. 108.
2. Newman, "The First Man Was an Artist" (1947), in ibid., p. 158.
3. Thomas B. Hess, *Barnett Newman*, exh. cat. (New York: Museum of Modern Art, 1971), p. 56.

Robert Rauschenberg
(b. 1925, Port Arthur, Texas)
White Painting, 1951

In the early 1950s, when gestural abstraction reigned supreme in New York, Robert Rauschenberg shocked the art world with the neutral, uninflected surfaces of his abstract *White Paintings*. By using a roller to cover these canvases with ordinary housepaint, Rauschenberg eliminated all traces of the artist's hand and seemed to disavow the possibility of personal expression. During the summer of 1951, Rauschenberg executed six *White Paintings*, each consisting of one or more panels. The paintings reflect an unusual combination of impersonality and spirituality, for, although Rauschenberg rejected the Abstract Expressionists' valorization of heroic individualism, he shared their belief that art could change the world.

For Rauschenberg, abstraction is a way to break down the boundaries between art and life. He thought that the emptiness of the *White Paintings* makes them "hypersensitive" to their surroundings: "One could look at them and almost see how many people were in the room by the shadows cast, or what time of day it was."[1] One of Rauschenberg's friends, avant-garde composer John Cage, was also struck by the way these flat, pristine surfaces respond to the environment, and described them as "airports for lights, shadows, and particles."[2] The paintings convinced Cage of the artistic possibilities of silence and inspired him to create *4'33"*, his most famous composition, consisting of a pianist sitting motionless at an open keyboard for four minutes and thirty-three seconds, thus focusing attention on the ambient sounds in the auditorium. Similarly, Rauschenberg's *White Paintings* downplay the role of the artist, refocusing the viewer's attention on his or her own situation and surroundings. In their emphasis on "real" time and space, monochrome coloring, anonymous surfaces, and a modular, nonrelational structure, the *White Paintings* anticipated Minimalism's cool attitude by nearly a decade. (R.B.)

1. Robert Rauschenberg, quoted in Mary Lynn Kotz, *Rauschenberg/Art and Life* (New York: Harry N. Abrams, 1990), p. 76.
2. John Cage, "On Robert Rauschenberg," *Metro* 2 (1959–60), p. 43; quoted in ibid., p. 76.

Helen Frankenthaler
(b. 1928, New York City)
Mountains and Sea, 1952

Made in October 1952, *Mountains and Sea* was the first painting that Helen Frankenthaler produced using her now famous soak-stain technique. Although other artists had used some staining in their works—generally as a kind of underpainting—Frankenthaler was the first to fully exploit the possibilities of this method. The painting was motivated by her desire to "shape the totally abstract memory of the landscape" that she had seen in Nova Scotia the previous summer.[1] Working from the center outward, she poured diluted paint onto unsized, unprimed cotton-duck canvas stapled to the floor of her studio. The colors soaked into the surface, creating subtle spatial ambiguities. In some areas, the pale, thin colors seem to hover slightly in front of the picture plane; in others, overlapping color shapes suggest an illusion of spatial recession. In both cases, the paint's transparency allows the weave of the canvas to show through, calling attention to the literal flatness of the support and emphasizing the illusoriness of pictorial space.

It was precisely this tension between literal flatness and pictorial illusion that made critic Clement Greenberg an early champion of Frankenthaler's work. As a formalist, Greenberg believed that all painting must fulfill three criteria: abstraction, truth to materials, and opticality. By eliminating all references to the material world, abstraction places art in an ideal realm and implicitly critiques materialist civilization. His idea of truth to materials meant that each art should exemplify the qualities and effects peculiar to its medium and rigorously eschew all others. Painting should therefore emphasize flatness, line, shape, color, and the illusory nature of pictorial space. Last, he believed that painting and sculpture should address themselves to the eye alone. This opticality denies that art is an object like any other human-made artifact, thereby negating art's commodity status. According to Greenberg, *Mountains and Sea* brilliantly succeeded on all three counts.

Jackson Pollock was a major influence on Frankenthaler, not only for his limited use of staining but also for the way he used his entire body to drip and fling paint onto large canvases laid on the floor. She took his process one step further and, without any intermediary implement, poured paint directly onto the canvas. When fellow painter Morris Louis saw *Mountains and Sea* in her studio in early 1953, he called it a

"bridge between Pollock and what was possible,"[2] pointing to the painting's significance for the Color-field painters of the 1960s. (R.B.)

1. Helen Frankenthaler, quoted in Gene Baro, "The Achievement of Helen Frankenthaler," *Art International* 11, no. 7 (September 1967), p. 36.
2. Morris Louis, quoted in John Elderfield, *Frankenthaler* (New York: Harry N. Abrams, 1989), p. 65.

Alberto Burri
(b. 1915, Città di Castello, Italy; d. 1995, Nice, France)
Sack 5 P, 1953

Ripped and stained, stitched and painted, the surfaces of Alberto Burri's *Sacchi* (Sacks) focus the viewer's attention on the artist's use of materials. The color and texture of *Sack 5 P*, 1953, were largely determined by the used burlap sacks with which it was made, while the fabric's gaping holes and ragged flaps give the piece a literal three-dimensionality. Burri was among the first of a growing number of European artists to turn to humble materials in the years immediately following World War II. These artists wanted to emphasize the material nature of art and to give abstraction a new significance, one that would reflect the spirit of the age. What could be more appropriate to societies devastated by war than an art based on materials worn or even ravaged by time and use?

Like many of his peers, Burri feared that abstraction was succumbing to a tendency toward mere decoration and that it was thus becoming sterile. In 1951, he signed the manifesto of the Gruppo Origine, whose stated goal was to return abstract art to the purity of its origins through the rejection of descriptive color, a focus on elementary images, and an antidecorative vision.[1] They hoped to revitalize abstract art by infusing it with the spiritual purpose it seemed to have had at the beginning of the twentieth century. By incorporating discarded sacks and investing his collages with a sense of real space, Burri produced works that are resolutely abstract yet richly evocative. The *Sacchi* (see also fig. 140) intimate the physical and spiritual redemption of the suffering human body. In *Sack 5 P*, the viscous red paint, stitched seams, and soiled fabric suggest bloody flesh wounds, carefully sutured and tenderly bandaged, perhaps referring to the artist's experience as a doctor in the Italian army during World War II, while the burlap alludes to sackcloth, with its connotation of salvation through humility and penitence. These collages also exemplify the transformative power of abstract art: the refuse of daily life, wrenched from its normal context, is aestheticized and

therefore ennobled. Last—and most important—the sack collages can be read as metaphors for "saving" and "healing" abstract art itself. Throughout his long career, Burri subjected diverse nonart materials (burlap, plastic, wood, and iron) to a variety of destructive and healing processes (ripping, burning, and sewing), creating abstractions that hint at the redemptive power of art. (R.B.)

1. "Manifesto of the Gruppo Origine" (1951), trans. Stephen Sartarelli, in *The Italian Metamorphosis, 1943–1968*, exh. cat. (New York: Guggenheim Museum, 1994), p. 714.

Robert Motherwell

(b. 1915, Aberdeen, Washington; d. 1991, Cape Cod, Massachusetts)
Elegy to the Spanish Republic No. 34, 1953–54

The *Elegies to the Spanish Republic* are Robert Motherwell's best-known works. Between 1949 and his death in 1991, he produced approximately 150 paintings on this theme, attesting to its importance in his oeuvre. All the pictures in the series share a similar format: black, irregular vertical and ovoid forms arrayed against a predominantly white background, sometimes containing patches of earthy colors. The biomorphic forms, somber palette, and stark pictorial oppositions—of black and white, vertical and oval—are meant to convey a sense of heroic struggle and tragic loss. Motherwell managed to produce an extraordinary variety within these seemingly narrow, self-imposed parameters. He attributed this fecundity of design to "psychic automatism," a technique that he borrowed from the Surrealists. But where the Surrealists had developed this procedure to aid them in discovering their unconscious desires, Motherwell used it in hopes of finding universal truths.

Motherwell was one of the earliest proponents of Abstract Expressionism and one of its major theorists. As his numerous essays show, he shared the group's sense of alienation from modern industrial society and their desire to imbue abstract art with ethical and moral force. He viewed abstraction, with its emphasis on the purely formal qualities of art, as a symbolic rejection of modern materialism: by eschewing figuration and references to the natural world, he hoped to convey eternal, spiritual values. These ideas link him to a romantic tradition of abstraction begun by the French Symbolist poets in the late nineteenth century. Like the Symbolists, Motherwell believed that abstract form is inherently meaningful, capable of transcending cultural conventions and therefore uniquely suitable for expressing the "universal"

and "timeless" experiences of life. However, Motherwell feared that an art with no recognizable imagery would be open to criticism as mere decoration. In an attempt to infuse these abstractions with socially relevant meanings, he dedicated them to the Spanish Republic, which had fallen to Fascist forces in 1939. Conversely, through abstraction, the paintings transcend the tragedy of any particular historical event and become a metaphor for the modern artist's futile struggle against the dehumanizing forces of materialism.[1] (R.B.)

1. Bradford R. Collins, "The Fundamental Tragedy of the *Elegies to the Spanish Republic*, or Robert Motherwell's Dilemma," *Arts Magazine* 59, no. 1 (September 1984), p. 96.

François Morellet

(b. 1926, Cholet, France)
Broken Arc of a Circle, 1954

The fractured geometry of François Morellet's *Broken Arc of a Circle*, 1954, humorously undermines the order, purity, and rationality associated with geometric abstraction. Here, a blue arc has been fragmented and dispersed over four separate canvases. Since the canvases are aligned but the pieces of the arc are not, any attempt to mentally recreate a pristine, unbroken arc are continually frustrated. Furthermore, any attempt to fill in the blanks in the discontinuous form draws the wall itself into the artwork. Morellet's spare, abstract vocabulary, anonymous surfaces, and literal sensibility (as demonstrated by the work's title, which merely states what it is) prefigured the Minimalist aesthetic and detached attitudes of many 1960s artists in Europe and America.

Totally opposed to the romantic, mystical, and metaphysical meanings ascribed to geometric abstraction, Morellet tried to create a purely visual and nonreferential art. He turned to geometric form because it seemed the most neutral and the most resistant to meaning. Morellet determined the disposition of the geometric elements in his work by using a system that was "simple, obvious and preferably absurd," and one that demonstrated his delight with the "marriage between order and disorder."[1] The strategies that he relied on—fragmentation, juxtaposition, superimposition, interference, chance, and destabilization—reduce artistic subjectivity to a minimum and increase the impersonality of his works. In a written statement from 1972, Morellet compared his abstractions to "picnic areas" where everyone eats only what they themselves have brought along. He declared that for the past twenty years he had "made useless (and therefore artistic) things, hallmarked by no

interest whatsoever in composition or execution, and by the presence of simple and obvious systems . . . I have (hopefully) reduced to a minimum my own hand in things, my creativity and my sensibility. I can therefore alert you to the fact that everything else you might (or might not) find, beyond my little systems, belongs to you, spectator."[2] Morellet's abstractions shift the focus away from the artist's intentions and toward the viewer's experience; the observer, not the artist, becomes the creator of all meanings. (R.B.)

1. François Morellet, quoted in Serge Lemoine, *François Morellet* (Zurich: Waser Verlag, 1986), pp. 43, 56.
2. Morellet, statement (1972), in ibid., p. 54.

Clyfford Still

(b. 1904, Grandin, North Dakota; d. 1980, Baltimore)
1954, 1954

One of the most striking aspects of Clyfford Still's abstractions is their scale. In the 1954 work illustrated here, large areas of flat color appear to be arbitrarily cut off by the edges of the canvas, suggesting that the painting continues indefinitely into space. The painting's large size and emphatic verticality reinforce the sense of boundlessness. Figure and ground are fused into a seamless whole, signifying the unlimited potentiality of formlessness. Through these devices, Still hoped to evoke feelings of liberation and exaltation in the spectator. Like his fellow Abstract Expressionists, Still was interested in the notion of the Sublime. Originating in the eighteenth century, the term describes the sense of awe and spiritual transcendence that human beings experience when confronted with the elemental grandeur of nature. Still's goal was to evoke a similar feeling of transcendence while eliminating references to natural phenomena. Although his signature abstractions (begun around 1947) have often been compared to the crags and fissures of wild landscapes of the American West or to flickering tongues of flame, Still denied specific associations for his work. He deliberately eschewed titles, believing that any such limitation of meaning restricts individual freedom.

An idealist, Still believed in art's ability to transform human life. He wanted each of his paintings to be a "fragment of a means to freedom."[1] For Still, freedom connoted liberation from all traditions, past and present: "I held it imperative to evolve an instrument of thought which would aim in cutting through all cultural opiates, past and present, so that a direct, immediate, and truly free vision could be

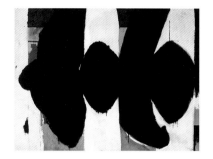

Robert Motherwell, Elegy to the Spanish Republic No. 34, *1953–54. Oil on canvas, 6 feet 8 inches x 8 feet 4 inches (2.03 x 2.54 m). Albright-Knox Art Gallery, Buffalo, Gift of Seymour H. Knox, 1957.*

François Morellet, Broken Arc of a Circle, *1954. Oil on wood, four panels, 23 ⅝ x 23 ⅝ inches (60 x 60 cm) each. Manfred Wandel Collection, Reutlingen, Germany, on long-term loan to Stiftung für Konkrete Kunst, Reutlingen.*

Clyfford Still, 1954, *1954. Oil on canvas, 9 feet 5 ½ inches x 13 feet (2.88 x 3.96 m). Albright-Knox Art Gallery, Buffalo, Gift of Seymour H. Knox, 1957.*

achieved."[2] He disliked the Surrealists' emphasis on primitive myth and personal associations, rejected biomorphic abstraction's evocation of natural form, and found geometric abstraction repressive and authoritarian. He renounced not only figuration, geometric forms, and specific content, but also elegant draftsmanship, sensuous surfaces, balanced compositions, and harmonious color relations. For Still, rigorous abstraction is a moral choice: shorn of all references to the past, nature, and other artistic styles, it symbolizes the absolute freedom of the autonomous individual.

1. Clyfford Still, "A Statement by the Artist," in *Clyfford Still: Thirty-three Paintings in the Albright-Knox Art Gallery*, exh. cat. (Buffalo, N.Y.: Albright-Knox Art Gallery, 1966), p. 18; quoted in Donald B. Kuspit, "Clyfford Still: The Ethics of Art," *Artforum* 15, no. 9 (May 1977), p. 32.
2. Still, letter to Gordon Smith (January 1, 1959), in *Paintings by Clyfford Still*, exh. cat. (Buffalo, N.Y.: The Buffalo Fine Arts Academy, Albright Art Gallery, 1959), unpaginated.

Mark Rothko

(b. 1903, Dvinsk, Russia; d. 1970, New York City)
Untitled, 1954

Although the rigorous format of *Untitled*, 1954, seems the epitome of abstraction, Mark Rothko denied that he was an "abstractionist" and claimed that he wasn't interested in "relations of color or form." Rather, he thought that color is the best way to express "basic human emotions" and that "if you . . . are moved only by [my pictures'] color relationships, then you miss the point."[1] Taking his cue from the romantic color theories popularized in the early decades of the twentieth century by Vasily Kandinsky and Henri Matisse, Rothko believed that colors act directly on the soul, evoking feelings of spiritual transcendence. Applying paint in thin, successive layers, he created an effect of disembodied color, lit from within, as though the numinous veils of paint mask some ineffable presence. The stacked rectangles of his compositions assert the ineluctable flatness of the canvas; yet their softly brushed edges and lambent hues seem to dematerialize the underlying support. By suppressing nearly all traces of the painter's touch, Rothko minimized the physicality of the art object, making it appear ethereal rather than earthbound: the shapes seem to hover in an indeterminate space, enveloping the viewer in a glowing nimbus of pure color.

Rothko was profoundly influenced by the ideas of Friedrich Nietzsche, the nineteenth-century philosopher who proclaimed the death of God. Both thought that art and ancient myths could fill the vacuum created when conventional religions lost their potency for modern society. Borrowing from archaic Greek mythology, Nietzsche identified the desire for transcendence as the Dionysian impulse—an urge to lose the sense of self and achieve a primal state of oneness with the universe. Rothko's painting illustrated here suggests unity and wholeness through large expanses of close-valued hues, whose feathery edges are almost coincident with the boundaries of the canvas. Rothko, like Nietzsche, related the Dionysian urge for cosmic union to tragedy, since the ultimate loss of self is death—a notion that is more apparent in the increasingly somber and monochromatic paintings that he produced in the years immediately preceding his suicide in 1970. Rothko's ideas about the metaphysical meanings of abstract art, along with his emphasis on intense color, monumental scale, frontality, and allover composition, were also characteristic of his Abstract Expressionist colleagues Barnett Newman and Clyfford Still. However, Rothko went much further than them in subordinating form and design to the expressive potential of color. Purging his abstractions of nearly all traces of line and discrete shapes, Rothko concentrated on color to convey a state of exaltation in which the individual is subsumed in the All. (R.B.)

1. Mark Rothko, in Selden Rodman, *Conversations with Artists* (New York: Devin-Adair, 1961), pp. 93–94; quoted in Diane Waldman, *Mark Rothko, 1903–1970: A Retrospective* (New York: Harry N. Abrams in collaboration with the Solomon R. Guggenheim Foundation, 1978), p. 58.

Ellsworth Kelly

(b. 1923, Newburgh, New York)
Black Ripe, 1955

In its unmodulated colors, crisply defined edges, and large scale, Ellsworth Kelly's *Black Ripe*, 1955, has the clarity of design characteristic of geometric abstraction. However, in this work Kelly balanced geometric abstraction's stability and order with the sensuousness of organic form. The eccentric black shape, which is nearly coincident with the picture's entire surface, seems to contract and expand in response to the pressure exerted by the framing edge. Although Kelly almost always begins each work with an idea based on something he has actually seen—the shape of a shadow, the line of a leg, the space between two objects—he so radically abstracts the image that the original source is usually unidentifiable. As he has said, beginning with nature frees him from the necessity of invention and allows him to investigate the "abstract shape of things."[1] An admirer of Russian and Greek icons, Kelly shares Byzantine artists' delight in elegant, economical contours and hard, brilliant hues.

Reacting against Abstract Expressionism's heroic individualism and grand metaphysical concerns, Kelly "wanted to get the 'personality' out of painting . . . to do paintings that were anonymous."[2] By the late 1950s, gestural abstraction's virtuoso brushwork and seemingly accidental drips and splashes had lost their power to express humanistic values such as "sincerity," "authenticity," and "originality." Furthermore, many artists, including Kelly, believed that painters should no longer even try to give expression to these values but should instead be concerned with purely pictorial qualities. Although originally a champion of gestural abstraction, formalist critic Clement Greenberg shifted his allegiance to these Post-painterly abstractionists (a term he coined) because their work seemed to fulfill his criteria of concentrating exclusively on the inherent physical characteristics of the medium—line, color, shape, and surface—thereby producing works that are abstract, unmistakably two dimensional, and addressed to the eye alone. *Black Ripe*'s flat colors, clean edges, and evenly painted surface lock figure, ground, and support into an indivisible whole and negate any illusion of spatial depth. Kelly's emphatically flat, reductive abstractions exemplify the simplified imagery, hard edges, impersonal paint handling, and bold colors typical of Hard-Edge abstraction. (R.B.)

1. "Interview: Ellsworth Kelly Talks with Paul Cummings," *Drawing* 13, no. 3 (September–October 1991), p. 58.
2. Ibid.

Ad Reinhardt

(b. 1913, Buffalo, New York; d. 1967, New York City)
Painting, 1956

In his "Twelve Rules for a New Academy," published in 1957, Ad Reinhardt enumerated the elements that he believed should be eliminated from abstract art: texture, brushwork, drawing, forms, design, colors, light, space, time, size, scale, movement, subject, object, symbols, images, and signs.[1] He came very close to achieving this in *Painting*, 1956, where these elements, though present, are greatly minimized. A cruciform arrangement of black squares, distinguishable only by minute differences in tone and texture, unifies the rectangular canvas and imparts an air of classical stability and stasis. The holistic effect is augmented by the nearly monochromatic coloring: one has to study the painting long and hard to

detect the subtle variations that result from small amounts of red, blue, or brown pigments having been mixed into the black of each square. Although the painting was brushed by hand, Reinhardt labored to remove all trace of gesture and touch in an attempt to suggest an impersonal, styleless, and therefore universal art. His rigorous rejections of formal relationships and nonart references and his uninflected surfaces pushed geometric abstraction to new extremes and made his work very appealing to the Hard-Edge abstractionists of the 1960s.

Reinhardt ridiculed his Abstract Expressionist contemporaries for what he called their "transcendental nonsense."[2] Whereas they seemed to regard painting as a means to an end— a way to express abstract metaphysical and intellectual concepts—Reinhardt proclaimed that painting is an end in itself. *Painting* celebrates what he termed "art-as-art": art that is about art and nothing else. In one of his many extremist statements, he declared that the goal of abstract art is "to make it into the one thing it is only, separating and defining it more and more, making it purer and emptier, more absolute and more exclusive. . . . The only and one way to say what abstract art or art-as-art is, is to say what it is not."[3] For Reinhardt, abstract art is *not* about life, metaphysics, personal expression, gallery sales, or museum shows. However, despite his disavowals of any religious or metaphysical implications in his work, the spiritual allusions are unmistakably present, particularly in his black paintings, which he produced between 1952 and 1967. The cruciform arrangement of squares in these works suggests a Christian cross or a four-pointed mandala (a Zen Buddhist meditation device, with which Reinhardt was very familiar, having taught Asian art history for a living). Moreover, he referred to painting as a "ritual" process, spoke of his writings on art as "dogmas," and likened the artist to God. In a 1966 interview, he claimed that his late paintings were the last paintings anyone could make.[4] Through a series of rejections and negations, Reinhardt believed that he had distilled abstract art into its pure, ultimate essence. (R.B.)

1. Ad Reinhardt, "Twelve Rules for a New Academy" (1957), in Lucy R. Lippard, *Ad Reinhardt* (New York: Harry N. Abrams, 1981), pp. 140–41.
2. Reinhardt, quoted in Irving Sandler, "Reinhardt: The Purist Backlash," *Artforum* 5, no. 4 (December 1966), p. 41.
3. Reinhardt, "Art-as-Art," *Art International* 6, no. 10 (December 20, 1962), pp. 36–37.
4. Bruce Glaser, "An Interview with Ad Reinhardt," *Art International* 10, no. 10 (December 20, 1966), p. 18.

David Smith
(b. 1906, Decatur, Indiana; d. 1965, Bennington, Vermont)
Five Units Equal, 1956

David Smith was one of the first American artists to fully exploit the sculptural possibilities of industrial materials and techniques in an abstract idiom. In *Five Units Equal*, 1956, he welded a stack of rectangular boxes of solid steel to metal planes in a vertical configuration. The green paint draws attention to the pictorial qualities of color, shape, and line while the steel elements convey volume and mass. This sculpture's regular geometry, symmetrical composition, and painted surfaces relate it to both the painterly and the sculptural traditions of geometric abstraction. However, Smith's abstraction, unlike that of his predecessors, was neither a rejection of nature nor an attempt to transcend it. He believed that the artist's life is the subject of his or her art and that, since all human beings are part of nature, even the most abstract art is ultimately connected to nature. As he explained, "Abstract art is a symbolic treatment of life just as is higher mathematics and music."[1]

Smith's industrial aesthetic does not celebrate modern technology; rather, it marks his acceptance of its importance in contemporary life. Convinced that art must be of its time, Smith used steel as his medium of choice because it exemplifies technology's positive and negative aspects. He asserted that "the metal itself possesses little art history. What associations it possesses are those of this century: power, structure, movement, progress, suspension, destruction, brutality."[2] Similarly, he chose the abstract mode because he believed that it was the "language of our time,"[3] signifying the modern artist's ability to be imaginative and creative, freed from the need to represent natural imagery, which had become the domain of photography. Smith's use of materials and techniques commonly associated with factory production would seem to link his work to that of the Russian Constructivists and the Bauhaus artists. These artists tried to elevate industrial design to the level of fine art, thereby aestheticizing even the most mundane implements of daily life and giving art a useful social function. In contrast, Smith was motivated by an art-for-art's sake sensibility: he wanted the factory to serve the needs of art, rather than vice versa. According to Smith, the sole purpose of abstract sculpture is "to create aesthetic enjoyment."[4] (R.B.)

1. David Smith, "On Abstract Art" (1940), in Garnett McCoy, ed., *David Smith* (New York: Praeger, 1973), p. 38.

2. Smith, "The New Sculpture" (1952), in ibid., p. 84.
3. Smith, "On Abstract Art," in ibid., p. 40.
4. Smith, "Modern Sculpture and Society" (1940), in ibid., p. 42.

Franz Kline
(b. 1910, Wilkes-Barre, Pennsylvania; d. 1962, New York City)
Mahoning, 1956

According to fellow painter Elaine de Kooning, Franz Kline was first struck by the artistic potential of brushmarks when he saw one of his figurative black-and-white sketches enlarged through a Bell-Opticon device, around 1949. The following year, he began to make abstract black-and-white paintings that seem to mimic the effects of gross magnification, in which the strokes expand until they become "entities in themselves, unrelated to any reality but that of their own existence."[1] Although his works have all the hallmarks of direct, spontaneous expression— vigorous brushwork, ragged forms, asymmetrical composition, and seemingly accidental drips and splotches—they were usually carefully and deliberately composed. Kline would first execute studies on printed pages torn from telephone books and newspapers, and then made freehand enlargements of these small-scale designs, continually reworking and modifying the surface until he had achieved the desired effect. As can be seen in *Mahoning*, 1956, the constant overpainting gives equal weight to white and black, preventing any illusion of deep spatial recession. Kline's emphasis on the end product rather than the process sets him apart from his Abstract Expressionist colleagues, with whom he shared an interest in massive scale and gestural paint application.

Kline's paintings are often compared to Oriental calligraphy, but such a comparison is superficial and misleading. The raw energy and brute power of his lumbering forms bear little relation to the elegant linearity and delicate balance of Chinese and Japanese characters. Furthermore, Kline painted the white areas as well as the black, meshing figure and ground in a tense equilibrium. A more apt comparison would be to industrial landscapes: his black-and-white compositions capture the dynamism and conflict of contemporary urban life in abstract form. The thrusting black diagonals suggest train trestles, bridges, or the exposed girders of buildings in the process of construction or demolition. These allusions to landscape and industry are reinforced by the paintings' titles. *Mahoning*, like several of his works, was named for a town in the coal country of Eastern Pennsylvania where

David Smith, Five Units Equal, *1956. Steel, 6 feet 1 ¼ inches x 1 foot 4 ¼ inches x 1 foot 2 ¼ inches (1.86 x .41 x .36 m). Storm King Art Center, Mountainville, New York, Gift of the Ralph E. Ogden Foundation.*

Franz Kline, Mahoning, *1956. Oil and paper collage on canvas, 6 feet 8 inches x 8 feet 4 inches (2.03 x 2.54 m). Whitney Museum of American Art, New York, Purchase, with funds from the Friends of the Whitney Museum of American Art 57.10.*

facing page:
Mark Rothko, Untitled, *1954. Oil on canvas, 7 feet 3 ½ inches x 5 feet 9 ⅛ inches (2.22 x 1.76 m). Collection of Adriana and Robert Mnuchin.*

Ellsworth Kelly, Black Ripe, *1955. Oil on canvas, 63 ⁵⁄₁₆ x 59 ⅛ inches (161.3 x 150.8 cm). Collection of Harry W. and Mary Margaret Anderson.*

Ad Reinhardt, Painting, *1956. Oil on canvas, 6 feet 8 ¼ inches x 3 feet 7 ⅛ inches (2.04 x 1.1 m). Yale University Art Gallery, New Haven, Connecticut, University Purchase.*

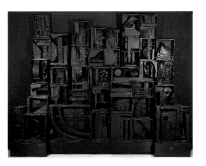

Sam Francis, The Whiteness of
the Whale, 1957. Oil on canvas,
8 feet 6 ½ inches x 7 feet 1 ½ inches
(2.6 x 2.17 m). Albright-Knox Art
Gallery, Buffalo, Gift of Seymour H.
Knox, 1959.

Louise Nevelson, Sky Cathedral, 1958.
Painted wood, 9 feet 7 ½ inches x
11 feet 3 inches x 1 foot 8 inches
(2.93 x 3.43 x .51 m). Albright-Knox
Art Gallery, Buffalo, George B. and
Jenny R. Mathews Fund, 1970.

Jean Dubuffet, The Exemplary Life of
the Soil (Texturology LXIII), October 13,
1958. Oil on canvas, 51 ⅛ x 63 ¼ inches
(130 x 162 cm). Tate Gallery, London,
Purchased 1966.

the artist was born and raised. Other
works were named for the engines of
coal-carrying trains, New York locales,
or foreign cities that Kline visited. On a
more abstract level, the clashing,
colliding, interpenetrating forms can be
read as analogues of the unresolvable
conflicts of opposing forces. (R.B.)

1. Elaine de Kooning, "Franz Kline: Painter of His
Own Life," *Art News* 61, no. 7 (November 1962),
pp. 67–68.

Sam Francis
(b. 1923, San Mateo, California; d. 1994,
Santa Monica, California)
The Whiteness of the Whale, 1957

The Whiteness of the Whale, 1957,
represents a turning point in Sam
Francis's oeuvre, for it marks his shift
from allover painting to a style in which
equal weight is given to both positive
(painted) and negative (unpainted)
space. Thinly painted bursts of pale,
luminous color drift lazily upward and
seem to continue beyond the boundaries
of the picture plane. By clustering
painterly incidents toward the edges of
the canvas, Francis opened the center of
the painting and augmented its
expansive feeling. Pictorial color and
space, through their ability to convey a
sense of infinity, had a nearly religious
significance for him. The title hints at
the artist's vaguely mystical ideas: he
took it from a chapter heading in
Herman Melville's *Moby Dick* in which
the nineteenth-century novelist
analyzed the color white and identified
it with the ineffable, the sublime, the
horrifying, and the void.[1]

Francis drew his inspiration from
Abstract Expressionism, Oriental art
and philosophy, and early twentieth-
century French painting. His
abstractions share several formal
qualities with those of the New York
Abstract Expressionists: large scale,
treatment of the canvas as a continuous
picture plane, and the use of controlled
accident, as evidenced in his painting's
stains, drips, and splotches. Like
many of the West Coast Abstract
Expressionists with whom he is loosely
grouped, his works also show traces of
an Asian aesthetic. The asymmetrical
composition and his use of unpainted
areas as an integral part of the design
are pictorial devices borrowed from
traditional Japanese painting. Although
Francis was not a practitioner of Zen
Buddhism, he was intrigued by the Zen
concept of the void as an empty but
energized space. He tried to convey
this notion of latent possibility by
enlivening the large white areas of his
paintings with tiny flecks and splatters
of pigment. In addition, Francis was
strongly influenced by a French
tradition of decorative, hedonistic color,
exemplified by the late works of Claude

Monet and the paintings of Henri
Matisse. Francis's abstractions
emphasize opticality more than
tactility; they rely on subtle allusions
rather than overt symbolism; and they
focus on the nature of materials and the
painting process itself instead of the
artist's personal expression. In these
respects, Francis shares the cooler, more
detached sensibility espoused by the
Post-painterly abstractionists of the
1960s. (R.B.)

1. Peter Selz, *Sam Francis*, rev. ed. (New York:
Harry N. Abrams, 1982), pp. 62–63.

Louise Nevelson
(b. 1899, Kiev; d. 1988, New York City)
Sky Cathedral, 1958

By abstracting ordinary objects from
their place in everyday life, Louise
Nevelson hoped to transform the
utilitarian into the transcendental.
The wooden boxes and crates of *Sky
Cathedral*, 1958, are held together by
gravity and crammed with bits and
pieces of scavenged wood: fragments
of old furniture, decorative molding,
rough planking, barrel staves, and
less identifiable scraps. The allover
application of black paint unites the
disparate elements while divesting them
of nearly all traces of their former uses.
The monochrome color, shallow depth,
and frontal presentation emphasize the
work's painterly qualities. Nevelson,
believing that there is more mystery in
two dimensions than in three, conceived
of her assemblages as a kind of drawing
in real space, using the "found" lines
created by stacked boxes and
juxtaposed objects.

Environmental and architectural
allusions abound in Nevelson's works.
By placing objects in boxes, the artist
created small interior environments,
the shadowy recesses of which evoke
feelings of intimacy and privacy. At
the same time, the work's enormous
size articulates and defines the space of
the surrounding environment. The
modular, gridlike configuration
suggests the eccentric geometry of the
New York cityscape, while the densely
articulated surfaces echo the deeply
carved pre-Columbian architecture
that Nevelson admired on her visits to
Mexico and Guatemala in 1950 and 1951.
Unconcerned with the religious function
or symbolism of Mayan monuments,
Nevelson tried to capture their sense of
awesome scale and mystery in her own
work. The objects in her sculptural
walls function like glyphs whose
meanings can only be guessed, never
deciphered. She wanted to give
mundane materials an "ultimate life, a
spiritual life that surpasses the life they
were created for. That lonely, lowly
object is not used any more for what it

was—a useful object. It becomes a
work of art."[1] (R.B.)

1. Louise Nevelson and Diana MacKown, *Dawns +
Dusks* (New York: Charles Scribner's Sons, 1976),
p. 83.

Jean Dubuffet
(b. 1901, Le Havre, France; d. 1985, Paris)
*The Exemplary Life of the Soil
(Texturology LXIII)*, October 13, 1958

In *The Exemplary Life of the Soil
(Texturology LXIII)*, 1958, Jean
Dubuffet subordinated form, color,
and composition to texture. He wanted
to convey a sense of "teeming matter,
alive and scintillating, that might be apt
for depicting a patch of ground but that
also evokes all sorts of indeterminate
textures, even galaxies and nebulae."[1]
The nearly monochromatic surface,
which is undivided by line or shape,
suggests that the painting continues
beyond the edges of the canvas. The
gritty texture—the result of adding
sand to the oil paints—augments our
awareness of the materiality of the art
object. With its emphasis on brute
materials, this abstraction mounts an
attack against oversophisticated,
modern Western society. The title's
reference to the ground and its textures
provides the key: Dubuffet valued the
banal, common, mundane things of
life for their earthy simplicity and
directness. He wanted his paintings
to have the visceral punch of Art
Brut, a term he used to describe the
imaginative, nonmimetic art of
children, primitives (by which he
meant prehistoric and contemporary
tribal peoples), and the mentally ill.

Dubuffet's art relates to a tradition of
abstraction that favors nature over
culture, the primitive over the civilized,
and sensation over ideation, a tradition
that has its roots in nineteenth-century
Northern European Romanticism. In
his speech "Anticultural Positions,"
delivered in Chicago in 1951, Dubuffet
expressed his belief that primitive
peoples are free from socially imposed
inhibitions and are therefore more in
touch with nature and its mysteries.[2]
Through painting, the modern artist
can recapture this sense of primal unity
and harmony, but only if he or she gives
up an outmoded desire to describe the
external appearance of things. Yet
Dubuffet also rejected pure abstraction,
with its emphasis on aesthetic beauty
and formal relationships, for he believed
that it has no connection with the
"real" lives of ordinary people. In
The Exemplary Life of the Soil, the focus
on texture—and the concomitant
absence of drawn line, figure-ground
relationships, and spatial illusionism—
is meant to convey the formlessness of
raw, primordial matter before it is
differentiated and organized into

discrete beings or objects. Thus, although the painting is abstract, it ultimately refers to a very concrete reality. (R.B.)

1. Jean Dubuffet, *Prospectus et tous écrits suivants*, 2 vols., ed. Hubert Damisch (Paris: Editions Gallimard, 1967), vol. 2, p. 130; quoted in Andreas Franzke, *Dubuffet* (New York: Harry N. Abrams, 1981), p. 118.
2. Dubuffet, "Anticultural Positions" (1951), *Arts Magazine* 53, no. 8 (April 1979), pp. 156–57.

Yves Klein

(b. 1928, Nice, France; d. 1962, Paris)
Untitled Blue Monochrome (IKB 48), 1958

Yves Klein's *Untitled Blue Monochrome (IKB 48)*, 1958, embodies the complex and often contradictory meanings that have been assigned to monochrome paintings and sculptures in the twentieth century. By eliminating color contrasts and all traces of drawn line, Klein hoped to convey a sense of unity and wholeness, pointing to a lost Edenic state when human beings were at one with the universe. The uninterrupted expanse of cobalt blue also suggests the unfathomable depths of sea or sky, evoking the vastness of infinite space. Klein thus used color and space as metaphors for the life of the spirit. As he declared, "[Monochromism is] the only physical way of painting which permits access to the spiritual absolute. . . . My monochrome paintings are landscapes of freedom."[1] Through contemplation of the painting, the viewer is invited to make a symbolic "leap into the void" and become immersed in a pantheistic communion with nature. Klein's visionary ideals were influenced by the beliefs of the Rosicrucian Society, a mystical sect whose teachings he studied for several years. According to Rosicrucian doctrine, Spirit is identical with Space, and both are symbolized by the color blue. Klein developed an especially vibrant shade of this hue by suspending pure pigments in synthetic resin, which he patented as International Klein Blue. In this painting, it creates a thick, rippled texture, like a frozen sea.

In Klein's monochromes, the elimination of almost all formal relationships pushes the reductiveness of geometric abstraction to its limits. By painting with a roller rather than a brush, he challenged the gestural abstraction of European Art Informel and American Abstract Expressionism, both of which posited the supposedly unrepeatable and self-revelatory gesture of the artist as proof of the painting's "sincerity" and "authenticity." With ironic intention, Klein simultaneously affirmed and negated abstract art's transcendental associations. The dense surface and uneven edges of the painting call attention to its literal objecthood, an effect enhanced by the enlarged supports that make the painting jut out from the wall and seem to enter the viewer's space. During the late 1950s and early 1960s, Klein executed several series of blue monochromes. Although the paintings within each series are nearly identical in size, shape, and color, Klein sold them for varying amounts. He justified this by explaining that each work has different amounts of "immaterial pictorial sensibility"—that is, the indefinable spiritual essence that distinguishes a work of art from all other images or products. By equating this "art essence" with monetary value, Klein called attention to art's status as a commodity at the same time that he denied it. (R.B.)

1. Yves Klein, "The Monochrome Adventure," undated manuscript in the Yves Klein Archives, quoted in Thomas McEvilley, "Yves Klein, Messenger of Space," *Artforum* 20, no. 5 (January 1982), p. 42.

Antoni Tàpies

(b. 1923, Barcelona)
Pink and Grey Relief, 1958

Antoni Tàpies created the thick, sensual surfaces of works such as *Pink and Grey Relief*, 1958, by mixing various roughening agents—powdered marble, chalk dust, earth, or sand—into oil paints and clear varnishes. Tàpies and others have compared his dense, opaque surfaces to walls, an effect enhanced by the calligraphic scribbles, gouges, scratches, and rough textures of areas that have been modeled in relief. The reference evokes the opacity of the picture plane, the war-scarred walls of the artist's native Barcelona, and Tàpies's last name, the Catalan word for "wall."

Tàpies's exploration of the expressive potential of brute materials in the late 1950s aligned him with contemporary European Art Informel. Paradoxically, many of the artists who pursued this approach, including Tàpies, tried to convey art's spiritual qualities by emphasizing the physical processes of painting, a goal that they believed could only be achieved through abstraction. By combining abstraction with an emphasis on materials, they attempted to make their paintings totally self-referential and self-contained. Tàpies conceived of his paintings as "magical objects," capable of revealing an "ultimate reality" beyond mere appearances. As the artist recently stated, "The real aim of my work has always been to try to change people's ideas so that they are no longer lost in an artificial reality."[1]

Like many of his contemporaries on both sides of the Atlantic, Tàpies blamed materialism for most of modern society's ills and anxieties. His abstraction was fueled by his need to find new transcendental values for a secular age. To do this, he drew upon a variety of disparate sources, including modern physics, ancient Eastern philosophies, and medieval Catalan mysticism. Modern physics taught that matter could be dematerialized and turned into energy, and thus seemed to debunk the Judeo-Christian distinction between mind (energy) and body (matter); the allover, nonhierarchical design of Tàpies's canvases, borrowed from Abstract Expressionism, signifies the unity of human beings' spiritual and physical natures. Taoism and Zen Buddhism call for meditating on simple and humble things in order to discover the true meaning of life; Tàpies saw abstraction as an exemplification of simplicity and therefore a means of attaining truth. He was also influenced by medieval Catalan mystics, as their interest in alchemy paralleled his desire to transmute base materials into transcendent paintings. Tàpies used "poor" materials in abstract compositions to convey the transformational capabilities of art. (R.B.)

1. Antoni Tàpies, quoted in Michael Peppiatt, "An Interview with Antoni Tàpies: The Soul Revealed by the Hand," *Art International* 13 (winter 1990), p. 34.

Lucio Fontana

(b. 1899, Rosario de Santa Fé, Argentina; d. 1968, Commabio, Italy)
Spatial Concept, Expectations, 1959

Lucio Fontana founded the Spazialismo movement in the late 1940s, and in 1951 issued his "Technical Manifesto of Spazialismo," in which he propounded a new form of abstraction conceived as a synthesis of "color, sound, movement, space, completing a unity of idea and matter."[1] In his *Tagli* (Cuts), begun in 1958, Fontana slashed the monochrome surfaces of his canvases. These irreversible gestures emphasized action and risk-taking, and, although Fontana denied any destructive implications, the references to violence are difficult to overlook. By lacerating the painting's surface, Fontana symbolically destroyed the notion of art as a precious commodity. The gesture also contains hints of eroticism and sadism: the holes and slashes can be read as female genitals and/or body wounds. From 1949 onward, Fontana titled each of his paintings and sculptures *Spatial Concept* (see also fig. 141). The paintings are generally subtitled *attese*, which, loosely translated, means "wait and see."

There are two primary sources for Fontana's preoccupation with space. First, he thought of himself as working

Yves Klein, Untitled Blue Monochrome (IKB 48), *1958. Dry pigment in synthetic resin on canvas, mounted on wood, 59 ¼ x 49 ⁵⁄₁₆ x 2 ⅜ inches (150.5 x 125 x 6 cm). Moderna Museet, Stockholm.*

Antoni Tàpies, Pink and Grey Relief, *1958. Mixed media on canvas, 44 ⅞ x 57 ½ inches (114 x 146 cm). Kunsthaus Zürich.*

Lucio Fontana, Spatial Concept, Expectations, *1959. Water-based paint on canvas, 4 feet 1 ⅛ inches x 8 feet 2 ¼ inches (1.26 x 2.51 m). Solomon R. Guggenheim Museum, New York, Gift, Mrs. Teresita Fontana, Milan 77.2322.*

Frank Lloyd Wright, Solomon R. Guggenheim Museum, New York, completed 1959.

Mark di Suvero, Che Farò Senza Eurydice, 1959. Wood and iron, 7 feet x 8 feet 8 inches x 7 feet 7 inches (2.13 x 2.64 x 2.31 m). Private collection, San Francisco.

within traditions initiated by the Baroque artists of the seventeenth century and by the Italian Futurists of the early twentieth century: he admired the Baroque artists primarily for their attempt to fuse painting, sculpture, and architecture into a total work of art, and shared the Futurists' fascination with motion, time, and technology. Fontana's cuts give his paintings a sculptural quality while opening them up to the architectural space surrounding them. They also literalize the concepts of space and time that are only implied in Futurist works. Second, Fontana was intrigued by modern science's conquest of space, an achievement that seemed to put human beings in closer touch with the universe. His holes and slashes metaphorically unite the illusory space of the picture plane and the actual space of everyday life with the cosmic space of the universe. Fontana believed that art and science are comparable and complementary disciplines, as both have the power to transform the world by increasing knowledge and expanding human horizons. Significantly, Fontana believed that only abstraction could fulfill this progressive function amid the constantly changing realities of modern technological society, and that, by eliminating the known forms of the past, abstract Spatialist art could express the unlimited potentiality of the future. (R.B.)

1. Lucio Fontana, "Technical Manifesto of Spazialismo" (1951), trans. Stephen Sartarelli, in *The Italian Metamorphosis, 1943–1968*, exh. cat. (New York: Guggenheim Museum, 1994), p. 715.

Frank Lloyd Wright

(b. 1867, Richland Center, Wisconsin;
d. 1959, Phoenix)
Solomon R. Guggenheim Museum,
New York, completed 1959

The Solomon R. Guggenheim Museum, completed in 1959, illustrates one of the primary tenets of Frank Lloyd Wright's architectural theory: "The space within the building is the reality of that building. . . . the new reality that is *space* instead of matter."[1] The museum's grand ramp spirals upward and outward in one continuous curve to the domed glass skylight nearly one hundred feet above the ground. For Wright, the spiral served important practical, aesthetic, and symbolic functions. It allows the viewer to take the elevator to the top, walk down through the exhibition space, and exit the museum without having to retrace his or her steps. The spiral also unifies the interior space while providing constantly changing views to spectators moving along the ramp. Wright believed that certain geometric forms symbolize particular ideas or values; for example, he equated the spiral with progress and the circle

with infinity. The museum is unified by circular motifs, which can be seen in the shape of the basement auditorium, the pattern of the terrazzo floors, and the railings and furnishings designed by the architect.

Wright claimed that his spiral building would make the perfect foil for abstract art: it would be "a suitable place for the exhibition of an advanced form of painting wherein line, color and form are a language in themselves . . . independent of reproduction of objects animate or inanimate, thus placing painting in a realm hitherto enjoyed by music alone. . . . Here in the harmonious fluid quiet created by this building interior the new painting will be seen for itself under favorable conditions."[2] In 1957, however, twenty-one artists (including Willem de Kooning, Franz Kline, Robert Motherwell, and Jack Tworkov) wrote a letter of protest to James Johnson Sweeney, the museum's director, in which they declared that works of art require a "rectilinear frame of reference."[3] Sweeney agreed. He found the ramp's linearity and incline unsuitable for exhibitions and was particularly appalled by the outward-sloping walls, which Wright tried to justify by comparing it to the angle of a painting propped on an artist's easel. To overcome these perceived obstacles, the director restored the paintings' verticality by attaching each to a single steel bar that jutted out from the wall. Despite the initial controversy, the Guggenheim Museum, with its innovative use of abstract form to mold space, has come to be regarded as one of the landmarks of twentieth-century architecture.

Abstraction played a key role in what Wright referred to as his "organic architecture"—that is, architecture in which the building's form and structure express its time, setting, and purpose. This idea, along with his emphasis on simple forms and the honest, direct use of materials, shows the influence of the nineteenth-century Arts and Crafts movement. However, unlike Arts and Crafts practitioners, Wright eagerly embraced mechanization and modern materials, which he believed could liberate architecture from certain structural restrictions and produce the clean, streamlined forms appropriate to the modern age. At the same time, he felt that the architect must still look to nature—not to imitate its outward forms, but rather to learn its abstract principles of structure and proportion. Wright believed that architecture is "essentially pure abstraction,"[4] and that it is capable of expressing humanistic values through abstract form. (R.B.)

1. Frank Lloyd Wright, "The Destruction of the Box" (1952), in *Frank Lloyd Wright: Writings and Buildings*, selected by Edgar Kaufmann and Ben Raeburn (New York: Horizon Press, 1960), pp. 284–85.
2. Wright, quoted in William H. Jordy, "The Encompassing Environment of Free-Form Architecture: Frank Lloyd Wright's Guggenheim Museum," in *The Impact of European Modernism in the Mid-Twentieth Century*, American Buildings and Their Architects, vol. 5 (New York: Oxford University Press, 1972, 1986), pp. 330–31.
3. *Frank Lloyd Wright: The Guggenheim Correspondence*, selected by Bruce Brooks Pfeiffer (Fresno, Calif.: The Press at California State University; Carbondale, Ill.: Southern Illinois University Press, 1986), p. 242.
4. Wright, letter to Hilla Rebay (February 6, 1944), in ibid., p. 43.

Mark di Suvero

(b. 1933, Shanghai)
Che Farò Senza Eurydice, 1959

The massive, weathered timbers of Mark di Suvero's *Che Farò Senza Eurydice*, 1959, are notched, bolted, and roped together, and seem too heavy to maintain their precarious balance. This air of threatening instability is reinforced by the work's lack of a central, organizing core. Earlier in the twentieth century, the Russian Constructivists had executed numerous sculptures in which they partially opened the center to the viewer's gaze; their goal was to demystify sculpture by revealing the central, organizing armature, thereby making the sculpture's rational construction visible. Di Suvero, following the lead of fellow American sculptor David Smith, completely eliminated the idea of a central core in his assemblages. Working with found materials on a nearly architectural scale, Di Suvero created open compositions of linear elements that penetrate the surrounding space, activating and energizing it. The result is an aggressively three-dimensional work characterized by disjunction and discontinuity rather than logic and rationality.

Di Suvero once said that his sculpture is "painting in three dimensions,"[1] hinting at his debt to Abstract Expressionism. Painterly gesture is here translated into the sculpture's literal gesture in space, with the monumental scale and environmental implications of allover painting realized in three dimensions, and the gestural painters' emphasis on spontaneity reflected in di Suvero's improvisatory process. His works, like those of many male assemblage artists in the 1950s and 1960s, display the macho sensibility and personal expressivity underlying Abstract Expressionist art and rhetoric. The recycled wood and hardware evoke the traditionally masculine domains of junkyards, construction sites, and garages, while their large size, raw

surfaces, and thrusting, asymmetrical arrangements suggest strength, assertiveness, and virility. In di Suvero's assemblages, the individual, represented by the artist-maker, symbolically dominates and transcends technological society by removing industrial materials from their utilitarian context and transforming them into abstract objects of aesthetic contemplation. (R.B.)

1. Mark di Suvero, quoted in James K. Monte, *Mark di Suvero*, exh. cat. (New York: Whitney Museum of American Art, 1975), p. 12.

Hans Hofmann
(b. 1880, Weissenburg, Germany; d. 1966, New York City)
Pompeii, 1959

Pompeii, 1959, demonstrates Hans Hofmann's attempt to reconcile geometric abstraction's clarity of structure with the brilliant hues and lush paint handling associated with more expressive modes of abstraction. With its opulently colored rectangles arranged in a gridlike format, tempered at top and bottom by more open, painterly forms, the work exemplifies Hofmann's key concepts of "plasticity" and "push and pull." For Hofmann, plasticity referred to the suggestion of volume and spatial depth created by contrasts of warm and cool colors. As can be seen in *Pompeii*, warm red, orange, ocher, and yellow forms seem to advance and expand while cooler blue, green, and black areas appear to recede and contract. By carefully balancing color planes in his compositions, Hofmann sought to set up a "push and pull" of opposing forces, so that the perception of spatial depth would be constantly countered by an awareness of the flatness of the support. The painting's spatial play had a quasi-spiritual connotation for Hofmann. Since pictorial depth is an illusory and immaterial quality, he believed, it alludes to an ideal, otherworldly realm; flatness, on the other hand, is a moral imperative, for it signifies the painting's "truth" to its medium. Hofmann felt subject matter to be unnecessary, believing that the tension between painterly truth and illusion would be enough to save abstract art from subsiding into empty decoration.

Hofmann's ideas about abstract art are an amalgam of those expounded by the major theorists of the early twentieth century, particularly those who proclaimed its universal and metaphysical implications. Hofmann gave these theories a new spin, draining them of their radical social content and foregrounding their purely artistic concerns. Whereas earlier artist-theorists had hoped that nonobjectivity would lead to a new, utopian world

order, Hofmann looked to abstract art to produce a self-sufficient world of its own, completely distinct from everyday life. Art can achieve autonomy, he believed, only if it does not refer to anything outside itself. In Hofmann's conception, art is a substitute for the spiritual rather than a symbol of it—the medium and the message are one. Through the many courses he taught after moving to the United States in 1930, his lectures, and his published writings, Hofmann became one of mid-century America's most influential exponents of art for art's sake. His ideas, which were codified by the formalist critic Clement Greenberg, became the rationale for an abstract art that could jettison subject matter while still retaining an ethical and moral force. (R.B.)

Josef Albers
(b. 1888, Bottrop, Germany; d. 1976, New Haven, Connecticut)
Homage to the Square: Apparition, 1959

Painter, designer, teacher, and theoretician Josef Albers is a major figure in the history of twentieth-century abstract art. His commitment to abstraction was unwavering, from his experiments in glass begun in the early 1920s to his *Homage to the Square* series, which occupied the last twenty-seven years of his life.

In many of his glass works, Albers sandblasted and painted gridded patterns onto opaque, milky glass. The recession of forms, interplay of colors, and attention to the interrelationships between form and material in these works all prefigured Albers's later paintings. Having studied and taught at the Bauhaus since 1920, Albers left Germany in 1933 for the United States, where he began to teach at Black Mountain College in North Carolina. There, he started to explore undiluted, textural color, in paintings that usually contain paired abstract forms.

By the time Albers embarked upon his *Homage to the Square* series in 1949, his agenda was firmly set. In these works, he undertook the investigation of pure color, the perception of forms, and the borders between colors in formulaic recombinations of squares within squares. In *Homage to the Square: Apparition*, 1959, and other paintings in the series (for example, figs. 151 and 152), Albers looked at the "discrepancy between physical fact and psychic effect,"[1] studying how combinations of colors can make one color appear to advance and another recede. Albers also played with perception; in *Homage to the Square: Apparition*, the four bands seem to slip into one another, their boundaries dissolving, while in fact the

rigid, carefully painted borders prevent any intermingling of colors.

Albers shared the Bauhaus mission to do away with the distinction between fine and applied arts. Emphasizing the study of materials and forms, Albers carried on the school's tradition when he taught at Black Mountain College and later at Harvard and Yale universities. A link between European and American abstraction, Albers wielded incalculable influence on painting and color theory in the United States. (I.B.)

1. Josef Albers, "The Color in My Painting," in *Josef Albers*, exh. cat. (Raleigh: North Carolina Museum of Art, 1962), pp. 14–15.

Frank Stella
(b. 1936, Walden, Massachusetts)
Luis Miguel Dominguin (second version), 1960

Frank Stella was the first artist to create an absolute congruence between the form of a shaped canvas and the painting's design. In *Luis Miguel Dominguin* (second version), 1960, the wide bands of aluminum paint, separated by narrow stripes of bare canvas, echo and affirm the notched shape of the painting. Motivated by a desire to achieve a truly abstract pictorial space, Stella chose a rigorously symmetrical pattern because, he said, it "forces illusionistic space out of the painting at a constant rate."[1] In Stella's view, this rejection of illusory space signals abstract painting's autonomy from the material world. He has stated that his paintings refer to nothing outside themselves: "My painting is based on the fact that only what can be seen there *is* there. . . . All I want anyone to get out of my paintings, and all I ever get out of them, is the fact that you can see the whole idea without any confusion. . . . What you see is what you see."[2]

Luis Miguel Dominguin both denies and asserts its status as a material object. On the one hand, the aluminum paint's reflectivity seems to dematerialize the surface, calling attention to the purely visual elements of line, shape, and color. On the other hand, the paint's opacity creates a hard, impermeable surface that gives the work an objectlike quality, an effect enhanced by Stella's habit of using unusually deep stretchers (approximately three inches deep), which push his paintings into the viewer's space. The objectlike character of Stella's paintings inspired a number of American sculptors during the 1960s whose work was variously categorized under the rubrics Literalism, Minimalism, ABC Art, Primary Structures, or Specific Objects. Although Stella shared these

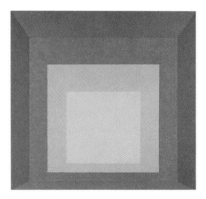

Hans Hofmann, Pompeii, *1959. Oil on canvas, 7 feet ½ inch x 4 feet 10 ⅛ inches (2.15 x 1.48 m). Tate Gallery, London.*

Josef Albers, Homage to the Square: Apparition, *1959. Oil on Masonite, 47 ½ x 47 ½ inches (120.6 x 120.6 cm). Solomon R. Guggenheim Museum, New York 61.1590.*

Frank Stella, Luis Miguel Dominguin *(second version), 1960. Aluminum oil paint on canvas, 8 feet x 6 feet (2.44 x 1.83 m). Private collection.*

Morris Louis, Beta Kappa, 1961. Acrylic resin on canvas, 8 feet 7 ¼ inches x 14 feet 5 inches (2.62 x 4.39 m). National Gallery of Art, Washington, D.C., Gift of Marcella Louis Brenner 1970. 21. 1.

Anthony Caro, Early One Morning, 1962. Steel and aluminum, painted, 9 feet 6 inches x 20 feet 4 inches x 10 feet 11 inches (2.9 x 6.2 x 3.35 m). Tate Gallery, London, Presented by the Contemporary Art Society, 1965.

John Chamberlain, Spiro, 1962. Welded steel, painted, 29 x 36 x 26 inches (73.5 x 91.5 x 66 cm). Collection of Edmund Pillsbury Family, Fort Worth.

sculptors' concern for clarity of design, antirelational composition, the use of industrial materials, and surfaces left uninflected by the artist's hand, he disagreed with their definition of art as just another kind of man-made object. Declaring that they had misinterpreted his painting, Stella argued that the purpose of his deep stretchers is to emphasize the painting's flat surface and therefore to make it "less like an object."[3] Stella's ideas coincide with those later expressed by formalist critic Michael Fried in his seminal essay "Art and Objecthood," in which Fried argued that art must differentiate itself from the world of mundane objects by asserting itself as pure, immaterial shape.[4] Fried claimed that this was just what Stella had achieved, and that, as a result, his work has something that his admirers' sculpture lacks—"presentness," a timeless, self-referential, and ultimately spiritual quality. (R.B.)

1. Frank Stella, lecture delivered at Pratt Institute, New York (winter 1959–60), in Robert Rosenblum, Frank Stella (Harmondsworth, England: Penguin, 1971), p. 57.
2. Stella, quoted in Bruce Glaser, "Questions to Stella and Judd," Art News 65, no. 5 (September 1966), pp. 58–59.
3. Ibid., p. 60.
4. Michael Fried, "Art and Objecthood," Artforum 5, no. 10 (June 1967), pp. 12–23.

Morris Louis
(b. 1912, Baltimore; d. 1962, Washington, D.C.)
Beta Kappa, 1961

In Beta Kappa, 1961, and other works in his Unfurled series, Morris Louis literally emptied the center of his paintings just as he metaphorically emptied his abstractions of all nonart meanings. The large expanse of bare canvas flanked by streams of flat, unmodulated color call attention to the utter flatness of the support and minimize any illusion of depth. The colors, soaked into the weave of the fabric, seem to be congruent with the surface of the painting, a result of Louis's technique of pouring paint onto the canvas and allowing gravity to determine the direction of paint flow. The notion of chance and spontaneity that this implies is countered by the orderly, symmetrical composition: the fourteen rivulets of paint on each side are remarkably similar in their width, spacing, and undulations, suggesting that the artist carefully controlled their placement.

Louis's abstractions were fueled by his desire to produce paintings that would be about painting itself. He wanted to free abstract art from the utopian notions and moral imperatives attributed to it by the Abstract Expressionists and other painterly

abstractionists in the decade after World War II. At the same time, he admired the American gesture painters, Jackson Pollock in particular, because their styles seemed to be a direct result of their painting techniques. Although he was familiar with Pollock's limited use of staining, it was not until after he visited Helen Frankenthaler's studio in 1953 that Louis began to systematically experiment with this technique. Louis's stain paintings are even more abstract than Frankenthaler's, since his are devoid of even the minimal references to nature found in her Mountains and Sea, 1952 (see p. 282). Furthermore, Louis virtually eliminated the spatial ambiguities present in Frankenthaler's painting, choosing instead to assert the flatness of the support more forcefully. Like many formalist abstractionists, Louis worked in series, isolating and progressively refining a particular idea, format, or painterly problem. His emphasis on abstraction, opticality, and the materials of painting made him a favorite of formalist critics Clement Greenberg and Michael Fried. (R.B.)

Anthony Caro
(b. 1924, London)
Early One Morning, 1962

The open, asymmetrical configuration of linear and planar elements in Early One Morning, 1962, downplays its physicality, focusing attention instead on its pictorial qualities. The allover application of red paint, while unifying the disparate pieces, reinforces the sculpture's sense of weightlessness: the metal rods, plates, and girder segments seem to hover and float in defiance of gravity. Caro wanted to free sculpture from its reliance on the monumental, the monolithic, and the vertical, thereby creating a "more direct relation to the spectator."[1] He combined conventions from painting and sculpture in an attempt to create works that would retain their sculptural presence while de-emphasizing their materiality. The extreme horizontal extension, open arrangement of forms, and absence of a preferred viewpoint in Early One Morning encourage the viewer to circumambulate the construction. At the same time, the flat, attenuated forms and uniform paint application negate sculptural mass and volume.

Strongly influenced by formalism, the dominant mode of criticism in the 1960s, Caro tried to fuse aesthetic form and meaning into one indivisible whole. He believed that the best art is first and foremost about art itself, yet he also asserted that "abstract art which is not expressive becomes arbitrary or decorative. . . . I want people to feel moved when they look at my art; I want

to touch their deepest feelings."[2] He tried to convey emotions through subtle formal relationships between simple nonorganic forms, and through color that would express the overall mood of a piece. Early One Morning owes its airy, lighthearted feeling to its bright red color and to the quirky relationships between its abstract forms.

Caro's emphasis on the formal relationships in his works earned him the approbation of formalist critics Clement Greenberg and Michael Fried, who also admired the optical qualities of works such as Early One Morning. They argued that art must defeat its status as a luxury object by addressing itself to the eye alone. In this way, it would transcend the world of everyday things and situate itself in an ideal, quasi-spiritual realm. By using an abstract idiom that emphasizes opticality, Caro tried to minimize the objecthood of his sculptures. His abstractions represent an attempt to dematerialize sculpture, thereby removing it from the mundane world of everyday objects. (R.B.)

1. Anthony Caro, quoted in "Anthony Caro—A Discussion with Peter Fuller," Art Monthly, no. 23 (1979); reprinted in Dieter Blume, Anthony Caro: Catalogue Raisonné, 4 vols. (Cologne: Verlag Galerie Wentzel Köln, 1981), Vol. III: Steel Sculptures 1960–1980, p. 38.
2. Ibid., pp. 33, 44.

John Chamberlain
(b. 1927, Rochester, Indiana)
Spiro, 1962

Most of John Chamberlain's painted metal sculptures are fabricated from junked cars, and traces of the former lives of his materials are still evident in their new, abstract configurations. Spiro, 1962, consists of ripped, twisted, and folded planes of painted and chromium-plated steel, asymmetrically arranged to convey a sense of dynamic motion or impending explosion. At the same time, its tightly compressed forms are reminiscent of a wrecked automobile after its consignment to the compactor. The mangled surfaces—scratched, dented, corroded, and torn—speak of the violent transformation that this material has undergone on the highway, in the junkyard, and at the artist's hands. Sometimes, Chamberlain uses metal fragments as he finds them, but more often he subjects them to further manipulation in his studio. Using industrial tools (such as steel-cutting chisels, acetylene torches, bandsaws, compactors, and spray guns), he paints and reshapes the various components before assembling them. Their rough, ragged edges, burns, and tears bear witness to his destructive/creative processes.

Chamberlain's works combine

Abstract Expressionism's emphasis on spontaneity, process, and the inherent properties of materials with a 1960s preference for the vernacular. Painted scrap metal introduces color into his sculptures without being decorative, while scratches, streaks of rust, and pinstripes operate as a kind of "found" drawing. Chamberlain never worked toward some predetermined form; rather, the overall composition is the result of randomly joining pieces on the basis of their ability to hold together by themselves. After assembling the pieces, he then spot-welded each construction only to make it easier to transport and maintain. Chamberlain was aware of the erotic connotations of elements that are joined to, mounted on, coupled with, or plugged into one another: "The assembly is a fit, and the fit is sexual. That's a mode I'm working."[1] Despite these implications of sex, violence, and consumer culture, the artist disavowed any social commentary in his works. Most important for Chamberlain, scrap metal signifies the poetic potential inherent in the detritus of urban life. His works express abstraction's ability to transform even the most mundane materials into art. (R.B.)

1. John Chamberlain, quoted in Michael Auping, *John Chamberlain: Reliefs 1960–1982*, exh. cat. (Sarasota, Fla: Ringling Museum of Art, 1983), p. 12.

Tony Smith
(b. 1912, South Orange, New Jersey; d. 1980, New York City)
Die, 1962

The apparent simplicity of Tony Smith's 1962 sculpture *Die*—a six-foot cube of black steel—masks its underlying complexity. The work was inspired by numerous sources, from the mundane (a card-file box) to the mysterious (ancient standing stones) and from the classical (a drawing by Leonardo da Vinci) to the contemporary (industrial landscapes). According to Smith, the dimensions were determined by Leonardo's famous drawing of a man with outstretched arms and legs whose hands and feet mark the corners of a square. Smith undercut the humanistic implications of this reference to "man as the measure of all things," saying: "Six feet has a suggestion of being cooked. Six foot box. Six foot under."[1] The complexity (and implied threat) extends to the work's title: "die" can be understood as the imperative of the verb "to die," as well as one of a pair of dice or an industrial tool. This multitude of references sets *Die* apart from the Minimalist objects with which it shares an emphasis on reductive abstraction, nonrelational and unitary form, and industrial materials and fabrication.

Die's large size and cubic form were undoubtedly influenced by the architectural training that Smith received at the New Bauhaus in Chicago, although Smith disliked what he saw as the school's empty formalism. He also rejected the metaphysical meanings attributed to geometric abstraction by many of its practitioners. Instead, Smith's abstraction signifies his desire to destroy the boundary that separates art from everyday life. In order to shift attention from the object itself to the viewer's experience of it, he reduced visual interest to a minimum. Presented directly on the floor, without a base, *Die* aggressively confronts the viewer in his or her own space, an effect enhanced by its human scale and blank surfaces. Since it was made in a factory, it has the anti-expressive anonymity of mass-produced commodities, while its geometric regularity alludes to the monotonous artificiality of a contemporary environment composed of expressways, high-rise buildings, and factories. In one of his most famous statements, Smith described the effect that a night-time drive on the unfinished New Jersey turnpike had on his ideas about art: "I thought to myself, it ought to be clear that's the end of art. Most painting looks pretty pictorial after that. There is no way you can frame it, you just have to experience it."[2] (R.B.)

1. Tony Smith, *Two Exhibitions of Sculpture*, exh. cat. (Hartford, Conn.: Wadsworth Atheneum; Philadelphia: Institute of Contemporary Art, University of Pennsylvania, 1966), unpaginated.
2. Smith, quoted in Samuel Wagstaff, Jr., "Talking with Tony Smith," in Gregory Battcock, ed., *Minimal Art: A Critical Anthology* (New York: E. P. Dutton, 1968), p. 386.

Dan Flavin
(b. 1933, Jamaica, New York)
the nominal three (to William of Ockham), 1963

Using the light emitted from standard lengths of fluorescent tubing, Dan Flavin illuminates the role that exhibition spaces play in our perception and reception of art. Generally, exhibition spaces such as galleries and museums present themselves as neutral—and therefore optimal—spaces for viewing works of art. Their blank white walls and unobtrusive lighting systems allow the viewer to focus on the work of art with few or no distractions. The exhibition space thus becomes a metaphor for the ideal realm, far removed from the world of mundane things. The intense white light from *the nominal three (to William of Ockham)*, 1963, dramatizes the space of the gallery through the creation of strong contrasts of light and dark. These contrasts radically alter the look of

any paintings or sculptures installed nearby; they also distort the spectator's perception of the surrounding architectural space. Although his installations depend on and interact with their surroundings, Flavin rejects the term "environmental" to describe his work, because he feels that it implies "an invitation to comfortable residence" when what he intends to create are "get in and get out situations." He believes that "to confront vibrating fluorescent light for some time ought to be disturbing for most participants."[1] Flavin's emphasis on situation, perception, and confrontation links him to the Minimalists, with whom he also shares a predilection for hard-edged, abstract elements made of industrial materials. However, while most Minimalists had their objects specially manufactured, Flavin's tubes are "readymades," available from commercial supply sources.

Prior to 1963, Flavin called many of his light abstractions "icons," thereby invoking a traditional artistic analogy between light and spiritual illumination. The title *the nominal three (to William of Ockham)* exemplifies Flavin's shift from a transcendental to a more phenomenological approach to abstract art. A famous medieval English scholastic, William of Ockham argued that reality consists solely of concrete, individual things and that universals are therefore merely abstract signs. In this piece, light operates as a metaphor for both intellectual and sensory perception, for both the mysterious and the mundane. Light's mystery derives from its status as one of the most abstract sensory phenomena: it is intangible and yet palpable, for it literally makes vision possible. Flavin conflates this with the mundane by using the kind of fluorescent tubes that are ubiquitous not only in galleries but also in shopping malls and office buildings. He has explained his apparently democratic intentions for art: "I believe that art is shedding its vaunted mystery for a common sense of keenly realized decoration. Symbolizing is dwindling—becoming slight. We are pressing downward toward no art—a neutral pleasure of seeing known to everyone."[2] (R.B.)

1. Dan Flavin, quoted in *Dan Flavin: Three Installations in Fluorescent Light/Drei Installationen in fluoreszierendem Licht*, exh. cat. (Cologne: Wallraf-Richartz-Museum, 1974), p. 95.
2. Ibid., p. 89.

Agnes Martin
(b. 1912, Maklin, Saskatchewan, Canada)
Night Sea, 1963

Agnes Martin's paintings exemplify the highly charged meanings assigned to

Tony Smith, Die, *1962. Steel, 6 x 6 x 6 feet (1.83 x 1.83 x 1.83 m). (No. 2 from an edition of 3.) Collection of Paula Cooper, New York.*

Dan Flavin, the nominal three (to William of Ockham), *1963. Daylight fluorescent light, 6 feet (1.83 m) high. Solomon R. Guggenheim Museum, New York, Panza Collection 91.3698.*

Agnes Martin, Night Sea, *1963. Oil and gold leaf on canvas, 6 x 6 feet (1.83 x 1.83 m). Private collection, San Francisco.*

Bridget Riley, Current, *1964. Synthetic polymer paint on composition board, 58 ⅛ x 58 ⅞ inches (148.1 x 149.3 cm). The Museum of Modern Art, New York, Philip Johnson Fund, 1964.*

Donald Judd, Untitled, *1965. Galvanized iron, seven units, 9 x 40 x 30 inches (22.9 x 101.6 x 76.2 cm) each, spaced 9 inches (22.9 cm) apart; 9 feet (2.74 m) high overall. Moderna Museet, Stockholm.*

grids and monochromes by many twentieth-century abstractionists. When *Night Sea*, 1963, is viewed from a slight distance, its delicate vertical and horizontal lines of gold leaf seem to dissolve into the blue background, evoking the boundlessness of infinite space. Here the grid acts as ground zero, an ultimate point of origin. It represents the void before creation, an emptiness in which no form is realized and all forms are possible. The gridded composition and monochrome color also echo and emphasize the surface and shape of the canvas, giving the painting a sense of wholeness and unity. By adding slight irregularities of line and touch to her highly ordered paintings, Martin stresses the hand of the artist and avoids any hint of mechanical precision.

Although Martin's work shares certain key characteristics with that of her Minimalist contemporaries—reductiveness, repetition, hard-edged geometry, and an allover, nonhierarchical composition—her emphasis on touch and expressive feeling shows her deeper affinities with Abstract Expressionism. Although she has often given her paintings titles that are redolent of natural imagery, Martin has stated that her works are "not about the world"[1] but are rather expressions of the sublime, spiritual feelings that contemplation of natural phenomena suggests to her. Inspired by the Oriental philosophies of Taoism and Buddhism, she strives to create what she calls a "classic" art, one that is detached from the concerns of our earthly lives.[2] Most important, she defines the "classic" as abstract and antinature, for "nature is conquest, possession, eating, sleeping, procreation. It is not aesthetic."[3] Martin's abstractions represent a desire for an unattainable state of perfection in which human beings, free from the cares of the world, are in harmony with their universe. (R.B.)

1. Agnes Martin, "The Untroubled Mind," in *Agnes Martin*, exh. cat. (Philadelphia: Institute of Contemporary Art, University of Pennsylvania, 1973), p. 19.
2. Ibid.
3. Ibid., p. 17.

Bridget Riley
(b. 1931, London)
Current, 1964

Although Bridget Riley was not the progenitor of Op art—that distinction belongs to Hungarian-French artist Victor Vasarely—she was perhaps the first to produce the kind of extreme visual effects found in *Current*, 1964. This painting consists of parallel curving black and white lines, oriented vertically, with the curves elongated in the top and bottom thirds of the canvas

and condensed in the middle, making the surface seem to pulse and vibrate with barely suppressed energy. The close, repetitive juxtaposition of strongly contrasting hues creates illusory flashes of disembodied color. As in the best examples of Op art, the painting forces the spectator into an active, uneasy participation as he or she tries to reconcile the material reality of a flat, stable, black-and-white surface with the optical perception of dynamic motion and subtly shifting colors.

Riley's paintings are often inspired by natural phenomena (such as the effects of heat haze, sun glare, rain, or fog), linking her works with the light and color experiments of late-nineteenth-century Impressionist and Divisionist painters. However, unlike her predecessors, Riley does not try to present visual experience more scientifically or "truthfully." Rather, her near-hallucinatory effects are meant to convey emotions or psychic states of being: repose or disturbance, exhilaration or anxiety.

Riley's work plays upon several twentieth-century traditions of abstraction. Her rational experiments with line, color, and nonobjective composition owe a debt to artists of the Bauhaus, although she rejects their desire to integrate art and industry. While her concept of a nonhierarchical, continuous picture plane relates to Abstract Expressionism, her paintings have none of that movement's emphasis on spontaneity and personal gesture. Instead, her works are based on serial progression, repetition, and an impersonal surface. Since they are fabricated by assistants, using templates drawn to her specifications, her paintings bear no trace of the artist's hand. In this respect, she typifies the "cooler" attitudes of the abstractionists of the 1960s, particularly the Minimalists. Of the many Op artists of the period, Riley is one of the few to continue painting in this mode, although she has since shifted to works in color. Based on the premise that visual perception operates identically in all human beings, Riley's optical paintings represent an attempt to make abstraction universally accessible and meaningful. (R.B.)

Donald Judd
(b. 1928, Excelsior Springs, Missouri; d. 1994, New York City)
Untitled, 1965

In works such as the untitled sculpture of 1965 illustrated here, Donald Judd tried to drain geometric abstraction of its pretensions to cosmic or metaphysical meanings. To do this, he emphasized the work's concrete,

physical qualities, such as shape, surface, color, and texture. With its evenly spaced, identical slabs of galvanized iron, this sculpture seems to refer to nothing but itself. The neutral surfaces of these industrially fabricated units, devoid of any trace of the artist's touch, negate the notion of art as a revelation of the artist's inner being. Although he was out of sympathy with the Abstract Expressionists' attempts to infuse their works with metaphysical content, Judd admired their use of an allover, nonhierarchical design, as it matched his belief in the inherent equality of all things. Like many of the Minimalist artists with whom he is often linked, Judd rejected the idea of relational painting, in which the relationships of part to part and part to whole are carefully arranged to form a balanced composition. He turned instead to modular repetition, in which identical units are separated by equal or mathematically calculated intervals to form a symmetrical entity that emphasizes wholeness. Judd believed that serial repetition also allows each part to retain its individual integrity within the configuration of the whole: since each element is identical, none is subordinate to or dominant over another.

For Judd, artistic illusionism is deceitful. He believed that abstract, three-dimensional form signifies honesty precisely because it is nonillusory: what you see in it is real in itself and therefore more potent than any representation could ever hope to be. In Judd's words: "Three dimensions are real space. That gets rid of the problem of illusionism and of literal space, space in and around marks and colors—which is riddance to one of the salient and most objectionable relics of European art. . . . A work can be as powerful as it can be thought to be. Actual space is intrinsically more powerful and specific than paint on a flat surface."[1]

Judd created a new term, Specific Objects, to describe his work and that of several of his contemporaries, since it is neither painting nor sculpture in the traditional sense. These works are "objects" because they are three dimensional and because, lacking a pedestal, they exist in actual space rather than an isolated, idealized realm. They are "specific" in that they refer only to their own tangible properties. Despite his disavowal of transcendent meanings, Judd did not think that art is meaningless, but rather that its meanings are limited to the sensually perceivable domain of aesthetics. A prolific art critic, Judd's writings, as well as his objects, were instrumental in

disseminating the ideas and aesthetics of Minimalism. (R.B.)

1. Donald Judd, "Specific Objects," in *Arts Yearbook 8: Contemporary Sculpture* (New York: Arts Digest, 1965); reprinted in *Donald Judd: Complete Writings 1959–1975* (Halifax: The Press of the Nova Scotia College of Art and Design; New York: New York University Press, 1975), p. 184.

Robert Ryman
(b. 1930, Nashville)
Winsor 34, 1966

As white and silent as an arctic wasteland, Robert Ryman's *Winsor 34*, 1966, seeks to escape the limitations of language by insisting on the reality and primacy of visual experience. Each element emphasizes the painting's purely physical qualities. The monochromatic white focuses attention on Ryman's conflation of brushstroke, gesture, and line into an indivisible whole. Devoid of illusions or allusions, the painting seems to refer to nothing outside itself; the title of the work refers only to the Winsor & Newton brand of paint that Ryman used to make it.

Although most of the paintings that Ryman has produced since the late 1950s are white, he has stated that white has no special or symbolic importance for him, and that he chose it because it seemed the best color for exploring the relation of surface to support, texture, brushstroke, and, above all, light.[1] While any other color would create some illusion of depth, white keeps the surface flat and impenetrable; it is also the most reflective color. Visually, *Winsor 34* seems to be related to the monochromatic painting tradition exemplified by Kazimir Malevich's *White on White* paintings of 1917–18 and Yves Klein's International Klein Blue monochromes of the 1960s. However, Ryman tries to empty his paintings of the mystical or metaphysical content that these painters struggled to incorporate into their works. Ryman's aesthetic is more closely allied to that of his Minimalist contemporaries, in that he insists on art's literal qualities while eschewing its metaphorical potential, and links the work of art to its environment.

Ryman considers himself a "realist" rather than an abstractionist. In a 1991 talk, he explained that both representational and abstract art invite the viewer into an imaginary world, one that is separated from real space by the frame. Because it is unframed, *Winsor 34* reaches out to the surrounding gallery walls, incorporating them into the artwork. "Realist" painting also eliminates what Ryman calls the "picture." His painting is not a picture of or reference to anything but itself. Content becomes the "painting

itself, and the environment. It's all that you see, all that's involved in the painting—everything. The surface, light and structure, movement and composition. That's it."[2] Since there are no hidden meanings or unrealizable promises of transcendence, Ryman's paintings offer an honest, ethical art, thereby expressing an upfront attitude in tune with 1960s sensibilities. Yet despite his dislike of symbolic meanings, Ryman does want his paintings to contain a powerful charge, one that is capable of transforming the spectator. As he sees it, the goal of his monochromes is to provide "an experience of . . . enlightenment . . . of delight, and well-being, and rightness."[3] (R.B.)

1. Nancy Grimes, "White Magic," *Art News* 85, no. 6 (summer 1986), p. 90.
2. "Robert Ryman: Interview with Robert Storr," in *Abstrakte Malerei aus Amerika und Europa/Abstract Painting of America and Europe*, exh. cat. (Klagenfurt: Ritter Verlag, 1988), p. 219.
3. Ibid.

Carl Andre
(b. 1935, Quincy, Massachusetts)
10 x 10 Alstadt Copper Square, 1967

The lateral spread of Carl Andre's floor pieces—arrangements of multiple identical metal squares or rectangles laid upon the floor—challenges the notion of sculpture as a unified, vertical form. In *10 x 10 Alstadt Copper Square*, 1967, the 100 pieces of copper, each almost twenty inches square, are juxtaposed rather than joined together, giving the work "anaxial symmetry," a term that Andre uses to describe the absolute interchangeability of standardized units. Surprisingly, Andre's concept was partly inspired by Constantin Brancusi, one of the most vertically oriented sculptors of the early twentieth century. Andre particularly admired Brancusi's *Endless Column*, 1918 (fig. 52)—a work made up of numerous identical modules stacked one on top of another—for its repetition, its lack of distinction between sculpture and base, and the way it seems to drive down into the earth itself. Andre also shared Brancusi's respect for the inherent characteristics of materials: the color of this floor piece is determined by the metal itself and may change over time due to oxidation or wear and tear. But where Brancusi laboriously hand carved his sculptural elements, Andre, like his fellow Minimalists, preferred the impersonal surfaces of industrially fabricated units.

10 x 10 Alstadt Copper Square posits a new relationship between the sculpture and its surroundings. Due to its flatness and extreme horizontal extension, it aggressively "cuts" into the surrounding space, seizing and

holding a disproportionate expanse of floor given the small volume of material used. Spread upon the ground, it invites the viewer to walk upon it, annihilating the traditional taboo against touching works of art. In a recent essay, art historian Anna C. Chave convincingly argued that these floor pieces invite the viewer to enact "dramas of humiliation"[1]: the idealized work of art, knocked from the pedestal that raised it above the mundane, is both literally and metaphorically laid low. Andre, however, conceived of these sculptures as places, rather than as structures or forms. For him, the ideal sculpture would be more like a road than a building—that is, it would have no single ideal vantage point, and it would have to be experienced over time. In either case, Andre's intentions seem to be light years away from the transcendental aspirations of earlier geometric abstractionists. Through abstraction, he hopes to drain art of burdensome cultural associations, thereby enabling it to express that which cannot be expressed in any other way.[2] (R.B.)

1. Anna C. Chave, "Minimalism and the Rhetoric of Power," *Arts Magazine* 64, no. 5 (January 1990), p. 58.
2. Phyllis Tuchman, "An Interview with Carl Andre," *Artforum* 8, no. 10 (June 1970), p. 59.

Barry Le Va
(b. 1941, Long Beach, California)
Continuous and Related Activities: Discontinued by the Act of Dropping, 1967

Barry Le Va's distribution pieces focus attention on actions rather than objects and on abstract thoughts rather than abstract form. In *Continuous and Related Activities: Discontinued by the Act of Dropping*, 1967, sheets of plate glass were dropped and shattered among bolts, strips, patches, and scraps of felt. The sense of destruction and disintegration is reinforced by the apparently disorderly distribution. The parts are not evenly spread over the floor; the elements are neither equidistant from one another nor in identical groupings; and we cannot discern a simple, repeating pattern. The activities referred to in the title are readily identifiable—folding, unfolding, cutting, shredding, dropping—and show Le Va's affinity with Process art. By the late 1960s, artists pursuing this approach began to question Minimalism's emphasis on the well-built, self-contained object by using flexible materials and/or unfixed elements in ways that highlight the work's relationship to its surroundings and its response to natural forces such as gravity.

Continuous and Related Activities incorporates both deliberation and

Robert Ryman, Winsor 34, *1966. Oil on linen, 62 ½ x 62 ½ inches (158.8 x 158.8 cm). Courtesy of The Greenwich Collection Ltd.*

Carl Andre, 10 x 10 Alstadt Copper Square, *1967. Copper, 100 units, ⅟₆₄ x 19 ¹¹⁄₁₆ x 19 ¹¹⁄₁₆ inches (.5 x 50 x 50 cm) each, ⅟₆₄ inch x 16 feet 4 ⅞ inches x 16 feet 4 ⅞ inches (.005 x 5 x 5 m) overall. Solomon R. Guggenheim Museum, New York, Panza Collection 91.3673.*

Barry Le Va, Continuous and Related Activities: Discontinued by the Act of Dropping, *1967. Felt and plate glass, dimensions variable. Collection of the artist. Included in* Barry Le Va: 1968–1988, *Newport Harbor Art Museum, Newport Beach, California, January 20–April 2, 1989.*

Robert Smithson, Mirror Trail (Cayuga Salt Mine Project), *Ithaca, New York, 1969. Eight mirrors placed at evenly spaced points. Estate of Robert Smithson, Courtesy of John Weber Gallery, New York.*

Sol LeWitt, Straight Lines in Four Directions Superimposed, *1969, first executed 1974. Graphite on white wall (vertical, horizontal, and 45-degree diagonal left and right lines drawn as close together as possible, approximately 1/16 inch apart), overall dimensions variable. The Museum of Modern Art, New York, Anonymous fund in honor of Mr. and Mrs. Alfred H. Barr, Jr., 1974. Installed at the Museum of Modern Art, New York, 1974.*

chance, demonstrating Le Va's fascination with modes of ordering. Although his distribution pieces look completely chaotic, most were carefully planned in drawings done on gridded paper, with Le Va using randomness as his ordering system. The dropped sheets of glass bring chance into play in the creation of the piece, as it would be difficult to forecast the resulting configuration. Le Va said that he wants each work to "transcend its first appearance of disorder to another level of order."[1] The work implies flux and impermanence, since it can easily be reconfigured by the artist for a different space or accidentally re-arranged by anyone walking through it. However, the participation that Le Va wants from his viewers is mental rather than physical. Intrigued by mystery novels, Le Va provides visual and verbal "clues" to the principles of order underlying his works. Using these clues, the viewer's goal is to reconstruct what the artist did and thereby discover the rationale for the artwork. Ultimately, the purpose of Le Va's abstraction is to force the viewer to think abstractly, to contemplate the systems that we use to impose order on the world. (R.B.)

1. Barry Le Va, quoted in Jane Livingstone, "Barry Le Va: Distributional Sculpture," *Artforum* 7, no. 3 (November 1968); reprinted in Richard Armstrong and Richard Marshall, eds., *The New Sculpture, 1965–75: Between Gesture and Geometry,* exh. cat. (New York: Whitney Museum of American Art, 1990), p. 119.

Robert Smithson

(b. 1938, Passaic, New Jersey; d. 1973, Tecovas Lake, Texas)
Cayuga Salt Mine Project, 1969

Robert Smithson created a dialogue in his work between spaces inside and outside the gallery or museum, using the terms "site" and "nonsite" to describe this relationship. His *Cayuga Salt Mine Project*, 1969, consisted of a grouping of mirrors (the site) temporarily placed inside a salt mine; an above-ground installation (the subsite) at the Cayuga Crushed Rock Company's quarry; several pieces (nonsites—for example, fig. 219) installed contemporaneously at the Andrew Dickson White Museum at Cornell University, Ithaca, New York, which were made of rock salt and rocks taken from the mine and quarry, and mirrors; and a two-foot-square mirror supported by fossilized rocks (the subnonsite) installed in the museum's basement. *Mirror Trail*—a trail of eight mirrors, placed outdoors at equal intervals—linked the site and subsite to the nonsite and subnonsite. By gatherings from the Cayuga mine and quarry the materials that he used to make the nonsite piece, Smithson

created works that are literally a part of the landscape to which they refer. By adding mirrors to both the site and nonsites, as well as laying down a trail of mirrors between the two, he parodied the notion that art and life somehow "reflect" each other. Smithson's site/nonsite works are also puns on vision, for the viewer can only see the nonsite (nonsight) in the gallery, while the site (sight) is elsewhere and thus cannot be seen.

While the regular, abstract forms and modular compositions that Smithson used in his *Cayuga Salt Mine Project* place the work within the twentieth-century tradition of geometric abstraction, Smithson used this style to criticize the transcendental meanings attributed to it by earlier artists. According to Smithson: "There is no escaping nature through abstract representation; . . . this does not mean a renewed confidence in nature, it simply means that abstraction is no cause for faith."[1] Although the nonart materials and blank, reflective surfaces of the project's various parts resemble many Minimalist sculptures, Smithson rejected Minimalism's emphasis on the well-built, self-contained object.

Important clues to Smithson's abstraction can be found in his ideas about mapping and science. For Smithson, the map signifies the unreliability of all systems of representation (including art). He explained that the nonsite is a three-dimensional, abstract "map" of the site from which its materials were collected. But since his "map" is abstract, it defeats our normal expectations: it does not help us to picture the site or to locate it in space. Smithson was also fascinated with entropy, a scientific concept that seems to parallel his anti-utopian theories about art and life. In thermodynamics, entropy describes the tendency of all systems to move toward a state of equilibrium unless energy is inserted. Smithson interpreted this to mean that all things ultimately degenerate over time. For this reason, he always chose sites that had been eroded or damaged in some way, often by human use, such as swamps, quarries, slag heaps, and gravel pits. His orderly arrangements of mundane materials from disrupted landscapes neither romanticize the ruin nor criticize destructive industrial processes. Rather, his abstract works are meant to convey an unsentimental acceptance of death and decay as natural and inevitable. For Smithson, neither abstraction nor nature gave any cause for faith. (R.B.)

1. Robert Smithson, "Frederick Law Olmstead and the Dialectical Landscape," *Artforum* 12, no. 5 (February 1973); reprinted in Nancy Holt, ed.,

The Writings of Robert Smithson: Essays with Illustrations (New York: New York University Press, 1979), p. 122.

Sol LeWitt

(b. 1928, Hartford, Connecticut)
Straight Lines in Four Directions Superimposed, 1969

Sol LeWitt intended his abstract wall drawings to appeal more to the mind than to the eye or the emotions. To achieve this, he avoided evocative imagery by using simple abstract formal elements in preplanned, systematic compositions. He further reduced subjectivity by separating the conception of the work from its execution. LeWitt's contribution to *Straight Lines in Four Directions Superimposed*, 1969, consisted of detailed, written instructions in which he specified only that straight lines should be drawn in hard graphite in four directions—vertical, horizontal, diagonal left, and diagonal right. Like the contemporary sculptors associated with Minimalism, LeWitt followed an industrial model of art making in which the artist functions as a designer rather than a producer of art. Yet his systematic approach allows for and even encourages the incorporation of chance, as some decisions are left to the discretion of the draftsperson (in this case, decisions about the number and lengths of the lines). Additionally, LeWitt considered any errors by draftspeople and imperfections in the wall surface to be part of the work. His wall drawings combine the autonomy and timelessness of an abstract plan with the site-specificity and contingency of a particular installation.

LeWitt's artworks and writings influenced the development and appreciation of Conceptual art. He wrote, "In conceptual art the idea or concept is the most important aspect of the work. When an artist uses a conceptual form of art, it means that all of the planning and decisions are made beforehand and the execution is a perfunctory affair. The idea becomes a machine that makes the art."[1] Some of these "ideas" question cherished notions surrounding the production of art, such as authenticity, originality, and value. Traditionally, works of art (paintings, drawings, sculptures) have been defined as singular and unique objects usually produced by lone individuals. Although such works are almost always reproducible, a clear distinction has generally been maintained between the original, authentic work created by the artist's own hand and copies produced by the hands of others or through mechanical reproduction. This distinction has monetary as well as artistic value, since

the original is worth more than any reproduction of it. LeWitt's plans can and have been realized in different locations by various draftspeople; like prints or photographs, his works lend themselves to multiplicity. Theoretically, anyone could follow LeWitt's written instructions and produce a drawing on a wall. According to the artist, the result would be an "authentic" LeWitt drawing, provided that the draftsperson had conscientiously followed LeWitt's plan and had chosen an "appropriate" site.[2] (However, it would lack the "certificate of authenticity" that LeWitt issues to those who buy wall drawings from him.) By driving a wedge between the idea for a work of art and its execution, LeWitt's conceptual abstractions force us to re-examine our definitions of art and our ideas about the role of the artist. (R.B.)

1. Sol LeWitt, "Paragraphs on Conceptual Art," *Artforum* 5, no. 10 (June 1967), pp. 79–83; reprinted in *Sol LeWitt*, exh. cat. (New York: Museum of Modern Art, 1978), p. 166.
2. LeWitt, "Excerpts from a Correspondence, 1981–1983," in *Sol LeWitt Wall Drawings 1968–1984*, exh. cat. (Amsterdam: Stedelijk Museum; Eindhoven: Van Abbemuseum; Hartford, Conn.: Wadsworth Atheneum, 1984), p. 22.

Richard Serra

(b. 1939, San Francisco)
One Ton Prop (House of Cards), 1969

The oppressive weight, raw finish, and ragged edges of *One Ton Prop (House of Cards)*, 1969, emphasize its physical nature and its contingent relationship with the material world. The work consists of four lead slabs, each weighing 500 pounds, which are held upright solely through the force of gravity and their own carefully balanced weight. Since there are no permanent joins, the work only "exists" during the periods when it is on display. Thus, it points to art's dependence on time as well as space, and subverts the notion of the self-contained, transportable, and timeless object so dear to formalist abstractionists. The work's precarious verticality has a threatening undertone: one fears that an inadvertent shove could destroy its stability and send it crashing to the floor. Successful placement of this piece demands a certain amount of engineering expertise, such as knowledge of weight loads, balance principles, and leverage techniques. "The fact that the technological process is revealed," Serra wrote, "depersonalizes and demythologizes the idealization of the sculptor's craft. . . . My works do not signify any esoteric self-referentiality. Their construction leads you into their structure and does not refer to the artist's persona."[1]

Serra's denial of art's potential for self-expression or self-revelation aligns him with many artists operating in the cool intellectual climate of the 1960s, especially the Minimalists. However, Serra found Minimalism too systematic and authoritative for his taste. *One Ton Prop* repudiates the inert stability and glacial precision of the Minimalist object, replacing them with an emphasis on the material's inherent qualities and structural possibilities. As his "Verb List, 1967–68" shows, Serra's thinking at the time he created the piece was in some ways closer to that of contemporary Process artists. This document lists different types of actions to be performed and various physical properties to be explored: "to support . . . to arrange . . . of tension . . . of gravity . . . of grouping . . . of inertia."[2] Although he emphasizes art's materiality and contingency, Serra also believes that sculpture should be nonutilitarian and devoid of any references to social or metaphysical concerns. Only abstraction would enable the work to meet these seemingly disparate standards. (R.B.)

1. Richard Serra, "Extended Notes from Sight Point Road," in *Richard Serra: Recent Sculpture in Europe 1977–1985*, exh. cat. (Bochum, Germany: Galerie m, 1985), p. 12; reprinted in Rosalind Krauss, *Richard Serra/Sculpture*, exh. cat. (New York: Museum of Modern Art, 1986), p. 47.
2. Serra, "Verb List, 1967–68," in *Richard Serra: Interviews, etc. 1970–1980* (Yonkers, N.Y.: Hudson River Museum, 1980), pp. 10–11.

Louise Bourgeois

(b. 1911, Paris)
Cumul 1, 1969

Cumul 1, 1969, exhibits several of the themes prevalent in Louise Bourgeois's work: sexuality and eroticism; relationships between the one and the many; nurturing, growth, and protection; and containment, isolation, and escape. Gently pressing upward through the marble folds, the chubbily rounded cylinders suggest some strange conflation of breasts and phalluses. The individual units huddle closely together, as if to give each other warmth, comfort, and protection. One small knob is isolated from the group by a particularly long fold in the stone drapery. Bourgeois described this element cut off from its nestling counterparts as one who has made a necessary escape from a "family that is too comfortable, too tight."[1] The pristinely delineated forms and highly polished surfaces illustrate Bourgeois's concerns for craftsmanship and formal perfection. The organic shapes and the title—derived from cumulus clouds—reflect her sensitivity to natural phenomena. *Cumul 1*'s sensual, burgeoning forms would seem to fit snugly within the twentieth-century

tradition of organic abstraction. However, unlike most of its precursors in this idiom, this sculpture presents neither an idealized nor a pantheistic view of nature. Instead, Bourgeois used organic abstraction to convey the strengths and vulnerabilities of human beings and the tenuous, often anxiety-producing nature of their social relations.

Like the Abstract Expressionists, Bourgeois tries to imbue abstract art with psychologically significant content. She has said, "When you work in the school of abstraction . . . the work has to be obviously three-dimensional, but it can not be decorative only; it can not be geometric only and it can not be literal or story-telling or sentimental either. It has to be formally perfect and it has to carry a message. It can only be symbolic."[2] Although Bourgeois was never associated with the Surrealists, she does have one thing in common with this group of artists: she believes that art's primary aim is to explore and express unconscious drives and emotions. Tapping into her unconscious, Bourgeois creates "messages" that operate on both personal and universal levels. By giving her negative impulses, fears, and anxieties concrete embodiment in sculpture, Bourgeois feels that she can exorcise her personal demons. She has said, "I am able to get along with people because I do my work, because my personal problems are translated and sublimated."[3] On a more general level, the abstractness of her sculpture avoids narrative and allows the viewer to create his or her own allusions or to appreciate the work solely for its formal qualities. (R.B.)

1. *Bourgeois: An Interview with Louise Bourgeois by Donald Kuspit* (New York: Vintage Books, 1988), p. 41.
2. Bourgeois, quoted in Marsha Pels, "Louise Bourgeois: A Search for Gravity," *Art International* 23, no. 7 (October 1979), pp. 47–48.
3. Bourgeois, quoted in Lynn F. Miller and Sally S. Swenson, "Louise Bourgeois," in *Lives and Works: Talks with Women Artists* (Metuchen, N.J.: Scarecrow Press, 1981), p. 5.

Eva Hesse

(b. 1936, Hamburg; d. 1970, New York City)
Contingent, 1969

The key to Eva Hesse's eccentric abstractions is absurdity, which, according to the artist, has to do with "contradictions and oppositions."[1] In *Contingent*, 1969, it can be seen in the contrasts between the geometric and the organic, the industrial and the natural, the beautiful and the repulsive, the permanent and the ephemeral. While each of the work's eight panels is a rectangular unit, their unequal dimensions, uneven

Richard Serra, One Ton Prop (House of Cards)*, 1969. Lead antimony, four units, 48 x 48 x 1 inches (122 x 122 x 2.5 cm) each. The Museum of Modern Art, New York, Gift of the Grinstein Family, 1986.*

Louise Bourgeois, Cumul 1*, 1969. Marble, 22 ⅛ x 50 x 48 inches (56.8 x 127 x 121.9 cm). Musée National d'Art Moderne, Centre Georges Pompidou, Paris.*

Eva Hesse, Contingent*, 1969. Cheesecloth, latex, and fiberglass, eight units, 12 feet ⅛ inch x 3 feet ⅛ inch (3.68 x .93 m) to 9 feet 4 ¹⁄₁₆ inches x 3 feet 2 ⁵⁄₁₆ inches (2.85 x .98 m) each. National Gallery of Australia, Canberra.*

Brice Marden, Range, *1970. Oil and wax on canvas, 5 feet 1 inch x 8 feet 9 inches (1.55 x 2.67 m). Courtesy of Matthew Marks Gallery, New York.*

Jackie Winsor, Bound Square, *1972. Wood and twine, 6 feet 3 ½ inches x 6 feet 4 inches x 14 ½ inches (1.92 x 1.93 x .37 m). The Museum of Modern Art, New York, Joseph G. Mayer Foundation, Inc., in honor of James Thrall Soby and Grace M. Mayer Fund in honor of Alfred H. Barr, Jr., 1974.*

Robert Mangold, Circle In and Out of a Polygon 2, *1973. Acrylic and black pencil on canvas, 6 feet ⅛ inch x 6 feet ⅞ inch (1.83 x 1.84 m). Solomon R. Guggenheim Museum, New York, Panza Collection 91.3771.*

edges, and varying surfaces subvert the geometric regularity. The distance between *Contingent*'s eight panels can be expanded or contracted to fit the space available; the work is therefore "contingent" upon its surroundings. The play of light over and through the thin sheets of translucent fiberglass and opaque rubberized cheesecloth gives this sculpture a fragile, ethereal quality that seems out of sync with its materials' industrial origins. Its warm, glowing color creates a sensual appeal, yet its beauty is held in check by an intimation of decay, an effect produced by the somewhat battered-looking surfaces and by the way the panels hang from metal hooks like animal hides. Its panels seem to sag in response to gravity, and although they look malleable, they are actually fixed and stable, since fiberglass and latex both harden as they dry. Degeneration is not only metaphorically but also literally present, for while fiberglass is a stable, permanent material, latex is fugitive, deteriorating over time.

Since Hesse's work blends aspects of several traditions of abstraction, incorporating geometric, biomorphic, and expressive elements, it does not fit neatly into any art-historical category. Like Minimalist or ABC artists, she often used repeating modules made of industrial materials, but her repetition highlights difference rather than sameness, calling attention to the subtle variety among similar, rather than identical, units. Hesse also saw repetition as a means to heighten the absurdity of a piece through exaggeration. Her work also relates to Anti-Form art of the late 1960s, soft and/or impermanent constructions created partly in reaction to Minimalism's idealization of the rigid, well-built object. Most important, Hesse shared the Abstract Expressionist painters' desire to infuse purely abstract form with highly personal and expressive meanings. (R.B.)

1. Eva Hesse, quoted in Cindy Nemser, "An Interview with Eva Hesse," *Artforum* 8, no. 9 (May 1970), p. 60.

Brice Marden
(b. 1938, Bronxville, New York)
Range, 1970

Range, 1970, emphasizes the two-dimensional plane, which for Brice Marden is one of painting's key characteristics. Although the work's three panels are of different colors—mustard yellow and medium and dark greenish-grays—the painting remains resolutely flat, with no sense of spatial expansion or recession. Marden created this effect by equalizing both the color

density and the size and shape of each panel. The sense of flatness is enhanced by Marden's technique of mixing wax and turpentine into his oil paints. The work's thick, smooth surface, which betrays little evidence of the artist's touch, calls attention to the literal physicality of the painting, as paint and canvas seem to be one indivisible whole. Since the only lines are those created by the juxtaposition of the three panels, Marden conflated the "real" and the painted edges, further emphasizing the painting's objectlike quality.

Range's reductive abstraction, geometric form, neutral surfaces, and emphatic literalism show Marden's affinities with his Minimalist contemporaries. However, Marden found Minimalism's emphasis on the facticity of painting, its "what you see is what there is" attitude, too cynical for his taste. He said: "Art isn't about cynicism; it's about faith and hope. This is a romantic point of view that is anathema to a certain sector of the art world, but the way that sector sees and talks about art is anathema to me."[1]

Marden's panel paintings blend the legacies of two streams of abstraction: a materialist tradition, which values painting's purely formal qualities (such as line, shape, color, and support) as ends in themselves; and a romantic conception, which underscores the expressive potential of those same formal qualities. Despite the "Spartan limitations" and "strict confines" of his austere canvases, Marden saw them as "highly emotional paintings not to be admired for any technical or intellectual reason but to be felt."[2] Marden intended the somber, muted colors of his works to carry the expressive charge. Although he avoided any dogmatic pronouncements regarding art's ability to transcend its material origins, Marden candidly admitted that he preferred to believe in art's mystical or spiritual powers.[3] While his style and technique undeniably call attention to the painting's concrete materiality, he claimed that "the rectangle, the plane, the structure, the picture are but sounding boards for a spirit."[4] (R.B.)

1. Brice Marden, quoted in Lilly Wei, "Talking Abstract, Part One," *Art in America* 75, no. 7 (July 1987), p. 83.
2. Marden, unpublished Master of Fine Arts thesis, Yale University, New Haven, Conn., 1963, pp. 3–4; quoted in Linda Shearer, *Brice Marden,* exh. cat. (New York: Solomon R. Guggenheim Foundation, 1975), p. 11.
3. "Brice Marden: Interview with Robert Storr," in *Abstrakte Malerei aus Amerika und Europa/Abstract Painting of America and Europe,* exh. cat. (Klagenfurt: Ritter Verlag, 1988), p. 67.
4. Marden, quoted in John Yau, "Brice Marden," *Flash Art,* no. 142 (October 1988), p. 94.

Jackie Winsor
(b. 1941, Newfoundland, Canada)
Bound Square, 1972

Jackie Winsor's *Bound Square,* 1972, has the brute simplicity of natural phenomena, but here nature has been subjected to the rigid human order of geometric form. The sculpture consists of four logs whose interlocking notched ends are hidden beneath heavy bindings of twine. The rough-hewn surfaces, uncomplicated structure, and bulky heft give *Bound Square* a raw physical presence evocative of the great outdoors. Yet Winsor's meticulous, almost obsessive process emphasizes the human labor required to shape recalcitrant natural materials. In a labor-intensive procedure, she unraveled the twine from larger hemp rope, knotted the strands together, then lashed the four corners. Winsor combined the Minimalists' preference for geometric form and well-built objects with the Process artists' respect for the inherent qualities of materials. While the work's square shape and carefully crafted construction are the result of the artist's transformation of raw matter, its massive scale, earthy colors, and rugged textures seem to have been determined by the materials themselves.

Bound Square stands in the viewer's space, relating to its surroundings in an aggressively three-dimensional manner. In one sense, it can be read as an analogue of the human body; Winsor drew a comparison between the lengthy, repetitive process of making it and the wealth of experiences undergone by an elderly human being. The rope-and-wood structure also has the look and weight of an archaic architectural element. At the same time, it acts as a pictorial "frame" for the blank white gallery wall that it leans against. Ultimately, however, Winsor's sculpture signifies the integrity and self-sufficiency of abstract form itself. Winsor rejected figuration because it creates only an illusion of reality, while abstraction, she believed, can create its own kind of "physical reality." In the artist's words: "I'm interested in what is holding things together and in presenting you with the real, in a real way so you get to read what that realness is about."[1] (R.B.)

1. Jackie Winsor, quoted in John Gruen, "Jackie Winsor: Eloquence of a 'Yankee Pioneer,'" *Art News* 78, no. 3 (March 1979), p. 59.

Robert Mangold
(b. 1937, North Tonawanda, New York)
Circle In and Out of a Polygon 2, 1973

Circle In and Out of a Polygon 2, 1973, suggests that geometry can be distorted or subverted, like any human system.

In this way, Robert Mangold questioned the utopian meanings attributed to geometric abstraction by many twentieth-century artists. Here, two regular, stable—and therefore "ideal"—geometric forms are created by the witty interplay of drawn lines and the shape of the canvas. While the penciled lines activate the painted field, the interpenetration of circle and polygon, of drawing and shaped support, prevents the establishment of a figure-ground relationship. Mangold further avoided any illusion of depth by using a roller to create a uniform, monochromatic surface. The reductive abstraction, anonymous paint facture, and single-image format of this work show why Mangold was one of the few painters to be commonly linked with Minimalism. However, his finely nuanced color and morphing shapes add a touch of human warmth and humor to Minimalism's cool impersonality and mechanical precision.

Mangold described his first exposure to Abstract Expressionism as a "religious conversion," because it showed him that abstract painting, though devoid of overt symbols, could be infused with content and thereby transcend the merely decorative.[1] Yet like many American artists who came of age in the 1960s, he disavowed the metaphysical implications and utopian political notions attributed to abstraction by the American gestural and Color-field painters of the 1940s and 1950s. "I think [abstraction]'s a language," Mangold explained, "and you either can get involved in it or you can't. . . . But I don't think that abstraction as such has a connection any more to a progressive idea of politics, or even an implicit content."[2] Instead, Mangold defined abstraction's "content" as an unspecifiable yet powerful emotional charge evoked by the interplay of formal elements. While he rejects any political implications to abstraction, Mangold attributes to it a moral dimension, believing that abstraction, by eliminating all references to anything outside painting, is the most direct, clear-cut, and honest way to make a statement. His reductive abstractions express directness and honesty through bold, frontal designs, flat colors, and simple compositions. (R.B.)

1. "Robert Mangold: Interview with Robert Storr," in *Abstrakte Malerei aus Amerika und Europa/ Abstract Painting of America and Europe*, exh. cat. (Klagenfurt: Ritter Verlag, 1988), pp. 182, 188.
2. Ibid., p. 187.

Daniel Buren

(b. 1938, Boulogne-Billancourt, France)
Within and Beyond the Frame, 1973

Daniel Buren's *Within and Beyond the Frame*, 1973, plays upon notions of inside and outside and calls attention to the way art-world contexts "frame" our perception of objects. A site-specific work consisting of nineteen black-and-white-striped cloth panels, *Within and Beyond the Frame* was installed at the John Weber Gallery in New York in 1973. The panels were suspended on two ropes at three-foot intervals and strung across the gallery, through an open window, and across West Broadway to a building on the opposite side of the street. The work exemplifies Buren's ideas about the sociopolitical functions of museums and galleries. He argued that museums and galleries are "privileged places" with three fundamental roles—aesthetic: they protect artworks from the ravages of the real world such as weather, vandalism, and political interference, thereby endowing them with the false appearance of immortality and timelessness; economic: art institutions insure sale values through selective collection and exhibition practices; and mystical: simply placing artifacts within a recognizably artistic milieu supposedly strips them of their economic and political functions, transforming them into idealized works of "art."[1]

Within and Beyond the Frame highlights these roles through the juxtaposition of art and nonart contexts. The motionless, pristine panels inside the gallery seemed to be unaffected by their surroundings, while those outside obviously responded to changing conditions, billowing, sagging, fading, and shredding according to the weather. Inside the gallery, the status of "art" was conferred on the industrially produced canvas panels, and while gallery visitors would have seen the panels outside as part of the artwork, they probably seemed to casual passers-by to be decorative banners. Since the piece was a temporary installation, theoretically it had no sale value; indeed, the canvas pieces were probably destroyed after the exhibition.

Although Buren's work incorporates some of the aesthetic elements of Minimalism, such as seriality, neutrality, and industrial fabrication, his hard-edged abstraction has a more overtly political agenda. Paraphrasing the French writer Roland Barthes's famous 1950s manifesto *Writing Degree Zero*, Buren stated that he wished to produce "painting at the zero degree," implying a painting devoid not only of metaphysical implications and personal expression but of any intrinsic meaning whatsoever. Instead, all meaning would come from the work's relationship with the world around it. To achieve this, Buren limited his materials to vertical stripes precisely 8.7 centimeters wide, woven or printed onto a support and alternating white with one other color (see also fig. 234). Only the color and the overall width and height of the work could vary. He believed that the standardized format and commercially produced materials of his work ensures impersonality and anonymity, debunking the notion of art as a unique and precious commodity. Buren asserted that the "work can neither be seen nor apprehended in itself, but only exists in connection with something beyond, which must always be re-defined." This "something beyond" is the work's context, its "ideological, cultural and material support."[2] Buren's striped abstractions destroy the myth of an ideal, autonomous art, isolated and insulated from the vulgar concerns of the material world. Instead, they point to the political functions of art and the institutions that protect, preserve, and promote it. (R.B.)

1. Daniel Buren, "Function of the Museum" (1970), in Richard Hertz, ed., *Theories of Contemporary Art* (Englewood Cliffs, N.J.: Prentice-Hall, 1985), pp. 189–92.
2. "Daniel Buren: An Interview with Jean-Marc Poinsot," *Art and Artists* 8, no. 4 (July 1973), p. 24.

Walter De Maria

(b. 1935, Albany, California)
The Lightning Field, 1974–77

Walter De Maria's *The Lightning Field*, 1974–77, consists of 400 stainless-steel poles arranged in a grid over an area of land in New Mexico measuring one mile by one kilometer. During storms, the poles provide a focal point for lightning, one of nature's most powerful and spectacular effects. An example of American Earth Art of the late 1960s and 1970s, the work posits a new relationship between art and nature: instead of merely depicting nature, *The Lightning Field* directly engages with it on its own turf. "The land is not the setting for the work," De Maria explained, "but a part of the work."[1]

The Lightning Field demarcates boundless, undifferentiated space and geographically orients the viewer, its rectangular grid providing direction on the trackless plain. Here, Minimalism's penchant for industrial materials, factory fabrication, and serial progression is nearly subsumed into the natural setting. Virtually no trace of the industrial processes of construction and installation can be found, but instead, the poles seem to sprout from the ground as naturally as the surrounding scrub. In the glare of midday, the highly polished poles hover at the edge of visibility; at sunrise and sunset, they glow with reflected light and color.

Daniel Buren, Within and Beyond the Frame, *1973. Striped canvas and rope, dimensions variable. Installed at John Weber Gallery, New York.*

Walter De Maria, The Lightning Field, *1974–77. Stainless steel; average height of poles: 20 feet 7 ½ inches (6.29 m); 5,280 x 3,300 feet (1.61 x 1.01 km) overall. Courtesy of Dia Center for the Arts, New York.*

Martin Puryear, Some Tales, *1975–77. Ash and yellow pine, approximately 30 feet (9.14 m) long. Panza Collection.*

Richard Long, A Circle in Alaska: Bering Straight Driftwood on the Arctic Circle, *1977. Photograph, 34 ⁷⁄₁₆ x 48 ¼ inches (87.5 x 122.5 cm). Courtesy of Anthony d'Offay Gallery, London.*

The work is subtle and self-effacing, constantly deflecting attention away from itself and toward the landscape in which it is embedded. Yet the gridded configuration also hints at an ambivalence toward the land, for it suggests both the desire to directly experience nature's wild beauty and a respectful fear of its power with a concomitant desire for control. De Maria rejected the romantic notions of many geometric abstractionists, who saw the grid as a "ground zero," or primal and natural point of origin. De Maria's grid signifies an abstract, arbitrary human system, one often used to superimpose a semblance of order onto the earth's irregular surface. That this order and the control it implies are illusory becomes chillingly obvious when lightning courses through the work during electrical storms. *The Lightning Field* gives new resonance to the eighteenth-century concept of the Sublime, a term describing natural phenomena that evoke both wonder and terror by suggesting the solitude and vulnerability of human beings in the face of nature's awesome power. Here, this power has been deliberately intensified through human intervention. Even on the balmiest, most idyllic days, the poles imply the danger of potential lightning strikes.

While more people have experienced the work through photographs than through visits to the site, De Maria claimed that no reproduction could adequately represent *The Lightning Field.*[2] For him, the sky-ground relationship is a central component of the work, and one that must be experienced in person. During lightning activity, the connections between earth and sky and between human order and natural chaos violently manifest themselves through this abstract earthwork. (R.B.)

1. Walter De Maria, "The Lightning Field," *Artforum* 18, no. 8 (April 1980), p. 58.
2. Ibid.

Martin Puryear

(b. 1941, Washington, D.C.)
Some Tales, 1975–77

Martin Puryear's organic abstractions seem to bridge the division between nature and culture. The six wooden elements that comprise *Some Tales*, 1975–77, have the brute simplicity of raw, unworked materials, but close inspection reveals the artist's role in shaping them. The notches on the saw-toothed piece gradually shift in orientation along its length, for example, and most of the seemingly natural shapes of the other elements have been formed from separate pieces of wood carefully joined together. Puryear's eccentric abstraction was both

influenced by and a reaction against the Minimalist aesthetic of the 1960s and early 1970s. While he admired the "purity and simplicity" of the reductive, geometric forms of Minimalist objects, Puryear was opposed to the distance created by their anonymous surfaces, industrial materials, and factory fabrication.[1] Searching for a more individualized, expressive style, Puryear generally chose natural materials and organic forms. His careful workmanship shows an obvious pride in meticulously crafting objects by hand and an admiration for handicraft techniques and traditions. By using methods normally associated with carpentry and the building trades, Puryear conflates the high and low arts and reaffirms the dignity of human labor.

Through abstraction, Puryear creates poetic objects open to multiple meanings. The elements of *Some Tales* are reminiscent of primitive farming or hunting implements, and the artist himself has compared the work to an Incan *quipu*, a mnemonic device used to calculate and to record.[2] The linear, horizontal configuration is suggestive of writing, the artwork forming a "text" consisting of visual, rather than verbal, signs. Puryear believes in the primacy and uniqueness of visual expression, feeling that art can express things that language cannot. He said: "I believe in work that defines itself and describes itself to the world, nakedly. . . . I know that in a situation as complex as we live in now it's a kind of ridiculous hope that art can still speak directly. I think finally it is is a question of faith."[3] His faith in art's ability to express emotions and ideas viscerally and directly links him to a tradition that posits abstraction as a kind of universal language, impervious to the limitations of cultural conventions. (R.B.)

1. Steven Henry Madoff, "Sculpture Unbound," *Art News* 85, no. 9 (November 1986), pp. 104–05.
2. Neal Benezra, "'The Thing Shines, Not the Maker': The Sculpture of Martin Puryear," in Benezra, *Martin Puryear*, exh. cat. (New York: Thames and Hudson; Chicago: Art Institute of Chicago, 1991), p. 25.
3. Martin Puryear, quoted in Dwight V. Gast, "Martin Puryear: Sculpture as an Act of Faith," *The Journal of Art* 12, no. 1 (September–October 1989), p. 7.

Richard Long

(b. 1945, Bristol, England)
A Circle in Alaska: Bering Straight Driftwood on the Arctic Circle, 1977

Through the simple physical activity of walking, Richard Long conflates art and life, nature and culture, the abstract and the concrete. He began transforming his rambles into art in 1967, when, for *A Line Made by Walking*, he walked back and forth across an English meadow until the grass was

sufficiently trampled to show as a line when he photographed it. Since then, he has made numerous walks, not only in his native England but also in Europe, Asia, Africa, the Americas, and Australia. For each, Long created one of three kinds of works to document his experience: a word piece; a map marked with the route of his walk; or a photograph of a sculpture made with materials found at the site. These works mount a subtle critique of art's commodification—since Long's artworks consist of transitory activities and ephemeral sculptures, they cannot be bought or sold, although documents of them can.

For *A Circle in Alaska: Bering Straight Driftwood on the Arctic Circle*, 1977, Long stopped at an unidentified spot while making a walk in Alaska and constructed a circular sculpture using driftwood found at the site. The sculpture's shape makes a subtle allusion to its location somewhere on the Arctic Circle. Unobtrusive and ephemeral, the piece reveals Long's respectful attitude toward nature: the elements, carefully arranged but unfixed, were probably scattered by the very next tide. Motivated by a desire to incorporate the experiences provoked by the natural landscape into art, Long defined his sculptures as "abstract art laid down in the real spaces of the world."[1]

Despite his strictly abstract vocabulary, Long considers himself a realist: "My work is real, not illusory or conceptual. It is about real stones, real time, real actions."[2] His use of real space, geometric form, quotidian materials, language, and photography point to his affinities with the Minimalist and Conceptual artists of the 1960s. However, he differs from the Minimalists in his use of natural, rather than industrial, materials and in the way his work directly engages the landscape. He also tended to place a much stronger emphasis on purely formal elements than most Conceptual artists. *A Circle in Alaska*, for example, can be appreciated solely for its play of light and dark, and the contrast of its circular form with the strong horizontals of the waterline and the horizon. Long's simple abstract shapes and natural materials express the balance between the "patterns of nature" and the "formalism of human, abstract ideas like lines and circles."[3] Where earlier geometric abstractionists turned to these forms in an attempt to transcend nature, Long, by placing abstractions in the landscape, points to our inescapable position within the natural world. (R.B.)

1. Richard Long, "Words After the Fact" (1982), in R. H. Fuchs, *Richard Long* (New York: Thames and

Hudson, 1986), p. 236.

2. Long, "Five Six Pick Up Sticks, Seven Eight Lay Them Straight" (1980), in ibid., p. 236.

3. Long, quoted in "An Interview with Richard Long by Richard Cork," in *Richard Long Walking in Circles*, exh. cat. (London: Hayward Gallery, 1991), p. 250.

Robert Irwin

(b. 1928, Long Beach, California)
48 Shadow Planes, completed 1983

Convinced that no art transcends its immediate environment, Robert Irwin tries to create artworks determined entirely by their site. Accordingly, the form and placement of *48 Shadow Planes*, which was completed in 1983, resulted from qualities of the architectural space within which the work is located—the nine-story atrium of the Old Post Office in Washington, D.C. The forty-eight rectangular planes of stretched scrim, suspended from the atrium skylight on stainless-steel wires in a gridded arrangement, echo the windowlike openings in the surrounding ambulatories. The work's Minimalist vocabulary provides a surprisingly broad range of effects. As the viewer's perspective shifts while he or she walks through the space, the grid alternately veils and reveals architectural details. The screens respond to the natural light flooding the atrium from the skylight, ranging from transparent to nearly opaque depending on the time of day and the weather.

Irwin has described his art as "phenomenal" and "nonobjective."[1] Like many American artists during the 1970s, Irwin was intrigued by the phenomenology of philosopher Maurice Merleau-Ponty, who held that "reality" is not some absolute external entity but is rather a function of perception and therefore constantly in flux. According to Irwin's interpretation, "phenomenal art" emphasizes the viewer's perception of the mutable effects caused by the interplay of light and space rather than calling attention to the self-contained art object. For him, the purpose of art is not to convey metaphysical meanings or sociopolitical messages, but only to further "aesthetic inquiry." Irwin hoped to empty his works of all extraneous, metaphorical meanings through nonobjectivity, which also allowed him to deflect attention from the object and onto the surrounding environment, articulating and enhancing the site's inherent qualities. As a result, Irwin's work challenges the traditional conception of artworks as discrete objects, offering a definition of art as a way of perceiving the ever-changing phenomena of the world. (R.B.)

1. Robert Irwin, *Being and Circumstance: Notes Toward a Conditional Art* (Larkspur Landing, Calif.: Lapis Press, 1985).

Gerhard Richter

(b. 1932, Waltersdorf, Germany)
Ozu, 1986

Gerhard Richter's *Ozu*, 1986, simultaneously affirms and denies gestural abstraction's potential for personal expression and transcendence. It also exemplifies the artist's dialectical approach to painting, in which he counterposes irreconcilable opposites such as reality and illusion, the personal and the impersonal, spontaneity and control. At first glance, *Ozu* seems to have the spontaneous brushwork, emotive color, and formless composition that signify immediacy and authenticity in Abstract Expressionist works. Closer inspection, however, reveals that Richter's painting was carefully and deliberately constructed in multiple layers, a working method that serves to destroy the expressive mark of the artist. Richter begins by covering the canvas with large, gestural strokes of paint, but then obliterates them—because he finds them too beautiful—by dragging a brush, painting spatula, or palette knife across the surface while it is still wet. These scraped striations of paint have all the "immediacy" and "personal expressivity" of television static. *Ozu*'s smoothly painted areas of cool blacks and bilious greens—at top center, bottom left, and bottom right—seem to recede in space, pushing the more brightly colored and roughly textured sections forward. The apparent solidity of the dark tubular form at center right seems to be melting in the hot, screaming colors of a blast furnace or an erupting volcano. The simulation of three-dimensional space reminds us of painting's illusory nature in relation to the external world.

Richter sees reality as elusive, uncertain, and ungraspable. He believes that we can only know it through models—representations in which we translate our perceptions of reality into some particular form, whether visual or verbal, figurative or abstract. While he underscores the importance of remembering that representation is just interpretation and is therefore always subjective, incomplete, and imperfect, Richter thinks that abstract paintings may make better models than figurative ones. Abstractions, he said, show a reality that is invisible and indescribable but that we nevertheless believe exists, and we usually express it in negative terms, as the unknown, the incomprehensible, the infinite. "For thousands of years we have described it with ersatz pictures with heaven, hell, gods, devils. —With abstract painting we created a better possibility to approach that which cannot be grasped or understood, because in the most concrete form it shows 'nothing.'"[1] In other words, abstract painting shows "nothing" but the characteristics of painting itself, and since it presents no recognizable person or object from the material world, it can function as a signifier of an immaterial reality. Richter emphasizes painting's constructed and illusionary nature lest we mistake the signifier (painting) for the signified (unknowable reality). He intends his abstract paintings to provide not definitive but possible models for an ineffable reality that lies forever beyond our grasp. (R.B.)

1. Gerhard Richter, statement, in *Documenta 7*, exh. cat. (Kassel: Documenta, 1982), vol. 1, pp. 84–85; quoted in Anne Rorimer, "The Illusion and Reality of Painting," in *Abstrakte Malerei aus Amerika und Europa/Abstract Painting of America and Europe*, exh. cat. (Klagenfurt: Ritter Verlag, 1988), p. 101.

Robert Irwin, 48 Shadow Planes, *completed 1983. Old Post Office atrium, Washington, D.C., Commissioned by the General Services Administration, Art-in-Architecture Program.*

Gerhard Richter, Ozu, *1986. Oil on canvas, 8 feet 6 ¼ inches x 13 feet 1 ½ inches (2.6 x 4 m). Private collection, Chicago.*